THE ARTS
OF MANKIND

EDITED BY ANDRÉ MALRAUX
AND ANDRÉ PARROT

HELLENISTIC ART

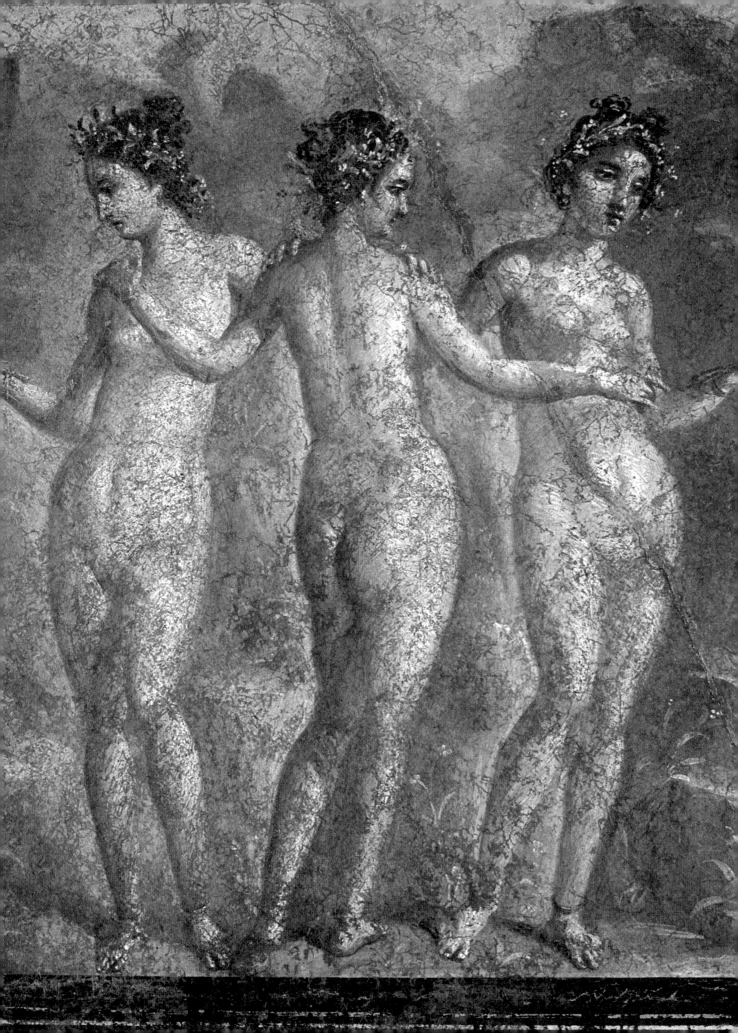

J. CHARBONNEAUX R. MARTIN F. VILLARD

HELLENISTIC
ART

330-50 BC

THAMES AND HUDSON

Translated from the French
GRÈCE HELLÉNISTIQUE
by Peter Green

Published in Great Britain in 1973 by
THAMES AND HUDSON LTD, LONDON

English translation © 1973 by Thames and Hudson Ltd, London,
and George Braziller Inc., New York

© 1970 Editions Gallimard, Paris

Printed in France

ISBN *0 500 03017 0*

Contents

VALEDICTION FOR JEAN CHARBONNEAUX

On 27 February 1970, a little over a year after the death of our much-lamented colleague and fellow-scholar Jean Charbonneaux, Pierre Demargne gave an address in his memory at the Institut de France. It was a moving and evocative occasion for everyone present, but especially for those who, over the years, had shared the same inspiring task: the conservation and enrichment of a museum, in Charbonneaux's case the Louvre.

In the account of his works, it was inevitable and fitting that reference should be made to the *Arts of Mankind* series, and particularly to those three volumes which, from their inception, were to be under Charbonneaux's special care. This ambitious plan proved triumphantly successful but, unhappily, fate was to prevent its complete fulfilment, for only two of the original French editions were finished at the time of his death. Charbonneaux lived to see *Grèce Archaïque* [*Archaic Greek Art*, 1971] on display in the bookshops and, at the time of his fatal accident, he knew that *Grèce Classique* [*Classical Greek Art*, 1973] would soon be off the presses. His contribution to this third volume, for which – as with its two predecessors – he was once again to write the section on sculpture, still lay on his desk in the form of a rough draft and a sequence of ideas expressed in the illustrations he had chosen. This material was too sketchy to publish as it stood, yet not to have used it at all would have been a sad loss. Jean Marcadé, who undertook to 'edit and adapt' Charbonneaux's notes, thus providing the illustrations with their essential commentary, has carried out his task with a nicety of judgment which should not be passed over in silence, but has modestly placed his own signature below that of the scholar on whose ideas this section is based.

The name of Jean Charbonneaux, then, figures in this third volume as a final, solemn farewell. In this Greek cycle, 'one of the very finest periods of artistic creativity' in Roland Martin's words, it becomes increasingly clear as time goes on that Jean Charbonneaux's contribution was one of capital importance, not only because of his enthusiasm and exhaustive knowledge, but particularly because of that sensibility which always enabled him to penetrate to the heart of the matter, to the essential spirit of Hellas. We are the poorer for his passing, but, happily, we still possess his books. These form a spiritual – and artistic – testament that is sure to survive the test of time.

ANDRÉ PARROT

Preface

The word 'Hellenistic' has often been misused in the sort of wider context where 'Hellenizing' would be more appropriate; whereas, when applied to works of arts, it properly denotes those produced in areas of Greek influence between the latter part of the fourth and the middle of the first centuries B.C. Even so, Hellenistic art is a hard concept to define, for it is hard to pin down the traits in which its individuality lies or to define the features common to a variety of artistic forms of expression as well as to different geographical areas.

Though Greek art was first revealed to the artists and literati of the seventeenth and eighteenth centuries through Hellenistic works discovered in Rome and elsewhere in Italy, these works still remain to a great extent elusive and indefinable, as hard to interpret stylistically as in terms of content and context. One reason for this is that far too many of them remain anonymous. A second is that, especially in the field of painting, all we have to go on are numerous low-quality copies, reproductions and imitations, turned out at a later date, of originals which have not come down to us; two or more replicas of a great work, however meritorious they may be, cannot match a signed original when it comes to conveying the personality of the artist.

Furthermore, the various centres of art shift, multiply, and change as a unified civilization develops in new regions of the ancient world. The basis of this civilization is Greek language, thought and art, but these are filtered through a variety of very different political, administrative, and ethnic patterns. While the studio-workshops of Pergamum are familiar to us through numbers of signed and dated works, those of Rhodes or Alexandria have not yielded sufficient firm attributions for us to assess their originality or to estimate the contribution they made to the common culture.

It is nevertheless true that, because of its very mysteries and ambiguities, Hellenistic art exercises a very special attraction; for it fashioned and elaborated that heritage which the Greek world transmitted to the West, and strongly influenced certain artistic movements in the Middle East which paved the way for Islamic civilization. Despite its diversity, it does not lack unity. The political changes and developments which the Greek world underwent after the death of Alexander transformed classical art – permeated and inspired as it had been by the life of the *polis*, and of the various political communities that evolved within the clearly-defined limits of the city-state –

into something far more individualistic (for proof one need only study the development of the portrait), and brought it into the service of Hellenistic royalty. Greece under these monarchies provided a favourable climate for the development of 'Court art'.

Nevertheless, there was no direct break with the past. The period of preparation went on a long time, and the changes were both slow and subtle. From the middle of the fourth century, however, one can detect signs of new trends in works that are still classical. Indeed the two elements sometimes co-exist on one and the same monument – e.g. the friezes of the Mausoleum at Halicarnassus, the execution of which was entrusted to four sculptors of widely divergent personality – or even in a single artist: the work of Lysippus is already strongly characterized by tendencies that become widespread during the next century.

This State-backed art, often designed to enhance the glory and prestige of princes, tends to enlarge volume and proportions in both sculpture and architecture, and encourages a splendid efflorescence of decorative mural painting, which seeks to broaden and enlarge both surfaces and masses by means of sensational architectural groupings. The result is an aim common to every field of artistic expression, a constant struggle to conquer space in all its dimensions.

One method of achieving this is by structuring space in clearly defined and limited masses, where the effects of architectural plasticity are organized in an ordered manner. Another is by the development of infinitely varied rhythms through giving vibrancy to all spatial elements in every direction; works of sculpture such as the Aphrodite of Cnidus or the Victory of Samothrace move within their own space, which they have freely conquered and assimilated. In painting progress in the mastery of colour makes it possible to perfect this conquest through a more subtle mastery of light and shade, which the artist could employ on draperies as well as on monumental façades.

That gusto for life which animates every aspect of this period breathes fresh vigour into its artistic creativity – sometimes producing excesses which taste does not invariably tone down. It manifests itself in touching and sometimes tragic expressions; by its tendency to accentuate relief-work and musculature, or to produce emphatic contrasts in architectural or pictorial compositions; and through a striving after the picturesque in subject-matter, attitudes, and alliances of form or colour – a trend which also emerges in markedly hominocentric interpretations of religious or mythological themes.

With all its variety and multiplicity, its movement and colour, its simultaneous embodiment of the plastic and the pictorial, Hellenistic art achieves unity – and provides a link between every field of artistic creation – through its constant striving after bold and vigorous expression.

ROLAND MARTIN

Architecture

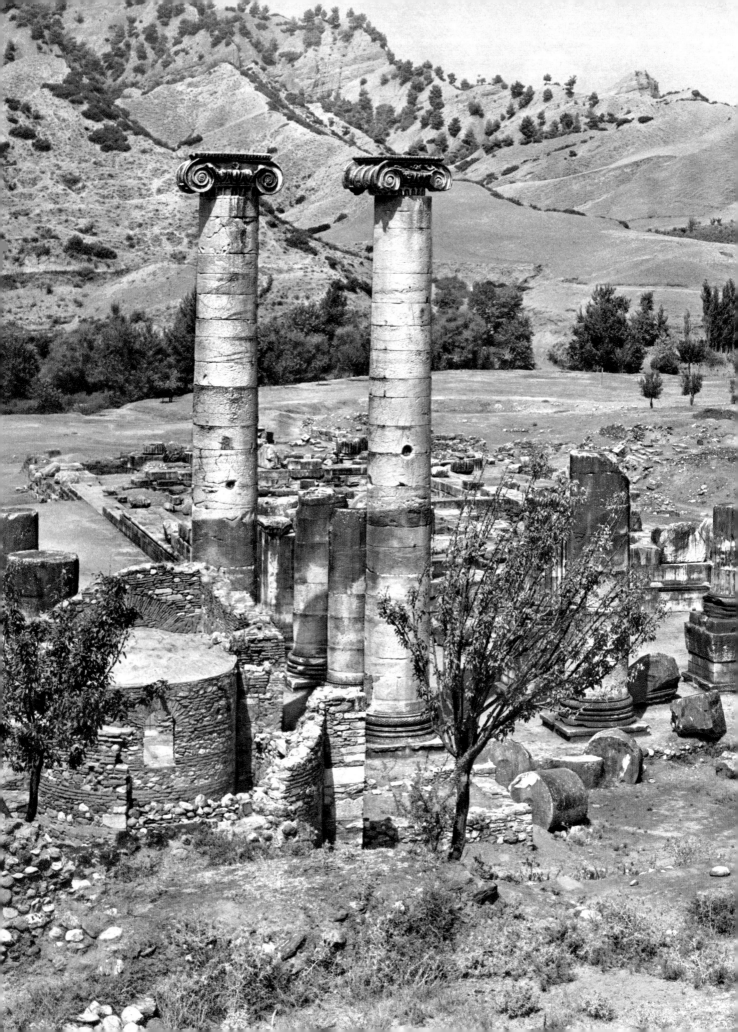

Introduction

In sharp contrast to the apparent calm of the classical period is the Hellenistic era's creative turbulence, which swells and inflates itself into vast monumental masses, where every resource of architectural technique is employed to amplify the proportions, enlarge the perspectives and give free play to the mass in an ever-wider urban setting. Formally and stylistically Hellenistic architecture can be slightly stereotyped, even, at times, desiccated; both form and style being no more than elements of a composition in which refinement of construction and decorative subtlety tend to be neglected in favour of amplitude in mass and perspective.

The architecture which succeeded that of the city-states was of a princely, monarchic type, accurately reflecting the evolutionary process which, after the conquests of Alexander, shattered the institutions – political, economic, social and intellectual alike – of classical Greece. It is true the ancient pattern of life survived in certain famous cities, such as Athens, Miletus or Rhodes, where the real power from now on lay in the hands of a wealthy merchant bourgeoisie. It is also true that these towns became the seats of famous and much-frequented universities, and that law-schools and sculptors' *ateliers* continued to flourish there. Yet at the same time the concept of a personalized Hellenism standing against a barbarian world (the latter long represented by the Great King of the Achaemenid dynasty) had permeated such centres also, and conditioned them to accept those visible signs of personal, monarchic power which presently appeared in the Greek world. From about 280 B.C., after forty years of bloody strife, the new dynasties – heirs to the Macedonian conqueror – settled down to consolidate their rule in the various areas they had carved for themselves out of Alexander's empire. These dynasties included the Antigonids in Macedonia (and, slightly later, Pyrrhus in Epirus), the Seleucids and Attalids in Asia and the Lagids in Egypt (where Ptolemaic rule only ended with the defeat of Cleopatra at Actium in 31 B.C.). This was indeed a period of struggle and of impassioned conflicts; but the rivalries it produced were very far from sterile, since they often served as a stimulus to artistic creation, besides encouraging literature, science and philosophy.

One expression of political power, and an element of the active diplomacy of these princely houses – also one of the most fruitful contributions of the Hellenization of the Eastern world as far as the Indus – can be seen in the foundation of towns and the

1. SARDIS. TEMPLE OF ARTEMIS.

3

introduction of sumptuous edifices and monuments: contributions that might be monumental, utilitarian, or merely official and functional. Urbanization, which was one of Hellenistic civilization's original features, entailed carrying out architectural programmes, the authors of which often drew upon various Eastern traditions as a means of re-invigorating traditional forms or structures. Moreover, the major centres of architectural creativity shifted eastward. Magna Graecia, exhausted by its struggle against Carthage, was finally overcome and conquered piecemeal by Rome, so that – except perhaps through certain revivals – it played almost no part in this renaissance. The cities of mainland Greece, tired of fighting, and given over to power-hungry intrigues conducted by supporters and agents of the various monarchies, both Asiatic and Alexandrian, were glad to accept gifts, or even to solicit them. Political emissaries were accompanied by creative and original architects, and the Attalids sent their own architects to Delphi or Athens when they wanted a stoa built; it was Antiochus' own representatives who undertook the work when he built the biggest ever portico in Miletus as an offering to that city. The innovations and programmes of the Héllenistic architects pioneered are specifically linked with the major centres of Macedonia, Asia Minor, Syria, Egypt, and such areas of Greece as absorbed their influence.

The economic developments and social changes which supported the power of a mercantile bourgeoisie in the cities of antiquity, together with the existence of a Court and the emergence of an official élite in the monarchical states (e.g. Macedonia, Pergamum and Alexandria), led to the development and growth of domestic architectural patterns such as the political and social structure of the traditional city-state had never encouraged. The palaces of Pergamum and Alexandria, the opulent private residences of Pella, the luxurious houses of merchants on Delos transformed urban building, while a vigorous brand of functionalism, directed towards commercial ends, integrated itself with the purely religious and civic architecture which had been characteristic in the classical period. A similar process accounts for the monumental character assumed by tombs and necropolises, the luxury and pomp of which are extensions of the lavishness common in private houses.

It is true that traditional ground-plans and styles of building still survived, whether through conservatism or in imitation of older edifices. Nevertheless the more decorative orders, Ionic and Corinthian, developed at the expense of the Doric, which was found too rigid and severe, though it was still used in the great architectural *ensembles* of Pergamum or Miletus, sometimes with some very odd toning down.

To define Hellenistic architecture means following the various phases of a profound metamorphosis. We begin with traditional elements and stable forms and we end with the triumph of pomp, circumstance and official grandiosity. This evolution is achieved through the development of proportion, the search for new decorative motifs, and the formal integration of these novelties in monumental architectural complexes where they have a functional role to perform, and thus come to embody new values. The originality of Hellenistic architecture stems from its deployment of types, plans and forms within a framework, and according to perspectives, the dimensions and aims of which are altogether different from the consciously limited horizons of the classical city.

Tradition and Innovation

At the outset of the Hellenistic era we find traditional trends still surviving. During the fourth century various formulas and construction methods had been perfected, and these constituted the basic elements in buildings which also contained more or less bold attempts at innovation; tradition was thus used to underwrite experiment.

As a result of her struggles against Macedonia, Athens had been seriously weakened, and one consequence was that her studio workshop – which as late as the fourth century were still turning out craftsmen in the great tradition of the constructors of the Acropolis – practically went out of business. It was in Asia Minor and the islands, at the end of the fourth century and the beginning of the third, that a vigorous reconstruction movement emerged, encouraged by the prosperity of the eastern Aegean. In the Artemisium of Ephesus, at Sardis and Didyma, in the sanctuary of Apollo at Claros, vast work-yards were opened for the erection or alteration of large buildings which were often very similar to their sixth-century predecessors. This was particularly true of the new temple of Artemis at Ephesus, the proportions of which were the same as those of its predecessor. Where it differed, however, was in the particular emphasis laid on sheer volume by means of a high podium, with thirteen steps, which raised the massive columns 8 ft 9 in. above the simple sixth-century stylobate. The Attic proportions and style of the column-shafts and capitals also contrasted with the archaizing form adopted for the base and the first drum, which carried relief decorations copied from the earlier temple. Though work went on until the middle of the third century, parts were left incomplete, and here guide-marks and incised line reveal the methods employed in the construction of this temple which (despite certain innovations) adheres with great fidelity to the traditional and monumental forms of archaic Ionia.

The history of the temple of Artemis at Sardis (see p. 351, figs 388-390) shows us just how permanent the concepts of Ionic architecture were. Considerable remains of this well-known temple survive. It stands on the banks of the Pactolus, the beautiful walls of the opisthodomus and the pattern formed by the columns blending harmoniously with the jagged peaks of a landscape savagely scoured by erosion. In the well-preserved cella the east chamber was devoted by Antoninus to the cult of Faustina, while that on the west continued to shelter a cult-statue of Artemis.

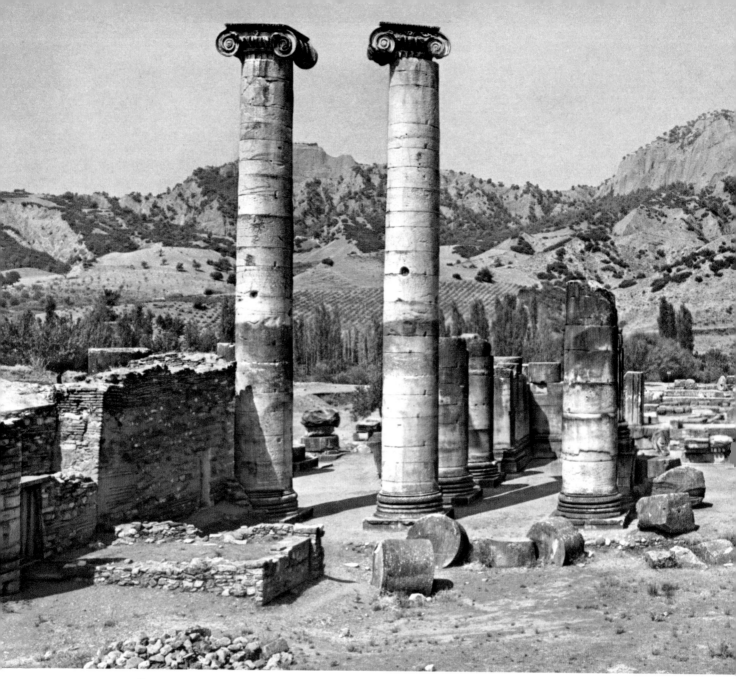

2. SARDIS, TEMPLE OF ARTEMIS. THE EAST FAÇADE.

At the start of the third century, the temple consisted of an esplanade at the western end of the present site, which formed the spatial setting for the altar of Artemis. As at Ephesus or Magnesia-ad-Maeandrum, this was originally the sole feature of the sanctuary. The naos was constructed at the beginning of the third century, its ground-plan representing a kind of compromise between Ionian traditions proper, and the more classical rules formulated by Pytheus of Priene. It has a long cella, divided into three aisles by two rows of six Ionic columns, and a deep pronaos, similar in form to those of the Samian temples and adorned with two rows of three columns, which contrasts with the small opisthodomus containing only two columns *in antis*: a reversal

6

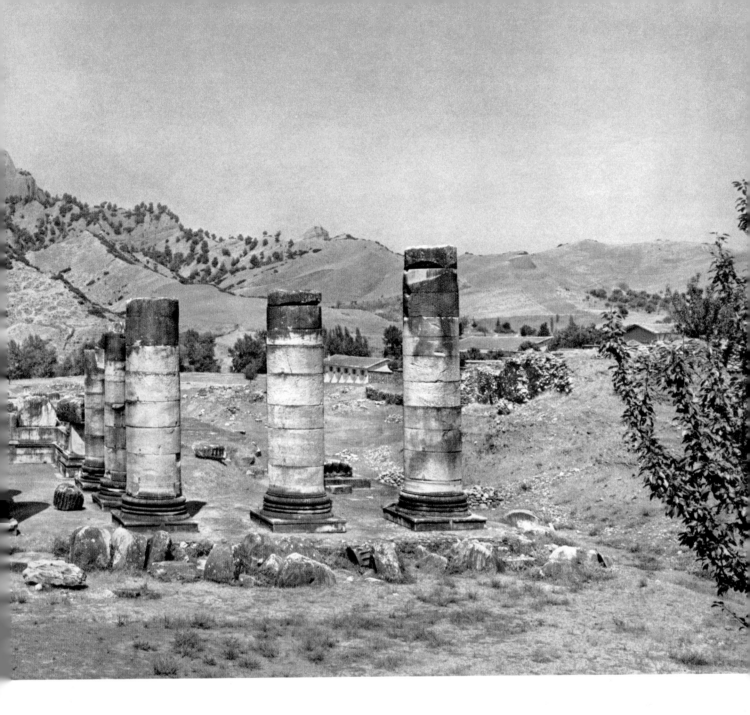

of the classical norms utilized by Pytheus in the temple of Athena at Priene. A fine Ionic capital of the internal order reveals the care and craftsmanship which went into this construction and also marks a transition between the formal balance of the classical period and the distortions which Hellenistic patterns were to introduce; while the full development of its volutes recalls Mnesicles' capitals for the Propylaea at Athens, its decoration reveals it as already Hellenistic: the ova on the kymation are more prominent, palmettes enlarged, and a floral motif appears between the volutes.

A century later, the influence of the new style in architecture is attested by the introduction of a full Ionian peristyle, allied to the pseudo-dipteron which Hermogenes

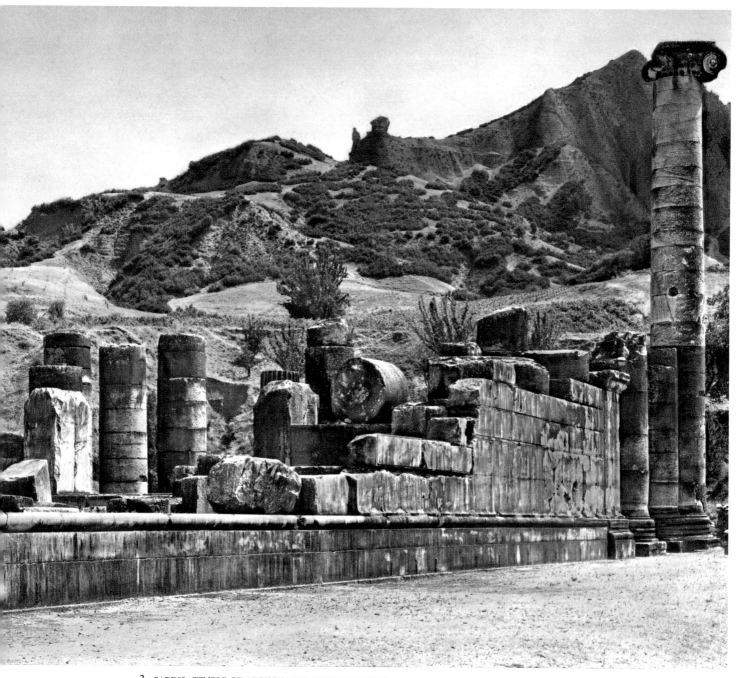

3. SARDIS, TEMPLE OF ARTEMIS. THE SOUTHERN WALL OF THE CELLA.

built about this time in Magnesia-ad-Maeandrum. The ancient naos was surrounded by an Ionic colonnade of vast proportions, but – in contrast to the earlier large-scale diptera (double ptera) at Didyma, Samos and Ephesus – on the two longer sides the second row of columns in the peristasis is replaced by a largely disengaged gallery. The architect at Sardis did not follow Hermogenes slavishly, however; for the façade he retained a prostyle arrangement of 4 × 2 columns, while suppressing the columns *in antis*; the interior of the cella was not altered.

8

The colonnade is not complete; the foundations of the eastern façade are in place, and the columns of the prostyle have been set up, but that is all. It is not until the middle of the second century AD, in the time of Antoninus Pius, that we find the project being picked up again, with no further alteration to the colonnade but some enlargement of the cella at the expense of the pronaos. The cella was divided, the chamber on the west side being kept for Artemis, that on the east devoted to the cult of Faustina and made accessible by a separate entrance. The colonnade on the west side was never completed.

All this provides a good example of the successive fashion in which Hellenistic monumental architecture developed, and of the progressive application of new theories by architects whose grandiose notions often outstripped the means of implementation their cities provided. The introduction of new concepts, together with the creative spirit of Hellenistic architects working within traditions inherited from the classical era, led to a number of original achievements. Good examples are provided by the temples of Apollo at Claros and Didyma. Though very different in scale, both buildings reveal the same desire to meet the requirements of an oracular cult by an original interior design encapsulated within a classical external structure.

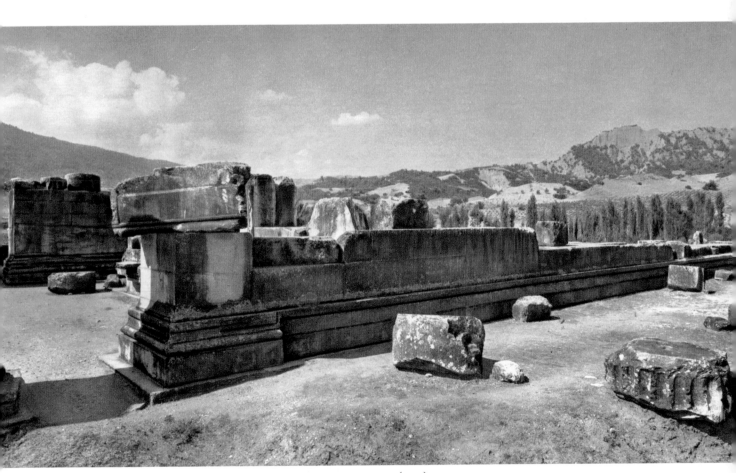

4. SARDIS, TEMPLE OF ARTEMIS. PRONAOS AND ENTRY TO THE CELLA (EAST).

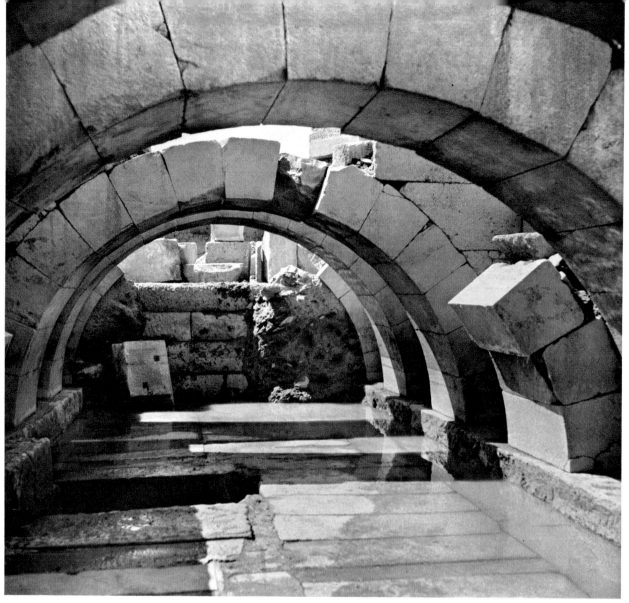

5. CLAROS, TEMPLE OF APOLLO. REAR CHAMBER OF THE ADYTON.

At Claros the order is still Doric. On a flat, solidly-based foundation, bordered by a high *krepis* containing five steps in blue marble, stands the colonnade of the peristyle. This is constructed in the classical rhythm of 6 x 11 columns, and its proportions are advanced, though not excessively so (ratio of base diameter to height 1: 6.62). The style of the columns (with wide and fairly deep arrises), the proportions of the capitals and the differences in technique which distinguish the columns *in antis* of the cella from those of the exterior galleries, all reveal a building programme of considerably later date than the erection of the cella – and we can deduce a series of such programmes, as at Sardis.

Access to the cella was by way of a deep pronaos, in which Ionian influence is apparent, entered through a monumental doorway with enormous side-pillars, weighing several tons each, which dominate the excavated site. The cella was divided into two separate chambers by means of a heavy wall, and contained at its further end a group

10

of cult-statues. In this group Apollo was represented in a sitting position, flanked by Leto and Artemis, his mother and sister, who were shown standing. Artemis was further honoured in another small temple nearby.

Beneath this cella lay the temple's most original feature, the oracular crypt, two successive states of which have been identified. Access to it was by way of two stair-ramps inside the pronaos, symmetrically placed on either side of the temple's main axis. From these stair-ramps two converging passages ran under the heavy blue marble flags of the pronaos till they met and formed a single axial corridor. When this reached the internal partition-wall and door, it once more divided into two branches which followed the foundation-lines of the cella's lateral walls and gave access to the first chamber in the crypt. From here a vaulted passage (piercing the foundation supporting the wall which divided the cella in two) enabled the prophet to reach the second chamber of the crypt, the adyton. Here he drew from a fitted basin the water that was indispensable for oracular inspiration. In the first state these two chambers were the same size and the crypt was covered by a plain floor supported on square pillars. The oracular basin was at the back against the western wall. As a result of damage inflicted at the beginning of the first century, the second room was reduced to half its size by the insertion of a massive foundation of rough-hewn or re-used materials which acted as a support for the group of monumental cult-statues above. A new basin was also installed in the surviving half of the chamber, and the flooring above both chambers was replaced by heavy flags. To support these a series of four complete arches with dressed voussoirs was constructed, which utilized the available space in a more monumental manner.

6. CLAROS, TEMPLE OF APOLLO. THE KREPIS OF THE FAÇADE.

7. CLAROS, TEMPLE OF APOLLO. COLUMN-DRUMS ON THE SOUTH SIDE.

11

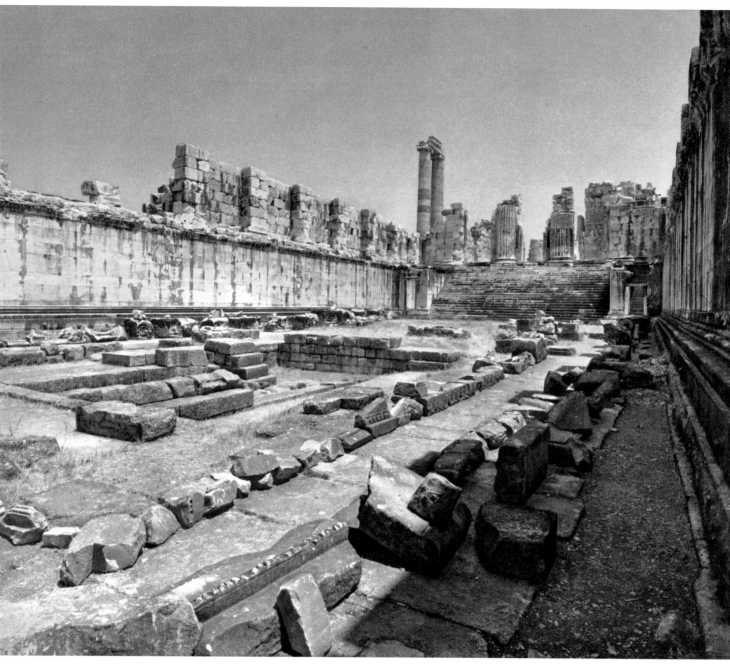

8. DIDYMA, TEMPLE OF APOLLO. INNER COURT.

Claros offers us the earliest instance of these crypts, which Hellenistic and Roman temples were afterwards to employ with some frequency. To the Roman period we must also attribute the renewal of work on the fabric and the construction of the outer colonnade, which was perhaps only completed by Hadrian, whose name and titles form the subject of the dedicatory formula carved on the architrave of the façade. Externally, both proportions and styles lack originality, and conform with the development of the

Ionic order during the last centuries of Hellenism. Inside, however, both structure and organization are freely adapted to the building's actual function, and we encounter here the two most characteristic features of later temples: the thalamus, or sacred chamber containing the god's image, and, under the thalamus, the crypt. Both are often associated with rites of oracular consultation or initiation into a mystery-cult.

An identical preoccupation inspired the architects of the temple of Apollo at Didyma. Using an architectural formula of far more ample proportions, they contrived to integrate the oracle's essential primitive elements – spring and sacred tree – within a sumptuous, yet still classical, outer framework. The primitive ground-plan, repeated and enlarged in the Hellenistic temple (see p. 352, fig. 391), was a traditional structure in the Ionic style. This enclosed an inner court, left open to the air, in which were grouped the spring, the sacred tree and, later, the cult-statue; the last was set within a shrine which became, as it were, the focus of the temple. Two architects, Paeonius of Ephesus (who had been one of the master-planners responsible for the Artemisium), and Daphnis, a Milesian, were commissioned about 300 B.C. to reconstruct the temple. From outside it was exactly like the traditional large Ionic double pteron, with a pronaos (the dodecastyle) containing four rows of three columns. These tall, slender columns supported a light, airy entablature (one-sixth of the column height) and stood on a platform composed of seven steps. On the façade these were converted into an entrance staircase of fourteen steps. The architects followed the principles that Pytheus had applied in the temple of Athena at Priene. The structure of the ground-plan falls into divisions which make up a regular pattern of which the module is a square with 8 ft 8 in. sides – i.e. half the distance between the column axes. The composition is thus rhythmically integrated within a mathematical system.

The spacious dodecastyle (its rich decoration will be treated in detail below) served a double purpose. It provided easy access to the two vaulted passages which led down to the inner court, and also formed a waiting-room where pilgrims received the answer to the questions they had just asked the oracle. The passages themselves were narrow and roofed with plain barrel-vaulting which was simply an unbroken upward continuation of the lateral walls, the whole structure forming one solid mass, very neatly faced and flush-jointed. They led down a gentle slope to the open court, which was surrounded by the continuous wall of a smooth-dressed platform some 13 ft high. This was surmounted by a cornice which formed the base of a high wall, broken at regular intervals by pilasters crowned with sumptuous capitals *en sofa*; the effect resembles the interior wall of a cella such as that designed by Scopas at Tegea. The enormous area of the court was broken up at its far, or western, end by the roofed shrine which housed the cult-statue, and at the eastern end by the majestic staircase (50 ft wide, with 24 steps) leading to the oracle chamber. At the east end of this chamber was an immense central bay or doorway, its threshold set above the pavement of the dodecastyle, which it overlooked. This was the sacred portal, or 'door of visions', from which the oracle spoke to the assembled crowd, its exceptional nature being emphasized by the monolithic jambs which framed the entrance; it was more of a theatrical stage than a means of access, since there was no means of passing over the threshold from the lower level of the pronaos.

13

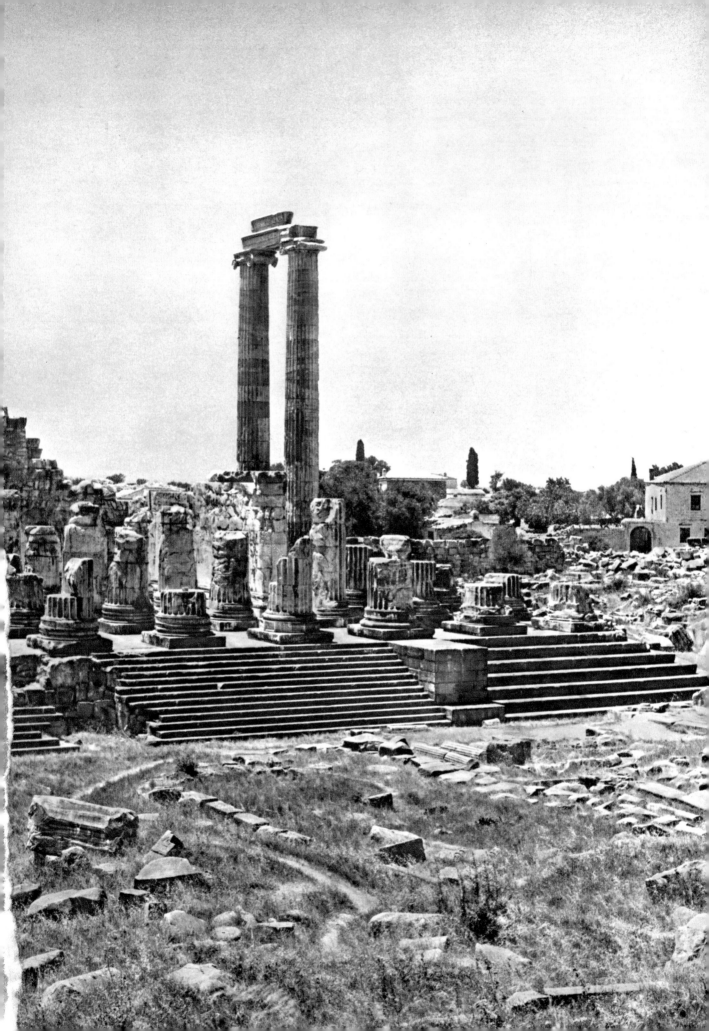

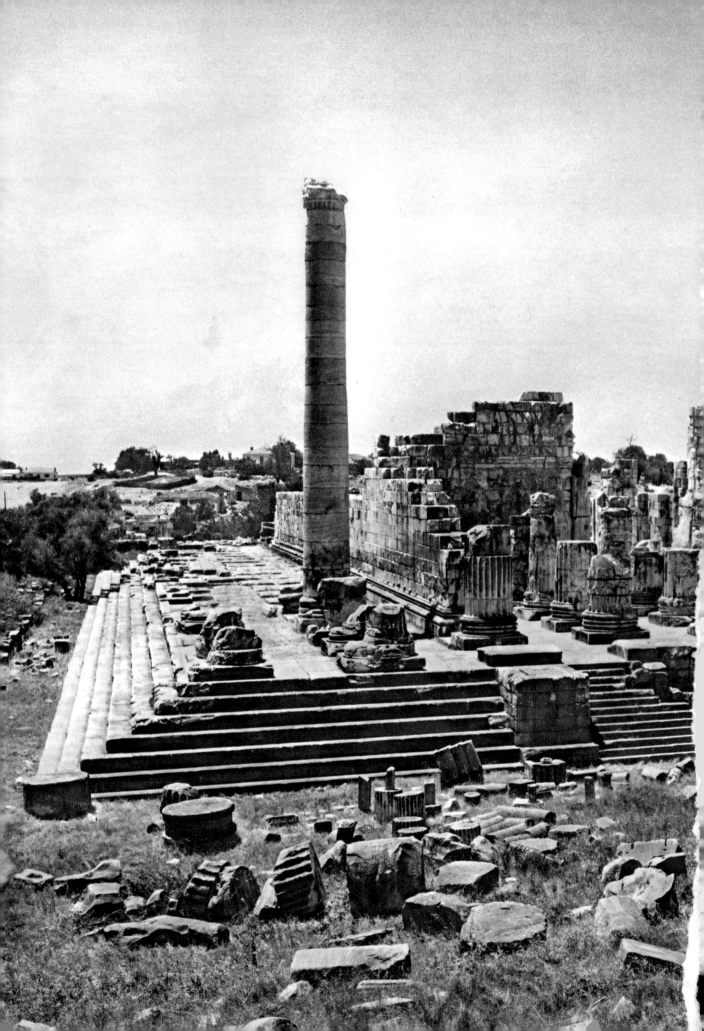

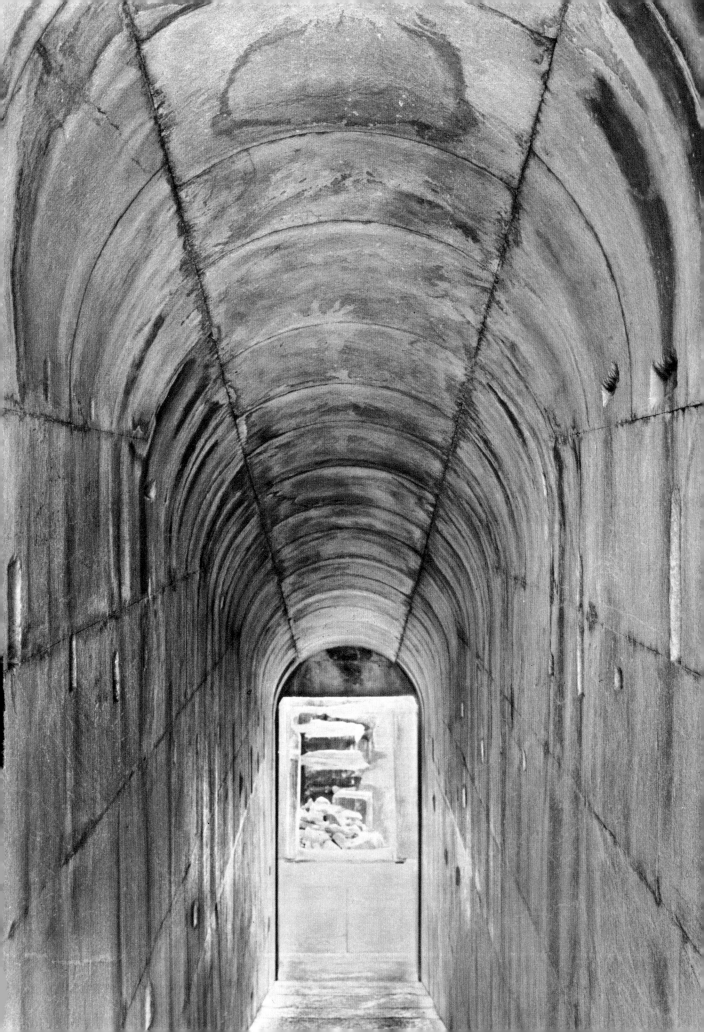

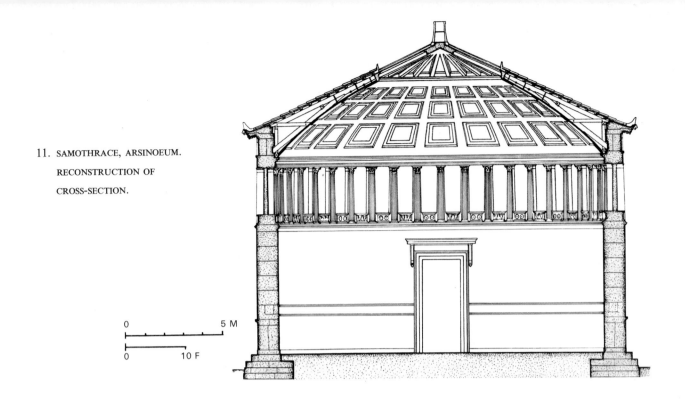

11. SAMOTHRACE, ARSINOEUM.
RECONSTRUCTION OF
CROSS-SECTION.

0 5 M

0 10 F

The particular skills and new interests of Hellenistic architects found ample scope in this edifice. Classical forms were taken to their extremes in order to give expression to a feeling for weight and mass, an intelligent organization of space and an almost excessive emphasis on the building's religious functions. Though decoration as such was certainly not neglected, stylistic detail tended to get lost in the striving after a gradiose overall composition. No edifice better demonstrates the metamorphosis imposed on classical form by the radical attitude of these new Hellenistic *ensembliers*.

A few further examples may serve to clarify the variety of taste of these notable practitioners, their free adaptation of styles and techniques and their flexibility of response to any problem which these assorted edifices reveal.

Among buildings with a circular ground-plan the Arsinoeum of Samothrace has novel features which distinguish it from the fourth-century tholoi of Delphi or Epidaurus. This rotunda was erected in honour of the Great Gods of Samothrace by Queen Arsinoe, wife of Lysimachus, between 289 and 281 B.C. Its proportions are comparable to those of the Thymela in the sanctuary of Asclepius at Epidaurus (diameter 66 ft 9 in.), but the composition is rooted in a wholly different spirit. One aim was to utilize all available internal space – hence the suppression of both inner and outer colonnades – and another was to adapt the architectural pattern to the ritual function of a building where, as the remains of altars indicate, sacrifices were carried out.

On a broad ring-foundation (8 ft thick) there stood a wall of Thasian marble surmounted by a moulded course decorated with palmette motifs both inside and out. Above this was a gallery, the decorative value of which was emphasized on the interior by Corinthian half-columns engaged in the inner face of the Doric columns of the exterior, with low parapets and openings for grilles between them. A lavish use of painted stucco, a technique of which the first half of the third century provides us with numerous examples, underlined the tendencies of the period.

Such a circular building implies technical progress in the art of frame-building. No doubt the method of supporting the roof involved convergent beams, their ends resting on a terminal cusp or cornice which perhaps also supported, right in the middle, a small suspended cupola made of wood. The same method was presumably used to cover over vast areas of space inside assembly-halls such as the Bouleuterion of Miletus (see fig. 413) or the larger stoas; this use of space is a constant feature in Hellenistic designs, whether for agoras or sanctuaries.

Hellenistic innovating tendencies also become apparent in theatrical architecture as the theatre develops and changes into a homogeneous edifice of vast proportions, its great bulk regularly dominating the other buildings around it. For a long time theatres were simply temporary structures, rudimentary wooden buildings that accommodated both performers and audience but aroused no architectural interest whatsoever. Then, about the middle of the fourth century, theatres of stone and marble began to be built. The semi-circular auditorium – still backed against the slope of a hill – was now equipped with regular rows of seats and cleverly spaced staircase-aisles between them. To raise the level of the scena, and to mask the passageways, a proscenium was built behind the orchestra. Here – as on the monumental façades of city gateways and tombs – the decorative impulses of the era found an immense new field in which to develop. The theatre of Epidaurus, built about the middle of the fourth century, provides one of this moment's best achievements.

The evolution of the theatre in the Hellenistic era operates in two directions. On the one hand, the component structures develop and gradually coalesce to form an integrated building, as the originally circular orchestra finds its surface reduced to three-quarters of a circle because of the forward extension of the scene-buildings, which also increase in height and show a tendency to join up with the extremities of the cavea. On the other hand, the theatre's monumental character makes it an important feature of the urban landscape. Though restricted by the natural contours of its site, it nevertheless achieves relative prominence, since the other buildings in the complex of which it forms part tend to group themselves around it.

In the theatre of Dodona, the size of the cavea, the vigour and strength of the masonry of the high bastions framing and supporting the tiers of the auditorium, the elegance of the walls behind the scena (aligned along the same axis as the other edifices of the sanctuary) all give striking expression to the innovations and values of an architecture which regarded simplicity of technique and good taste in material as the essential basis of its aesthetic standards. But if the theatre of Dodona is designed to match the grandiose landscape which forms the setting of the oracular sanctuary of Zeus, then the theatre of Pergamum, set on the acropolis of the Attalids, does even better. Set in a fold of ground that spreads out round it like a fan, it becomes a genuine feature of the landscape; it juxtaposes the majestic curvature of the cavea with the sweeping straight lines of the fortified walls of the enceinte (attributed to Eumenes II) which crowns the summit of the hill and those of the porticoes which punctuate the entire Pergamene acropolis (see figs 404-405). Tiered porticoes, temple with terrace and podium, mighty buttresses plunging vertically all along the slopes to be cut short by the horizontal cross-lines of the terraces that throw into prominence the

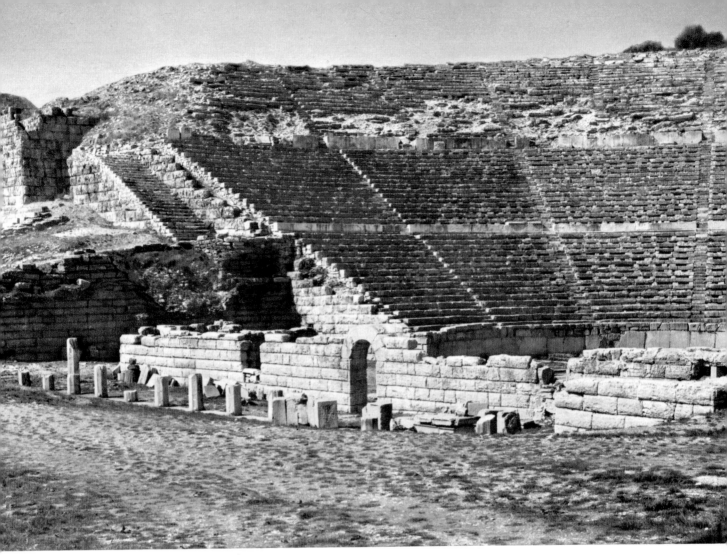

12. DODONA. THE THEATRE (DETAIL).

13. DODONA, THE THEATRE. BASTION WALL OF THE CAVEA.

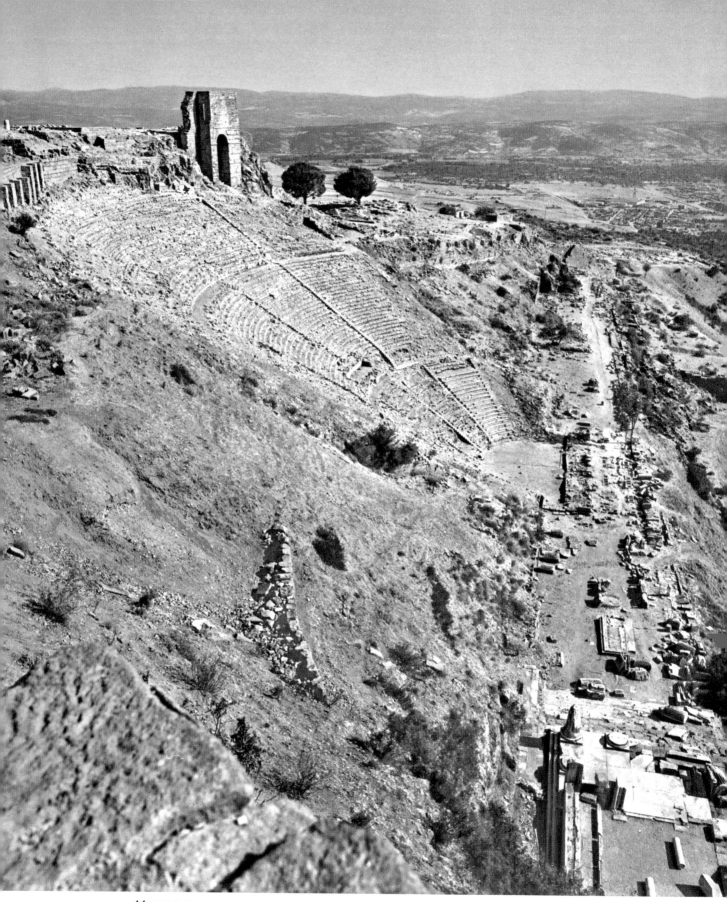

14. PERGAMUM. THE THEATRE.

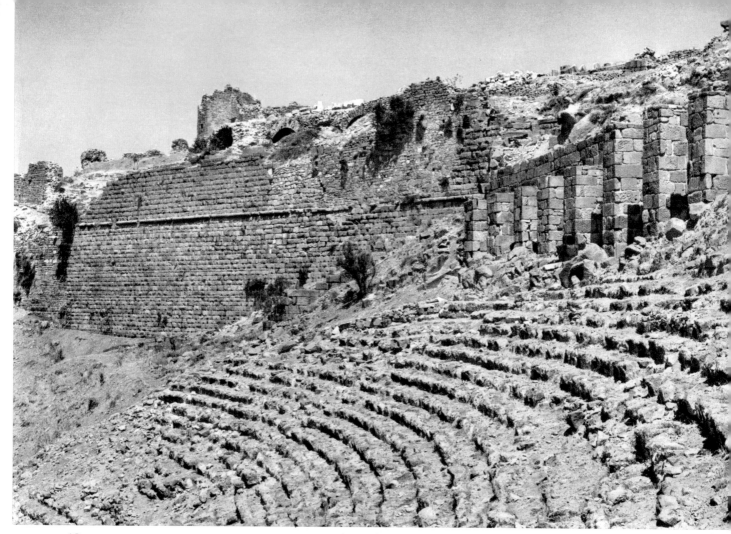

15. PERGAMUM. THEATRE AND THE WALL OF EUMENES II (DETAIL)

mass of each individual edifice – all the elements of the theatre and its environment combine to enhance the massive quality of the architectural complex which evolved during the reigns of Attalus I and Eumenes II, in the late third and early second centuries. Mass and volume are of greater concern to the designers than the elaboration of detail and decorative minutiae. By virtue of its structure, its composition, and its relationship to the other features of the acropolis, the theatre of Pergamum is no less essential a monument for the study of the history of Hellenistic architecture than the theatre of Epidaurus. It translates and develops the principles of composition the constructional methods which had been inherited from the fourth century. The architects contrived to extend (and to exploit on a wholly new scale) those trends that had been worked out for and were contained in the final phase of the classical era.

When studying the history of these formal developments, it is essential to isolate the point at which features already implicit during the fourth century, though still in the embryonic stage, were given more elaborate and vigorous expression, and enriched by a partially foreign influence.

The sanctuary of Zeus at Labranda, the huge terraces of the Amyzon sanctuary, or the spacious planning of the urban site of Alinda – all emphasize the importance of

21

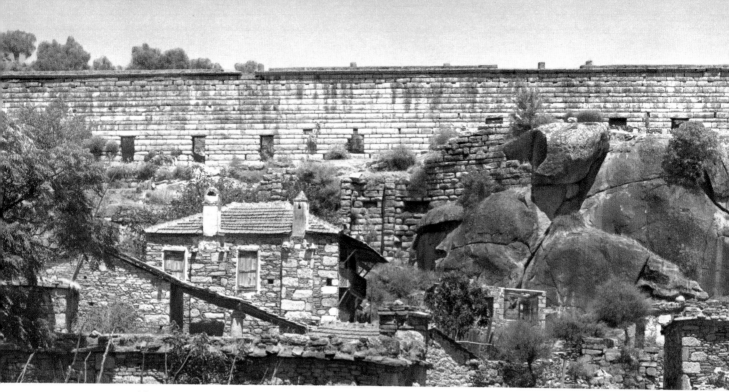

16. ALINDA. OUTER WALL OF THE LARGE STOA IN THE AGORA.

that burst of architectural creativity stimulated by the various members of Mausolus'
family, in particular Artemisia and Idrieus.

At Labranda, the sanctuary of Zeus was built on a series of terraces. Access to it was
from the east, where a long Sacred Way led up to two simply designed propylaea in the
Ionic style. On each terrace, linked by stair-ramps, were tiers of temples and shrines,
their façades, whether Doric or Ionic, enhancing one another through this 'stepped'
effect. As at Amyzon, the long terrace walls, with strong, vigorous coursing, emphasize
features of the landscape by drawing one's eye toward the façades which form an
integral, but dominant, element. This contrasts sharply with the random, not to say
chaotic, manner in which buildings are crowded within a temenos; though the
temenos has a clearly defined shape, the only signs of internal planning are detailed
effects linking successive programmes and individual buildings.

The layout and organization of Alinda, in the same part of Caria, reveals identical
architectural concepts. The town is perched on a steep acropolis, ringed by fortification-
walls, the towers of which mark changes in the angle of the slope, and it spreads out in
a series of large terraces, with the theatre on the highest one, and the agora at the
bottom. The placing of the agora necessitated the building up, at the valley side, of an
esplanade bordered by a long portico, which, to judge by the proportions and outline
of its pillars, must have been erected about the third century. The lower level of the
portico was treated as a basement or area, for on its outer side it presents a long wall,
in regular courses of dark local stone, pierced by variously shaped openings that gave
access to the warehouses inside. The upper level, opening on to the agora, provided a
view over the plain through the pillars. These ideas were to be amplified and enriched
by the Pergamene architects.

22

Formal or Display Architecture: the evolution and transformation of classical styles

Hellenistic architecture had a predilection for developing monumental masses, but it also produced many and varied decorative motifs (some of great complexity). It strove after a relief technique based on opposition and contrast, and attempted to find satisfaction for a tormented and at times baroque taste in linear movement and the relationship of form and mass. It rejected the disciplines of the previous period and picked out for emphasis in any traditional style such elements as suited this new aesthetic approach.

Though the Doric order was still widespread, its use was limited to the ample colonnades of those long porticoes which bordered public squares and, somewhat later, monumental avenues. Very few temples were now conceived in this over-severe style, those of Athena at Pergamum and Apollo at Claros being notable exceptions. Even in its place of origin (the Peloponnese or central Greece) it lost its former popularity after a final burst of construction towards the end of the fourth century, which produced the temples of Artemis at Epidaurus, of Asclepius at Corinth, of Athena Pronaia at Delphi (Marmaria). The third-century buildings at Epidaurus rely on different orders: Ionic and Corinthian.

The change came about not only for practical but also for theoretical reasons, and much preoccupied the leading architects of the era. According to Vitruvius (*De Architectura* 4. 3. 1-2) both Pytheus and, later, Hermogenes expatiated on the superiority of the Ionic order – the former apropos the temple of Athena at Priene, the latter in connection with the temples of Artemis at Magnesia and Dionysus at Teos. Ionic proportions and rhythms were better suited to their line of development than the over-constrictive rules governing the Doric entablature. The passage from Vitruvius is worth quoting, since it sheds much light on the most basic trends of the period:

> Some of the ancient architects said that the Doric order ought not to be used for temples, because faults and incongruities were caused by the laws of its symmetry. Arcesius and Pytheus said so, as well as Hermogenes. He, for instance, after getting together a supply of marble for the construction of a Doric temple, changed his mind and built an Ionic temple to Father Bacchus [at Teos] with the same materials. This is not because it is unlovely in appearance or origin or dignity of form, but because the arrangement of the triglyphs and metopes is an embarrassment and inconvenience to the work.

It is true that, by requiring a triglyph on the axis of each column and yet insisting on two contiguous triglyphs to form the articulation above the angle-columns, the rules of the order were guilty of inconsistency. They also had repercussions on the form and dimensions of the neighbouring metopes. The classic reduction of the two end bays on each façade provoked anomalies in the overall design of the building and (in an order where, on the face of it, geometry reigned supreme) actually led to irregularities and asymmetrical effects – a direct contradiction of that striving after mathematical

proportion which dictated the form of both ground-plan and elevation at the close of the classical era. Thus excessive stiffness and formality, combined with a constraint which architects found it increasingly hard to accept and an increasing taste for the decorative, between them reduced the Doric order to a mere accessory. It might be useful enough for long colonnades, or to provide a background against which more important edifices could stand out – in short, for the domestic and other inexpensive types of building – but it was thought inappropriate for original projects, for formal or public architecture. What strikes us most about Hellenistic Doric is that it seems a utilitarian and somewhat secondary style, used in the service of the great Ionic and Corinthian orders; its decadence is bound up with this subordinate role, all the influences and repercussions of which emerge in its proportions and formal pattern. It is, then, the decorative orders, Ionic and Corinthian, which achieve their fullest, most grandiose expression in Hellenistic architecture.

The capital designed by Pytheus for the temple of Athena at Priene marks a transitional stage between the end of the classical style and the innovations of the third century. It retains the elongated proportions of the traditional Ionic style, inherited from the capitals of Ephesus; the volutes are amply developed, but the height has diminished and the balusters adhere closely to the abacus, the bearing-surface of the support, as though to reinforce it. At Sardis the capitals of columns of the internal order from the original temple preserve a remarkably supple line, the relief effect being accentuated by the hollowing-out of the volutes to leave their flattened spirals boldly defined. The central part of the channel is decorated with a floral motif which was later to become widespread on Ionic capitals of Italy and the West. The ova of the echinus,

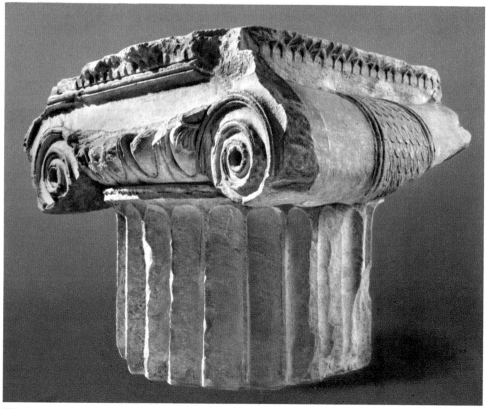

17. PRIENE, TEMPLE OF ATHENA. CAPITAL. STAATLICHE MUSEEN, BERLIN.

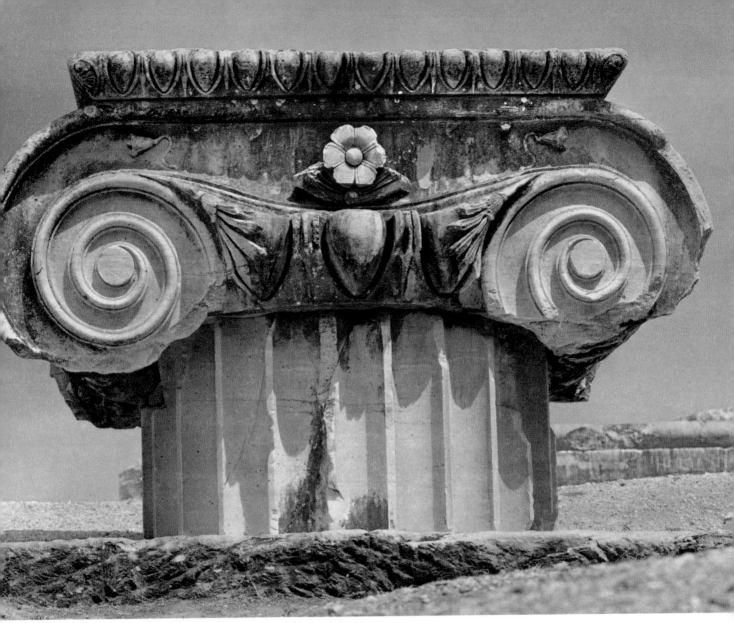

18. SARDIS, TEMPLE OF ARTEMIS. CAPITAL.

carved out in deep relief are partly hidden by the palmettes which spread inwards from the volutes while, on the sides, the balusters are thrown into prominence by deep grooves before losing themselves in decorative motifs (leaves, astragals, etc.).

We see from this that all the elements of the Hellenistic capital – as found in third- and second-century buildings at Didyma, Magnesia-ad-Maeandrum or Priene – have already moved into place. At the same time the Corinthian order assumes steadily increasing importance, lines having been established in such major mainland buildings as the temple at Tegea and, particularly the tholos of Epidaurus. The classical features of the capital are firmly stated in the Hellenistic version of the Olympieum at Athens – of which we can still trace echoes in copies made under Hadrian. The calathus is heavily laden with acanthus-leaves, arranged so as to form two high crowns, and from these the leaves that follow the lateral volutes project to a higher level. In the centre,

25

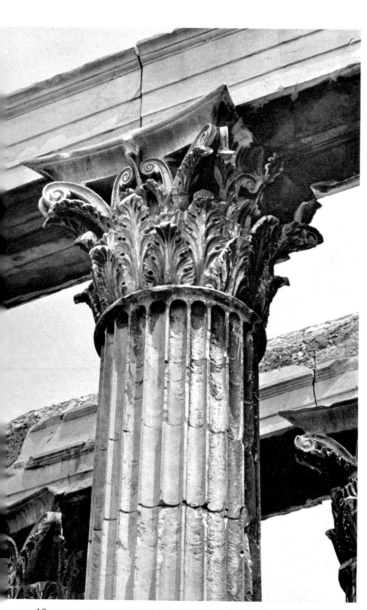

19. ATHENS, OLYMPIEUM. ENTABLATURE (DETAIL).

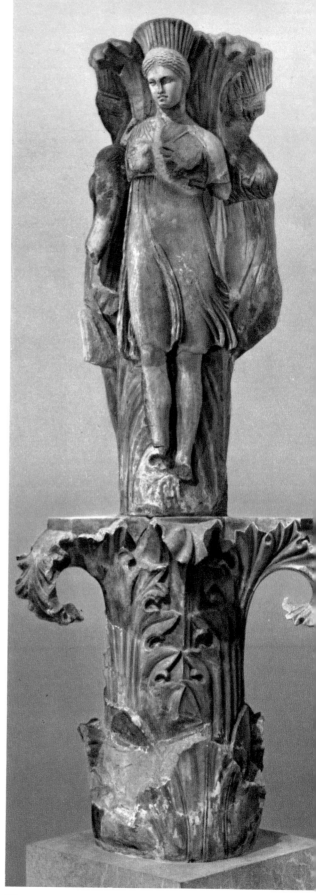

20. DELPHI. UPPER PORTION OF THE 'DANCERS' COLUMN. DELPHI MUSEUM.

emerging from their rigid caudicles, two decorative volutes face one another, while above them, in the central groove of the moulded abacus, we have the convolvulus flower sometimes also found on the channel of the Ionic capital, as at Sardis. Solidly held in place at its base by a smooth astragal, this acanthus-bell firmly supports the four corner volutes on which rest first the abacus and then the architrave. The latter, with its horizontal lines, is identical to that of the Ionic order, and poses no rhythmic problems for the architect. Furthermore, the Corinthian capital, when employed in peristyle colonnades (and especially at corners), resolves the problems of the Ionic capital, which was too elongated, too uncompromisingly bifacial, and particularly ill-adapted for corners where it was called upon to mark the articulation of the entablature. The first known instance of the capital conceived in terms of a square, and developed with its volutes attached, is in the Nereid Monument at Xanthos. It spread throughout the Peloponnese and, by the Hellenistic era, had reached every part of Greece. But its function was not clearly assimilated and, as time went on, the volutes came to be regarded as a separate and sometimes embarrassing ornament. On certain capitals from Delos they almost appear to have been stuck on the abacus artificially.

The acanthus-leaf steadily gained ground. Its decorative function was exploited with a wealth of imagination, first on classical funerary stelae, and later on capitals. A good illustration of this trend is the column topped by a group of three dancing girls from Delphi. This early third-century piece already embodies numerous motifs afterwards used in large-scale architecture. Each column-drum emerges from a bell of broad leaves, their tips curling back down towards the base – a forerunner of those later columns in the palace at Ptolemaïs and of many others known from texts and wall-paintings. The floral motif spreads out to form a base for the sculptured group.

Columns, walls, half-columns (pilasters), entablature, door-jambs – every surface was ready to receive decorative motifs. No building better illustrates the themes and flavour of decoration in Ionic architecture than the temple of Apollo at Didyma where, though the columns of its monumental façade have preserved the form and proportions proper to the classical order, the bases and capitals reveal a systematic striving after diversity. They alternate between the Attic pattern (a deep concave scotia, or trochilus, between two tori); proportions more characteristic of the Aegean coast, being derived from Samian bases, with grooves and smooth-polished astragals set in tiers, and surmounted by a single torus; and cylindrical bases of the Ephesian type. But some of the innovations are more original. The square plinth is retained – and even elevated, by Pytheus and Hermogenes, to the role of module – but the mouldings of the base are replaced by a section carrying eight panels, each framed in flat fillets and exquisitely carved with a variety of decorative motifs: spreading palmettes, foliate scrollwork (both clustered and interlaced), sea-creatures and dragons. The tori are sometimes fluted and sometimes decorated with tracery-work or imbricated leaves, the latter forming a kind of bundle bound together at intervals by a cross-belt, adorned with similar motifs. Despite this variety we find a definite correspondence between the bases themselves, between the columns of the peristyle and those of the pronaos, and between the latter and the foot of the walls, which rest on a massive base of classical type. A smooth plinth, analogous to that of the columns, and a plain cavetto moulding

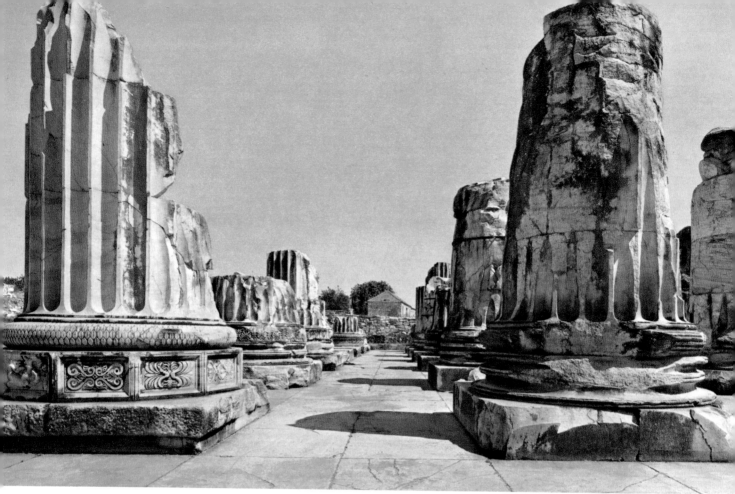

21. DIDYMA, TEMPLE OF APOLLO: THE COLONNADE OF THE EAST FAÇADE.

frame an Attic composition of two sculptured tori, separated by a scotia with a highly elongated lower curve which echoes the flared line of the bottom of the wall above it. The tori are not sculptured along the whole length of the lateral walls, but only on the antae and in the dodecastyle.

A similar inspiration animated the upper parts – capitals, entablatures and wall-copings. On the angle-capitals of the peristyle busts of Zeus, Apollo, Artemis or Leto were carved on the volutes, while the corner volute gave way to a jutting griffin *protome*. This is the first time in Greek architecture that we find the systematic implementation of the historiated capital – an innovation probably based on some Oriental model, to judge by the success it met with in North African architecture (which often drew on Phoenician or Carthaginian traditions). The architrave was surmounted by a frieze, decorated with foliate scrollwork and palmettes. An even greater degree of animation is visible in the capitals of the pilasters set at intervals along the inside wall of the adyton. Built into the stonework work and projecting in low relief from its facing, these were topped off by an elongated capital of the 'sofa' type – so called from the elegant curve, resembling the arms of a sofa, which the lateral mouldings assumed before curving round into volutes. Decoratively speaking, this represents a transposition into Hellenistic terms of a form already familiar in the Peloponnese and Sicily during the Archaic period. The central part is occupied by the arabesques of a vigorous foliate motif, which extends in a sequence of undulating

28

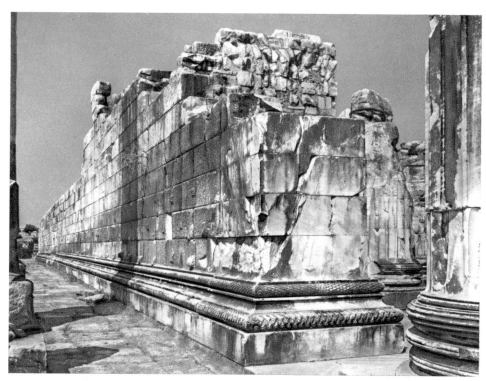

22. DIDYMA, TEMPLE OF APOLLO. THE SOUTH-EAST ANTA (DETAIL).

23. DIDYMA, TEMPLE OF APOLLO. MURAL DECORATION (DETAIL).

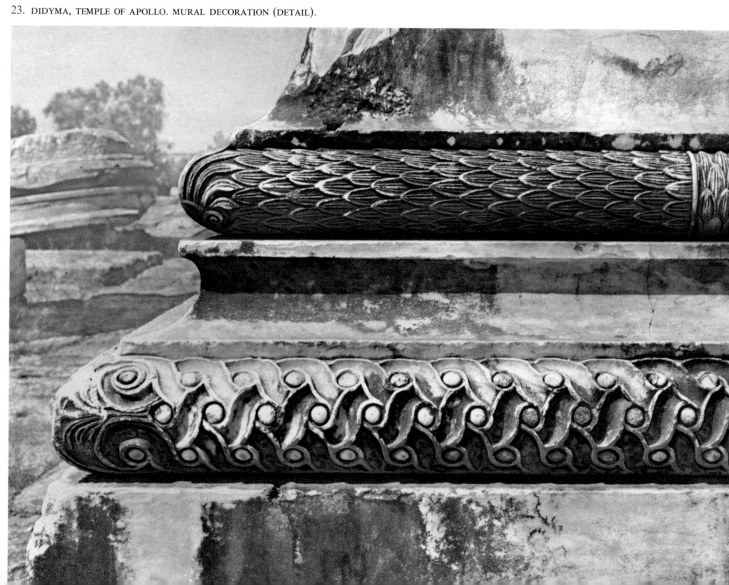

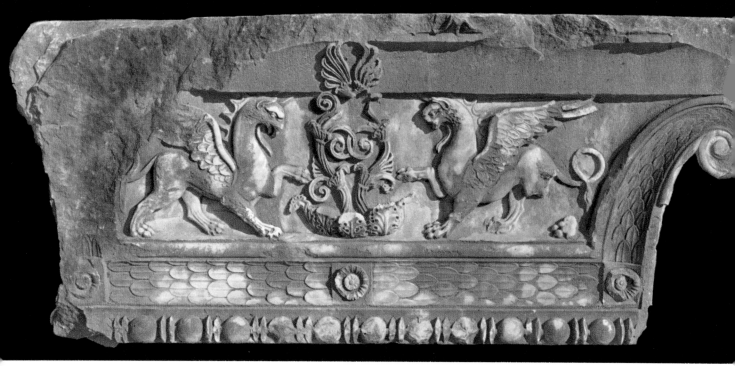

24. DIDYMA, TEMPLE OF APOLLO. PILASTER CAPITAL WITH ANIMAL MOTIF.

volutes and tendrils over the whole panel. Such capitals alternate with ones of similar design in which this vegetal theme is restricted to a central motif which serves as a support for two fantastic animals (lions, griffins, chimaeras) set face to face. Here, again, Oriental theme is transposed into a Hellenistic context. Between the capitals was a frieze carved with similar animal figures, while both upper and lower edges of the architrave bore traditional leaf-and-tongue decoration.

The sculptors of Didyma already had a rich, though often highly specialized, repertoire at their disposal. In adapting it to the highly varied contexts and architectural features presented by a monument which was itself very much out of the ordinary, they deployed the numerous decorative motifs available to them with remarkable subtlety and brilliance. Subsequent decorators of the temple, during the second and first centuries, and later during the Imperial period, did no more than draw on the Didymaean repertoire and develop all the resources it offered: octagonal bases, historiated capitals, foliate friezes, as well as foliate motifs embodying various animals – motifs which were already adapted to a number of different architectural features (pillars, lintels, door-jambs, and so on).

The Mausoleum at Belevi, near Ephesus, allows us to guess at the sources of these motifs, borrowed from fourth-century architecture and subsequently exploited for their own sake, almost without reference to those architectonic elements with which they were originally connected. Everything at Belevi falls into the category of formal, or display, architecture. The building stands on a natural rock, trimmed to carry, as a kind of top-dressing, an architectural superstructure which shows all the variety and exuberance of the period. The Corinthian capital of Belevi, supporting nothing but a

30

25. BELEVI, HEROÖN. CORINTHIAN CAPITAL.

26. DIDYMA, TEMPLE OF APOLLO. PILASTER CAPITAL WITH FLORAL DECORATION (DETAIL).

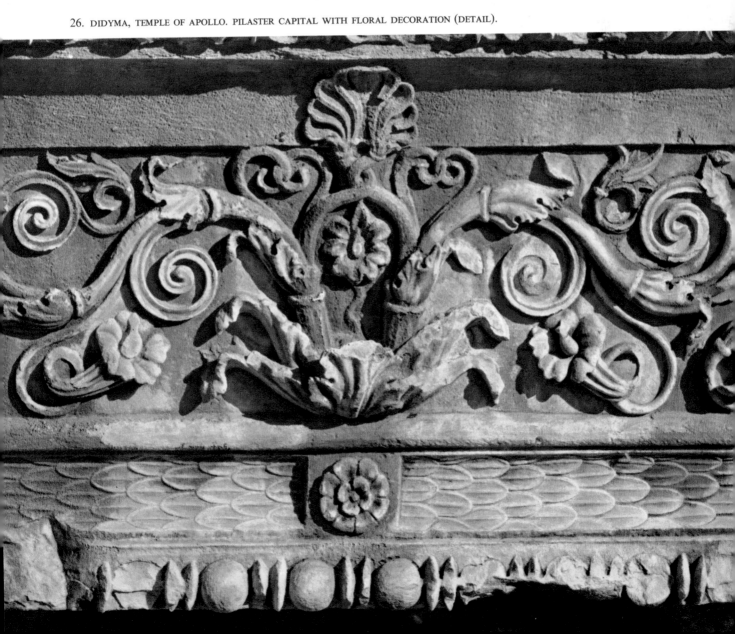

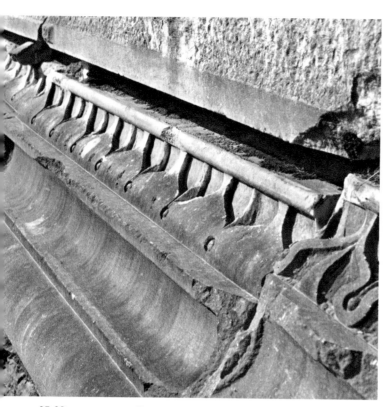
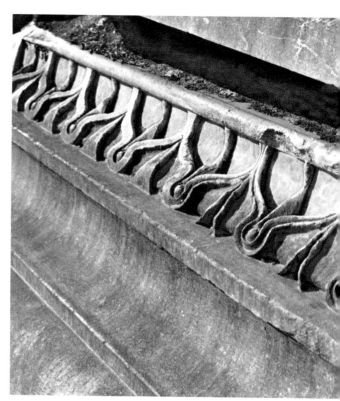

27-28. BELEVI, HEROÖN. TWO SUCCESSIVE PHASES IN THE DECORATION OF THE KREPIS.

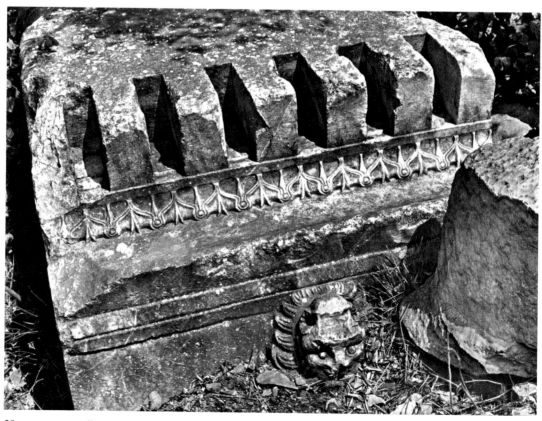

29. BELEVI, HEROÖN. WEATHER-MOULDING BLOCK (CORONA) WITH DENTILS.

display entablature, is akin to that of the tholos at Epidaurus, though the leaves it carries are more voluminous, wider spreading and more deeply carved. The entablature expresses the same taste for somewhat blown, heavy decoration – a style exactly suited to the princes for whom such edifices were built. The vegetal decoration lies flat on the frieze (which at Epidaurus was, to begin with, no more than a plain, well moulded groove). A heavy mass of palmettes and lotus-flowers; emphasized by winding spirals, foreshadows the foliate frieze and probably derives from the same inspirational source as that at Didyma – if, indeed, it was not itself the source, for, when the great work-yard was first set up at Didyma, an architect from Ephesus, Paeonius, came and collaborated for a while with the Milesian architect, Daphnis.

The wall-foundations at Belevi, huge blocks laid against the rock-face as a revet-ment, also reveal bold decoration, the unfinished state of which enables us to follow its technique. On the half-completed blocks the outlines of a leaf-and-tongue pattern, and the nodules dividing each leaf-and-tongue from the next, were first traced with a compass, and the motifs then roughed out. Next they were cut clear and shaped with the chisel, and finally finished to match the other smooth-cut features of the decora-tion: torus and scotia. The latter's moulding, though shallow, is emphasized by two fillets with prominent edges.

Hellenistic architecture allowed the decorative element to become largely indepen-dent of architectonic of functional considerations. This led to great liberties being taken with the traditional rules governing the employment of the orders, and was also responsible, to a great extent, for the stylistic decadence which now begins to appear. It is a commonplace that during this period proportions become finer and more elon-gated, formal design undergoes a process of attenuation and desiccation, while surfaces tend to be developed at the expense of mass. But this process is neither a straightfor-ward evolution based on tendencies already discernible during the fourth century, nor the progressive impoverishment of inspiration and technique. It is a wholly new aesthetic, the theory and principles of which were formulated by the architects of the third and second centuries, above all by Hermogenes. Whether his native city was Priene or Alabanda, he came from a region, near the Maeander, where architectural development had been both abundant and original during the decades immediately prior to this birth (during the second half of the third century). Echoes of Hermogenes' treatises filter down to us via comments on them by Vitruvius, while his practical achievements can be analysed in his buildings at Magnesia-ad-Maeandrum.

It is, first of all, in his ground-plans that Hermogenes sets about transforming Ionian tradition. While preserving the external appearance of the dipteral temple with eight or ten columns on the façade, like the Artemisium at Ephesus or the Samos Heraeum, he suppressed the inner column-row, though making no change in the size or proportions of the cella. This pseudo-dipteral temple is thus defined by Vitruvius (*De Arch.* 3. 2. 6.):

> ... so constructed that in front and in the rear there are in each case eight columns, with fifteen on each side, including the corner columns. The walls of the cella in front and in the rear should be directly over against the four middle columns.

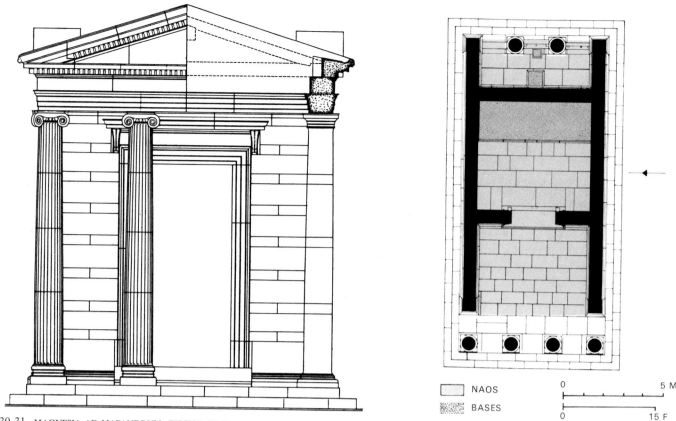

30-31. MAGNESIA-AD-MAEANDRUM, TEMPLE OF ZEUS SOSIPOLIS. CROSS-SECTION AND GROUND-PLAN.

NAOS

BASES

0 5 M

0 15 F

Thus there will be a space, the width of two intercolumniations plus the thickness of the lower diameter of a column, all round between the walls and the rows of columns on the outside. There is no example of this in Rome, but at Magnesia there is the temple of Diana [Artemis] by Hermogenes...

He also states that Hermogenes' aim was to economize on labour and costs while preserving the outward appearance and apparent dimensions of the traditional temple; in addition he provided a wider colonnade for people to stroll in, and a more spacious refuge for worshippers and pilgrims in case of rain. Here one comes up against Vitruvius' essentially pragmatic temperament. He was not so much an architect as a construction engineer, and he remained blind to the evolution of an aesthetic theory which extended the innovations of the ground-plan into elevation and overall proportion. The object of the changes was to obtain in the vertical dimension a play of empty space to match the new horizontal freedom of the colonnade. To this end the column-height was increased and the intercolumnar space widened, and Hermogenes worked out a new system of proportions for colonnades, relating the intercolumniation to the lower diameter of the columns. In the pycnostyle the intercolumniation was $1\frac{1}{2}$ diameters, in the systyle 2 diameters, while the diastyle and the araeostyle were more open still, with intercolumniations of 3 and $3\frac{1}{2}$ diameters. In the diastyle a stone architrave began to pose problems and in the araeostyle, says Vitruvius, the span was so great that only a wooden beam would serve. Hermogenes chose a compromise solution, the eustyle, with an intercolumniation of $2\frac{1}{4}$ and a height of $9\frac{1}{2}$ diameters.

34

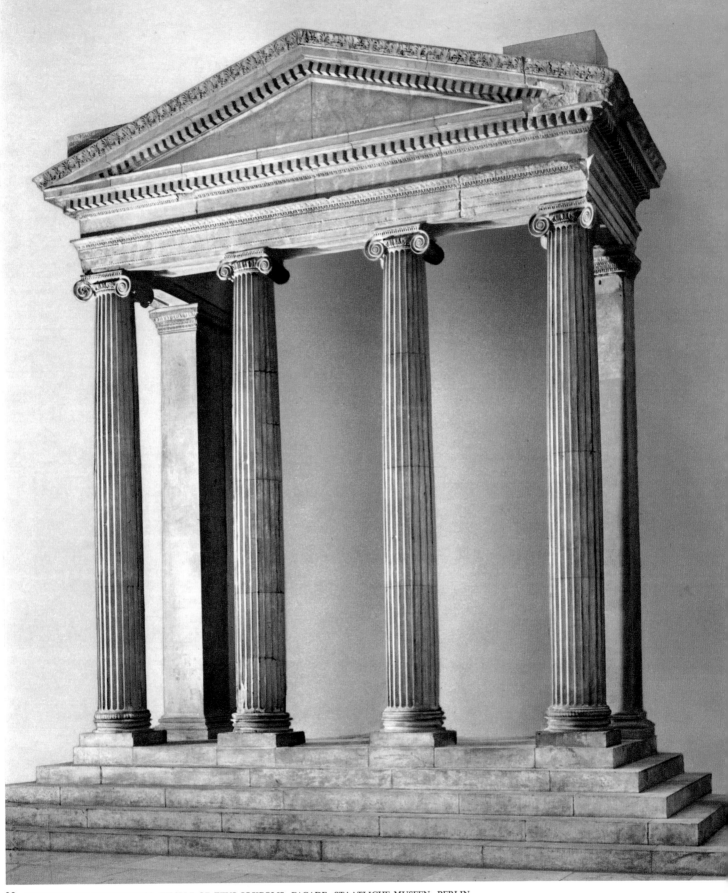

32. MAGNESIA-AD-MAEANDRUM, TEMPLE OF ZEUS SOSIPOLIS. FAÇADE. STAATLICHE MUSEEN, BERLIN.

The reasons for these changes were not solely practical. They also corresponded to a new concept of architecture in which plastic effects offset the striving after pictorial significance, and balance did not lie exclusively in the mathematical disposition of mass but also in the relationships between solid bodies and spaces, in transitions from light to shade, where the design and perspective were more pleasing than the juxtaposition of masses. Furthermore, the role of decoration (whether painted or sculptured) increased while the resources of colour and draughtsmanship were exploited side by side with the old, purely architectonic preoccupations. Sometimes, indeed, they eclipsed, or at least imposed themselves on, the latter, leading to various kinds of 'display architecture', or even to pseudo-architectural effects in painting and stucco. The Hellenistic period is one of those moments in the history of art when architecture finds itself closely associated with, and sometimes subservient to, sculpture and painting.

We are fortunate enough to be able to study the application of Hermogenes' theories in the monuments themselves. Excavation has revealed the remains of those buildings in Magnesia-ad-Maeandrum which antiquity regarded as the perfect illustration of the new principles. The temple of Zeus Sosipolis, which once stood in the agora, embodies Hermogenes' theoretical patterns. Behind the prostyle façade (now to be seen, restored, in Berlin), with its four columns, stood a deep pronaos, a cella of identical proportions and a narrow opisthodomus with two columns *in antis*; the areas of the three divisions were in the ratio 2:2:1. The shape of the pronaos is repeated in the façade (column-height 20 ft 8 in., width between axes of lateral columns 20 ft 10 in.). This stands on an Ionian *krepis* with five steps (shallower ones than the three traditional steps found in Greece proper), and the proportions of the order are those of the eustyle: the column-height (20 ft 8 in.) is $9\frac{1}{2}$ times the lower diameter, while the intercolumnar distance is $2\frac{1}{4}$ diameters. We have here an attempt to strike some sort of balance between pure Ionian traditionalism and the order's more Attic characteristics. Though the column-bases still retain their typically East Greek pattern (a fluted torus supported by two grooves and an astragal), the mouldings at the base of the walls are Attic, with double torus and scotia. The entablature juxtaposes the frieze, by now common in Attica, and dentils which properly belong to Ionia; in this case the dentils actually continue beneath the cornices of the pediment. The capitals are squashed under the entablature, and all that stands out is the sharply defined motif of the volutes. Thus we have here an association of all those elements, structural or decorative, which guarantee the supremacy of the Hellenistic Ionic order.

It seems certain that the temple of Zeus was built during the first two decades of the second century. Afterwards it was enclosed within a colonnade, integrated with the layout of the town, which surrounded the principal agora of the new city. Both topographically and architecturally this colonnade was associated with the sanctuary of Artemis Leucophryene, which was itself designed along Hellenistic lines. This temple stood inside a vast colonnaded court, the orientation of which was left intact, although it did not match the town's new axial-grid ground-plan. It was built according to Hermogenes' principles – and almost certainly by Hermogenes himself, though its construction seems quite a bit later than that of the temple in the agora; it is by no means impossible that the same architect was responsible for both, at about twenty-five

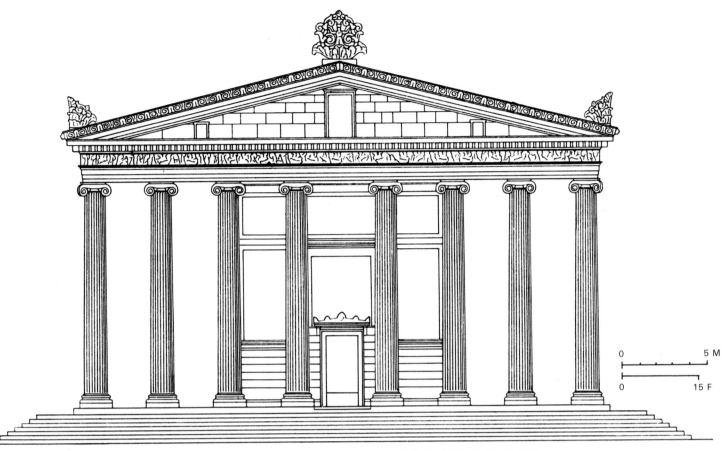

33. MAGNESIA-AD-MAEANDRUM, TEMPLE OF ARTEMIS LEUCOPHRYENE. RECONSTRUCTION OF THE FAÇADE.

or thirty years' interval. The ground-plan (see p. 354, fig. 399) reveals a strict application of the pseudo-dipteral concept. On a seven-step platform stood a peristasis of 8 x 15 columns, their proportions more or less identical with those of the temple of Zeus. The width of the intercolumniation (12 Attic feet) formed a module controlling the overall plan: the width of the colonnade was two modules; the depth of the naos (four intercolumnar spans) was the same as that of the cella and double that of the opisthodomus, giving the same ratio as in the temple of Zeus. The breadth of the cella matched the four intercolumniations on the façade, as Hermogenes recommends, and all surfaces were related to the basic intercolumnar span. The frieze on the entablature was given sculptured decoration and (as in the temple of Zeus) was surmounted by dentils, though these did not extend under the sloping cornices of the pediment. Here we may note a feature which occurs elsewhere: the tympanum of the façade was pierced by a large opening above the central intercolumniation (which is wider than the rest) and by smaller ones over the second and sixth intercolumnar spaces. Doubtless we must relate this characteristic to the interior ground-plan of the cella, with its two rows of columns standing very close together, which lead one to infer the existence of a lantern; the depth of the pronaos and the separation of cella and opisthodomus must have necessitated some illumination of the interior, particularly of the central chamber. Besides this, the striving for lightness of proportion in the colonnade and the inter-axial widening, of the central intercolumniation in particular, made it inevitable that entablature and pediment should be lightened too.

37

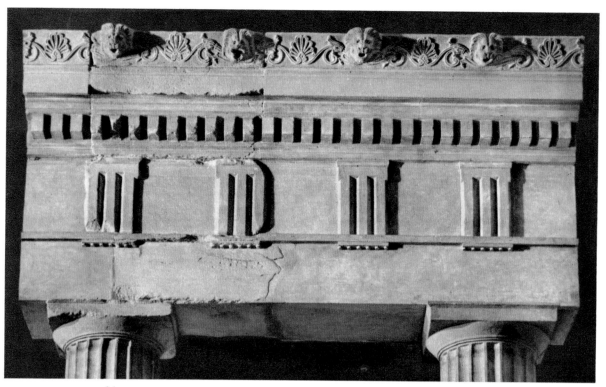

34. PRIENE, AGORA, NORTH STOA. DETAIL OF THE ENTABLATURE. STAATLICHE MUSEEN, BERLIN.

Hermogenes thus appears as the true innovator and theoretician of Hellenistic architecture, the ascendancy of old-style temples at Ephesus and Didyma and the persistence of the classical tradition having held up the transformation of architecture by a new aesthetic until the beginning of the second century.

In the field of religious architecture there are several other temples which we can group with those of Magnesia because they share the same underlying principles. These include the shrine of Apollo Smintheus from Chrysa in the Troad; that of Dionysus at Teos, which Vitruvian tradition likewise attributes to the *maestro* of Alabanda; the Hecateum of Lagina in Caria; and the temple of Apollo at Alabanda itself. All were built during the second century, each follows the pseudo-dipteral ground-plan; whether it is executed in Ionic style (Magnesia, Chrysa, Teos), Corinthian (Lagina), or even Doric (Alabanda), and all have an eight-columned façade and a deep pronaos. However, the rear façade varies: the narrow opisthodomus of the Magnesian temples may be preserved (Chrysa) or suppressed (Lagina, Alabanda), which leads to variations in the lateral colonnade (14 columns at Chrysa, 11 at Lagina, 13 at Alabanda).

The striving for spatial freedom, the wish to lighten forms and make colonnades open and airy, the preoccupation with contrasts of light and shade in a pictorial rather than a plastic perspective – these trends brought about great flexibility in the use of forms and styles, and led to associations hardly sanctioned by the classical rules. The entablature of the temple of Athena at Priene hints at these new developments. The decoration is expanding, and has made a clean break with the more specifically

38

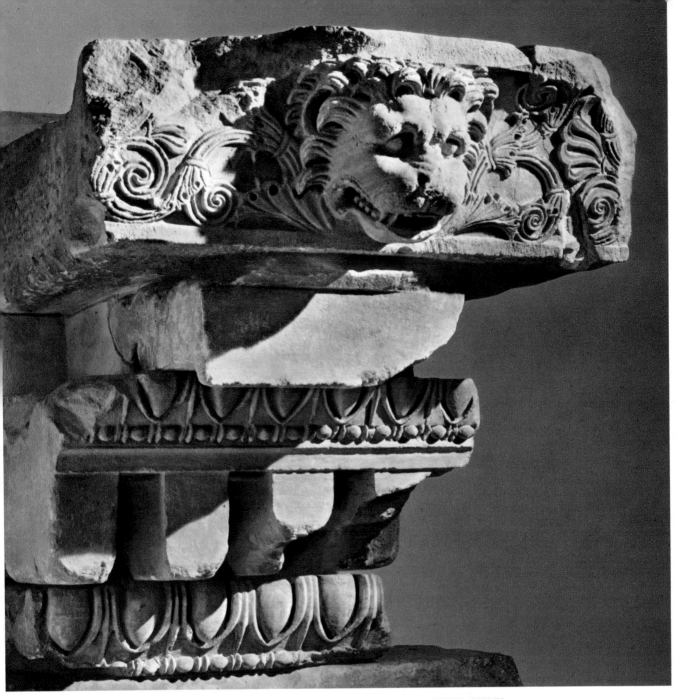

35. PRIENE, TEMPLE OF ATHENA. DETAIL OF THE ENTABLATURE. STAATLICHE MUSEEN, BERLIN.

architectonic features – consider, for instance, the independent course above the architrave, where the ovolo decoration has attained unusual height. The motif is repeated above the dentils and underscored by a cavetto and a line of bead-and-reel moulding. The entablature is topped by a high drip-moulding, its sima decorated with luxuriant scrolls of foliage with gargoyles in the shape of strongly carved lion's heads.

In buildings of the 'Hermogenic school', we find a blending of styles and a steady development of decorative motifs. We have already seen how the dentils on the façade of the temple of Zeus Sosipolis extended under the cornices of the pediments. From

39

now on frieze and dentils are regularly associated, and we even find the latter introduced into the Doric entablature. The Doric colonnades at the foot of Athena's terrace beside the agora of Priene, are given a mixed entablature. Above the architrave and triglyphed frieze (itself bordered with a smooth-cut ovolo motif) there rests a block carved in dentils, and a gutter which has an Ionic soffit but an upper moulding derived from Doric hawksbeak. On the drip-moulding we can observe the stereotyping of decorative motifs, lions' heads and foliate scrollwork, on late second- or early first-century buildings.

This mixture of decorative motifs led to a muddling of proportions. Above wide intercolumniations, framed by fine columns, Doric or Ionic, the frieze grew longer, and the triglyphs and metopes multiplied. In the great third-century stoas of Pergamum three or four metopes to each intercolumnar space replace the two metopes which had been common in the previous century. The temple in the agora there presents a triglyphed entablature above columns combining a Doric capital with Ionic fluting and bases: the inner face of the architrave is Ionic, with two bands, whereas the outer face is Doric, with a very prominent taenia. Lastly, in the porticoes of the temple of Athena at Pergamum, the Ionic columns of the upper storey support an Ionic architrave above which is a triglyphed frieze with five metopes to each intercolumnar bay, while in the Bouleuterion at Miletus we actually find the echinus of the Doric capital decorated with an exclusively Ionic-style ovolo motif. Confusion is now total, and heralds the variant types of mixed capital that characterize the Roman period.

In the formal sphere, architecture during the second and first centuries was enriched by a welcome innovation: the use of the arch and vault. Here, too, the fourth century had pointed the way, in east and west alike. The beautiful Porta Rosa at Velia, the barrel-vaulted funerary chambers of the Macedonian tombs, the arched gates of the theatre at Alinda – all foreshadow the splendid achievements of the period that followed. One fairly recent discovery has been the crypt and doors of the Necromanteion at Ephyra. The edifice is constructed in a crudely vigorous fashion of polygonal blocks in more or less regular courses, and it contains some ground-floor rooms in which, even at this early date, the doors have a semicircular arch, with drafted voussoirs. One curious point is that, even when a heavy slab serves as a horizontal lintel, the crowning courses are arranged so as to form a relieving arch – a technique common in Roman architecture, but known also to Greek builders. The combination of arch and vault is seen at its best in the crypt. The subterranean chamber is roofed with a barrel-vault supported by a series of drafted arches which form the framework of the crypt, the voussoirs standing proud of the courses which bear on them.

The arch serves a double purpose, both utilitarian and decorative. From the second century onwards, as we can see from one of the entrance gates of the Letoön theatre at Xanthos it may be associated in the latter role with the traditional motif of the triangular pediment. This would conventionally be associated with columns, but is here transformed into a purely decorative feature and treated as applied ornamentation, independent of the rest of the composition. Here again, Roman architects were to adopt a Hellenistic invention.

36. EPHYRA, NECROMANTEION. INNER CHAMBERS.

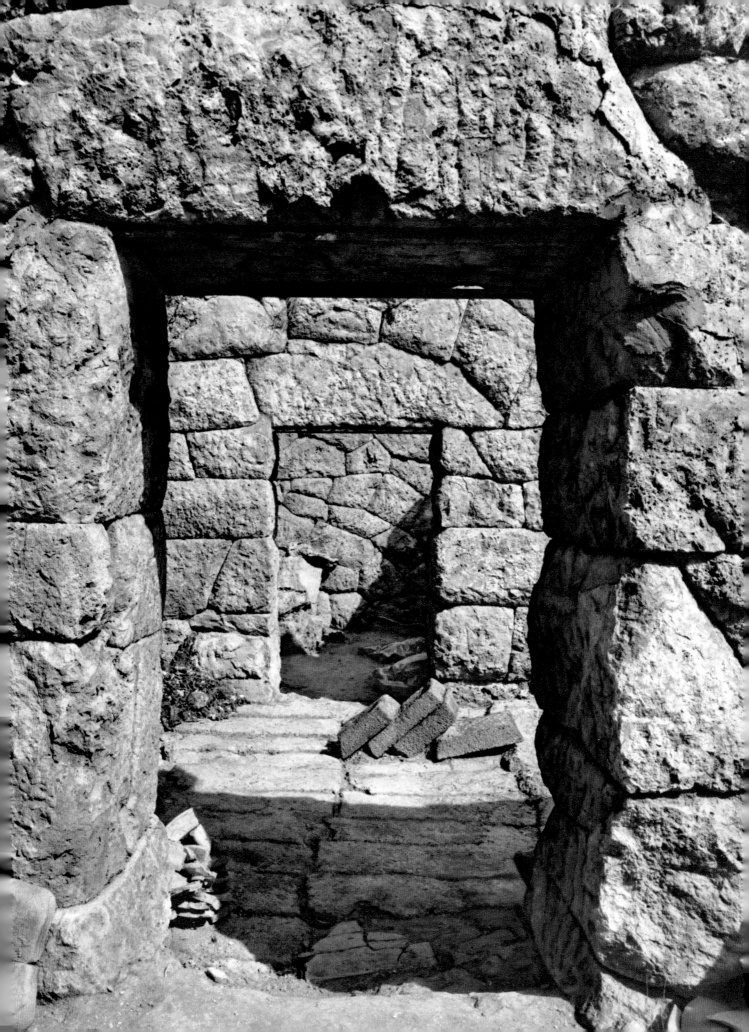

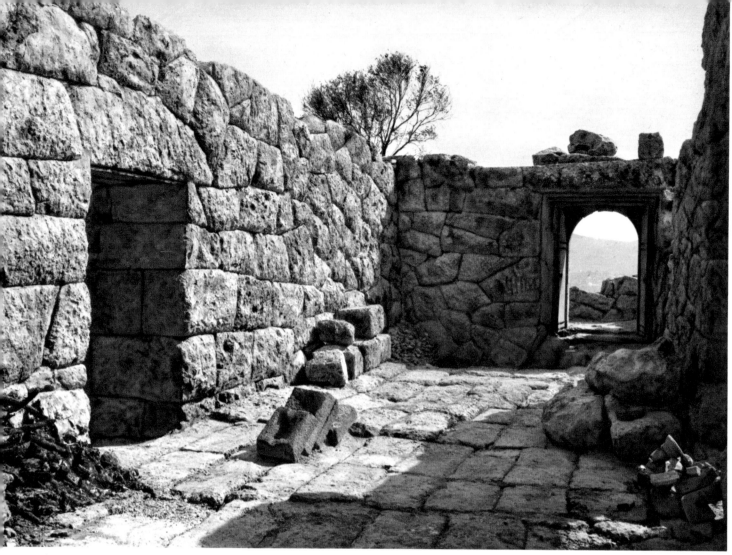

37. EPHYRA, NECROMANTEION. THE ENTRANCE.

38. EPHYRA, NECROMANTEION. VAULTED UNDERGROUND CHAMBER.

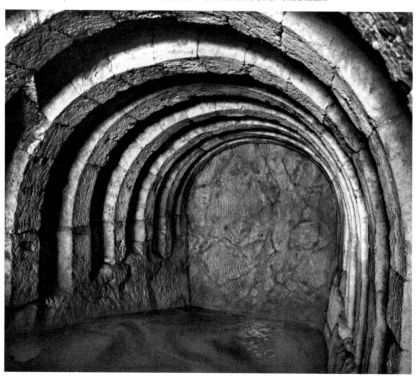

42

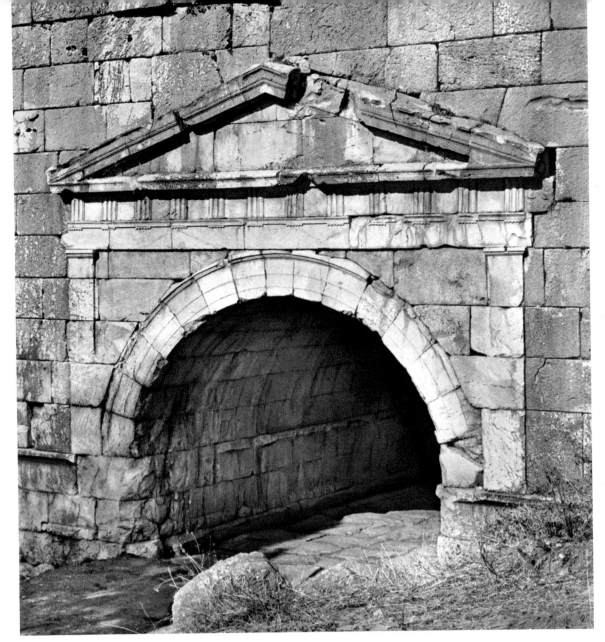

39. XANTHOS, LETOÖN THEATRE. ENTRANCE-GATE.

In underground construction Hellenistic architects very quickly learnt to replace lintel-course coverings by this system of parallel arches supporting flagstones or concrete foundation of the floor above. Certain cisterns on Delos, notably that of the theatre, illustrate a transitional phase. The arches stand out from stone-faced pilasters in the walls, and carry partition-walls, built of large slabs of schist, on which the upper covering rested. The same principle was adopted for the adyton of the temple of Apollo at Claros, when the shrine was being altered during the second half of the first century B.C. Here the sequence of arches was set up inside some existing chambers which had been damaged by fire. Each arch rests directly on a ledge, scarcely any higher than the pavement, and forms a single flying span, without the support of vertical pilasters.

43

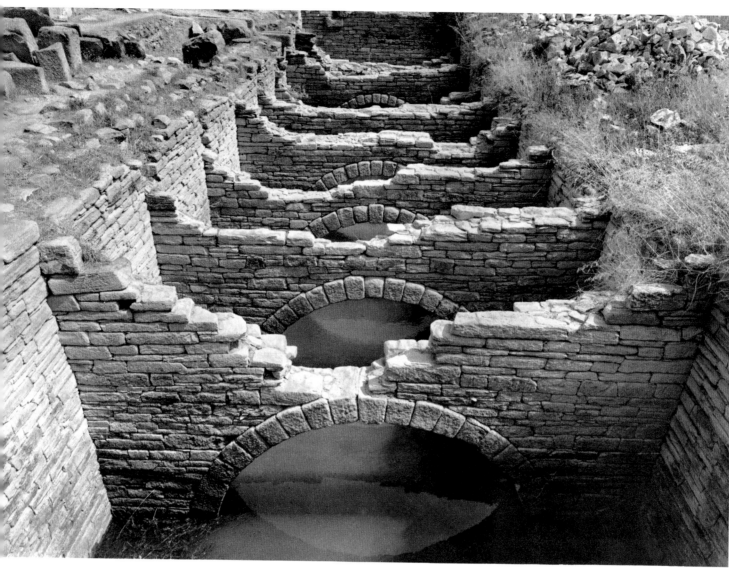

40. DELOS. CISTERN OF THE THEATRE.

The builders' expertise is clearly revealed by Pergamene-type vaulting, not only at Pergamum itself, but also in buildings constructed by the Attalids' work-teams (for towns and sanctuaries alike) throughout the Greek world. At Pergamum, the entrance to the gymnasia, which gave access from the street to the lower and middle terrace, takes the form of a subterranean stairway of two flights, each covered by a perpendicular vault. These are placed on different levels, avoiding the difficulties which arise when two barrel-vaults meet. This problem was not sidestepped in the design of the terrace of Attalus I at Delphi: in front of the portico, and beneath the terrace itself, the architects built a subterranean exedra with three aisles – a pattern used in the Pergamum acropolis and later in a number of towns in Asia Minor. Two parallel aisles open on the street running below the terrace, while the third links their inner ends. The roof takes the form of semicircular barrel-vaults, penetration being achieved by means of a square arch in the re-entrant and a groined arch in the salient angle. The builder's

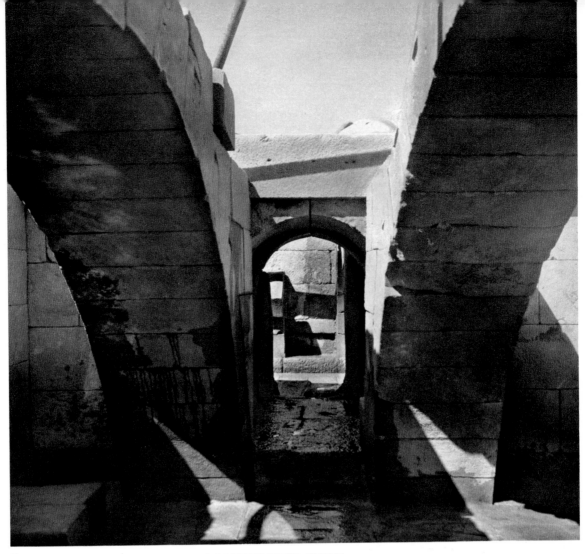

41. CLAROS, TEMPLE OF APOLLO. VAULTED DOORWAY IN THE ADYTON.

42. CLAROS, TEMPLE OF APOLLO, ADYTON.
DETAIL OF THE ARCHES OF THE VAULT.

45

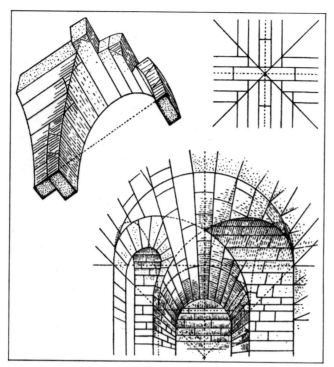

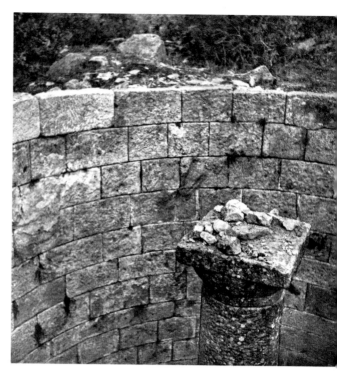

43. PERGAMUM, STAIRWAY TO THE GYMNASIA. SKETCH OF VAULTING. 44. PERGAMUM, ACROPOLIS. DETAIL OF THE CISTERN.

hesitant attitude can be deduced from the delicate shaping of the voussoirs that carry the juncture between the two barrel-vaults. Almost all of them are groined, or cross-vaulted, a form which, while emphasizing the mass of the vaults themselves, also increases the risk of collapse. Nevertheless it remains true that, from the end of the third century onwards, Pergamene architects solved the most delicate vaulting problems – though these were the exception rather than the rule until Roman times.

Finally, it is by no means impossible that Pergamene architects experimented with schemes for roof-construction over a circular ground-plan. Such efforts would inevitably involve some attempt to produce an improved cupola, and a cistern on the acropolis at Pergamum preserves a central pillar which probably supported a keystone on which roofing-slabs engaged – although, since excavation has not produced enough material evidence, a set of concentric arches buttressing themselves on the pillar cannot be altogether ruled out. Early methods would probably have resembled that used by Andronicus in the Athenian clock-tower traditionally known as the 'Tower of the Winds', where the roof consists of slabs bearing on a central keystone. Numerous small buildings – rotundas or tholoi – were roofed in this fashion; and, by the close of the Hellenistic period, monolithic cupolas also appear.

The striving of Hellenistic architecture for plastic and pictorial effects could not but encourage artists to lay greater emphasis upon decorative sculpture. Though the Attic frieze was adopted by the Ionians, and Hermogenes introduced it into the entablature of the temple at Magnesia, the relationship which was sought between architectural

45. ATHENS, 'TOWER OF THE WINDS'. ROOF-VAULTING.

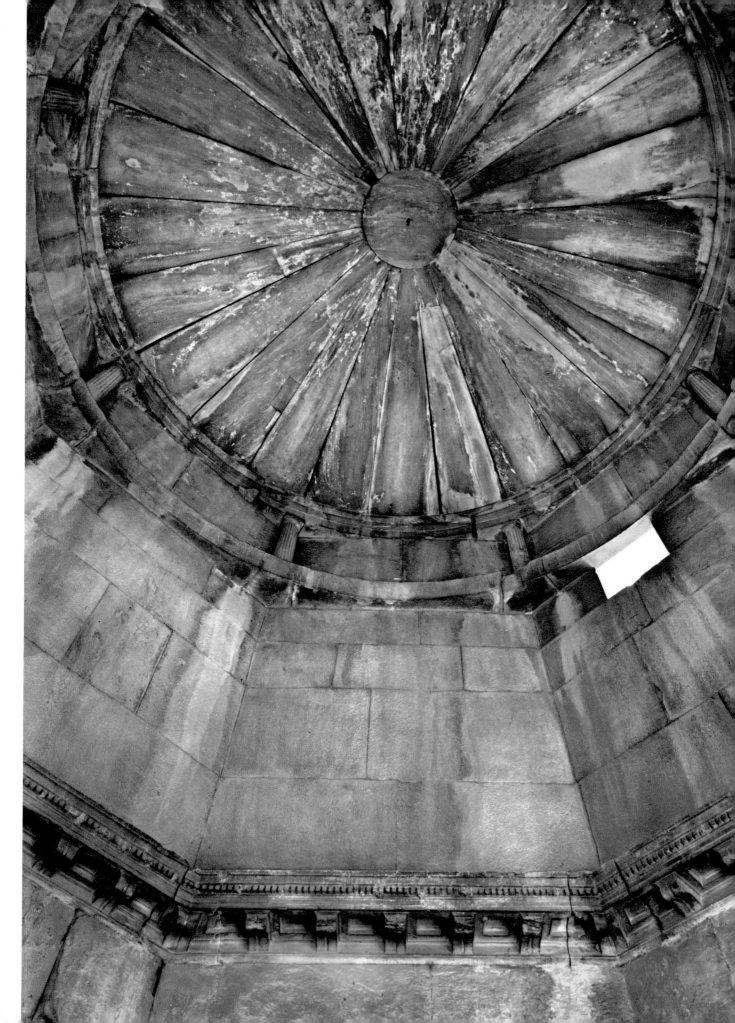

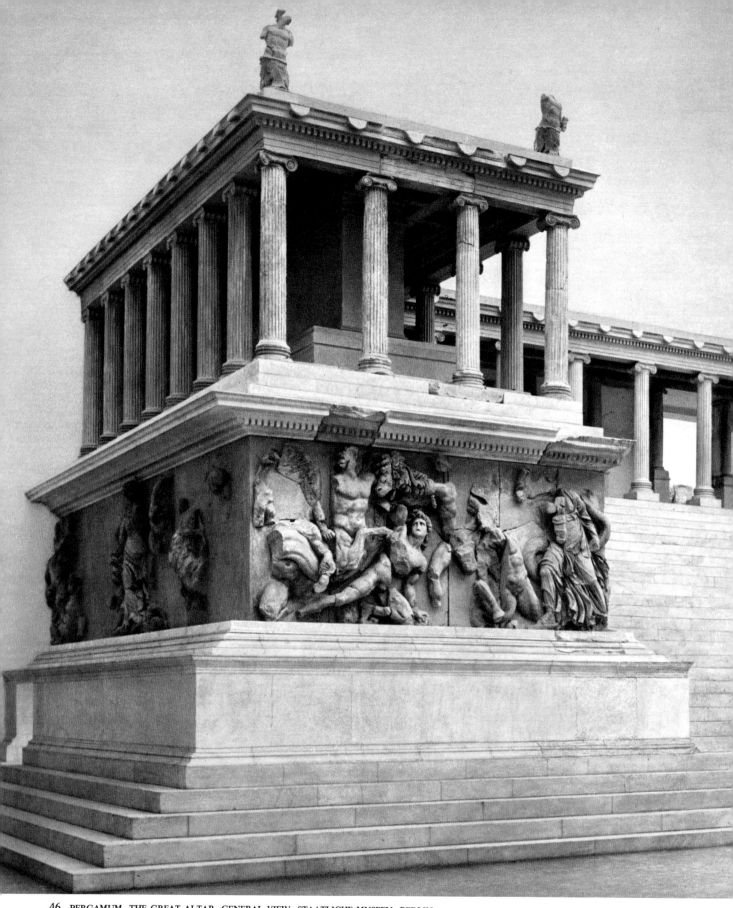

46. PERGAMUM, THE GREAT ALTAR. GENERAL VIEW. STAATLICHE MUSEEN, BERLIN.

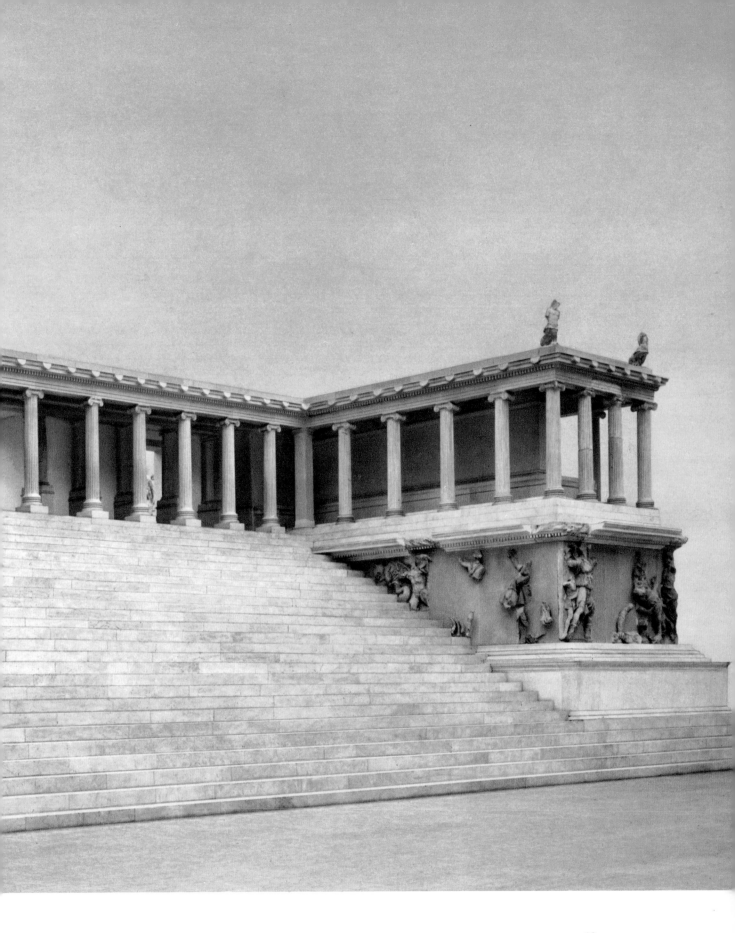

structure and plastic form was rather different. The colonnade came to be associated with sculpture, the one providing a setting that enhanced the other, which in turn gave life to the empty intercolumnar spaces. An example of this already existed in the fourth-century Nereid Monument of Xanthos, where (for religious and local, rather than aesthetic, reasons) statues had been arranged on the base, alternating with the Ionic columns. We know also how ample a treatment the famous fourth-century sculptors and architects, amongst them Pytheus, Scopas and Bryaxis, bestowed on a comparable section of Mausolus' lavish funeral monument; the sculptures – quite apart from the friezes – are so rich that they create constant difficulties when it comes to finding a place for them in the various attempts at restoration.

When we look beyond the funerary sphere, we find that monumental altars in the Ionian tradition have likewise developed along new lines as a result of collocating colonnades and sculpture. The most famous (and also the most complex) is the Great Altar of Pergamum, the reconstruction of which, thanks to Humann's discovery of sculptured and architectural remains in the Byzantine fortification-wall (for which they had furnished excellent material), forms the crowning glory of the Staatliche Museen in Berlin. The altar-table, placed on a vast stepped base in accordance with Ionian tradition, was here made an integral feature of a monumental architectural *ensemble*. The platform on which it stood was surrounded on three sides by a wall and an exterior colonnade, the wings of which extended far enough to flank a large and majestic staircase giving access to the platform on the west side (see p. 354, fig. 400). The colonnade itself was based on a high podium with three constituent elements. First there was an almost square *krepis* (120×112 ft) with five steps. Then came a foundation-course of smooth orthostats (facing slabs), their moulded crowning forming the base of the famous frieze – among the most impressive productions to emerge from the Pergamene sculptors' *ateliers* – which, in a space 7ft 6in. high and nearly 400ft long, portrayed episodes from the battle of Gods and Giants (figs 286-302). On the wall surrounding the altar itself was a frieze illustrating the legend of Telephus (figs 303-305). Statues of divinities or allegorical figures stood in the bays overlooking the stairway, and perhaps also surmounted the eastern portico to give it more prominence.

Commissioned by Eumenes II (197-159 B.C.) and consecrated to Zeus, Athena, and a whole pantheon of deities, the Great Altar of Pergamum served as a model for other, slightly later, constructions at Priene and at Magnesia-ad-Maeandrum. Facing Hermogenes' temple in the sanctuary of Artemis at Magnesia an altar was erected during the latter half of the second century, the ground-plan of which resembled that at Pergamum, except that it was smaller (see p. 355, figs 401-403). The altar-table stood on a platform and was surrounded by an Ionic order, forming a winged portico towards the west and a wall with half-columns on the east and at the ends. As at Pergamum, the monumental flight of steps giving access to the platform was framed by two bastions. The base supporting the colonnade had no sculptured reliefs; but the bays of the colonnade itself, both on the façade and at each end, were occupied by a series of figures carved in the round. The theme thus developed in second-century buildings lies behind a motif that was to enjoy great popularity: the niche. Here we find an architectural façade, with columns and pediments, sheltering some divine or human

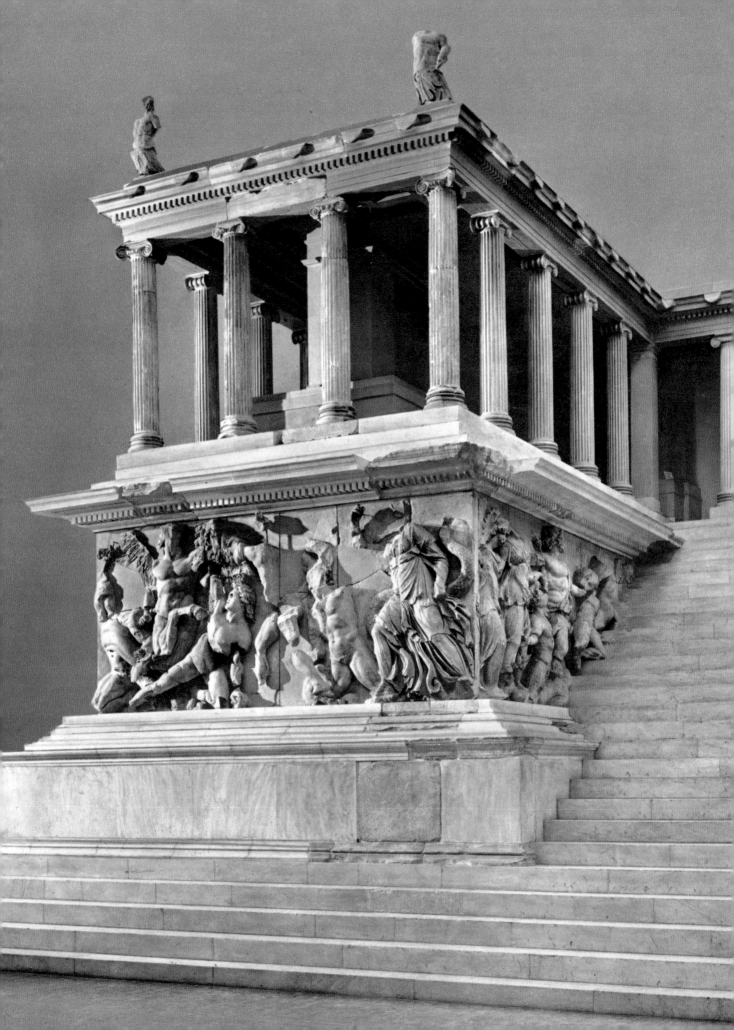

48. BELEVI, HEROÖN. GENERAL VIEW.

image. The latter, treated as an autonomous element, was later to enliven the façades of scene-buildings, nymphaea, and palaces in Roman architecture.

This flexibility and independence of forms and motifs that typifies architectural invention of the Hellenistic period serves to explain the development of a variety of structures in fields which the classical era had barely touched, or totally neglected.

Funerary architecture made rapid strides, and in some towns of Africa or Asia Minor necropolises occupied as much space as the cities of the living. Attention has already been drawn to the importance of the Belevi Mausoleum as regards the history of decorative fashion early in the third century, but, while taking its place in the tradition of the Nereid Monument and the Mausoleum at Halicarnassus, it also reveals in its structure the new features of 'display' architecture. It is no more than the 'outer

52

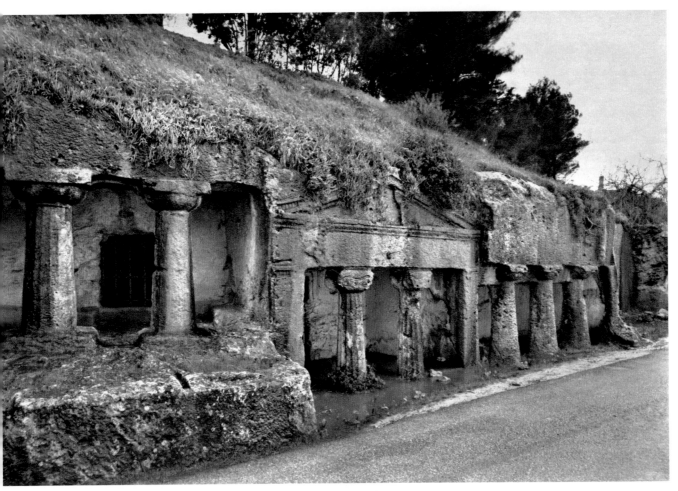

49. CYRENE, ROCK-TOMB. FAÇADE.

dressing' for a rock-tomb, the chamber of which is hollowed out within the living rock. The outer walls have been dressed to receive an architectural covering consisting of a stepped *krepis*, a moulded foundation-base, a plinth of large blocks in even courses (*isodomum*) and a Corinthian-style coping. Inside the chamber the walls are similarly faced and dressed, and the (unidentified) person for whom the Mausoleum was built lies on a richly decorated funeral couch.

It is a matter for regret that we cannot 'place' funerary architecture more precisely within the history of the orders; there is abundant material, but it has not yet been sufficiently studied, and its dating is often controversial. Some examples from the huge necropolis of Cyrene may illustrate various aspects that remain to be explored. Some tombs are completely detached, others partially hollowed from the rock, and their façades reveal a composite mingling of architectural features. We see squat, dumpy columns surmounted by Doric capitals (the echinus sometimes curiously 'archaic' in treatment) or quadrangular pillars, very strictly shaped, carrying heavy entablatures of variable proportions. Sometimes we find high architraves, their moulded upper edge directly supporting the pediment; sometimes the frieze, looming over a reduced architrave, recalls the more archaic forms of the order. Some tombs have a pedimental

53

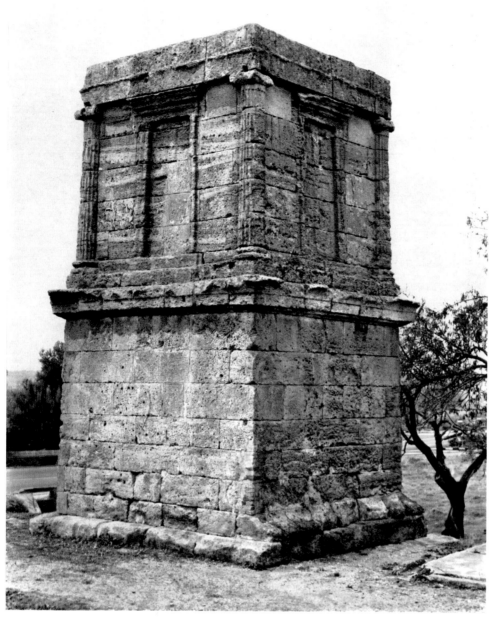

façade, others develop lengthwise and – above a half-column order – retain the full attic storey, its walls made of large blocks and backed at either end by two pillars.

There is one constant factor running through these variegated architectural phenomena: they all possess façades which are treated as mere surface decoration and do not imply any relation with an interior architectonic design. From now on we can better understand the development of the orders, and their extension – throughout this period – to the interior of funerary chambers in Asia, Alexandria, and Macedonia. The tombs in the Mustapha Pasha necropolis at Alexandria show how the orders were adapted to such a purpose. An order of Doric half-columns, supporting an architrave with regulae and a triglyphed frieze, gives the impression of a peristyle colonnade, some further details of which are supplied by painting on stucco. One of the links marking the spread of this architecture westward towards Spain, where it was to become widespread

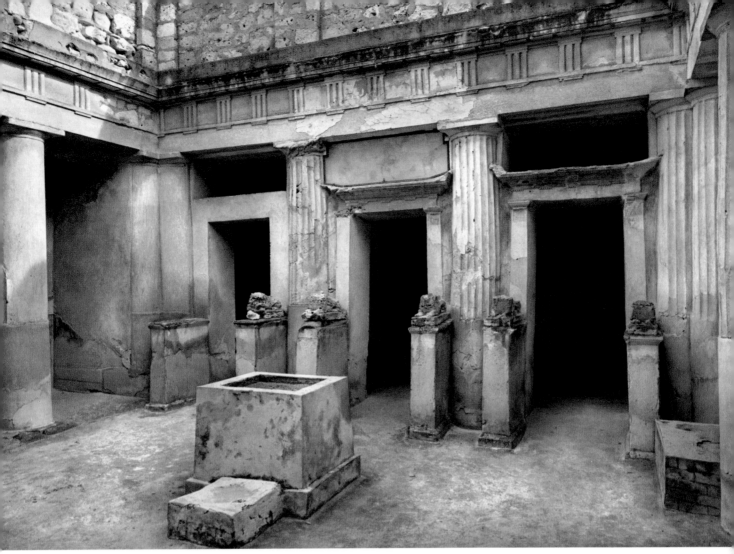

51. ALEXANDRIA, NECROPOLIS OF MUSTAPHA PASHA. DETAIL OF A FUNERARY MONUMENT.

52. CYRENE, ROCK-TOMB. THE FAÇADE.

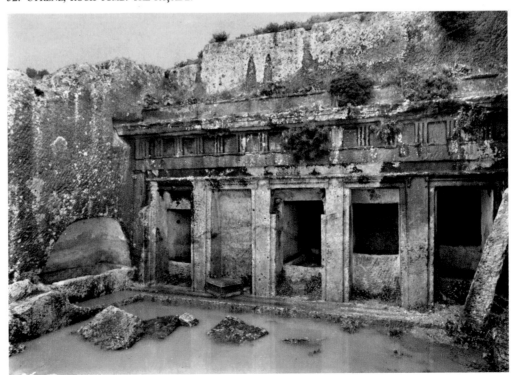

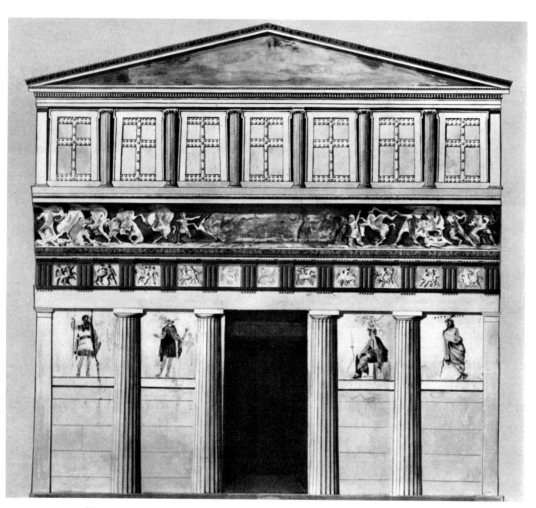

53. LEVKADHIA, TOMB. RECONSTRUCTION OF THE FAÇADE.

during the Roman period, is the monument of Theron in Agrigento (Acragas). This takes the form of a square base, constructed of large blocks, supporting a shrine, the architecture of which is essentially decorative. A Doric entablature is supported at each corner by an Ionic column.

An account such as this cannot omit some reference to the façades of the Macedonian tombs, mostly dating from the third century, which draw on every resource of applied ornamentation, including stucco-work and painting on plaster. One of the most complete and best composed of these façades is that of the Levkadhia tomb (see p. 353, figs 396-397). It consists of two storeys, one Doric the other Ionic, the masonry itself being closely associated with areas of painted stucco. On the ground floor, the Doric order (with four columns between the antae) leaves an enlarged central intercolumniation for the doorway. The other spaces simulate the interior of a portico, with the dressed wall of the base acting as a plinth for four panels, each of which is decorated with a single figure. The two levels are separated by a frieze of painted stucco, which emphasizes the monument's purpose by association with the mausolea of Asia Minor. The upper level takes the form of an elegant Ionic-style attic storey, its intercolumniations decorated with false windows, and surmounting the whole is a plain

56

54. YAZILIKAYA, PHRYGIAN TOMB. ROCK FAÇADE.

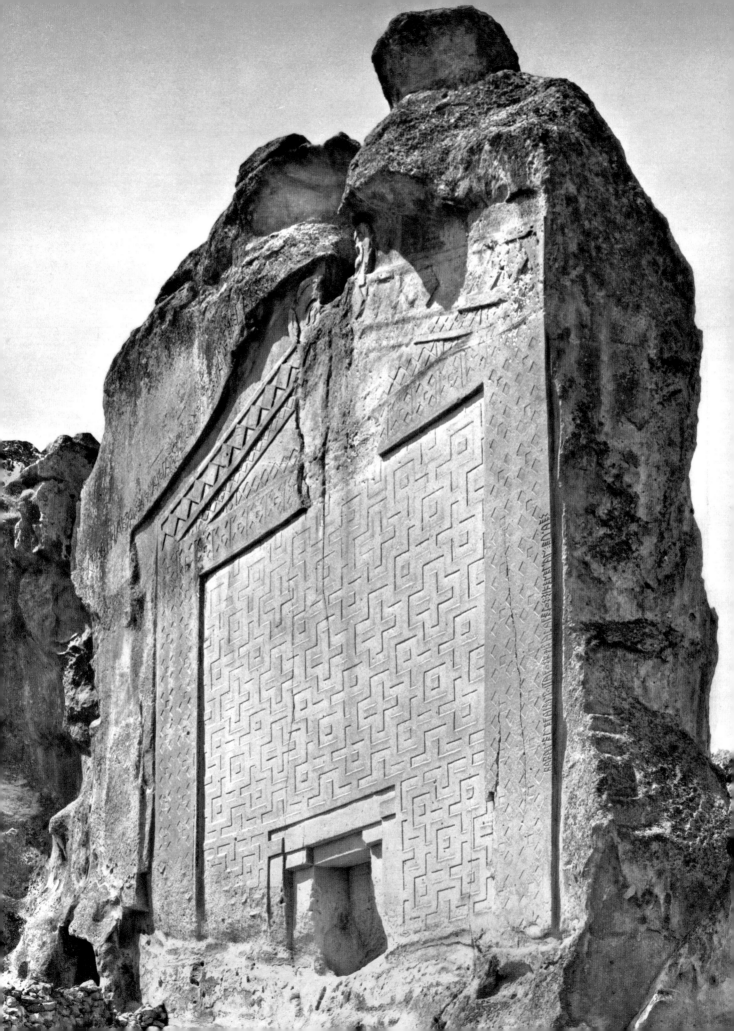

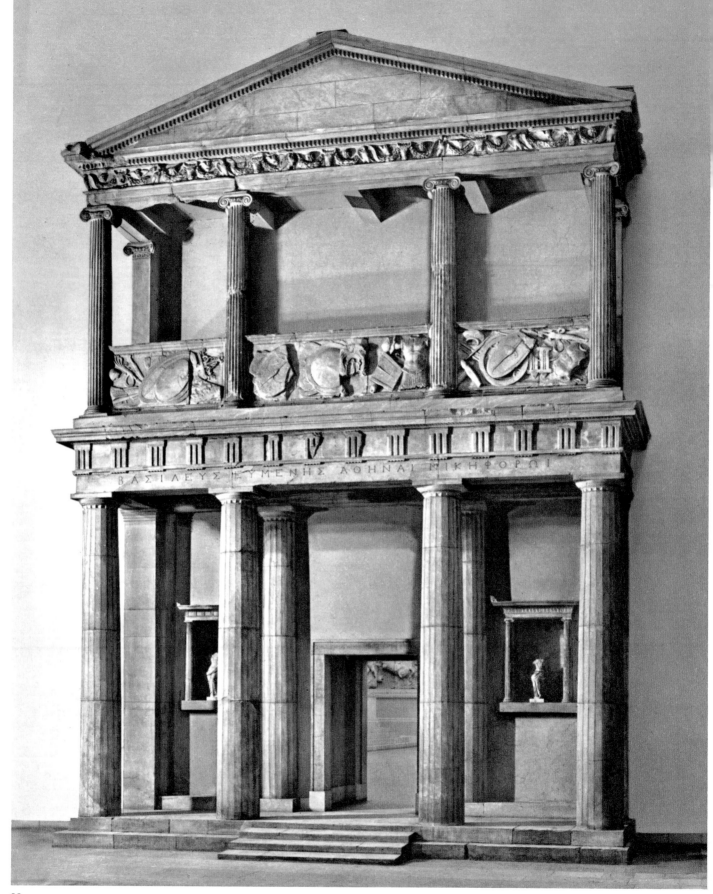

55. PERGAMUM, SANCTUARY OF ATHENA. THE PROPYLON. STAATLICHE MUSEEN, BERLIN.

56. MILETUS, SOUTH AGORA. THE GREAT GATE. STAATLICHE MUSEEN, BERLIN.

pediment. Other façades (e.g. those of the Langaza tomb, or those at Palatitsa) attach preponderant and quasi-symbolic importance to the fine marble-panelled doors, on which details of the casing such as cross-bars and bronze studs are shown in relief, and sometimes also heightened with paint.

Here, then, was the impetus behind an invention which subsequently transformed architectural design during the Hellenistic period: the monumental façade and those orders of applied ornament which form patterns on the outer surface of a building without reference to its ground-plan or construction. Propylaea, city-gates, military edifices, scene-buildings in theatres, façades for nymphaea – all found here every element they needed for rapid proliferation. The characteristic features of this development emerge clearly from a comparison between the propylon of the sanctuary of Athena at Pergamum (early second century B.C.) and the great Gate of the South Agora in Miletus (first century A.D.). Both monuments are simply façades, conceived *in vacuo* to serve as facing for a portico.

At Pergamum, however, unity is preserved by the exact correspondence between two superimposed orders, Doric at ground level and Ionic for the upper storey, forming a kind of prostyle in front of the antae and the interior colonnade of the portico. Yet the proportions are decorative rather than architectonic. The three wide intercolumnar spaces of the Ionic order in the upper storey – designed to emphasize the loggia and its sculptured balustrades – have also influenced the spacing of the Doric columns below, which is very unusual. This results in some fine and very slender columns, a narrowing down of the frieze and architrave, and an unusual number of metopes and triglyphs above each intercolumniation. The epistyle ceases to be part of a functional structure and is here no more than a plain strip, a space for Eumenes II's dedicatory inscription. Nevertheless, the overall design – including considerable use of decorative sculpture in the upper storey – still maintains well-balanced proportions and has a certain architectural value. The Miletus gateway, on the other hand, is no more than an assembly of decorative motifs, no longer even connected by an apparent unity of structure. The central motif is isolated, with a view to emphasizing the central section of the upper storey with a niche set prominently below an interrupted pediment. On both sides rise the wings, given a depth which defines the central mass, as was then the fashion with theatrical scene-buildings or nymphaea. The mixture of orders, Ionic and Corinthian, together with the isolated double column motifs, each pair supporting an entablature and a little pediment – all this indicates an exclusive striving for decorative effect in which sculpture and architecture are made to serve the needs of a pictorial aesthetic.

The consequences of such a development are observable even in free-standing structures. It is odd to see the principle of the 'curtain-wall' applied in an anonymous temple at Epidaurus, of the early third century (see p. 351, fig. 387). Reduced to a thickness of 10½ in., this wall serves only to stop the gaps between the columns of an interior order and the half-columns outside, which alone have any important structural function. Thus a framework of supports exists within the edifice, and the recesses and detached panels of the wall are available for emphasizing the decorative motifs.

As a result of this spirit, and encouraged by new social and economic conditions, domestic architecture began to flourish as never before. It was far freer, and more

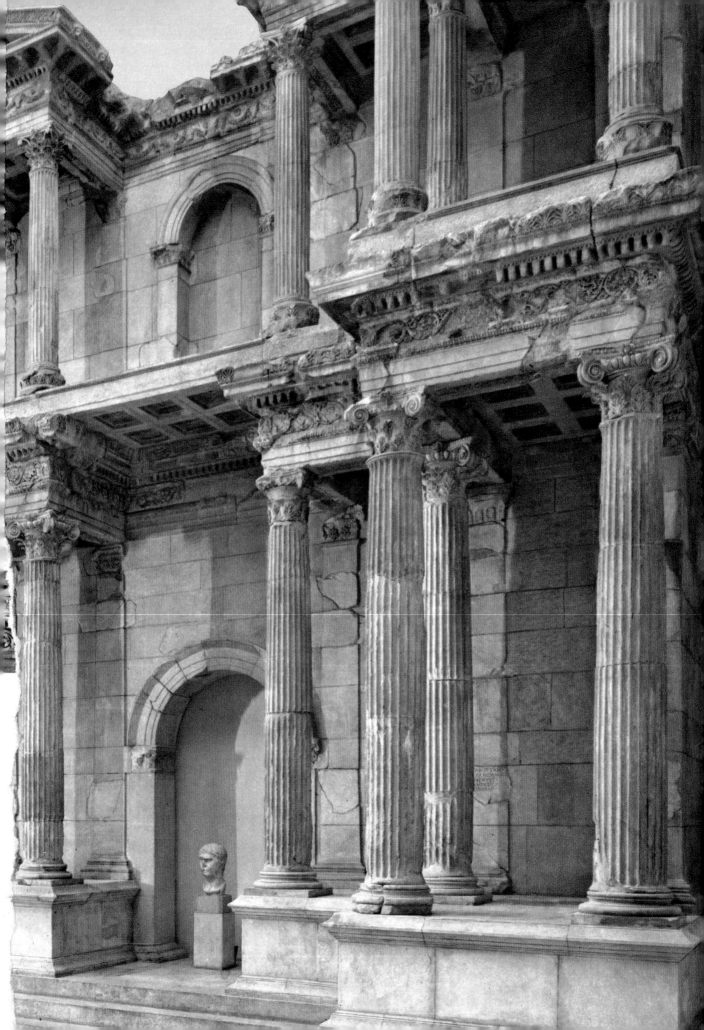

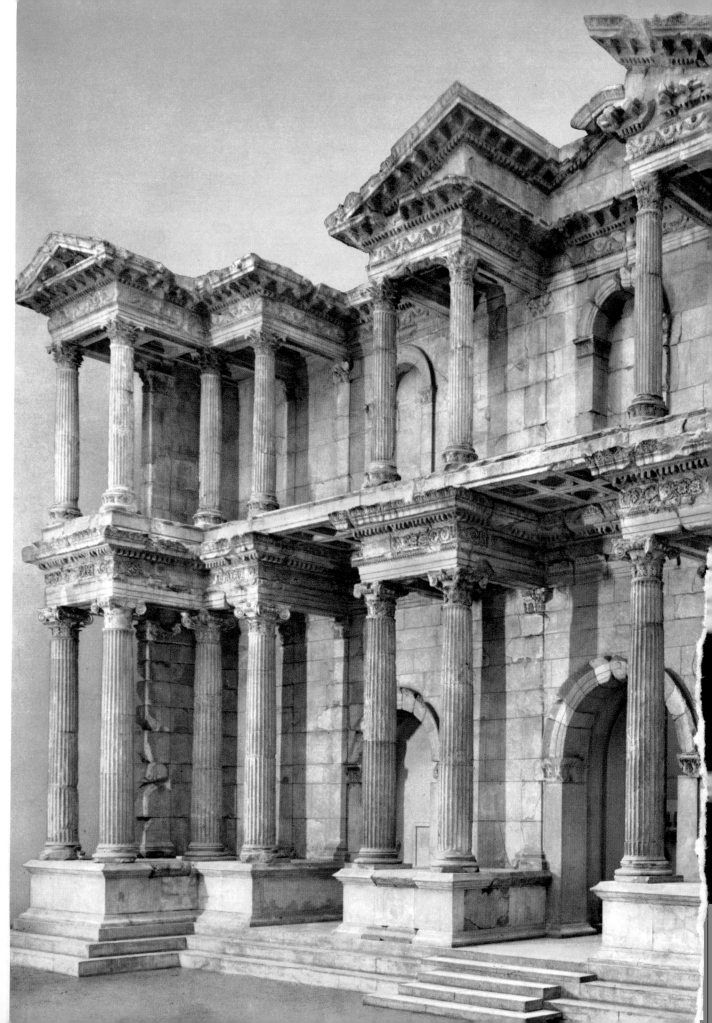

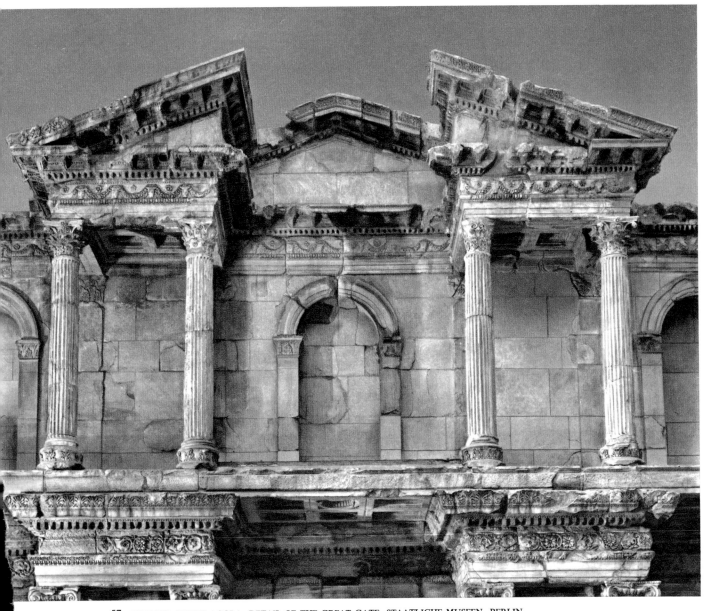

57. MILETUS, SOUTH AGORA. DETAIL OF THE GREAT GATE. STAATLICHE MUSEEN, BERLIN.

independent of classical tradition; it drew on every resource provided by the three great arts of architecture, painting, and sculpture, combining them in overall designs that were sometimes very elaborate.

Recent exploration in Pella, the Macedonian capital, has enriched our knowledge of domestic architecture. While the general ground-plan of a house is still based on a peristyle court and formal reception-rooms, interior spaces receive very full treatment, and the use of architectural orders of columns and pillars is combined with mosaic floors of varied and flexible technique. Nowhere else has the pebble-mosaic – here elaborated over large areas laid in geometrical motifs based simply on the natural colours: white or grey or green – been so well adapted to its architectural setting. In

62

58. PELLA. MOSAIC FLOORS MADE OF LARGE PEBBLES.

59. PELLA. HOUSE WITH PERISTYLE AND MOSAIC FLOOR.

addition to the patterns executed in large pebbles, Pella builders produced some masterpieces of small-pebble figured mosaic; hunting scenes in particular, based on the daily life of Macedonia's princes, seem to have enjoyed great popularity. The softness and friability of the local material employed for these buildings, a conchitic limestone, led to the systematic employment of stucco, even on the colonnades of the peristyles; the remains of this, in conjunction with the remarkable traces found in tombs, shows that Macedonia was one of the most important centres for the development (and doubtless the diffusion) of painted stucco in Hellenistic architecture.

Delos – which still remains a peculiarly rewarding site for the study of the Hellenistic period and its domestic architecture – doubtless profited from the interest of the princes of Macedonia. This interest shows itself in the construction of several large stoas, especially those of Antigonus Gonatas and Philip V, but the participation of Macedonian workers in these projects, and the employment of materials and techniques imported from Macedonia, make it reasonable to infer a more widespread influence on building methods throughout the island.

64

The ground-plan of a Delian house is conditioned by the topographical requirements of the site, but certain features are constant. There is always a peristyle court with colonnades on all four sides, one of them sometimes being equipped with an upper gallery (the so-called 'Rhodian' portico). The court always has a cistern beneath it, and its floor is often decorated with mosaics, as are the passages and the entrance-lobbies. There are always formal reception-rooms, lavishly decorated with mosaics and wall-paintings, opening on to the colonnade. In other respects, however, the houses vary considerably, the irregular plan of the city imposing different layouts: some houses are paired, others have to be truncated. On the slopes by the theatre, or in the Inopus valley, plan and elevation alike are adapted to the terrain. The so-called 'House

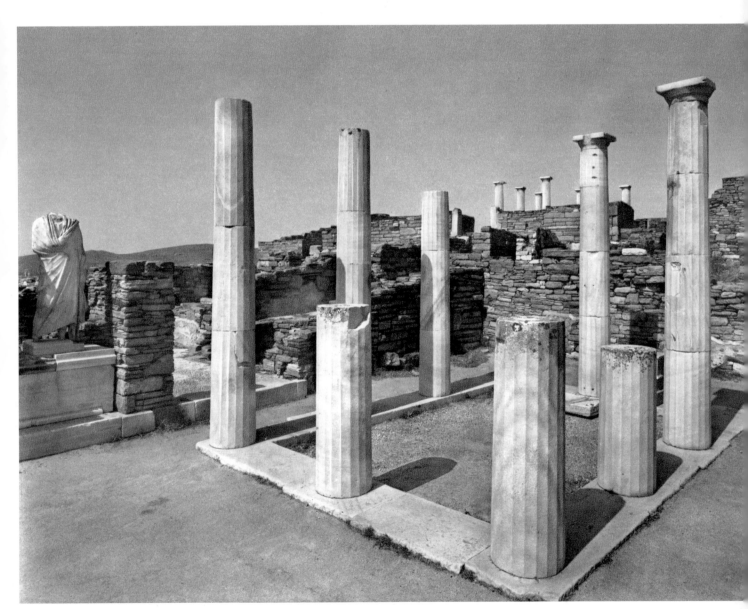

60. DELOS. HOUSE WITH PERISTYLE (THE SO-CALLED 'HOUSE OF CLEOPATRA').

65

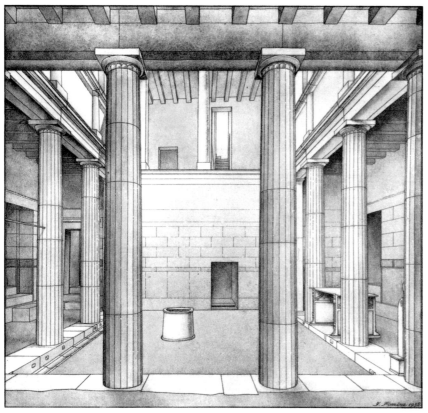

61. DELOS. RECONSTRUCTION OF THE SO-CALLED 'HOUSE OF HERMES'.

of Hermes' demonstrates the skill of Delian architects in making traditional patterns and plans serve the requirements of any particular site. The house is built on several different levels, each a little further back up the slope; lack of space has led to the omission of the colonnade on one side, and the rooms are arranged in a horseshoe pattern. On the uphill side several wide doorways, linked by stairs, facilitate movement between the different levels. These original arrangements embody certain calculated effects of perspective, and helped to focus attention on a piece of decorative statuary which – to judge from excavation finds, in particular a base bearing Praxiteles' signature – must have enjoyed considerable importance. In such a setting, where the play of light varies from one level to the next, one can appreciate the decorative role sculpture played in private houses. The Delos Museum's storerooms are crammed with surviving evidence for this craze, but some pieces have been left *in situ*, and still form part of the colonnades' perspective – for example, the statues in the 'House of Cleopatra', which combine with a Doric peristyle to frame the view towards Rheneia.

One must explore the area round the theatre, or the recently excavated site by Skardana Bay, in order to appreciate the harmonies established between all the different forms of decoration: between richly coloured mosaic pavements, Doric or Ionic colonnades, made of milky-white local marble or the bluish marble of Tinos, and the painted stucco of the interior. This last sometimes imitated the regular pattern of

62. DELOS, THE SO-CALLED 'HOUSE OF HERMES'. DETAIL OF THE INTERIOR COLONNADES.

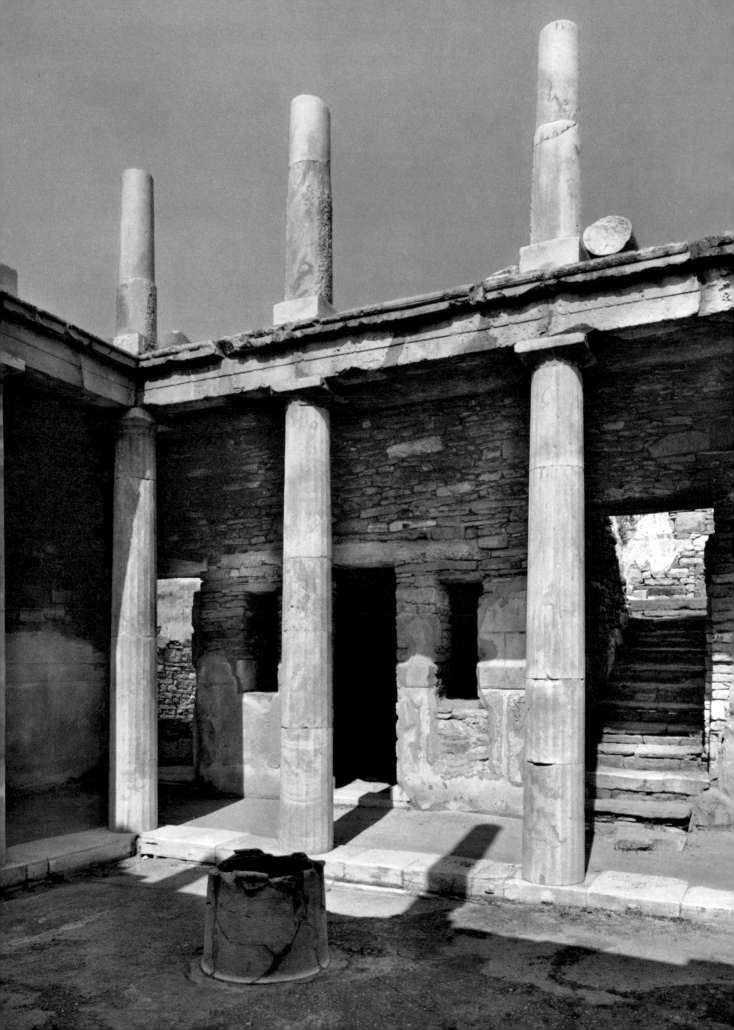

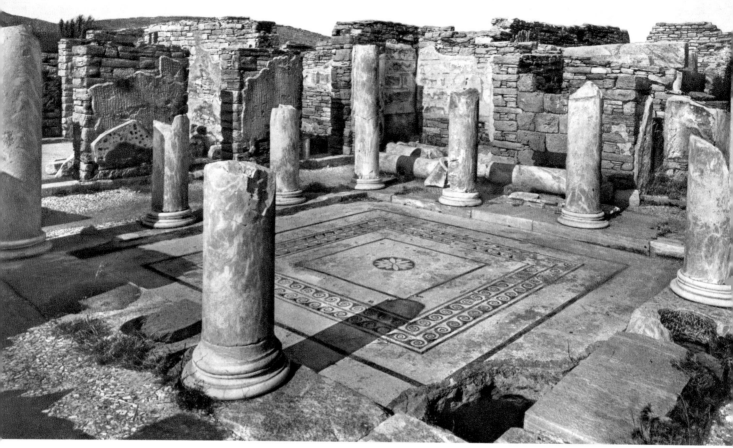

63. DELOS. PERISTYLE OF HOUSE WITH MOSAIC PAVEMENT.

wall-courses (*isodomum*), or, more often, was broadly deployed in large monochrome panels. Plinths, orthostats and cornices were mottled to counterfeit the coloured marbles of the Aegean, and stucco ornamentation was used to recall those interior orders found in the large-scale palatial architecture of Asia Minor or Alexandria.

In such a context all constructional techniques were bent to the task of producing vibrant, scintillating lines, interplay of light and shade, endless opposition and contrast. Here one can trace the formal evolution of Hellenistic architecture towards a complex, at times rococo, style overloaded with colour and decoration, which does not hesitate to make use of *trompe-l'œil* effects, or facings in rare materials – even precious metals. Is this 'decadent' architecture? Is it 'false', because detached from its basic structural functions? Before reaching a precise and measured opinion, one must judge it in the context of large-scale monumental masses, and against the urban background from which it can never be isolated.

68

Urban Architecture and the Development of Monumental Complexes

During the third and second centuries B.C. a genuine revolution took place in the principles of architectural composition. A building was no longer treated *in vacuo* as an isolated, self-sufficient entity with an individual character and specific functions, independent in its proportions and volume. The search for plastic and pictorial qualities led architects to compose in groups, or blocks: to integrate several individual edifices into a planned and organized whole, with the object of highlighting certain features against a linear or decorative background that would throw them into special prominence. As a result an architectural landscape developed, in which monumental masses were dependent on (and enhanced) one another, while at the same time being subordinated to a context in which rules of symmetrical balance, axial disposition, and relationship between volumes could emerge – discreetly at first, but more and more emphatically as time went on. Sanctuaries and agoras had originally been composed of separate buildings, isolated in space and variably oriented according to their own rules, or according to exterior features (terraces, streets, crossroads). Now they became progressively more enclosed. Esplanades and squares were surrounded by porticoes which singled out and defined an area which was treated as a unity.

The new political and economic conditions in the Hellenistic world may not themselves have given rise to this monumental architecture, but they certainly encouraged its development. It was well suited to the policy of self-advertisement practised by Hellenistic princes. Together with the urbanization movement, launched by Alexander and systematically developed by his successors, it formed the characteristic hallmark of conquering Hellenism – as recent excavations at Aï Khanoum in Afghanistan demonstrate. The Attalids at Pergamum, the Seleucids in Seleucia (and afterwards in Antioch), the Ptolemies in Alexandria – all employed teams of architects and engineers who created, and were for ever embellishing, the architectural setting against which their power could show to most advantageous effect. Architecture was no longer exclusively at the service of gods and city magistrates; now it aspired to match the political ambitions of princes and was disseminated throughout their zone of influence. It took on an ostentatious character which transformed every building – even a private one, like a *heroön* – into a complex architectural mass. It turned the traditional house into a palace, and the public square into a vast monumental complex. It took small edifices, whether public or private (fountains, baths, and so on), and linked them into a cohesive urban design in which the street itself became a monumental setting, interacting with other features, such as the decorative façades of nymphaea and gymnasia, palace loggias, and the propylaea of temples or market places. The princely capitals and the subject cities benefited from this policy; nor were the towns or sanctuaries of mainland Greece or the islands overlooked. Athens, Corinth, the towns of Asia Minor, the African colonies, Delphi, Delos, Dodona – all boasted buildings financed or built by the princes of Pergamum and Syria, and by the Ptolemies. The dedicatory inscriptions of these families are found at most of the well-known sites in Greece.

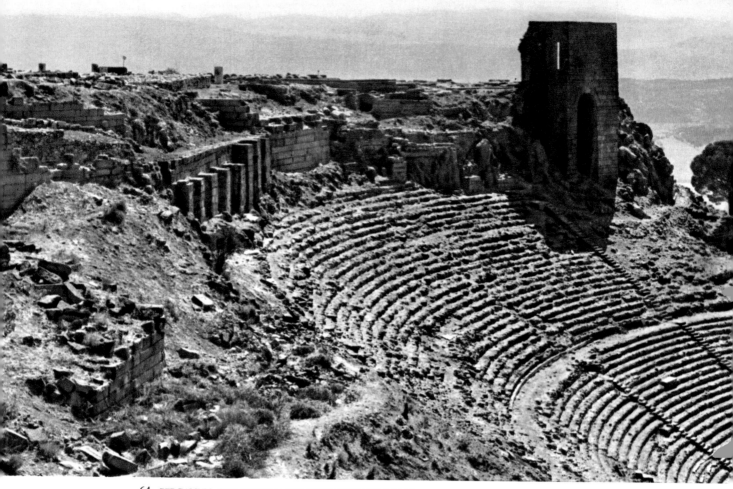

64. PERGAMUM. THE THEATRE AND VIEW OVER THE PLAIN.

Thanks to its size, and the wealth of archaeological exploration carried out there, Pergamum provides the finest example of the development and achievements of this important trend in creative architecture. The city stood on a magnificent site, at the southernmost tip of a mountainous massif, well watered and wooded. It dominated the plain at the confluence of two valleys (those of the Selinous in the west and the Cetius in the east) extending towards the Aegean coast at Pitane, the port of Pergamum. The defensible nature of the site made it a natural refuge, and it had already been occupied, in a modest way, for many centuries. Towards the end of the fourth century, however, Lysimachus, one of Alexander's lieutenants, chose it for the safe-keeping of his war-booty, which he placed under the charge of an officer named Philetaerus. On the death of his master Philetaerus – a crude, thrustingly aggressive character – seized the treasure and set up a small independent kingdom, reigning undisturbed until his death in 263 B.C. His immediate successors, Eumenes I (263-241) and Attalus I (241-197), consolidated the kingdom and extended its frontiers, in particular at the expense of the Galatians to the east. Nor did they neglect their own city, for the first object of their

70

solicitude was its divine protectress. The temple and sanctuary of Athena Nikephoros ('bringer of victory'), occupying pride of place on the terraces of the acropolis, was enlarged and enriched. In the next century, under Eumenes II (197-159), the building programme expanded still further, giving rise to ever more systematic projects and arrangements which make the Pergamene acropolis one of the most astonishing manifestations of Hellenistic city-planning.

The overall arrangement of the town at once reveals the basic principle on which the master-planners worked: to adapt to the terrain, and establish a close, unifying association between the landscape and the architectural complex (see p. 356, fig. 404). Even the line of the walls, supple and sinuous, follows the contours in such a way as to embody the more sheerly inaccessible spurs in the defence-system. The town's axis follows the same principle, curving with the slopes and using them to link the large complexes, each of which stands on a natural terrace. These terraces were latterly shaped and enlarged; to begin with they had remained individual planning projects, but were later related to one another.

Entrance to the city was through the South Gate, built under Eumenes II. From the start this emphasized the originality of Pergamene architecture. It was set by the architect, rather thoughtlessly, on a bend of the road which was enclosed internally by a court some 65 ft square; as travellers went through this court they passed beside a portico along the east wall, behind which was the entrance to a strong tower connected with the courtyard. Here we have our first glimpse of the recurrent motif in every Pergamene composition: a portico emphasizing and shaping the natural terrain.

The skill and subtlety of these arrangements are apparent from the first complex we encounter, immediately beyond the gateway: the so-called Lower Agora, which dates from the early second century. This is a market pure and simple, comprising porticoes and shops, and arranged around a completely enclosed square (210 × 112 ft). On the north the portico is built into the hill, and their upper storey communicates with the main street skirting the agora on the uphill side. At the southern end the upper storey of the portico corresponds to the esplanade of the agora, while the bottom floor lies at a lower level. All the colonnades are in Hellenistic Doric of modified proportions.

If the visitor continues down this same street, past shops and houses, he will reach the entrance to the gymnasia. These form a remarkable complex, designed on three terraces adapted to the natural contours. Access was through a propylon, beside which stood a large fountain, and colonnade; next came a double flight of stairs, each flight roofed with semicircular vaulting, the cradles of which were perpendicular and set on two different levels. The design gradually spreads out as we approach the highest gymnasium, which is the most complete and the most luxurious. It covers a terrace 650 ft long and 150 ft deep, and the buildings are arranged round three sides of this terrace, each side being edged with a colonnade. The fourth side consisted of the upper storey of the covered way, a stade (695 ft) in length, which communicated with the intermediate terrace. On the north side the main rooms backed on to the natural slope of the hill, which had been cut and shaped to form the back walls of an odeum, the ephebeum (approached through the portico by means of a four-column façade) and various exercise rooms. Several of the latter had an apsidal ground-plan, and were covered, at least during the Roman period, by a semi-cupola. Those parts dating from the Hellenistic period are built of local dark-coloured andesite, while Roman repair-work and rebuilding are in marble. The Doric order was frequently reinforced or replaced by Corinthian columns; nevertheless, the design as a whole – the main buildings and the linking sections – goes back to plans of the Hellenistic period.

Somewhat apart from the upper terrace of the gymnasium, at its north-west corner, stood the sanctuary of Demeter (see p. 357, figs 407-408). No ensemble more clearly illustrates the Pergamene architects' progressive achievements and discoveries. Early in the third century Philetaerus had a small temple *in antis* built on a long narrow terrace, with an altar before it on the east side. On the north side stands a simple portico, its eastern end in line with the altar. This gives way to steps, flanking the empty area to the east of the altar, which could be used only by those taking part in religious ceremonies. This is a characteristically classical arrangement, imitated from Greece.

At the end of the third century, however, Attalus I's wife Apollonis, of Cyzican origin, introduced a very different conception from which the principles governing

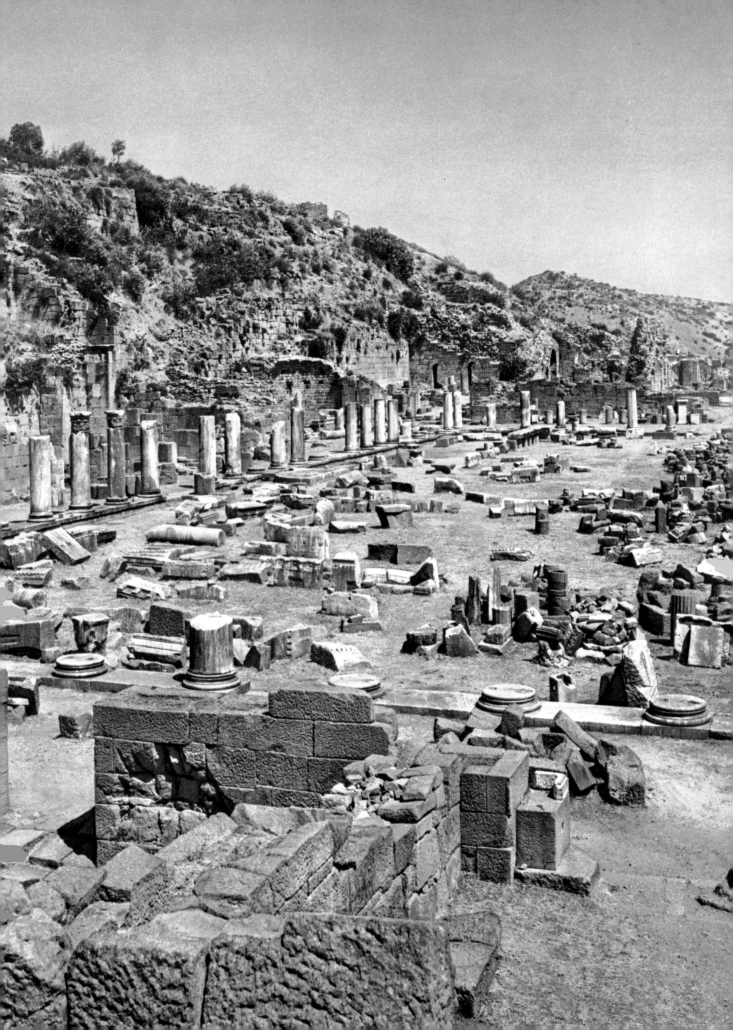

Pergamene architectural aesthetics emerge with some clarity. A double portico, 280 ft long, runs along the southern edge of the terrace, its outer edge resting on foundations built up from a lower level. An underground gallery, with access by way of a raised ramp, has been cut in the outer face of the foundation to make a terrace which looks out over the plain to the south. To the west we find a colonnade which links the south and the north porticoes and closes off the inner court. The north portico itself is prolonged behind and above the steps, on an extension of the esplanade cut in the slope of the hill, and has a clear view out over the southern stoa. Finally, the east end of the sanctuary is embellished with a propylon. The rules of Pergamene architecture are now fully formulated. The terraces are 'structured' by means of porticoes, which both enlarge them and regularize their shape, while 'taking root' on the slope through a series of massive buttresses which impose a rhythmic pattern on the landscape. The lower levels are treated like area basements. The success of underground vaulted passages (*cryptoportici*) in Roman architecture is well-known, but Rome borrowed them from complexes built by Pergamene architects not only for their own city, but throughout the Greek world: Aegae, Assos, Miletus and Smyrna all rapidly adopted the new types of portico. At the same time certain formal innovations took place. Apollonis imported the ancient palm capital from Cyzicus, using it on propylaea; thenceforth it was regularly used in interior orders, to distinguish them from façades – where Doric was the rule at ground level and Ionic on the upper storey.

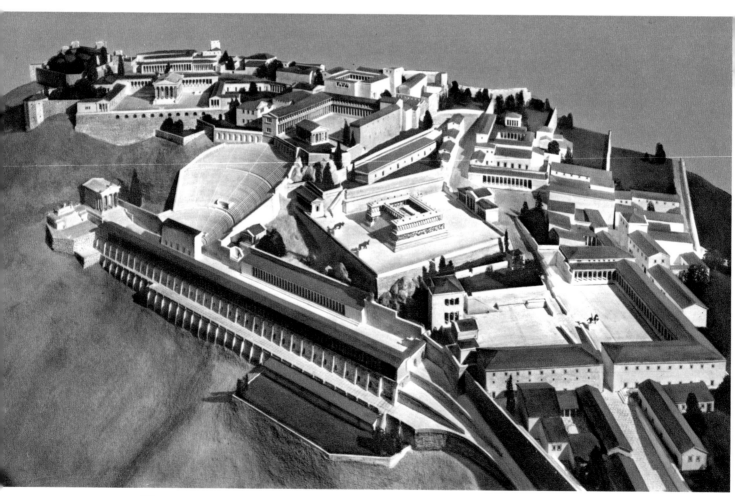

66. PERGAMUM, ACROPOLIS. SCALE MODEL. STAATLICHE MUSEEN, BERLIN.

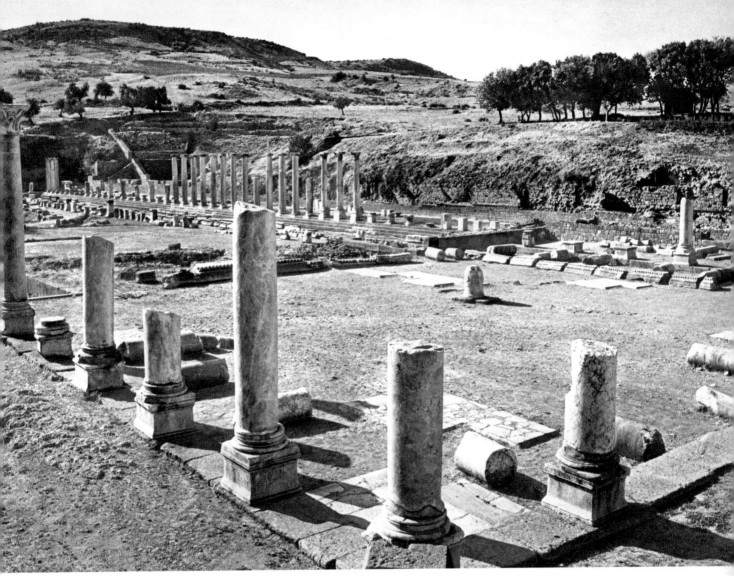

67. PERGAMUM, ASCLEPIEUM. COURT AND PORTICOES.

The first beneficiary of these innovations was the Pergamum acropolis (see p. 357, fig. 405). It is true that, after the work done by Eumenes II, this gives a strong impression of conscious overall planning; all the terraces are 'stepped' down the hillside from summit to agora, fanning out harmoniously round the theatre, and give the impression of being supported by the long terrace in front of the temple of Dionysus, with its massive porticoes and buttresses which impose themselves on the landscape. The composition was in fact progressive, the result of several successive works which originally had no direct connection one with another. The first construction project was the temple of Athena, in the Doric style, built by Philetaerus early in the third century with a classical ground-plan; it occupied a dominant position on a precipitous spur overlooking the theatre. Then private houses occupied the terrace where Eumenes II was to build the Great Altar of Zeus, while the first palaces stood away to the east, in a well-fortified position along the rocky ridge. On the summit itself the construction of arsenals and depots reveals the dynasty's military preoccupations.

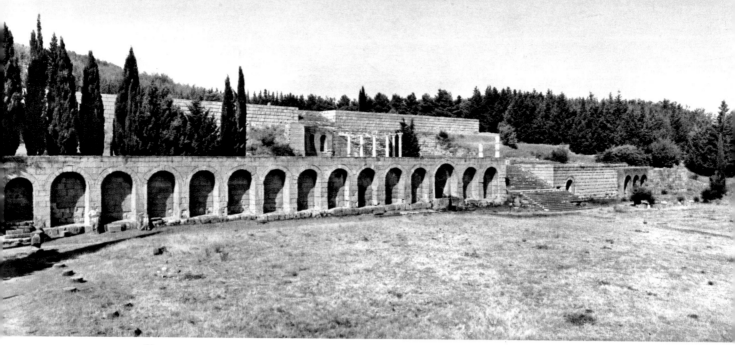

68. COS, THE ASCLEPIEUM. THE LOWER COURT AND THE TERRACES.

Under Attalus I and Eumenes II, the buildings progressively increased, arranging themselves after the three essential functions – religious, military and residential – reserved to the Pergamum acropolis. The domain of the gods occupied the western part of the site. Here, arranged in a fan shape, we find the Trajaneum (reconstructed during the Roman Empire over a Hellenistic complex), the sanctuary of Athena Nikephoros, the Great Altar of Zeus and of all the gods, and the temples of the agora. To the east, at the outer edge of the fan, there was a succession of palaces and houses belonging to high officials; on the summit stood the barracks and arsenals. At the entrance, on the south side, was the market, with a *heroön* close by. Though each terrace was treated according to its function, the principles of their arrangement were the same: there was a large and more or less disengaged esplanade, surrounded by a colonnade, or cloister, and by porticoes adapted to the lie of the land. This formed a setting that was freely utilized to set off the principal buildings; only the Trajaneum, because of the respect it shows for the laws of symmetry and axiality, is stamped as a product of the period in which it was rebuilt. The regular practice is to employ the Doric order for colonnades at ground level, and Ionic for the upper storey, with occasional syncretism in the entablature; for interior colonnades the palm capital becomes increasingly popular.

Having been perfected on the slopes of the acropolis, the principles of Pergamene architecture spread to various other sites – even in the plain, as we may see from the Asclepieum of the lower town, though the Roman building partially eliminated the old Hellenistic structure. Towns allied to, or friendly with, Pergamum welcomed the architects and masons sent by the Attalids, and both Aegae and the towns of Pisidia, further south in their mountain fastnesses, learnt to apply the same formulas.

Some fine architectural complexes had been achieved in the sanctuaries and cities of Greece before the lessons of Pergamum finally won acceptance in the first century B.C. among the architects of Italy and Rome. The sanctuary at Praeneste is wholly Pergamene in spirit, though formally and stylistically it shows signs of heavy Romani-

76

zation. On the other hand, the great sanctuary of Asclepius on Cos – somewhat closer to the Attalids' sphere of influence – reveals in the various phases of its planning both Pergamene influence (through the direct intervention of Eumenes II) and the systematic elaboration of a new architectural aesthetic. Here one can observe the transition from classicism to the forms of the Hellenistic period, ready to be transmitted to the Roman world of the West.

About the middle of the fourth century, a modest sanctuary was consecrated to Asclepius on a terrace half-way up the range of hills that border the plain of Cos at its southern end (the plain itself lies on the island's north coast). It consisted merely of a sacred cypress wood and a simple altar. At the beginning of the third century a temple of modest proportions (28 ft 8 in. × 49 ft 5 in.) with an Ionic façade *in antis* was built to the west of the altar. Those portions still surviving were reworked in the style of

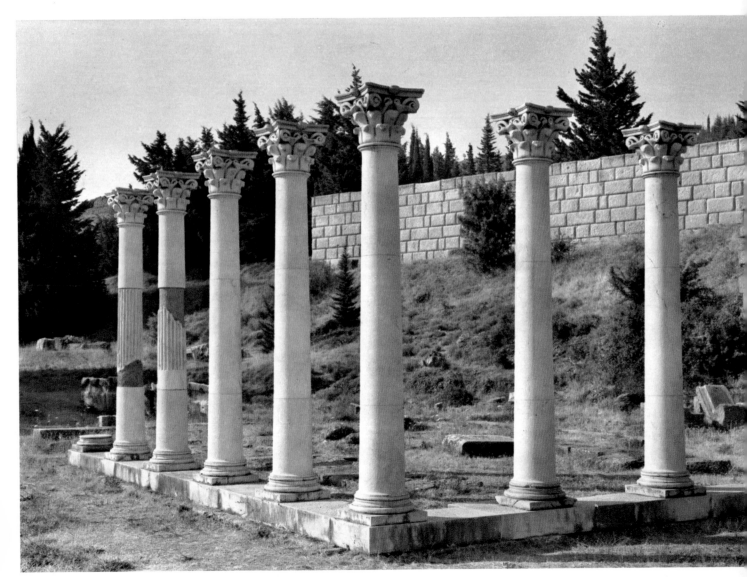

69. COS, ASCLEPIEUM. THE MIDDLE TERRACE AND TEMPLE.

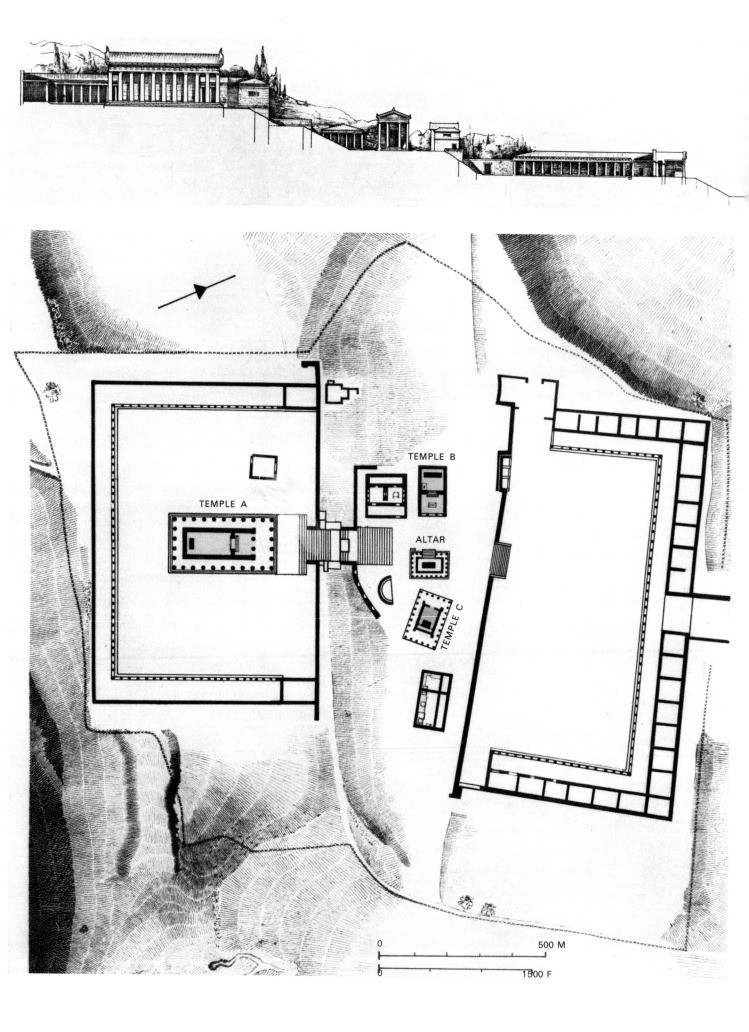

TEMPLE B

TEMPLE A

ALTAR

TEMPLE C

0 500 M

0 1500 F

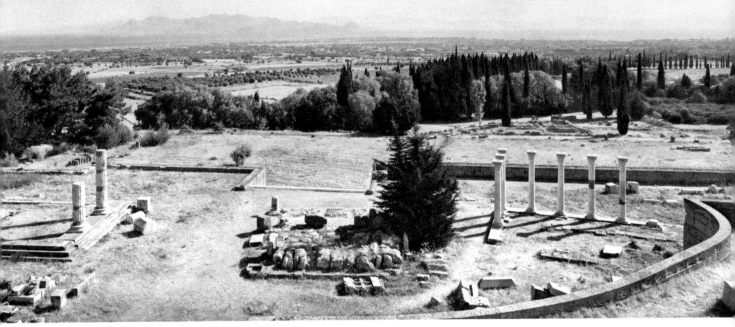

72. COS, ASCLEPIEUM. VIEW OVER THE MIDDLE AND LOWER TERRACES.

Hermogenes early in the second century. A building with an almost square ground-plan also appears – no doubt an adyton for pilgrims – and a small portico close beside the altar. All the buildings are laid out in the old way, with no interrelationship of mass and proportion but distributed at random on the same level, and designed only to serve the requirements of the cult and the ritual attendant upon a consultation of Asclepius.

About the middle of the second century – perhaps during the first half – a radical change took place in the architectural layout of the sanctuary: an open reception court was laid out below the original terrace, and a new complex, which now became the crowning-piece of the whole, was built on a further terrace above.

At the lower level, 20 ft below the ancient temenos, we find a vast open court, 305 × 154 ft, enclosed on the north, east and west by a Doric colonnade, while on the south side a massive retaining wall with two ornamental fountains, marks the outer limits of the sanctuary. Pilgrims entered this court through an open propylon, arranged along the same axis as a monumental stairway, some 33 ft broad, which gave access to the temple terrace. In order to tone down the uncompromisingly geometrical effect of this axial design, the porticoes at east and west were not carried right through to the retaining wall, open passages being left at either end; this made it possible to view the colonnades from an oblique angle, which was more in conformity with classical taste.

To achieve a satisfying effect, the composition required a crowning-piece, and this was obtained by the arrangement of the upper terrace, which lay some 36ft higher than the middle one and was approached by a further stairway. The esplanade was enclosed on the south, east and west by a colonnade corresponding to the shape of the portico framing the reception court, but with its open side facing north. This formed the backcloth to the mass of a new temple – Doric and peripteral, with six columns on the façade – a replica of the temple of Asclepius at Epidaurus, but of larger proportions. The terrace itself was shored up by a second retaining wall, identical to the first one. The ambitious scope of the project did not at first allow this colonnade to be built in

stone, and wooden pillars were used, in the archaic tradition. Thanks to Eumenes II, who took the sanctuary under his personal protection, this wooden colonnade was later (c. 170-160) replaced by one of marble. The change did full justice to this grandiose composition, a worthy example of the new aesthetic, in which the buildings were located and designed in such a way as to bring out their plastic and pictorial value, rather than according to the part they played in the sanctuary's religious activities. For example, the temple, conceived as a device for rounding off this multi-level composition, did not even have an altar, so limited was the space between its façade and the upper stairway.

In addition to the relationship between masses (brought out by the stepping of the terraces, with the dominant verticals of the stair-ramps and the horizontal emphasis of the colonnades and retaining walls) symmetry and axiality were involved here. Thus it was a comparatively easy matter for later builders to give this complex a specifically Roman appearance, breaking the monotony of the terrace-walls with a series of arches, which accentuated the constant search for pictorial effect by introducing new patterns of light and shade.

The same principles lay behind the design of the sanctuary of Athena on the acropolis at Lindos (see p. 362, fig. 419); here colonnades and stair-ramps are even more closely associated, since they interlock. Once again it took several successive phases of construction to reshape and link two originally separate terraces, and the architectural devices used in this process are noteworthy and instructive. The sanctuary of Athena Lindia had occupied the upper platform since the Archaic period. At some point in the sixth century the first temple was erected, close to the cliff-edge – according to Gruben, to supersede the cult centred on an architecturally improved grotto below. Because of the shape of the site the symmetry that subsequent planners strove for was never achieved, and only the altar found a place along the axis of the monumental

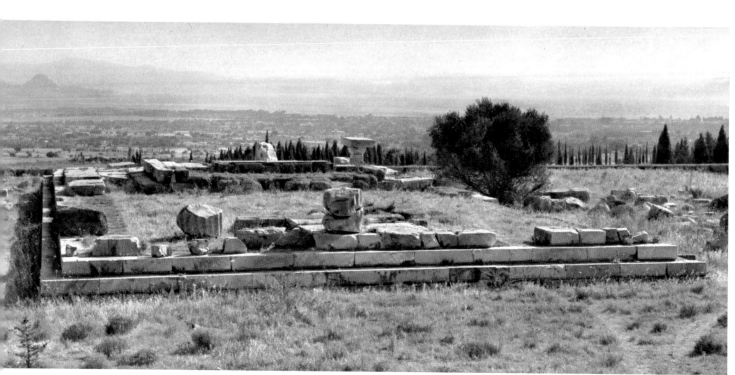

73. COS, ASCLEPIEUM. TEMPLE A AND THE UPPER TERRACE.

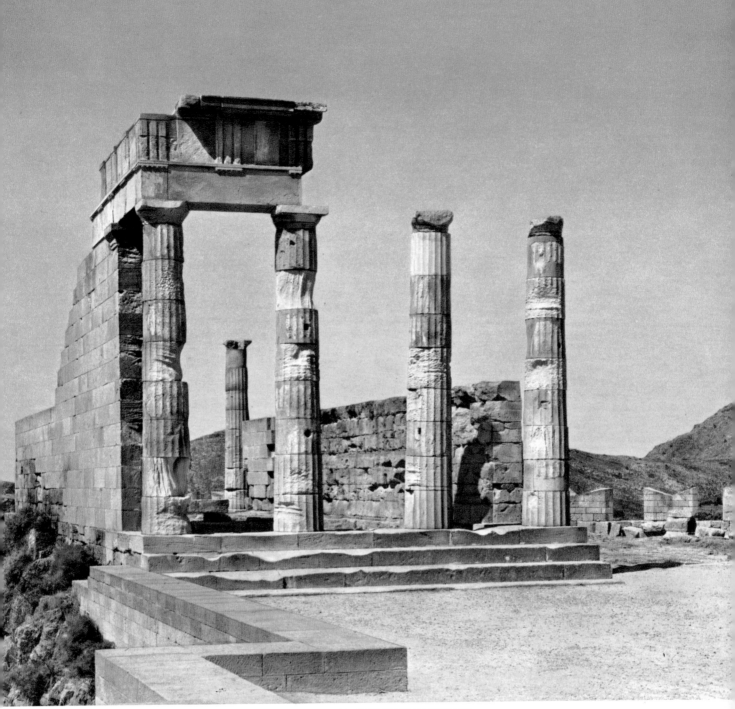

74. LINDOS, SANCTUARY OF ATHENA. THE TEMPLE OF ATHENA ON THE UPPER TERRACE.

stairway. Early in the third century the temple was restored and the first general planning project carried out. Visitors approached the site through an imposing propylon, recalling Mnesicles' Propylaea in Athens, having five doors behind a ten-column façade with a four-column prostyle bastion at either end. The court itself was surrounded by porticoes on the north, east and west, but the position of the temple meant that the east portico had to be a false gallery, only 3 ft in depth (even so it hid the

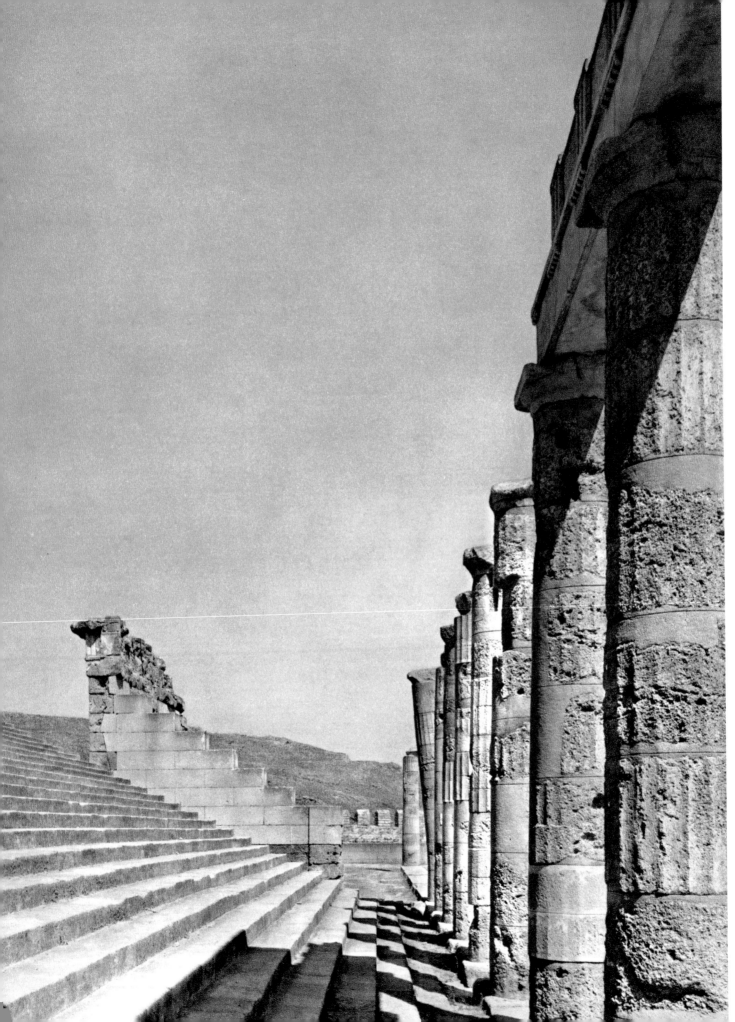

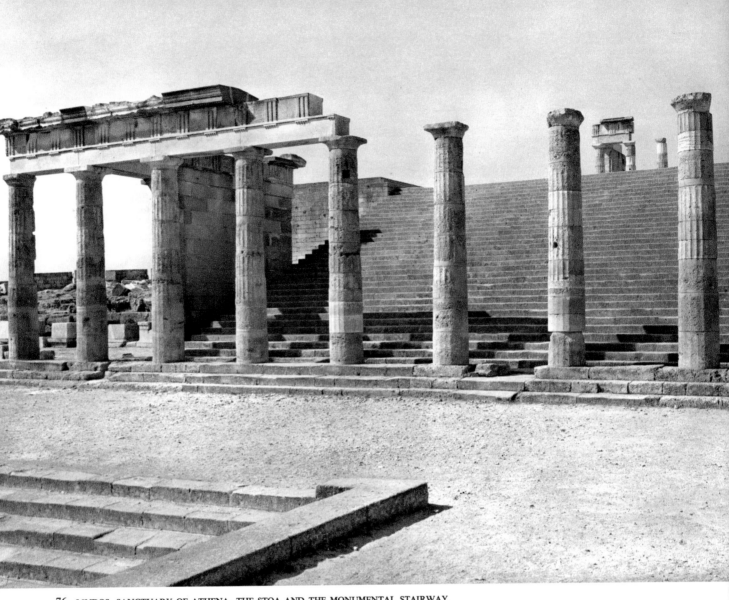

76. LINDOS, SANCTUARY OF ATHENA. THE STOA AND THE MONUMENTAL STAIRWAY.

north-east angle-column of the temple). Everything was sacrificed to the decorative function of the colonnade. Late in the third century, or at the beginning of the second, we find the winged portico motif more amply deployed on the lower terrace at the foot of the great stairway. However, there was insufficient space to build the entire portico, and only the colonnade, some 223 ft long, is unbroken throughout its length; the interior of the portico is sacrificed to the stairway, the foot of which lies directly against the stylobate. Two wings with four prostyle columns recall the motif of the upper propylaea. The design was typical of its age, and – at the price of a few anomalies – was executed in perfect harmony with its setting.

When conceived on the grand scale – at city-level – Hellenistic design could produce some truly remarkable complexes; Camirus on Rhodes provides a good example. The

75. LINDOS, SANCTUARY OF ATHENA. DETAIL OF THE MONUMENTAL STAIRWAY.

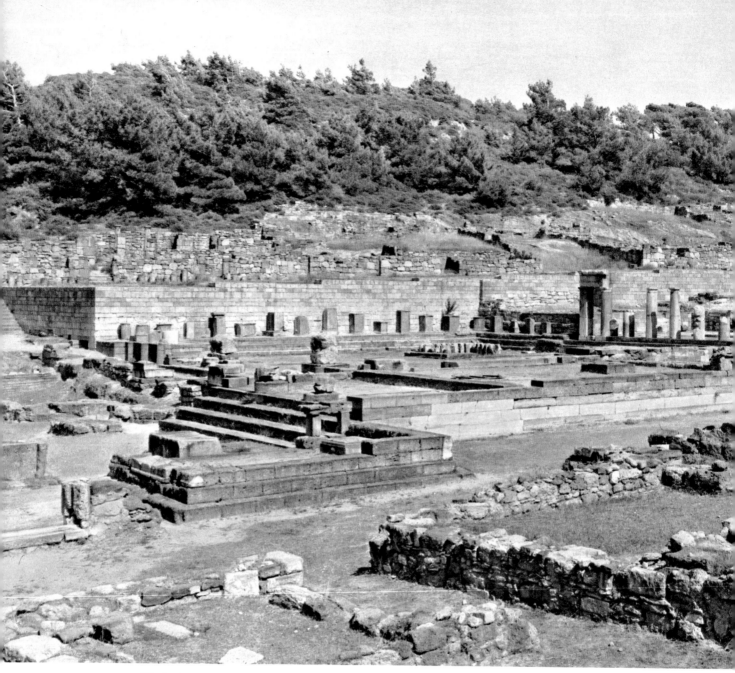

77. CAMIRUS. GENERAL VIEW.

town spreads across a shallow coomb with the main street along its axis. The upper end was bounded by a portico over 300 ft long, bordering the platform of the acropolis; at the mouth of the coomb, on the seaward side, stood the public buildings, grouped in small units and surrounded by porticoes. Rhodes, Halicarnassus and Delos – the last especially on the hill where the theatre stands and in the Inopus valley – provide other urban examples. Terraces and descending levels are linked and associated with a fair degree of unity; but at the same time the terraces, given regular shape by the porticoes which define their lines and contours, throw into prominence the monumental volumes

84

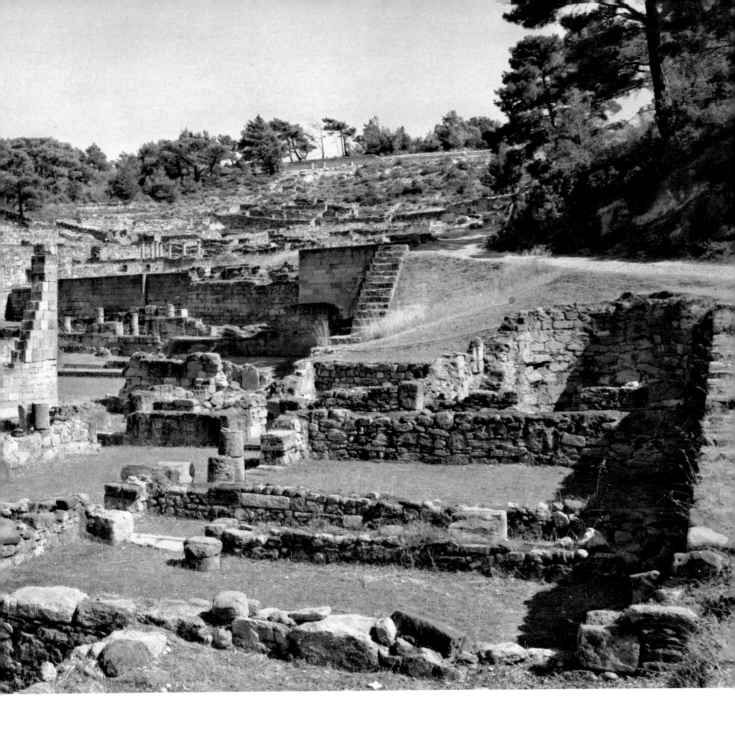

and masses. This treatment – architectural landscaping – was influenced by advances in drawing and, in turn, was to inspire Alexandrian and Roman painters.

It would nevertheless be wrong to neglect the functional aspects of Hellenistic architecture, which this passion for monumentalism contrived to preserve (and sometimes to develop) in well-balanced and vigorously articulated compositions. Side by side with Pergamene city-planning, we find a more linear and geometrical variety developing, based on the orthogonal or axial-grid ground-plan. The principles and features of this can be seen at Miletus and numerous colonial foundations.

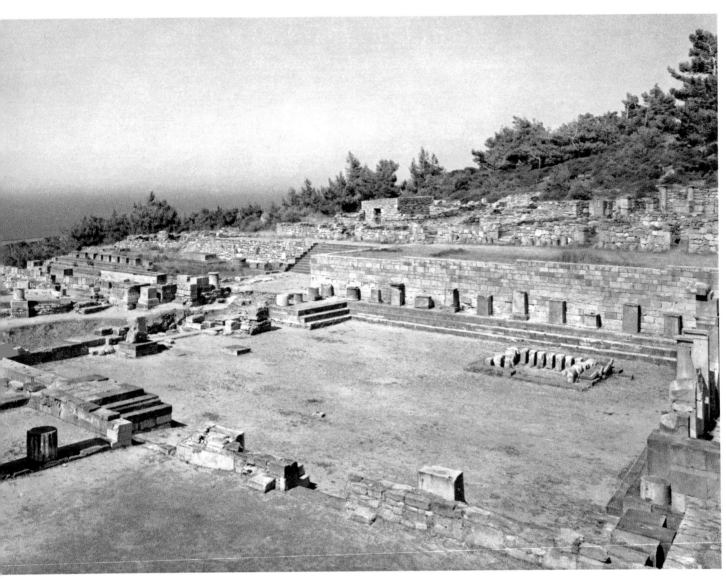

78. CAMIRUS. LOWER QUARTER OF THE TOWN.

Recent excavations have revealed that, even in the Archaic period, the plan of Miletus followed certain rules of orientation which were later applied to the Milesian colonies on the Black Sea. But the turning-point for Miletus came in 475 when, after its liberation (a by-product of the Persian Wars), the city was rebuilt on a regular axial-grid ground-plan. The principles followed were those of a philosophically minded geometrician named Hippodamus, heir to the philosophical school which had won his city such fame during the sixth century. The town's various functions – political, religious, commercial, educational, residential – were grouped in zones, the architecture of each being adapted to its function. But the realization lagged far behind the plan, and it was only with the large-scale building schemes of the Hellenistic era that the features of Miletus' urban landscape were finally settled (see figs 409-413). It was laid

79. DELOS. STREET LEADING FROM THE THEATRE.

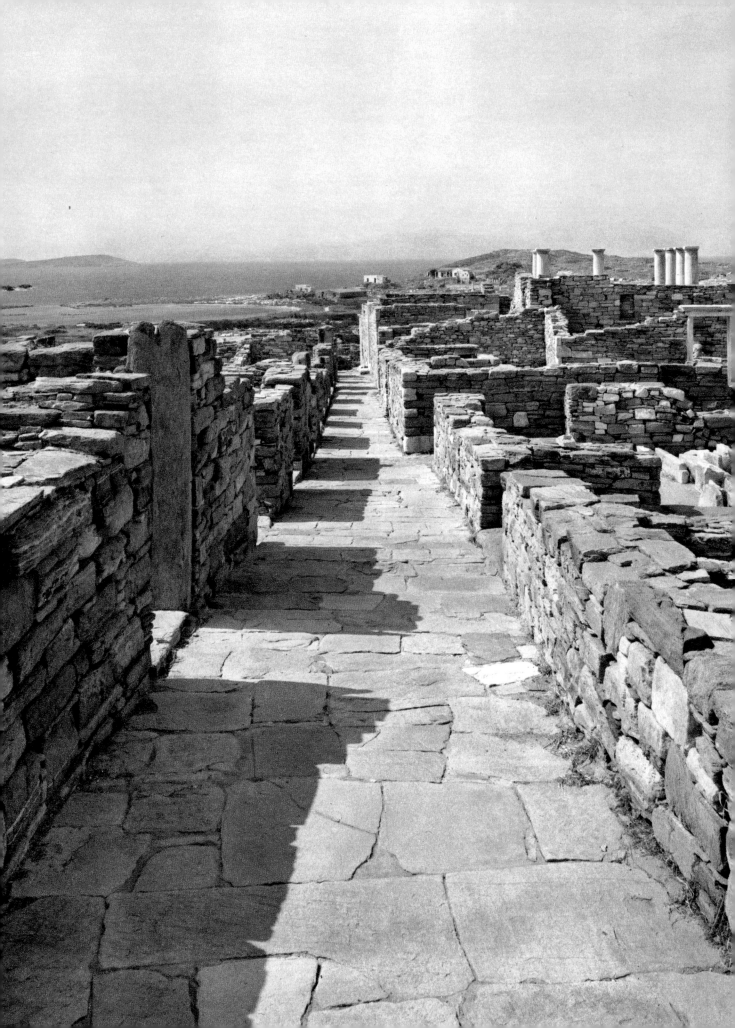

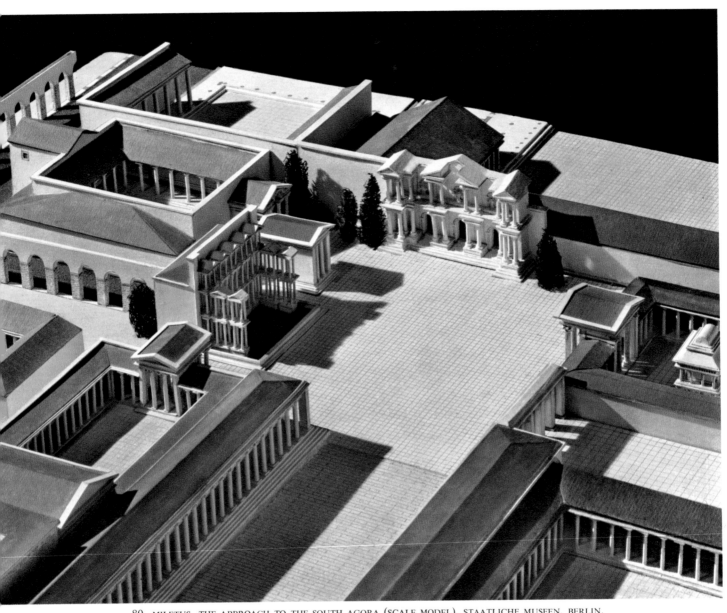

80. MILETUS. THE APPROACH TO THE SOUTH AGORA (SCALE MODEL). STAATLICHE MUSEEN, BERLIN.

out in a right-angle (the northern arm extending along the Lion Harbour and the western arm out to the theatre, with the South Agora forming the intersection), the axes and outlines of its squares, sanctuaries, markets and gymnasia marked by Doric porticoes and colonnades. Specially noteworthy is the large portico of the South Agora; with its double colonnade and its triple row of shops along the east side of the square, it ranks as the vastest and most impressive of all such commercial centres known to us. At the end of the main street, which linked the monumental gateway of the South Agora to the markets to the north, out the Doric façade of a propylon stood out, and beside it was the nymphaeum; a fretwork of niches and miniature columns,

88

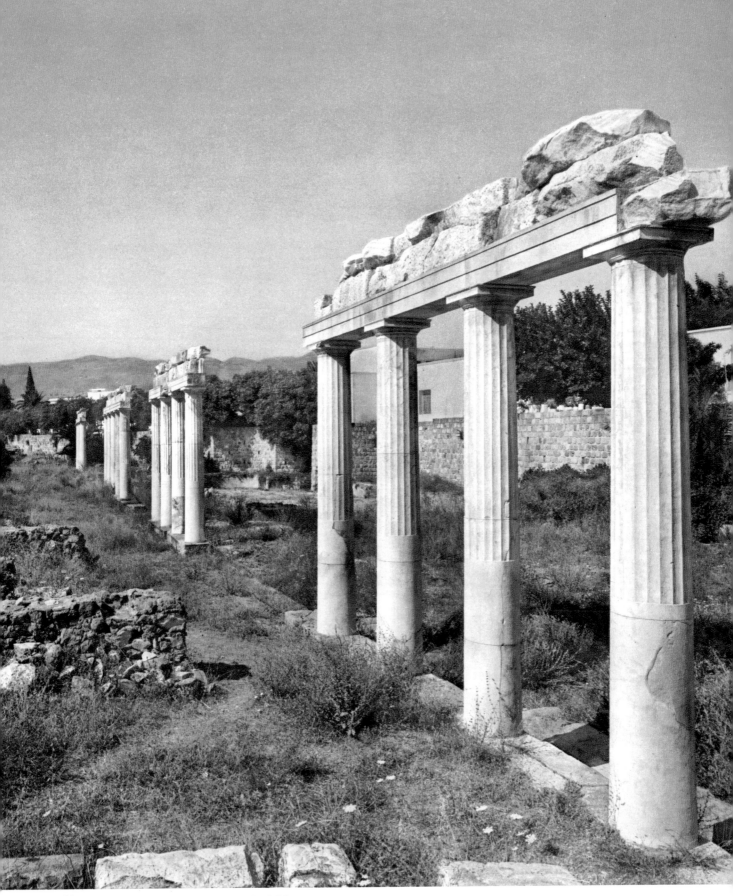

81. COS, GYMNASIUM. STREET AND COLONNADE.

82. PRIENE, GYMNASIUM. THE FOUNTAIN.

83. DELOS, MINOE FOUNTAIN.

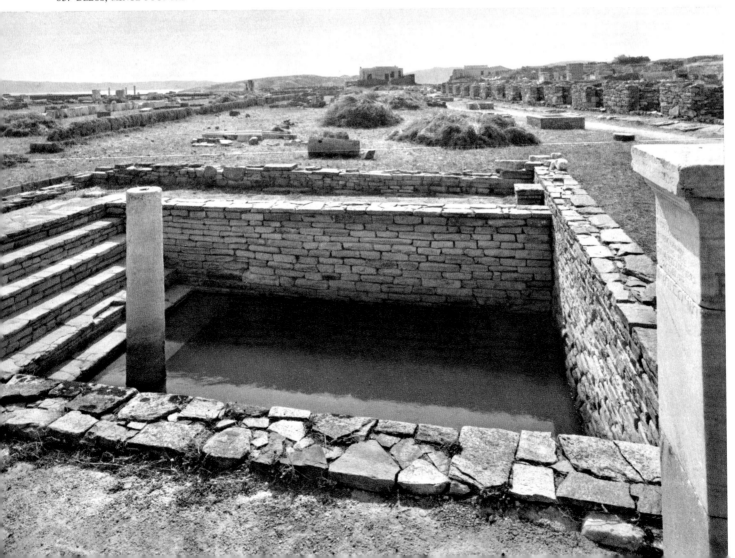

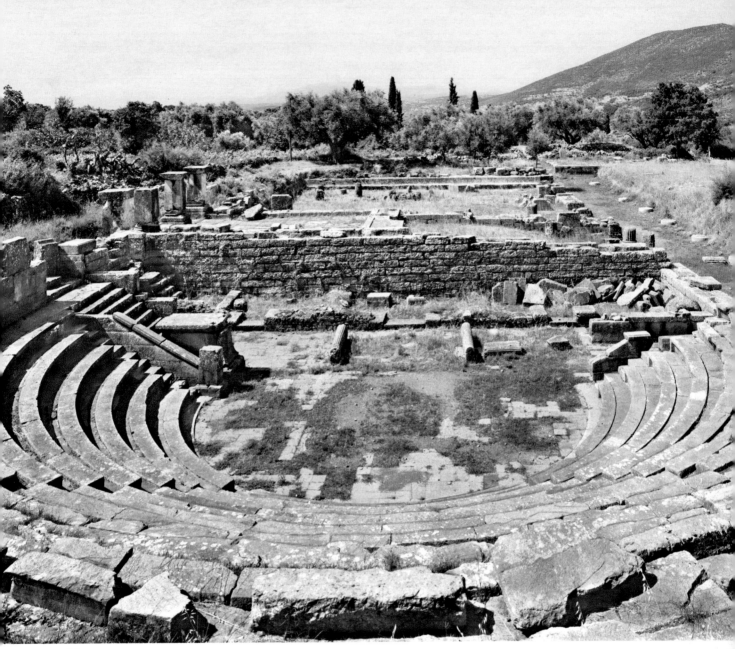

84. MESSENE. THE AGORA.

arranged in several storeys and decked with statues – all reflected by the water of a
large pool at its foot. A little way off, in the north Agora, the façades of the temple and
the propylaea were made to project, so as to break the monotony of those endless
Doric colonnades; the latter's extent and size explain (but do not always justify) the
signs of stylistic negligence noticeable there.

The composition no longer relies on terraced levels and interrelationships of masses;
it now seeks its decorative effects in projecting features and the setting off of motifs
against a background in which colonnades play a major role. Here is the source of
those monumental avenues which were to become so popular throughout the East

early in the Christian era; Antioch, Apamea, Perge, Side and Ephesus all strove to out-do one another in the size and magnificence of porticoes which stretched for hundreds of yards on either side of spacious avenues. However, the beginnings of such compositions appear as early as the second century B.C. on Cos, and result from the association of agora or gymnasium with the road beside them, the latter absorbing the décor of the buildings. What we may turm 'aesthetics of the street' from now on pose a problem unknown in the classical period. Little by little a stock repertoire was built up, its main items (besides colonnades) being fountains, nymphaea and, later, triumphal arches. As early as the Archaic period fountains had ornamental façades, but they had not become totally independent structures; now, however, they assume a more important role, both in buildings and in the urban scene as a whole. The gymnasium at Priene preserves a fine fountain, its basins still in place against the end wall of a large hall which was entered through a pillared vestibule. Ancient fountains, such as that of Minoe on Delos, were given a more monumental structure. Sometimes their setting is exploited to achieve a picturesque effect; the fountains of Locri, their basins in natural grottoes, follow that taste for the picturesque which the Fountains of Peirene and Lerna at Corinth, with their skilful association of natural surroundings and decorative façade, had popularized.

By now the taste for monumental effects had taken firm hold and was giving fresh stimulus to traditional forms of architecture. Domestic architecture was enriched with the emergence of the princely palaces. Those of Alexandria we know only from literary sources, while the palaces of the Attalids are in a poor state of preservation, but we can picture the setting in which Macedonia's princes lived from the ruins of their palace at Vergina (see p. 352, fig. 398). Excavations have revealed its huge peristyle court, together with the living-quarters that surround it, and it seems clear that the entrance had a double-storey portico with the Ionic order superimposed on the Doric. With its succession of circular halls and luxurious vestibules the palace must have presented a most impressive façade, the architectural features of which should permit a fuller attempt at restoration. The use of columns and frame-beams now made vast interior spaces possible, the finest examples of which are the Bouleuterion of Miletus, and the hypostyle hall on Delos (see p. 359, fig. 413, and p. 352, figs. 394-395). The development of various heroic and princely cults similarly gave new impetus to funerary architecture, which now assumed ampler proportions. Sometimes, as at Pergamum or Calydon (see p. 362, figs 416-418), the vault was part of a complex incorporating porticoes, exedras with ornamental façades, and even crypts. This technique was further developed by Roman and Christian architects in later centuries.

Hellenistic innovations also produced greater order and regularity, even inside older structures. The ancient agoras became surrounded by vast colonnades: in Athens, for instance, where the scattered buildings of the old Agora were grouped behind colon-nades which obliterated their former disorderly individuality (see pp. 360-1, figs. 414-415). On the west side, at the foot of the Kolonos Agoraios, a colonnade, continuing that of the Stoa of Zeus, joins the Metroön, a temple of Demeter, some archive-rooms and the Bouleuterion in a somewhat artificial unity. On the south side are huge porticoes designed for administrative and commercial use, and on the east side stands

85-86. ATHENS, THE STOA OF ATTALUS. UPPER AND GROUND-FLOOR GALLERIES.

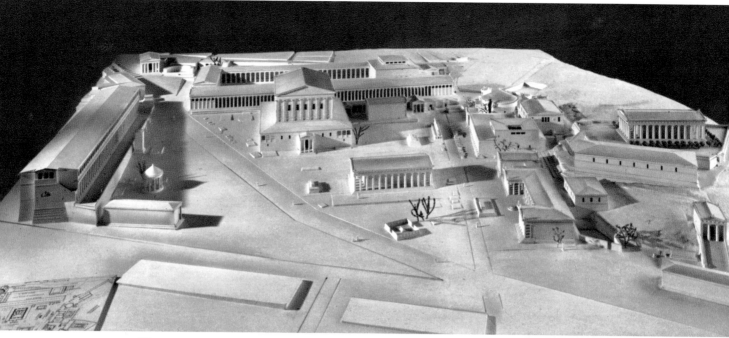

87. ATHENS, THE AGORA. SCALE MODEL. ATHENS, AGORA MUSEUM.

the Stoa of Attalus, a reminder of the efforts made by the Attalids to win favour from the once unchallenged capital of Hellenism.

The recently excavated agora of Messene illustrates the new formal developments, and the spirit, of such constructions. Assembly-halls, offices and sanctuaries are no longer treated as independent buildings, but integrated with colonnades, which transform open squares or old crossroads into enclosed complexes. The unifying link is the portico – a permanent feature of every architectural composition in the Hellenistic world. The reconstruction of the Stoa of Attalus in Athens explains the reasons for this. The portico provided a solution to the problems posed by the new architecture: it increased the useful space and linked together old or isolated buildings whose individuality had to be eliminated; the monumental aspect of its colonnades marked off and structured space and landscape; it could be used to emphasize specific masses and, finally, it provided a field for the free play of decorative and stylistic motifs, which appeared in great diversity both on the façades and in the interior.

By its creative richness, its taste for decorative and pictorial values, its ingenuity in varying the available formulas while employing a simple and relatively small range of elements, and its free-wheeling attitude to classical tradition, Hellenistic architecture succeeded in bringing out numerous qualities which, though already latent in classical architecture, had not then fully germinated. It also, by hammering out new formulas, contrived to keep pace with the profound changes in the Greek world during the final centuries before Christ. Yet these innovations would still have no more than a limited value had they not provided, in addition, all the basic ingredients for the great developments in Roman and Western architecture.

ROLAND MARTIN

94

PART TWO

Painting

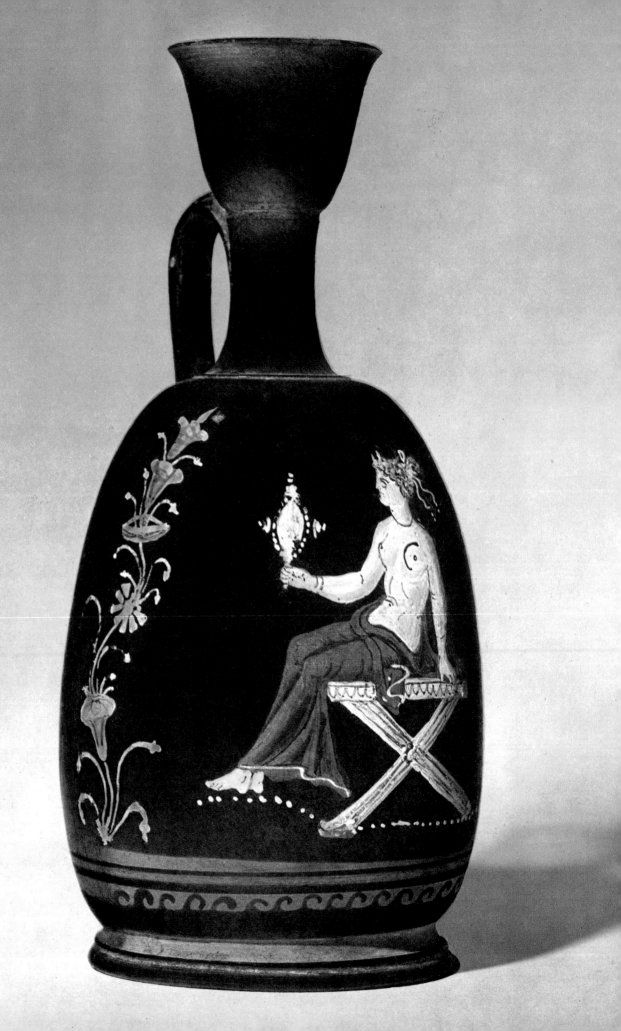

The Conquest of Space (330-280 B.C.)

Introduction

In the sphere of pictorial art, the close of the classical period saw a complete divorce between the somewhat mediocre work turned out by anonymous craftsmen, and masterpieces by painters like Nicias or Apelles. Nevertheless, it is worth a last look at the painted vases of south Italy and Sicily, production of which was soon to cease. In the absence of any great surviving originals of the period [apart from the Greek tomb paintings found recently at Paestum] they at least give us some notion of trends at a time when Greek painting began to take an increasing interest in the logical grouping of figures in spatial compositions, and in their integration into a framework that, as time went on, was to become enlived by the play of light and subtle nuances of colour.

It is not long, however, before our knowledge of Hellenistic painting is considerably enriched. Though we possess little enough information about the painters themselves (ancient sources devote far more space to tittle-tattle than to stylistic analysis), nevertheless, from the end of the fourth century onwards, there are a number of original works of second rank – murals, mosaics, painted stelae – which are more than mere imitations of 'Old Masters'. Thanks to these, which we can date with fair accuracy, it is sometimes possible to pick out, among Roman paintings, works copied (at a greater or lesser number of removes) from first-class Greek originals.

Thus, by combining secondary evidence of Hellenistic date with more important paintings from the Roman period, we can attempt to trace the development of an art just as lively and rich in new discoveries as sculpture or architecture. Despite sometimes considerable differences between the various schools, for almost three centuries Hellenistic painters seem to have advanced along logical enough lines. Their first object was the mastery of a three-dimensional space formed by the geometric convergence of figures and objects. The next step involved the increasingly emphatic use of an architectural (and later natural) setting, animated by light and shade; eventually these natural elements of landscape and the depiction of reality, sometimes to the point of artifice, assumed an increasingly important role. The last Hellenistic painters managed to achieve a synthesis of all these trends.

88. APULIAN ARYBALLOID LEKYTHOS, 'GNATHIA' STYLE: SEATED WOMAN. MUSEO NAZIONALE, TARANTO.

97

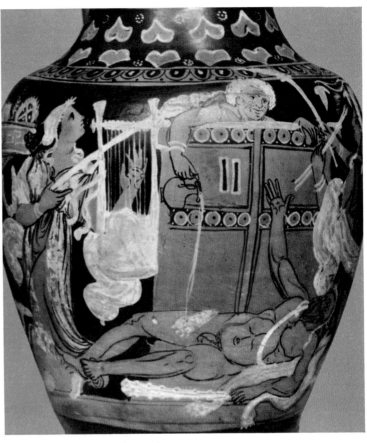

89. APULIAN OENOCHOE (DETAIL): DANCE SCENE.
JATTA COLLECTION, RUVO.

90. SICILIAN OENOCHOE (DETAIL): THE DRUNKEN HERACLES.
HERMITAGE, LENINGRAD.

The End of Painted Pottery

At the beginning of the Hellenistic period vase-painters were still producing a few notable works, but all these late achievements were concentrated in southern Italy and, above all, in Sicily. However, major compositions, such as those of the Apulian studios or the ceramic artists of Paestum, gave way to pictures of smaller dimensions, to scenes of a domestic or intimate nature, in which the feeling for space and colour was developed. In the so-called 'Gnathia' pottery from Apulia (characterized by poly-chrome painting on a black ground), the subject is often reduced to a single figure, as on the aryballoid lekythos on p. 96. Nevertheless, despite the traditional character of this scene, in which foreshortening and perspective are barely hinted at, one innovation may be observed. The folds of the woman's dress are deepened by heavily emphasized shadow-work, which gives some plasticity to an otherwise more or less two-dimensional subject.

Few vase-painters still limited themselves to a strict observance of red-figure technique, except in mediocre work. One of the last examples is provided by an Apulian oenochoe in the Jatta collection, Ruvo. The theme is, on the face of it, banal, and the flute-player follows a stereotyped pattern that had long been current in

98

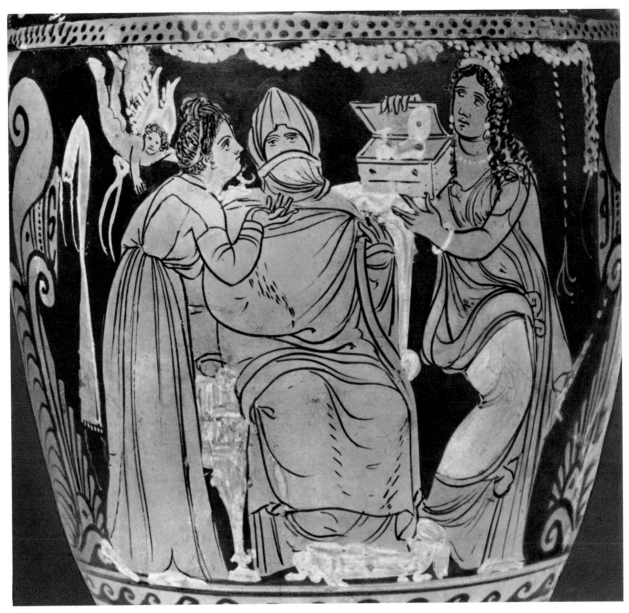

91. THE 'ADRANO GROUP'. PYXIS (DETAIL): THE BRIDE'S TOILET. PUSHKIN MUSEUM OF FINE ARTS, MOSCOW.

classical painting. Yet the veiled dancer shown full-face is incontestably original: the foreshortening of the arm thrust out towards the spectator, together with the rapt expression, give this somewhat clumsy figure unexpected depth.

Certain Sicilian vase-painters at the end of the fourth century attempted more ambitious compositions. On the Leningrad oenochoe the grouping of figures in the middle of the picture suggests – though still with some awkwardness – an attempt at spatial depth. The mood is one of theatrical parody; Heracles, accompanied home by a couple of girl musicians with torches, collapses in the street, dead drunk, and an old woman with exaggeratedly realistic features leans over her door to pour water on him.

The two central figures are shown full-face, the out-thrust legs and left arm of Heracles are foreshortened, and the doorstep is drawn in perfunctory perspective; yet none of these devices is sufficient to give the scene as a whole any spatial value, since the two musicians who frame it have not been assimilated to the central group.

Just such a fusion is achieved on the Moscow pyxis, which likewise belongs to the 'Adrano group'. The young veiled bride seated in the centre is, for the first time, presented to the viewer directly full-face. More important, she and her two companions form a genuine group: they surround her with their gestures, and even more with their sinuous bodies which form a kind of living circle about the hieratic bride. The plasticity of the figure on the right is further emphasized by the marked torsion of her body and the open casket she is holding out (shown foreshortened). Little is lacking for the composition of a genuine painting except shadow-work, here barely indicated by a little hatching, and colour, which still remains subdued.

Thus it is not really surprising that some of the best work by Sicilian painters towards the end of the fourth century should utilize all the resources of polychromy. The 'Lipari Painter', in particular, gives red-figure technique a genuine pictorial value. Rather than cover female bodies with white paint, as some of his prodecessors had done, he keeps the natural pale-brown tint of the clay to indicate bare flesh, and lets it stand out amid the surrounding pastel colours. The two women, facing one another and seen in three-quarter view, form a composition which harmonizes with the shape of the bowl. The lines of convergence meet behind the two figures, towards the centre of the scene – a principle of composition which reappears in structurally more complex mosaics and contemporary paintings from Greece proper.

The Palermo pyxis shows another type of grouping: the figures are superimposed at two different levels. However, this arrangement is not conceived as a simple juxtaposition of persons facing one another, for the four women in the background, effortlessly arranged in space, are, as a group, facing the viewer. The figures in the foreground – either sitting or reduced in size – emphasize the double-level arrangement. Above all, the painter has contrived, despite the crowding of his subject-matter, to suggest a semicircular composition in space: the seated Silenus and the nymph behind him (he shown almost full-face, she completely so) give depth to the centre of the picture, while the two figures on either side (symmetrically depicted in three-quarter view) suggest an enveloping movement which is accentuated by the gesture of the maenad on the left and the drapery on her arm. Finally, the richness of the palette, with subtly contrasting blue and pink pastel shades, is even more suggestive of painting – only the black background points to vase-painting in particular.

Funerary painting is, by definition, poorer in inspiration, and moreover the decorator of the Apulian hydria shown overleaf has stuck to an old-fashioned type of composition. Yet his technique by now has little in common with that normally used on pottery; its mauves, purples and greens, together with the shading on the clothing of the seated man, rather suggest a mural. But while this hydria can be compared to certain funerary stelae, we find other contemporary pictorial work (mosaics in particular) still under the influence of vase-painting – one indication, among others, that the background has not yet acquired an essential role in the picture.

92. THE 'LIPARI PAINTER'. LEKANIS: SEATED WOMEN. MUSEO EOLIANO, LIPARI.

93. SICILIAN PYXIS (DETAIL): SILENUS AND NYMPHS. MUSEO NAZIONALE, PALERMO.

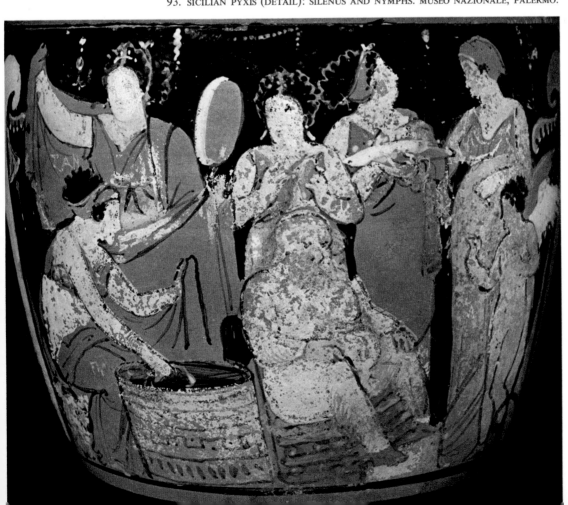

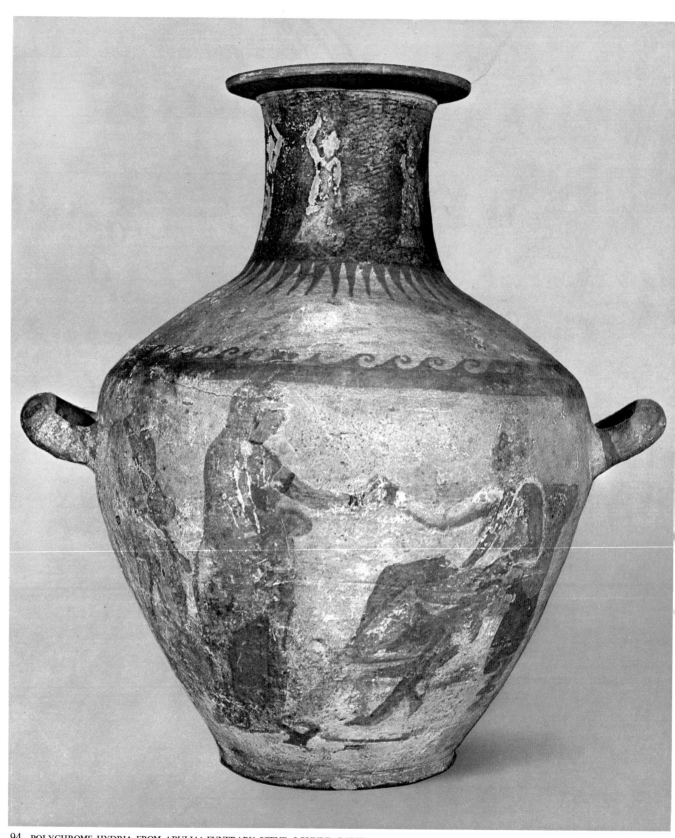

94. POLYCHROME HYDRIA FROM APULIA: FUNERARY SCENE. LOUVRE, PARIS.

102

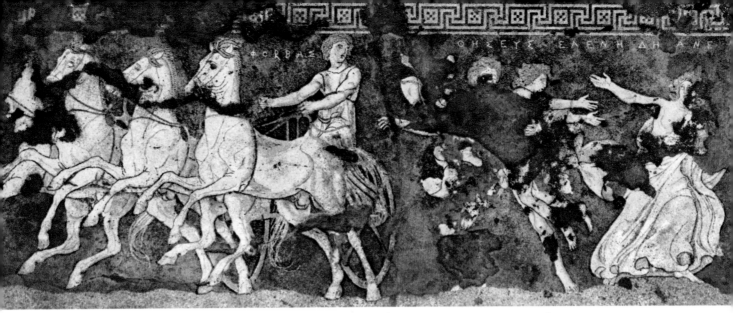

95. PELLA. MOSAIC: THE ABDUCTION OF HELEN BY THESEUS. PELLA (TEMPORARY MUSEUM ON THE SITE).

96. ALEXANDRIA, NECROPOLIS OF MUSTAPHA PASHA. WALL-PAINTING: HORSEMEN, AND LADIES OFFERING SACRIFICE.

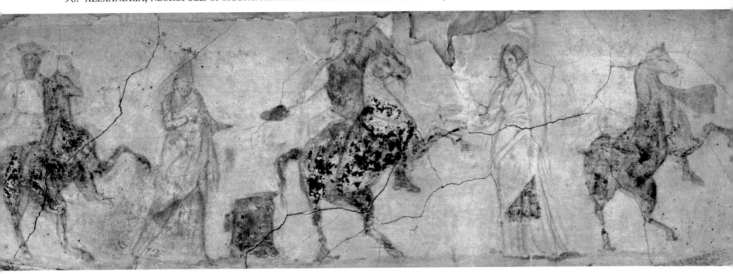

Original Works: mosaics and paintings

At first sight, there could be nothing more traditional than the scene of Helen's abduction by Theseus on a mosaic at Pella. The horizontal composition, like the figures in three-quarter view – all on the same plane, a strip of rocky ground – could easily date from the previous century. The design, in light tones on a dark background, also recalls the technique employed on red-figure vases. Another Pella mosaic, of Dionysus on his panther, similarly presents an elegant (and faintly coloured) design against a dark background; only its mannered style suggests the Hellenistic period.

Despite their use of a light background, the oldest tomb-paintings from Alexandria are equally close to traditional models. The painting in a tomb in the Mustapha Pasha necropolis is very simply composed, with a row of figures set side by side, all shown full-face or in three-quarter profile with foreshortening. However, at a period when the painting had suffered less from the ravages of time, it was possible to make out quite

103

97. PELLA. MOSAIC: DIONYSUS ON A PANTHER. PELLA MUSEUM.

98. LEVKADHIA. WALL-PAINTING: CENTAUR AND LAPITH.

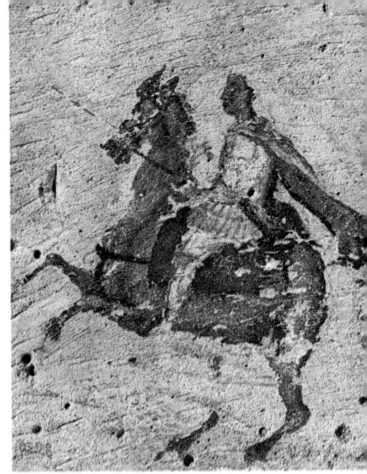

99. ALEXANDRIA. PAINTED FUNERARY STELE: HORSEMAN WITH SERVANT. 100. ALEXANDRIA. PAINTED FUNERARY STELE: MACEDONIAN HORSEMAN.

strong shadows, cast on the riders by the horses' necks and withers; in addition, each figure was encircled with an irregular shadow-line. That such a device was no isolated exception is clear from the Pella mosaic, in which Dionysus' body is sharply distinguished from that of the panther by dark lines; it reaches its logical conclusion in the painted metopes of a Macedonian tomb at Levkadhia, where shadows are used to make masses stand out from their background and to emphasize their plasticity. In a sense this foreshadows the engravings of Andrea Mantegna, but it may also look back to certain famous works which we know of solely through a reference in Petronius' *Satiricon* [83]: 'Those sketches by Apelles (which the Greeks call monochromes)'.

Even humble craftsmen, however, had become acquainted with the existence of more frankly pictorial techniques (largely through their sedulous exploitation, at the close of the classical period, by the Athenian painter Nicias) and attempted to increase their tonal range by stronger highlighting. But this use of light and shade to produce relief effects figures only very discreetly on the funeral stelae of Alexandria, the composition of which remains in other respects fairly elementary.

In order to produce a more balanced assessment of Greek painting at the beginning of the Hellenistic period, it might be more profitable to turn our attention to certain Etruscan paintings, far superior in quality, which were inspired by Greek models. The Golini tomb at Orvieto, for instance, achieves strictly limited effects with light and shade,

105

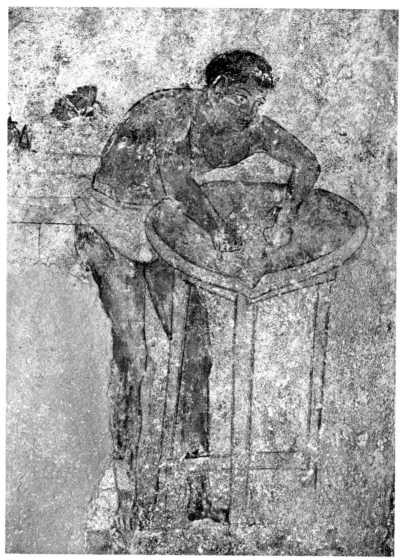

101. ORVIETO. ETRUSCAN WALL-PAINTING: SERVANT WITH PESTLE AND MORTAR.
MUSEO ARCHEOLOGIOO, FLORENCE.

while the positioning of the figures in space is successful only in details – e.g. the servant bent over his mortar – and not over the picture as a whole.

Towards the end of the fourth century, however, certain new concepts began to appear in original works of widely varying provenance and technique. The similarity between the methods adopted in Italy, Macedonia, and Thrace, by artists who had no direct contact with one another, is, I would submit, proof enough of how important a phase this was in the evolution of Hellenistic painting.

The 'Amazon sarcophagus', found at Tarquinia, could at first sight pass for a traditional work; in fact scholars have frequently argued that it was executed in Etruria, shortly after the middle of the fourth century, by a Greek painter from southern Italy. The painting is of remarkably high quality and most delicately executed. There can be little doubt that it is a Greek original, though perhaps painted in Tarentum – both the quality of the stone and the clumsy manner in which the

106

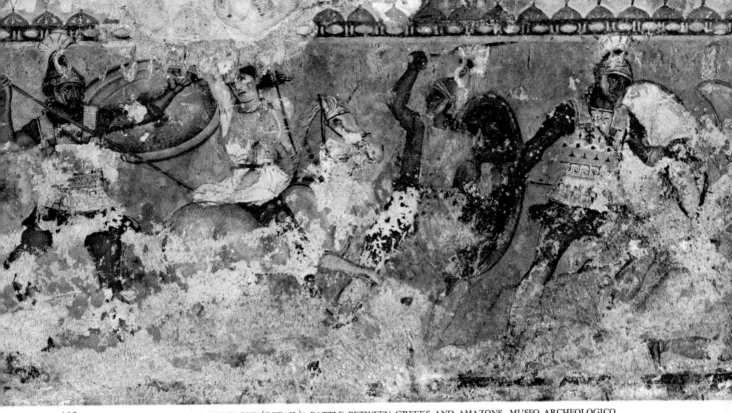

102. TARQUINIA. PAINTED SARCOPHAGUS (DETAIL): BATTLE BETWEEN GREEKS AND AMAZONS. MUSEO ARCHEOLOGICO, FLORENCE.

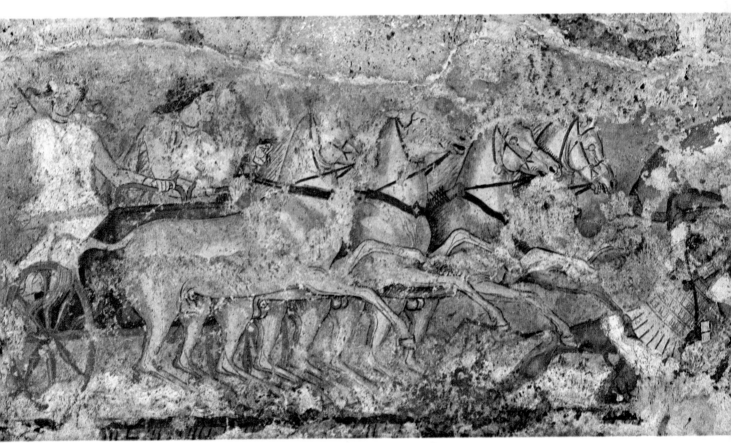

103. TARQUINIA. PAINTED SARCOPHAGUS (DETAIL): AMAZONS IN A QUADRIGA. MUSEO ARCHEOLOGICO, FLORENCE.

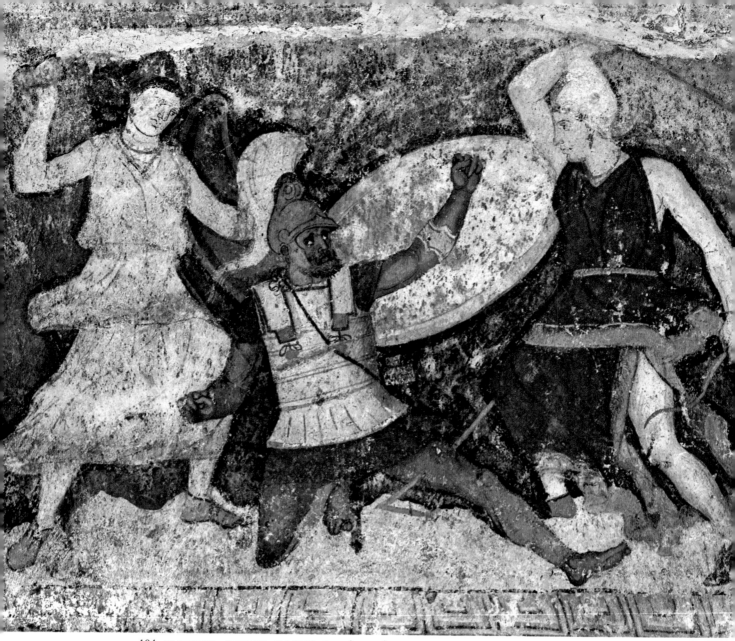

104. TARQUINIA. PAINTED SARCOPHAGUS (DETAIL): AMAZONS FIGHTING A GREEK. MUSEO ARCHEOLOGICO, FLORENCE.

sarcophagus was used by its Etruscan owner tend to confirm this. The disposition of figures on the longer sides, with combatants arranged more or less in a row on the same level, still shows classical influence. So does the uniform background, here rose-pink in colour – though it is true that this subsequently recurs as a feature of all the Hellenistic painting of Magna Graecia, from the pottery of Centuripe to the murals in the Villa of the Mysteries.

Nonetheless certain innovations are apparent. There is a hitherto unknown degree of tonal gradation, as well as highlighting of salient parts of the body. The latter, combined with foreshortening, gives some of the figures a remarkable depth, an impression which is reinforced by a fairly widespread use of cast shadows, notably on the faces of the Greeks and on the horses drawing the *quadriga*. Above all, the group on the end of the sarcophagus is, for the first time, conceived in terms of essentially

108

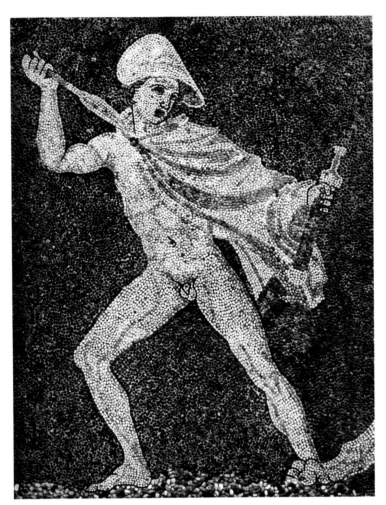
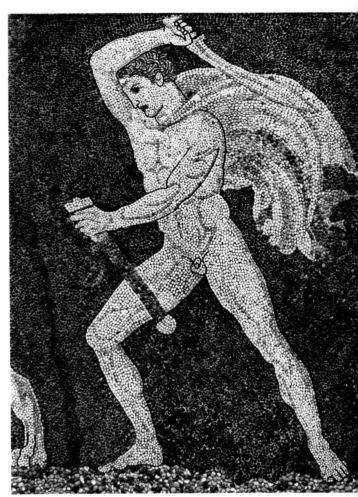

105-106. PELLA. MOSAIC: THE LION-HUNT (DETAILS). PELLA MUSEUM.

spatial values. The picture reveals a skilfully balanced pattern of intersecting oblique lines which form the framework of a three-dimensional space, and the ground on which the Greek warrior kneels is shown in perspective. The warrior himself, thanks to foreshortening of his arm and leg, is projected towards the viewer and, in a sense, bisects the angle formed by the two Amazons. The oblique planes set up by the movement of legs and bodies intersect behind the wounded man, and the unity of the composition is accentuated still further by the Greek's dark-skinned body (in contrast to the whiteness of the Amazons) and by his tortured face and eyes, which draw one's attention to the centre of the group.

These same anxious faces, even the same ultra-muscular bodies, recur in the mosaics at Pella, the capital of the Macedonian monarchy. It is true that these mosaics, being made for the most part of light and dark pebbles, could hardly encompass the tonal gradations possible in painting, nor could they achieve the same play of light and shadow. What predominates is the design: so much so that outlines are sometimes emphasized by thin strips of bronze. Nevertheless, even the mosaic of the lion-hunt, despite the simplicity of its conception, testifies to a developed sense of movement.

109

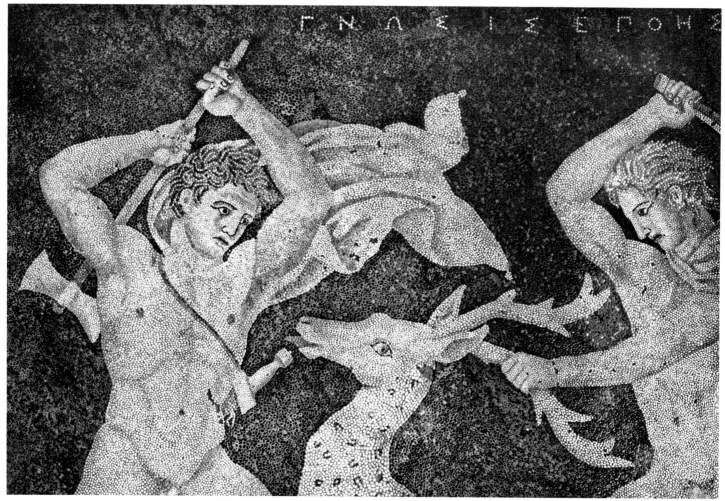

107. PELLA. MOSAIC BY GNOSIS: A STAG-HUNT (DETAIL).

The large mosaic signed by Gnosis reveals creative ability of a much superior order. Everything in it is planned so as to produce an almost illusionist impression of volume, including the fine vegetal decoration which frames the picture. It is not simply a matter of rendering the figures with an eye to plastic effect (accentuated by the liberal use of shadow-work, particularly noticeable in the wind-blown draperies), nor yet of the group's pyramidal composition, parallel examples being available in the work of Lysippus. Once again, the picture's foreshortening, shadow-work and linear structure are no more than integral elements in a spatial composition.

The stony terrain is shown in perspective, which at once suggests the 'angled' arrangement of figures already observed on the 'Amazon sarcophagus' at Tarquinia. The movement of the dog attacking the stag emphasizes the centre of the group and makes it stand out in the foreground, while the two hunters, symmetrically arranged in three-quarter profile, are placed on slanting planes which intersect behind the stag, precisely in the centre of the picture. If we make allowance for those pictorial qualities which no pebble-mosaic could possibly achieve, then this work by Gnosis undoubtedly ranks among the closest reflections we possess of the best Greek painting towards the

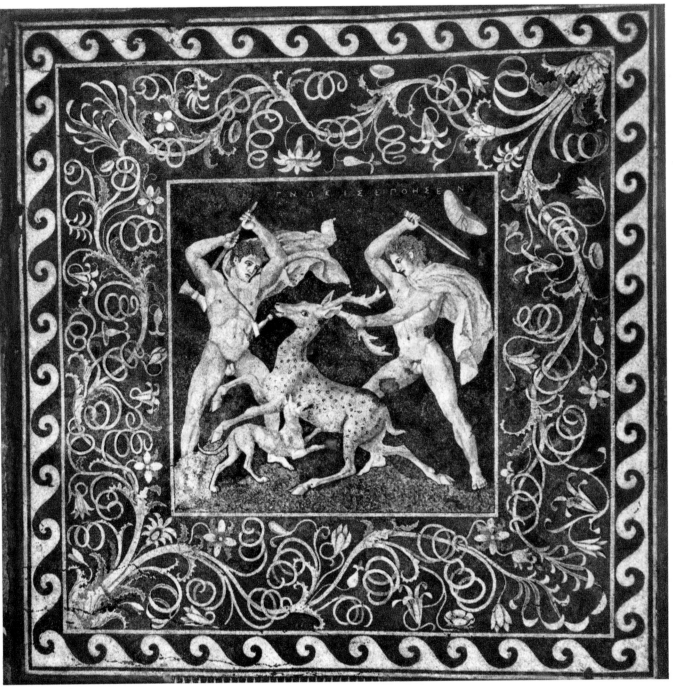

108. PELLA. MOSAIC BY GNOSIS: A STAG-HUNT.

close of the fourth century – a painting that is still very much attached to figurative realism. We know that Apelles and Protogenes, too, were excellent at portraying animals; Pliny, for example (*HN* 35.36.102), while discussing a work by Protogenes, states that the picture 'contains a dog, the execution of which verges on the miraculous'; but the conquest of pictorial space went no further than living characters; the natural setting was still non-existent.

111

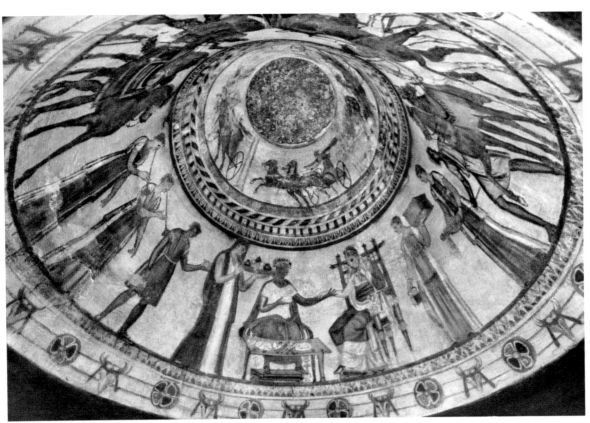

109. KAZANLAK, TOMB. MURAL ON THE CUPOLA: THE PRINCELY PAIR RECEIVING HOMAGE.

The contemporary wall-paintings which adorn the tomb of a Thracian prince at Kazanlak, in Bulgaria, were doubtless executed by a Greek painter of no more than average ability, bearing in mind that the great masters of the day painted almost nothing but easel-pictures. Moreover, the artist had to adapt himself to the local architecture, in the form of a cupola tomb, so that, in view of the partially convex form of the dome (which is closed by a lantern), one can hardly blame him for having chosen a 'strip' composition rather than a single unified theme.

The decoration is composed exclusively of figures, all of which have at least the appearance of being on the same level, with no suggestion of a natural background. Nonetheless the central group, the prince with his wife and a servant-girl, observes the same principles of composition as already seen in the Tarquinia sarcophagus-painting and the mosaic by Gnosis. The prince sits facing the viewer, and the foreshortening of his legs reinforces the depiction, in perspective, of the laden table; flanking him are the two female figures, each set at an oblique angle, whose position is given added emphasis by their gestures and accentuates the impression of spatial depth conveyed by the central character.

The use of foreshortening and attention to elementary rules of perspective are by now becoming general, and the same is true of the play of light and shade, which from this point on becomes a very important element in painting. The draughtsmanship

110-111. KAZANLAK. MURAL ON THE CUPOLA (DETAILS): THE PRINCELY PAIR RECEIVING HOMAGE; A QUADRIGA, AND WOMEN CARRYING OFFERINGS.

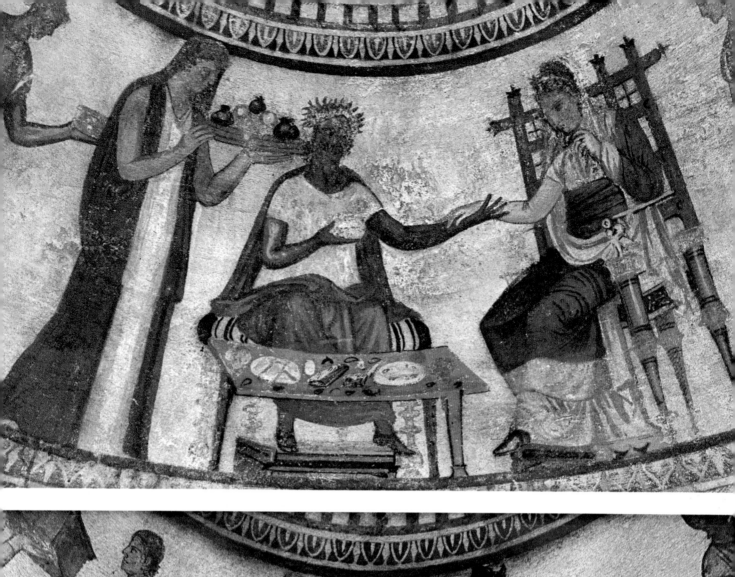

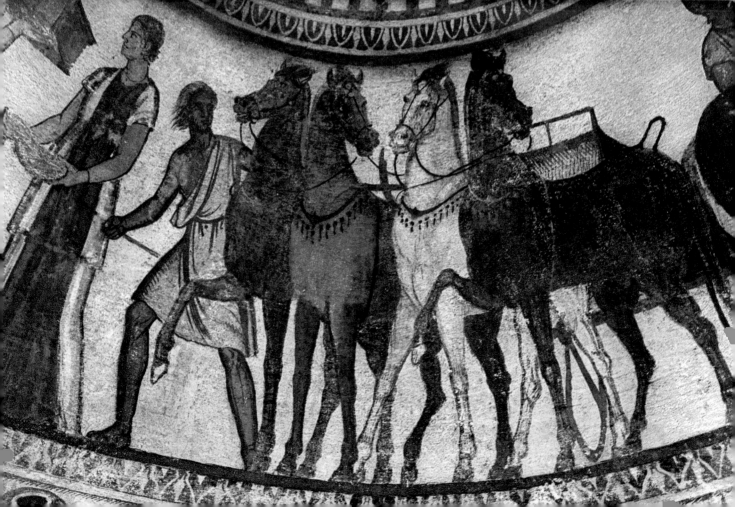

112-113. KAZANLAK. MURAL ON THE CUPOLA (DETAILS): THE GROOM AND THE PRINCESS.

tends to become blurred; its outlines are often swamped by thick shadow-work, while the various masses are indicated by lighter shading, sometimes in the form of fairly close hatching. The Kazanlak painter is merely producing his somewhat inept version of a pictorial art-form which, through its use of light, is already on the road to expressionism.

Replicas of Hellenistic Works

Thanks to such second-rate originals it does not seem an altogether impossible task to try and pick out, from the mass of paintings and mosaics of a later period (principally those buried in Campanian towns by the eruption of Vesuvius in A.D. 79), various more or less distant replicas of originals dating from the early Hellenistic period. These, by definition, would be the works of those famous Greek painters whose pictures were fought over by Roman collectors and adorned the porticoes and sanctuaries of the *Urbs*.

Unfortunately literary sources make only brief allusions to the subjects of works, and almost never provide grounds for certain identification. For instance, one painting from the House of the Vettii in Pompeii might possibly reflect a picture by Apelles,

114

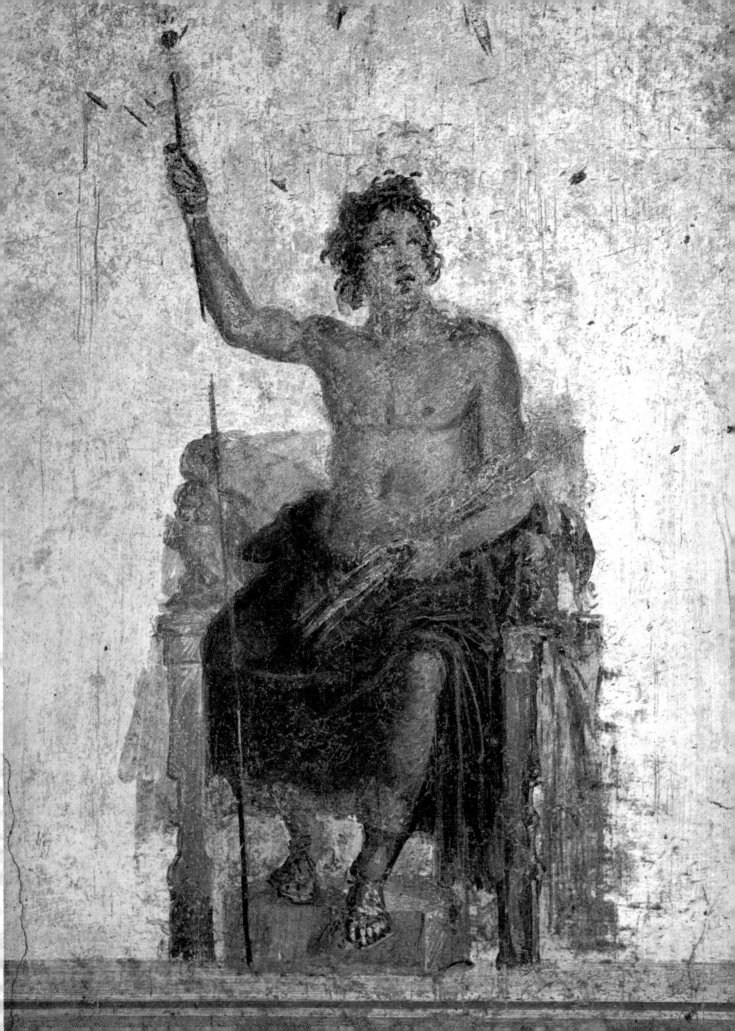

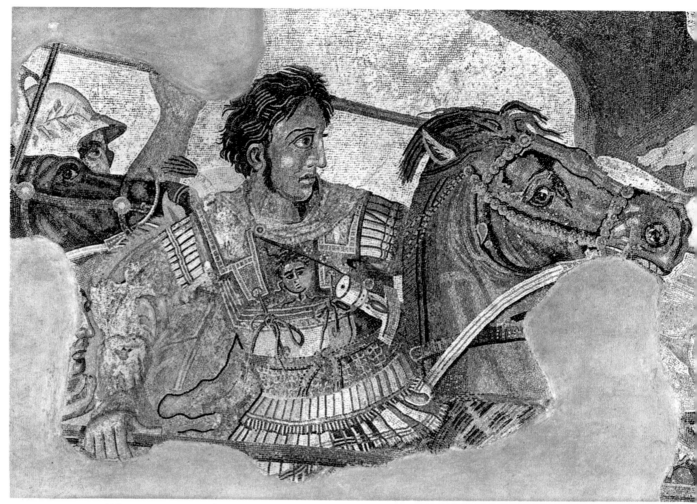

115. POMPEII. MOSAIC (DETAIL): ALEXANDER THE GREAT. MUSEO NAZIONALE, NAPLES.

Alexander's official portraitist, who painted 'Alexander the Great holding a thunder-bolt... The fingers have the appearance of projecting from the surface and the thunderbolt seems to stand out from the picture' (Pliny, *HN* 35.36.92). Plutarch states (*Vit. Alex.* 4. 2) that Apelles 'made him darker and swarthier than he really was.' This full-face figure, draped in purple and seated on a golden throne, looks very much like the young sovereign of the great mosaic at Pompeii. The Roman copyist has retained in a modified form foreshortening effects which (like the use of shading) are associated with the spatial advances of the early Hellenistic period.

This vision of space acquires a new amplitude in the great mosaic from the House of the Faun at Pompeii, perhaps copied from a fresco by Philoxenus of Eretria, 'who painted for King Cassander a picture that holds the highest rank, containing a battle between Alexander and Darius' (Pliny, *HN* 35.36.110). The original must date from the end of the fourth century, but the transposition by a Greek artist, a century and a half later, into a mosaic may well (despite certain errors of execution) be reasonably faithful. At all events, the overall composition is there, with its swarming mass of figures, their numbers suggested by that forest of lances – the great Macedonian sarissas – a device which oddly foreshadows Uccello.

116. POMPEII. MOSAIC (DETAIL): DARIUS IN HIS CHARIOT. MUSEO NAZIONALE, NAPLES

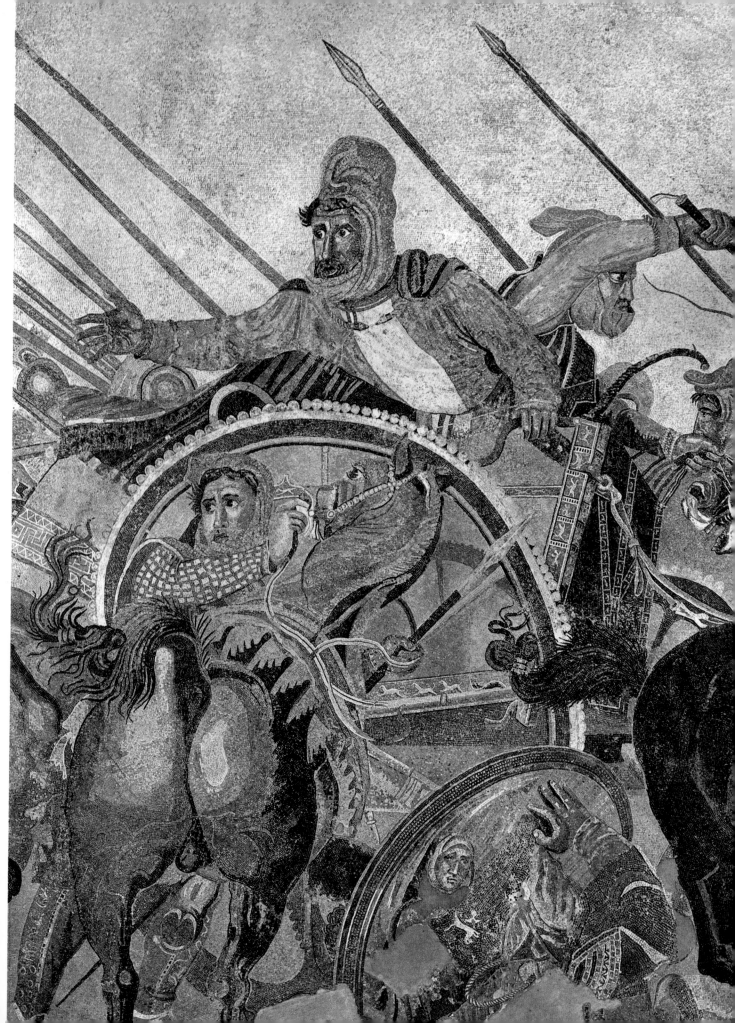

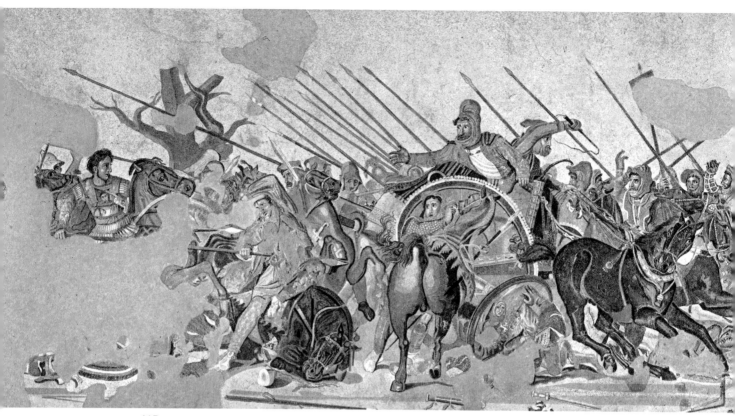

117. POMPEII. MOSAIC: BATTLE BETWEEN ALEXANDER AND DARIUS. MUSEO NAZIONALE, NAPLES.

The figures are arranged so as to achieve a double effect. One, primarily linear in intention, is obvious enough: the oblique lines slanting down towards the right give an impression of flight and pursuit. The other aims at the creation of space. The terrain rises sharply towards the background, while the eye is caught by the weapons, shown in perspective, which litter the foreground. Above all, the group centred on the chariot recedes into the picture, an effect achieved by the remarkable foreshortening of the horse in the foreground, the leaning pose of the Persian king and the semicircular space which opens round him. The exploitation of shadow and colour is far fuller, and, for the first time, the light is from a specific direction, projecting long shadows towards the right; but there is no real sky, and the physical setting is represented solely by a tree.

During the fourth century, the scenery and subject-matter of classical tragedy had provided inspiration for the ceramic artists of Magna Graecia – and doubtless for painters of easel-pictures as well. The highly dramatic theme of Medea meditating the murder of her children was taken up in the late Hellenistic period by Timomachus, but Aristolaus of Sicyon had already treated it during the second half of the fourth century, and it was, perhaps, the latter's work which was the model for a painting at Pompeii. The architectural setting looks uncommonly like a stage-design, and indeed the figure at the window recurs in theatrical scenes on Italo-Greek vases. Its composition is very simple and the portrayal of emotion restrained, but the use of light is somewhat overdone for an interior, as the shadows thrown by the children's bodies demonstrate.

118

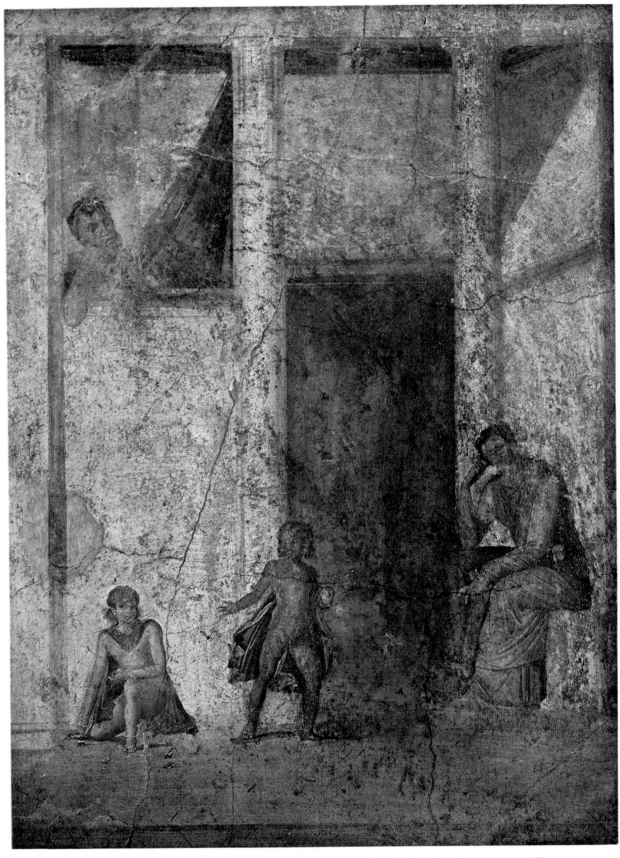

118. POMPEII. WALL-PAINTING: MEDEA MEDITATING THE MURDER OF HER CHILDREN. MUSEO NAZIONALE, NAPLES.

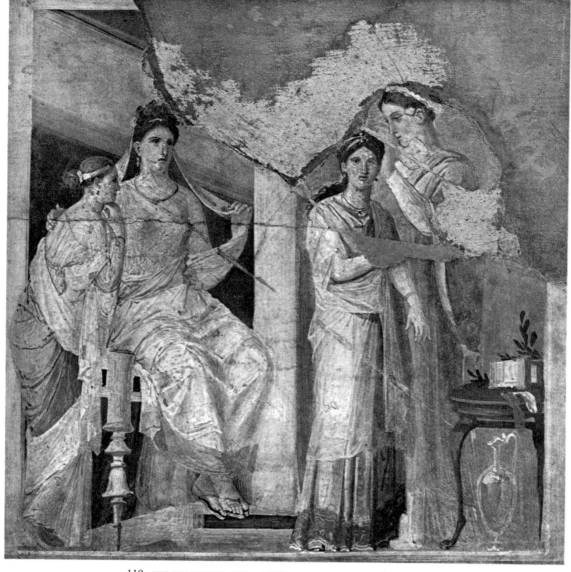

119. HERCULANEUM. WALL-PAINTING: A YOUNG GIRL'S TOILET. MUSEO NAZIONALE, NAPLES.

A group of stylistically similar murals from Herculaneum portray indoor scenes against a fairly elementary architectural background of pilasters, walls and doors. The furniture and the garments are purely Greek, and the simplicity of the poses and gestures, not to mention the delicacy of the tonal range, still recalls the classical period. Nevertheless, the highlighting and the use of shadow are just as seen in Hellenistic painting of the late fourth and early third centuries: more generally applied in the scenes of a young girl's toilet or the celebration in honour of a champion flute-player, more concentrated on the figures in the depiction of the dedication of a mask by an actor who has won a tragedy competition.

Could such pictures be Hellenizing or neo-classical pastiches of the Roman period, rather than replicas of Hellenistic originals? The question is legitimate, since these three murals have all been attributed to a Campanian painter working at the beginning

120

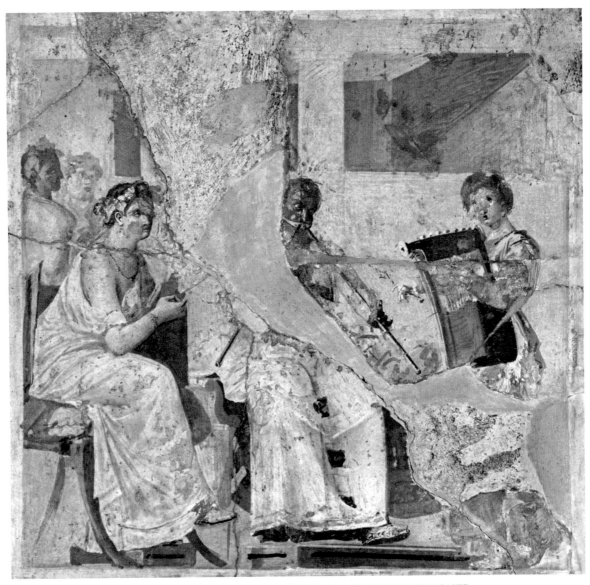

120. HERCULANEUM. WALL-PAINTING: CELEBRATION IN HONOUR OF A CHAMPION FLUTE-PLAYER. MUSEO NAZIONALE, NAPLES.

of the first century A.D., known as the 'Hellenic Master'. In point of fact, however, genuine pastiches – of which a whole series exists – betray themselves by minor anachronisms, which do not occur here. The comparatively simple arrangement of the figures, set in three-quarter profile on intersecting planes, is exactly in keeping with the earliest application of Hellenistic discoveries concerning the disposition of groups in space. This does not apply to the two smaller characters in the background of the mural of the flute-player, but they do not figure on a third-century painted stele from Demetrias (fig. 126). The 'Hellenic Master' is certainly Greek in style and inspiration.

While the source of light does now become identifiable, in the majority of cases it remains fairly diffuse, and, despite the fact that all these compositions are set indoors, the use of chiaroscuro is still rare. However, some of the light-effects used figure in literary sources: thus at the beginning of the third century Antiphilus of Egypt had

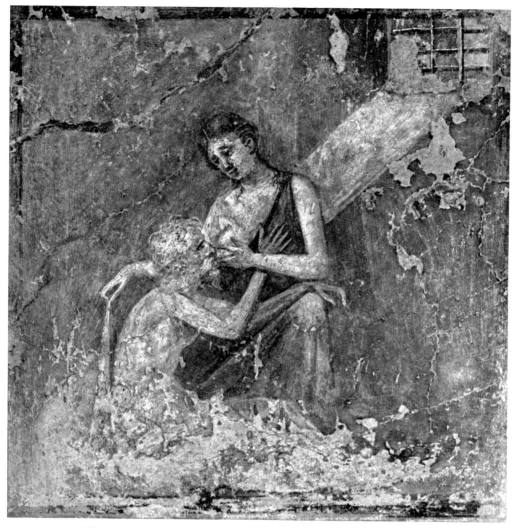

121. POMPEII. WALL-PAINTING: MICON AND PERONA. MUSEO NAZIONALE, NAPLES.

painted 'a young boy blowing a fire, which illuminated both the interior of the house (a very beautiful scene) and the boy's face' (Pliny, *HN* 35.40.138). There actually exists a Pompeian mural – it shows Perona suckling her old father Micon in his prison cell, to sustain his failing strength – where a shaft of light slants in through a barred window to illuminate the two central figures. This is not yet true chiaroscuro, since the contrast between the dark cell and the two illuminated figures is not rendered with any great subtlety. Nevertheless, confronted with a work of this sort – the discreet tinge of pathos in the style makes it pretty certain that we cannot posit a date for the original earlier than the third century – one can foresee the growing interest painters were to take in the study of light-sources and in using light to isolate mass within a space.

Large compositions with numerous figures, similar to the Battle between Alexander and Darius, but in the form of indoor scenes, such as Aëtion's famous 'Wedding of Alexander and Roxane', had also been part of the easel-painter's repertoire since the beginning of the Hellenistic period. But the difficulties involved in their execution may well account for the fact that they seldom attracted the attention of copyists during the

122

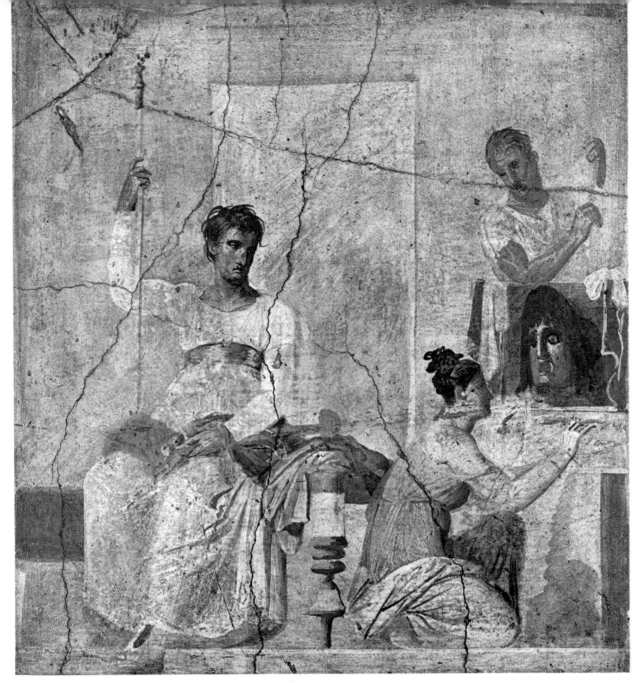

122. HERCULANEUM. WALL-PAINTING: VICTORY OF A TRAGIC ACTOR. MUSEO NAZIONALE, NAPLES.

Roman period. This, of course, makes the few copies that have survived even more interesting for the student.

One, from the House of the Tragic Poet in Pompeii, represents the well-known theme of the surrender of Briseis by Achilles. This forms the crucial opening episode of the *Iliad*, and explains the quarrel that arose between Achilles and King Agamemnon before Troy. Briseis – a captive loved by Achilles – is unjustly claimed and seized by the commander of the expedition. A psychological element is thus added, which introduces new forms of sensibility into pictorial art. Even earlier, in the Alexander mosaic, Darius' shattered expression, the agony emanating from every inch of his body,

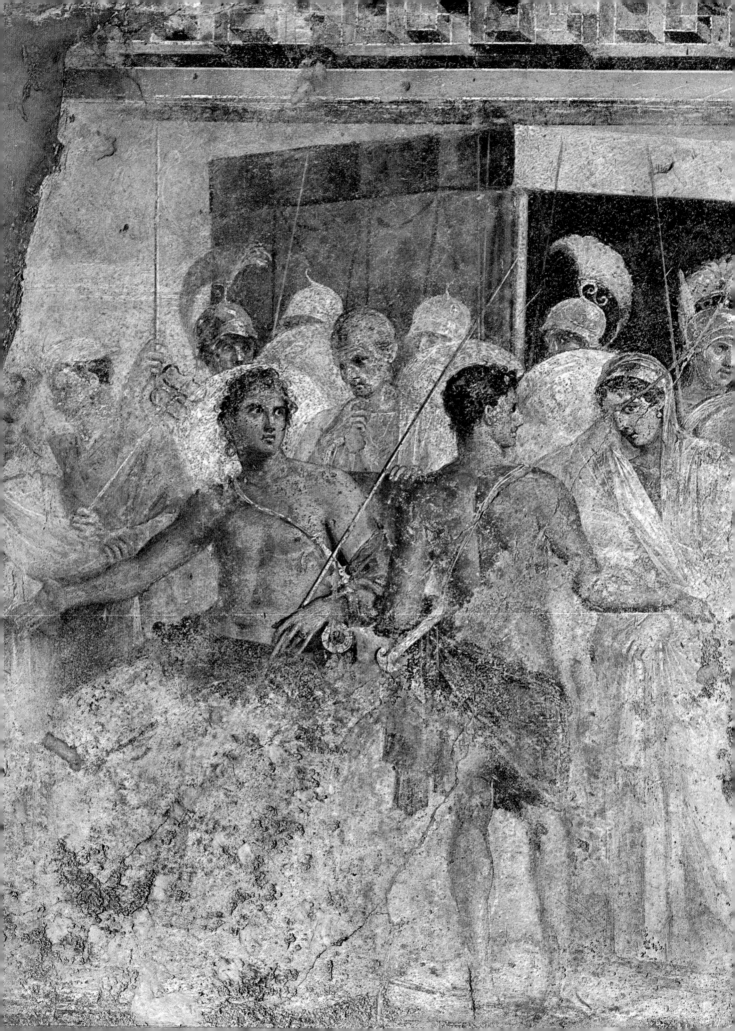

belonged to a new experimental trend. Here, the painter has contrived to endow Achilles' features and gesture with a significance, at once straightforward and complex, which combines resignation, rebelliousness and proud, yet controlled, anger. The attitude of Briseis, though more restrained, is no less expressive. This was the period when, according to Pliny (*HN* 35.36.98), Aristeides was the 'first among artists in portraying the mind and the expression of human feelings, moral no less than emotional.'

As in the indoor scenes described above, we have here a very simple architectural background: a door and an arras, seen from an angle. Yet this slight movement of surfaces, together with the treatment of the ground (seen in perspective between the legs of the figures), is enough to give the scene a three-dimensional quality. The arrangement of the figures in two or three superimposed rows both fills this space and adds depth, and the device of half hiding warriors' heads behind shields accentuates this effect, while also creating an intermediate background which emphasizes the faces of the protagonists. Lastly, the way in which Achilles is presented – sitting almost full-face – lends added depth to the centre of the picture in a way which is already familiar. The use of light is fairly subdued, but very consistent; shadows are produced by a single source of illumination on the right. The colours are little modified by the effects of highlighting; on the other hand some new contrasting shades – blue, pink, green, mauve – are used, though still fairly discreetly. The richness of this – on the face of it so restrained – picture gives cause for regret that we know nothing about the artist.

This anonymity in all probability does not apply to another multi-figure composition, which represents Odysseus and Diomedes discovering Achilles, disguised as a girl and hidden in the women's quarters at the court of King Lycomedes on Scyros; the clash of arms and the sound of the trumpet arouse the young hero's ardour for battle, and we see him just as he has decided to fufil his destiny before the walls of Troy. Two Pompeian murals give parallel versions of this scene, varying only in points of detail – proof that both were derived independently from a common Greek original. Now we know from Pliny (*HN* 35.40.134) that Athenion of Maronea, active in the late fourth century, was famous for paintings containing numerous figures, and that, in particular, he had executed an 'Achilles disguised in female dress detected by Odysseus'.

In fact, through all the distortions which the original may have undergone, we can in this instance still recapture the spirit of Greek painting towards the close of the fourth century. The scene is set indoors, as a perfunctory architectural background makes clear, but its scope in depth is emphasized by the way the floor has been drawn in perspective, and the numerous figures crowded on to it, on a greater number of different levels than in the picture of Achilles and Briseis. In the work attributed to Athenion we again have a semicircular spatial composition (more elaborately worked out than in the minor paintings described above) with a central axis formed by the overlapping full-face figures of Achilles and, behind him, King Lycomedes. In addition, the uproar provoked by the appearance of Odysseus and Diomedes and by their call to arms (which sends the women scattering in terror), together with Achilles' abrupt decision, combine to produce a lively overall movement, expressed by means of a V-shaped linear composition.

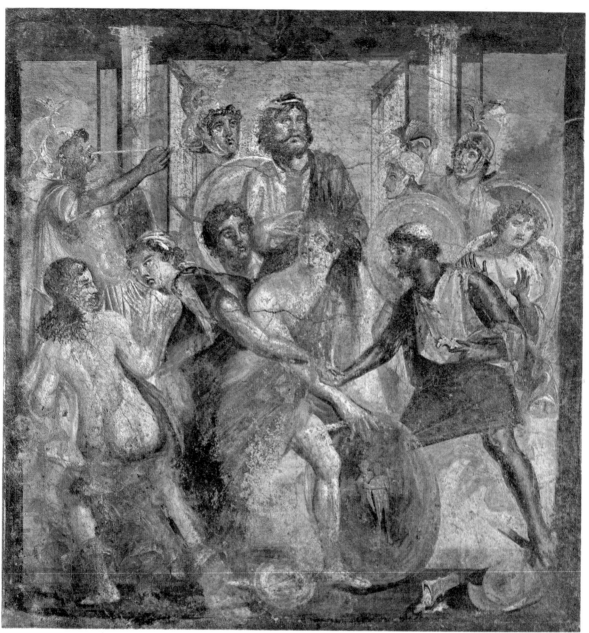

124. POMPEII. WALL-PAINTING: ACHILLES ON SCYROS (AFTER ATHENION?). MUSEO NAZIONALE, NAPLES.

Sadly, the more mediocre of the two replicas is the only one reasonably well preserved, and the lumpish nudity of the fleeing girl surely misrepresents the original. Doubtless this was more faithfully represented by the fragmentary painting found in the House of the Dioscuri; the pleasing gesture of Achilles' mistress, the lovely Deidamia (shown starting back half naked), and the delicate colouring of her flesh and swirling veil contrast sharply with the brutal urgency of the warriors in the foreground. It is on the latter that the light falls most directly, illuminating their bodies and weapons with a metallic sheen. Thus, by the end of the fourth century, a painter like Athenion knew how to use both colour and light to give his work vividness.

125. POMPEII, WALL-PAINTING (DETAIL): ACHILLES ON SCYROS (AFTER ATHENION?). MUSEO NAZIONALE, NAPLES.

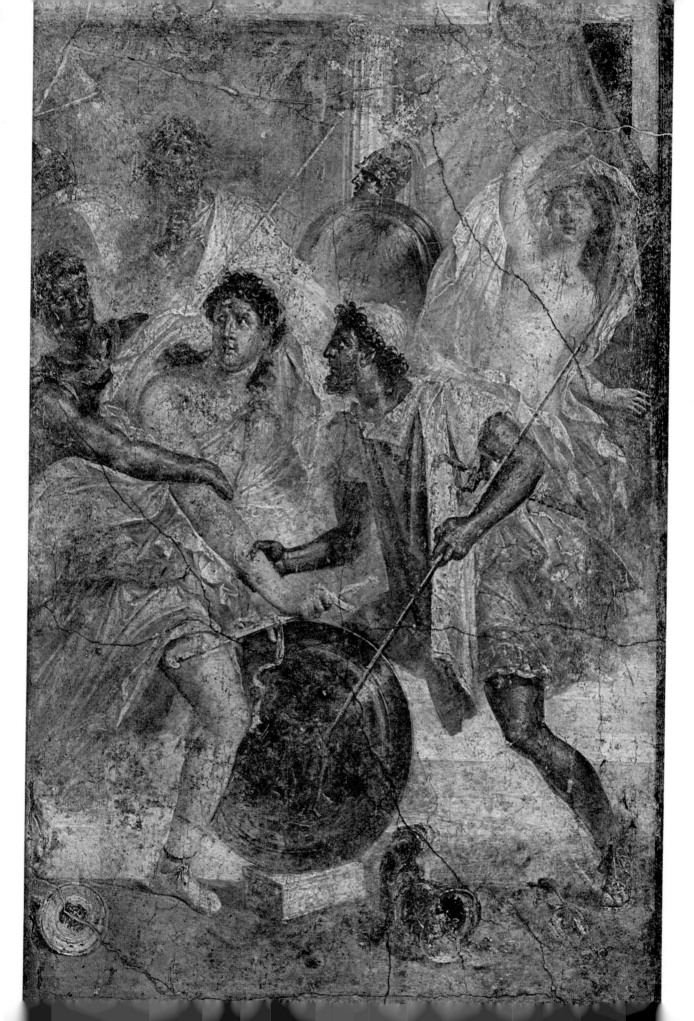

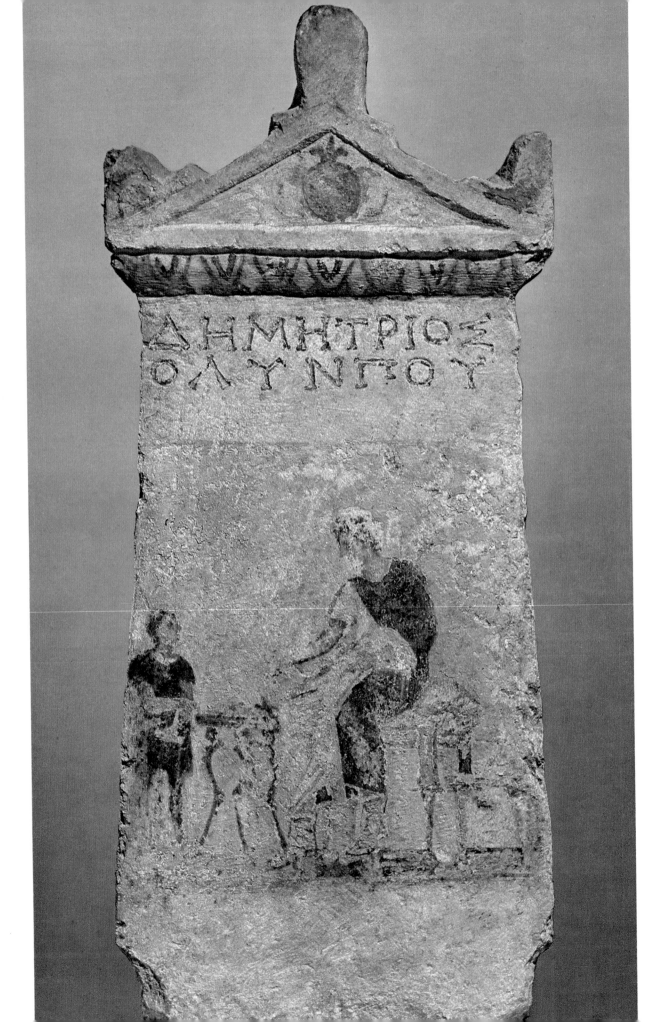

Light and Colour (280-150 B.C.)

The middle of the Hellenistic period is beyond doubt the point at which the evolution of Greek painting is hardest to grasp. During this phase original works are rare and almost wholly lacking in significance, replicas are of uncertain attribution, and even the written sources more or less dry up. Yet new trends do appear, which broaden the scope of pictorial art. Man is no longer the essential (if not the only) element depicted; the physical setting assumes growing importance as animals, plants and other objects become accepted as themes and are rendered with the colour and light appropriate to open-air settings. Finally, knowledge of composition and realism of expression become more profound, while new trends, which eventually lead to a type of painting with something very like illusionist tendencies, begin to appear.

Original Works

Funerary stelae and painted pottery give only a very faint reflection of the various stages in this evolutionary process. The truth is that the Greek, Egyptian and Sicilian craftsmen who decorated them were still primarily influenced by the lessons of the past. For example, the stele of Demetrius, son of Olympus, shows two figures, in three-quarter view, but both are more or less on the same level. The furniture is drawn in fairly accurate perspective, but both figures (as the old tradition prescribed) have their faces in profile, a device that merely enhances the impression the painting gives of being a coloured sketch. Yet the inscription makes it impossible to date the stele earlier than the second quarter of the third century.

The painting on the more or less contemporary stele of Pelopides the Thessalian, found at Alexandria, already shows signs of having been more strongly influenced by third-century pictorial fashions. Despite the simplicity of its theme, and the marked clumsiness of its execution, there is a clear distinction between background and foreground. The terrain is drawn in perspective; the horse is seen in three-quarter view, turned away from the viewer (like the rider struggling to get it under control), and foreshortened. This by no means negligible attempt at 'angled' composition, with its use of highlighting, shows how widespread these experiments in positioning figures in space had become.

Certain marble grave-stelae from Demetrias, in Thessaly, bear more finely executed paintings. Unfortunately, the best of these are in a poor state of preservation. However, their colours were a good deal fresher at the time of their discovery – as we can see from older reproductions – and the technique employed, encaustic painting, implies a tonal subtlety now almost completely lost. All we can see today is the preparatory design that guided the painter when he was spreading and superimposing his layers of coloured wax.

At all events a stele like that of Archidice embodied the most delicate tonal gradations and a wide range of more or less strongly marked shadows produced by

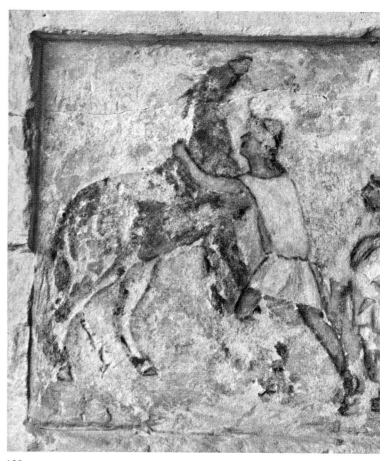

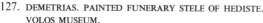

127. DEMETRIAS. PAINTED FUNERARY STELE OF HEDISTE. VOLOS MUSEUM.

128. ALEXANDRIA. PAINTED FUNERARY STELE. THE METROPOLITAN MUSEUM OF ART, NEW YORK.

light shining from an oblique angle. Despite the simplicity of the poses, which reveal a decidedly classical spirit, the painter has modified the traditional schema of mistress and servant: Archidice sits three-quarters facing the viewer, with her back to the centre of the picture. It needed no great imaginative effort for the Thessalian painter to take a fairly banal type of representation, and adapt it to the aesthetic fashion.

There can be no doubt that the funerary stele of Hediste comes far closer to easel-paintings of the time. The scene, a complex and dramatic one, portrays a young woman who has died in childbirth, surrounded by members of her family. This vigorously realistic group is placed in a setting which suggests the interior of a house – in greater and more specific detail than the paintings from Herculaneum. Hediste (it would seem that she has only just expired) lies stretched out on her bed, half-turned towards the viewer, while another woman, sitting at the foot of the bed, leans over towards her. There is a large doorway in the middle of the picture, through which we glimpse a second room, or a corridor, with an open door at its far end. In the second room (seen in a sort of bird's eye view) two other figures, half hidden by the pilasters which separate the chambers, remain largely in shadow. All the light comes from a

130

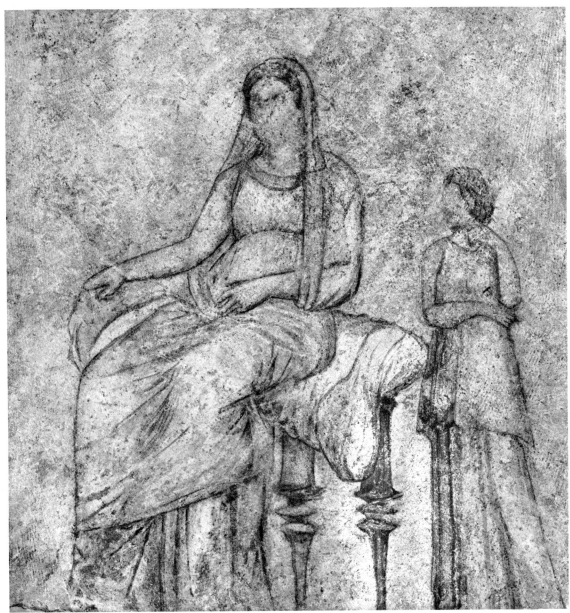

129. DEMETRIAS. PAINTED FUNERARY STELE OF ARCHIDICE. VOLOS MUSEUM.

single source, somewhere on the left, and is concentrated on the foreground. The top of the pillow, part of the girl's face, her breasts and the coverlet, half drawn up over the corpse, are all picked out in vivid patches of brightness which also serve to give added emphasis to the accentuated shadows.

This original piece of evidence, though it remains the work of an anonymous craftsman, reveals the interest which great contemporary artists took in the study of light-diffusion within a specific area of clearly determined dimensions. Unfortunately, however, the colours – as we saw earlier – have faded so much that today it it impossible to determine what role they played in the composition as a whole.

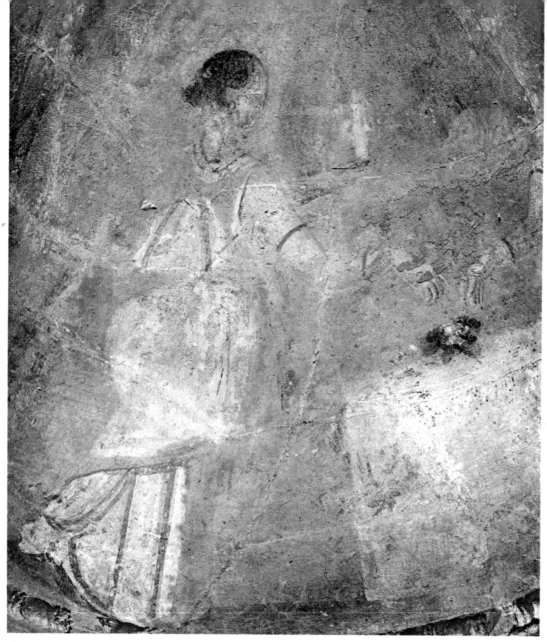

130. CENTURIPE. POLYCHROME PYXIS (DETAIL): WOMAN OFFERING SACRIFICE. THE METROPOLITAN MUSEUM OF ART, NEW YORK.

However, we possess other evidence which enables us to appreciate the progress that had taken place in this field. About the same time Centuripe, in Sicily, had an important and flourishing *atelier* of ceramic artists, who used purely ornamental pots as a medium for genuine paintings (in fact their pottery is also heavily loaded with relief ornamentation). In accordance with the tradition we saw emerge in Southern Italy at the beginning of the Hellenistic period, these scenes depict figures painted on a uniform background which varies from red to rose-pink; the architectural setting disappears completely, and there is nothing to bring the characters alive but variations of colour and the play of light and shadow.

Nevertheless a sense of space is not altogether absent. The woman making sacrifice (on the lid of a large pyxis now in New York) stands on ground which, like the altar

132

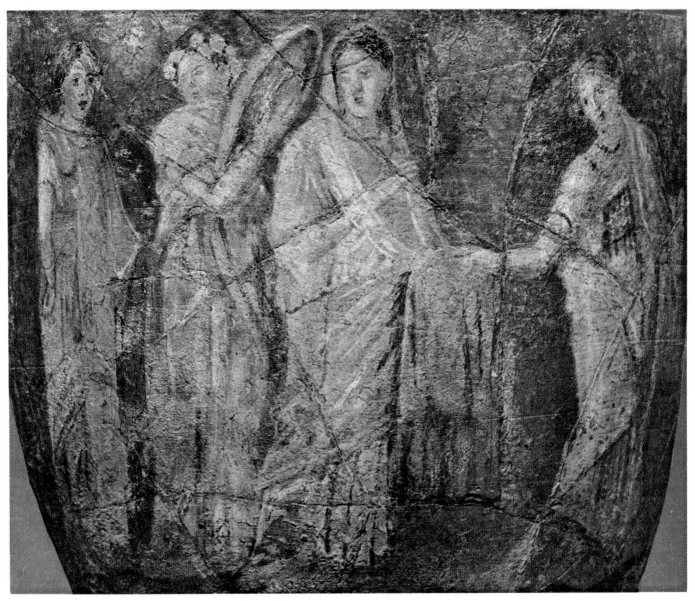

131. CENTURIPE. POLYCHROME KRATER (DETAIL): CULT SCENE. THE METROPOLITAN MUSEUM OF ART, NEW YORK.

before her, is drawn in perspective. The sole function of the ground is to emphasize the turning motion of her body (subtly indicated by the legs) and the shadow she casts ahead of her. The colours are handled with delicacy, yet they cannot match the sacred procession on the New York krater. Here the delicately shaded pastel tints – rose-pink and pale blue, mauve and yellow – show a genuine instinct for chromatic composition.

But the Sicilian artist contrived to use light in a more subtle manner still: outlining flesh with light shadow-work, employing an authentic glaze technique to render its brightness of texture and to convey the transparency of fabrics in superimposed folds. This preoccupation with plastic form, modelled by means of subtle light effects, is characteristic of Hellenistic painting at its apogee. Furthermore, each figure, whether isolated or (like those on the left) part of a group, is positioned in a three-dimensional

133

space; observe how the woman with the tambourine draws herself up, half turning away from the viewer. Lastly, even in such a minor work as this, we find an obvious concern with facial expression – witness the dancing-girl and the tambourine-player.

Replicas: indoor scenes

Surviving originals by first-class painters are always sadly few, though particularly so in the case of the middle of the Hellenistic period. By the nature of things the work of ordinary craftsmen only ran to exterior settings reduced to their simplest possible form, but the same was not true of greater paintings. From now on, as we shall see, the setting – whether natural or architectural – came to assume an increasing importance; only a few major compositions (doubtless based on wall-paintings) preserve the tradition of a more or less neutral background. The great Boscoreale mural, now in the Naples Museum, has a pseudo-architectural border in *trompe-l'œil*, while its figures stand on a three-dimensional floor and are set off by a wall, the revetment of which imitates marble. It is possible, however, that this mural, dating from the middle of the

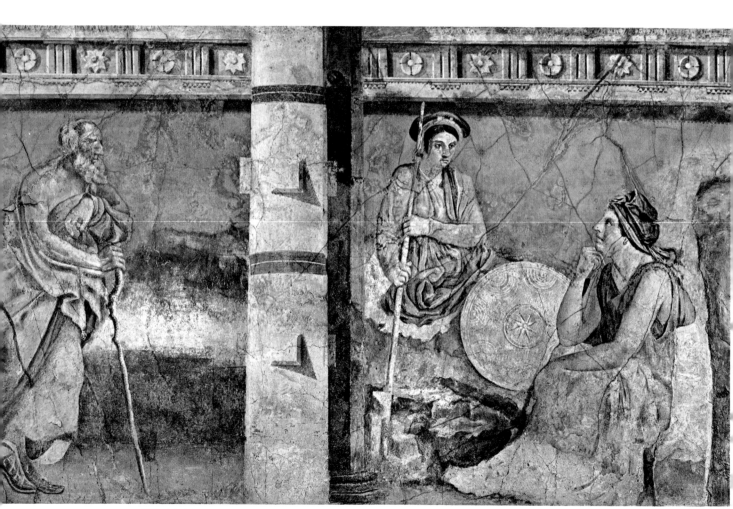

132. BOSCOREALE. WALL-PAINTING: THE ROYAL FAMILY OF MACEDONIA AND A PHILOSOPHER. MUSEO NAZIONALE, NAPLES.

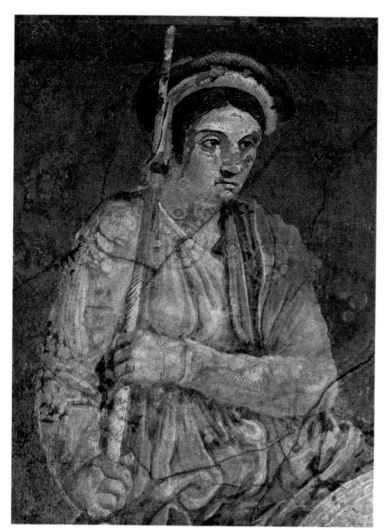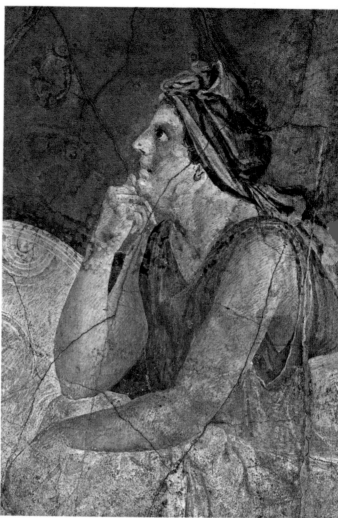

133-134. BOSCOREALE. WALL-PAINTING (DETAILS): THE MACEDONIAN ROYAL FAMILY. MUSEO NAZIONALE, NAPLES.

first century B.C., may follow the rules of the Pompeian 'Second Style', involving large scenes of figures against a background of simulated architecture, which we shall find expressed below (figs 197-202) in the decoration from the Villa of the Mysteries.

At all events, the paintings from Fannius Sinistor's villa at Boscoreale are undoubtedly reproductions of third-century Greek originals, since the royal personages in Macedonian costume (perhaps identifiable as Queen Phila and her son, King Antigonus Gonatas) derive unmistakably from a model of this period. The philosopher lecturing them – perhaps Menedemus of Eretria – belongs to the same century: one during which the various schools (Stoic, Epicurean, Cynic) produced a remarkable number of great teachers and thinkers. Thus the sumptuous architectural décor, which suggests a palace rather than a private dwelling, may ultimately derive from the original composition.

In the Boscoreale mural we can recognize the same methods as we observed above, in embryo, on pottery from Centuripe. Here, however, they are exploited with far greater skill. The figures have a remarkable spatial presence, thanks to the emphatic foreshortening and torsion of their bodies and to the use of shadow (which, besides

135

bringing out torsos and drapery in depth also makes possible a minutely detailed representation of muscles and tendons, and gives whole sections of the garments a three-dimensional quality). The portrait of the philosopher reveals the same slightly *outré* plastic quality as contemporary sculptures of Antigonus of Carystos or Epigonus of Pergamum. His immobile figure is animated by the treatment of light and shade – a far cry from the crude, diffuse light-effects of Nicias' day, which merely picked out salient parts of the body, and surrounded them with thick shadow. The feeling for tones and the plasticity of mass here already, in a sense, vies with late Quattrocento painting. But light and colour are also used in the portraits of the king and queen to bring off more subtle glazing effects, more lightly hatched shadows and simultaneous contrasts and gradations of tone. The Campanian painter's work also seems to preserve to some extent a concern with psychological expression, which is reflected not merely in the faces, but in their poses and attitudes.

Later on, in the first century A.D. Roman copyists drew their inspiration exclusively from easel-pictures, whose painters for the most part remain anonymous. In the same tradition as the replicas executed at Herculaneum by the 'Hellenic Master' we may also place a composition which adorned the triclinium of the Imperial Villa at Pompeii. Compared with earlier works, however, this indoor scene embodies certain new features, the most striking of which is the way the background has been opened up: between the pilasters a second building can be seen, and a patch of sky. The lighting of the interior (which comes from the left) is here augmented by a luminous, if limited, glimpse of the outside world. The modified highlighting technique does not produce sharp contrasts of light and shade, yet it gives rise to a whole range of subtly varying tones. This is particularly clear in the figure of the servant in the background, where highlighting, shadow-work and colour-gradation are combined.

Another sign of development is the composition's spatial organization. The painter feels sufficiently confident in his technique to discard the centripetal schema of the early Hellenistic era, and his lines slant away towards the left of the picture, creating an impression of depth which is, perhaps, more genuine than previous efforts in this direction because less artificial. At the same time he has managed to avoid the monotonous effect that would have resulted had all the lines run in one direction; the architrave of the portico and the stool at the foot of the bed form horizontal bars, enclosing the picture at both the top and the bottom.

The same skilled handling of light, colour and composition recurs on a fragmentary marble plaque from Pompeii, no doubt based on a more or less contemporary original. We have the same slanting lines, emphasized by an architectural background; the same subtle grading of colours – though this seemingly did not preclude some fairly sharp contrasts. However, in this scene portraying the massacre of Niobe's children the play of shadow is far more vigorously exploited; indeed, it almost achieves a genuine chiaroscuro effect. The gestures and expressions also help to create a dramatic atmosphere.

Thus shading and colour, far from merely being juxtaposed like two unrelated elements, according to the tonal concept of painting still current at the beginning of the Hellenistic era, are henceforth intimately blended. The light not only enhances the

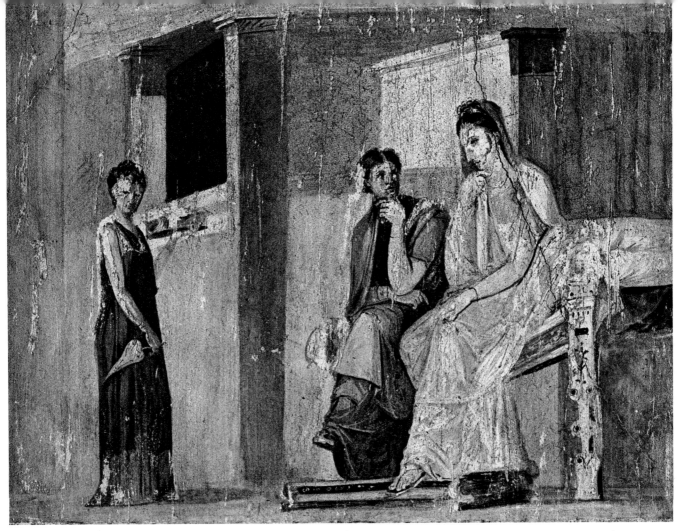

135. POMPEII, IMPERIAL VILLA. WALL-PAINTING: SCENE IN THE WOMEN'S QUARTERS.

136. POMPEII. PAINTING ON MARBLE:
NIOBE AND THE NIOBIDES.
MUSEO NAZIONALE, NAPLES.

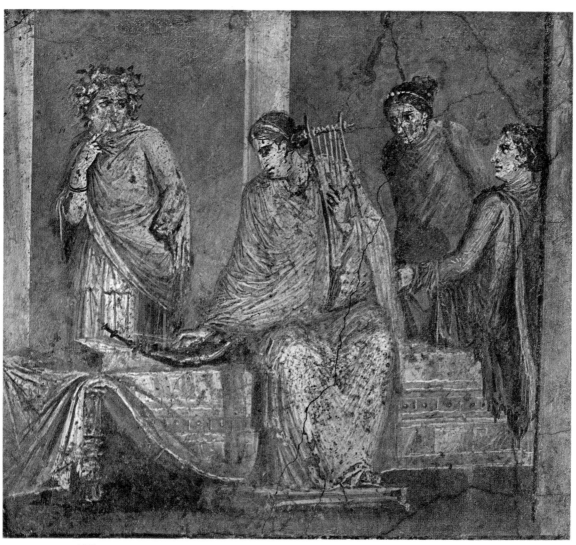

137. STABIAE. WALL-PAINTING: PREPARATIONS FOR A CONCERT. MUSEO NAZIONALE, NAPLES.

figures' plasticity of form, but helps to render them more vivid by transmuting the colour itself and giving it an almost vibrant quality.

Two more or less comparable indoor scenes allow us to judge the progress made since the beginning of the century in the use of colour. In the picture from Stabiae which shows preparations being made for a concert, the freedom of the painter in positioning his figures and his skill at suggesting three-dimensional space are striking. A large couch divides the figures into two groups, located on different planes. The portico in the background provides extra space, and the girl musician and her companion seated at the right serve to enhance the feeling of depth. Passing briefly over the realism of these expressions – ranging from considered admiration to curiosity and plain jealous uneasiness – one is struck by the quality of the light-effects. This can be seen in the transparent sheen of the cithara-player's robe (note the way in which its silken folds are tinted yellow in places), in the delicate gradations of green and brownish-red in the garments of the two women on the right, and – above all – in the

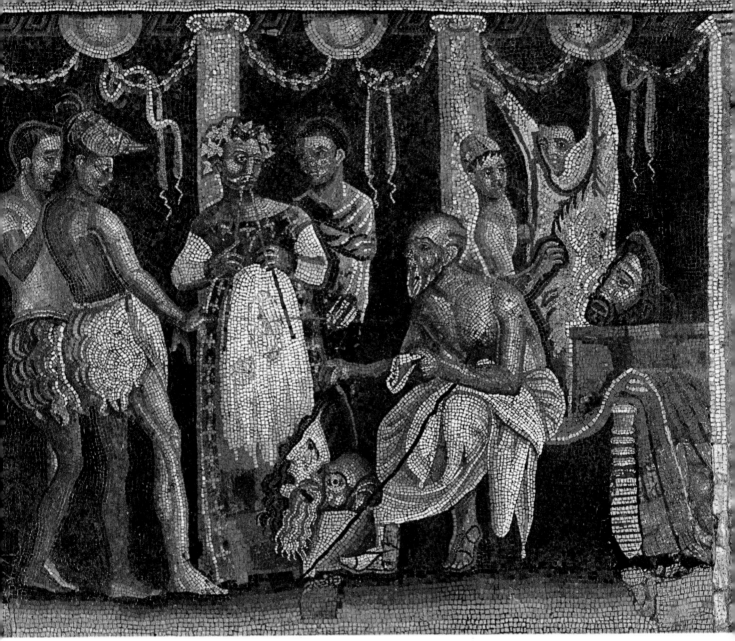

138. POMPEII. MOSAIC: PREPARATIONS FOR A SATYR-PLAY. MUSEO NAZIONALE, NAPLES.

sumptuous material spread over the couch, which here and there actually reflects the light.

The mosaic from the House of the Tragic Poet at Pompeii is inevitably somewhat less subtle in its effects. Like almost all mosaics of the Roman period, it is made of stone cubes which are relatively large in comparison with the minuscule ones employed by mosaicists of the late Hellenistic era – for example, in the 'Alexander mosaic'. Nevertheless the principles which underlie its composition are virtually the same as those of the painting from Stabiae, even if the treatment of perspective in the mosaic is somewhat more perfunctory. We find a similar urge to render the varying contours of flesh and clothing through picking out body-structure or folds of material with the aid of light-effects alone.

139

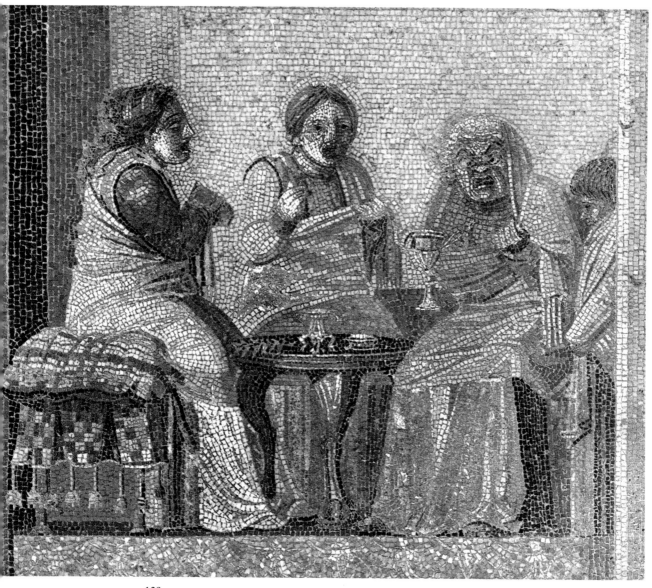

139. POMPEII. MOSAIC SIGNED BY DIOSCURIDES: SCENE FROM A COMEDY. MUSEO NAZIONALE, NAPLES.

The small mosaic pictures found in the Villa of Cicero at Pompeii, and signed by the Greek copyist Dioscurides of Samos, are much more finely executed. The lettering of the inscription dates them to the latter half of the second century B.C., but their inspiration almost certainly derives from third-century Greek originals. The group of strolling musicians recurs (with minor variations) in a later painting from Stabiae, but also in certain statuettes from Myrina, datable before the end of the third century.

The composition of the comedy scene above (depicting a visit to a sorceress, or 'wise woman') falls into a fairly ancient pattern. The characters are grouped with a central axis formed by the three-legged table (in perspective) and the woman sitting behind it, who is shown full-face with the foreshortening that such a position implies. On the

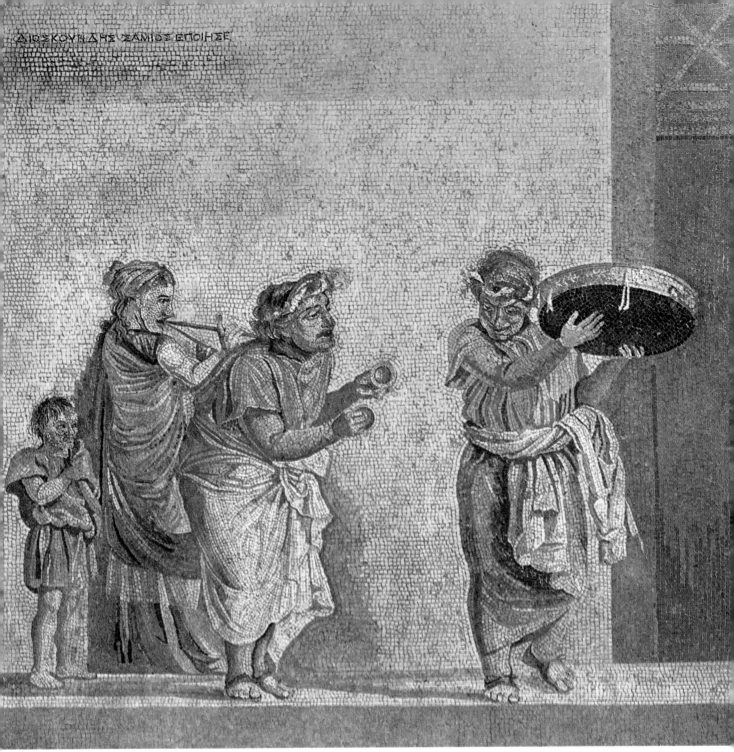

140. POMPEII. MOSAIC SIGNED BY DIOSCURIDES: STROLLING MUSICIANS. MUSEO NAZIONALE, NAPLES.

other hand the strolling musicians, or street-players, are already portrayed in an open-air setting where the background, though very perfunctorily conveyed (it consists of nothing but a bare wall and a house-door), for the first time assumes a spatial value in direct relationship with the actors: large shadows cast on ground and wall suffice to 'place' each figure. Though their disposition may at first sight appear to be rather arbitrary, in fact each one possesses, to the very highest degree, its own plastic value.

141

No less remarkable in both pictures – especially the second, where the illumination of the street outshines that of the stage – is the use of colour. The mosaicist, not content with using light-effects to modify an already varied tonal range, has made the sun, quite literally, alter and transform colours; in particular, the bluish-green of certain garments becomes a golden-yellow where the light falls most directly on it. This represents a remarkable degree of realism in observing the effects of light; it was never to be surpassed in ancient painting, not even when the taste for a natural setting, for landscape as such, became widespread.

Replicas: open-air scenes

This taste for nature developed slowly in Hellenistic painting. At first, in accordance with a tradition going back to Polygnotus of Thasos, the natural setting was represented only by a few rocks (which broke up the uniformity of the ground and provided something for figures to lean on), or by bare skeletal trees. Nature here had no background, vegetation or sky, and, as we have seen, it was by way of human arte-facts, buildings in particular, that the outer world first entered scenes with figures.

It should not therefore surprise us to find in certain paintings from Pompeii – which, through their restrained style of composition, still adhere to a 'classical' tradition – that the architectural setting predominates, while 'nature' serves only as an unobtrusive background. The picture of three women conversing is a very simple one, yet these human figures, sitting or leaning on conventional architectural supports, stand out against a background of greenery and shrubs, the colour of which is picked up by the sky. We may also note how the light produces tonal transformations in the blue-green and mauve of the clothes worn by the two women on the left. Thus the techniques we have observed in the mosaics by Dioscurides reappear here, albeit with more conscious restraint – however, this does not, in my opinion, justify our regarding this picture as a straightforward piece of neo-classicism: it is far more likely to be a copy of some third-century original.

Imitation is more obvious when, as on the walls of the Pompeian cryptoportico, reproductions assume the appearance of a picture-collection with each item protected by wooden shutters. In Pompeian 'Second Style' decoration of this sort everything is artificial – the *trompe-l'œil* architecture no less than the fake picture-gallery. Yet this sequence of scenes from the Homeric poems, executed shortly after the middle of the first century B.C., is undoubtedly copied from older Hellenistic works, as we can tell from its stylistic delicacy, the vivid illumination (which heightens the colours) and the figures, which stand out against a luminous yet still more or less neutral background.

That a picture is a replica becomes more obvious when two or three copies of the same original survive. The picture of Theseus triumphant (after his victory over the Minotaur) is a case in point. The most complete replica is also the most mediocre, and its attempt to reproduce the schema of the original work is decidedly inadequate. Conversely, a better-quality copy from Pompeii is the most fragmentary, but it does allow us to conclude, *inter alia*, that the wall in the other version is a copyist's

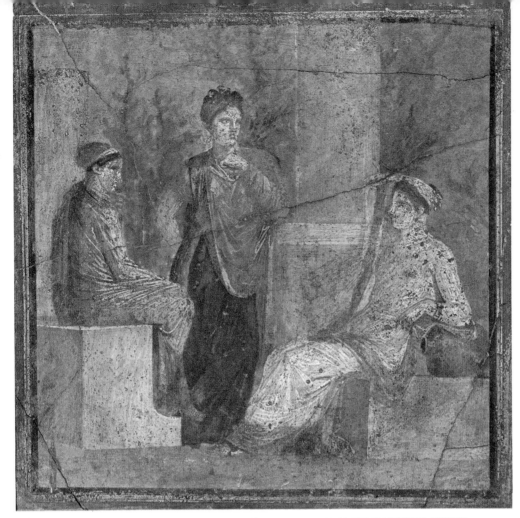

141. POMPEII. WALL-PAINTING: CONVERSATION UNDER A PORTICO. MUSEO NAZIONALE, NAPLES.

142. POMPEII. HOUSE OF THE CRYPTOPORTICO. WALL-PAINTING: SCENE FROM THE ODYSSEY.

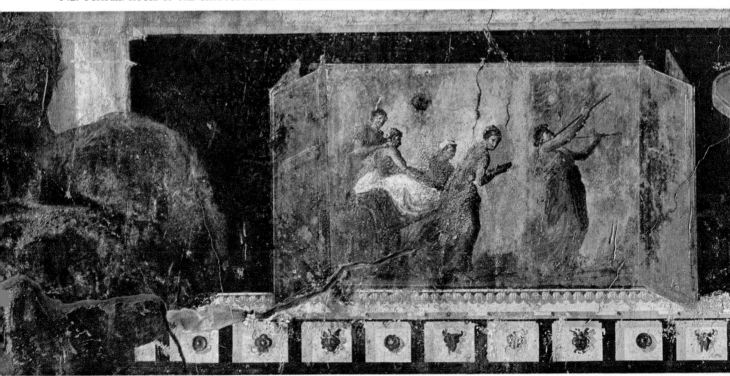

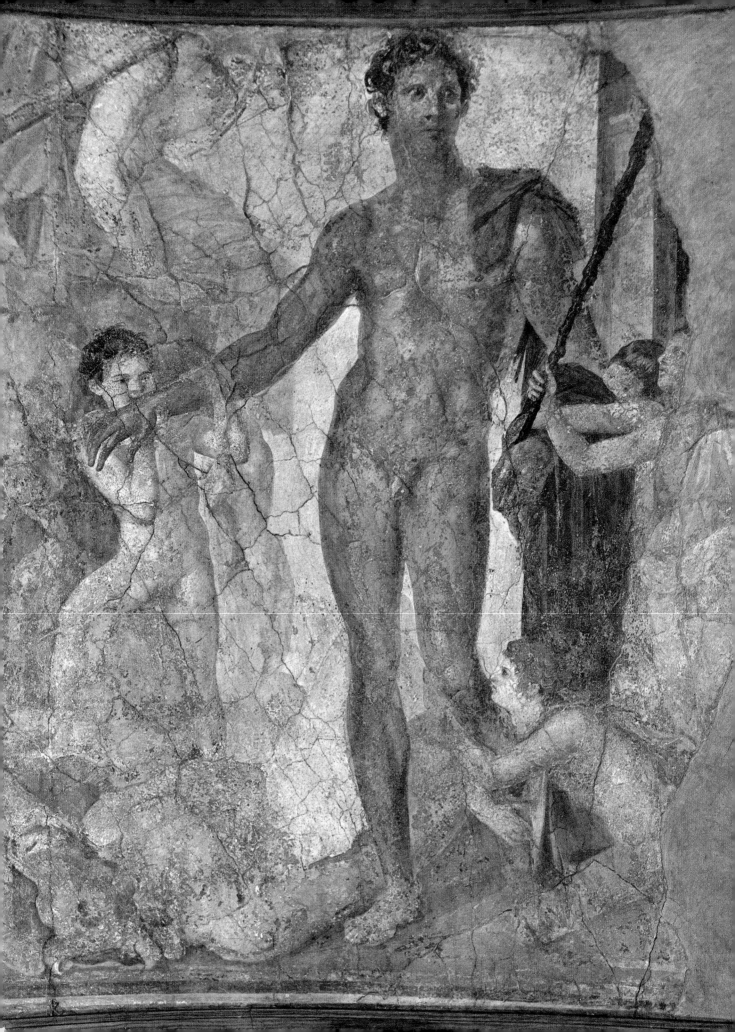

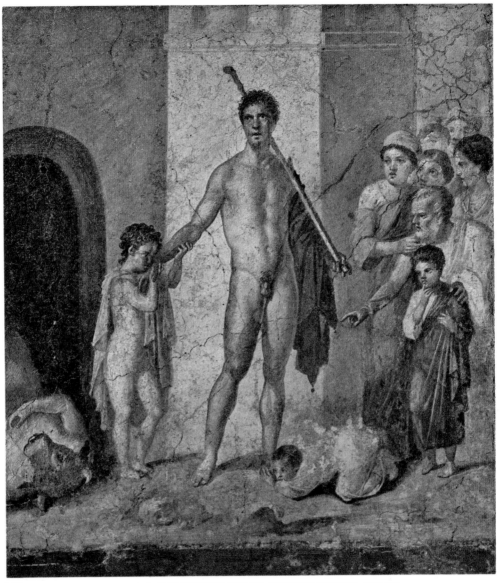

144. POMPEII. WALL-PAINTING: THESEUS TRIUMPHANT. MUSEO NAZIONALE, NAPLES.

invention. In fact we can see from the third and best replica, that from Herculaneum, that the figures stood out against a background of pilasters and rocks, seemingly with a patch of sky on the right and two seated female figures dominating the scene on the left. At all events the picture contained numerous figures placed on different levels, and, as we can deduce from the Herculaneum fresco, the light subtly modulated both the solidity of the bodies and the colouring of their attire.

As time goes on, the external setting grows in importance. Sometimes an architectural background is employed, assuming imposing proportions in relation to the figures in the foreground: in one Pompeian mural the town with its fortifications, terraced houses and a patch of sky above forms the decorative background to a

143. HERCULANEUM. WALL PAINTING: THESEUS TRIUMPHANT. MUSEO NAZIONALE, NAPLES.

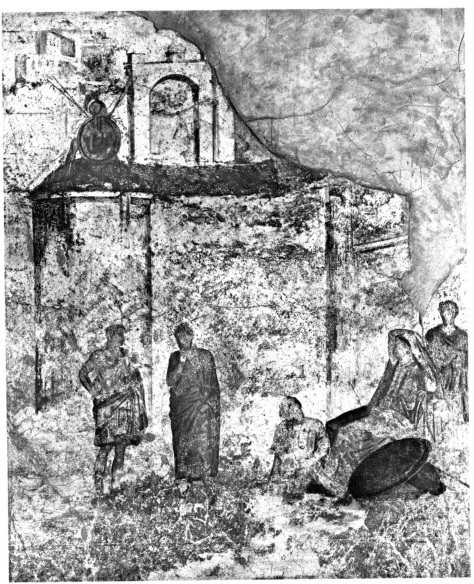

145. POMPEII. WALL-PAINTING: PHOENIX ON SCYROS(?). MUSEO NAZIONALE, NAPLES.

formally restrained group of figures. Sometimes, however, the sky also becomes an element in the landscape. One painting from the Villa Farnesina in Rome, datable to about 30 B.C., is undoubtedly inspired by older Hellenistic models: note its oblique composition and the light-and-shade effects, which produce the most delicate modulations on figures executed in a very pure Hellenic style. These are shown against the wall of a sanctuary, while above them stretches a wide expanse of luminous pale blue sky.

It is again the sky – but a cloud-laden sky above the rocky island of Naxos – that plays a large part in a composition of which we possess three replicas. In the best of them, from the House of the Cithara-player, Dionysus' discovery of the sleeping Ariadne is depicted with remarkable lyricism. The arrested movement of Dionysus,

146 146. ROME. WALL-PAINTING (DETAIL): DIONYSUS REARED BY THE BACCHANTES. MUSEO NAZIONALE, ROME.

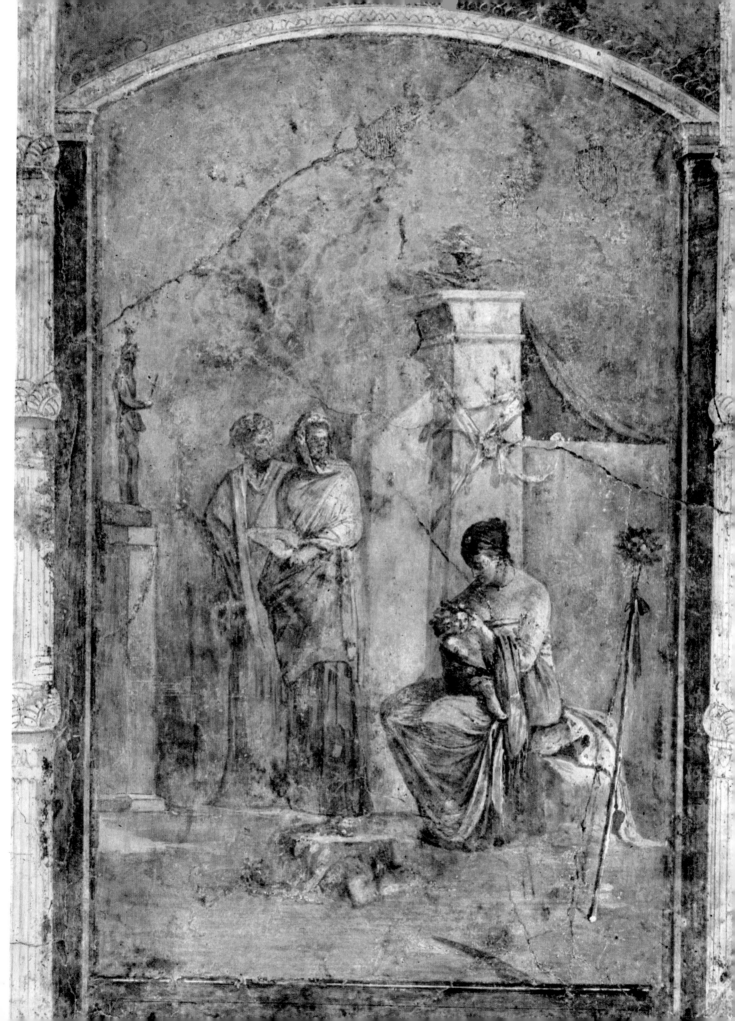

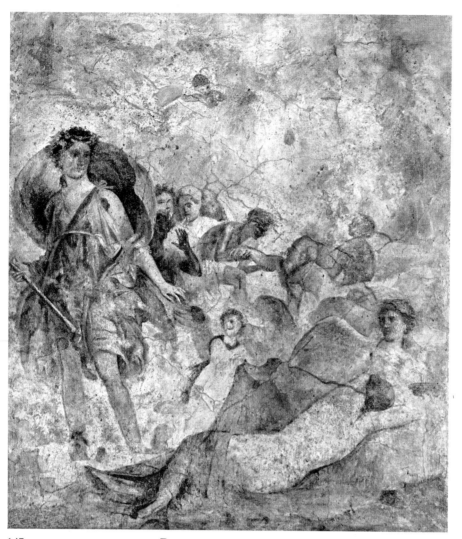

147. POMPEII. WALL-PAINTING: DIONYSUS DISCOVERING THE SLEEPING ARIADNE.
MUSEO NAZIONALE, NAPLES.

with the wind swirling round him, and Ariadne's lovely naked body fill the foreground. Behind them throng Dionysus' companions; only the old Pan has already registered Ariadne's discovery, and his gesture echoes that of the young god. A satyr turns to call a companion in the background at the top of the rocks, and his movement enhances the depth of a space rendered almost ghostly by the morning mist. This pale dawn casts no more than the lightest shadows, but the warm, soft colours, gold, green and reddish-brown, present an infinite variety of tones under the effect of the light: shadows are mere variations of colour, and the light itself seems no more than a reflection of these subtle nuances.

The natural setting, in the form of even a sketchy landscape, is still lacking. It does appear, however, in other compositions, such as the two Pompeian murals which perhaps draw their inspiration, somewhat freely, from a picture by Artemon, whose 'Heracles and Dejanira' is mentioned by Pliny (*HN* 35.40.139). The mountains, trees,

148. POMPEII. WALL-PAINTING (DETAIL): DIONYSUS DISCOVERING ARIADNE. MUSEO NAZIONALE, NAPLES.

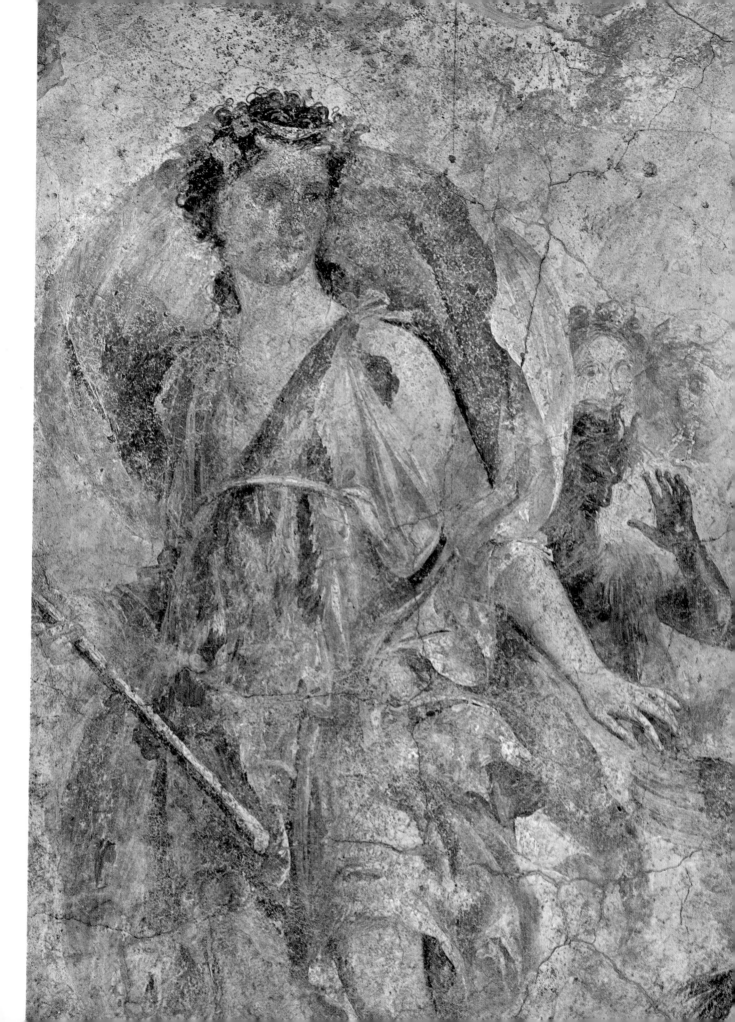

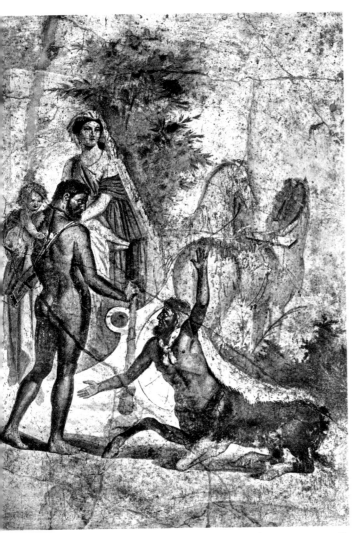

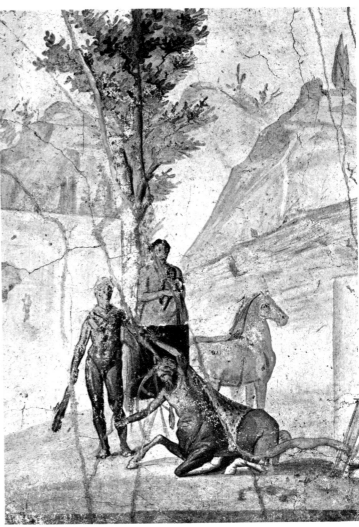

149. POMPEII. HERACLES AND NESSUS (AFTER ARTEMON?).
MUSEO NAZIONALE, NAPLES.

150. POMPEII. HERACLES AND NESSUS (AFTER ARTEMON?).
MUSEO NAZIONALE, NAPLES.

and shrubbery form a first attempt at landscape proper. On the other hand the light is badly suited to this outdoor scene. It looks too garish, a midsummer glare which emphasizes the shadows but imposes a certain uniformity on each colour and leaves the sky white. Neither at the beginning nor in the middle of the Hellenistic period was the conquest of landscape truly achieved; man had not yet been assimilated to nature.

What is more, those major mythological compositions which (to judge by the way themes are handled) belong incontestably to the middle of the Hellenistic era, saw little need for what we might term a picturesque setting. The scene of Helen's embarkation, with its more or less typical oblique composition and its remarkable use of chiaroscuro (the latter giving the figures an excellent plastic value), is set against a more or less neutral background, which in no way suggests the proximity of the sea. The essential feature of the background is still an architectural motif.

151. POMPEII. WALL-PAINTING: THE EMBARKATION OF HELEN. MUSEO NAZIONALE, NAPLES.

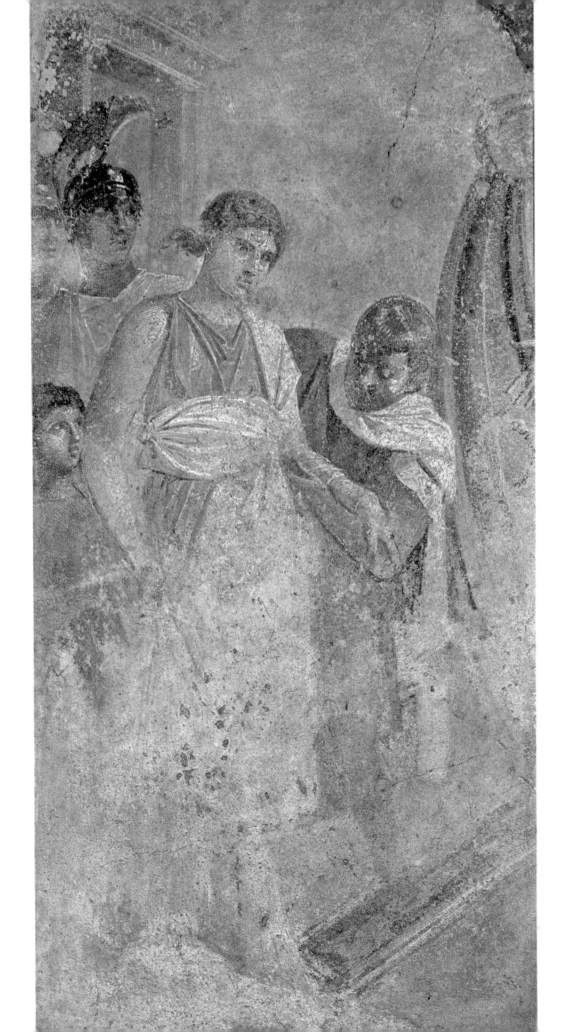

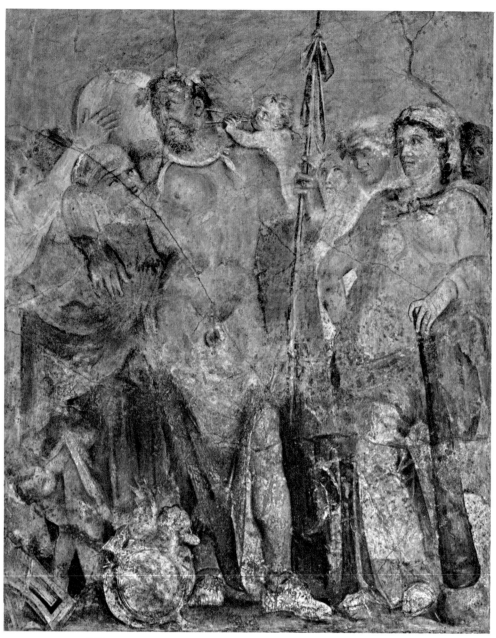

152. POMPEII. WALL-PAINTING: HERACLES AND OMPHALE. MUSEO NAZIONALE, NAPLES.

If we compare this with another picture, representing Helen's seduction by Paris, it takes little effort to perceive that the lighting of both works is basically much the same, even though the second portrays an indoor scene. The two painters differ in personality and mode of interpretation, but they employ similar chiaroscuro effects and reveal an identical contempt for the setting, which merely serves to localize the episode portrayed. Yet Paris' ungainly sculptural pose – half obliterated – shows that the original, for all its restraint, was indeed a Hellenistic work.

On the other hand, one would feel no hesitation in assigning a picture like the Heracles and Omphale above to a fairly advanced phase of Hellenistic art. The artist's obvious disrespect for the hero at once suggests this, as do Heracles' too-agonized

152

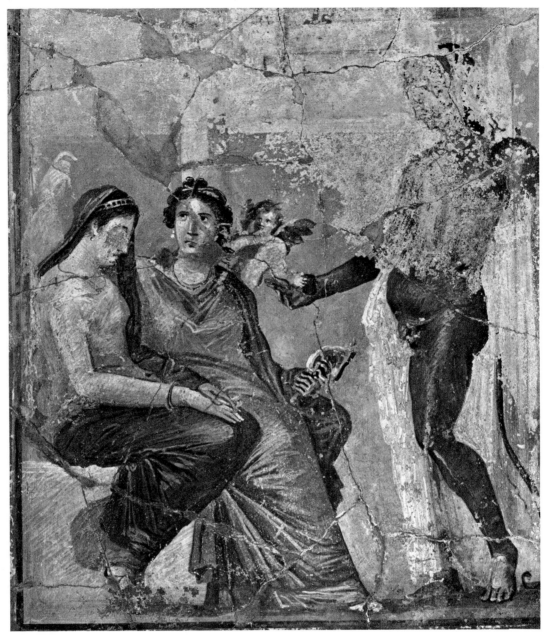

153. POMPEII. WALL-PAINTING: THE SEDUCTION OF HELEN. MUSEO NAZIONALE, NAPLES.

expression, the transparency and cleverly revealing arrangement of Omphale's tunic, the playful handling of the Amorini, and the figures clustered in the background, for whose portrayal a new technical device is adopted. Far from dominating the scene these last seem to be very slightly smaller, as is normal, and only their faces appear in the gaps. The treatment of light is fairly advanced, but there is virtually no background – just a bluish-green surface which might perhaps be the sky.

The Three Graces group is also Hellenistic in origin. Originally a sculptural theme, it is here expressed in terms of a new outdoor vision. The shadowed whiteness of naked bodies stands out against a background of rocks with a patch of sky above; for the first

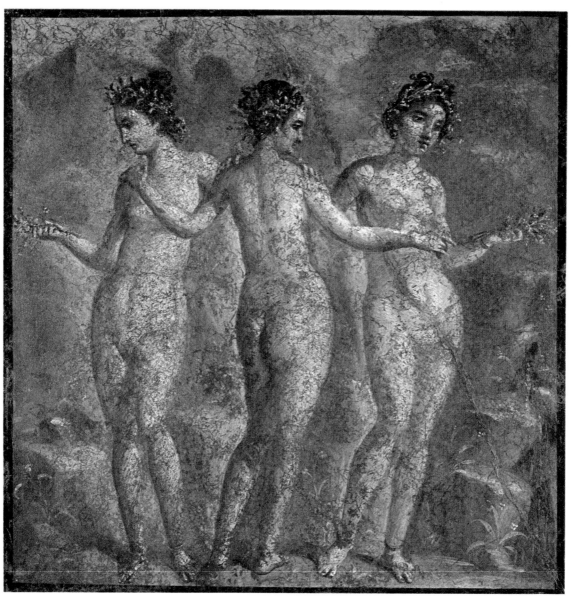

154. POMPEII. WALL-PAINTING: THE THREE GRACES. MUSEO NAZIONALE, NAPLES.

time, however, the light colours the ground with large patches of a diaphanous blue. Such experiments were only to be fully realized in the final phase of Hellenistic painting.

Mannerism and Still-life

In other spheres, however, the final trends of Hellenistic art become apparent from the first half of the second century, and the various schools tend to develop individual characteristics. On thematic grounds one painting from Herculaneum looks very much as though it was inspired by Pergamene 'Display art': it shows Heracles discovering his son Telephus, who was rescued by the Nymphs of Arcadia, and suckled by a doe.

155. HERCULANEUM. WALL-PAINTING: HERACLES AND TELEPHUS. MUSEO NAZIONALE, NAPLES

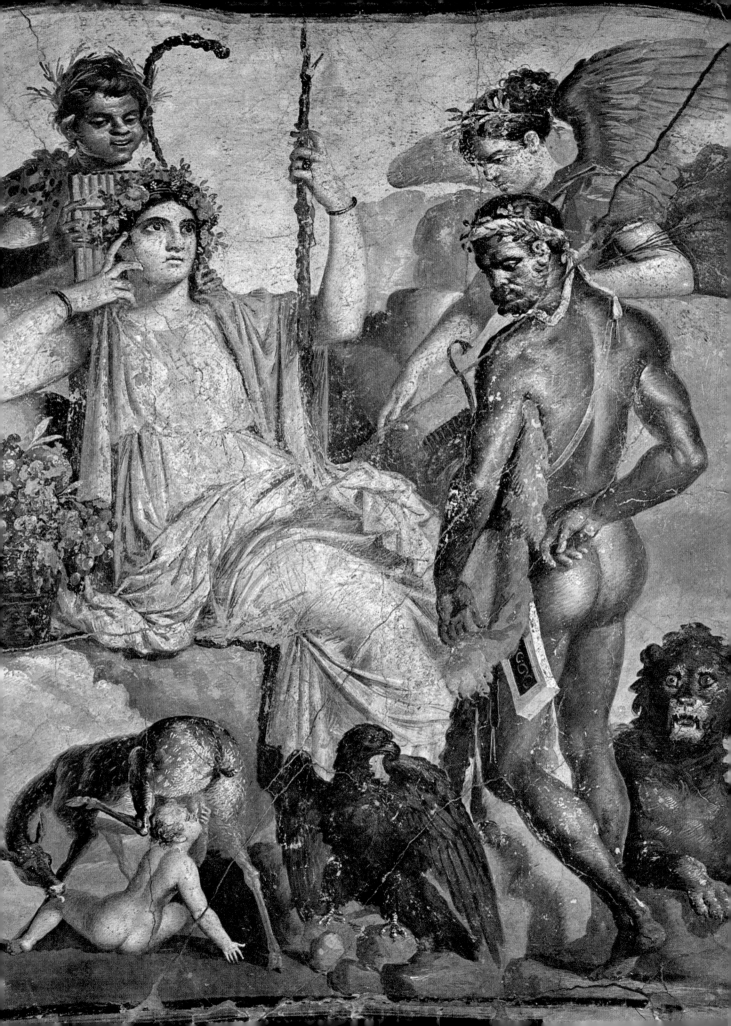

Telephus was the legendary founder of Pergamum, and the entire V-shaped composition draws one's eye to the eagle of Zeus in the foreground – the emblem of the royal dynasty. One can sense the quality of the original, with its multi-level composition and the elaborate use of chiaroscuro, despite the copyist's clumsiness (the lion is pure caricature); on the other hand, the natural setting remains artificial. Nevertheless the work embodies some interesting innovations: a *genre* scene – the suckling of Telephus – with definite signs of mannerism, and the appearance of a still-life motif – a magnificent and realistic basket of fruit.

This last is not an addition by the Roman copyist. We know that an early second-century mosaicist, one Sosus of Pergamum, had a reputation for works combining elements of *genre* and still-life. Of one of his works Pliny wrote (*HN* 36.25.60): 'What people admire about this mosaic is a dove drinking, and colouring the water with the shadow of its head. Other doves are shown, basking in the sun and preening themselves, on the edge of the vase'. The model was widely known, and the best replica dates from the second century A.D., but other more perfunctory ones have been found at Pompeii and even in a house on Delos dating from the latter half of the second century B.C.. The shadow-effect mentioned by Pliny has disappeared from the Roman copy, which nevertheless remains a brilliant study in reflected light and chiaroscuro. Not until the painter had fully mastered light-effects could the painting of objects achieve any real standing on its own.

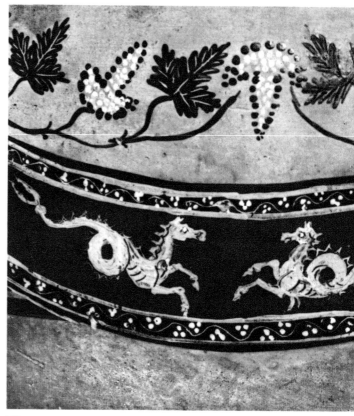

156. ROME. DETAIL OF A MOSAIC AFTER SOSUS. THE VATICAN. 157. ALEXANDRIA. HYDRIA (DETAIL). MUSÉES ROYAUX, BRUSSELS.

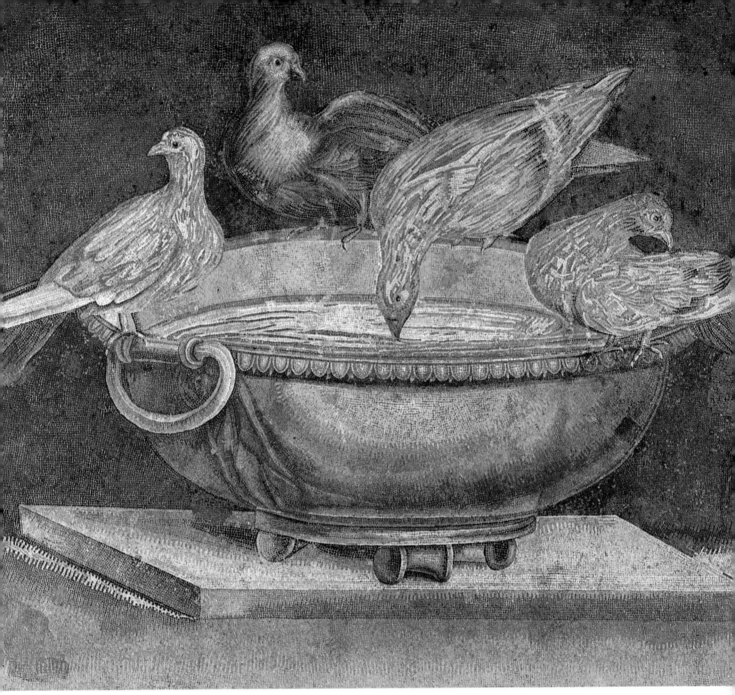

158. TIVOLI. MOSAIC: DOVES (AFTER SOSUS). MUSEO CAPITOLINO, ROME.

Sosus was also the creator, again according to Pliny, of 'what is known as "The Unswept Room" [*asarotos oikos*] because it portrayed . . . the detritus which is customarily removed, just as though it had been scattered on the ground and then left'. There is a mosaic of the Roman period which surely preserves some recollection of this work (fig. 156). In it we find the same taste for minute observation harnessed to rather trivial realism; each object is emphasized by the shadow it casts on the ground.

Mannerist decoration is not peculiar to Pergamum; from the third century B.C. onwards, we find numerous traces of it throughout Greece and in Italy, most

157

159. ALEXANDRIA. HYDRIA (DETAIL): GORGONEION ON A SHIELD. THE METROPOLITAN MUSEUM OF ART, NEW YORK.

noticeably in works produced by ordinary craftsmen. The few painted vases to survive from this period reveal a similar taste in ornamentation – often by no means realistic. They include certain funerary hydrias, from Attica or Alexandria (fig. 157), decorated with stylized foliage and fantastic animals. In the same category comes a polychrome hydria from Hadra, decorated with a shield bearing a Gorgon's face – painted with an expressive realism quite appropriate for the head of a living person.

Another equally common feature of these vases (which sometimes reveal the obvious influence of contemporary painting) is the *genre* scene. This influence is particularly clear in those with white painting on a black ground, where for a while we find a tradition parallel to that of Gnathia-type ceramic art. On the fragment of a phiale from Rome, for example, we find a chariot-race between Amorini, done with full chiaroscuro and in an affected style, as we see from the prancing of the horses.

In addition, we sometimes find tendencies towards 'impressionist' art, a trend which was to develop more fully during the last phase of Hellenistic painting, especially in the studios of Alexandria. A skyphos from the Athenian Agora typifies this new form of

158

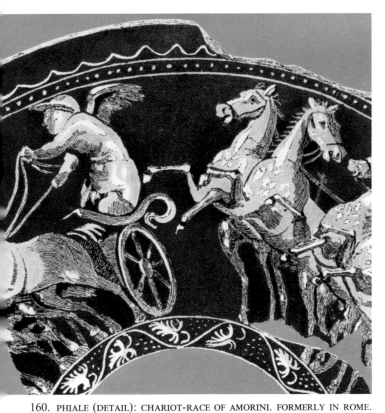

160. PHIALE (DETAIL): CHARIOT-RACE OF AMORINI. FORMERLY IN ROME.　161. SKYPHOS (DETAIL). AGORA MUSEUM, ATHENS.

sensibility (which exploits a somewhat artificial attitude to the natural world). The hunting scene used as decoration on it takes place in front of a little *naiskos* containing a statue – the prototype of all those shrines and images which were to fill the late Hellenistic landscape. The animals, slender, graceful creatures, are patched with light and shadow, and move in a semi-ghostly lunar glow, which recurs in certain small Pompeian pictures of the first century A.D.

Realistic painted portraits are notably lacking, though our literary sources testify to their existence and they subsequently enjoyed a lengthy vogue in Egypt. Those few contemporary mosaics which survive, however, show mannerist tendencies, though in a somewhat attenuated form. The taste for allegory comes out in a mosaic signed by Sophilus, who, towards the end of the third century, depicted Alexandria in personified form, crowned with the prows of ships and holding a ship's rudder. Another example of 'mannered' ornamentation, intermingled with *trompe-l'œil* effects, is the (slightly more recent) mosaic from the House of the Dolphins on Delos (fig. 168).

We see a new attitude of mind which, as in literature, avoids heroic themes (or only retains them for purposes of caricature) and, while coming close to nature through its penchant for realism, yet presents it in a decidedly artificial context. Probably the most complete testimony to this new approach is to be found in Graeco-Egyptian art, which, unfortunately, we know better through its plastic than its pictorial expression.

Alexandrian bourgeois art was the aesthetic expression of that new class which was the dynamo at the heart of the Hellenistic cities and monarchies – a bourgeoisie capable of setting up in the very centre of their city an artificial hill planted with trees

159

162. THMUIS. MOSAIC SIGNED BY SOPHILUS: PERSONIFICATION OF ALEXANDRIA. MUSÉE GRÉCO-ROMAIN, ALEXANDRIA.

and consecrated to Pan, and which scattered baroque pavilions, shrines and rockeries all over the Alexandrian suburbs. Nothing could better symbolize this art than a painted glass goblet found at Begram in Afghanistan but originally from Alexandria, painted with scenes representing the abductions of Ganymede and Europa by Zeus in the guise respectively of an eagle and a bull. The juxtaposition of these themes, well calculated to bring out the god's erotic ambivalence, has a humorous flavour which is emphasized by the exaggerated rotundity of, for example, Europa or the bull. Tendencies towards mannerism are exemplified by Europa's somewhat precious gesture and the airy flutter of her scarf, while the taste for still-life comes out in the frieze of piled arms at the bottom. Seen at a distance, the abundance of golden tones makes this modest goblet resemble metalwork. Stylistically, its patches, lines, tiny flecks of light

160

163-164. BEGRAM. PAINTED GLASS GOBLET: THE ABDUCTIONS OF GANYMEDE AND EUROPA. MUSÉE GUIMET, PARIS.

and vividly contrasted colours give it an impressionist air. Here, again, we see the foreshadowing of certain trends that were to reach their full development in the Roman period.

In such a small-scale work nature can only play a very subordinate part (though even here the painter has portrayed the sea under the bull's feet). Nevertheless, one of the most striking innovations ascribable to Alexandrian painting would seem to be the use of landscape as a theme of prime importance or as an end in itself. Moreover in Egypt the already well-developed tradition of still-life painting, and the equally marked

161

165. POMPEII. MOSAIC (DETAIL): NILOTIC SCENE. MUSEO NAZIONALE, NAPLES.

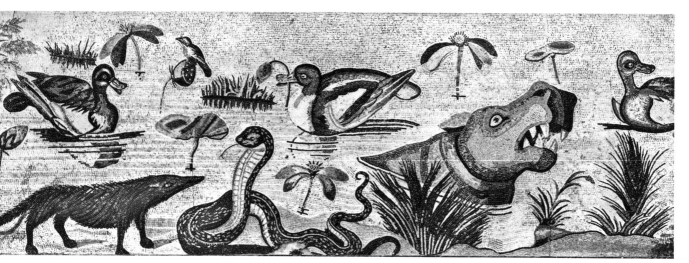

166. POMPEII. MOSAIC (DETAIL): NILOTIC SCENE. MUSEO NAZIONALE, NAPLES.

predilection for the minutely detailed, almost scientific observation of plants and animals, easily take on an exotic quality. Hence these Nilotic scenes – the mosaic from the House of the Faun at Pompeii is a good example – which in the first instance simply offer a realistic picture of the marshland in the Delta, are teeming with highly typical local flora and fauna. Every resource of light and colour has been used to convey the rippling, sparkling quality of the water. As yet the landscape is only examined at close range and in detail; but later its full range is brought into play.

162

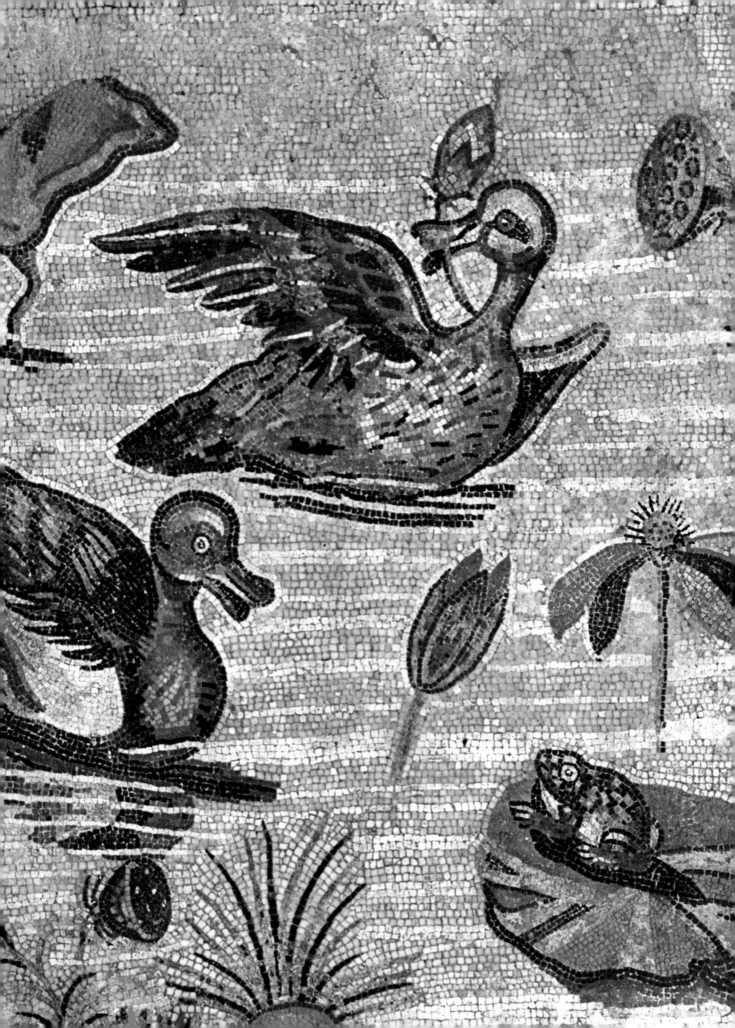

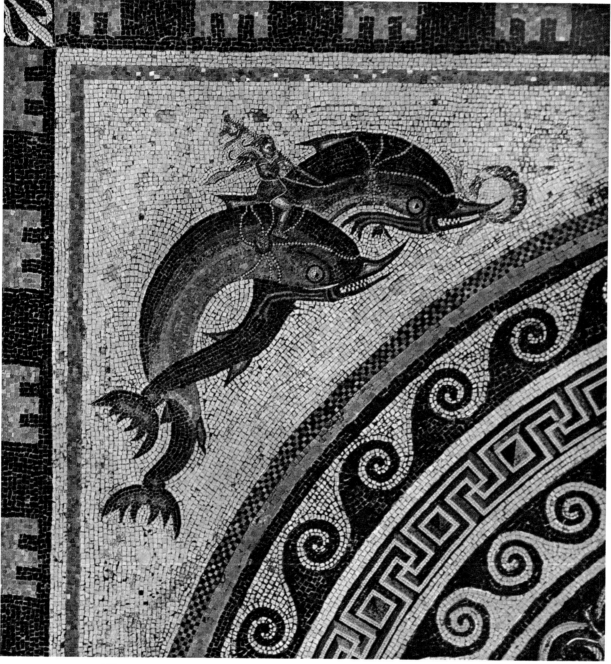

168. DELOS. HOUSE OF THE DOLPHINS. MOSAIC (DETAIL): EROS WITH DOLPHINS.

There is one painting from Pompeii which perhaps illustrates an early stage in this (originally Alexandrian) attempt to portray landscape for its own sake. As before, the main natural feature consists of rocks, but they are here composed into a skilfully arranged perspective of unreal mountains. Vegetation is represented only by an isolated tree and a few bushes, but the human element also appears in a subordinate, almost anecdotal, role; the result is a genuine landscape, with a distorted, fantastic sky, and scenery illuminated and thrown into relief by some very remarkable light-effects.

169. POMPEII. WALL-PAINTING: LANDSCAPE WITH PASTORAL SCENE. MUSEO NAZIONALE, NAPLES

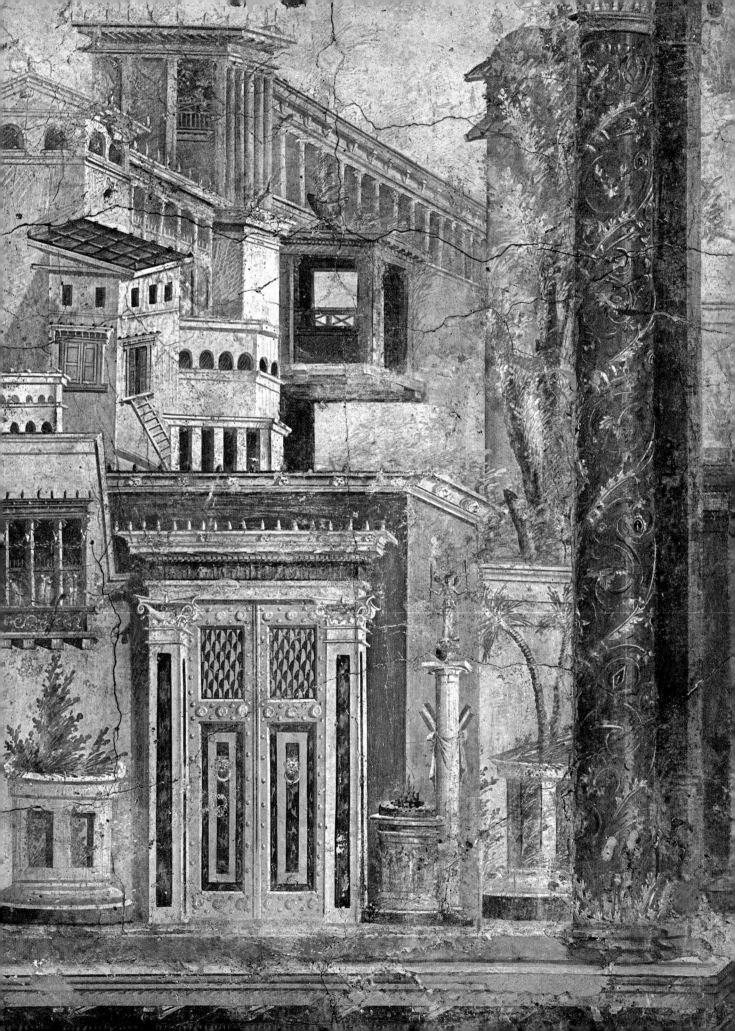

Landscape, Nature and Realism (150-50 B.C.)

When we come to the final phase of Hellenistic painting, it is impossible to ignore the influence of Rome. Both politically and economically Rome dominated or controlled the entire Greek (and Hellenized) world, from Sicily to Syria, from Macedonia to Egypt. Yet in the spheres of art and thought, at least until the establishment of the Empire, Rome and Italy were still no more than provinces of the Hellenistic world. Most painters in Rome and Campania were either Greek by birth or at least Greek-orientated as a result of their upbringing; the inscriptions that appear on some works are in Greek, and themes and styles draw their inspiration from still lively Hellenistic sources. Roman painting, as such, did not really emerge and develop until the reign of Augustus, when it took three main forms: an artificial, academic reversion to classical models; the spontaneous creation of popular imagery based on daily life; and, above all, the development of painting along purely utilitarian lines with the object of covering walls with architectural fantasies or imitation gardens.

A decorative wall-painting such as that from the villa of Fannius Sinistor at Boscoreale (the direct and unmistakable, Hellenistic inspiration of which was discussed earlier) marks the transition from Greek to Roman aesthetics. When Vitruvius was composing his treatise *De Architectura*, about 30 B.C., large-scale realistic wall-decorations in perspective were already a thing of the past. In fact he contrasts with disapproval the fantastic and imaginary decorations of contemporary artists with the murals of those painters who, shortly before, had 'made such progress as to represent the forms of buildings, and of columns, and projecting and overhanging pediments' (7.5.2). The great *ensembles* from Boscoreale mark the climax of these experiments; walls open out in perspectives so complex as to produce an impression of unreality, while nature, far from being treated as a mere feature of the landscape, is rendered in *trompe-l'œil*.

From this moment, formal easel-paintings were doomed to disappear – the last pictures by an acknowledged master, Timomachus of Byzantium, can be dated to Caesar's lifetime – and it was now that works from the past came to be included in mural decorations, in the shape of more or less faithful copies. But side by side with the major compositions described earlier, which were mainly inspired by fourth- or third-century Greek originals, Campanian decorators continued to produce those small, picturesque, slightly artificial landscapes popularized by Alexandrian art. In this field Hellenistic inspiration remains very active until the first century A.D., but the resulting works are now, strictly speaking, not so much replicas of earlier works as a form of art that goes on repeating the same decorative formulas for almost two centuries.

170. BOSCOREALE. WALL-PAINTING (DETAIL): ARCHITECTURAL PERSPECTIVES. THE METROPOLITAN MUSEUM OF ART, NEW YORK.

171. ROME. HOUSE ON THE ESQUILINE. WALL-PAINTING: ODYSSEUS AMONG THE LAESTRYGONIANS. VATICAN LIBRARY.

172. ROME. HOUSE ON THE ESQUILINE. WALL-PAINTING: CIRCE'S PALACE. VATICAN LIBRARY.

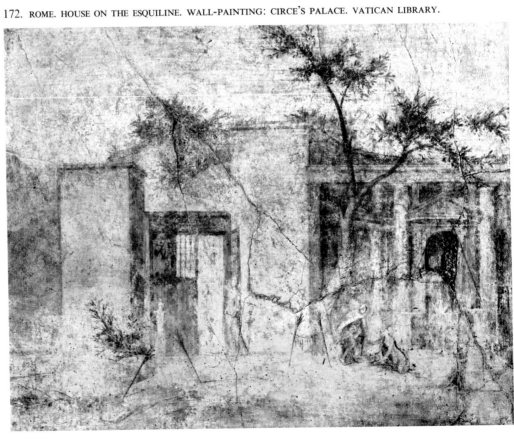

173. POMPEII. WALL-PAINTING: DETAIL OF LANDSCAPE FROM THE 'ABDUCTION OF HYLAS'.

174. POMPEII. WALL-PAINTING: LANDSCAPE WITH ARCHITECTURAL FEATURES. ANTIQUARIUM, POMPEII.

The Development of Realistic Landscape

'In these paintings there are harbours, promontories, seashores, rivers, fountains, straits, fanes, groves, mountains, flocks, shepherds; in some places there are also pictures designed in the grand style, with figures of gods or detailed mythological episodes, or the battles at Troy, or the wanderings of Ulysses.' These remarks by Vitruvius (*De Arch.* 7.5.2), which refer to paintings done shortly before his own day, could serve as a gloss on a cycle of murals painted by some Greek artist shortly after the middle of the first century B.C. for a villa on the Esquiline in Rome. Here the wanderings of Odysseus in fact serve primarily as an excuse for fine studies of the natural setting in which the various episodes depicted take place. The sea, naturally enough, plays an important part; but with Circe's palace we also find an architectural background, and the disembarkation in the land of the Laestrygonians provides an excuse for piles of rocks – one of the most basic features in Greek landscape-painting.

As in the Pompeian mural discussed above, with its little pastoral scene set against a vast mountainous background, the figures here occupy a very unimportant place in the composition as a whole, though theoretically they constitute the *raison d'être* of each picture. What is more, these Esquiline landscapes are at once over-realistic and too

170

175. HERCULANEUM. PAINTING ON MARBLE: LANDSCAPE WITH SHRINES. MUSEO NAZIONALE, NAPLES.

artificial. Circe's palace is no longer a conventional façade, but a real building. These are real trees and bushes quivering in the breeze; the steel-bright water reflects the goat as it drinks; occasional clouds drift across the sky. Yet the shape of the rocks, in the land of the savage Laestrygonians recall that Alexandrian passion for a slightly artificial setting.

In another painting from Pompeii (in which the abduction of Hylas appears, on a minute scale, in a landscape setting) nature is portrayed with what may well be the highest degree of realism this tradition ever achieved. The tree, the mountains, the forest in the background, the sky and the light-effects – all combine to make an exceptional landscape, almost modern in feeling. One final advance, however – direct imitation of nature – remained, and it does not look as though this was ever made. Hellenistic landscape remains to the end an imaginary composition, even though its various features are based on observation. Their artificial deployment in Alexandrian art was to give rise to a special kind of landscape, expressed in small pictures often reminiscent of the *chinoiseries* of eighteenth-century French decorators.

171

Alexandrian Mannerism and its Influence

The walls of Pompeii are in fact covered with these small compositions. Though arbitrary and artificial, they are very pleasing to the eye; and, despite their diversity of treatment, what strikes one about them is the consistency and freshness of their inspiration. One basic and recurring feature is the presence of little buildings made of light materials: kiosks, shrines and towers, surmounted by pergolas, with crooked pediments and pointed or misshapen roofs. These edifices (which have nothing *really* fantastic about them), in apparent disorder, are often framed by porticoes. Trees spring up at random among them, and nearby stand stelae and little statues on columns, round which various tiny figures busy themselves. In the background we glimpse some rocks – sometimes with buildings on them – and a sky with clouds trailing across it.

Contrasts are vividly emphasized by the use of light; yet this garish illumination lacks the brilliance that one associates with the sun. The light appears to be drowned in a weird mist, and as a result these pictures resemble moonlit scences. The outlines of the buildings are emphasized by a harsh contrast between illuminated surfaces and those in shadow. The vegetation and all the little figures, on the other hand, are portrayed in a purely impressionistic style by a combination of irregular light and dark patches; only the long shadows have sharp outlines.

This type of picture, unlike certain scenes with a marine setting, was not a Campanian invention. The origin and date of these small artificial landscapes do not, in fact, seem open to doubt: some of them, such as the painting on marble from Herculaneum, or some other murals from Boscoreale, show close affinities with first-century B.C. fashion, and we have noted the emergence of a comparable style and themes on an Alexandrian goblet and on a skyphos from the Athenian agora, both made over a century before that. As we shall see below, the great Palestrina mosaic (almost certainly Egyptian in inspiration) contains a number of very similar buildings.

176. ROME, VILLA PAMPHILI. WALL-PAINTING: BUCOLIC LANDSCAPE. MUSEO NAZIONALE, ROME.

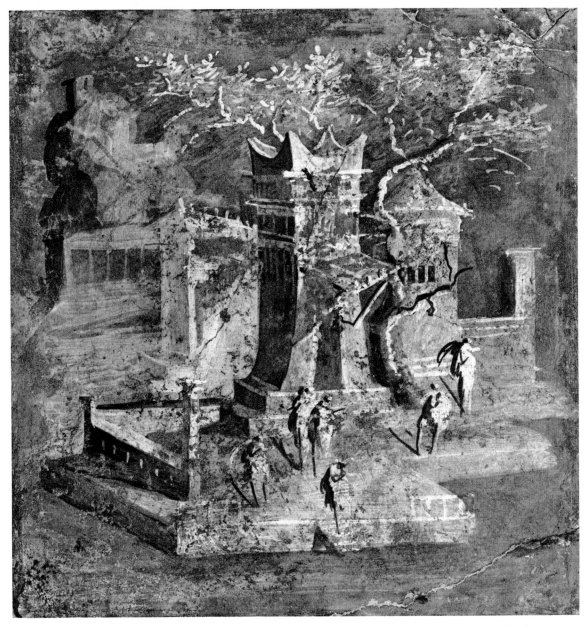

177. POMPEII. WALL-PAINTING: LANDSCAPE WITH ARCHITECTURAL FEATURES. MUSEO NAZIONALE, NAPLES.

Alexandrian mannerism, however, comes out in other types of landscape, stylistically less artificial, but perhaps more so as regards their inspiration. We know what a success bucolic poetry scored in the more cultivated circles of Alexandria, offering another sort of escapism to an already over-urbanized society, and long before Virgil, Theocritus and his rivals had built up a rich repertoire of pastoral themes. Echoes of these can be found in the earliest Roman painting, a good example being the decoration of a tomb belonging to the Villa Pamphili in Rome, datable to about 25 B.C. The storks on the roof of the hut would appear to locate the scene in Africa.

173

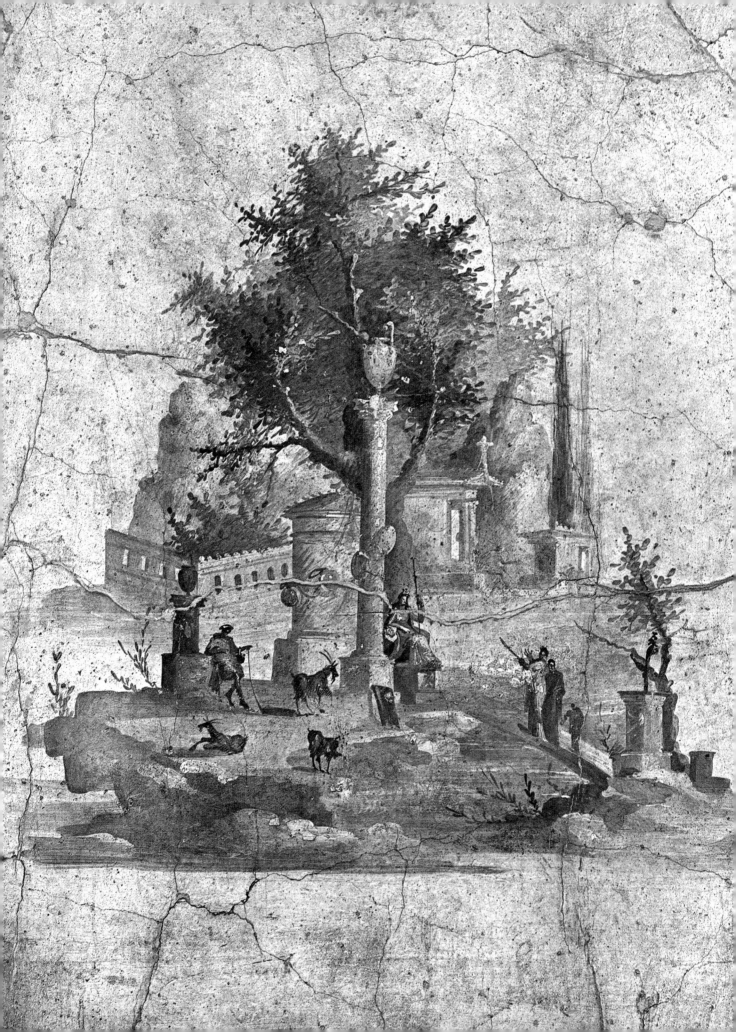

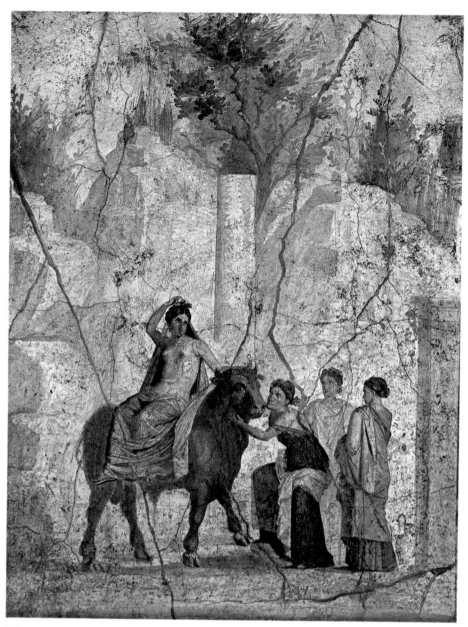

179. POMPEII. WALL-PAINTING: THE RAPE OF EUROPA. MUSEO NAZIONALE, NAPLES.

Unlike the carefully composed moonlit landscapes, this delightful sketch has a neutral background. This would seem to be characteristic of a series of rather more ambitious looking compositions on bucolic subjects, in which the various themes and inspirations of Alexandrian painting meet and blend. Nothing could be more artificial, more affected, or more purely factitious than the great landscape from the villa of Agrippa Postumus at Boscotrecase. Here the white background lends added emphasis to the pyramidal elements which form the picture – an astonishing mixture of trees, small buildings, columns, stelae and statuettes, rocks reflected in a pond and small

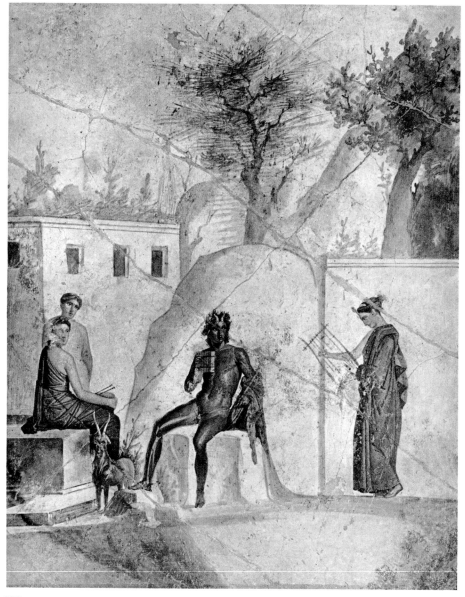

180. POMPEII. WALL-PAINTING: PAN WITH NYMPHS. MUSEO NAZIONALE, NAPLES.

figures as idyllic as they are bucolic. There would seem to be grounds for suspecting that the Campanian painter has cleverly re-arranged a number of features, all of Hellenistic origin. The same, I believe, is true of certain Pompeian paintings which, in some respects, may well be mere neo-classical pastiches of Greek painting, executed about the beginning of the Christian era. The *Rape of Europa* or *Pan with Nymphs* – both attributed to the Campanian artist justly known as the 'Maestro Chiaro' – show a hotch-potch of figures (in classical Greek style and almost without tonal gradation) set against a landscape background in the late Hellenistic tradition: a strange, almost visually embarrassing marriage between the academic and the rococo!

It is, however, in an original work of the late Hellenistic period that we find a genuine synthesis of all the elements which go to make up the Alexandrian landscape,

176

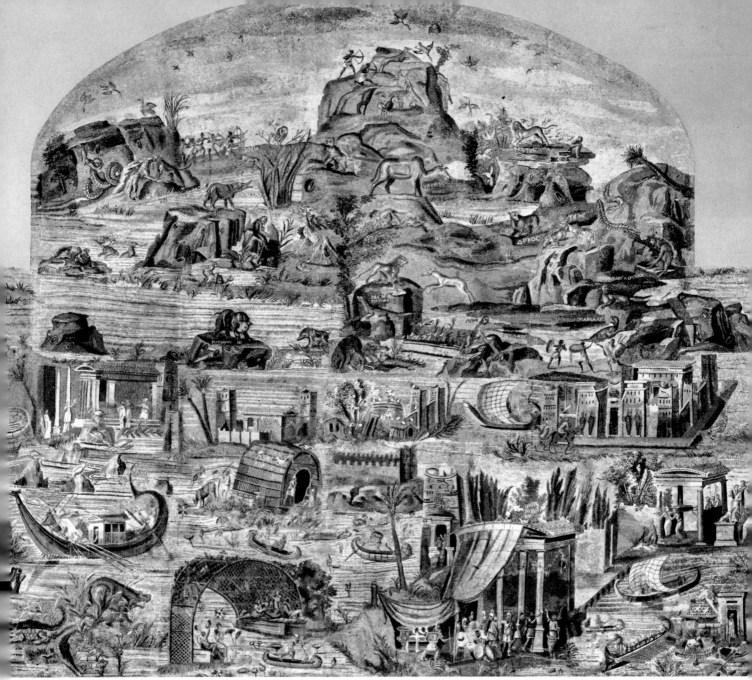

181. PRAENESTE. MOSAIC. NILOTIC SCENES. MUSEO PRENESTINO BARBERINIANO, PALESTRINA.

with its inextricable blend of realist observation and *genre* scenes which are distinctly artificial. The great mosaic created about 80 B.C. for the sanctuary of Fortuna at Palestrina (ancient Praeneste) is the work of Greek artists, doubtless – to judge by their choice of theme – of Egyptian origin. This Greek original executed on Italian soil has, unfortunately, suffered from too many attempts at restoration, which, though they do not alter the general structure of the work, mean that we have to discount many details as partially inauthentic.

Nevertheless the overall concept is clear enough: a synthetic picture of the Nile Valley, swarming with life, and its semi-desert approaches, where wild beasts roam.

177

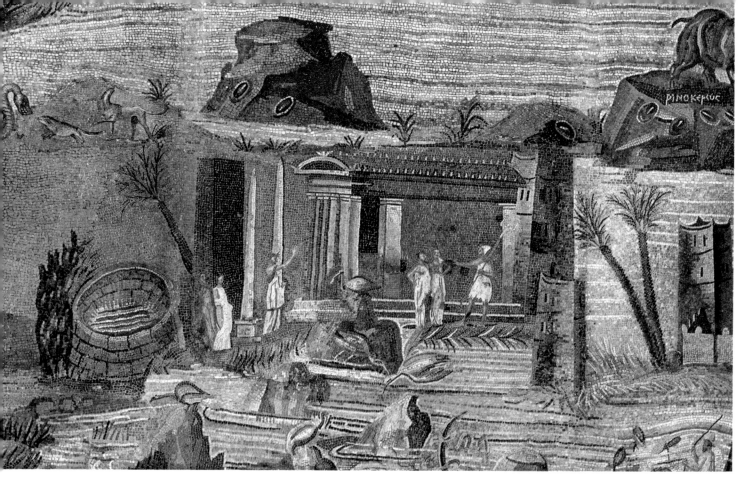

182-184. PRAENESTE. MOSAIC: NILOTIC SCENES (DETAILS). MUSEO PRENESTINO BARBERINIANO, PALESTRINA.

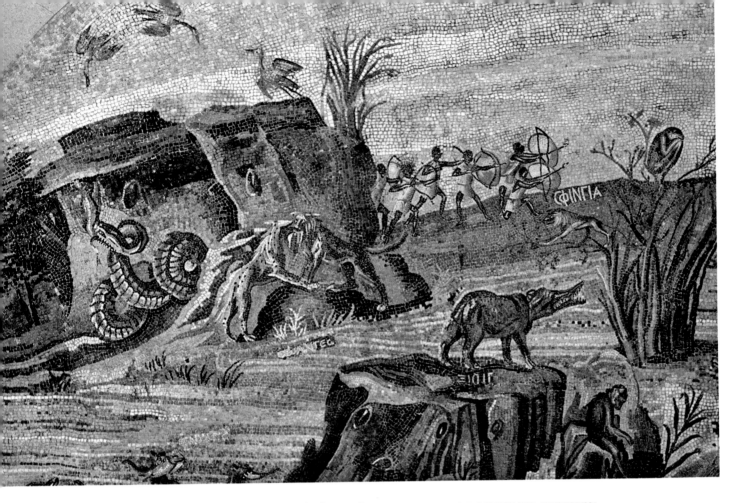

185-186. PRAENESTE. MOSAIC: NILOTIC SCENES (DETAILS). MUSEO PRENESTINO BARBERINIANO, PALESTRINA.

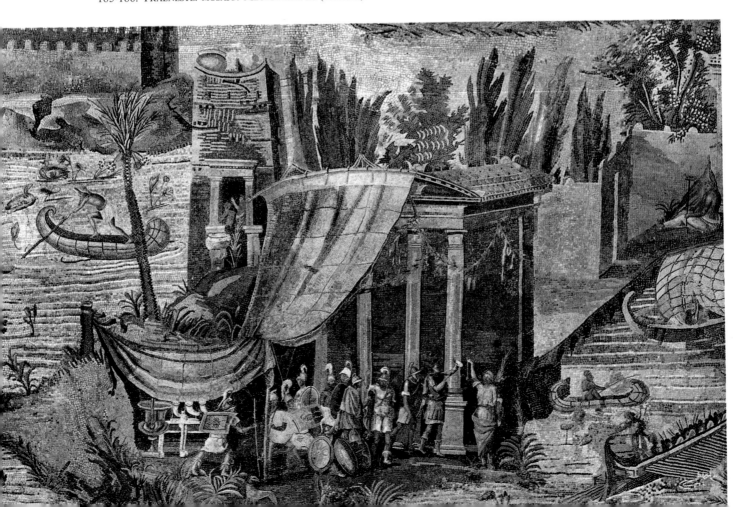

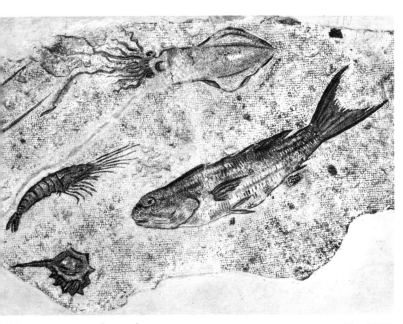

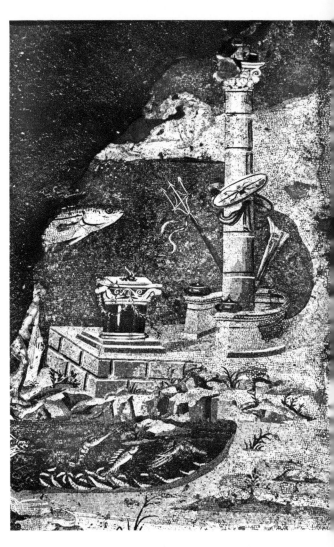

187. ROME. MOSAIC (DETAIL): MARINE SCENE. PALAZZO DEI CONSERVATORI, ROME.

188. PRAENESTE, ANTRO DELLE SORTI. MOSAIC: MARINE SCENE.

This cavalier impression of a vast tract of countryside bears even less resemblance to a real landscape. It is not even a stylized map, but rather a collage of various picturesque scenes – often the result of direct and realistic observation – linked by the calm and glittering waters of the Nile, by lines of rocky little hills (no less artificial than those in the scenes from the *Odyssey* on the Esquiline), and, lastly, by a sky striated with bright and iridescent bands of colour.

This vast picture is picked out here and there with patches of light, which introduce variety into a otherwise fairly uniform *éclairage*, their main object being to make the buildings stand out more clearly. If we compare the Palestrina mosaic with the mosaic of Nilotic scenes from the House of the Faun at Pompeii (which is half a century older), we find the same reflections and shadows on the water, and the same detailed realism (especially in the observation of the fauna), though at Palestrina they are less systematically exploited. But if the Palestrina mosaic is less finely executed and testifies, even at this early stage, to a decline in the skill of Alexandrian mosaicists, for wealth of inspiration it stands alone.

181

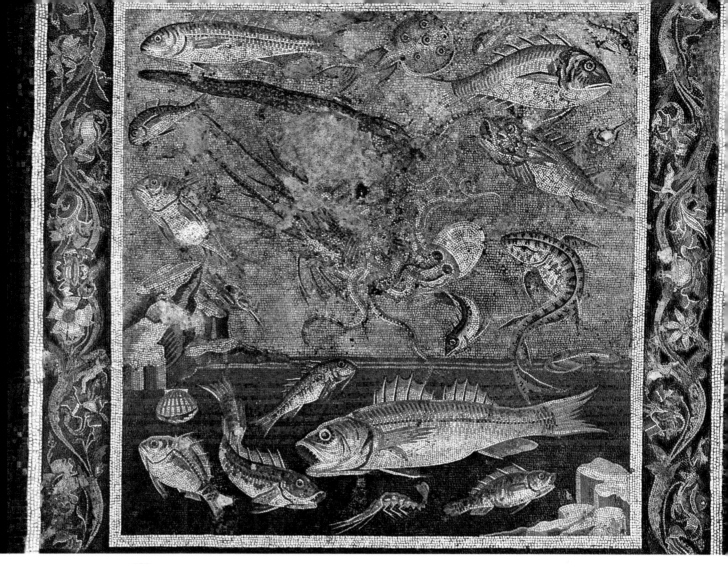

189. POMPEII. MOSAIC: MARINE LIFE. MUSEO NAZIONALE, NAPLES.

The taste for exoticism and local colour, with its hippopotami, crocodiles, rhinoceros, monkeys, jackals, ibises and storks, was doubtless never again carried quite so far in Greek art. However, the exoticism is itself arranged and ordered with Greek logic. In the foreground is Hellenized Egypt, with its Greek temples and sacred groves, its companies of hoplites, its galleys, its riverside banqueters. All around stretches native Egypt (which is also the Egypt of the workers), with pylons and colossal statues guarding its sanctuaries, with towers of brick, osier cabins and the papyrus boats from which a whole tribe of fishermen ply their trade. Beyond lies the still-savage Egypt of the desert, where Nubian hunters roam. Moreover, not only are the various subjects contrasted, but also the manner of their rendering: the military scene in the foreground is handled with great delicacy and a good technical command of chiaroscuro, whereas the rocks, animals, and desert hunters are all portrayed in a vigorously impressionistic style.

Our study of the Palestrina mosaic would not be complete without some reference to a second mosaic (smaller, and unfortunately in a rather fragmentary condition) which

182

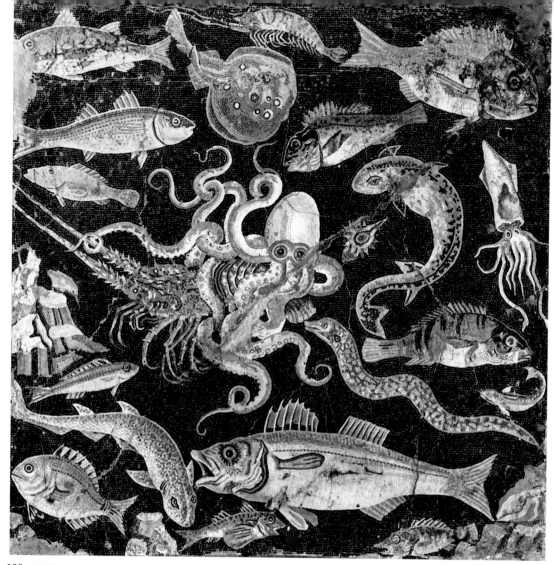

190. POMPEII. MOSAIC: MARINE LIFE. MUSEO NAZIONALE, NAPLES.

adorned another part of the sanctuary. Contemporary with the previous example, but of finer workmanship, it exemplifies that preoccupation with still-life and the detailed observation of fauna which we saw develop at Pergamum, in the work of Sosus, during the second century B.C. The highly artificial 'seascape', with its quay, altar and trophy, is in fact a *genre* picture; but its main function is to provide an excuse for a study of marine fauna in which the fish, observed with a naturalist's precision, appear to float, quite arbitrarily, on the surface. That this type of representation is not unusual is clear from a more or less contemporary fragment of mosaic found in Rome (fig. 187).

The best examples, however, come from Pompeii: two mosaics of the late second century B.C. (one of them found in the House of the Faun) derived from a common original. They show a strange scene of marine life which not only occupies the surface of the sea but also spreads itself, and even more extensively, over the sky. The landscape is no longer even an excuse: all that matters is the realistically perfect rendering of marine fauna – and also of animals, plant life and objects generally, as we can see from the border enclosing one of the two mosaics.

Mannerism and the rococo, then, are not, as phenomena, specifically limited to the painting or mosaics of Alexandria. We find clear traces of them, though in another form, when we turn to the incontestably Greek mosaics, from the second half of the second century B.C., in certain houses on Delos. Here, as at Pergamum, what matters is the motif or object depicted, and it is not felt necessary to place it against a background or landscape, however factitious. In this sense Alexandrian pictorial art can far more justifiably be labelled 'rococo' than 'mannerist', if we apply the latter term to the rather elementary mannerism of mainland Greece or Asia Minor.

Despite its somewhat perfunctory execution, the little mosaic from the House of the Trident on Delos is quite definitely a still-life study. The amphora given as a prize at the Panathenaic Games is shown with a symbolic ear of corn and the olive-wreath that

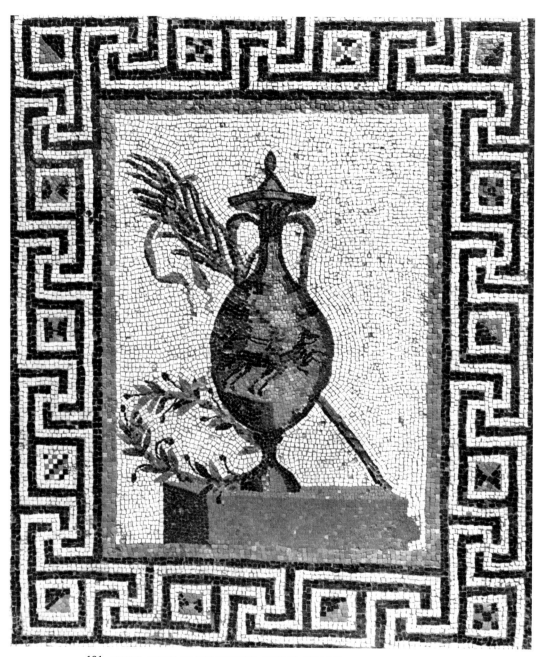

191. DELOS, HOUSE OF THE TRIDENT. MOSAIC: PANATHENAIC AMPHORA.

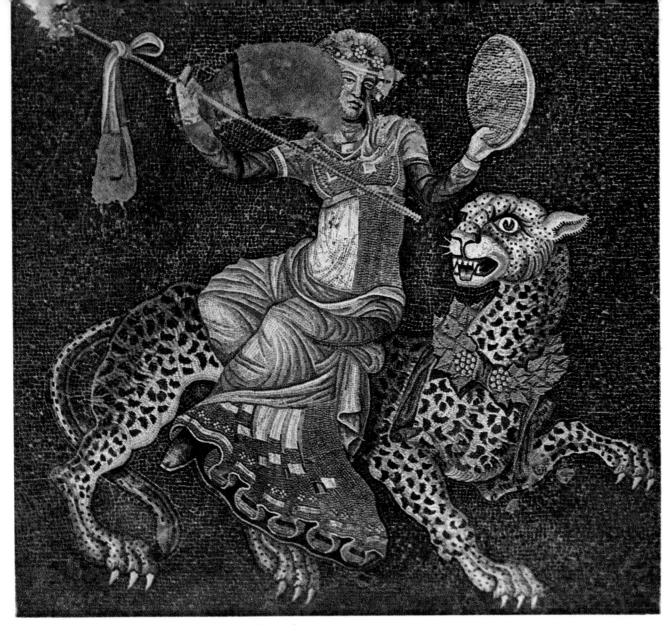

192. DELOS, HOUSE OF THE MASKS. MOSAIC (DETAIL): DIONYSUS ON A PANTHER.

went to the victorious athlete. This somewhat misshapen painted pot is depicted as reflecting the light – though not so brilliantly as Sosus' bowl with doves.

The other mosaic from the House of the Masks is altogether more important. The theme of Dionysus on a panther had already appeared in a mosaic at Pella (fig. 97), so that one can readily appreciate how far the plastic representation of figures had advanced in the two centuries since then. Here every known device of foreshortening and chiaroscuro is used to produce a striking three-dimensional quality. Yet observe the deliberate and gratuitous complications introduced into a theme which was, after all, perfectly simple to begin with: affected gestures (including the movement of the panther), the sinuous folds and convolutions of Dionysus' robe, the garland and ribbon round the panther's neck. The trend is unmistakably towards affectation and mannerism.

185

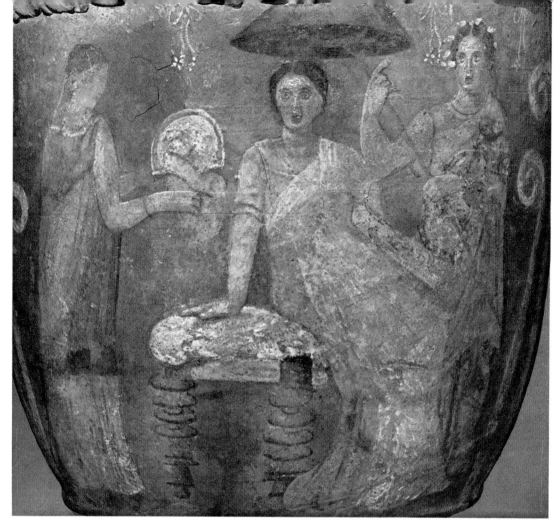

193. CENTURIPE. POLYCHROME PYXIS (DETAIL): A LADY'S TOILET. ISTITUTO DI ARCHEOLOGIA, CATANIA.

186

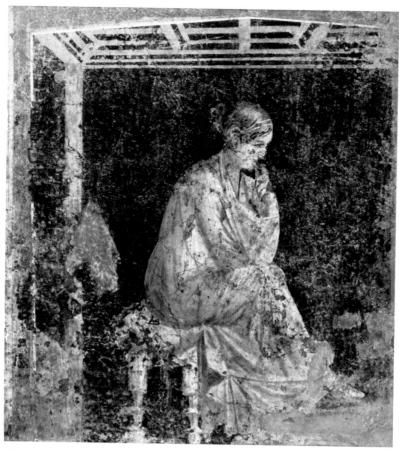

195. POMPEII, VILLA OF THE MYSTERIES. WALL-PAINTING: SEATED WOMAN. MUSEO NAZIONALE, NAPLES.

The End of Hellenistic Painting in Magna Graecia

In southern Italy and Sicily, on the other hand, such mannerist or rococo tendencies seem to have been imports from abroad, rather than of native origin. The mosaics from Palestrina or the House of the Faun, like the paintings on the Esquiline, were the work of artists from the eastern Mediterranean basin. But the existence of a solid tradition of wall-painting with figurative themes may explain the re-appearance, towards the end of the Hellenistic period (and rather earlier in Campania), of large figured murals.

All the same, the mural with figures is not entirely absent from late-period Greek decoration, either; but the scenes from tragedy painted about 125 B.C. in a house on Delos only occupied a limited section of the wall-space (the facing on the remainder being painted in imitation of marble). In Italy, however, the wall-paintings from the Villa of the Mysteries, like those from Fannius Sinistor's villa at Boscoreale, show the development of large-scale compositions with a purely human content; the same false marble facings appear, but here they serve only as a background to the figures.

It would also seem significant that this background assumes a colour which is seldom found in nature: the famous 'Pompeian red'. However, there is every likelihood that this red background derives from an older local tradition, since we also find it on polychrome pottery from Centuripe, the latest examples of which can be dated to the

194. DELOS WALL-PAINTING: SCENE FROM A TRAGEDY. ARCHAEOLOGICAL MUSEUM, DELOS.

187

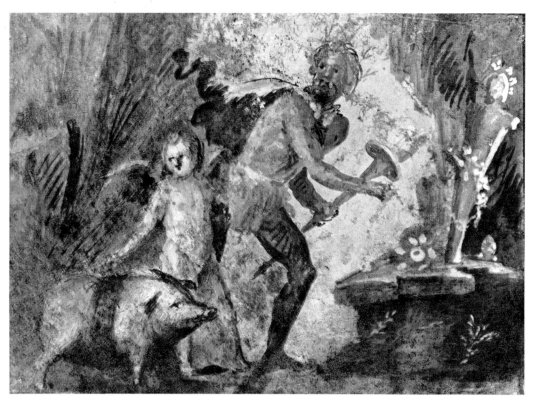

196. POMPEII, VILLA OF THE MYSTERIES. WALL-PAINTING: OFFERING AND SACRIFICE TO PRIAPUS.

early first century B.C. A pyxis from Catania (fig. 193) testifies to the continued vigour, in the west, of traditions going back to the very beginning of the Hellenistic era. The simplicity and grace of the figures' attitudes, and the artist's unobtrusive use of highlighting, almost make this a neo-classical work. The female figure seen from behind is alone consonant with a more developed type of representation, and is, to a limited extent, comparable with the seated priestess in the great painting from the Villa of the Mysteries – who likewise has her back to the viewer.

Certain other paintings from the same villa, such as the graceful figure of a seated woman meditating, bear witness to a similar approach. But this tradition is by no means the only one, for other paintings from the villa reveal very different tendencies; for instance the little scene depicting an offering to Priapus is handled in a typically impressionistic style recalling the Begram goblet, though without its mannerism.

Thus it comes as no surprise, when we examine the great scene of initiation into the Dionysiac Mysteries, to find a variety aesthetic trends flowing together: a final synthesis, as it were, of the diverse tendencies and styles of classical and Hellenistic painting. This is not, however, in any way to disparage the Campanian master who produced this magnificent work, for the qualities of his painting and the originality of his vision come across so clearly in some of his female heads that there is no need to stress his individuality. Yet the great initiation scene is composed of decidedly heterogeneous elements, with little enough connection between them. Some of the figures seem ultra-classical, yet beside them we find others for which the inspiration is frankly Hellenistic – the bucolic group in the initiation scene and the somewhat

198. POMPEII, VILLA OF THE MYSTERIES. WALL-PAINTING: THE MISTRESS OF THE HOUSE

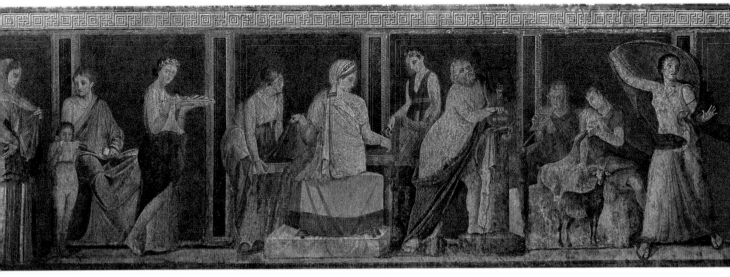

197. POMPEII, VILLA OF THE MYSTERIES. WALL-PAINTING: INITIATION SCENE.

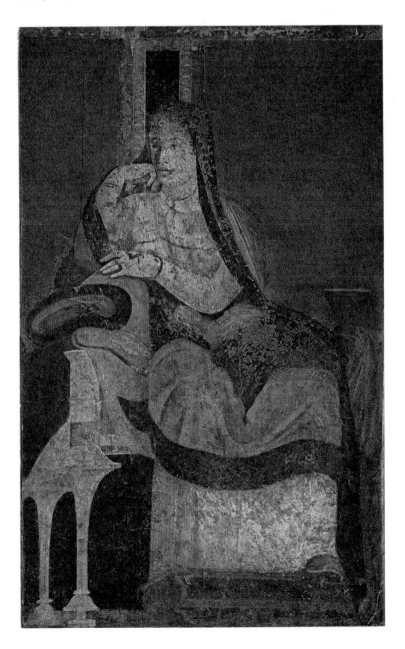

189

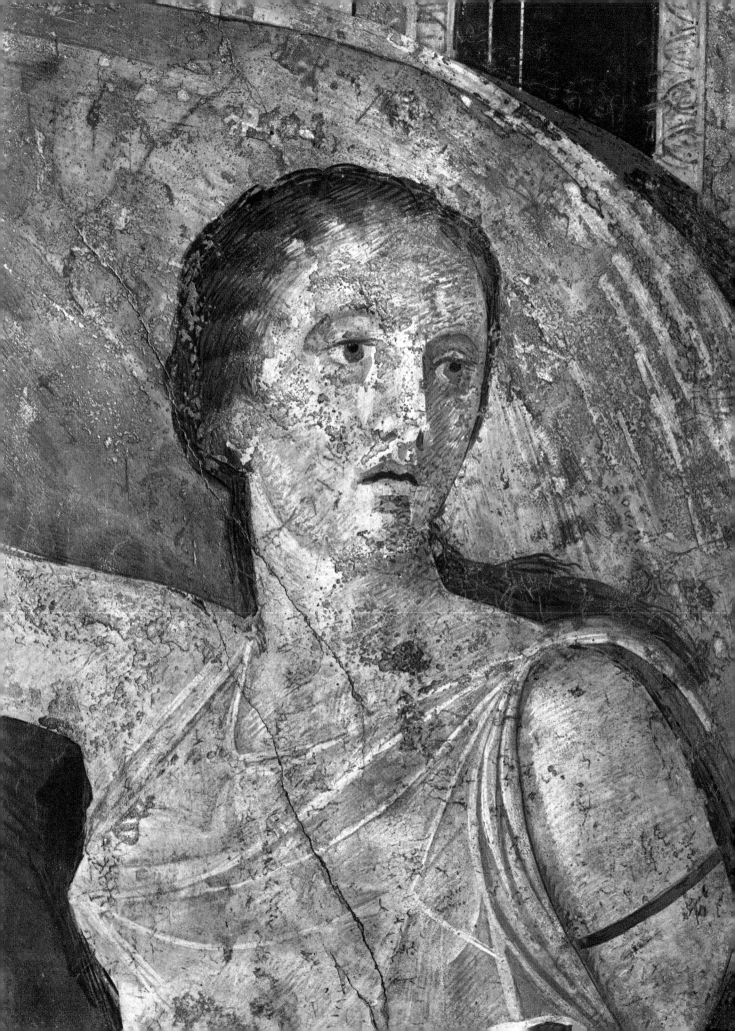

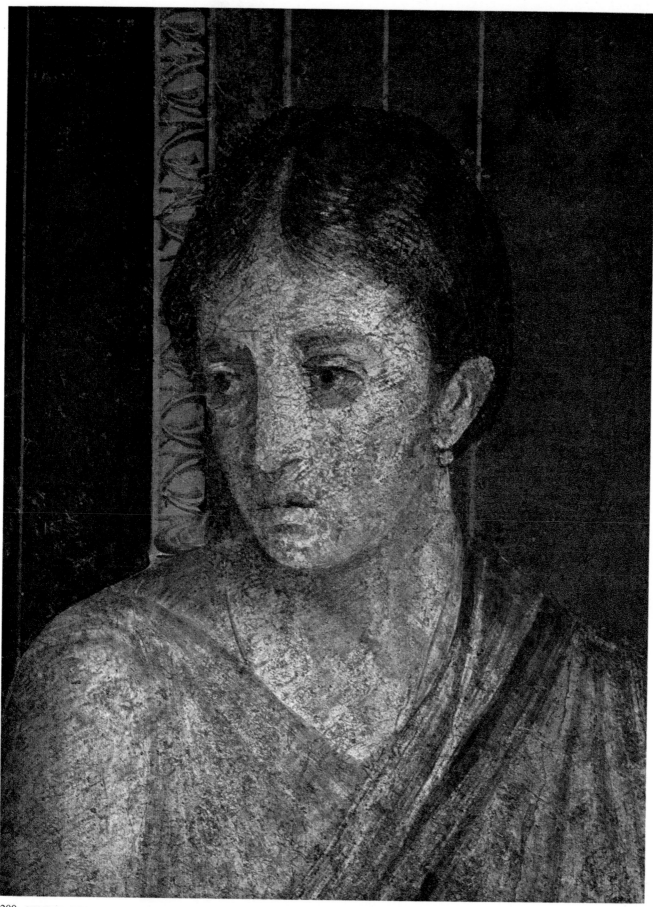

200. POMPEII, VILLA OF THE MYSTERIES. WALL-PAINTING (DETAIL): THE INITIATRIX.
199. POMPEII, VILLA OF THE MYSTERIES. WALL-PAINTING (DETAIL): THE TERRIFIED WOMAN.

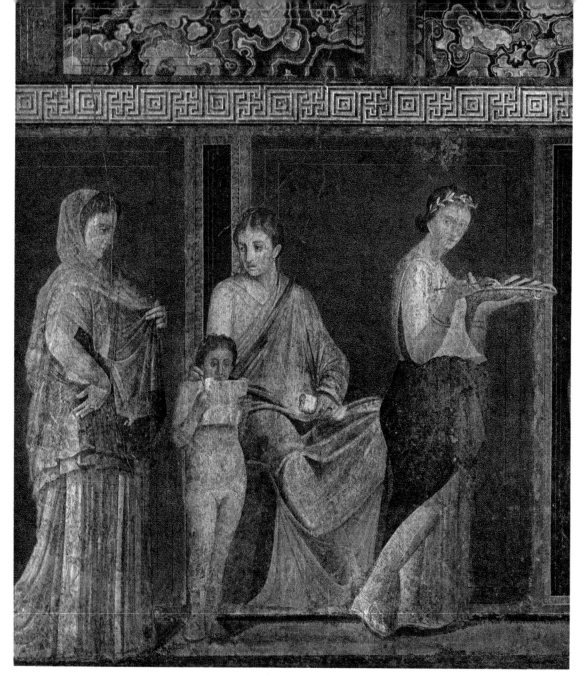

201. POMPEII, VILLA OF THE MYSTERIES. WALL-PAINTING (DETAIL): READING THE RITUAL.

mannered swirl of some of the draperies, particularly those of the frightened woman or the semi-naked dancer with the castanets. The fine and expressive portrait of the mistress of the house, who sits presiding over the ceremony, counterbalances that of the heavily conventional matron with whom the sequence opens. One could note inconsistencies within a single group, or even an individual figure: for example, the exquisite form of the dancer stands out against the improbable garment which drapes her companion's all-but-deformed body. We can see the degree of eclecticism that went to the making of this work – the last original Hellenistic painting executed on Italian soil, a creation no longer truly Greek, but not yet openly Roman.

192

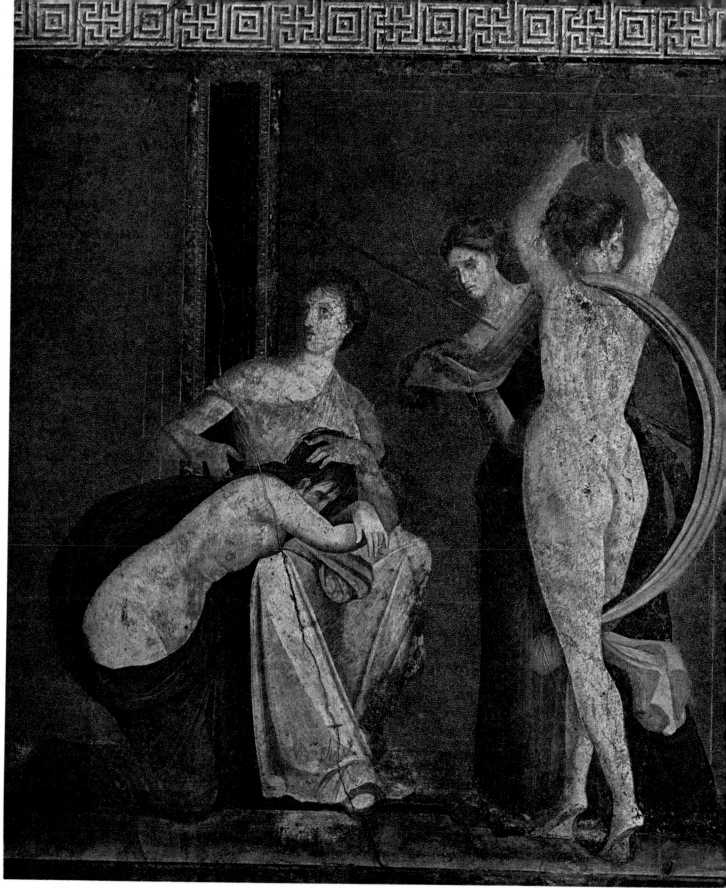

202. POMPEII, VILLA OF THE MYSTERIES. WALL-PAINTING (DETAIL): GIRL UNDERGOING FLAGELLATION, AND BACCHANTE.

The final Echoes of Great Painting

During the final phase of the Hellenistic period the sources remain silent as regards easel-painting devoted to heroic or mythical themes. This may well be significant, for, to judge from the abundance of *genre* scenes, landscapes and still-lifes that have survived, one might suppose that most first-class artists of the period devoted the greater part of their talent to this type of work. Nor does tradition preserve the name of any outstanding painter – and this at a time when the Ptolemies in Alexandria and the Attalids in Pergamum were collecting Old Masters at enormous cost.

It was not until the very end of the Hellenistic Age, about the middle of the first century B.C., that Greek easel-painting flared up in one final burst of brilliance, and for

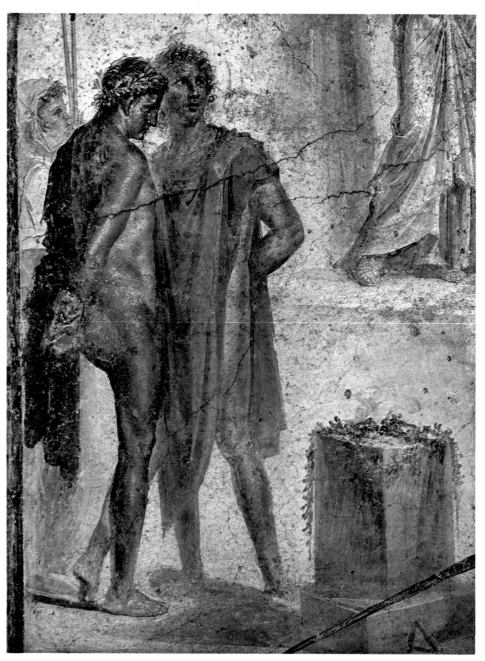

203. POMPEII. WALL-PAINTING (DETAIL): ORESTES AND PYLADES (AFTER TIMOMACHUS?).
MUSEO NAZIONALE, NAPLES.

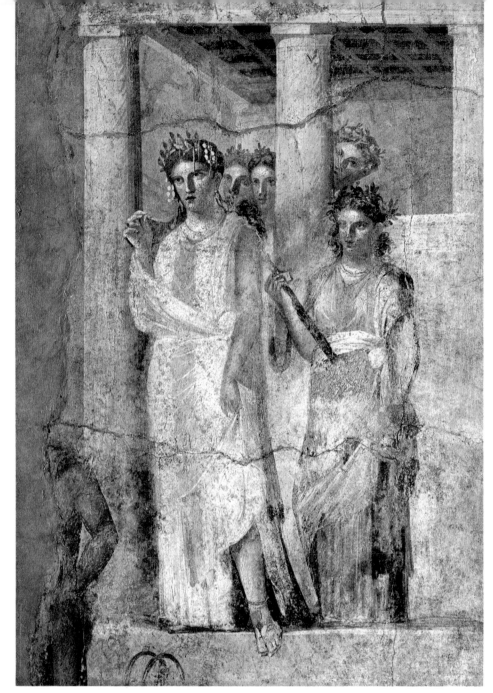

204. POMPEII. WALL-PAINTING (DETAIL): IPHIGENEIA IN TAURIS (AFTER TIMOMACHUS?). MUSEO NAZIONALE, NAPLES.

a while recaptured the great themes of the past. The entire phenomenon is linked with a single name, that of Timomachus of Byzantium, who even during his own lifetime was so famous that Caesar bought works by him for exorbitant sums. Pliny roundly declared of him that 'he had restored its ancient dignity to the art of painting'.

We can, albeit perhaps only partially, catch a glimpse of Timomachus' manner through those Campanian replicas which, it is fairly clear, derive from two of his best-known works: *Iphigeneia in Tauris* and *Medea*. Two fragmentary murals from Pompeii,

195

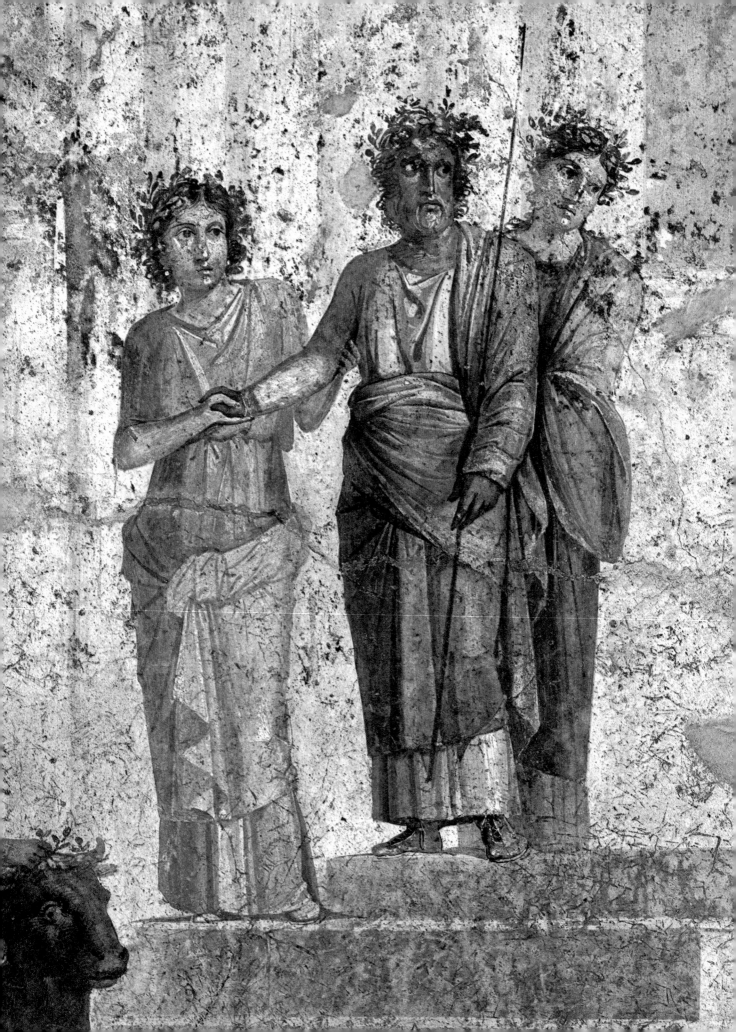

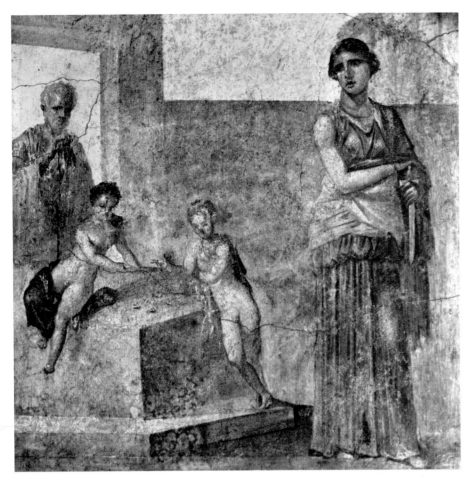

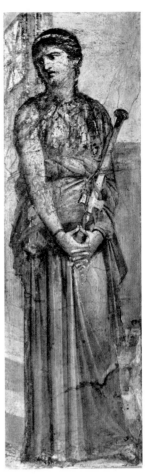

206. POMPEII. WALL-PAINTING: MEDEA AND HER CHILDREN (AFTER TIMOMACHUS?).
MUSEO NAZIONALE, NAPLES.

207. HERCULANEUM. MEDEA.
MUSEO NAZIONALE, NAPLES.

which more or less fill in each other's gaps, give some idea of the original, which
depicted the reunion between Iphigeneia (coming down from the temple in Tauris, of
which she had been made the priestess) and her brother Orestes, standing manacled
beside his friend Pylades. The group of Pylades and Orestes is a magnificent exercise in
plastic representation, as remarkable for the quality of its line (the guard beyond them
reveals equally fine draughtsmanship) as for its masterly highlighting of those gleaming,
well-muscled bodies. There is also a look of agonized uneasiness on their faces, in
sharp contrast with the thoughtful, self-confident gravity of Iphigeneia. Her features
are clearly inspired by classical art, though the light and colouring (particularly of the
sky) belong to a different era. In some respects the *Iphigeneia* is very similar to certain
neo-classical works by the 'Maestro Chiaro', notably the group of Pelias and his
daughters from Pompeii. Both these stage-inspired compositions are also (like the
murals from the Villa of the Mysteries) to some extent eclectic works.

Some memory of the *Medea* is preserved in a very mediocre painting from the
House of the Dioscuri in Pompeii; in a scene based on the theatre, but with an
unusually open background, she is shown meditating the murder of her children. To
judge by the numerous descriptions of the original found in late authors, all interest
was concentrated on the person of Medea, which expressed a grave moral conflict: that

205. POMPEII. WALL-PAINTING (DETAIL): PELIAS AND HIS DAUGHTERS. MUSEO NAZIONALE, NAPLES.

197

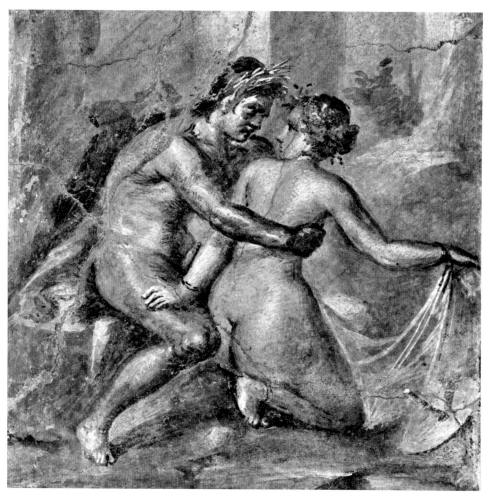

208. POMPEII. WALL-PAINTING: SATYR AND MAENAD. MUSEO NAZIONALE, NAPLES.

of the wife and mother 'torn between her hatred and her love for her children' (Antiphilus). A fresco from Herculaneum (fig. 207), which contains only the figure of Medea, doubtless gives a far more faithful impression of the heroine's still-hidden inner torment.

After Timomachus, large-scale epic subjects were never again to offer more than a cut-price repertoire for bourgeois Roman art fanciers during the early years of the Empire. Yet for some time the methods and style of major painting survived in *genre* scenes, such as that of a satyr and maenad from the House of the Epigram at Pompeii, datable to about 30 B.C. Here, perhaps even more than in Timomachus' work, we find, as it were, a synthesis of all Hellenistic painting: the sense of space and light, the association of chiaroscuro with an impressionist technique, the three-dimensional and fully expressive rendering of the human figure, the setting borrowed from nature. One might say – without wishing to push the analogy too far – that the evolution of Greek painting stopped short on the very threshold of the Baroque age.

FRANÇOIS VILLARD

Sculpture

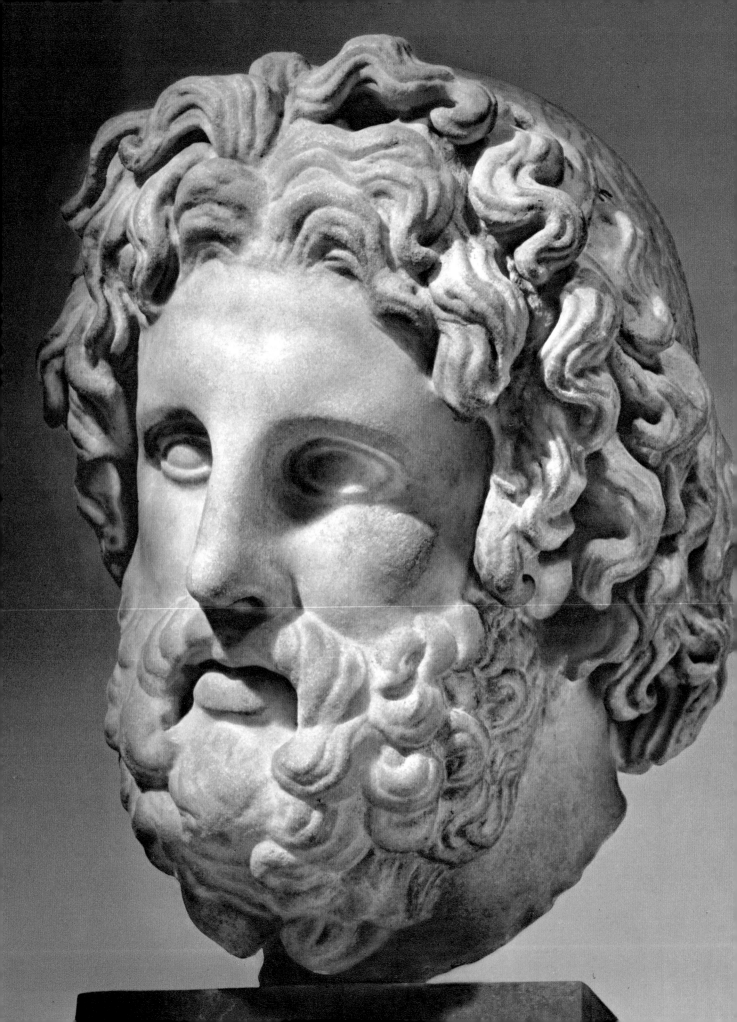

The Fourth-century Metamorphosis

A New Realism

The tendencies which appear in Greek sculpture from the earliest years of the fourth century herald a progressive swing from classical to Hellenistic canons. This is not so much a continuous movement as a series of actions and reactions influenced by the interplay of various artists' temperamental differences and rivalries, their originality and capacity for innovation. Sculpture, indeed, developed *pari passu* with those scholarly or philosophical advances that deepened and extended the range of human knowledge. With the Mausoleum of Halicarnassus, about 350 B.C., we see the lure of the East stimulating and animating a more direct vision of reality and a new interpretation of figurative themes. While discussing the large-scale relief-work of this temple-tomb in *Classical Greek Art*, we considered the part generally assigned to Timotheus and Scopas, in which the style, modified by the personal touch of each of these two sculptors, still keeps within the limits of classical taste. As an introduction to our study of Hellenistic sculpture, we must now examine other parts of the frieze, doubtless attributable to Bryaxis and Leochares, from which emerges a new sense of depth and movement in the spatial handling of figures.

The work of Bryaxis cannot easily be isolated, it is true. The reliefs on a signed base, found at Athens, do show us a type of horse which can be easily enough recognized on certain slabs from the Mausoleum – notably No. 1019, one of the most animated in the entire frieze; on the other hand, the large statue wrongly said to be of Mausolus, cannot be unreservedly attributed to this artist. Moreover, until quite recently argument was still going on over the Alexandrian Sarapis which, according to the literary tradition, was Bryaxis greatest achievement. At all events, this Sarapis is particularly interesting for the style of the head; the pyramidal design of the upper part of the face, the convex forehead with its central ridge, the thick hair with locks falling over the brow (matching the great beard, with its clusters of corkscrew curls) all suggest comparisons with the Eubuleus of Eleusis and the Blacas Asclepius. The most immediate analogy is a votive relief from Epidaurus, which portrays Asclepius seated with Hygieia standing beside him: it is tempting to see here an echo of the cult-group Bryaxis had sculpted for Megara. The career of this artist, who claimed Athenian

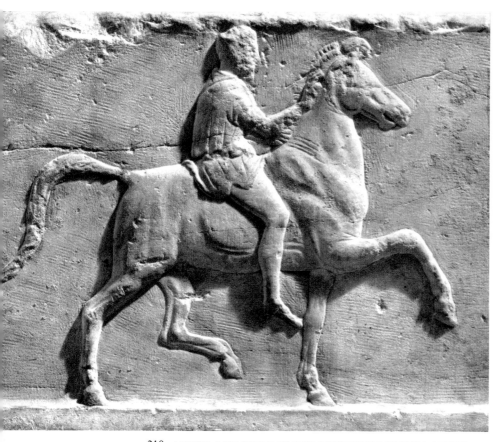

210. ATHENS. BASE SIGNED BY BRYAXIS NATIONAL MUSEUM, ATHENS.

211. EPIDAURUS. VOTIVE RELIEF
(DETAIL): ASCLEPIUS.
NATIONAL MUSEUM,
ATHENS.

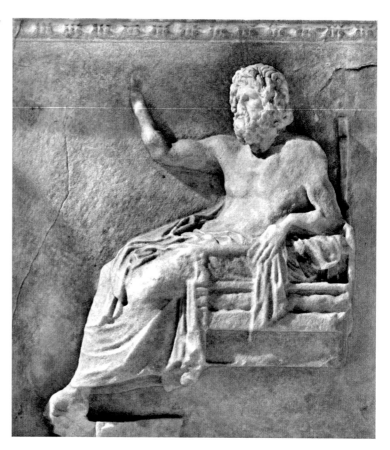

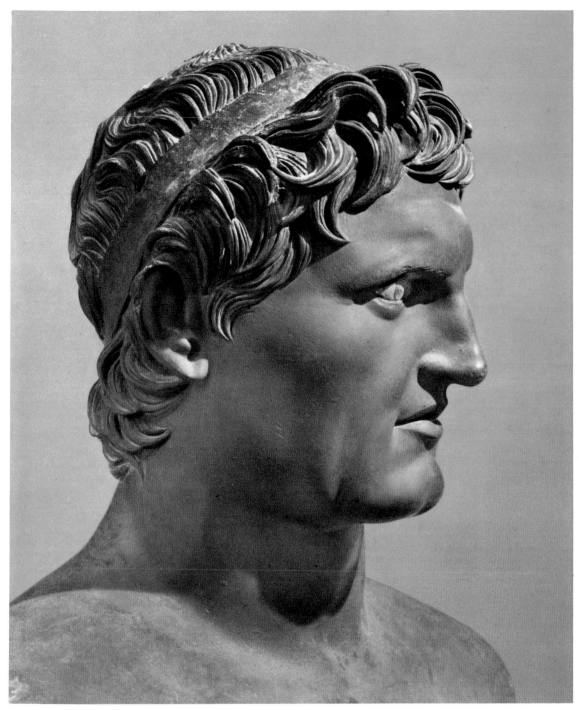

213. HERCULANEUM. SELEUCUS NICATOR. MUSEO NAZIONALE, NAPLES.

origin but bore a Carian name, seems to have been divided between Greece and the Hellenized East, between the classical revival and the dawn of a new era. One of his last works must have been the Apollo as Cithara-player at Daphne, near Antioch, which we only know from coins. According to Pliny (*HN* 34.19.73) he also executed a bust of Seleucus Nicator which, judging by the Herculaneum bronze, was a striking work.

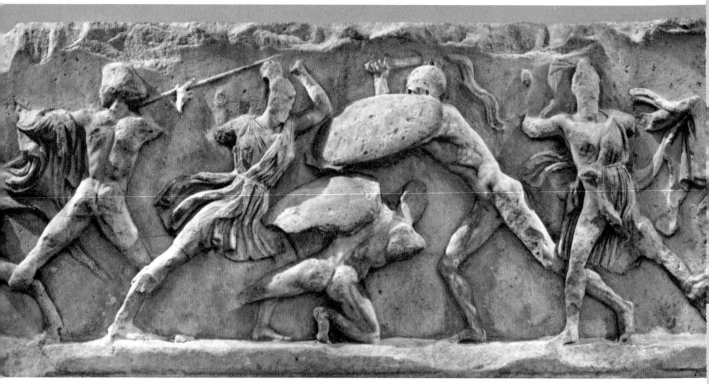

214. HALICARNASSUS, MAUSOLEUM. AMAZONOMACHY (BATTLE OF GREEKS AND AMAZONS), BY LEOCHARES. BRITISH MUSEUM, LONDON.

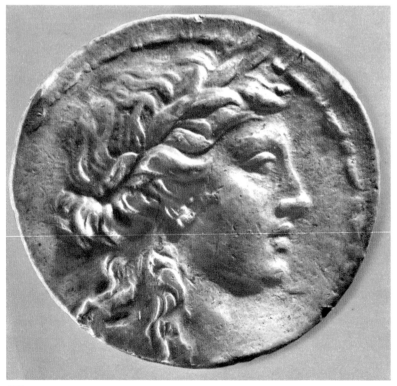

215. COIN OF ANTIOCHUS IV EPIPHANES: APOLLO. BIBLIOTHÈQUE NATIONALE, PARIS.

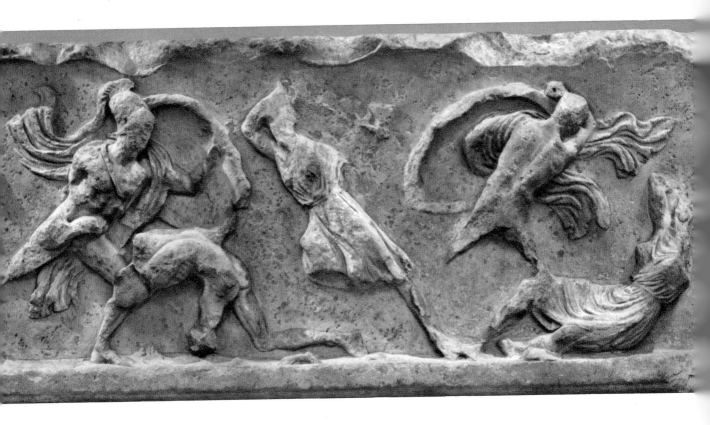

But to return to the Mausoleum. On slabs 1020 and 1021 of the Amazonomachy frieze a sequence of ten combatants shows unmistakable signs of trying to break loose from the classical mode of expression. Figures are neatly composed and counterbalanced in pyramidal groups, but the stormy movement which carries the action along goes beyond normal rhythmic oscillation, accelerating motion, and elongating strides to make gestures carry further, while the air stirred up by the mêlée sets the fighters' draperies swirling in the air. The two most characteristic figures are a Greek warrior whose extraordinarily elongated body stretches forward almost to the point of over-balancing, and the Amazon striding behind him. Certain aspects of these figures – in the warrior, lack of bodily proportion, stress on muscularity rather than harmonious outline, the face hidden by the shield and the crest fluttering in the breeze; in the Amazon, a movement of the torso interrupting the leftward thrust and turning back abruptly to the right, so that the folds of her dress swing away from her body – indicate a change of vision, formal description and composition, and a new grasp of movement in space. These are highlighted in the position of the Greek's shield, turned partly outwards, and the arrested swirl of the Amazon's drapery.

One can hardly doubt that this sequence of slabs (1020-1021) bears Leochares' hallmark. Indeed, to the west of the Mausoleum – where Leochares' *atelier* was traditionally located – the figure of a charioteer from some other frieze was found. In it the forward reach of the body, the elongation of outline, the streaming, undulating folds of the tunic, all suggest the breakneck speed of the race-course in a style much akin to that we have just been analysing; the square-cut face adds an extra touch,

216. HALICARNASSUS, MAUSOLEUM. FRAGMENT OF A FRIEZE: CHARIOTEER, BY LEOCHARES. BRITISH MUSEUM, LONDON.

212. ELEUSIS. 'EUBULEUS'. NATIONAL MUSEUM, ATHENS.

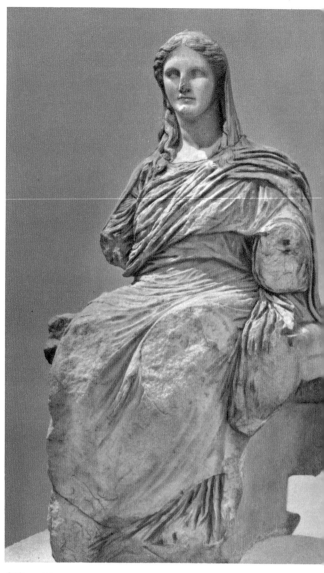

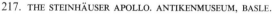

217. THE STEINHÄUSER APOLLO. ANTIKENMUSEUM, BASLE. 218. DEMETER OF CNIDUS. BRITISH MUSEUM, LONDON.

missing in the Amazonomachy. Another piece found amid the ruins of the great monument at Halicarnassus – a fine head of Apollo, his expression smiling yet imperious (fig. 220) – is clearly from the same hand, as witness the amplitude of form and the crisply curling hair. One also thinks of a portrait of the young Alexander, now in the Acropolis Museum, and the Demeter of Cnidus in the British Museum. The parallels extend beyond the facial structure to detailed aspects of individual features. Fullness of outline, a profile eloquent of the will to power, with chin and brow-ridge jutting noticeably forward – these are the same tendencies as in the Apollo Belvedere, particularly the (unretouched) head in the Basle Museum. Thus we get a very good idea of Leochares' style – his liking for attitudes inspired by choreography, and his virtuosity in using drapery to emphasize the action, or the significance, of his figures.

219. ATHENS. PORTRAIT OF THE YOUNG ALEXANDER. ACROPOLIS MUSEUM, ATHENS.

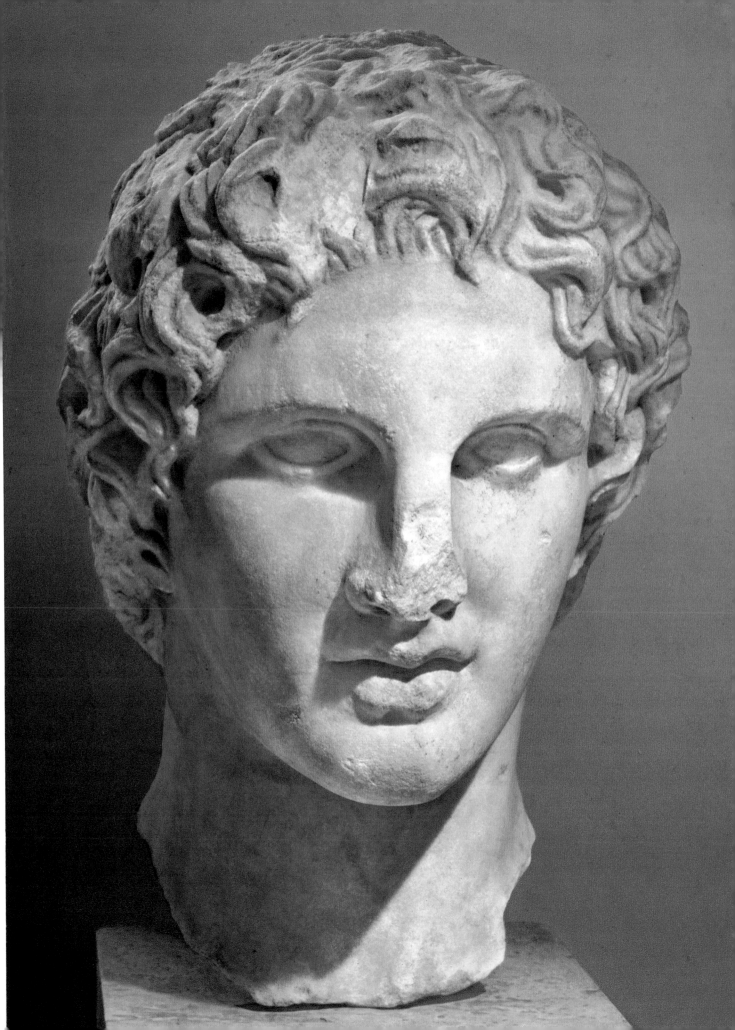

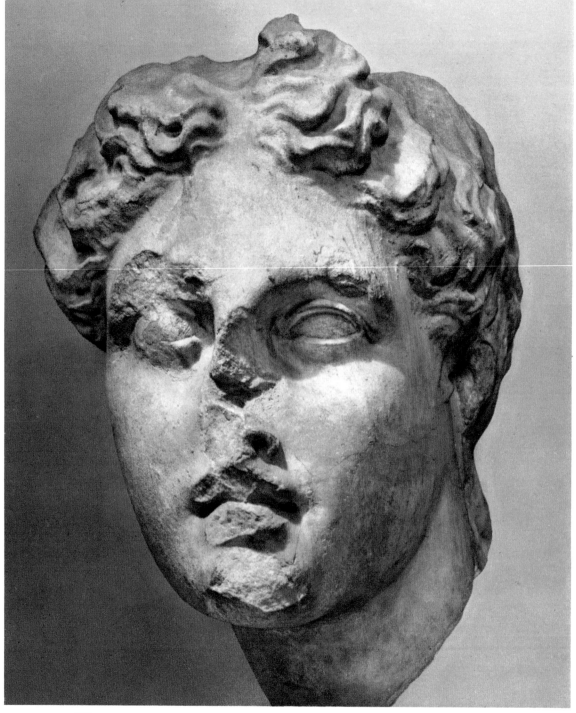

220. HALICARNASSUS, MAUSOLEUM. HEAD OF APOLLO. BRITISH MUSEUM, LONDON.

The latest fixed date in Leochares' career is about 320, when Craterus commissioned him (among others) to execute a group, Alexander Hunting, for the sanctuary at Delphi. It must have begun before 370 with Zeus the Thunderer, the fame of which is attested by Pliny (*HN* 34.19.79). The profile of Zeus on a stater of the Arcadian League, struck at the time of its foundation, is directly derived from it, and a bronze statuette (fig. 221) preserves the design of a work that inspired countless imitations. The distribution of weight still conforms to Polycleitus' chiastic principle; but the face,

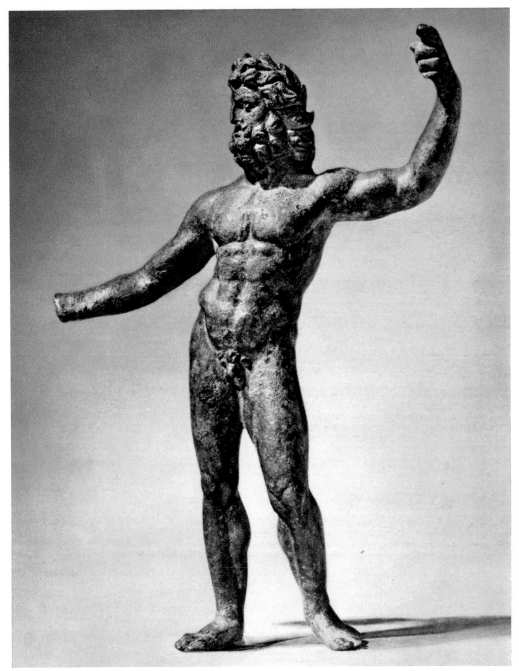

221. STATUETTE OF ZEUS. BIBLIOTHÈQUE NATIONALE, CABINET DES MÉDAILLES, PARIS.

looking over the right shoulder, dictates the gesture of the arm, the pivoting of the torso, and the turned and slightly raised left foot. The composition is breaking free from the abstract rhythm governing fifth-century statuary, and suggest the presence of real space. In Leochares' work it looks forward to the Apollo – a slimmer, more resilient figure which transforms the threat of action into suspension of the initiated act; in the fourth-century artistic renaissance it helps us appreciate the part played by Lysippus, a greater and more prolific genius, bolder still in rendering movement.

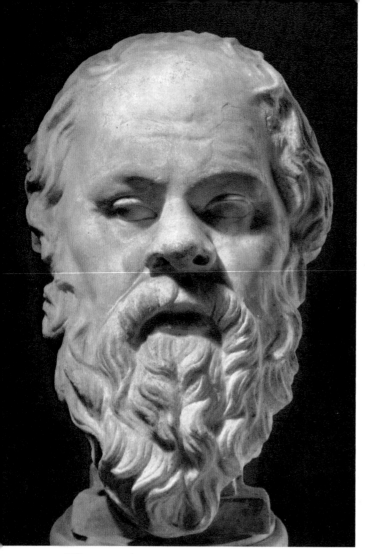

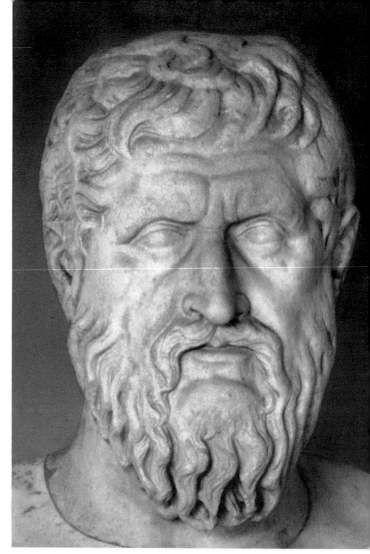

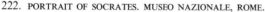

222. PORTRAIT OF SOCRATES. MUSEO NAZIONALE, ROME. 223. PORTRAIT OF PLATO. HOLKHAM HALL, NORFOLK.

Such experiments developed *pari passu* with psychological considerations – especially now that artists were once again pre-occupied with making portraits true to life. During the first half of the fifth century there had been several unmistakable signs of a swing towards realism; what checked it was that insistence on correctness and harmony which underlay classical theory in its purest form. This trend re-appeared in the fourth century and soon led to a remarkable development in portraiture. At the same time, no doubt, other factors were partly responsible for the progressive abandonment of idealized abstraction which led to the acceptance of certain physiognomical details and the expression of individual personality, among them the part played by the theatre in evoking long-vanished heroes, the growing importance of philosophy (which discovered a divine nobility of thought beneath the ugly Silenus-mask of Socrates) and also the Greek's natural curiosity about strange or exotic characters.

Let us consider the bronze head found at Olympia, which everything points to as being an original work by the sculptor Silanion, executed about 335. As evidence for the new realism it is all the more impressive in that it frankly portrays a victorious pugilist but includes the characteristic marks which his career has left. Behind these

212

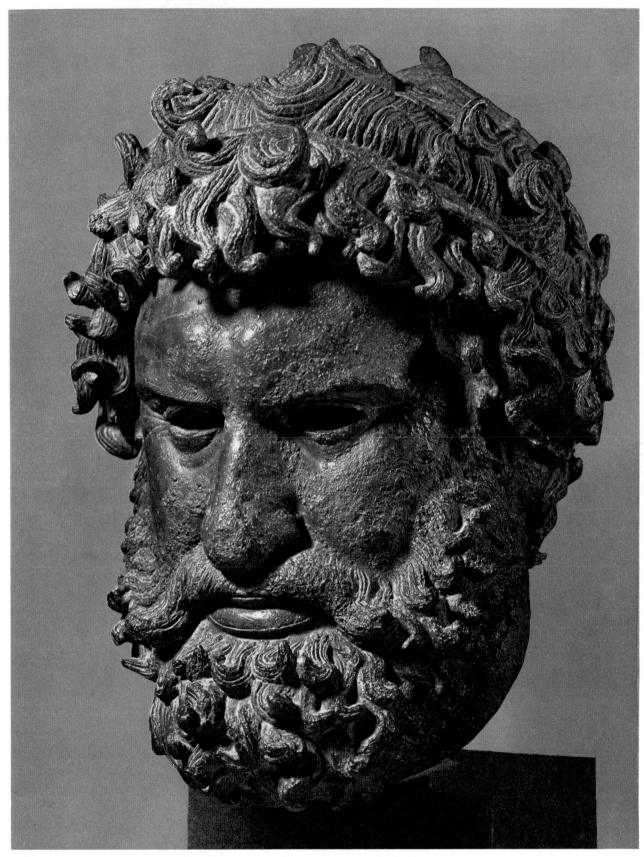

224. OLYMPIA. SILANION: HEAD OF THE PUGILIST SATYRUS. NATIONAL MUSEUM, ATHENS.

213

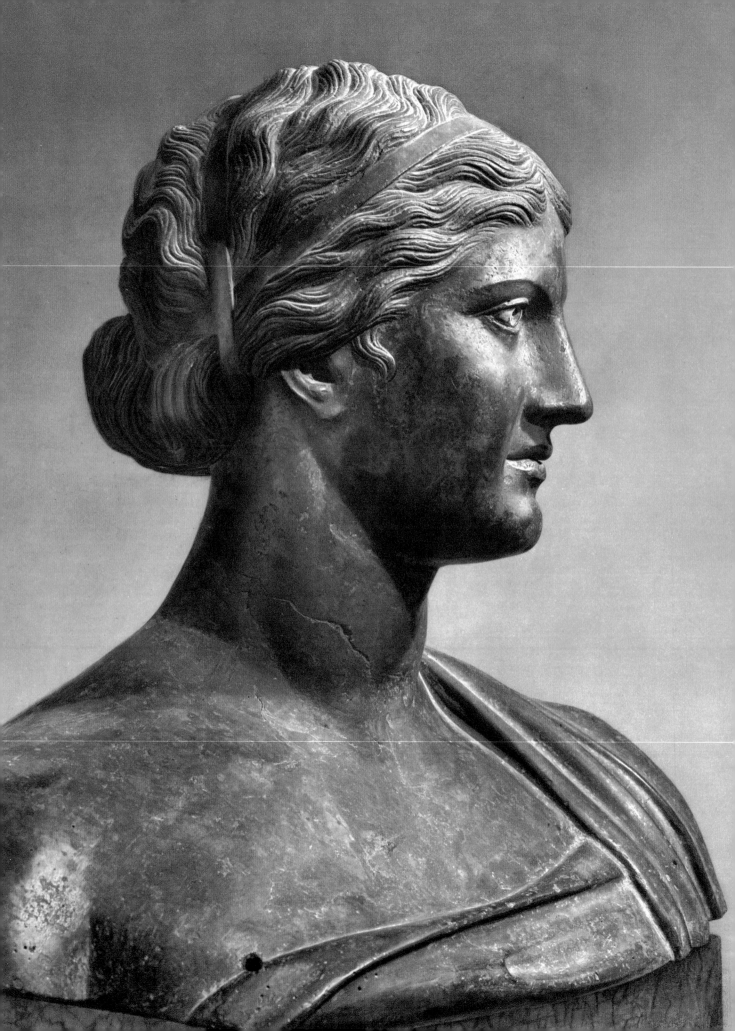

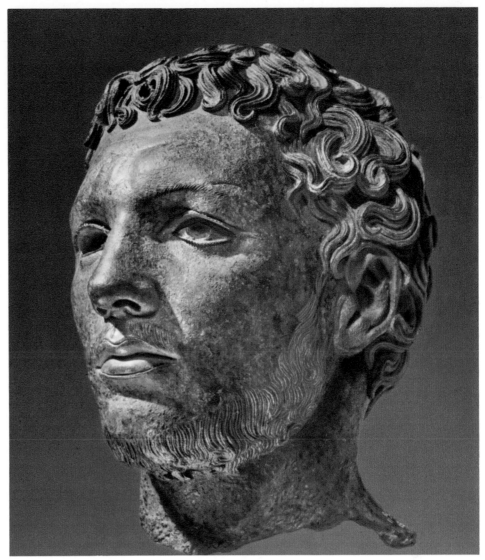

226. CYRENE. PORTRAIT OF A LIBYAN CHIEFTAIN. BRITISH MUSEUM, LONDON.

marks (perhaps indicative of a type rather than an individual), we perceive a structure similar to that of the same artist's portrait of Plato, done some thirty years earlier, but the detailed finish of the design reveals the progress towards verisimilitude that had been accomplished since then. In this context we may also compare the imaginary poetic portrait of Sappho executed by Silanion about 350 (some memory of which has probably been preserved by a bronze bust now in the Museo Nazionale at Naples), and the British Museum's bronze head of a Libyan chieftain from Cyrene; the latter work, anonymous and of somewhat later date, provides a good example of how Greeks were liable to interpret a foreign ethnic type. What strikes one, unmistakably, is the amount added by the presence of genuine detail and realistic inflections which break up the regularity of an imaginary face. It is significant that the fame of Alexander throughout the Greek world developed during this period, at a time when the curiosity of artists and public alike had created a demand for the true likenesses of famous living persons.

Lysippus

In at least two fields, the transformation of sculptural rhythm-patterns and the development of portraiture in all its various aspects, Lysippus' influence was very considerable, especially during the second half of the fourth century.

It is clear from his admiration for the 'canon' of Polycleitus, and his predilection for athletic types (witness the numerous statues he executed of Heracles and of victors at the Games), that Lysippus' work has its roots in Argive tradition. Like Michelangelo or Tintoretto, Lysippus belongs to the breed of artists who are born masters rather than disciples; it seems clear that he was still under thirty when, at some point between 370 and 360, he got the commission to make a statue of Pelopidas, the most distinguished general of his time. For earlier works, up to the middle of the fourth century, we are thrown back almost entirely on literary or epigraphical evidence. On the other hand we know the mature Lysippus from surviving replicas, which show him subordinating faithfully observed images of reality to those proportionate relationships which Pliny (*HN* 34.19.65) described by the Greek word *symmetria*, and to the new rhythms born of his calculations. Let us look, first, at a large bronze statuette in the British Museum, a Roman copy (reduced in scale but otherwise a faithful replica) of a statue representing the bearded Heracles. Compare the attitude and structure of this figure with those of, for example, Naucydes' Discus-thrower, and one instantly appreciates the wealth of originality that went into Lysippus' statue. The Discus-thrower is frozen in an interrupted movement, whereas the Heracles at once makes us feel that he is solidly established in the space he occupies. It is not immobility which produces this air of self-assurance, but rather the life which animates his limbs and arranges them in space: the obliquely divergent positions of the head, right arm and right leg combine to suggest three-dimensional depth and allow one to sense the solidity of the body. Furthermore, the head is held high, and in its full amplitude (seen from in front or behind) reveals itself as a harmoniously articulated physical structure. Though there is a visible reference to Polycleitan models, the proportions are different. A narrower torso serves to emphasize the breadth of shoulder; the play of the muscles is more supple and lively, though without prejudicing the clarity of the design; the less emphatic movement of the hips heralds a change of posture, or perhaps imminent action. Also relevant is the bronze of the young Heracles holding the apples of the Hesperides. Though his attitude is more balanced than that of the bearded Heracles, he expresses more vibrant energy, a greater impatience for action.

Lysippus' mastery is displayed most brilliantly in the famous statue of Agias from Delphi. To convey the unbeatable strength of this pancratiast, who had a whole string of victories to his credit, Lysippus reduced to a minimum not only the displacement of the free leg and the inclination of the torso, but also the spread of the arms, the movement of the head, and the slightly frowning expression. These movements, like the restrained use of relief, are nicely calculated to give the impression of concentrated energy, ready to resume some interrupted action at any moment. With this statue we are past the mid-point of the century. A few more years, and the artist was to produce his most famous work, the Apoxyomenos (Man with a Scraper).

216

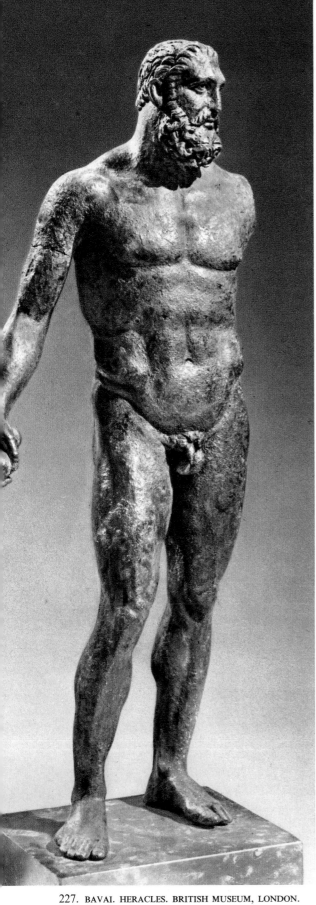

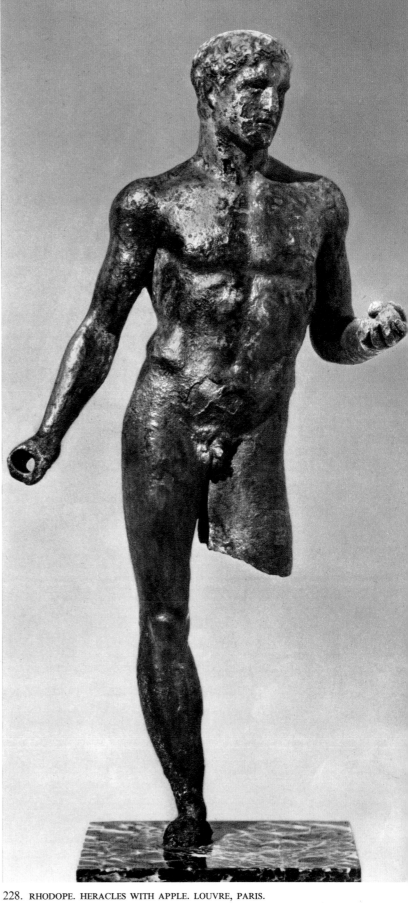

227. BAVAI. HERACLES. BRITISH MUSEUM, LONDON.

228. RHODOPE. HERACLES WITH APPLE. LOUVRE, PARIS.

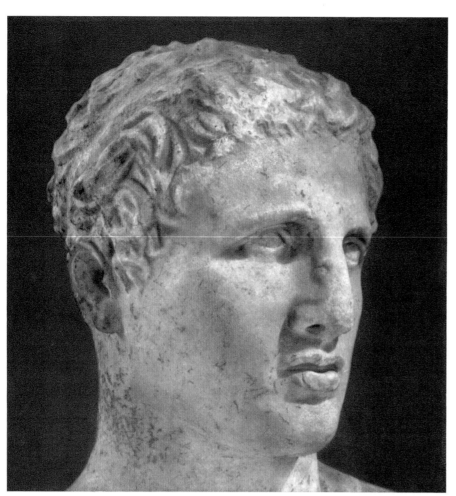

229. DELPHI. LYSIPPUS: AGIAS (DETAIL). DELPHI, MUSEUM.

Ever since the archaic period, the male nude, Greek sculpture's ideal subject, had always been portrayed with torso facing the viewer and, even when the statue portrayed action, entirely unencumbered. The Apoxyomenos departs from this rule. The chest is covered, for the first time, by the left arm which draws the strigil along the underside of the outstretched right arm. We can better appreciate this innovation if we compare Lysippus' Apoxyomenos with a bronze statue of the same subject from the Vienna Museum. The latter's unknown creator (perhaps Daedalus of Sicyon, compatriot and predecessor of Lysippus) showed the athlete scraping from his left hand the last of the oil he had rubbed on before taking exercise in the palaestra. In order to leave the torso visible, he very naturally lowered the arms and bent the head, making the figure round-shouldered. By contrast, the Apoxyomenos of Lysippus stands erect, head held high; the movement of the arms, raised almost horizontal, matches this spirited mood and lends prominence to those long, elegant legs, ready to shift the balance of the body with a quick, gliding, dancer's movement. Above all, the volume of air circumscribed by the arms shows, in quasi-geometrical fashion, a taking possession of three-dimensional space. What is more, there is a beckoning quality about that outstretched right arm which draws the spectator forward to circle this figure.

230. DELPHI. LYSIPPUS: AGIAS. DELPHI, MUSEUM.
231. LYSIPPUS: THE APOXYOMENOS (RECONSTRUCTION). NATIONAL MUSEUM, WARSAW.

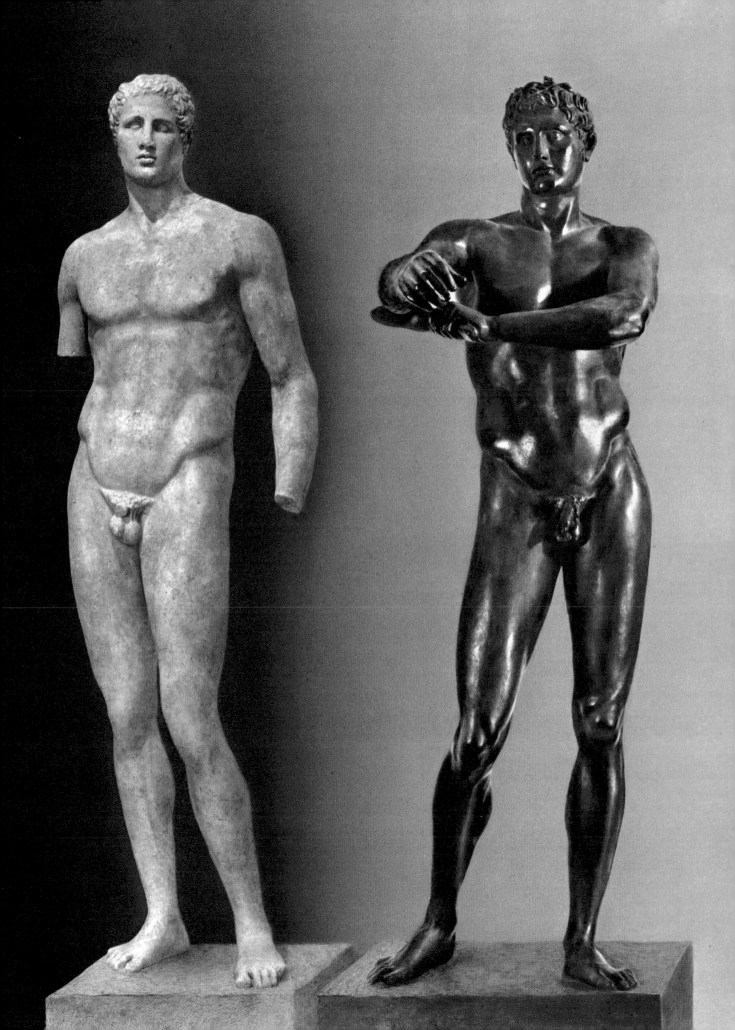

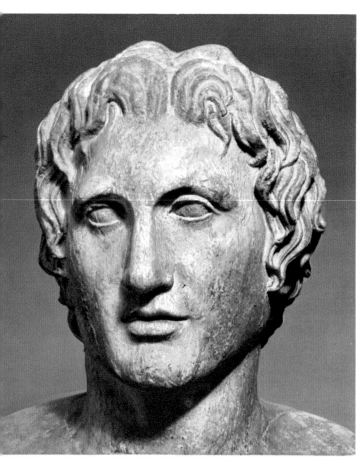

232. TIVOLI. THE 'AZARA HERM' OF ALEXANDER. LOUVRE, PARIS.

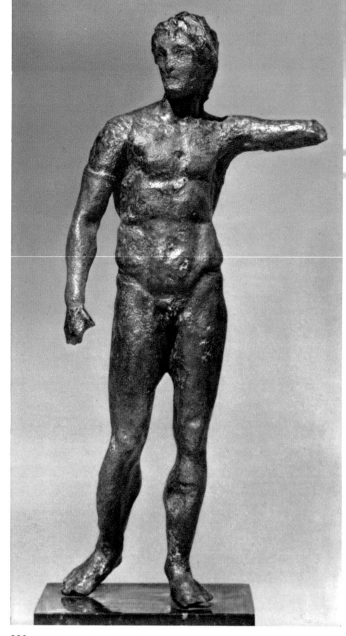

233. LOWER EGYPT. ALEXANDER WITH A SPEAR. LOUVRE, PARIS.

The heads of Agias and the Apoxyomenos, allowing for differences in their expressions (the first somewhat tense, the second triumphant), both illustrate one essential characteristic of Lysippus' style: the tendency to concentrate characteristic features in the middle of his face. The small, close-set eyes, sunk deep under their orbital arches, the fine-nostrilled nose and the little mouth are all contained within a narrow triangle, inscribed in that broad oval set on a muscular neck. Lysippus' predilection for this facial structure (which concentrates attention on the subject's expression) is even apparent in his best-attested portrait of Alexander. The 'Azara Herm' has been harshly dealt with by time, and the marble replica could hardly recapture all the subtleties of the bronze original. The head is set too squarely and the leonine mane of hair has lost its wild disarray. Yet, despite all this, the structure of the

220

face reveals the master's touch: note the daring freedom with which the features have been 'remodelled', so as to enhance their vigour and authority.

One of Lysippus' latest works in the tradition we are here examining must have been his statue of Alexander with a Spear (the portrait copied in the 'Azara Herm' also belonged to this series). The work was doubtless executed towards the end of the conqueror's brief career, if not after his death – that is, at some point between 330 and 320 B.C. A bronze statuette in the Louvre, though unfortunately much corroded, does give us some idea of its general appearance. At first glance the pose appears a simple one, but in fact we find an extraordinary range of movements animating the limbs, and indeed every muscular plane. The dazzling mobility of this heroic nude admirably expresses Alexander's conquest of the known world, and matches the phrase that an ancient epigram attributes to him: 'Earth is *my* footstool; Zeus, you can keep Olympus'. Unfortunately, the statuette's diminutive size and worn state do not allow us to appreciate that minutely detailed relief-work which (according to literary sources) was a special concern of the artist's; for this we must turn to the so-called 'Farnese Heracles', the original of which must have been executed at the same period as the Alexander with a Spear. It is known through numerous replicas, some of which complaisantly exaggerate the hero's muscular development, yet the work itself clearly possessed great character. Observation of detail was firmly subordinated to *symmetria* in the pyramidal composition, the lines of which coincide, ideally, with the positions of the limbs and with the rhythmic pattern of curves and countercurves, from left to right, from front to back, set up by inclinations of the head, torso and limbs. We can better appreciate the variety of expression Lysippus employs to indicate a transition from rest to action in seated statues such as the Hermes at Rest, or the Heracles Epitrapezios.

The problem of the draped statue is easier than the treatment of a male nude in that it admits of solutions where close and minute study of the living model can be supplemented by sheer virtuosity – witness the delightful figurines from Tanagra. Nevertheless, the artist is still bound by two rules: drapery must follow the lines of the body and, secondly, one must strive to achieve a basically geometrical stylization which takes into account not only the articulation of the body but also the special qualities inherent in drapery. Scholars are doubtless right to see both the large and the small versions of the so-called 'Woman of Herculaneum', numerous Roman replicas of which exist, as examples of the Lysippean style applied to a draped female portrait. Close scrutiny reveals minutely detailed work on the drapery – in particular, a combination of geometric patterns, triangles and trapezoids, the lines of which follow, and emphasize, the inclinations and movements of the body, very much in the spirit of Lysippus' art. The same phenomenon can be seen in the Naples Aeschines, the interpretation of which differs radically from, say, that of the Lateran Sophocles: the impression is of two rival styles. We are told, nevertheless, that Lysippus and Leochares worked together on the large statue-group of Alexander Hunting, at Delphi. This new group formula, soon to develop on the most remarkable scale, probably owed its main impetus to Lysippus. Traditional sources speak of a composition portraying Alexander with his comrades from the Battle of the Granicus, and some evidence exists of a series of bronzes representing the Labours of Heracles.

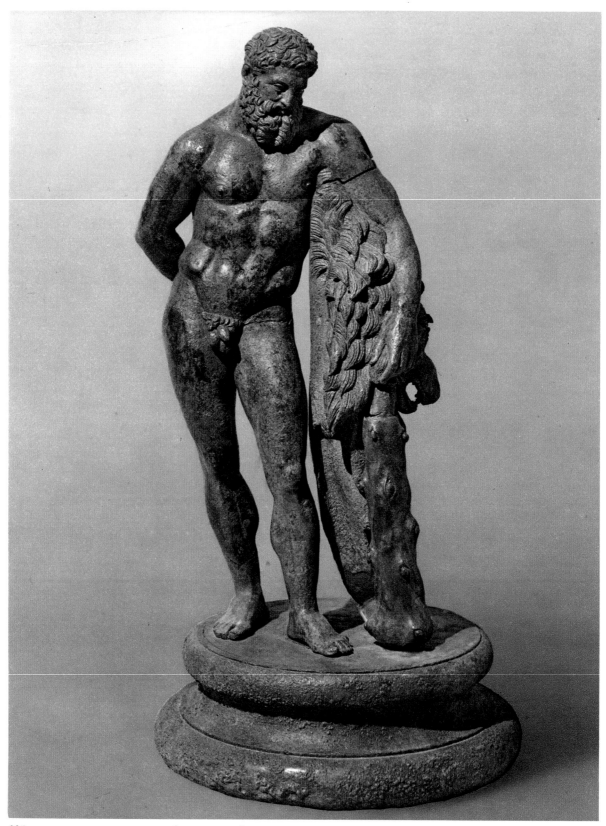

234. PERUGIA. HERACLES AT REST (FARNESE TYPE). LOUVRE, PARIS.

235. HERCULANEUM. HERMES AT REST. MUSEO NAZIONALE, NAPLES

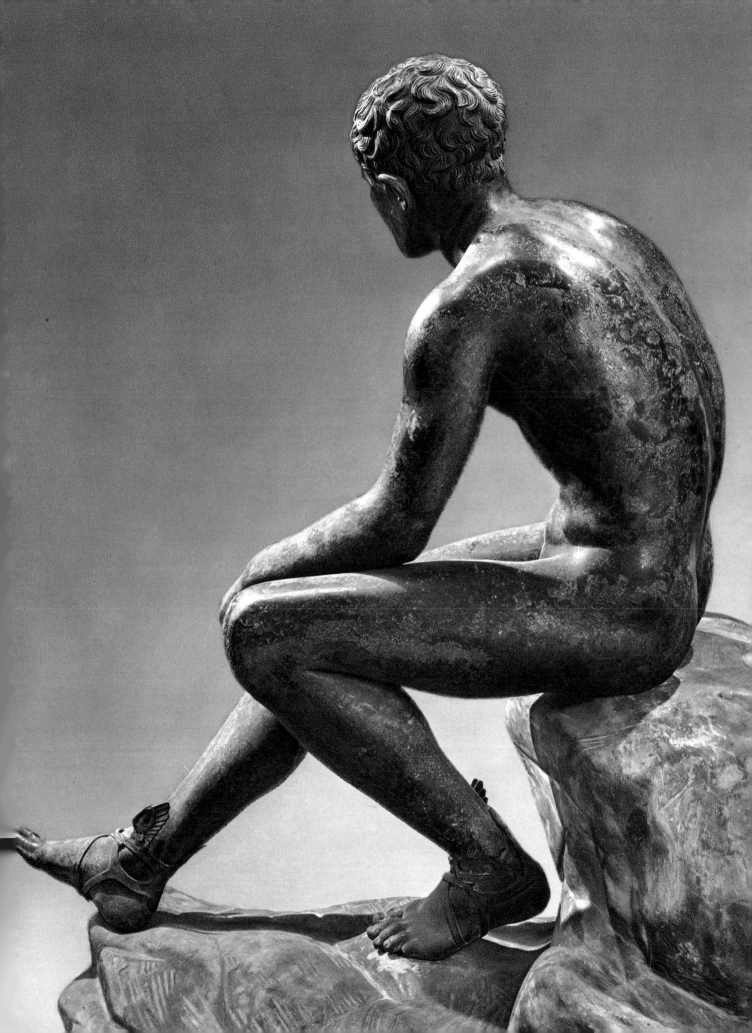

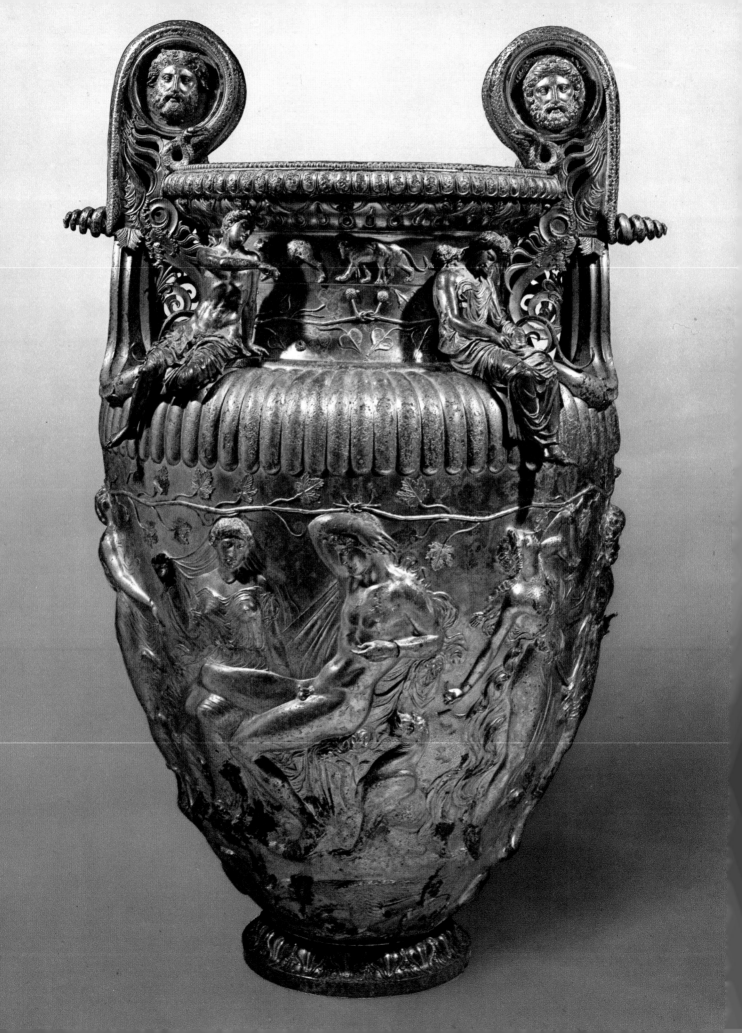

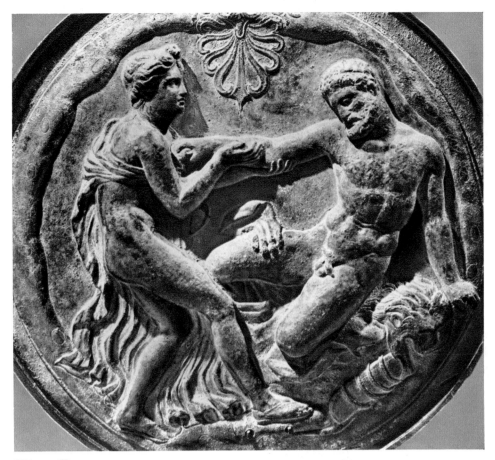

237. ELIS(?). LID OF BOX-MIRROR: HERACLES AND AUGE. NATIONAL MUSEUM, ATHENS.

Craftsmanship in Greece and Hellenism in the East

Throughout the entire Hellenistic period we can trace Lysippus' influence, as we can that of Praxiteles; but both of them, in the first instance, directly affected the artistic activity of their day in the field of craft products. Not surprisingly we find the figurine-makers' workshops reflecting in miniature the various styles and types adopted by large-scale sculpture (especially female figures). Lids for bronze mirrors are decorated with compositions inspired by sculptures on metopes, and votive reliefs display the animated movement and depth of monumental friezes. The development of funeral stelae even clearer borrowings from first-class works of art; during the second half of the fourth century the architectural setting steadily develops in importance, while little by little figures detach themselves from their background, so that the relief becomes a statue. In an age when strictness of civic discipline was generally relaxing, classical restraint likewise tended to disappear, and artistic imagery, now seeking its subject-matter in the real world, reflected a pre-occupation with the theatre. On some stelae this theatrical realism looks distressing or ridiculous, but other monuments do not disgrace the masters from whose work they derive their inspiration; the Rhamnous stele reminds one of Leochares and Praxiteles, while the young man on the Ilissus stele, staring into the distance while his old father watches, recalls both Lysippus and Scopas.

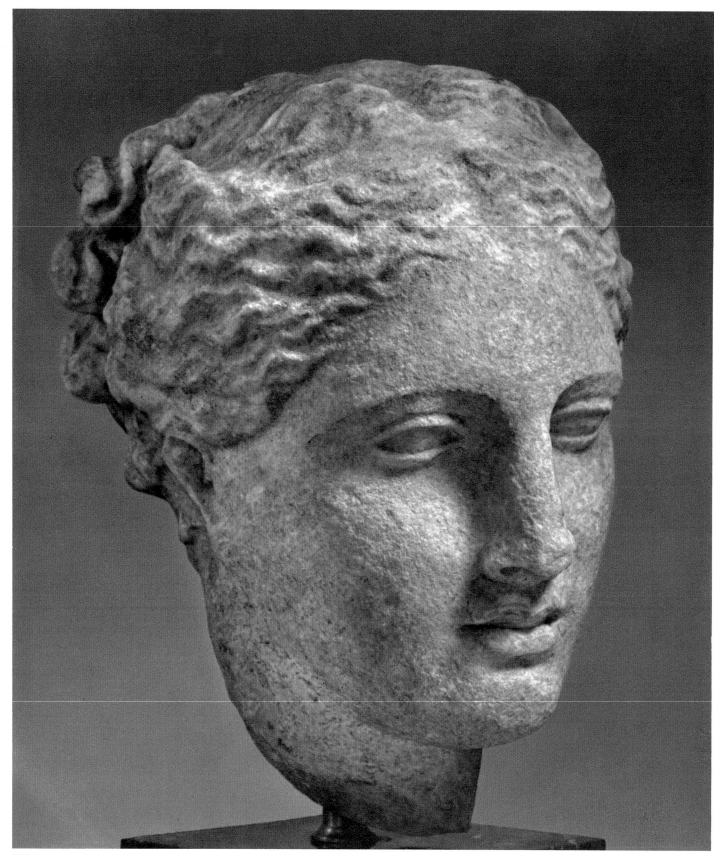

238. TEGEA. SO-CALLED 'HEAD OF HYGIEIA'. NATIONAL MUSEUM, ATHENS.

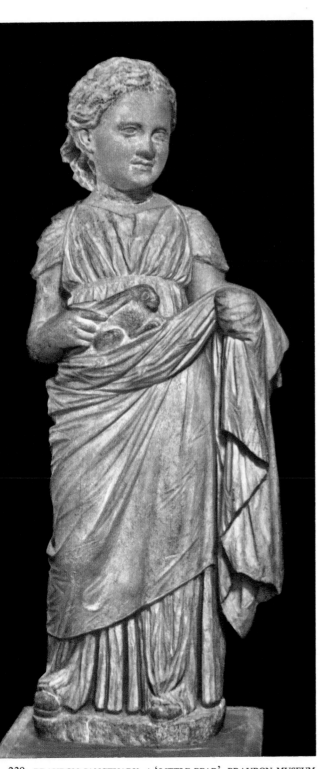

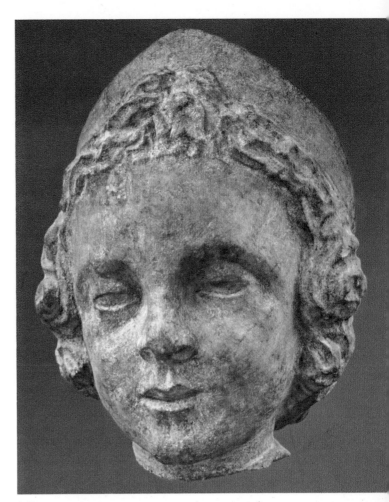

240. BRAURON SANCTUARY. A BLIND 'LITTLE BEAR'.
BRAURON MUSEUM.

239. BRAURON SANCTUARY. A 'LITTLE BEAR'. BRAURON MUSEUM.

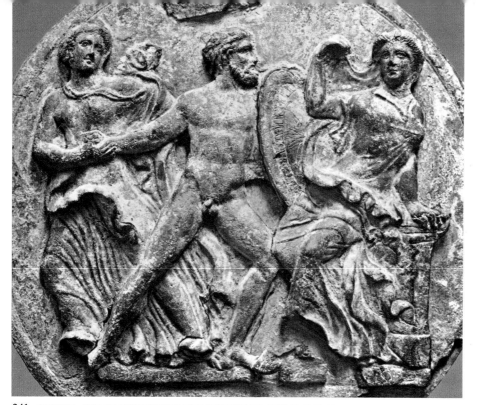

241. VONITSA, LID OF BOX-MIRROR: THE MEETING OF AENEAS AND HELEN,
BIBLIOTHÈQUE NATIONALE, PARIS.

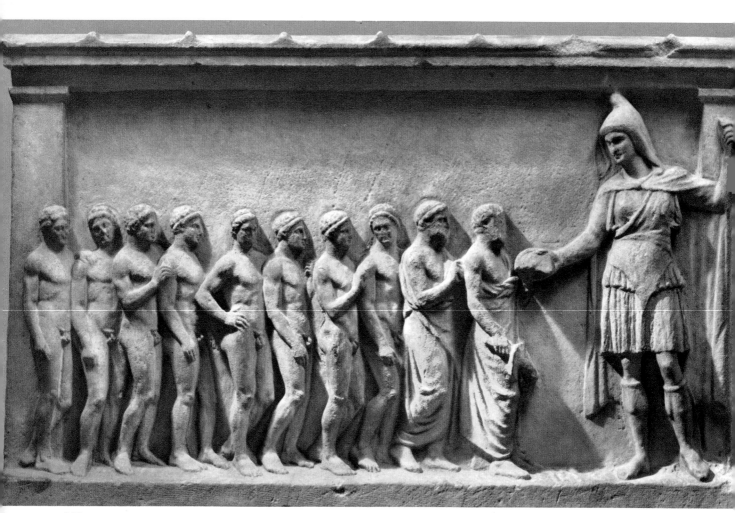

242. PIRAEUS. VOTIVE RELIEF DEDICATED TO BENDIS. BRITISH MUSEUM, LONDON.

244. TARENTUM(?). FUNERARY RELIEF. WOMAN AND YOUNG MAN BY AN ALTAR. THE METROPOLITAN MUSEUM OF ART, NEW YORK.

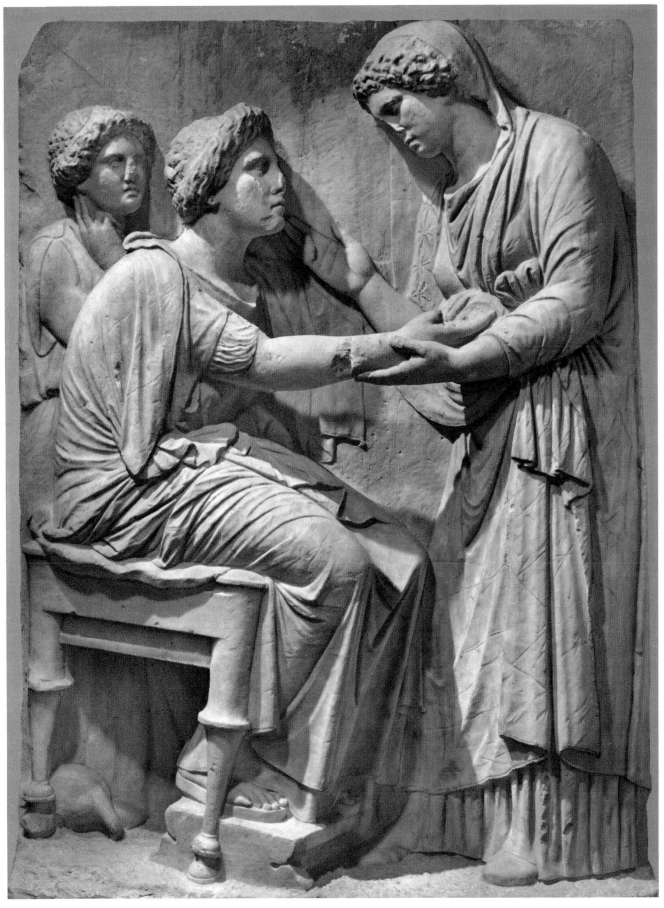

245. ATHENS. FUNERARY STELE OF EUCOLINA. NATIONAL MUSEUM, ATHENS.

246. CYRENE. PARTLY VEILED FEMALE HEAD. MUSÉES DES SCULPTURES, CYRENE.

247. MENIDI. SEATED WOMAN. STAATLICHE MUSEEN, BERLIN

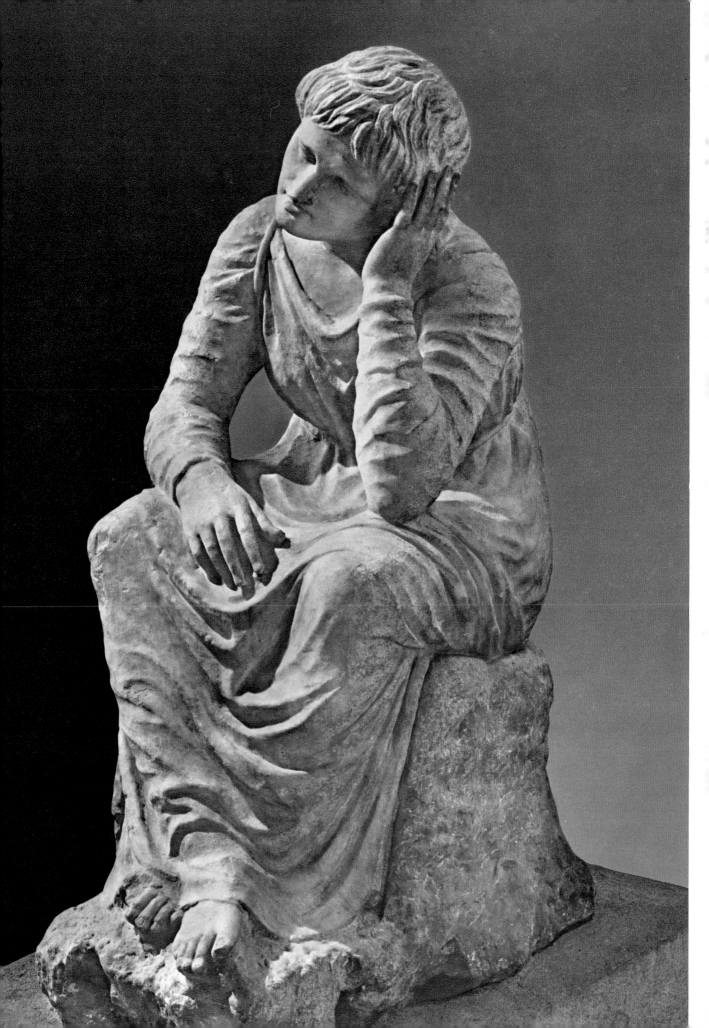

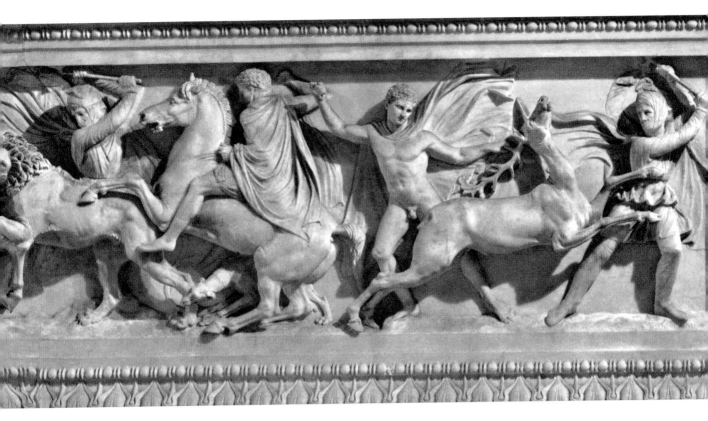

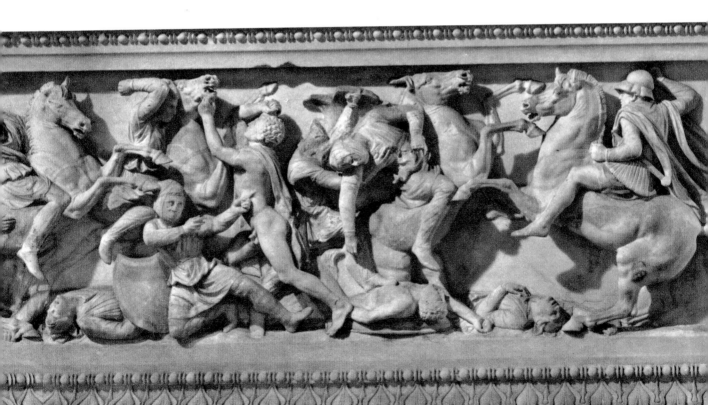

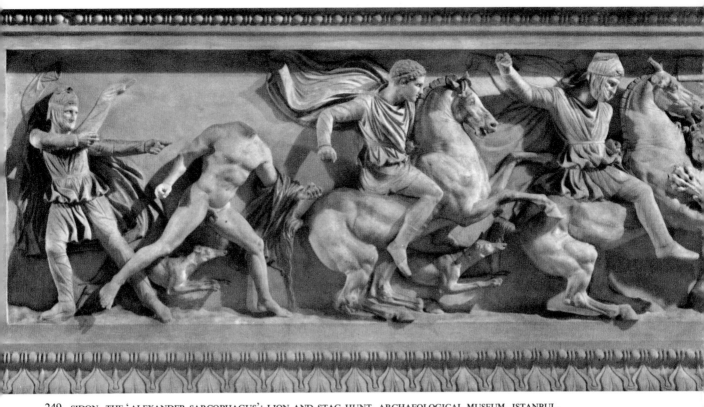

249. SIDON. THE 'ALEXANDER SARCOPHAGUS': LION AND STAG HUNT. ARCHAEOLOGICAL MUSEUM, ISTANBUL.

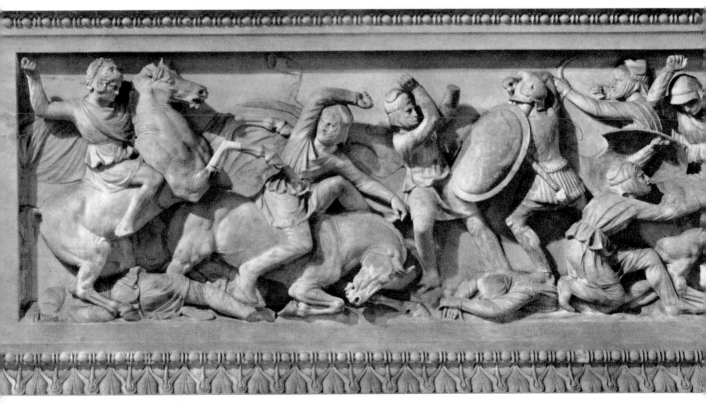

250. SIDON. THE 'ALEXANDER SARCOPHAGUS': BATTLE BETWEEN GREEKS AND PERSIANS. ARCHAEOLOGICAL MUSEUM, ISTANBUL.

248. SIDON. THE 'ALEXANDER SARCOPHAGUS' (DETAIL): DEMETRIUS POLIORCETES. ARCHAEOLOGICAL MUSEUM, ISTANBUL.

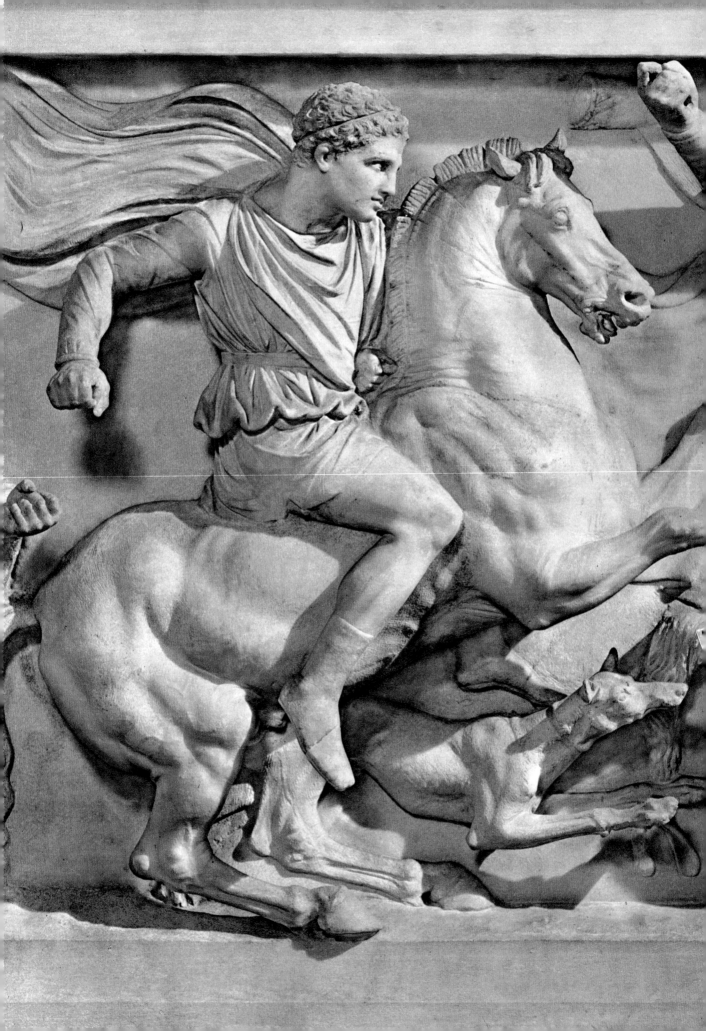

In Attica, generally speaking, until Demetrius of Phaleron's law forbidding luxurious expenditure on funerary sculpture, we seldom find any obvious attempt to portray the actual features of the deceased. The so-called 'Alexander Sarcophagus' from Sidon, however, constitutes a special case.

This great marble shrine, brightened with marvellously preserved touches of colour, is now in the Istanbul Museum. The only justification for its popular title is the presence of the conqueror on horseback in the great battle-scene on one of its long sides; the elderly commander wearing a Macedonian helmet, shown facing Alexander, as a sort of counterpart at the other end of this scene, is Antigonus the One-eyed. On the opposite side of the sarcophagus his son, Demetrius Poliorcetes, comes to the aid of a Persian king attacked by a lion. These scenes are symbolic rather than historical in character, and the glorification of their royal protagonists is dynastic propaganda. After their victory over Ptolemy at Salamis on Cyprus (306), Antigonus and Demetrius were the first of the Diadochi ('Successors') to lay claim to Alexander's heritage in its entirety, and to assume the royal fillet. The sarcophagus was, it seems clear, commissioned for Abdalonymus, the last Sidonian king of Persian extraction (in 304 Demetrius appointed Philocles, a Greek, as his successor), and illustrates both the military triumph of the Macedonians, and the Graeco-Persian reconciliation which the conqueror desired. In the hunting scene the Persian king occupies the place of honour, though yielding the leading role to his overlord Demetrius, but whether the fusion of the two races got much beyond the stage of good intentions and initial examples is another matter. With the exception of certain Iranian gargoyle motifs, the style of this sarcophagus is entirely Greek, and its architectural decoration belongs to the Ionian tradition. The reliefs themselves look to past and future simultaneously. There is academicism (inspired by classical models) in the hunting scene, but a new aesthetic approach and a new vision of reality in the battle-scene, where the liveliness of the mêlée is enriched by the density and depth of the composition and by the boldness of attitude and gesture. The influence of historical painting, for example the Alexander mosaic (fig. 117), will not suffice to explain this far-reaching change of mood and attitude. The image of a new world is gradually becoming clearer: a monarchical society, in which the person of the king as Saviour carries a halo of reflected divinity – we have entered the 'Hellenistic' period. As the fourth century passes into the third, various factors – change of political regime, rivalries between Alexander's successors, the vast spread of Hellenism (with a consequent dissipation of creative energies) – all tended to modify the normal development, if we may so term it, of Greek art. There are, it is true, no outright repudiations; but we find a whole crop of assimilations and exchanges, the occasional retreat into the past, and some genuine experiences, in the wake of that powerful movement which Lysippus' work set afoot.

While sculptural activity remained very considerable in the traditional centres of the craft, new demands also had to be met elsewhere. The evidence of the 'Alexander Sarcophagus' for relief-work is supplemented, as regards sculpture in the round, by that of the Tyche of Antioch – a statue commissioned in 300 B.C. by Seleucus Nicator, from Lysippus' pupil Eutychides, to celebrate Antioch's foundation as the new capital of the kingdom of Syria, and to be the image of the city's destiny. Today this lively

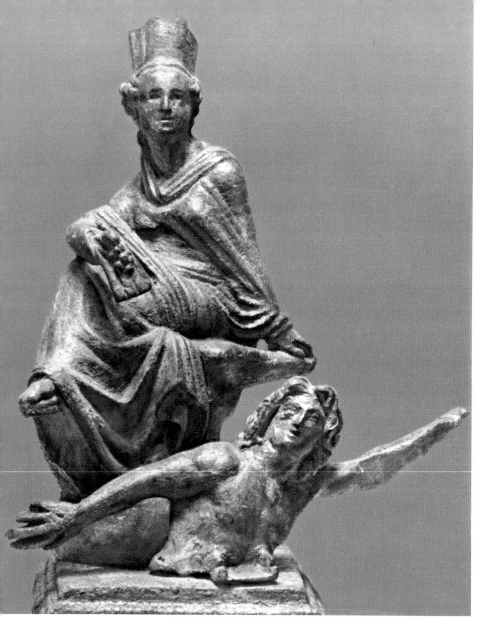

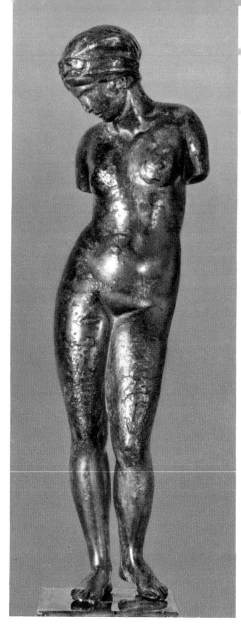

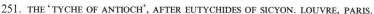

251. THE 'TYCHE OF ANTIOCH', AFTER EUTYCHIDES OF SICYON. LOUVRE, PARIS.

252. VERRIA. WOMAN BATHING. STAATLICHE ANTIKENSAMMLUNGEN, MUNICH.

allegorical composition with its wealth of historical and religious significance, can be judged only through miniature replicas (although the original was quite certainly on a colossal scale). Even so, these statuettes at least suffice to show us Eutychides' intentions. He meant to convey, at one and the same time, both Fortuna's fickleness and her attachment to the new city; he therefore represented her, swathed in rich draperies and wearing a mural crown, sitting on a rock with one foot on the shoulder of a half-length nude youth (a personification of the river Orontes) in the attitude of a swimmer. What gives this group its idiosyncratic style is the way in which its various aspects are developed, and the movements of body and drapery intermingle and oppose each other. Torsion effects and divergent lines have a vibrant quality, radiating into space, and the tunic is treated as though it were some rather stiff Eastern fabric, its folds now close-bunched, now opening out like a fan and cascading down almost on to

253. MANTUA. BOEDAS OF BYZANTIUM: YOUNG MAN PRAYING. STAATLICHE MUSEEN, BERLIN.

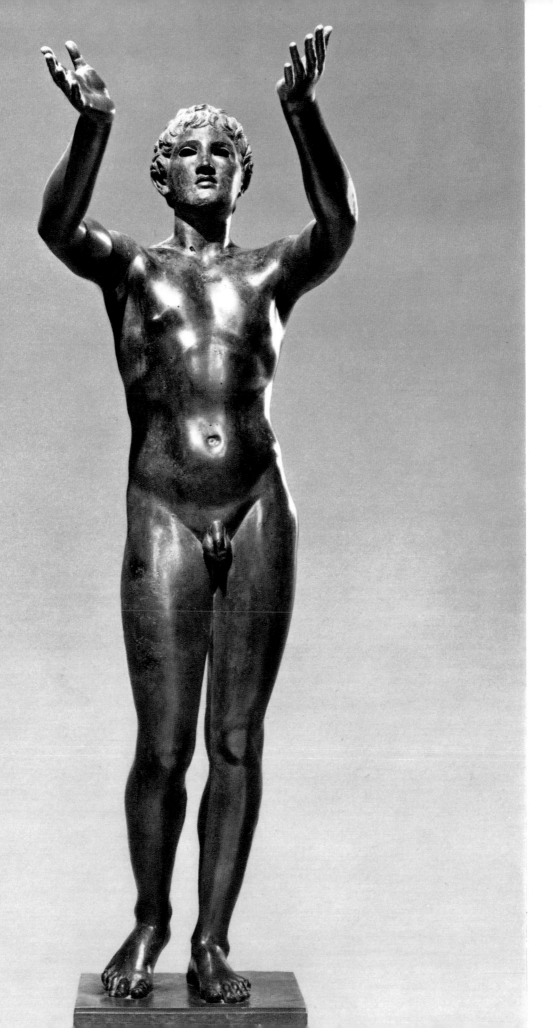

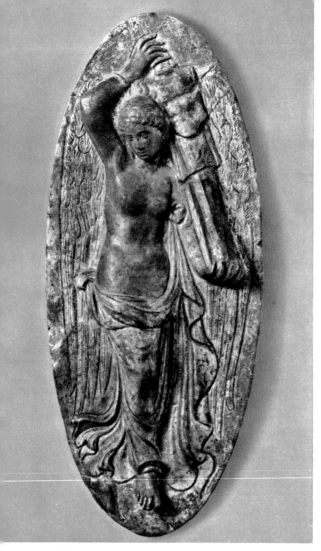

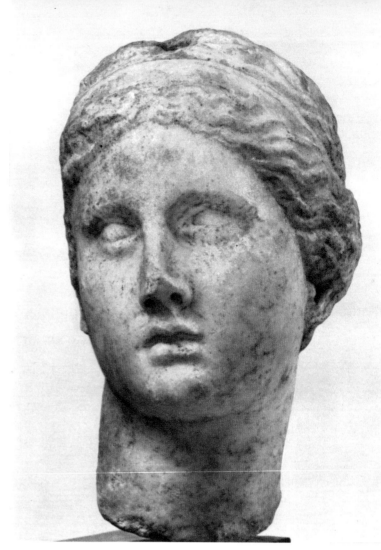

254. TARENTUM. NIKE WITH A TROPHY. ANTIKENMUSEUM, BASLE.

255. COS. FEMALE HEAD. WÜRTTEMBERGISCHES LANDESMUSEUM, STUTTGART.

the swimmer. In this remarkable creation Eutychides was following the example of Lysippus. Lysippus' favourite pupil was Chares of Lindos who, in this same period, set up the largest colossus of antiquity at the entrance to Rhodes harbour. This statue of the island's patron deity (Helios the Sun-God), destroyed seventy years later by an earthquake, was over a hundred feet in height. A liking for colossal was characteristic of this period – it suited the ambitions of Alexander's successors – and Rhodes, which in 304 had successfully resisted the attacks of Demetrius Poliorcetes, then master of the seas, demonstrated its pride as a free and independent city with similar emphasis.

Since colossal sculptures caught the imagination of the ancient world, the dates of their erection are recorded. On the other hand, sorting out ordinary sized statuary of the first Hellenistic generation, both in mainland Greece and elsewhere, involves serious chronological difficulties. To make matters worse, there is a famous passage in Pliny condemning everything produced in the third century and the first half of the second, up to the emergence of neo-classicism; this has encouraged the attribution to famous fourth-century sculptors (or much later imitators) of many works by their immediate successors.

240

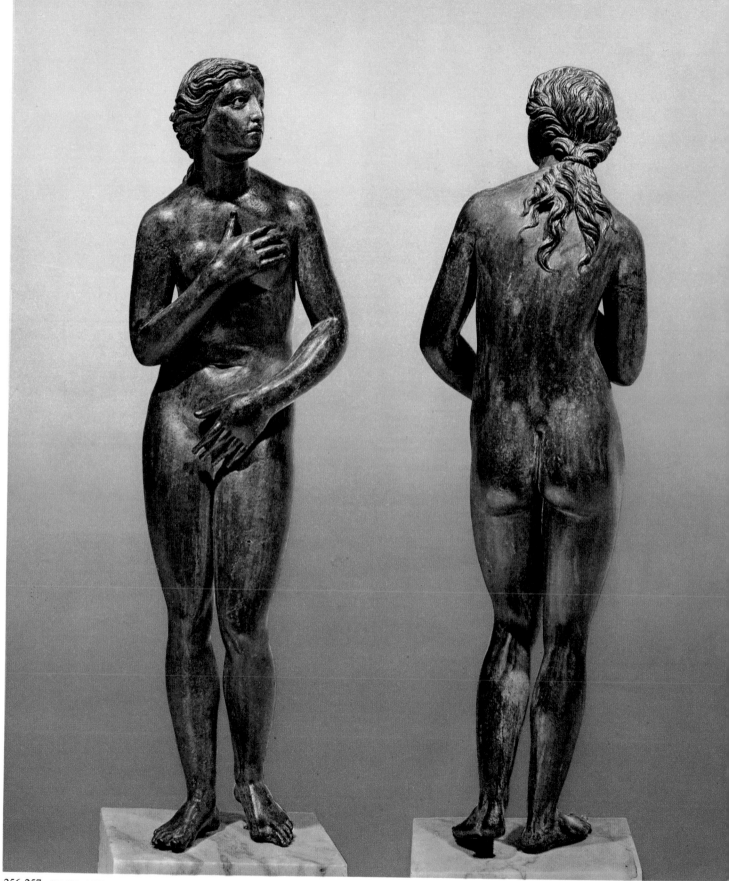

256-257. SIDON. APHRODITE. LOUVRE, PARIS.

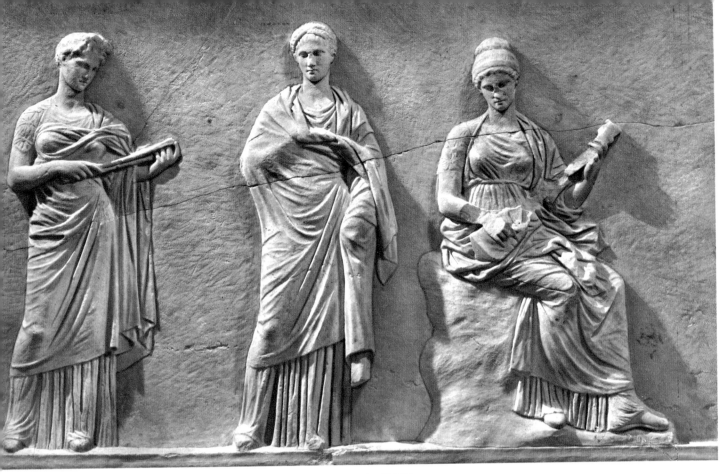

258. THE 'MANTINEA BASE': THREE MUSES. NATIONAL MUSEUM, ATHENS.

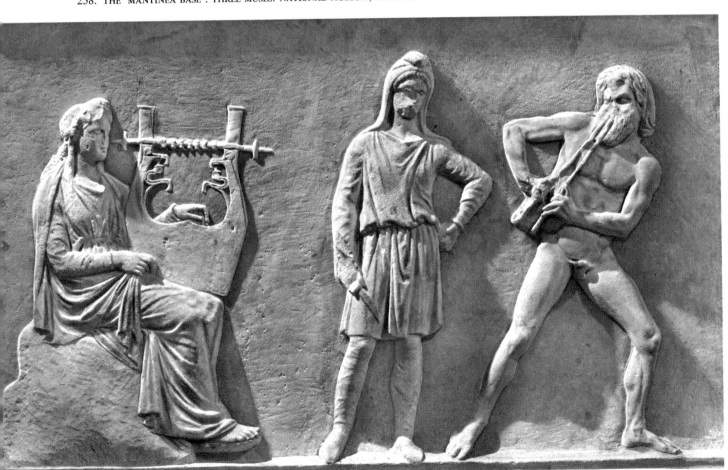

259. THE 'MANTINEA BASE': MUSICAL CONTEST BETWEEN APOLLO AND MARSYAS. NATIONAL MUSEUM, ATHENS.

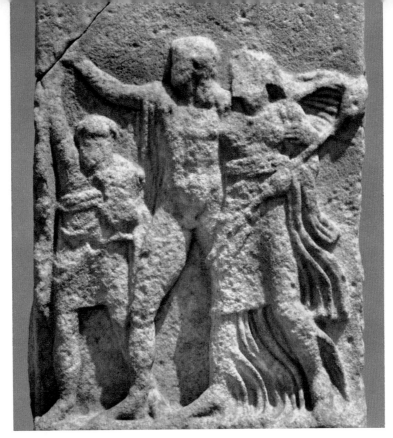

260. DELOS. CHOREGIC EX-VOTO OF CARYSTIUS:
DIONYSUS, SILENUS AND A MAENAD.

Third-century Art

Allegories and Portraits

In antiquity a certain well-known group depicting Niobe and her Children was variously attributed to Scopas and to Praxiteles, though, as far as one can judge from the over-restored replicas in the Uffizi at Florence (see p. 347, fig. 381), a date around 300 B.C. seems more plausible; the same applies to a group of Muses of which the best replicas are in the Vatican (see fig. 380). The language of these figures, at once sensual and intellectual, is echoed in countless figurines from Tanagra and elsewhere, and has the same effect as an actor, equipped with all the artifices of an ancient and refined civilization, who can recreate in the spectator's mind a world of images and emotions springing from poetry, music or meditation. In the early third century Attic art above all conveys a sense of what might be termed nostalgic withdrawal. To make people forget lost liberties, Alexander's successors encouraged culture. Ptolemy endowed a splendid foundation for the maintenance of scholars and poets: the Museum, or 'House of the Muses', at Alexandria. Attalid munificence brought unheard-of splendour to the festivals and games in the Muses' sanctuary on the slopes of Helicon; and statues of the Muses, singly or in groups, multiplied greatly.

The classical revival was chiefly centred on Athens, but it can also be illustrated by a head of Dionysus from Thasos, originally part of the central figure in a group of allegorical statues (Tragedy, Comedy, Dithyramb) dedicated at some time in the first

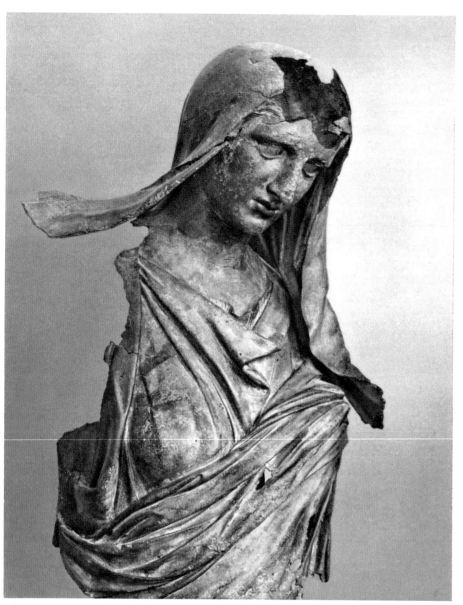

261. ARAP ADASI. TORSO OF A STATUE OF DEMETER. ARCHAEOLOGICAL MUSEUM, IZMIR.

part of the third century to commemorate a cycle of theatrical productions. In portraying the god's face, the artist rejected almost every expressive device of fourth-century sculptors (lines on the forehead, beetling orbital ridges, movement of the eyelids, cheekbones). What he meant to convey was serenity, but the dominant impression is of an almost feminine softness and gentleness.

The return to classical standards makes itself felt precisely where one would least have expected it: in portraiture. The features of Menander, and of Epicurus and his disciples Metrodorus and Hermarchus, known through numerous reproductions, bear ample witness to this. Tradition attributes to Cephisodotus and Timarchus (Praxiteles' son) the lost original portrait of the comic poet Menander, from which a whole host of variously interpreted Roman copies are derived. In style, however, it plainly looks back

244

262. THASOS. HEAD OF DIONYSUS. THASOS, MUSEUM.

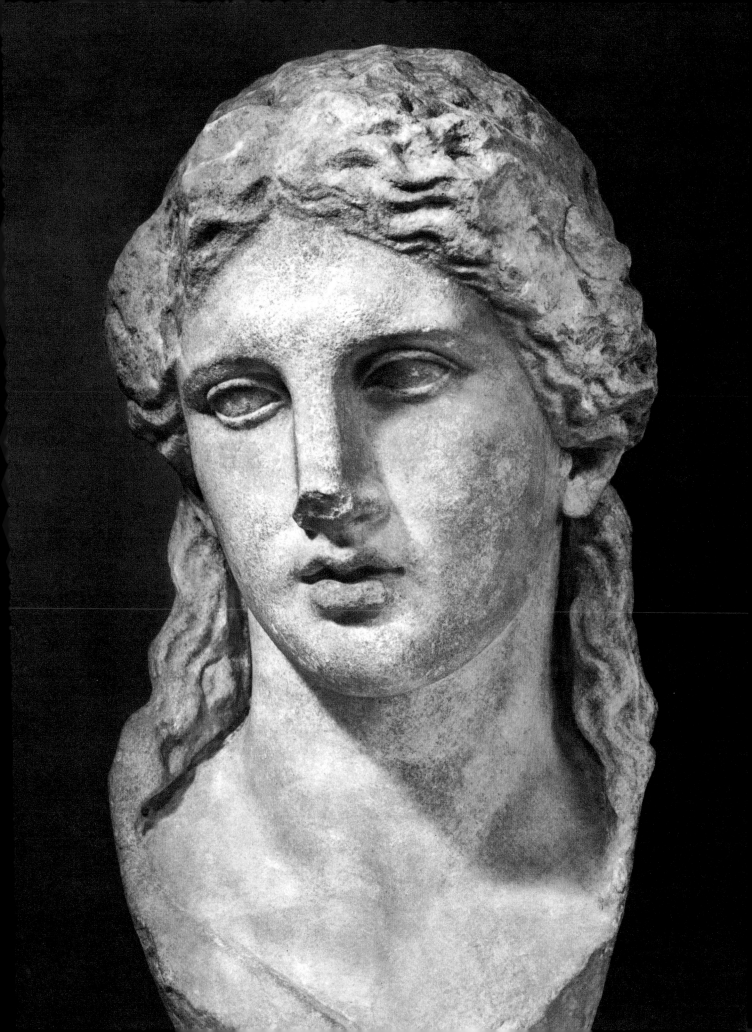

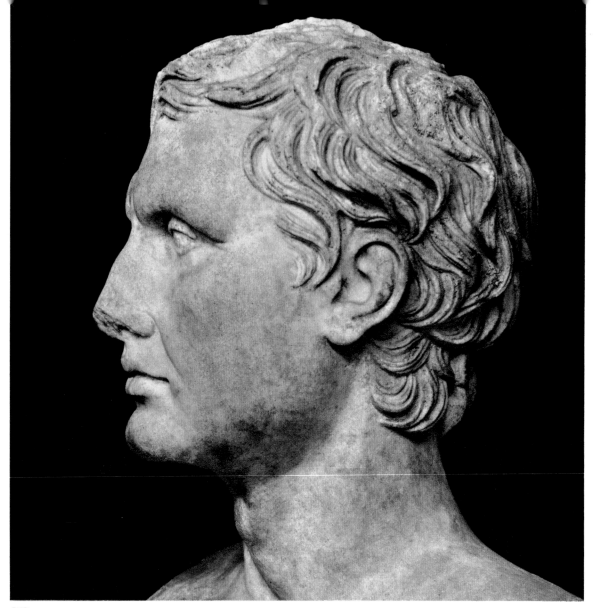

263. TORRE ANNUNZIATA AREA. PORTRAIT OF MENANDER. MUSEUM OF FINE ARTS, BOSTON.

to classical models, and indeed to those of the fifth century rather than the fourth. That fine, regular profile, the clear outline of eyelids or lips, the attention to rhythm in the undulations of those long, meticulously chiselled locks – all these belong to the earlier period. Some students, on first seeing this face, have identified it as that of Virgil – an understandable mistake, for the Greek sculptors who worked for Augustus also sought their terms of reference in the classical epoch.

The characteristics we have noted in the portrait of Menander also appear in that of Epicurus, for the features of this ascetic and sickly philosopher have been ennobled in an identical fashion, and perhaps by the same artist. On the other hand, the sitter has been observed in even greater detail, to convey the concentration of a mind bent on laying down rules for human conduct amid the political and moral uncertainties of a shattered world. Copies of typical statues of Epicurus and his disciples, Hermarchus and Metrodorus, are preserved in museums at Florence and Copenhagen. The pose of

246

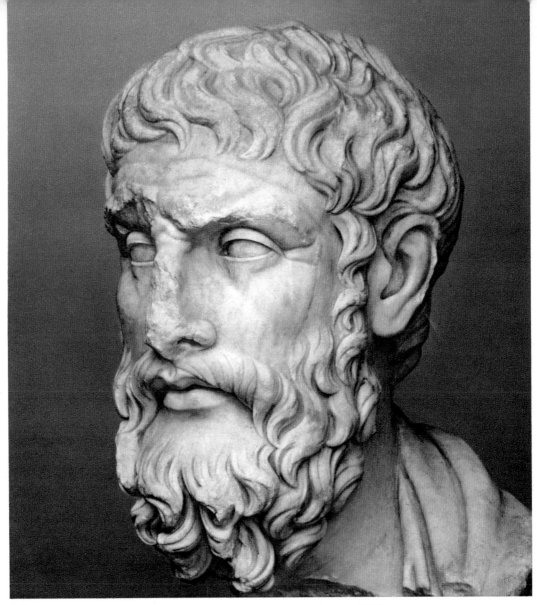

264. PORTRAIT OF EPICURUS. THE METROPOLITAN MUSEUM OF ART, NEW YORK.

the three philosophers, varying slightly between one figure and another, suggests meditation rather than exposition; it links them to the Muses in the Vatican series, which reveal the same calm, collected attitude and the same tight swathing of drapery.

This static phase in the progress of realism did not last for long, nor, as we shall see, did it occur universally throughout the Greek world. In Athens itself the bronze statue of Demosthenes by Polyeuctus (see p. 345, fig. 370) attests the return to life-like portraiture – a fact all the more remarkable since this likeness of the great orator was not set up in the Athenian agora until 280 B.C., forty-two years after his death. Yet it seems incontestable that the sculptor worked from a portrait done during Demosthenes' lifetime, so clearly does the detailed treatment of physiognomy in the best replicas suggest a real rather than an imaginary personality. Demosthenes is not shown in the heat of declamation (as he would have been a century later at Pergamum or Rhodes), but motionless, head bent, in a moment of intense reflection. The whole significance of

247

this heroic presence is summed up in the calm of a man standing with hands folded, and in the features, recreated with great respect but without flattery, which suggest an incessant conflict between passion and paramount will.

Because of its meditative attitude, this statue of Demosthenes is similar to those of the three Epicureans. Nevertheless, it marks a decisive advance, for its creator has freed himself from the old purely ornamental arrangements of classical drapery. The simplicity of the pose combines with the severe lines of the heavy drapery to produce a pattern of geometrical strictness; by thus combining realism with geometry, Polyeuctus links the lines of the material swathing the body more closely with the language of gesture and expression. His successors followed in his footsteps. A statuette of a seated 'philosopher' in the Bibliothèque Nationale in Paris – a miniature of a large-scale bronze, datable to the middle of the third century – reveals an identical restraint in its handling of drapery which matches the movements of head, arms, and legs. At the same time there is a monumental feeling about the pose – something which frequently occurs in figure-sculpture of the latter half of the third century, with groups or individual statues straining to suggest the exact moment of tension or release which gives the action its significance.

The climax of this intellectual realism, which is, strictly speaking, an Attic pheno-menon, is marked by the seated statue of the Stoic philosopher Chrysippus (see p. 345, fig. 371), the most famous Stoic dialectician. We know its creator, Eubulides the Athenian, and its approximate date, around 210. Chrysippus died soon afterwards (205) at the age of seventy-five, and the marble statue in the Louvre, a faithful replica of the original bronze, shows a bent old man wrapping the plain mantle of the ascetic about his emaciated body. Yet above this half-starved body, the head is energetically poised, and its features – worn, hollow, swollen with intensity of thought – stand out sharply against the ill-trimmed beard. The old teacher is about to clinch an argument with a gesture of his outstretched hand, which is pointed up by the angular bunching of the folds of drapery. This statue is perhaps the most eloquent portrait from all antiquity – a living theorem, which not only creates a faithful likeness of the man but also relates this to his qualities as thinker and teacher.

As a result of the taste for allegorical subjects and the popularity of portraits of poets and thinkers, these two trends tended to develop at the expense of other themes. The standing male nude, which had been a favourite subject from the early Archaic period until the end of the fourth century, seems to have disappeared almost completely soon after the beginning of the third. Physical education did continue to play an important part in the upbringing of young people (as the number and luxury of the gymnasia testify), but sculptors no longer devoted themselves to creating new varia-tions of a type already illustrated by such a wealth of masterpieces. What had given these images of naked god or athlete their characteristic quality was the fact that they blended individual and city, city and god, in the same glorification of the male ideal; now far-reaching social and political changes had drained this symbol of its substance.

However, a new model, also blending the real and the ideal, now presented itself: that of the god-king, successor and imitator of Alexander. No royal statue from the third century has survived, but we do have an elegant and virile bronze statuette, now

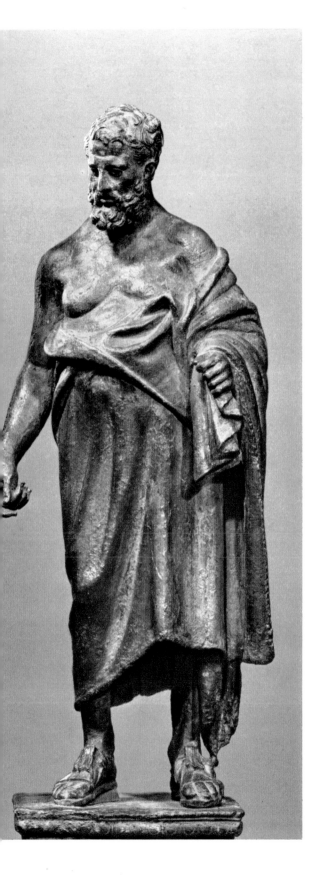

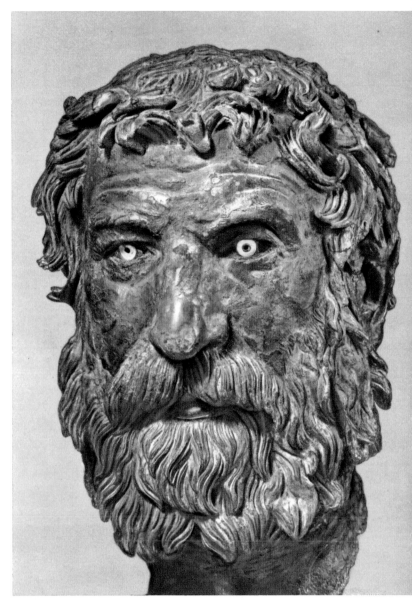

266. ANTICYTHERA, PORTRAIT OF A PHILOSOPHER. NATIONAL MUSEUM, ATHENS.

265. HERMARCHUS(?). THE METROPOLITAN MUSEUM OF ART, NEW YORK.

249

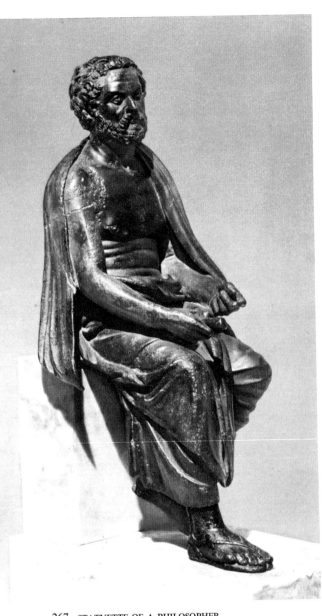

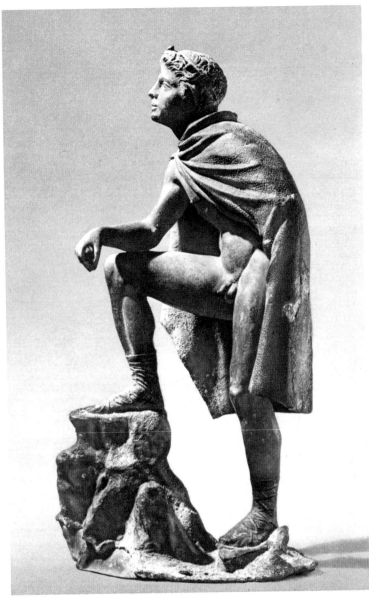

267. STATUETTE OF A PHILOSOPHER.
BIBLIOTHÈQUE NATIONALE, PARIS.

268. HERCULANEUM. DEMETRIUS POLIORCETES.
MUSEO NAZIONALE, NAPLES.

in the Naples Museum, which preserves the general outline of a standing portrait of Demetrius Poliorcetes; and very instructive it is. The type had already been transposed from a relief to three-dimensional sculpture during the fourth century, for a statue of Alexander and for the Isthmian Poseidon attributed to Lysippus. The king wears a stiff felt *chlamys* and the laced boots of a hunter and warrior, his right foot is set on a high rock, and his eyes are raised and gazing into space. Peeping through his hair (bound with the royal fillet) are short bull's horns, an attribute of divinity. The attitude chosen (and imposed upon Teisicrates, the presumed sculptor) and the wearing of a Macedonian *chlamys* hint at the sitter's claim to Alexander's heritage. But this short drapery also introduces an element of reality, at once symbolic and decorative, which implies the renunciation of total nakedness; the relevant iconography must also be added to designate a god or hero.

250

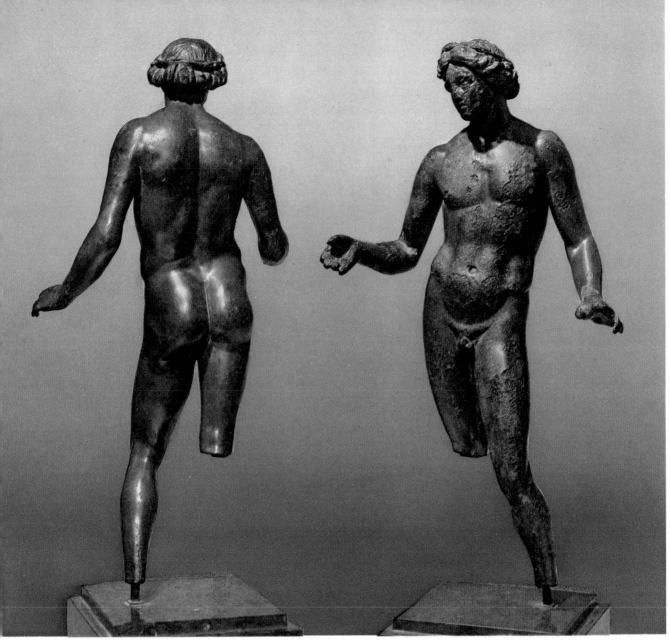

269-270. LA COURRIÈRE. STATUETTE OF APOLLO. LOUVRE, PARIS.

Tradition and New Sensibility

Even among statues of gods those few examples of the male nude that are datable to
the third century should be associated with those who carried on the tradition
established by the great masters in the second – that is, the sons or pupils of Praxiteles
and Lysippus. One bronze statuette (of quite exceptional quality, and perhaps of Greek
workmanship, though found in France) portrays a very tall, slim type of Apollo, arms
held away from the body in an elegantly nonchalant attitude, and with the face
overshadowed by a thick crown of hair, knotted above the nape of the neck in a
chignon. (An identical Apollo, even the hair-style, figures on the coinage of the
Seleucids and of Antigonus Gonatas during the first half of the third century.) The

251

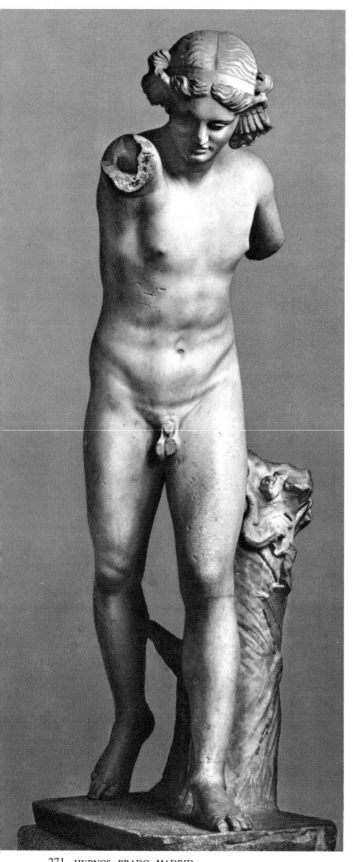

271. HYPNOS. PRADO, MADRID.

252

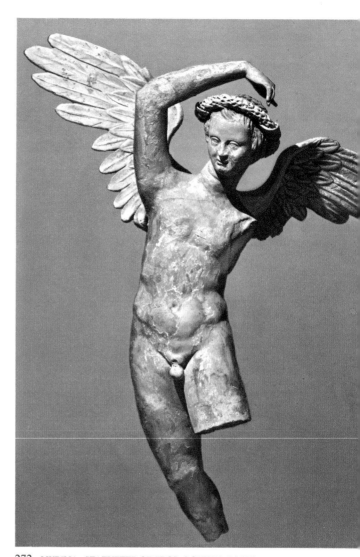

272. MYRINA. STATUETTE OF EROS. LOUVRE, PARIS.

proportions and general outline of the body are in the Lysippean tradition, but the ease of the pose – above all, a certain balance of the shoulders well-suited to those arm-gestures and rippling muscles – implies an influx of vitality that upsets the composition's carefully planned equilibrium.

Another example is a statue of Hypnos (its fame attested by a marble replica in the Prado, numerous bronze copies and a similar reproduction, on a Roman sarcophagus in the Louvre, showing Hypnos and the sleeping Ariadne). The god of sleep appears as an adolescent with a lissom, almost feminine body, stepping lightly and swiftly forward. With rare felicity the actual progress of the movement is suggested: the torso releases the right leg, pivots and leans to the left, indicating – by subtle modulations of curves, hollows and folds – the transition from one step to the next. Whoever created this Hypnos has gone beyond the models provided by Praxiteles, Scopas or Leochares; like the creator of the Apollo, he introduces formal elements worked out during the classical age, but he does so with a wholly new sensibility and a much freer handling of space. But Apollo and Hypnos are both divine figures who still belong to the idealized world. From now on artists pay less attention to such themes, turning instead to reality, scrutinizing the features of individuals and studying the anatomical peculiarities of children, old people, exotic types generally, and every kind of movement.

The appearance of infancy as a theme makes it plain that a real change has taken place, in taste and *mores* alike. It is true that there are numerous representations of Eros dating from the fourth century but they all portrayed the god as an adolescent. One thing is quite clear: those soft, round, childish bodies, with no firmly marked articulations, do not correspond to the long-established Greek tradition of the male nude. Nevertheless, the regular portrayal of the female nude from the middle of the fourth century onwards, Praxiteles' preference for sinuous postures and youthful subjects, and the development of sentimental attitude towards the family were all

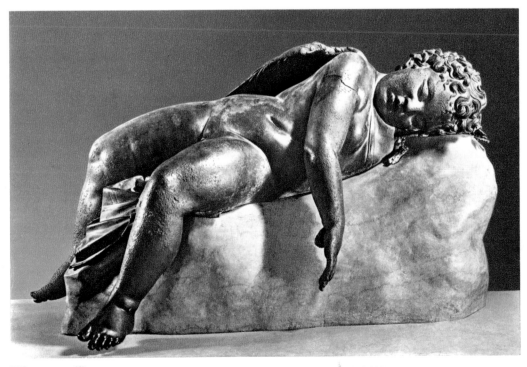

273. RHODES(?). EROS ASLEEP. THE METROPOLITAN MUSEUM OF ART, NEW YORK.

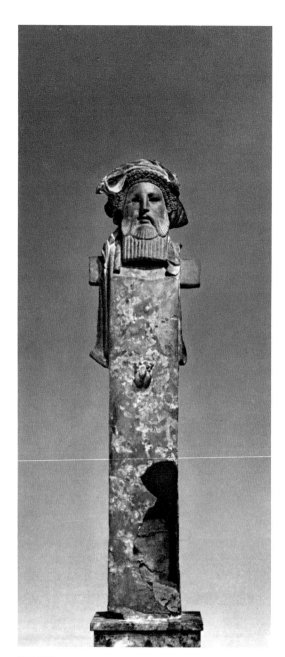
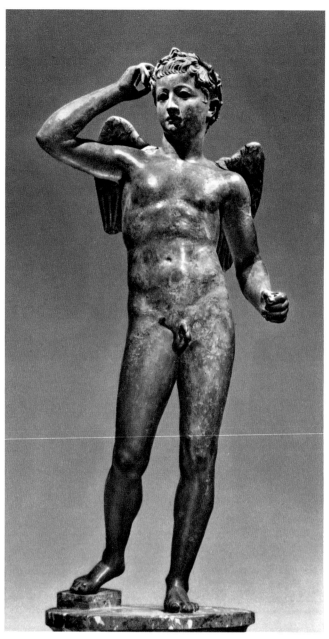

274-275. MAHDIA. BOETHUS OF CHALCEDON: HERM OF A BEARDED GOD AND 'AGON'. MUSÉE NATIONAL DU BARDO, TUNIS.

preparing the ground for an artistic exploration of childhood. There are passages in literature which evoke this new sensibility. An *Idyll* of Theocritus (XXIV) describes Heracles' first exploit, when, aged rather less than one year, he strangled the serpents sent by Hera. Mythology is here transposed into the most domestic terms: Alcmena is a tender mother watching over her children's slumbers, Amphitryon a good husband. About the same period (the first half of the third century), in a *Mime* by Herodas (IV), two women visiting the sanctuary of Asclepius on Cos stop and gaze in admiration at a marble group of a child strangling a goose. ' "You'd think it was about to speak", one of them remarks' (vv. 30-33).

276. TIVOLI. CROUCHING APHRODITE. MUSEO NAZIONALE, ROME

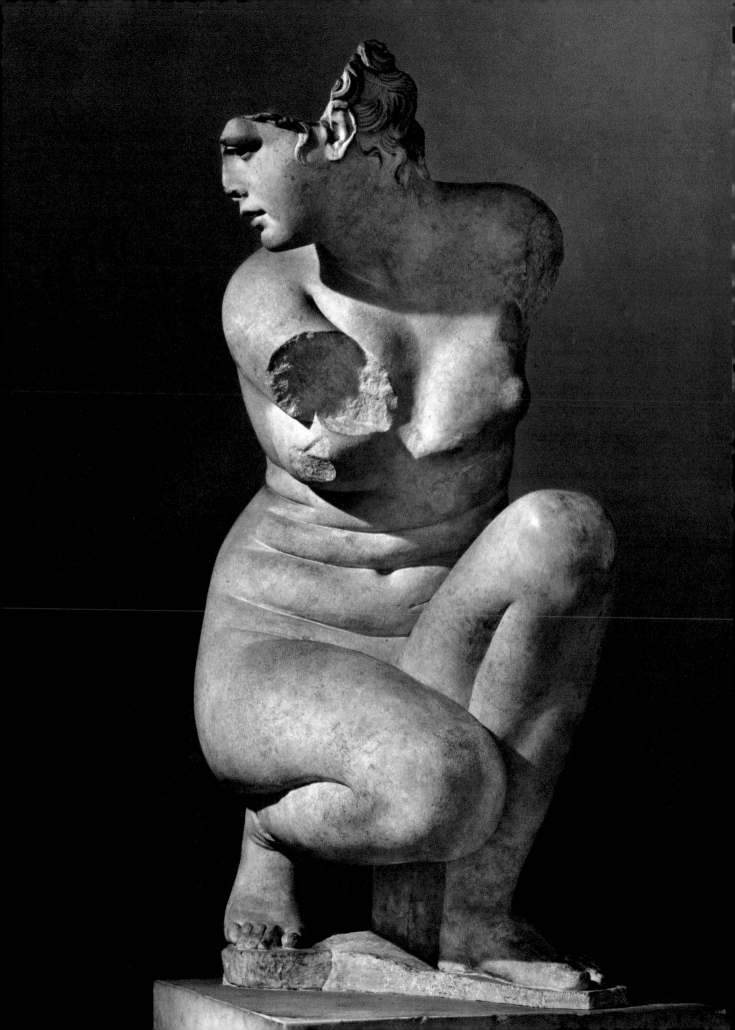

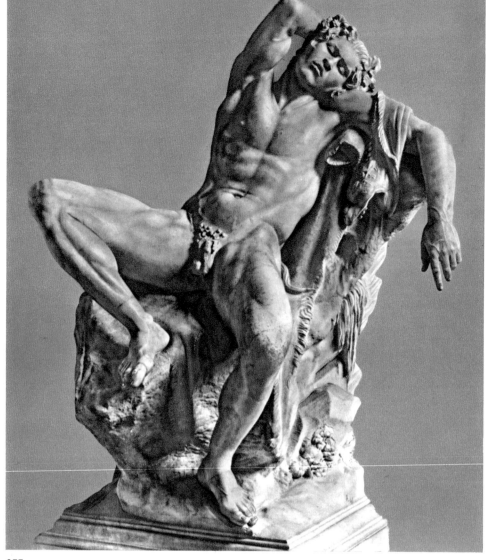

277. ROME. THE BARBERINI FAUN. STAATLICHE ANTIKENSAMMLUNGEN UND GLYPTOTHEK, MUNICH.

A famous statue reproducing this motif is known through several reproductions; the original bronze was undoubtedly contemporary with the work Herodas mentions. Both its concept and the freshness of its naturalism mark this Child with a Goose (see p. 346, fig. 375) as the first in a long and varied line of Amorini and infants which continues beyond the Hellenistic era into Roman sculpture. The name of Boethus – unfortunately there were several such – is associated with this type of subject by ancient sources (cf. Pliny *HN* 34.19.84), and it is not impossible that the artist of the Child with a Goose was the grandfather and namesake of Boethus of Chalcedon, who, shortly before 150, signed a bronze group from Mahdia (now in the Bardo Museum) of a winged genie (Agon?) raising a hand to his circlet as he passes the herm of a bearded god.

The similarity of treatment between the Child with a Goose and the Crouching Aphrodite by Doedalses of Bithynia would seem to favour such a derivation – especially if the goddess was originally accompanied by a little Eros, as several coins of the Empire indicate, and various reproductions (e.g. the Vienne Venus in the Louvre) allow us to assume. Whatever the truth about the *putto*, the plump sensuousness of this Crouching Aphrodite is worth emphasizing.

256

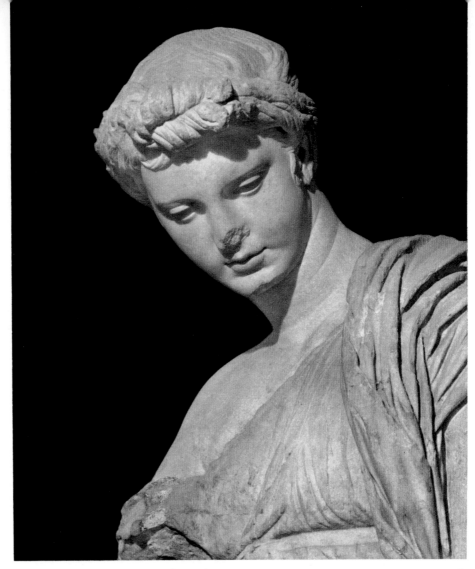

278. HEAD OF THE 'FANCIULLA D'ANZIO'. MUSEO NAZIONALE, ROME.

It is not just a matter of triumphantly affirmed realism. The elasticity of the pose, the pattern formed by the crossed arms (right hand touching left shoulder, the fingers of the left hand brushing the right thigh, a simultaneously graceful and modest gesture), and the long, taut curves reveal a remarkable unity of balance and rhythm. This transforms the motif into pure three-dimensional sculpture: a turning body endowed with that multiplicity (or rather continuity) of aspects through which its independence is established. With the classical revival, at the end of the second century, imitators of this work showed the goddess crouching with her torso to the front and her legs sideways, in the traditional pattern shown in drawings and reliefs; by thinning down the mass of her body, they merely destroyed her monumental equilibrium.

The work of Boethus and that of Doedalses exemplify the same attempt to renovate classical imagery by subjecting it to a more meticulous observation of nature, and, when dealing with divinities, to give it a more familiar or domestic interpretation.

No third-century sculpture, not even the 'Barberini Faun' (now in Munich), reveals more direct contact with reality than the so-called 'Fanciulla d'Anzio'. This depicts a

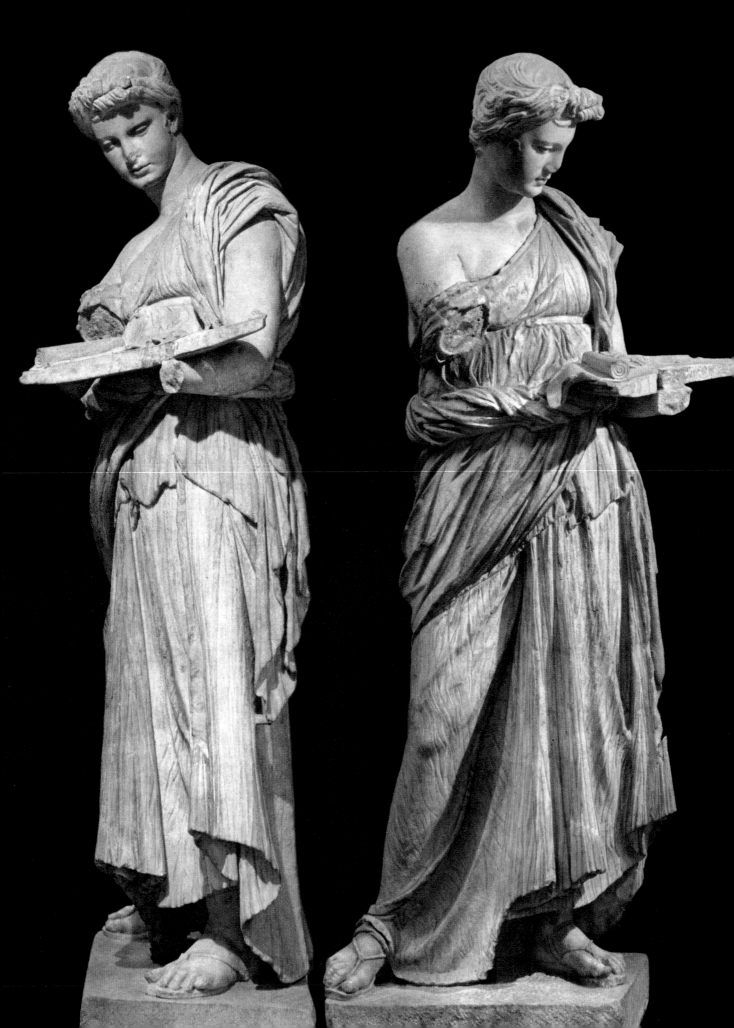

girl with hair dishevelled; her ill-adjusted tunic leaves her right shoulder bare and brushes the ground between her feet; her mantle, flung over her left shoulder, is carelessly bunched up round her waist. She carries a tray on which she has just placed (or from which she is about to remove) certain cult-objects. The work gives an impression of freshness and grace which places it in the climate of Theocritus, and there are, in my opinion, two details which help to fix its date: first, the daring freedom of the coiffure – one of the few statues to parallel this is the Crouching Aphrodite (in the copy from Hadrian's Villa); second, in the neckline of the tunic a strip of material cut on the bias and used to hold the pleats in place. This device came originally from Egypt, but achieved its greatest popularity in Asia Minor, and is clearly recognizable on a faience vase 'with the Queen's portrait' which bears the name of Ptolemy III's wife Berenice. The 'Fanciulla' must have been executed soon after the middle of the third century – and probably in the Greek East, so free is it from classical conventions.

Early Pergamene Influence

The development of an influential art-centre at Pergamum in the second half of the third century B.C. is a historical fact of the greatest importance – less, perhaps, because of the incontestable quality or novelty of the works produced than because of the purpose behind their creation and development, which set in motion, for centuries to come, the vast artistic output of the Graeco-Roman world. It was here, in the last-established of the Hellenistic kingdoms, that art as dynastic propaganda was given its fullest and most brilliant expression; and it was here that artists first began to exploit the classical heritage in a systematic fashion. Philetaerus and his successors attracted the finest artists in the Greek world to Pergamum; coming from many different countries and trained in a variety of traditions, they gradually evolved a homogeneous style which in the reign of Eumenes II (197-159) found magnificent expression in the decoration of the Great Altar of Zeus, and the marble statues of that period.

The original variety of concepts, and the convergence of the lines of innovation and experiment, are attested by two well-known groups: Menelaus and Patroclus (see p. 348, fig. 385) and the Ludovisi Group (fig. 282). There are good reasons for attributing the first group to Antigonus of Carystos and the second to Epigonus of Pergamum, both of whom, along with other sculptors, had been called upon in about 230 B.C. to celebrate Attalus I's victories over the Galatians. The subjects of both works are very similar – a living person supporting a corpse – and such a theme is well calculated to arouse the pity and fear which, according to Aristotle, constitute the mainspring of tragedy. The two compositions are clearly related; both are pyramidal in form and have been conceived in three-dimensional terms, but they represent two distinct formulas. Whereas these are combined in the group representing Niobe and her Children, where the close-knit group of Niobe and her youngest daughter (see p. 347, fig. 381) is counterbalanced by the more open group of the brother and sister, they are used separately by the creators of the Homeric and of the Ludovisi groups respectively. The former is a literate artist, brought up in the great humanist tradition, and full of technical knowledge handed down by Lysippus' successors. The latter takes his subject

directly from life and thus naturally produces a more original version of the theme: passion and despair are externalized without restraint; empty spaces are used to enhance movement and make one feel the breaks in the rhythm; that formidably muscled warrior, triumphant in his nakedness, despite his short floating mantle, is in ostentatious contrast to the slumping cadaver. Nonetheless, one senses an echo of the more violent episodes of the Amazonomachy on the Mausoleum at Halicarnassus; the theatrical impact of gesture and attitude is taken to its utmost. Real exoticism, however, is limited to facial expressions, the disarray (in fact, very cleverly arranged), of the hair and the fringe of the woman's robe.

There is far greater verisimilitude, and a more faithful reproduction of ethnic characteristics, in the Dying Gaul in the Museo Capitolino in Rome, with his coarse features, shaggy hair, lumpish solidity and gaunt, corded muscles. The original of this defeated warrior, with three others in similar poses, was very probably set on top of a

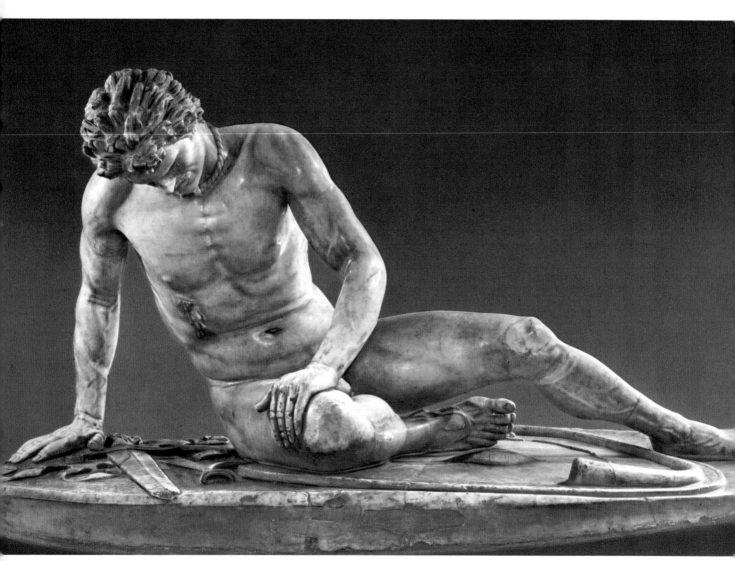

281. DYING GAUL. MUSEO CAPITOLINO, ROME.

282. LUDOVISI GROUP: GAUL KILLING HIMSELF OVER THE BODY OF HIS WIFE. MUSEO NAZIONALE, ROME.

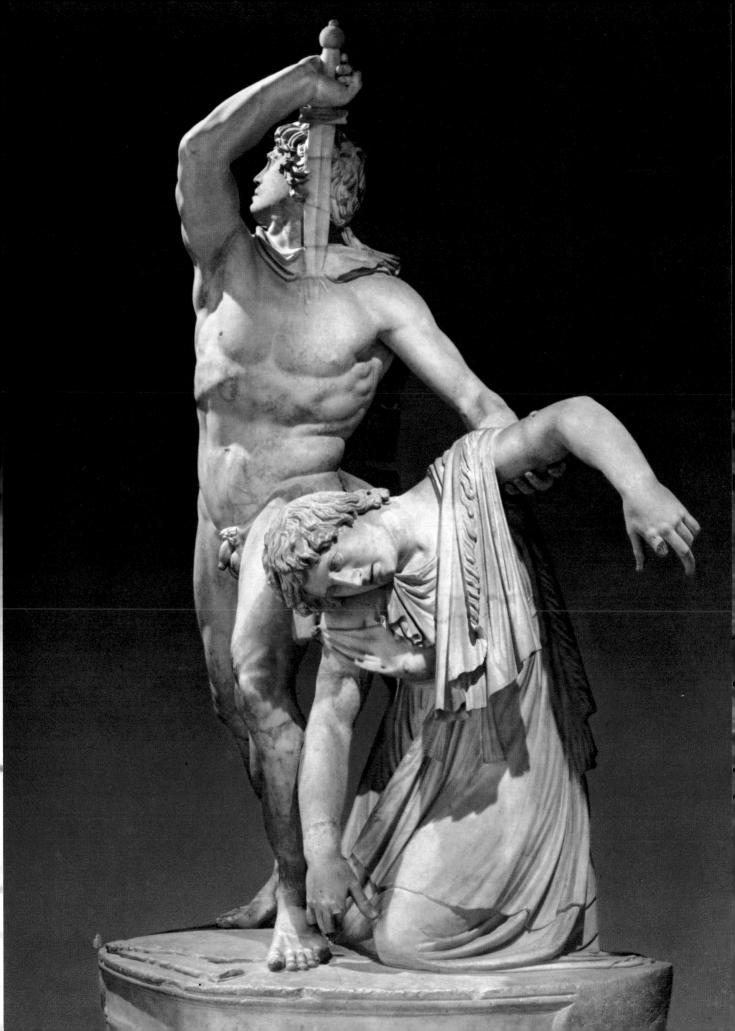

large circular plinth, the foundations of which have been found on the esplanade of the Pergamene sanctuary of Athena. The chieftain stabbing himself over his dead wife would have been placed in the centre of this composition thus bringing out the convergence of its masses and the divergence of its movements (see p. 348, fig. 386). Must we then also attribute the Dying Gaul to the artist responsible for the central group – and with it an accuracy of observation, a restrained and demanding realism seldom found in Hellenistic sculpture? I doubt it. The concept of the monument, with its six figures, belongs to the sculptor in charge of the project (almost certainly Epigonus of Pergamum), but others worked with him, at the king's behest, to embellish the town and its sanctuaries.

The Homeric group, the Ludovisi group, and the Dying Gaul provide examples of styles which, while well differentiated, are nevertheless all dependent on the most precise and demanding observation the Greeks had ever known. The difference lies in interpretation. The first deliberately, and with considerable skill, keeps to the great classical tradition. The theatrical approach of the second is the work of some Asiatic Greek (it has on occasion been described as baroque). The frankness of the third does not altogether ignore traditional work, but subjects its image to those exacting limitations imposed by reality. It has been suggested, convincingly, that the characteristics of these three styles can also be recognized in a much larger group of statues, reproductions of which are dispersed in several museums. This second Pergamene votive offering cannot, however, be assigned to a period immediately following the first, for historical and technical factors suggest it dates from Attalus II's reign (159-138): a fact which demonstrates the persistence of parallel trends throughout the Hellenistic period.

There are other instances, however, where a chronological difference produces completely altered attitudes to the same theme. One example is the musical contest between Marsyas and Apollo, which, during the fourth century, had been depicted in vase-paintings and on one of the reliefs from the Praxitelean 'Mantinea Base' (see p. 242, fig. 259). This was the subject of three statue-groups datable to the Hellenistic period, each one illustrating a different episode in the drama: the audition of Marsyas, that of Apollo, and the punishment of the defeated flute-player. Their main interest is concentrated on Marsyas himself, of whom they offer us three different aspects, or masks. From the first group nothing survives save Apollo's challenger, in a fine reproduction (Rome, Borghese Gallery) ineptly restored with cymbals rather than the double flute which he played as he danced. This Marsyas dates from the middle of the third century and bears a close family resemblance to Theocritus' Polyphemus, who fell in love with Galatea. A wild man, with long, muscular limbs and a powerful torso, whose ugliness and shagginess recall his animal origins, is, at the same time, touchingly naive and, as is clear from his brash defiance, conceitedly confident of his own talent.

There is a striking contrast between this dancing musician and the late third-century Marsyas who is suspended by the wrists and about to be flayed. We pass from descriptive lyricism to tragedy, where pity and terror are given full play. Marsyas' tortured body is observed in the most meticulous anatomical detail, and the crouching posture of the Scythian, sharpening his hunter's knife, is rendered with strict verisimilitude. Even the dramatic effect is original, for – whereas Menelaus and Patroclus, or

283. ROME, SCYTHIAN EXECUTIONER. UFFIZI, FLORENCE.
284. MARSYAS HANGED. LOUVRE, PARIS.

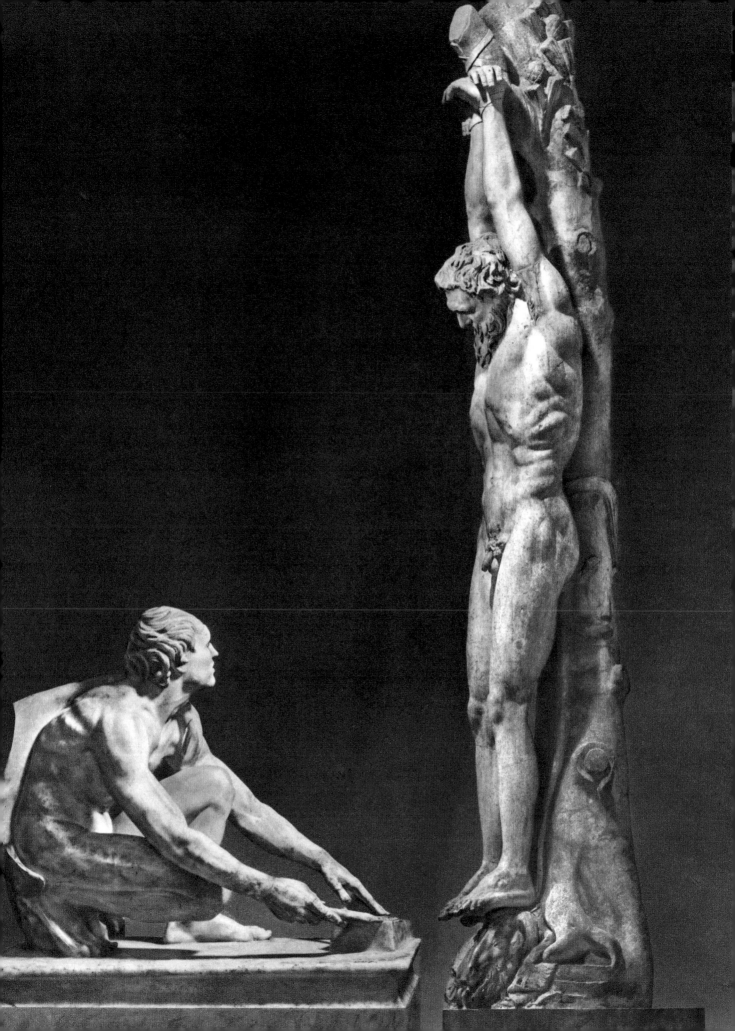

the Gaul and his wife are united, even after death, by ties of affection and race – victim and executioner (as here conceived by the sculptor) have nothing in common save the dreadful act now imminent. All trace of animality has vanished from Marsyas' suffering frame; his features are stamped with noble resignation, and the lines on his cheeks and forehead foreshadow the most moving faces of the Gigantomachy at Pergamum, while the Barbarian in Apollo's service comes about as near the brute beast as one could conceive.

It is not certain whether Apollo figured in the 'torture' group; but he was undoubtedly present in a third group, which can be more or less restored as follows. Naked and erect, he has just finished his recital. A seated Muse looks at him in admiration; Marsyas already knows he is beaten, but raises his head defiantly, lips parted for a curse. The figures are grouped and treated in that eclectic manner typical of the second century. The god, with his bland features, is an early example of neo-Attic style, while on Marsyas' torso the arch of the rib-cage and the ribs themselves follow a stereotyped pattern derived from Pergamene nudes. Thus the Marsyas legend finally ran its course, both sculpturally and spiritually, in that atmosphere of lassitude and decadence which was engulfing the Hellenistic kingdoms generally. The theme became impoverished for the lack of any fresh inspiration, and the only way in which the figures could be further developed was by the artificial device of stylistic variations – detrimental to the sculptural unity of the group, as well as to its dramatic impact.

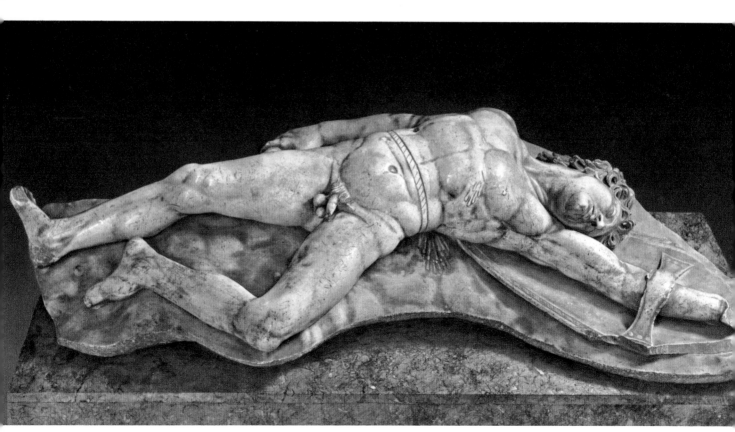

285. DEAD GALATIAN. MUSEO ARCHEOLOGICO, VENICE.

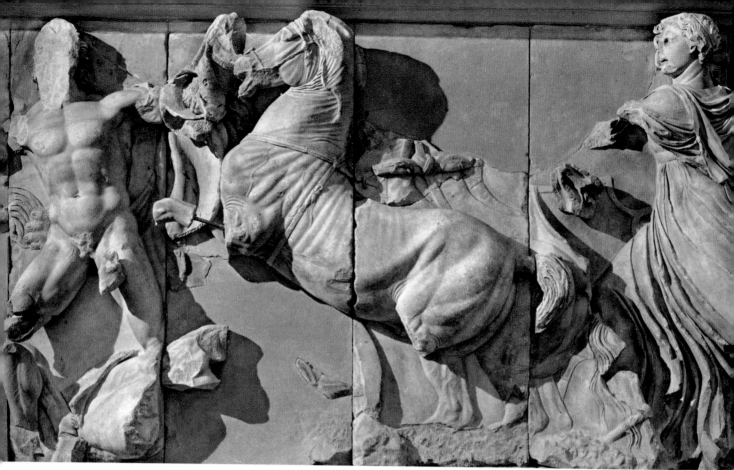

286. PERGAMUM, GREAT ALTAR. GIGANTOMACHY (BATTLE OF GODS AND GIANTS), SOUTH FRIEZE (DETAIL): HELIOS IN HIS CHARIOT. STAATLICHE MUSEEN, BERLIN.

The Friezes of the Pergamum Altar

The masterly representation of the hanged Marsyas had been created in the fever of an inspiration, at once violent and munificent, aroused by tumultuous wars and stimulated by artistic rivalry. In 188 B.C., nearly half a century later, Eumenes II of Pergamum was at the height of his power and doing all he could to promote himself as the standard-bearer of Hellenism in Asia. In honour of Athena 'the bringer of victory' (*nikephoros*), the patron deity of his kingdom's capital, he instituted a regular festival, the *Nikephoria*, which soon achieved Panhellenic status. On the acropolis, the old citadel was replaced by a vast, multi-level complex of decorative marble buildings. Throughout history, large-scale building projects have proclaimed the power and ambition of monarchs, and their significance acquires maximum force when amplified by the multiple resonances of a plastic language at once new and traditional. Above the steep wedge-shaped tiers of the theatre's cavea, a little below and to the south of the vast esplanade on which Athena's sanctuary stood, a new terrace was levelled out. At its centre was the Great Altar of Zeus. This traditional title does not, in fact, adequately reflect the monument's historical and religious significance. The patron goddess of Pergamum was also that of Athens, and the Athena who appears on the Gigantomachy of the Great Altar (east frieze) is shown in the same pose as the one on

265

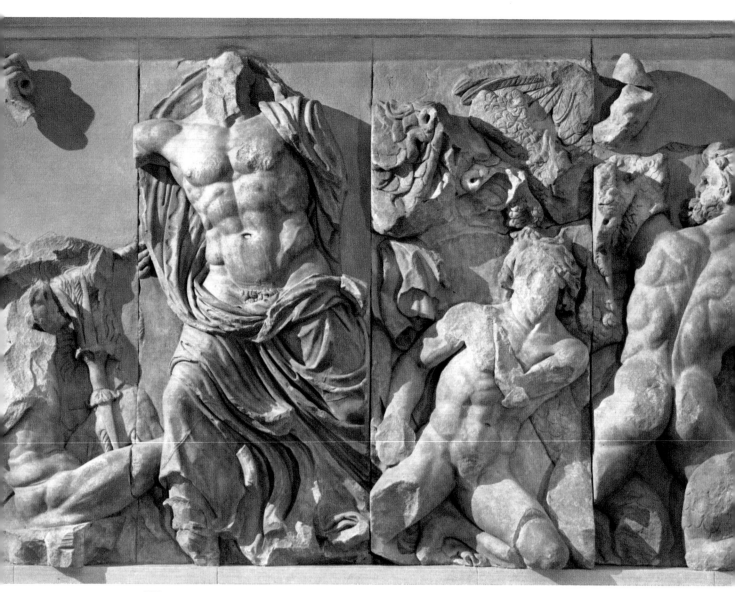

287. PERGAMUM, GREAT ALTAR. GIGANTOMACHY, EAST FRIEZE (DETAIL): ZEUS AND PORPHYRION.
STAATLICHE MUSEEN, BERLIN.

the west pediment of the Parthenon – clearly a deliberate and significant reference.
There is, however, one change. The god who forms her counterpart is no longer,
Poseidon, as at Athens, but Zeus, and this substitution, too, is important. Through the
medium of art and mythology Eumenes II was inviting the Attic genius and Olympic
Panhellenism to take up residence on his acropolis. The struggle between gods and
giants was a clear allusion to the Pergamene dynasty's victories over the Galatians, but
at the same time it powerfully recapitulated the most glorious canto from the legend of
the Greek gods. Moreover, on the frieze of the inner portico of the Great Altar were
portrayed the adventures of Heracles' son, Telephus, miraculously transported from
Arcadia to Mysia, where he became king and founded a dynasty; by linking his own
dynasty with this heroic line, Eumenes was laying claim to divine descent – Heracles
being the son of Zeus. The subtler implications of this visual propaganda elude us, but

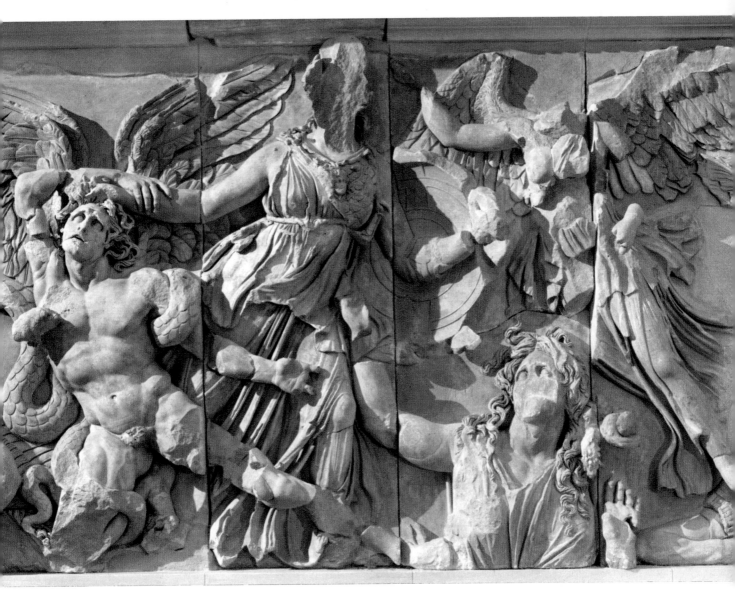

288. PERGAMUM, GREAT ALTAR. GIGANTOMACHY, EAST FRIEZE (DETAIL): ATHENA AND ALCYONEUS, GE AND NIKE.
STAATLICHE MUSEEN, BERLIN.

it has nonetheless given rise to two compositions (both in an uneven state of preservation) of major interest for the history of Hellenistic art.

After the hiatus of the third century, the Gigantomachy returns to the technique and function of the monumental relief. It is a colossal base-frieze running round the north, east, and south sides of the structure and, on the west, skirting the two wings flanking the great stairway to the platform of the altar proper. The retaining wall is largely filled with a vista of figures, their torsos almost invariably shown in frontal or rear view. Decorative details are used mainly to enliven the somewhat shadowy background. This throws into relief the vigorous modelling of the nudes and the deep furrows of the drapery, which punctuate the movement at intervals and, despite the frenzy of the action, impose an essentially architectonic character on the composition. The resumption of a theme borrowed from age-old mythology (thirty or forty years after Epigonus

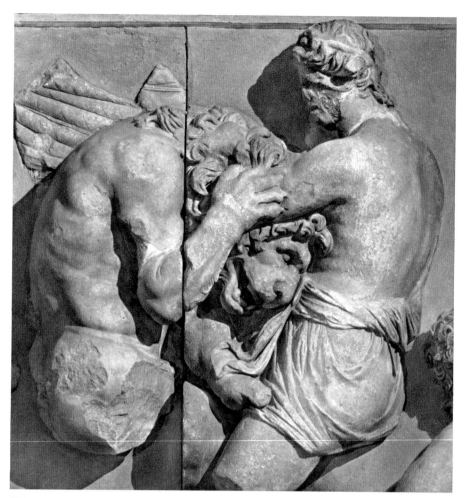

289. PERGAMUM, GREAT ALTAR. SOUTH FRIEZE (DETAIL): AETHER FIGHTING A GIANT.
STAATLICHE MUSEEN, BERLIN.

had based the figures of his great ex-voto, dedicated to Athena, on direct observation of combat) can also be linked to the deeply rooted tradition of addressing gods in their own appropriate language. Never before, however, had a sculptural rendering of the conflict between gods and giants included so many figures – every god and giant is meticulously characterized, the hallmark of that mythological erudition which proliferated during the third and second centuries, based on the poems of Homer and Hesiod. Never, furthermore, had the typological canon departed more widely from fifth-century Atticism, or borrowed so much (even in the Archaic period) from stock Oriental motifs.

One's first impression is that the animal element predominates over the human – or at least that its basic power both threatens and permeates the human form. The limbs of numerous giants are prolonged as scaly serpents which flourish open, threatening mouths at the end of their coils. One human torso thickens out at neck and shoulders to reveal bull's horns sprouting above a still partially human face, and another giant has the head and paws of a lion. Poseidon's chariot is drawn by sea-horses (*hippocampi*), their equine forequarters equipped with sharp fins. Some giants, and several gods and goddesses, are winged, as are the horses of Hera's chariot. This more or less

290. PERGAMUM, GREAT ALTAR. GIGANTOMACHY, EAST FRIEZE (DETAIL): ALCYONEUS. STAATLICHE MUSEEN, BERLIN.

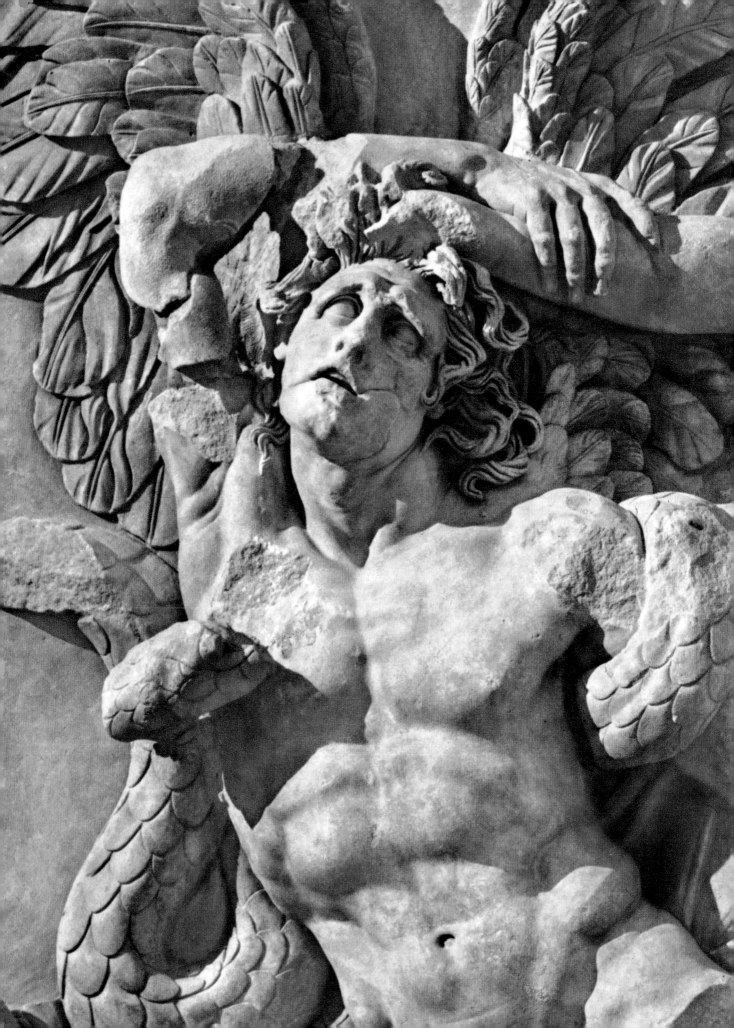

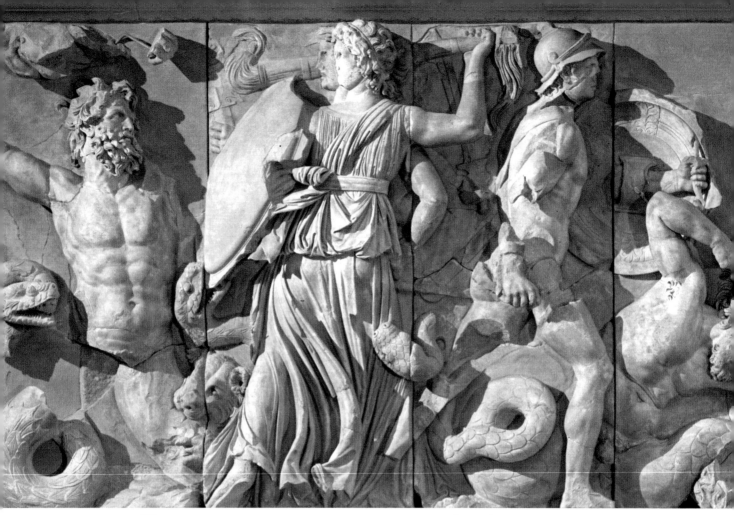

291. PERGAMUM, GREAT ALTAR. GIGANTOMACHY, EAST FRIEZE (DETAIL): THE TRIPLE HECATE AND CLYTIUS, OTUS AND A FALLEN GIANT. STAATLICHE MUSEEN, BERLIN.

composite bestiary drawn from three elements – earth, air and water – is reinforced by lions, horses and dogs, attendants or companions of certain divinities. In this context the Olympians only defeat the Titans (their own brothers or kinsmen, according to the ancient Theogony) by preserving a part of their own animal nature of by allying themselves with the beasts they have tamed. Furthermore, the way these gods brandish their weapons suggests the implacable ferocity of a squaring of dynastic and familial accounts. Such imagery is clearly more at home in Greek Asia Minor than on the mainland. Yet its arrangement, its theatrical aesthetics and its humanism are all incontestably Greek; even without taking into account the reference of the groups of Zeus and Athena on the east side to the central group on the west pediment of the Parthenon, the associative principle emerges clearly enough. Most of the chief Olympians (including Athena and Zeus) are on the east face, and each of the other sides was, by and large, peopled with generically similar deities: of sky and light (south face); of darkness and water (north face); sea-dwellers, moving round from the north, continue their combat on the west face, while, on the other side of the steps, Dionysus and his rout of satyrs and nymphs mingle with protagonists from the south. The general conflict consists of individual confrontations, all following a rhythm of flux and reflux, of alternately convergent and divergent diagonals. The close pattern is interrupted here

270

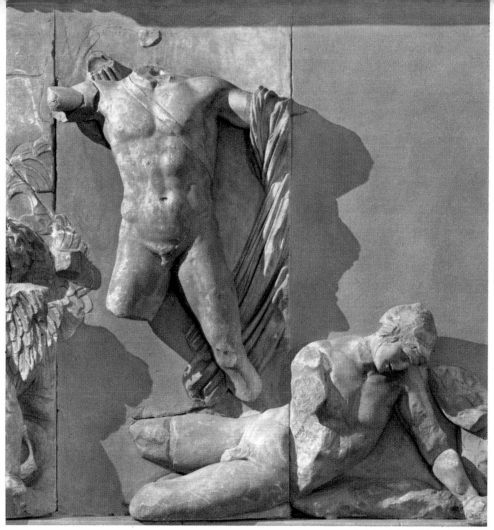

292. PERGAMUM, GREAT ALTAR. GIGANTOMACHY, EAST FRIEZE (DETAIL): APOLLO AND EPHIALTES. STAATLICHE MUSEEN, BERLIN.

and there – by an emphatic, sweeping gesture (that of Zeus, or the handsome naked Apollo); by the passing of a chariot or by opulent and seemingly conciliatory goddesses such as Cybele, Eos or Selene riding through the throng; or by some fine figure, like Helios or Nyx (Night), with heavily shaded and highlighted draperies.

Late third-century sculpture had already reflected the anatomical knowledge gained from dissections carried out by two doctors, Herophilus and Erasistratus. The precision thus bestowed upon the male nude made possible a flexibility of movement and a range of relief effects here sometimes indulged to excess; but sometimes, as in the group of Apollo and his adversary, there was a clear reversion to the sobriety of the classical 'grand style'. As for the female deities, whatever conscious variations of drapery and hair-styles they may reveal, they are almost always equal in stature with their male companions, and they plunge into the fray with the same vigour, the same murderous gestures, and the same powerful strides.

Behind the work of a large number of executants (not all equally skilled) we sense the presence of a master-sculptor; behind the renewal of the old legend by means of exotic and ferocious detail, we still perceive the entire history of Hellenism. Certainly the myth is humanized – or perhaps one should rather speak of the transposition into

271

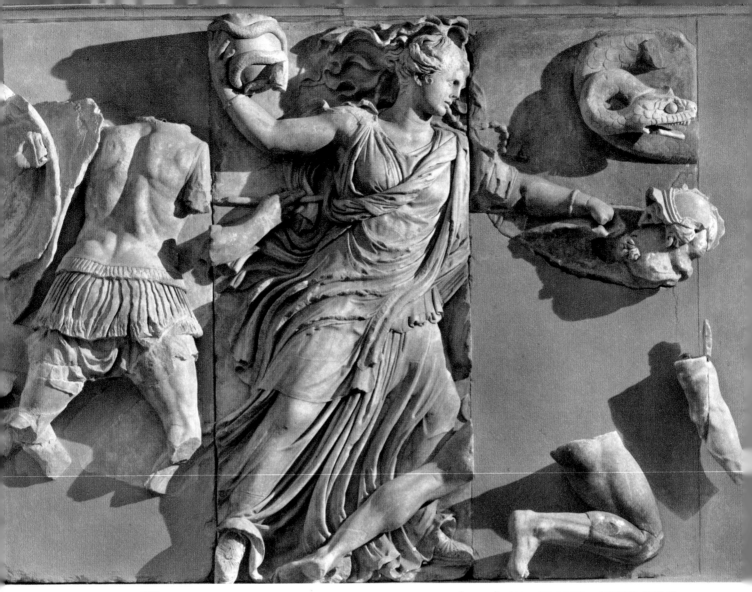

293. PERGAMUM, GREAT ALTAR. GIGANTOMACHY, NORTH FRIEZE (DETAIL): NYX. STAATLICHE MUSEEN, BERLIN.

the ideal mythic world of an event both imagined and, to give it some semblance of authenticity, described with realistic detail – and the action is shaped and coloured by the period and place in which this new interpretation was born. The Pergamum Gigantomachy shows the metamorphosis Hellenism underwent as it spread throughout the Mediterranean world; yet, despite all appearances, that fundamental humanism which characterized the Greek genius still survives here. It comes out in the beauty of the faces, the vigour and harmony of the bodies (even when they end in reptilian coils or sea-horses' hindquarters) and the richness and rhythm of the draperies; it shows in the *civilizing* nature of the action (taming the animal world and defeating those monstrous emblems of chaos) and even in the pathetic dignity of the conquered, towards whom the spectator's sympathies are drawn. This generous and prophetic humanism prefigures the Adam of the Sistine Chapel and François Rude's bas-relief *La Marseillaise* which, unknown to their creators, were descendants of a line transmitted from the pagan to the Christian world by a flood of images emanating from Pergamum.

294. PERGAMUM, GREAT ALTAR. GIGANTOMACHY, NORTH FRIEZE (DETAIL): THE FACE OF NYX. STAATLICHE MUSEEN, BERLIN.

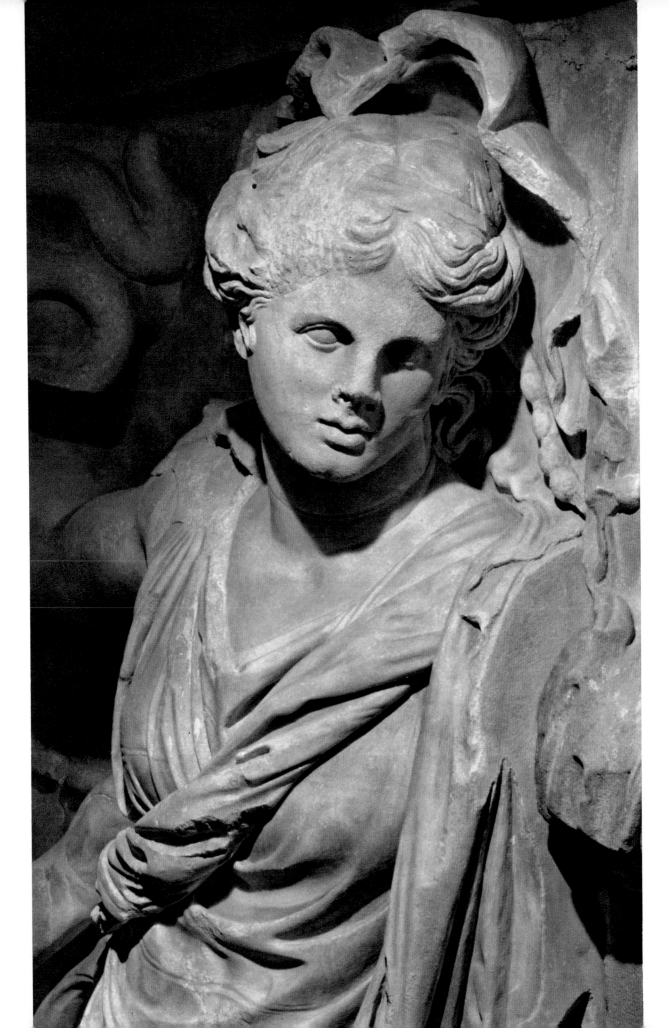

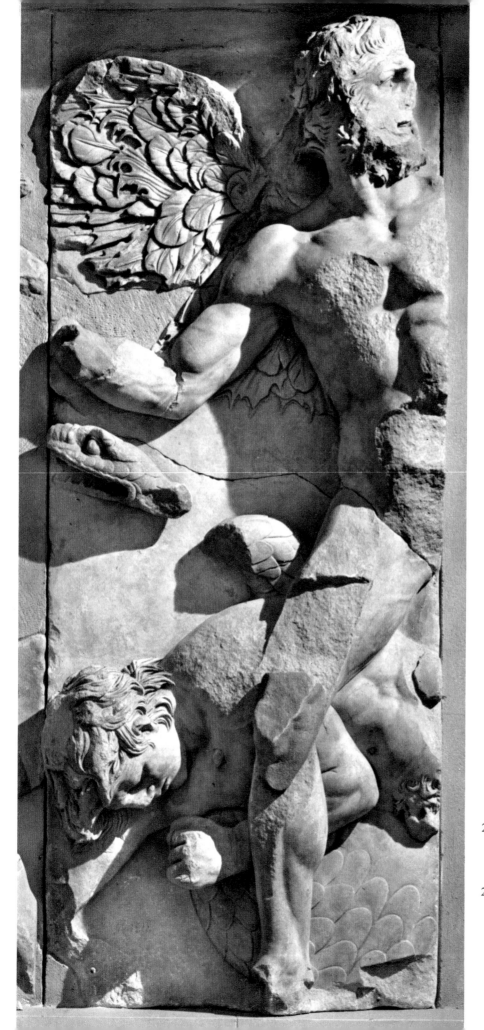

295. PERGAMUM, GREAT ALTAR.
GIGANTOMACHY, SOUTH FRIEZE
(DETAIL): WINGED GIANT.
STAATLICHE MUSEEN, BERLIN.

296. PERGAMUM, GREAT ALTAR.
GIGANTOMACHY, NORTH FRIEZE
(DETAIL): COMBAT BETWEEN A
GODDESS WITH A LION AND A
GIANT. STAATLICHE MUSEEN,
BERLIN.

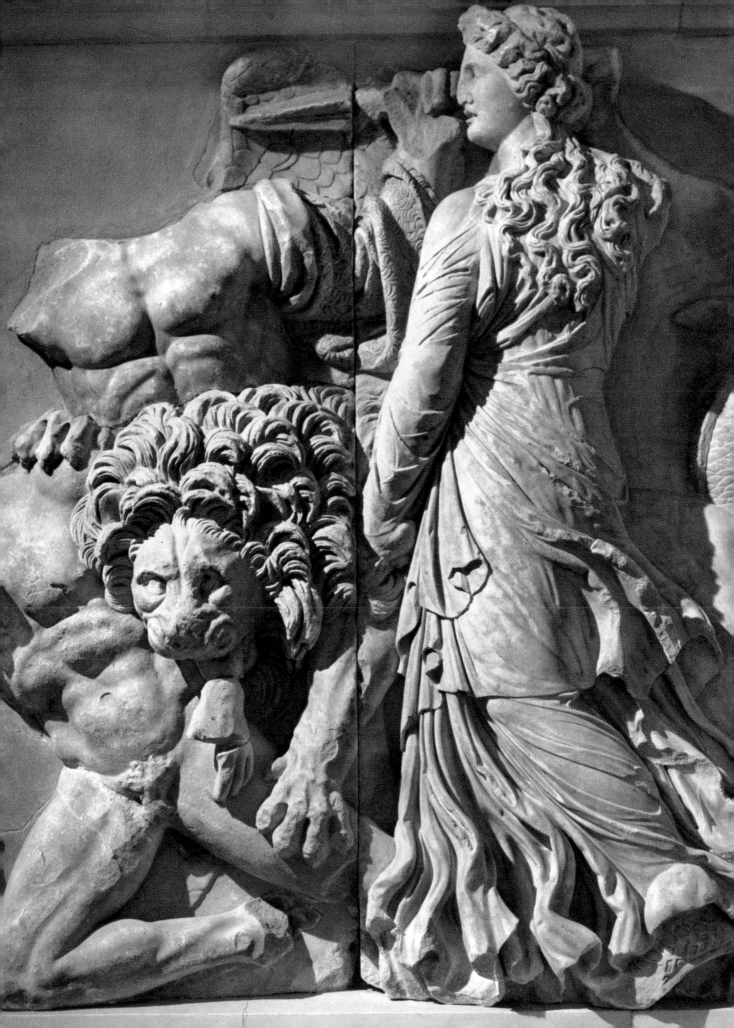

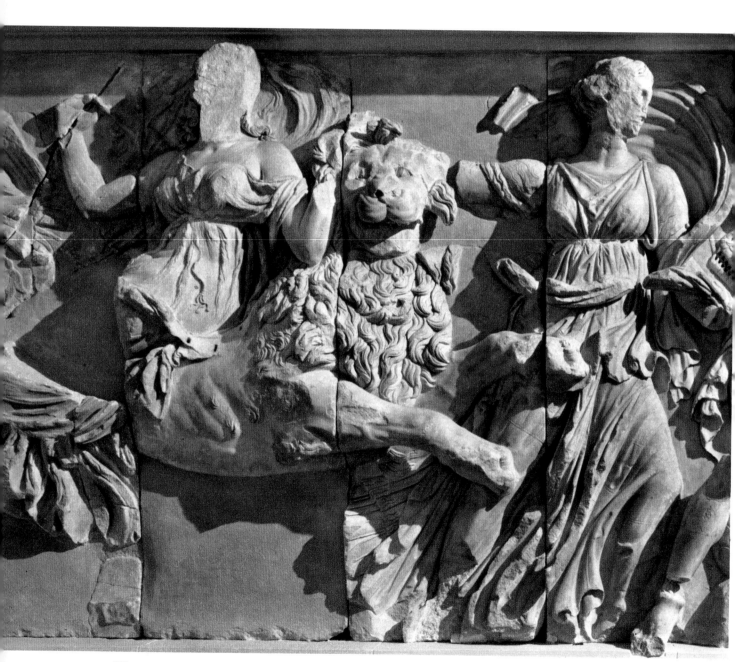

297. PERGAMUM, GREAT ALTAR. GIGANTOMACHY, SOUTH FRIEZE (DETAIL): RHEA AND ADRASTEIA. STAATLICHE MUSEEN, BERLIN.
298. PERGAMUM, GREAT ALTAR. GIGANTOMACHY, SOUTH FRIEZE (DETAIL): HEAD OF THE GIANT CLYTIUS. STAATLICHE MUSEEN, BERLIN.

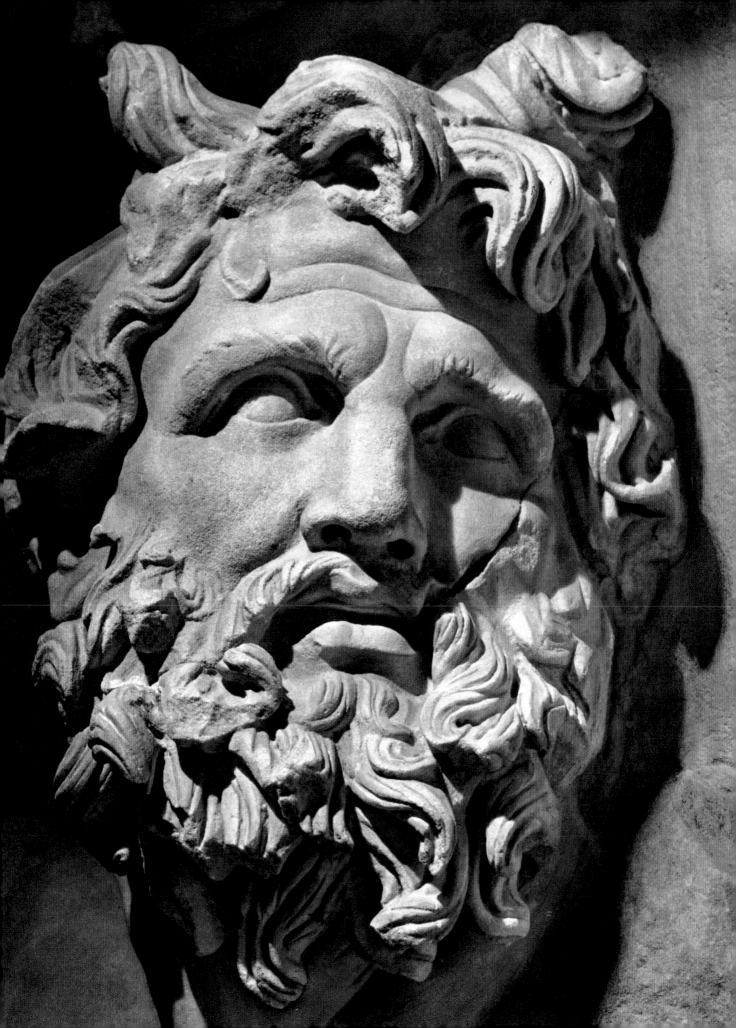

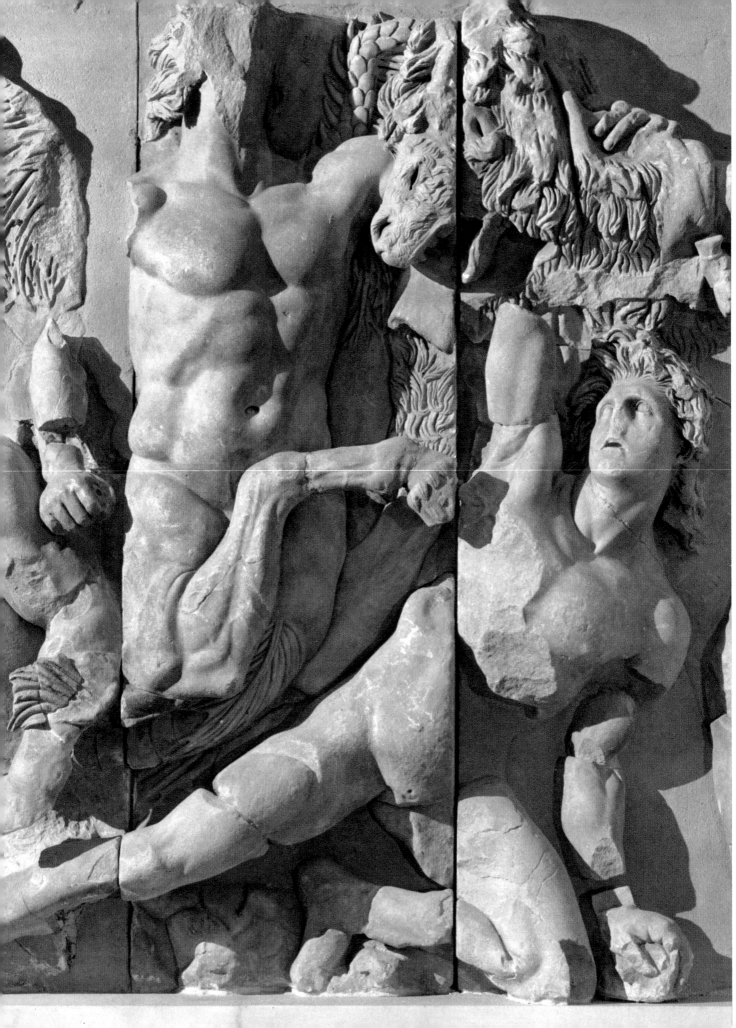

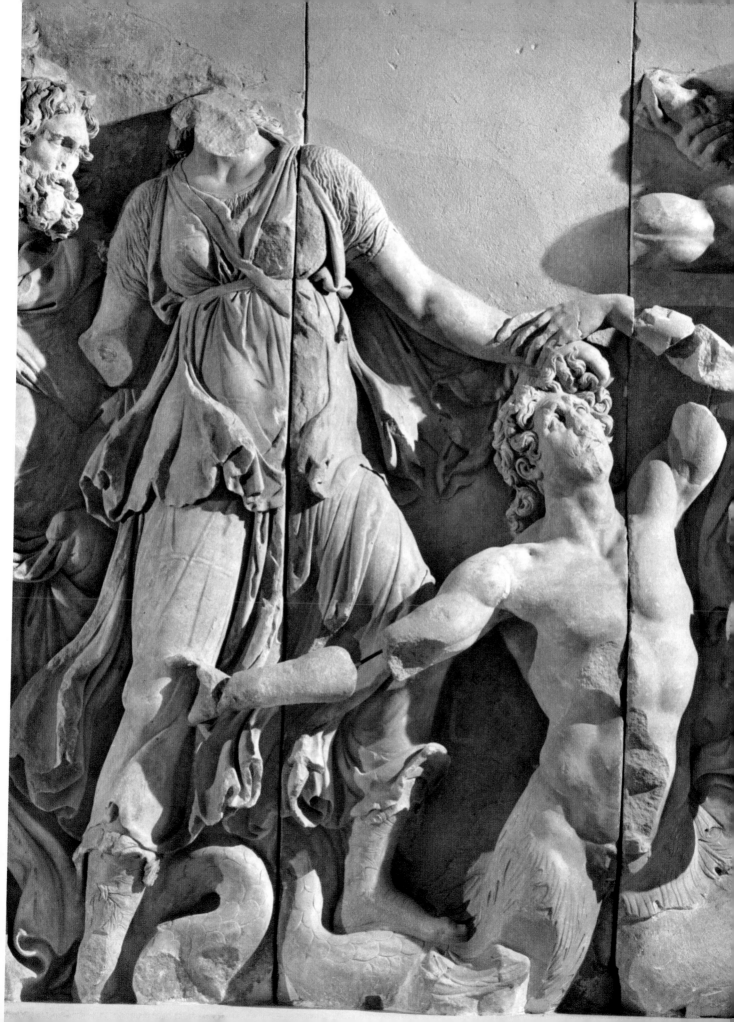

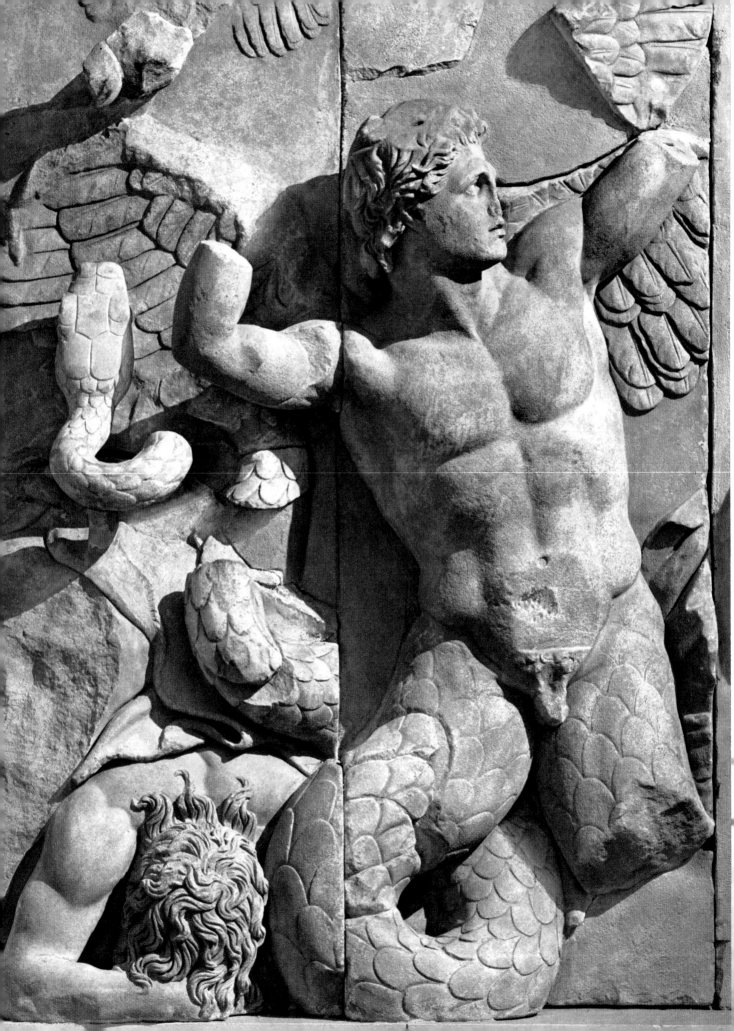

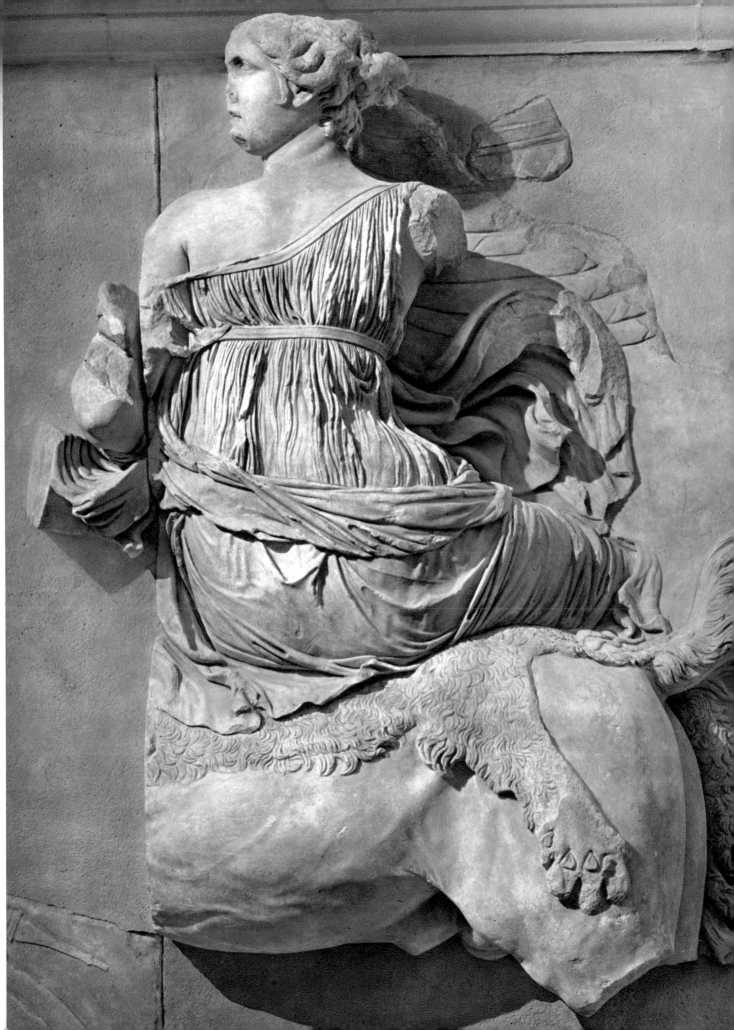

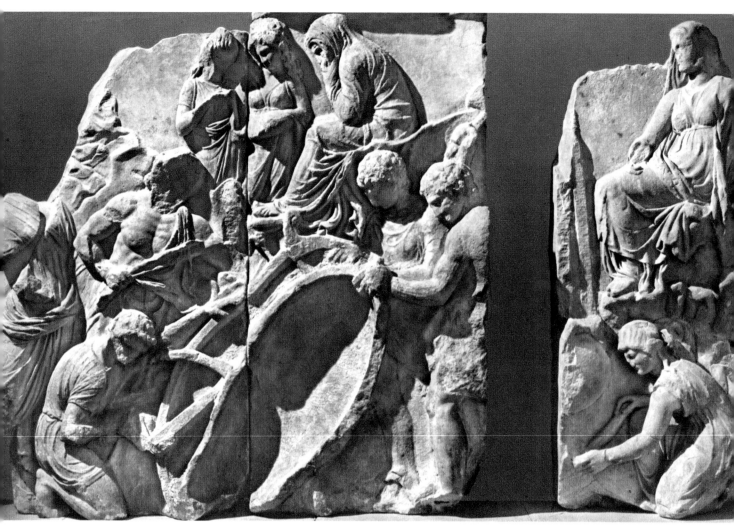

303. PERGAMUM, GREAT ALTAR. TELEPHUS FRIEZE (DETAIL): THE BUILDING OF AUGE'S BARK.
STAATLICHE MUSEEN, BERLIN.

 The Telephus frieze, designed for the back wall of a portico which ran round three sides of the upper platform of the Great Altar, makes a striking contrast with the great base-frieze. It is not simply a question of subject-matter but also of technique and method of composition. Greek monumental sculpture had hitherto been subject to a basic law laying down, *inter alia*, that decorative and architectural elements should match each other. Here, on the contrary, the height of the frieze has been determined quite arbitrarily. In addition, the height of the frieze does not determine that of the figures. These are disposed with considerable irregularity, sometimes spread out on two or even three levels with none ever occupying more than two-thirds of the vertical space. Trees or architectural motifs fill the gaps above their heads and suggest open, unencumbered space. There is an obvious analogy with painting here. A few votive reliefs had pointed the way in the fourth and third centuries, but here we move from the small sculpted picture to the fresco-in-relief, which implies a conscious willingness to confuse the *genres*. By adopting a plastic composition in imitation of painting (not simply embodying pictorial effects), the artist has abandoned the principle of differen-

301. PERGAMUM, GREAT ALTAR. GIGANTOMACHY, NORTH FRIEZE (DETAIL): WINGED GIANT. STAATLICHE MUSEEN, BERLIN.
302. PERGAMUM, GREAT ALTAR. GIGANTOMACHY, SOUTH FRIEZE (DETAIL): SELENE. STAATLICHE MUSEEN, BERLIN.

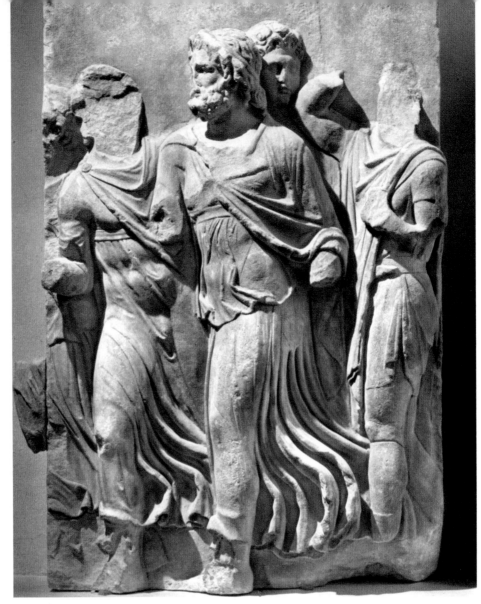

304. PERGAMUM, GREAT ALTAR. TELEPHUS FRIEZE (DETAIL): TEUTHRAS AND HIS TRAIN. STAATLICHE MUSEEN, BERLIN.

tiation which laid down an appropriate language for each *genre*. The mixture of techniques both hinders the deployment of colour and breaks up the sculptural rhythm.

Since the colouring has vanished, we can no longer appreciate the pictorial qualities of this frieze; on the other hand, those elements that do survive enable us to appreciate its composition and plastic achievement. It takes the form of an illustrated story in which episodes are denoted by a tree, a column, a pillar, or simply by the back-to-back juxtaposition of the last figure in one scene and the first in the next. Contrary to the classical principle which imposed the unity of a timeless action, and set it against a neutral background, this visual chronicle unfolds within a context of real space and time. Instead of a series of attitudes all harmonized by the same rhythm, as in a classical frieze, we get an instantaneous vision of attitudes (both static and moving), evoked and linked by the action yet remaining very different, their diversity reflecting the variety of actions, feelings and positions – moral or social – of the persons involved.

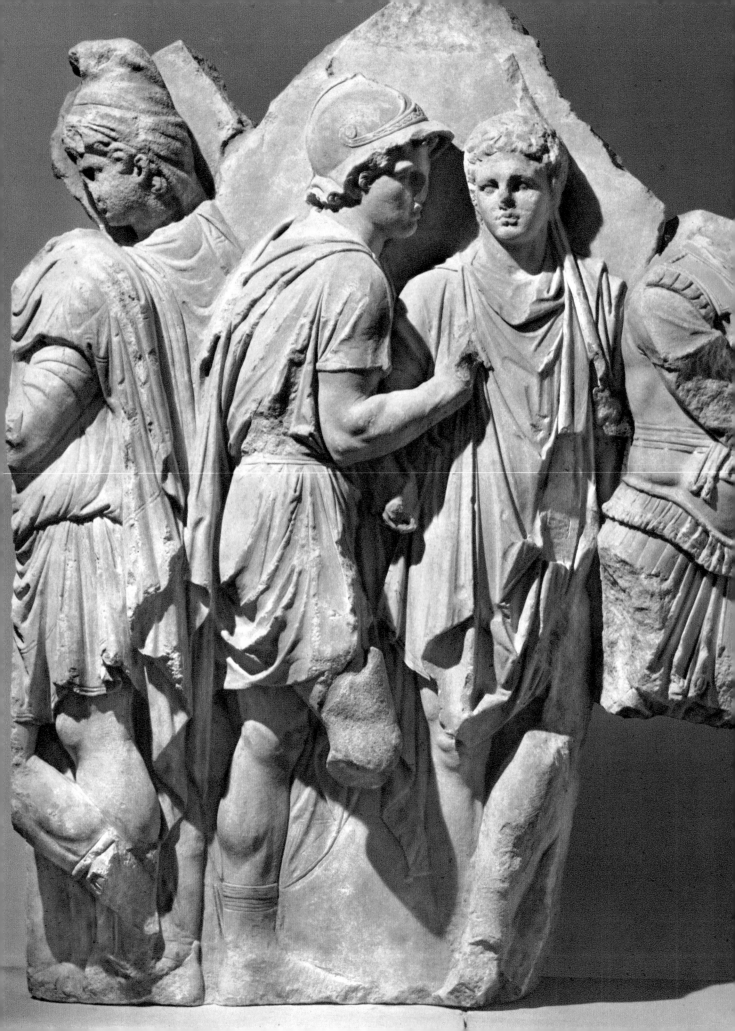

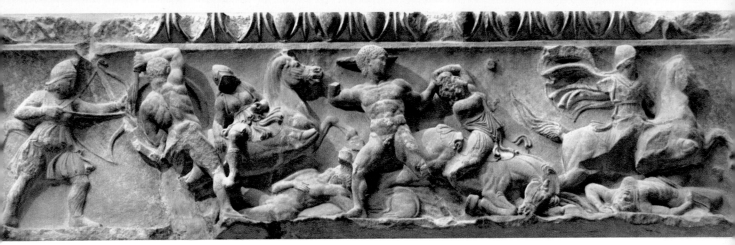

306. MAGNESIA-AD-MAEANDRUM, TEMPLE OF ARTEMIS LEUCOPHRYENE. AMAZONOMACHY. LOUVRE, PARIS.

The dialogue of plastic expression is here replaced by a picturesque narrative to be read from left to right, exactly as with writing, beginning on the north wall. Tragedy has been succeeded by an epic revival. Yet this is an anecdotal, almost domestic, epic, very much in line with Alexandrian poetry as we know it from the works of Theocritus and Callimachus; a romantic epic, its plot studded with oracular prophecies, unforeseen encounters and predictable recognition-scenes (which nevertheless keep the reader, or spectator, in suspense till the last possible moment). On the frieze as in the poems, legend takes on the colour and accent of daily life, with its picturesque details, its amused (or sentimental) prettiness. The tragic or cruel event loses its edge, and one follows the sequence of episodes with more curiosity than emotion.

The two friezes of the Great Altar at Pergamum, each in its own *genre*, constitute a remarkable achievement: all the more striking in that the friezes of later Hellenistic temples (which one might, at first, be tempted to relate to them) look banal or mediocre by comparison. The Amazonomachy from the Ionic temple of Artemis Leucophryene in Magnesia-ad-Maeandrum (now in Paris, Berlin, and Istanbul) reveals a mere mechanical adoption of motifs that had been repeated for the past three or four centuries; it has benefited very little from the new attitudes and groupings to be seen at Pergamum. The frieze from the temple of Hecate at Lagina, near Stratoniceia in Caria, is more skilfully executed, while the Gigantomachy along the west side, and various other groups of divinities or personifications portrayed elsewhere, undoubtedly contain a number of Pergamene reminiscences. Yet the images for the most part remain static, paratactic; they have no physical 'presence', and lack a sense of living reality.

Nevertheless, this new concept of monumental decoration (which the Telephus frieze, exemplifies so well) subsequently enjoyed considerable vogue over a long period. Examples from both Roman and Renaissance art are plentiful – I need only mention Trajan's and Marcus Aurelius' columns in Rome, and Ghiberti's famous doors for the Florence Baptistry. Whether Pergamum should be given sole credit for the invention is another question, for it is difficult to estimate just how original any given art-centre may have been during the Hellenistic period. Picturesque and anecdotal qualities were also appreciated elsewhere – at Rhodes, and above all at Alexandria – and we lack sufficient evidence about the possible influence of other *ateliers*, whether in Greece proper or in the Hellenized East.

305. PERGAMUM, GREAT ALTAR. TELEPHUS FRIEZE (DETAIL): TELEPHUS AND HIS COMPANIONS IN MYSIA.
STAATLICHE MUSEEN, BERLIN.

285

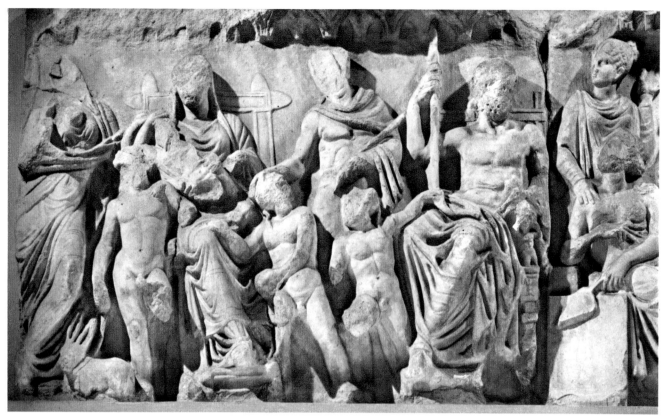

307. LAGINA, HECATAEUM. SOUTH FRIEZE (DETAIL): LOCAL DIVINITIES AND HEROES. ARCHAEOLOGICAL MUSEUM, ISTANBUL.

308. RHODES(?). VOTIVE RELIEF WITH DIVINITIES. STAATLICHE ANTIKENSAMMLUNGEN, MUNICH.

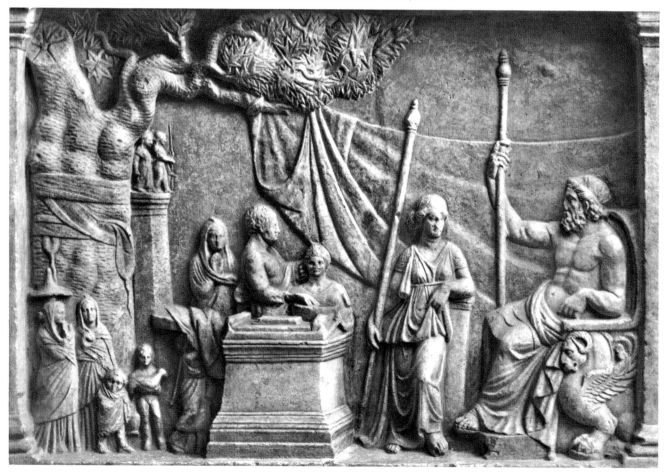

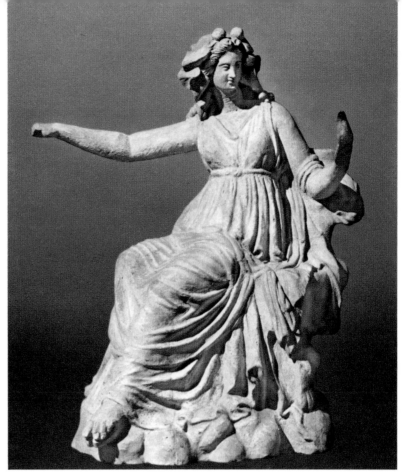

309. MYRINA. SEATED MAENAD. LOUVRE, PARIS.

Second-century Trends

The Victory of Samothrace and Other Draped Statues

There is a specific historical connection between the Victory of Samothrace and the Great Altar of Pergamum. In 190 B.C. the war which Rome, Pergamum and Rhodes had waged against Antiochus III of Syria was brought to a close by two decisive battles: the naval action of the Rhodian fleet, off Myonnesus, and Eumenes II's victory at Magnesia. Both Eumenes and the Rhodians celebrated their triumph, at Pergamum and on Samothrace respectively; and it seems clear that the dedication of the Rhodian ex-voto offering in the sanctuary of the Cabeiri took place before that of the Great Altar at Pergamum. Modest though the Rhodian monument may appear by comparison, its brilliant siting nevertheless announces a new concept of open-air statuary, placed in a large-scale architectural composition. The Victory, on its prow, stood at the summit of a 'landscape', formed by the buildings of the sanctuary rising in tiers up the slopes of the sacred valley. How the monument was positioned can be seen from the way its base is set at an angle to the wall behind. The statue stood in three-quarters

287

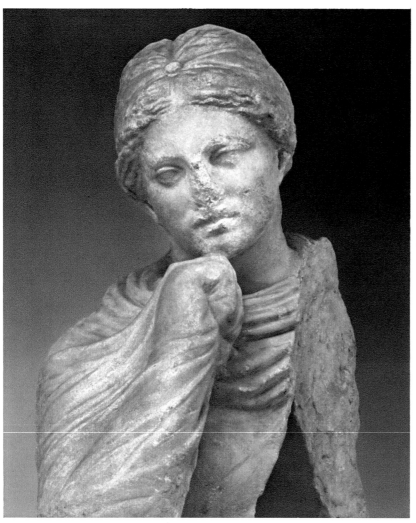

310. RHODES. FRAGMENT OF A STATUE OF POLYHYMNIA. ANTIKENMUSEUM, BASLE.

profile; the sculptor had planned the movement and disposition of the draperies so that the figure had its fullest effect on someone approaching it from the left – either up the tiered auditorium of the theatre, or along the portico which skirted the top of the theatre on the right-hand side. Everything was worked out with this lateral view in mind. The fine curve of the prow enhances the dynamic impression, while counter-balancing the spread of the wings and of the drapery, blown back by the wind like a sail. The mechanical effect obtained through the canting and pitching of lines and masses is humanized by the extraordinarily subtle relief-work, which reveals the female form through the flimsy material.

The impetus and *élan* of the Victory first strike us in that high, out-thrust breast and the slant of the long column formed by the torso and left leg; our initial impression is reinforced by the close, flowing movement of the tunic over the stomach, and the counter-cascade of the bunched material eddying in vigorous folds between the legs. There is a precedent for this effective allying of tricks of drapery with the human form in the tumultuous dance of the Xanthos Nereids.

311. THE VICTORY OF SAMOTHRACE. LOUVRE, PARIS

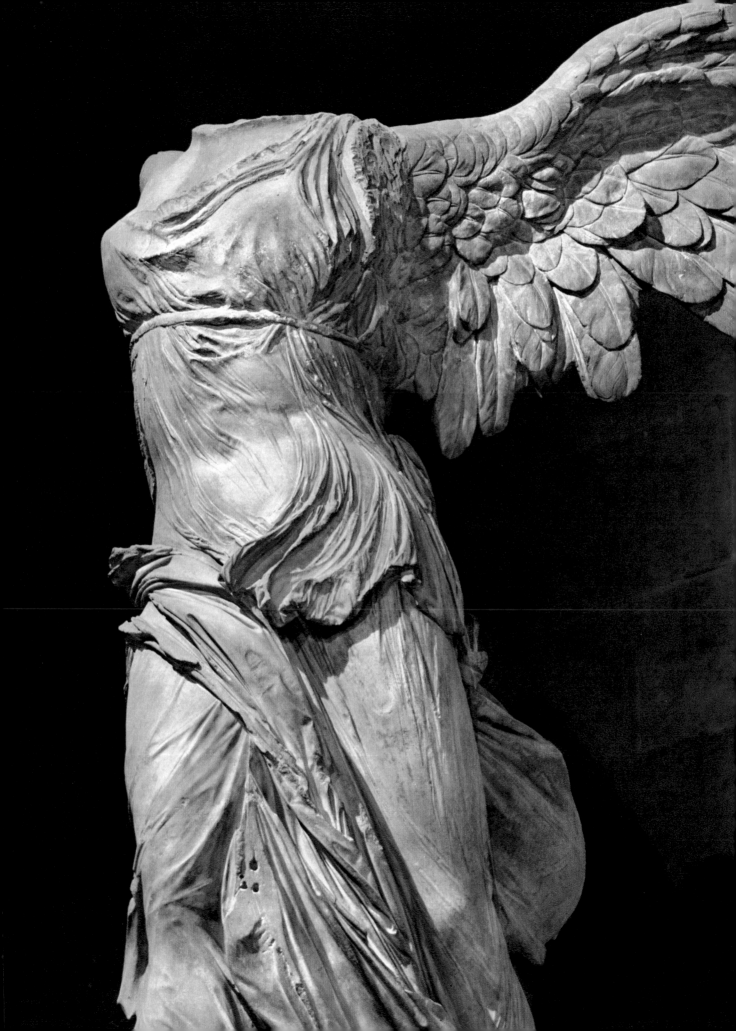

312-313. DELOS. HOUSE OF CLEOPATRA. STATUES OF CLEOPATRA AND DIOSCURIDES.

Variations in the play of draperies were greatly developed during the second century. The third century's striving for accuracy of detail and objective naturalism was now applied to clothing, and the final result – a virtuoso achievement – was the imitation, in marble, of the transparent effect of a light veil laid over the folds of a tunic. This process is evident, in a restrained form, in the Victory of Samothrace and the goddesses of the great Pergamene frieze, though it would seem that credit for the original idea should go to some ingenious worker in terracotta. Its inspiration came from the fine linen made on Cos, the so-called *Coae vestes*. A fair number of statues from the great cities of Asia Minor or the islands bear witness to the success of a fashion which began as mere sartorial eccentricity but ended by enriching sculptural aesthetics. Among the best, and most precisely dated (138-137), are those of a young Athenian lady named Cleopatra and her husband, found in their house on Delos.

290

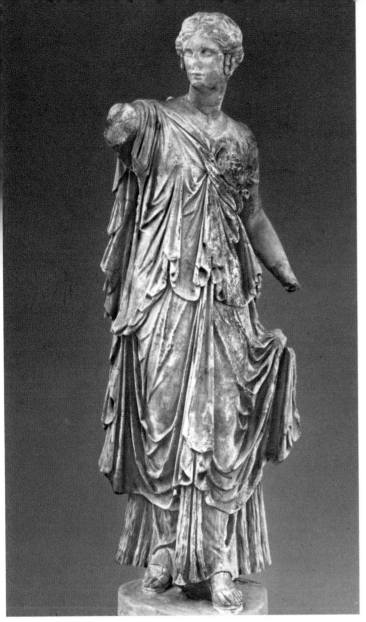

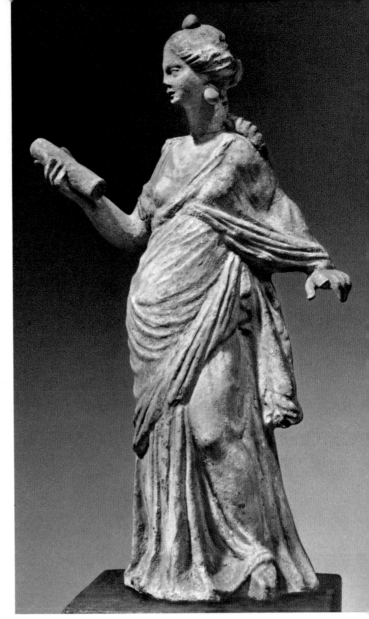

314. PERGAMUM. WOMAN (ORIGINALLY) HOLDING A CANDELABRUM. STAATLICHE MUSEEN, BERLIN.

315. MYRINA. MUSE WITH SCROLL. LOUVRE, PARIS.

A Rhodian sculptor, Philiscus, used this technique to bring the imagery of the Muses into line with contemporary taste. The combinations of vertical, curving and oblique lines afforded by a cloak worn over a robe were doubled by the substitution of a transparent veil for the cloak. Furthermore, the balanced rhythm of the hips and the sweeping folds produced by the motion of the free leg – the former conveying a sense of physical suppleness, the latter that of suppleness in the drapery – was now diversified by means of elongated proportions and by the enlargement of the figure below the breasts. Polyhymnia (see p. 346, fig. 376) is the most original figure of the group. A complete Roman replica survives in the Museo dei Conservatori, in which she is shown in profile, her pose meditative, staring raptly into the distance, as though absorbed by some musical dream. We can also study her in an adaptation almost contemporary with the original, a Rhodian statue the upper half of which survives (fig. 310).

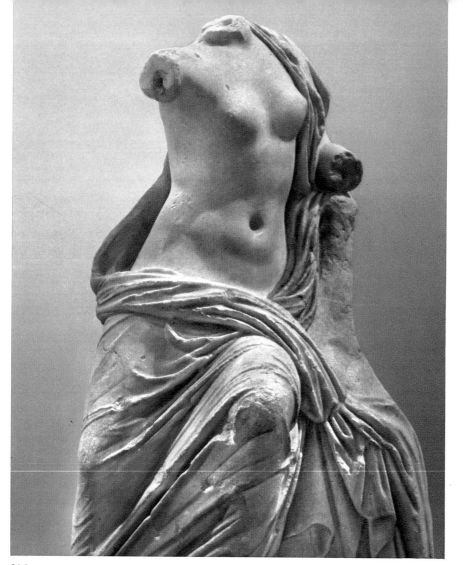

316. RHODES. TORSO OF SEATED NYMPH. ARCHAEOLOGICAL MUSEUM, RHODES.

If we can trust the British Museum relief signed by Archelaus of Priene, the Philiscus group stood in a mountainside sanctuary of the Muses. The attitudes of the various figures were related one to the other, forming a sort of *tableau vivant*, as in certain scenes of the Telephus frieze, and one is also reminded of those Pompeian wall-paintings, based on Pergamene models, which show Dionysus' train winding down through the rocks to gaze at Ariadne, asleep on the shore of Naxos. A version of this episode, in high relief, was used to decorate the pediment of the Etruscan temple at Civitalba. The atmosphere of those literary circles favoured by Hellenistic princes (in which scholarly allegory and the theme of the Muses found an ideal breeding-ground) is well evoked by the bottom 'strip' of the composition because of which the relief is generally known as 'The Apotheosis of Homer'. Behind the enthroned poet stand Chronos and Oecumene (Time and the Inhabited World, with the features of Ptolemy IV and Arsinoë III) while the different types of drama, led by Myth and History and accompanied by Physis (Nature), come forward to make sacrifice in his honour.

317. BOVILLAE. ARCHELAUS OF PRIENE: RELIEF KNOWN AS 'THE APOTHEOSIS OF HOMER'. BRITISH MUSEUM, LONDON.

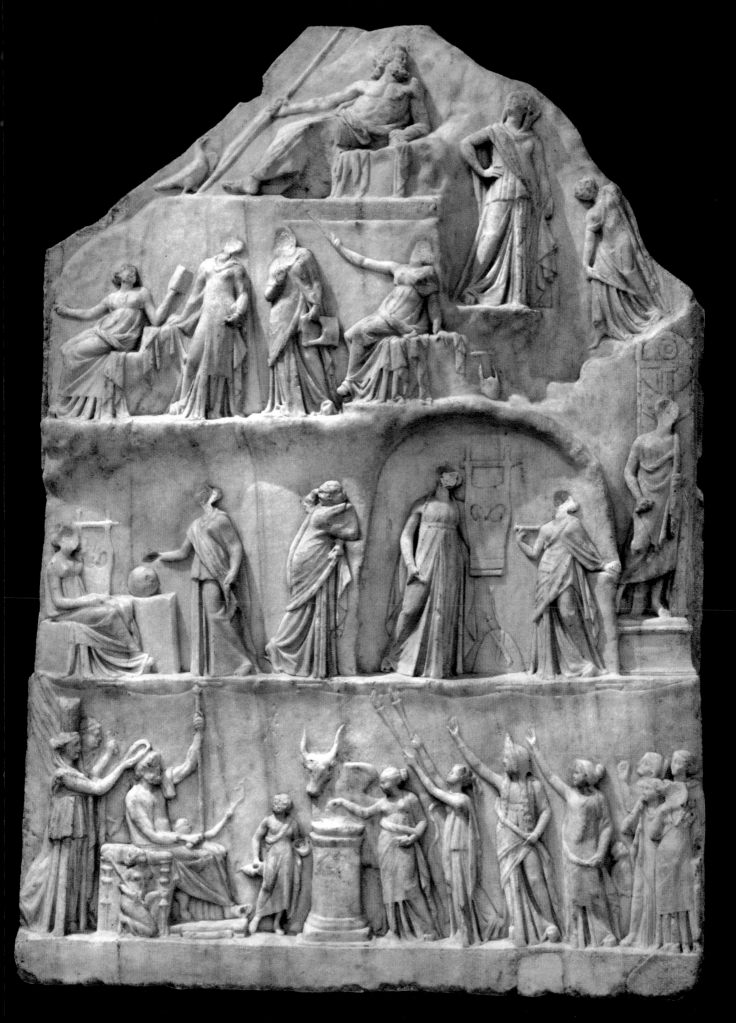

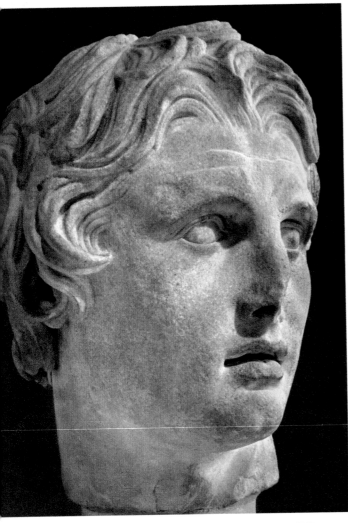

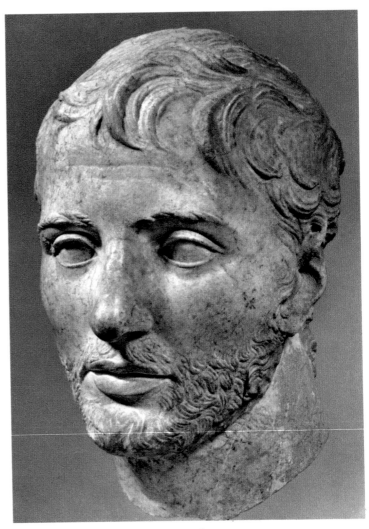

318. PERGAMUM. HEAD OF ALEXANDER.
ARCHAEOLOGICAL MUSEUM, ISTANBUL.

319. DELPHI. MALE HEAD (FLAMININUS?). DELPHI, MUSEUM.

Portrait-effigies and the Male Nude

It is a curious fact that the portrait of Homer found less wide a distribution in the Roman world than did those of Menander and the unknown Greek poet who was at first, erroneously, identified as Seneca. The elegance (liberally tinged with classical idealism) of the former (see p. 246, fig. 263), and the violent pathos which ravages and animates the Pseudo-Seneca's features, were both, it would seem, more immediately attractive than the lofty inspiration and poetic significance of a typical Blind Homer portrait (the best reproduction of which is that in the Louvre). Some unknown sculptor of the mid-fifth century had suggested Homer's blindness by portraying him with closed eyes. The creator of the Hellenistic portrait rejects such a stratagem. A close and accurate observer of detail and a master of recomposed form, he employs exclusively plastic devices to achieve the loftiest symbolic significance. The way the eyes are set in their hollow sockets, and the deathly stillness of eyeballs and eyelids, evoke the blind, unfocussed gaze, while the irregular eyebrows (like the lined forehead and hollowed cheeks) seem less the marks of age than mute witnesses to the processes of thought. The

294

320. ROME. HOMER. LOUVRE, PARIS.

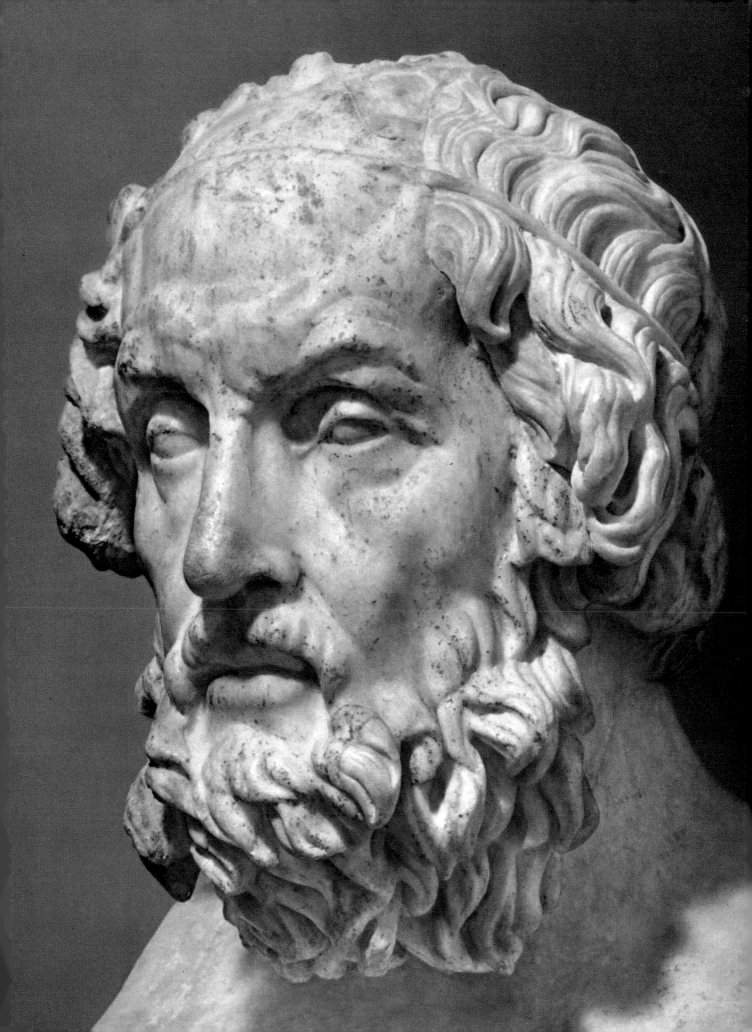

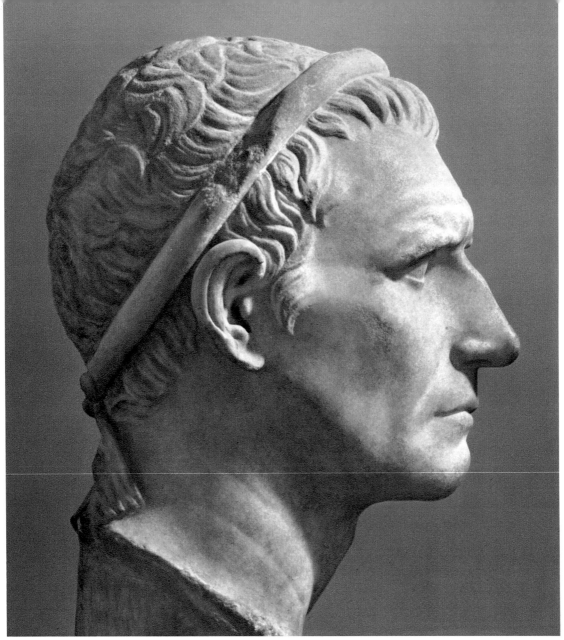

321. ITALY. PORTRAIT OF ANTIOCHUS III. LOUVRE, PARIS.

breeze that ruffles hair and beard but leaves that serene countenance unchanged, the parted lips and 'eloquent cheeks' – all reveal the poet's function.

To what date should we assign the first appearance of this Blind Homer – originally, no doubt, a seated figure in bronze? It has long been argued that this Hellenistic masterpiece (thought to be the work of some Rhodian artist) was contemporary with the Laocoön, itself attributed to the third quarter of the first century B.C. on the basis of epigraphical evidence, which, however, has been shaken by the recent discoveries at Sperlonga. Whatever the true dating of this famous group, the nearest parallel to the 'Blind Homer' portrait is one of Antiochus III, which reveals the same way of building up the features and the same mode of plastic expression. In the irregular relief-work reinforcing the outline of the orbital arch, and in the lines on the forehead, with fleshy

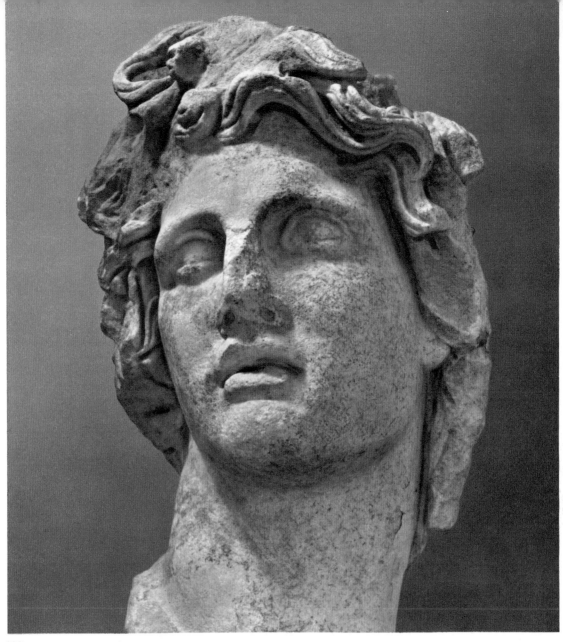

322. HEAD OF HELIOS. ARCHAEOLOGICAL MUSEUM, RHODES.

ridges between them, it also shows the same technique for conveying an inner tension which both catches and holds the eye. Now the bronze effigy of Antiochus III (of which the head in the Louvre is a perfect replica) must have been executed when the king gave himself the title of 'the Great', which was almost certainly in 205 B.C., and, if this theory holds good, then portrait-art around 200 reveals three very different styles. At one extreme is the bare, stern Attic art of Eubulides' Chrysippus, at the other the theatrical, pathos-laden realism of the Pseudo-Seneca. In between comes the grand manner – vigorous and restrained, yet intensely expressive – of Antiochus III and Blind Homer. (One thinks of the three styles of Hellenistic eloquence – Attic, Asiatic and Rhodian – studied and practised by Roman orators.) It is a pity that in three cases out of four all that remains is the head.

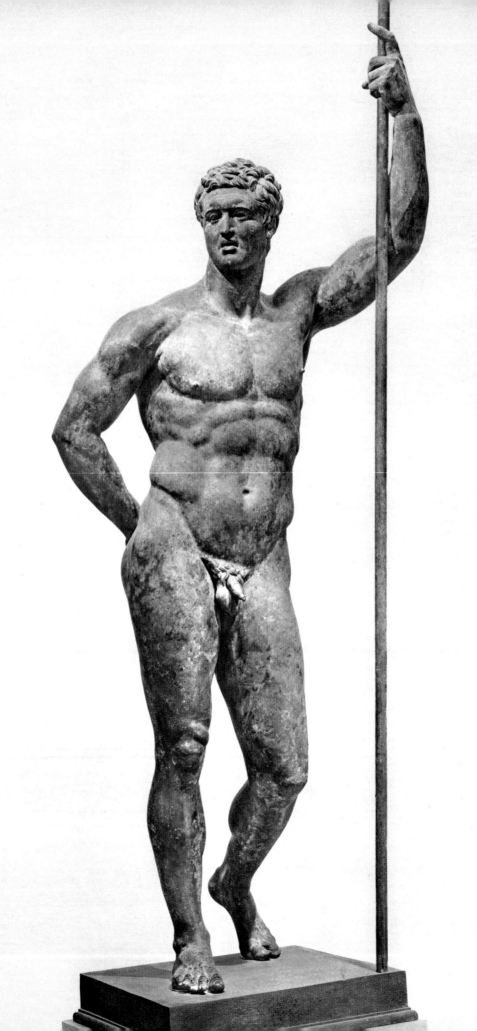

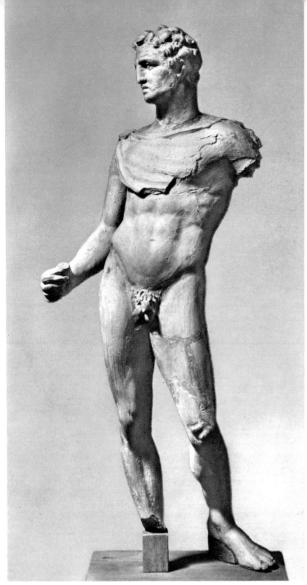

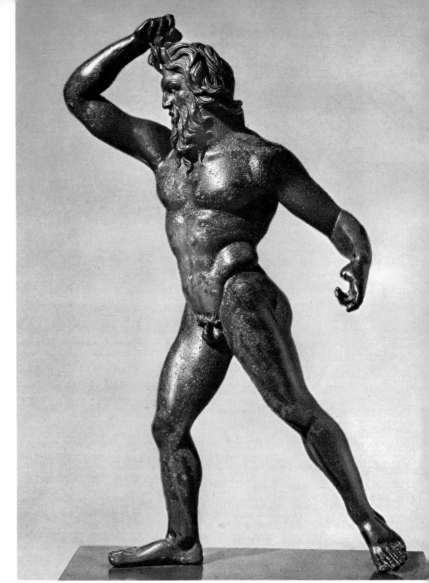

324. SMYRNA. ALEXANDER I BALAS. LOUVRE, PARIS.

325. THE 'JAMESON POSEIDON'. LOUVRE, PARIS.

The striking development of realism in portraiture during the third century was certainly not propitious, as far as the body was concerned, for the retention of traditional forms of classical idealization. On the other hand, about the mid-second century, when sculptors once more turn their attention to the great classical models (this corresponds to the 'renaissance' in art which Pliny mentions) it is not surprising to find nudity, a mark of deification, reappearing in royal iconography. Consider the large bronze identified as Demetrius I of Syria (162-150). At first sight this statue recalls the Alexander with a Spear (not merely an artistic allusion, but also a reminder of the Seleucids' dynastic ambitions); in fact, however, the figure's presentation and proportions, even its pose (which conveys a sense of massive and imposing stability), are more closely allied to Polycleitus than to any Lysippean model.

However, the main effect in this instructive example of multiple influence is borrowed from the final flowering of the Pergamene tradition; note the distribution of highlight and shadow (especially in the relief-work on face and torso) and the pad of

323. ROME. DEMETRIUS I OF SYRIA. MUSEO NAZIONALE, ROME. 299

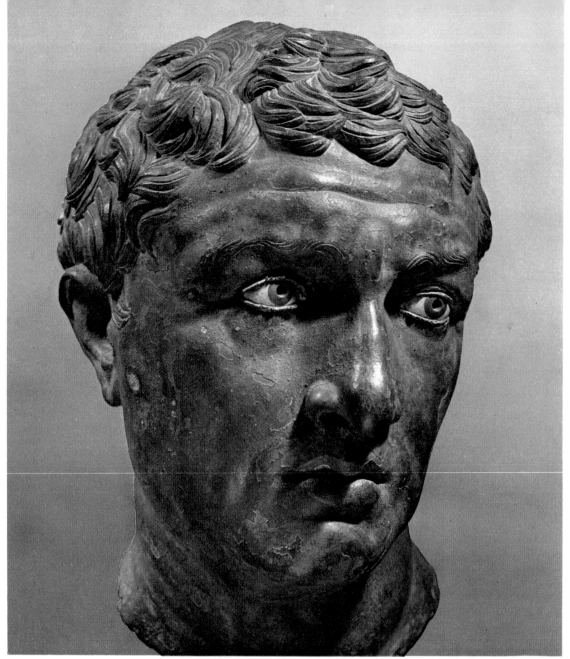

326. DELOS. MALE HEAD. NATIONAL MUSEUM, ATHENS.

muscle below the rib-cage. Yet observation of detail is giving way to a mere formula, repeated on the torsos of warriors in an ex-voto of Attalus II, also datable to *c*. 150.

This interpretation of the male nude (which tends to fragment the structure of the body artificially with a view to emphasizing superhuman power) recurs on a large statuette of Poseidon brandishing his trident (fig. 325). All expression has been externalized: the long sinuous locks of hair and beard, the relief-work on the face, the swelling of the muscles. Even so, the weight of long tradition still gives this figure a majestic atmosphere and marks it with a definite style. But during the second half of the second century – when the great dynastic lines came under the heel of Rome, and foundered in a bloody welter of corruption and chaos – the disintegration of Hellenistic

300

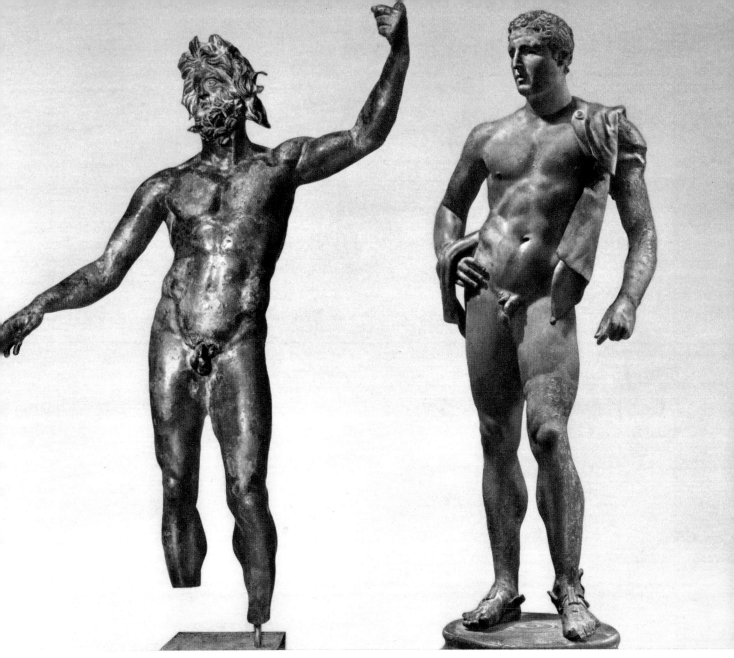

327. THE 'LOEB POSEIDON'.
STAATLICHE ANTIKENSAMMLUNGEN, MUNICH.

328. POMPEII. ANTIOCHUS VIII GRYPUS.
MUSEO NAZIONALE, NAPLES.

society was duly reflected by an anarchic eclecticism in its art. Though few royal statues
of this period survive, small replicas exist in terracotta or bronze. In a miniature
standing portrait of Alexander I Balas (150-145), an example of the best work of
Smyrna, the boldly chiselled features exactly match the profile on his coinage and well
suggest the personality of this usurper who dared to adopt not only the great
Alexander's name but also the wreath of white poplar that was Heracles' prerogative.
His ostentatious and (in both senses of the word) eccentric pose, though still sustained
by firm relief-work, foreshadows the disarticulation of a large statuette from Pompeii
which (with a new reference to Lysippus) depicts one of the last Seleucids, Antiochus
VIII Grypus (121-96), shod with Hermes' winged sandals and carrying a short *chlamys*.

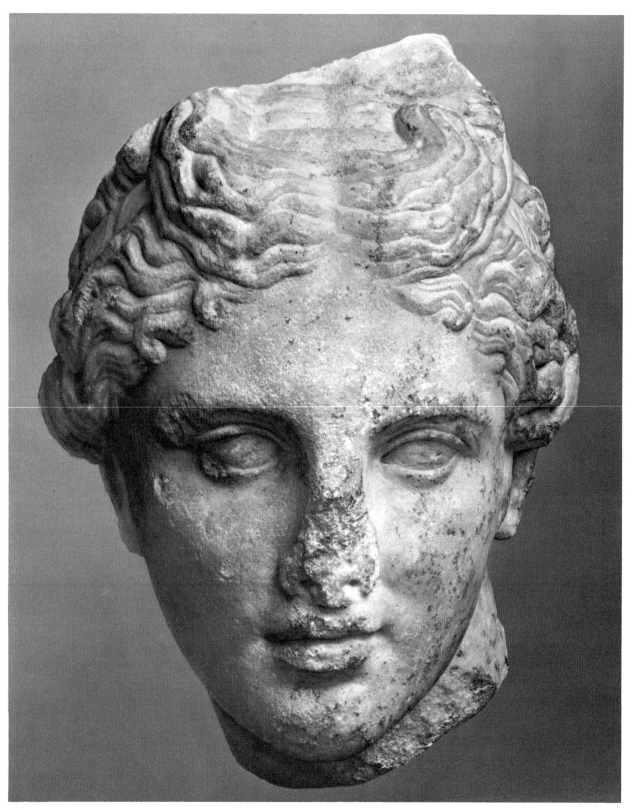

329. HEAD OF APHRODITE. STAATLICHE ANTIKENSAMMLUNGEN, MUNICH.

302

330. HORBEIT. DRAPED APHRODITE. LOUVRE, PARIS.

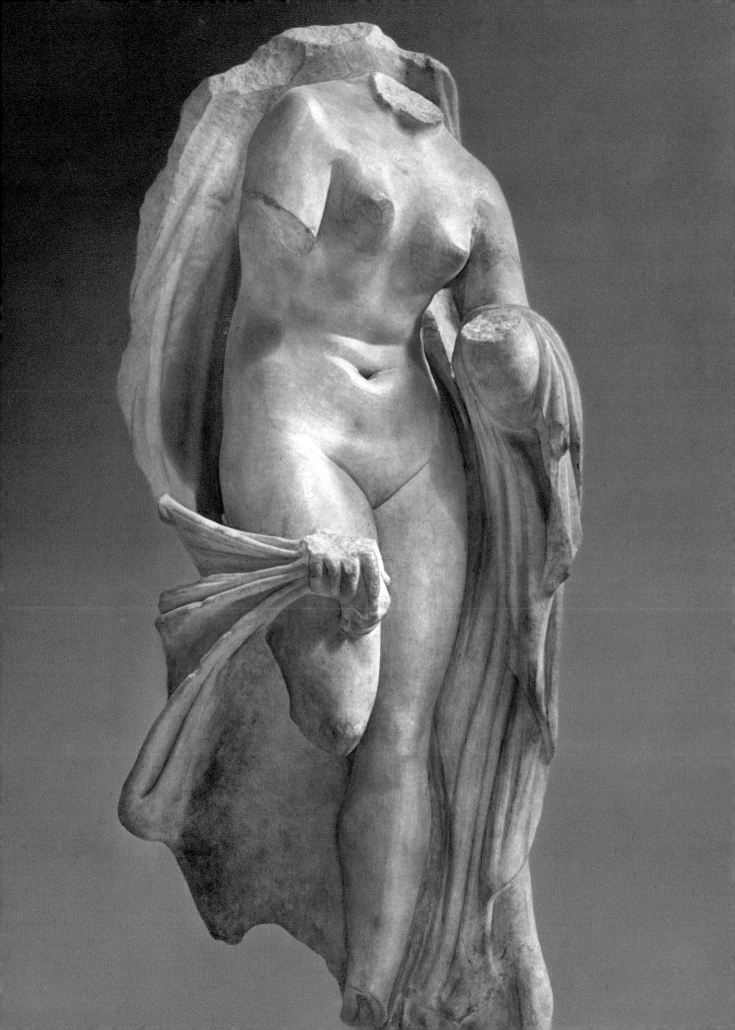

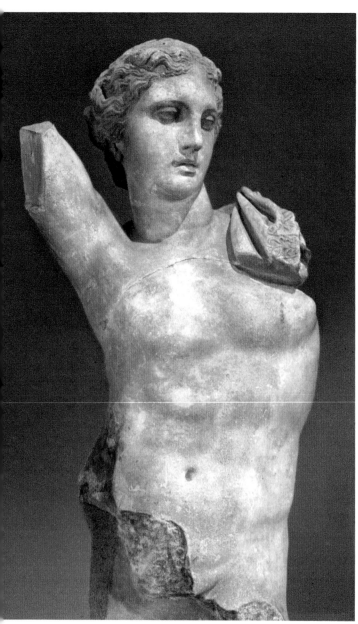 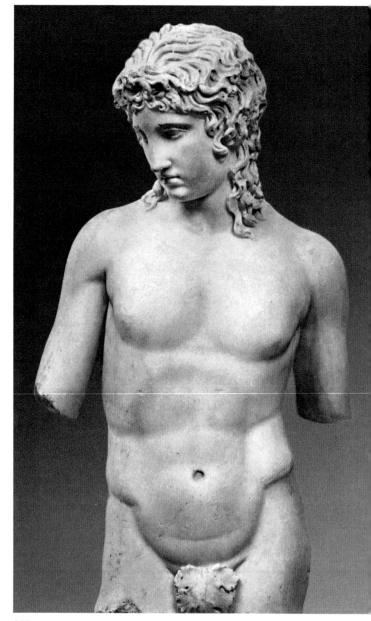

331. TRALLES. APOLLO. ARCHAEOLOGICAL MUSEUM, ISTANBUL. 332. CENTOCELLE. EROS. VATICAN MUSEUMS.

While the Lysippean and Pergamene types find their final avatars in works of this sort, Praxitelean smoothness continues through the second century and the early years of the first with a number of divine and mythological figures in which formal elegance and charm of expression assume a character by turns poetic, mysterious, disturbing and sensually equivocal. We have already mentioned the Apollo in the latest of those groups devoted to the Marsyas legend. Contemporary with this, and in much the same vein, is a rather too-pretty young satyr in marble, found at Lamia. Sinuous postures; the calculated unveiling of the female body; the ambiguous, chrysalid grace of

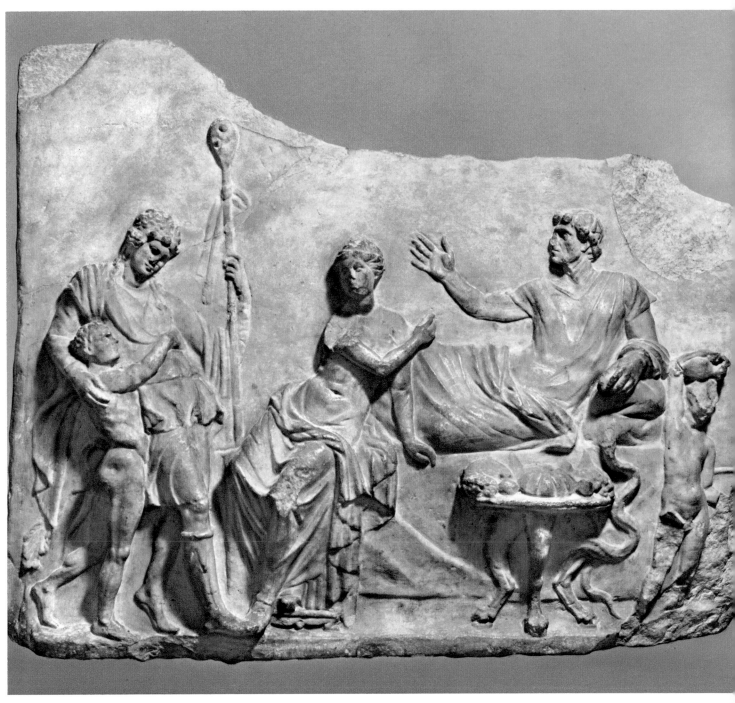

333. PIRAEUS. VOTIVE RELIEF: VISITATION OF DIONYSUS TO THE POET. LOUVRE, PARIS.

adolescence; subtly delicate facial expressions; exquisite softness of feature – all these are now favourite themes. The sculptures (whether in the round or in relief) which retain most interest have either received an invigorating and original infusion of Alexandrianism, or are distinguished by that hyper-refinement associated with court art.

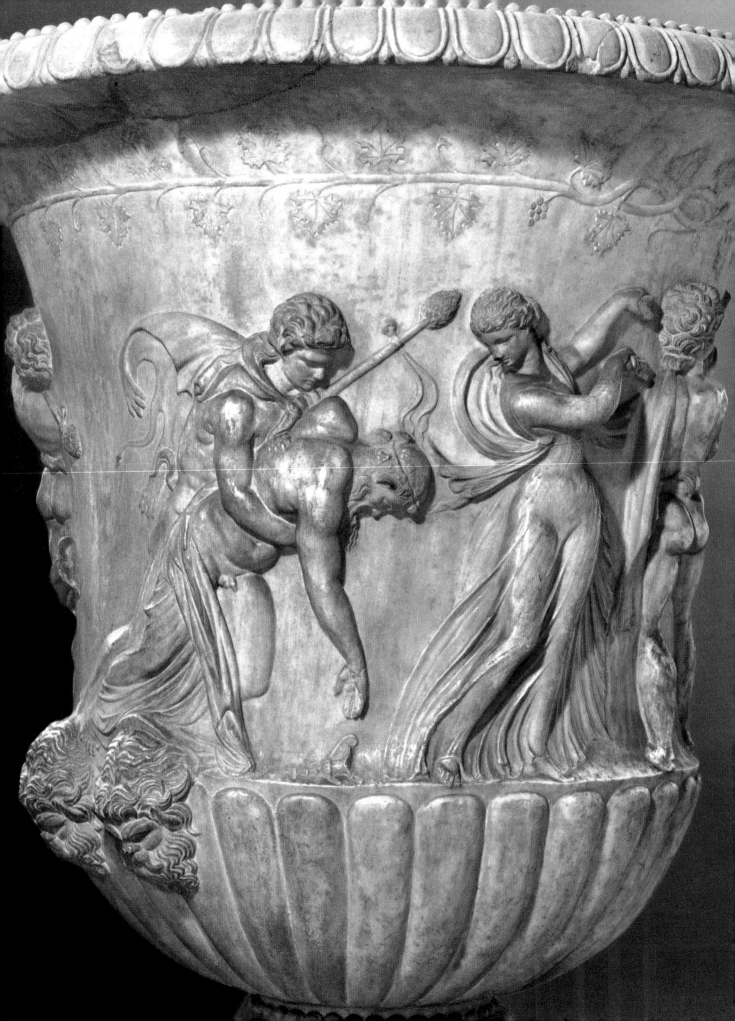

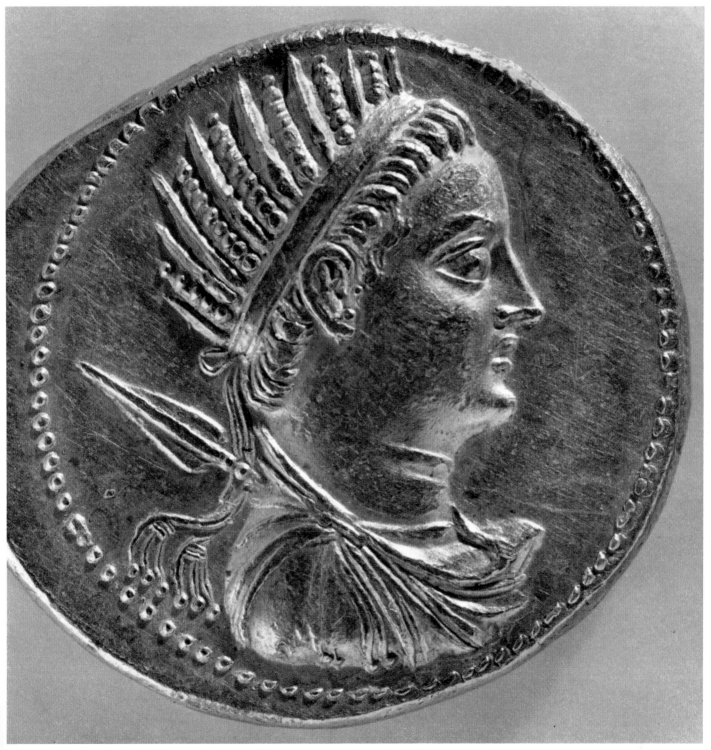

335. OCTODRACHM: PTOLEMY V EPIPHANES. BIBLIOTHÈQUE NATIONALE, CABINET DES MÉDAILLES, PARIS.

334. THE 'BORGHESE VASE' (DETAIL): SATYR SUPPORTING THE DRUNKEN SILENUS; MAENAD. LOUVRE, PARIS.

Alexandrianism and Erotic Mythology

By securing the body of Alexander (who had proclaimed himself the son of Ammon) the first Ptolemy strongly emphasized his own desire to establish a dynasty in the Pharaonic succession. At the same time, however, he made his new capital of Alexandria (dedicated to the deified world-conqueror) an indisputably Greek city, looking towards the centres of Hellenism. The sculpture that resulted from this confluence of two great traditions is almost all lost. Successive waves of looting and destruction – not to mention soil subsidence and rebuilding – have, between them, more or less obliterated the ancient city. Nevertheless there do survive one or two pieces significant enough to attract into their orbit (by way of confirmatory evidence) an important group of sculptures which, though later, are in the same style. Amongst these exceptional pieces is the great cameo, shaped like a hollow plate, known as the 'Farnese Cup': a piece of visual dynastic propaganda from the last years of the reign of Cleopatra I, between 175 and 173. It symbolically portrays the benefits obtained – thanks to the dead king's divine intervention – from the flooding of the Nile. At the bottom is the sphinx of Osiris (with the features of Ptolemy V Epiphanes), on whose back sits the queen mother Isis (Cleopatra); above her is the heir apparent, Horus-Triptolemus (Ptolemy VI Philometor), his right hand on a plough-handle. To the left sits Nilus holding a cornucopia; on the right are symbolic figures, identifiable by their attributes as the seasons of flooding and harvest. Overhead flutter the Etesian winds, responsible for making the waters rise and so for fertility.

With the exception of the sphinx, which is typically Egyptian, all the figures give us valuable information about the formal repertoire of Alexandrian art at this period. The Hellenized Isis retains the Libyan coiffure with corkscrew curls, as well as the fine features and amiable roundness of face which recur on two small sculptural portraits in the Louvre. The fermale figure type used, however, shows strong Ptolemaic-Egyptian influence: narrow torso with rounded, jutting breasts, hips swelling out in an ample calyx, the curve of which follows the thighs and breaks away along the line of the lower limbs (the most typically Greek masterpiece in this Alexandrian tradition is the so-called 'Luynes Venus'). The general concept of the figure may be compared with the 'Sleeping Ariadne' type. Though the attitude of the latter is more abandoned, the 'Farnese Cup' reveals an identical preoccupation with plastic effect; the richer, more complex drapery alone betrays the influence of Rhodes and Pergamum.

The Seasons on the 'Farnese Cup' – seen from front and back respectively, as in a beauty contest – provide models of youthful grace in which echoes of the female silhouettes from Pharaonic reliefs are allied to the Praxitelean tradition. This pair of beauties, so revealingly disrobed, inevitably call to mind the Sleeping Hermaphrodite, whose hair would seem to have been designed by the same artist. It is, similarly, almost impossible to avoid seeing in this voluptuous, mannered concept the inspiration for the original group of the Three Graces – copied and imitated, century after century, from what has too often, and too confidently, been identified as a painting. Of all the male figures on the Cup the seated Nilus is the most obviously Alexandrian; he has the splendid features of a philosopher-god, but his heavy plumpness reminds us that, for

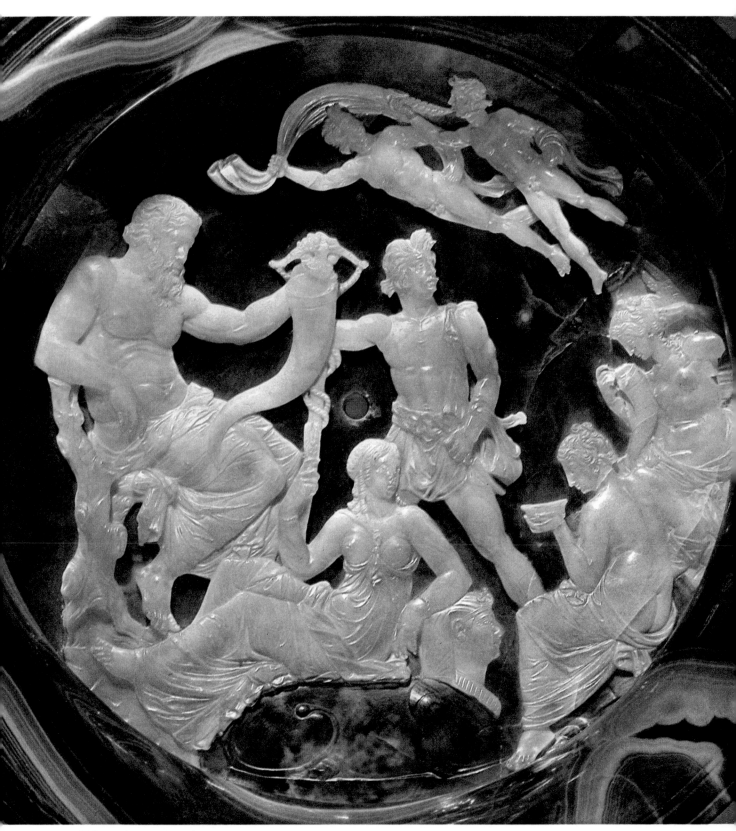

336. THE 'FARNESE CUP'. MUSEO NAZIONALE, NAPLES.

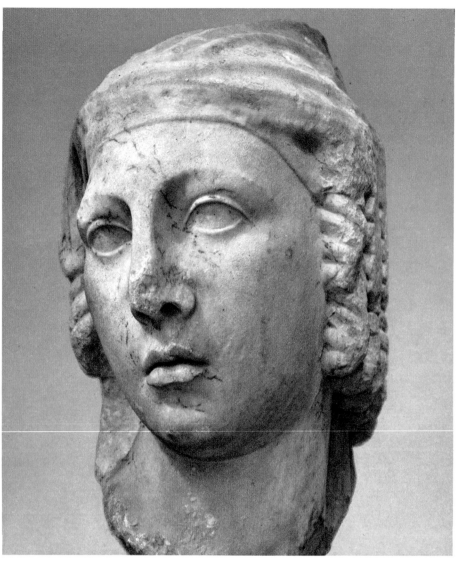

337. FEMALE HEAD. MUSÉE GRÉCO-ROMAIN, ALEXANDRIA.

the Egyptians, he was androgynous. (Certain details of the hair-style make it clear that the original of the Recumbent Nilus in the Vatican was also an Alexandrian creation, though the copy shows academic characteristics.) The Horus-Triptolemus figure need not detain us; it evokes both the romantic portraits of Alexander and the Pergamene Galatians. As for the Etesian winds, these could quite well figure in any number of the Dionysiac processions found throughout the Greek world, though exactly what part Ptolemaic court art played in promoting this type of subject is very hard to determine.

Among the range of royal likenesses in the round (identified by epigraphical means or from coin-portraits) are some which, in material, presentation and the combination of traditional attributes with a dash of Greek realism, suggest a politically based desire for assimilation. But the most interesting (and most frankly Alexandrian) portraits are the statues and statuettes of Egyptian priests – the 'Priest of Isis' (fig. 339) is a superb example – and certain other likenesses and caricatures (figs 340-344).

310

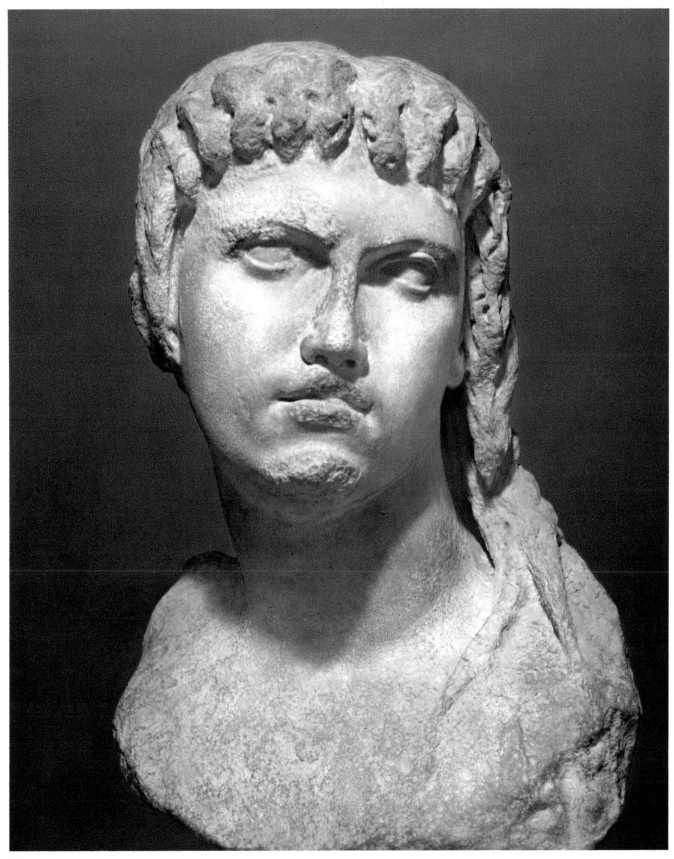

338. CLEOPATRA II. LOUVRE, PARIS.

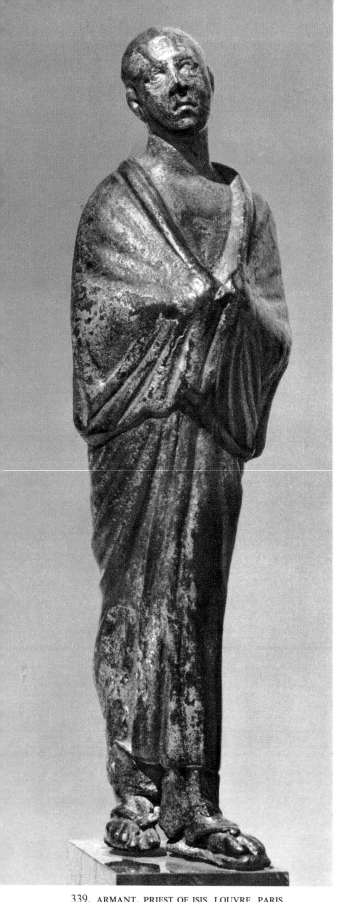

339. ARMANT. PRIEST OF ISIS. LOUVRE, PARIS.

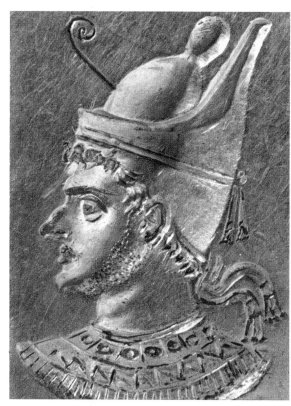

340. RING-BEZEL: PTOLEMY VI PHILOMETOR. LOUVRE, PARIS.

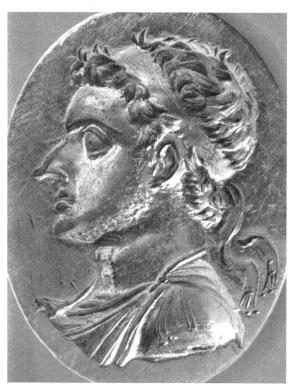

341. RING-BEZEL: PTOLEMY VI PHILOMETOR. LOUVRE, PARIS.

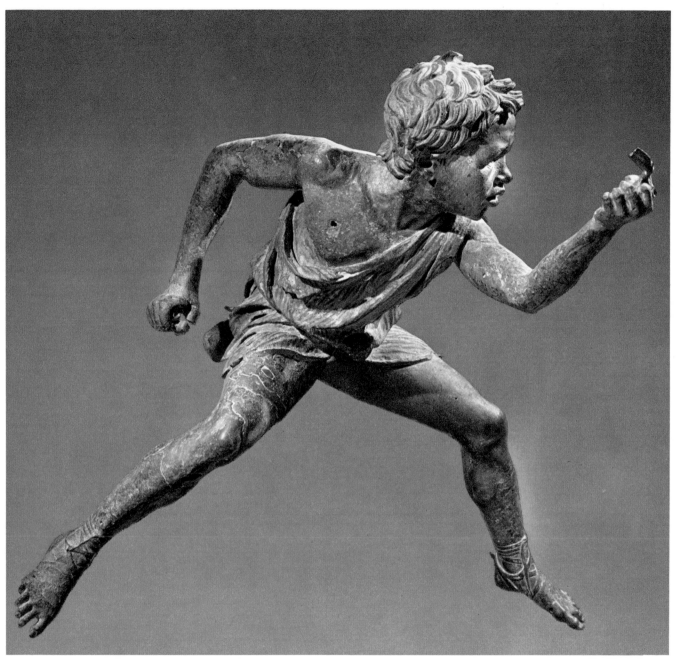

342. CAPE ARTEMISION. JOCKEY. NATIONAL MUSEUM, ATHENS.

313

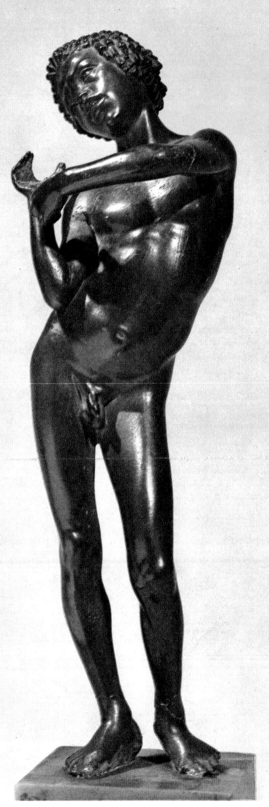

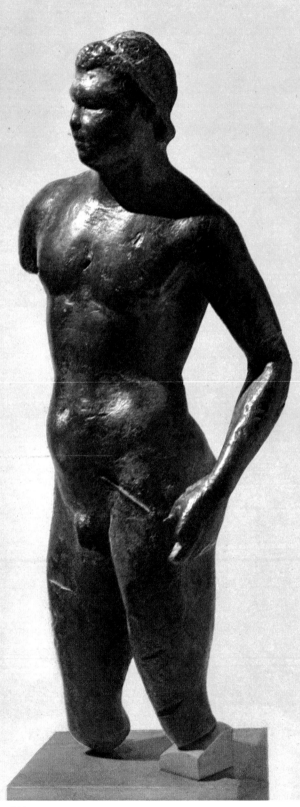

343. CHALON-SUR-SAÔNE. STATUETTE OF A NUBIAN.
BIBLIOTHÈQUE NATIONALE, PARIS.

344. PTOLEMY VII. LOUVRE, PARIS.

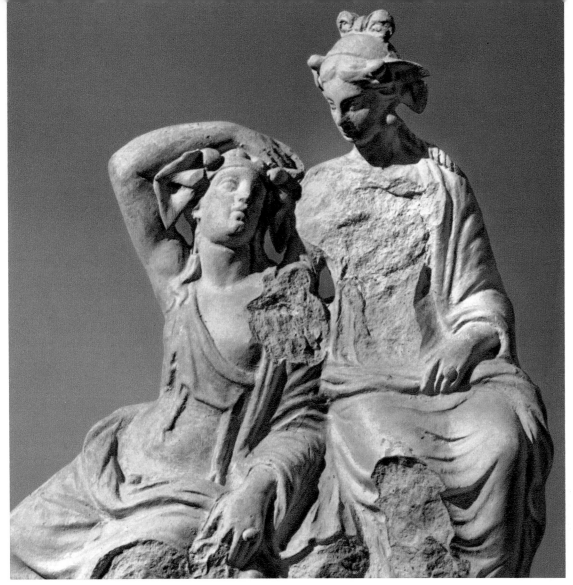

345. MYRINA. DIONYSUS AND ARIADNE. LOUVRE, PARIS.

From the beginning of the second century the development of picturesque decoration in sanctuaries and royal residences led to the spread of certain sculptural motifs of mythological nature, notably Dionysiac or otherwise erotic groups; the popularity of these with the Romans ensured that numerous reproductions survive to the present day. Behind this trend we find two influences, philosophy and the theatre. It may be recalled that at the end of Xenophon's *Symposium*, after a discussion of love, the guests are offered an entertainment in which two performers re-enact the marriage between Dionysus and Ariadne. The real novelty in the Hellenistic period was the appearance of such subjects (formerly restricted to the minor arts) in sculpture. The erotic groups embody aspects of love which, according to Socrates and Plato, are in theoretical opposition: both appear in the allegorical Eros and Psyche group (fig. 347). This composition – as an exercise in philosophical poetry, without any specific political or religious connections – is animated by the interplay of sensual and spiritual elements. The two-figure scenes from the Dionysiac cycle sometimes preserve a more direct

315

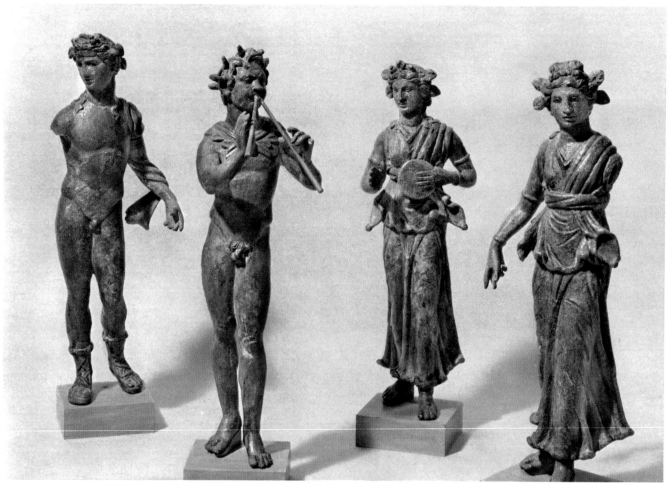

346. LOWER EGYPT. DIONYSIAC GROUP. LOUVRE, PARIS.

relationship with some local manifestation of the cult – or so one might gather from the reproduction, on a Roman coin of Cyzicus, of two statues from the group known as the 'Invitation to the Dance'. The satyr and nymph theme clearly originated in a climate quite different from that surrounding the meeting of Eros and Psyche. Eros recalls the Standing Hermaphrodite (fig. 348) or, even better, the Sleeping Hermaphrodite (fig. 350); the hair is treated with the same delicacy – a specifically Alexandrian trait. Psyche is a variation on a late fourth-century type of half-naked Aphrodite. The satyr of the 'Invitation' shows a more 'Pergamene' accentuation of light and shade, while the nymph repeats the turning movement of the Tyche of Antioch (fig. 251).

The 'Invitation to the Dance' may well, chronologically speaking, head that series of erotic or Dionysiac groups with highly complex compositions which appear in various guises throughout the second century and later. A group such as that which can be seen in Rome (fig. 349) is vibrant with desire and defiance; but later on such pieces tend to lapse into mere routine conventionality. By the time we reach the Pan and Aphrodite from Delos (fig. 353) all conviction has drained away. The goddess is making a vague, perfunctory gesture to fend off the timid advances of a shaggy Pan, whose importunity suggests, more than anything else, an over-enthusiastic dog.

347. ROME. EROS AND PSYCHE. MUSEO CAPITOLINO, ROME.

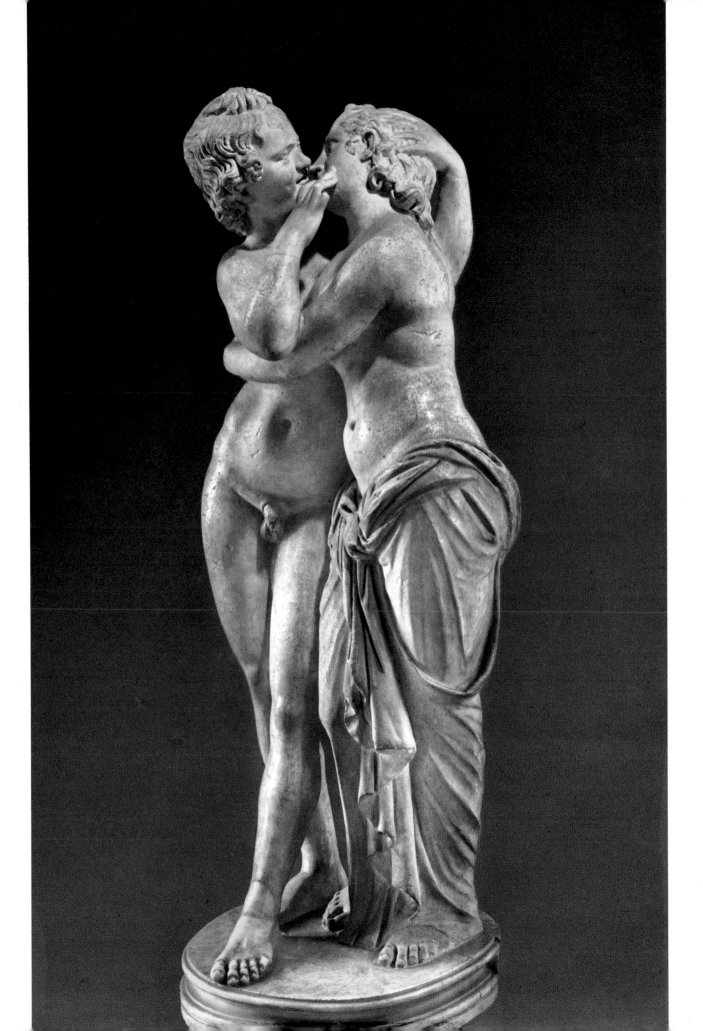

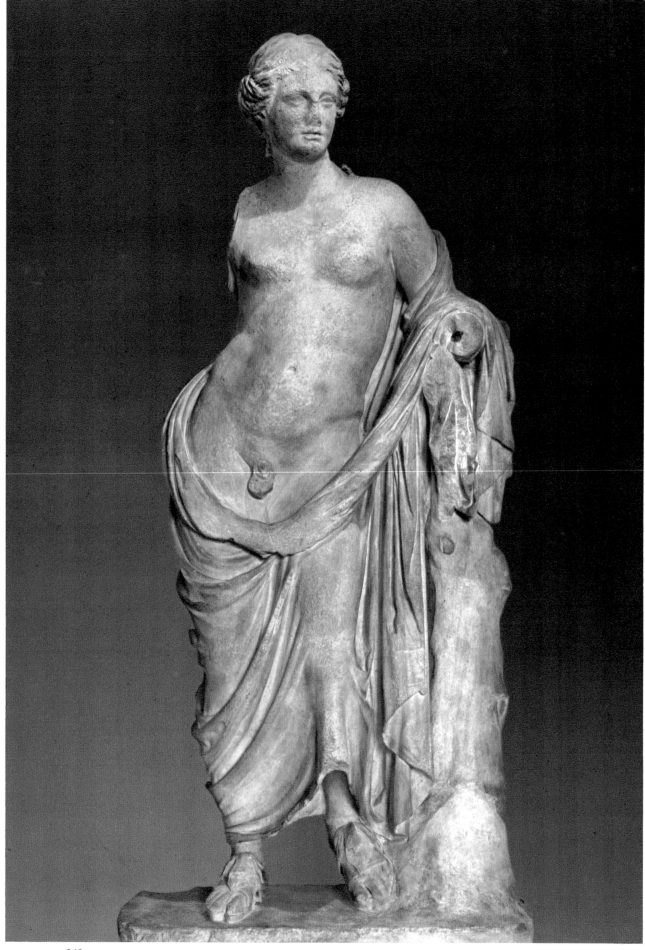

348. PERGAMUM. HERMAPHRODITE. ARCHAEOLOGICAL MUSEUM, ISTANBUL.

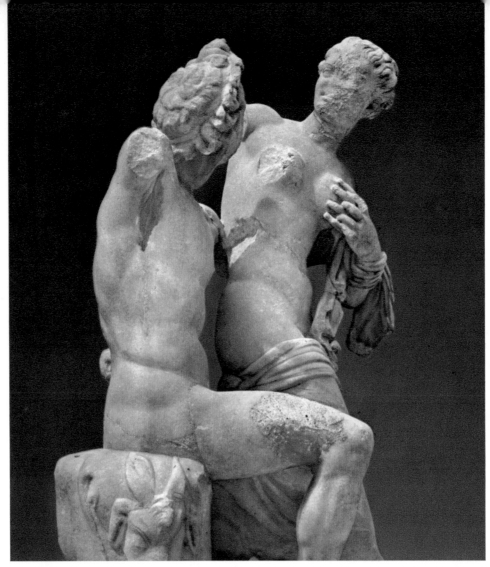

349. SATYR AND NYMPH. MUSEO NAZIONALE, ROME.

350. ROME. SLEEPING HERMAPHRODITE. MUSEO NAZIONALE, ROME.

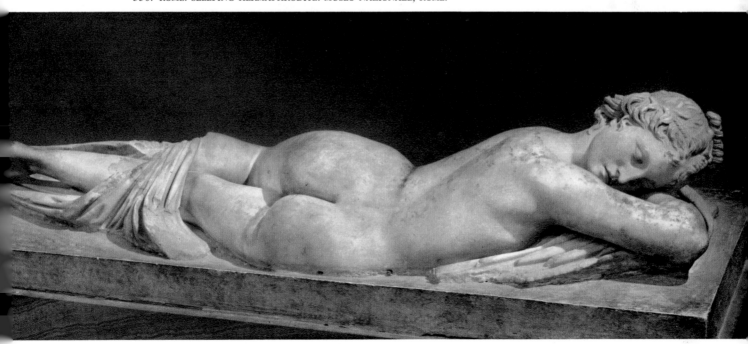

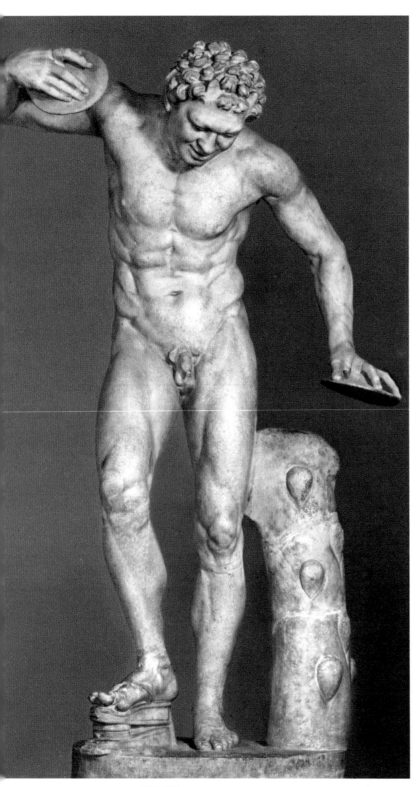
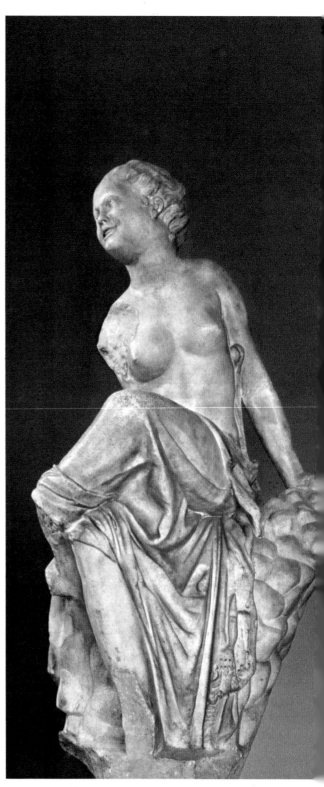

351-352. SATYR AND NYMPH FROM THE GROUP 'INVITATION TO THE DANCE'.
UFFIZI, FLORENCE, MUSÉE D'ART ET D'HISTOIRE, GENEVA.

320

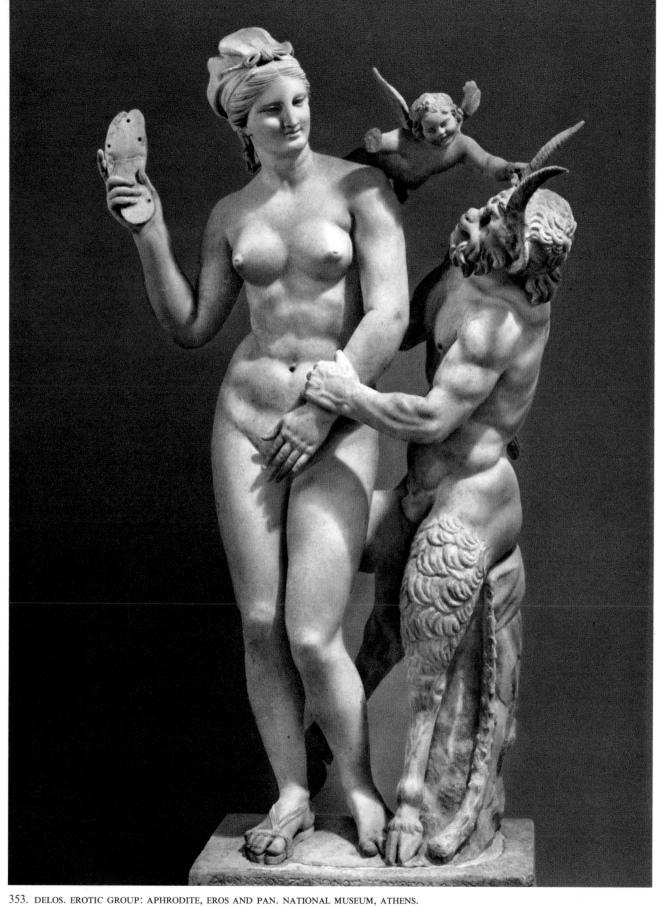

353. DELOS. EROTIC GROUP: APHRODITE, EROS AND PAN. NATIONAL MUSEUM, ATHENS.

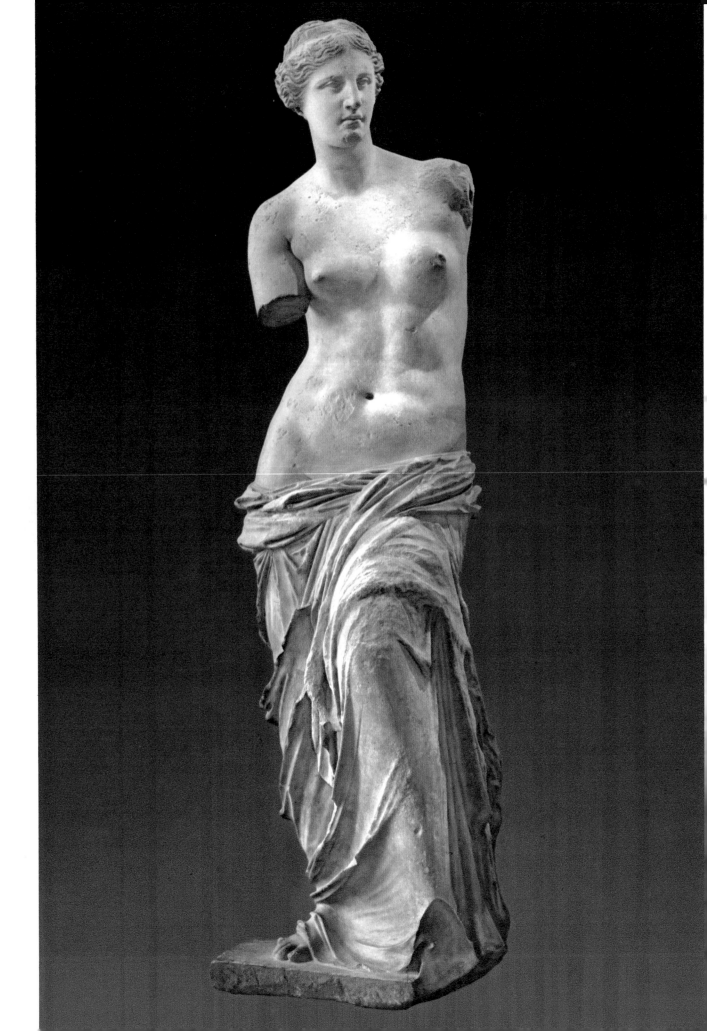

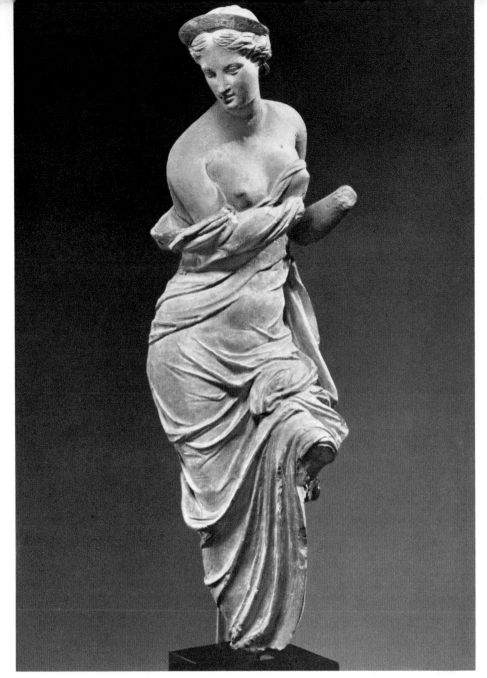

355. THE 'HEYL APHRODITE'. STAATLICHE MUSEEN, BERLIN.

Yet it was about the same date (*c.* 100 B.C.) that the creator of the Venus de Milo managed to take a model from Lysippus' work and infuse it with a wholly desacralized sensuousness. This is neither some academician's tribute to an Old Master, nor a mere frigid imitation; the Aphrodite of Capua, derived from a relief, was designed for a profile view, but by taking this sculptural motif and transposing it into a frontal attitude, the creator of the Venus de Milo radically changed the initial concept. The raising of the left foot at once alters the rhythm, and the great undulating movement that runs right down the figure is not to be found in any prototype. Though the left leg

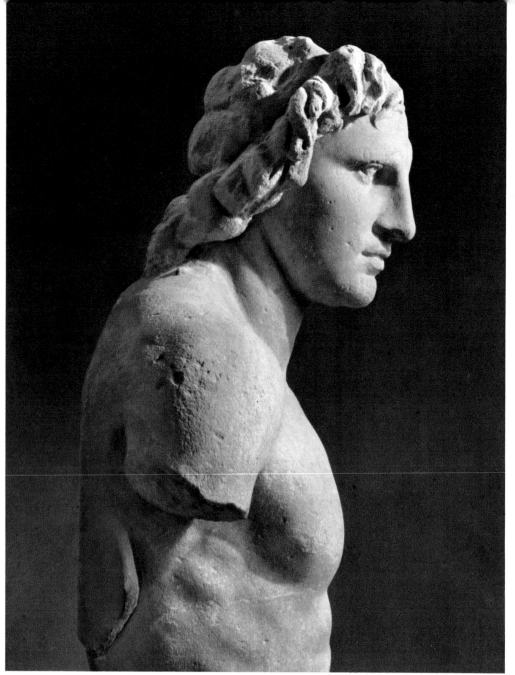

356. DELOS. TORSO OF THE 'PSEUDO-INOPUS'. LOUVRE, PARIS.

inclines towards the right (to follow the movement of the drapery), while the torso pivots fractionally in the opposite direction, this divergence is calculated with rare felicity; the sinuous curve of the outline, being governed by the rules of geometrical proportion, avoids slipping into baroque. This masterpiece of restrained good taste – classic in the highest sense of that term – is without doubt by the same hand as the 'Pseudo-Inopus' in the Louvre (the two profiles bear a quite striking resemblance to one another); and it is tempting to identify the latter as the upper part of a portrait-statue of Mithridates VI Eupator, king of Pontus from 120 to 63 B.C.

357. THE VENUS DE MILO (DETAIL). LOUVRE, PARIS

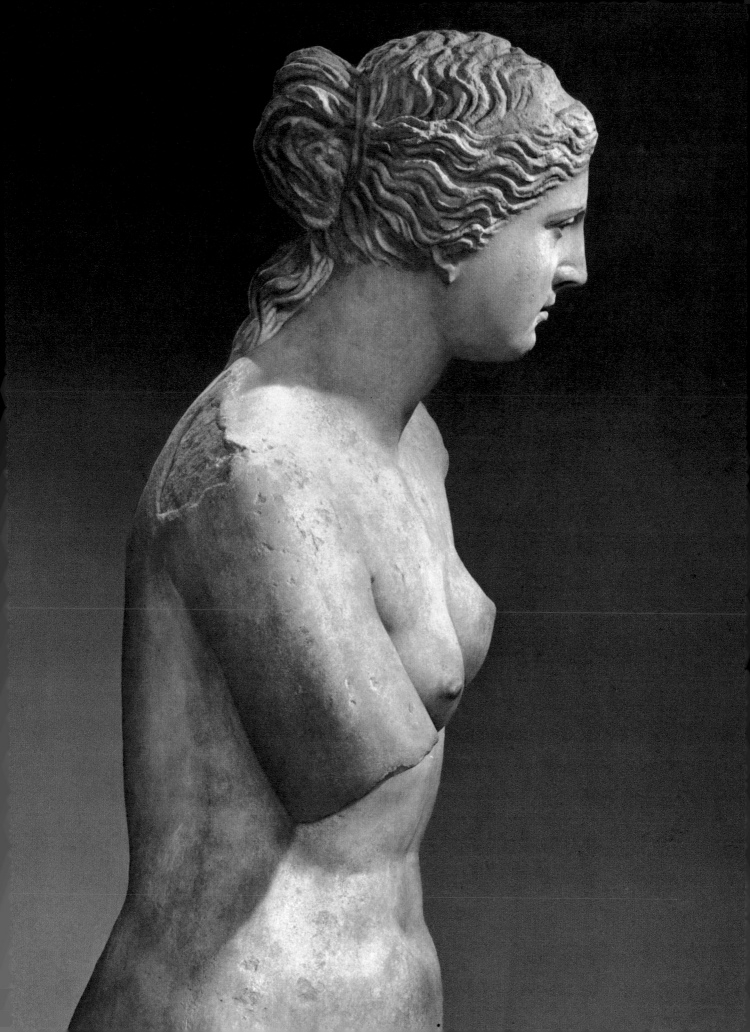

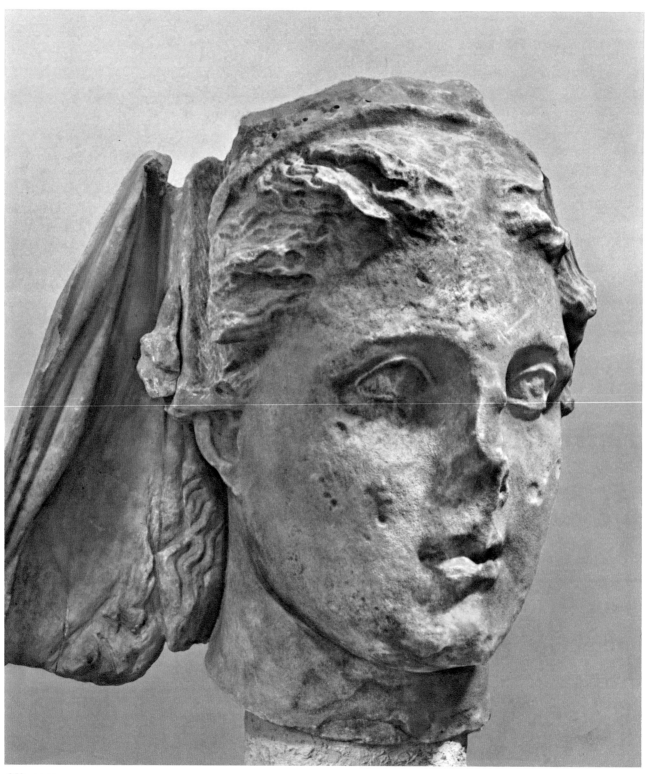

358. LYCOSURA. DAMOPHON OF MESSENE: HEAD OF DEMETER. NATIONAL MUSEUM, ATHENS.

359. AEGEIRA. EUCLEIDES OF ATHENS(?): HEAD OF ZEUS. NATIONAL MUSEUM, ATHENS.

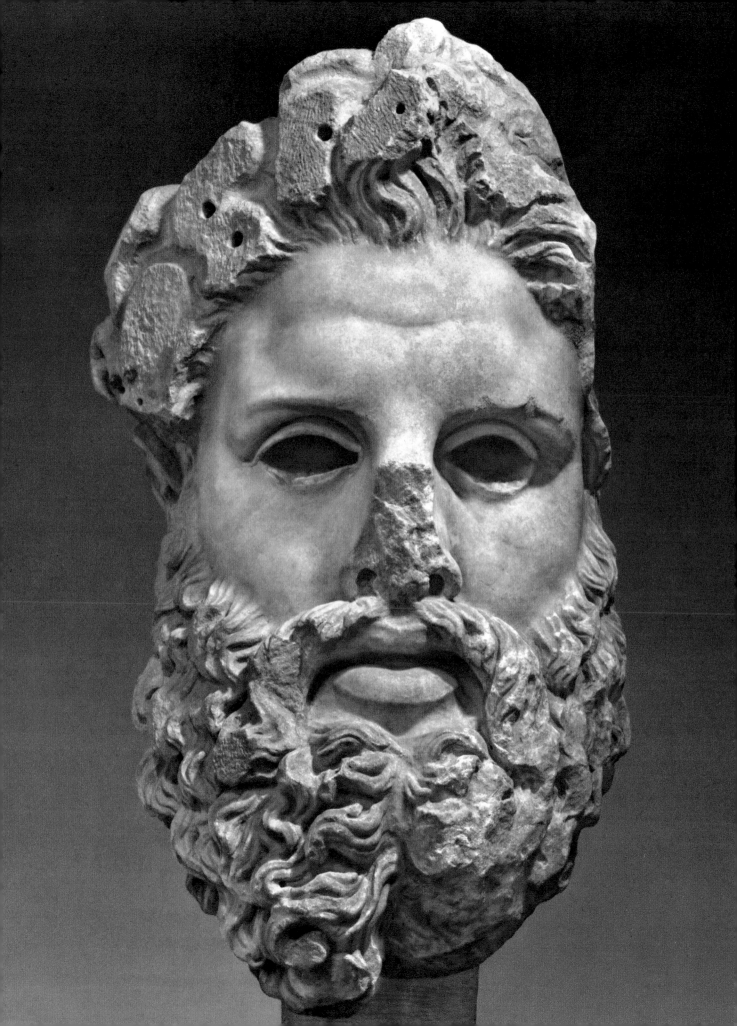

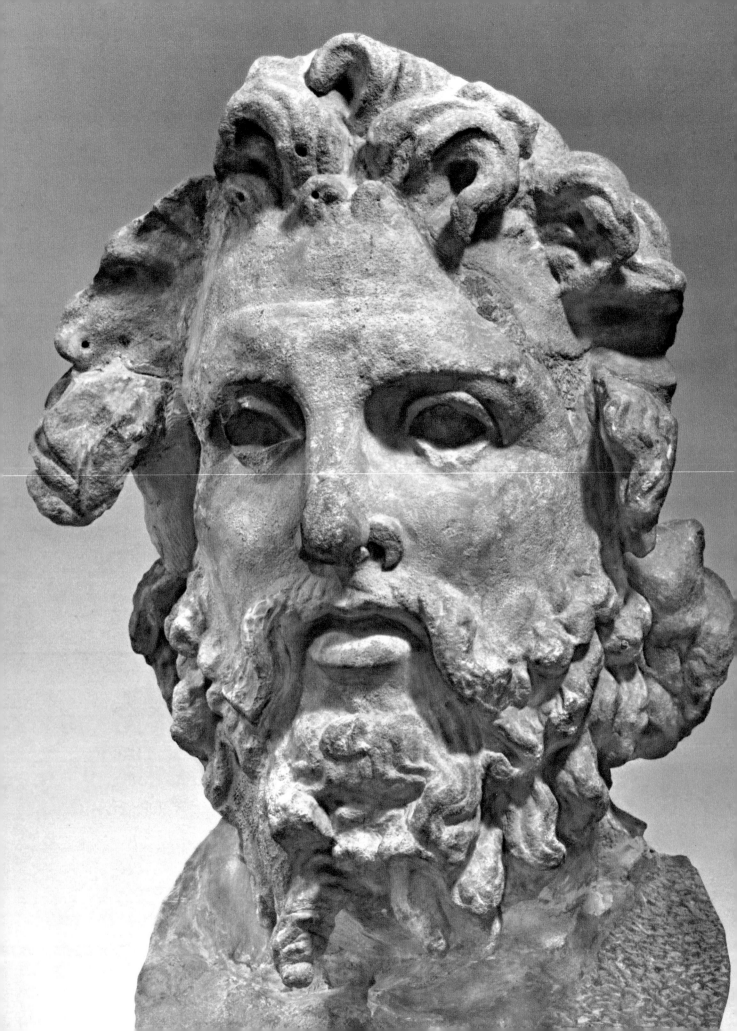

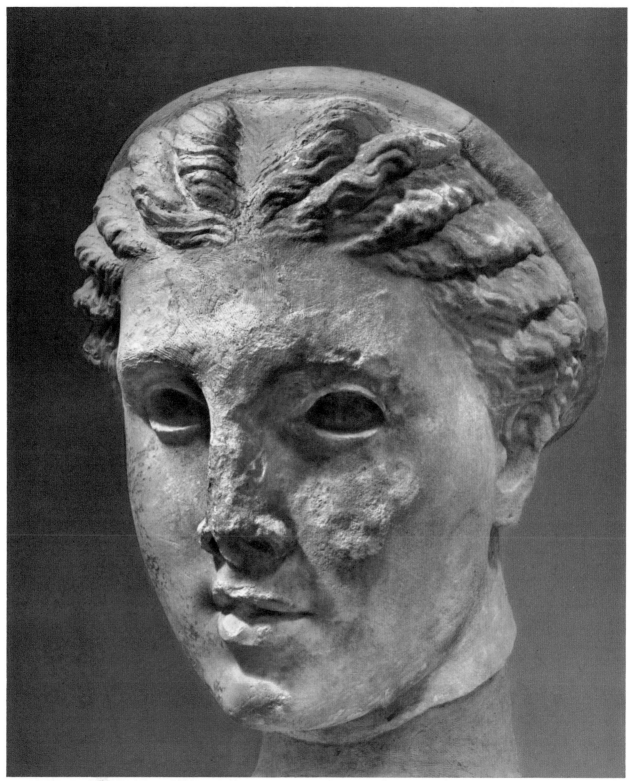

361. LYCOSURA. DAMOPHON OF MESSENE: HEAD OF ARTEMIS. NATIONAL MUSEUM, ATHENS.

360. LYCOSURA. DAMOPHON OF MESSENE: HEAD OF THE TITAN ANYTUS. NATIONAL MUSEUM, ATHENS. 329

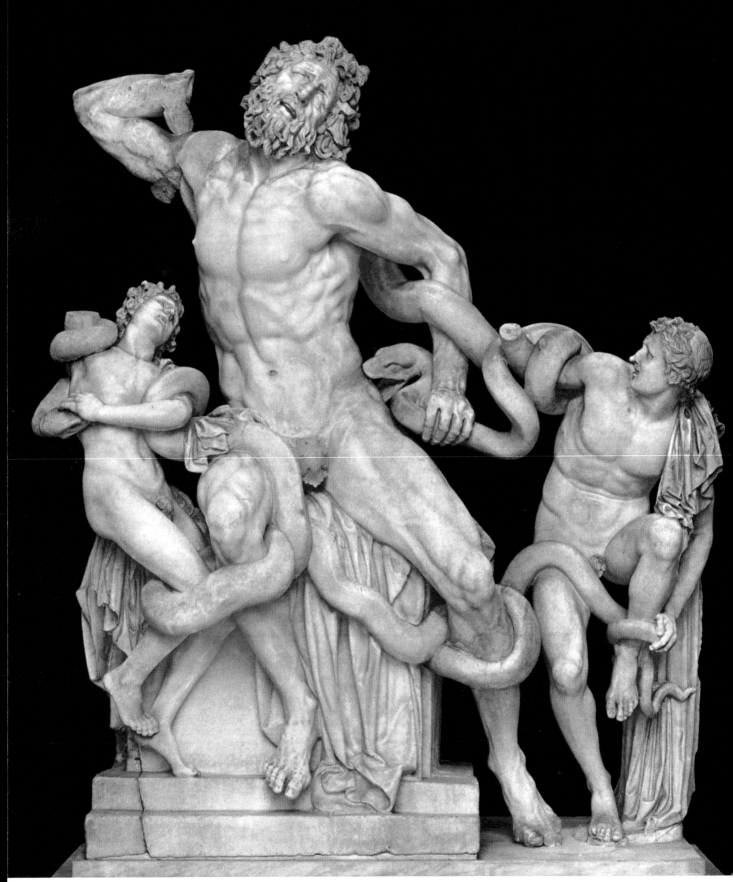

362. ROME. LAOCOÖN AND HIS CHILDREN. VATICAN MUSEUMS.

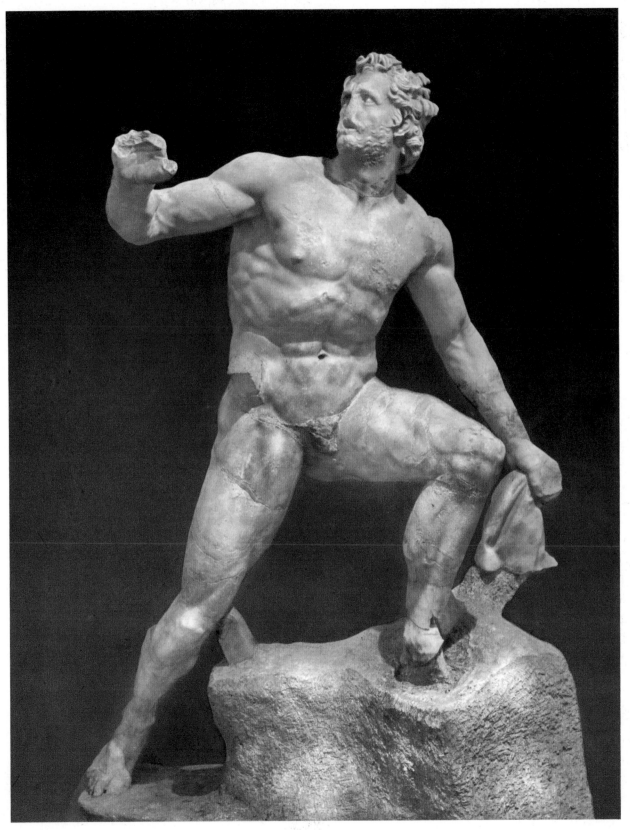

363. SPERLONGA. A COMPANION OF ODYSSEUS. MUSEO ARCHEOLOGICO NAZIONALE, SPERLONGA.

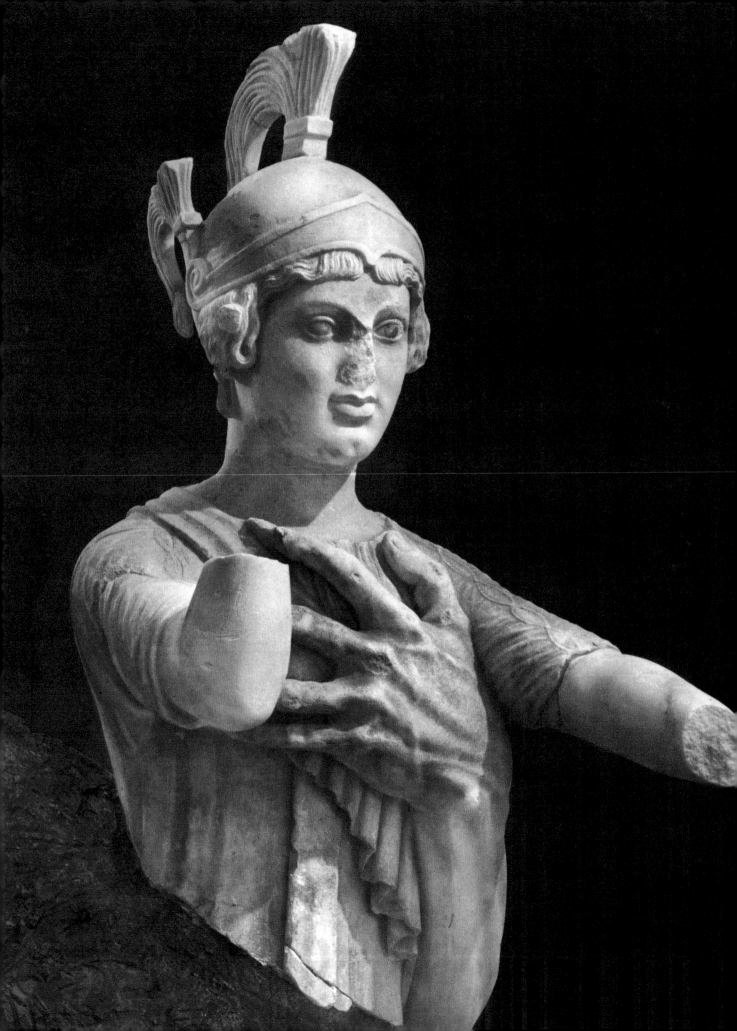

A work like the Venus de Milo, coming at the point it does, underlines the problems which the Hellenistic Age poses for the art-historian. Up to and including its final phase our literary sources have little to say about the period, and, despite the number of artists' signatures that have come to light, the reconstruction of individual careers is all but impossible. Its sculpture reveals numerous powerful, interconnected and more or less lasting influences, and is also permeated, to the point of obsession, with classical reminiscences. If we are trying to establish a chronological sequence, the rigid framework appropriate to a general and smooth evolutionary pattern simply will not do; in this much-discussed, and absorbing field, appreciation of the various styles must always remain at least partially subjective, since each individual's taste, imagination and sensibility need to be taken into account – not to mention his critical prejudices and enthusiasms. It would be highly desirable to have external criteria to refer to, but such fixed points are rare. A certain number of problems have been resolved, but others remain, and each fresh discovery raises new ones.

One current controversy concerns that colossal group by Damophon of Messene in the cella of the temple of Despoena, at Lycosura in Arcadia. Pausanias (8.37.4-5) has left us a description of it: Demeter and Despoena were shown enthroned, with Artemis and the Titan Anytus standing beside them. Excavations towards the end of the last century recovered important fragments of the group, and the remarkable technique they reveal (we find marble sculpture imitating both toreutic work and weaving) and their artistic eclecticism (the handling of detail is far more skilful than the large-scale relief-work) have always proved an embarrassment to critics. There are obvious analogies between the head of the Titan Anytus and that of the Zeus from Aegeira, while it is tempting to compare Demeter's delicately worked *himation* with the finely sculpted drapery on the shoulder of the Tralles Apollo, now in Istanbul. Recent stratigraphical probes around the base have led to the supposition that the date of this group must be brought forward as late as the second century A.D. Such an inference is not, perhaps, quite so inevitable as was originally thought; but the question remains of whether such outsize groupe, formerly regarded as Hellenistic, may not in fact have been executed in the Roman period.

The collapse of the Hellenistic world ushered in a low-class 'neo-Atticism' that lacked the saving grace of originality and abandoned itself to the imitation of classical models – when not copying reliefs in an archaizing manner. The various 'grand styles', evolved to assuage the propagandist urges of Near Eastern potentates (and for which literary inspiration had provided a certain amount of spiritual uplift) were equally in decline. At the same time there can be no doubt that the occupying Romans still found a sizable legacy to inherit. We know how much of our knowledge of Greek classicism is owed to copies made in the time of Hadrian, but the discoveries in the grotto at Sperlonga, or the Laocoön, exhumed on the Esquiline amid the ruins of Titus' palace, offer clear evidence of the influential part played during the final centuries of Hellenism by the taste of famous collectors. It is quite another matter, however, to work out firm dates for the active careers of the Rhodian sculptors Hagesander, Polydorus and Athanodorus, who are named by Pliny (*HN* 36.11.37) as the creators of the Laocoön. Their signature has been discovered at Sperlonga on the group depicting Odysseus and

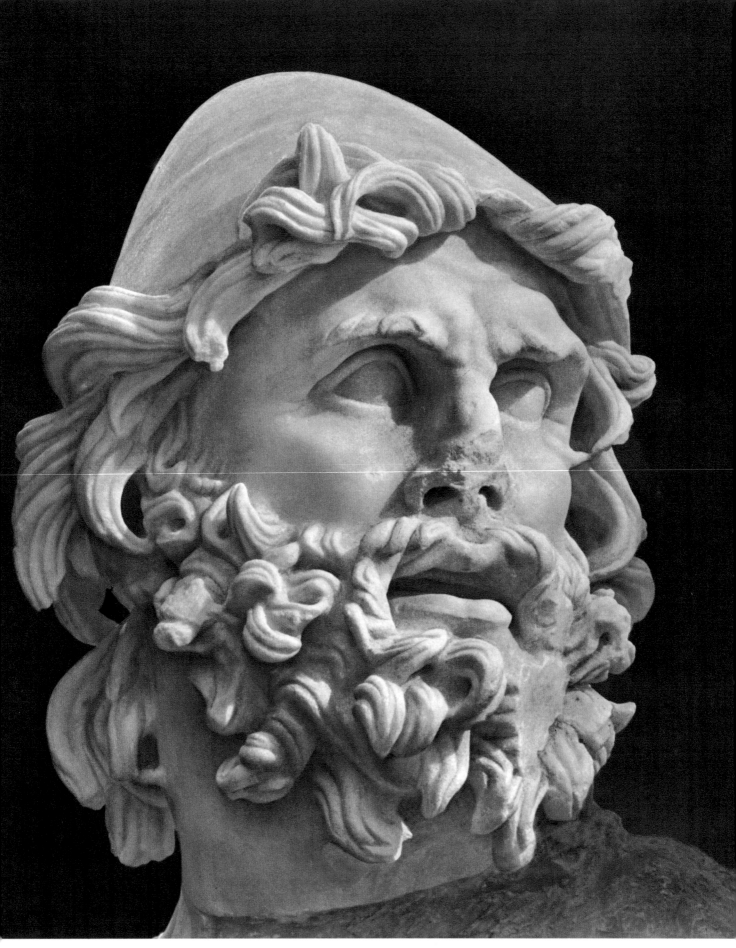

365. SPERLONGA. HEAD OF ODYSSEUS. MUSEO ARCHEOLOGICO NAZIONALE, SPERLONGA.

his companions attacked by the monster Scylla, and the old reconstruction of these artists' background, placing their *floruit* in the latter half of the first century B.C., has therefore been thrown back into the melting-pot. According to expert epigraphical opinion, the inscription is of the Imperial era – but does it represent the original signature? Nothing could be less certain; and, stylistically speaking, comparison of the Laocoön or the head of Odysseus with the Blind Homer or the great frieze at Pergamum is still inevitable.

It would be pointless to deny that chronological uncertainties and fluctuations still bulk large in the history of Hellenistic sculpture. But this is the result of an unprecedented efflorescence, expansion and diversification of the Greek genius. It was in the Hellenistic world that those intellectual or technical advances and those systems of philosophy which provided the Roman Empire with its foundation – and thus constitute the bedrock of our modern world – were first formulated and developed. The final impression which Hellenistic sculpture leaves with us is of wide-ranging curiosity, an ever-deepening search for new approaches, under the guidance of a sophisticated sensibility and exemplary humanism. To a very great extent it furnished the inspiration for Roman, and later for Renaissance, art, and its very considerable historical importance adds immeasurably to its interest.

JEAN CHARBONNEAUX

Text edited and adapted by
JEAN MARCADÉ

Conclusion

To sum up this volume virtually means inviting the reader to take in, at a single glance, all the major features of a widespread and variegated landscape, its ultimate horizon reaching right back to Aegean art. The period we have been surveying is among the very finest in terms of artistic creativity, and for centuries afterwards its vibrations were to influence both the form and the feeling of an exceptionally broad range of artistic expression.

Through their constant striving to master and organize volume and space – whether by boldly working them into architectural and pictorial compositions, or by disciplining them in dynamic three-dimensional sculpture – the artists of the Hellenistic period set the seal on what had been a long process of conquest and discovery. Its first manifestations go back at least as far as the seventh century B.C.: to Daedalic sculpture and Orientalizing pottery, which, even at this early period, were attempting to break up the rigid contours of a too-geometric and purely linear form of expression. Greek art struggled to birth amid such poverty and destitution as not even bright memories of the artistically flourishing civilizations of Crete and Mycenae could mitigate – despite those 'renaissances' which scholars once claimed to discern behind its earliest manifestations. Its development should rather be seen as a gradual, progressive and permanent conquest, helped forward (sometimes simultaneously, more often sporadically) by all those vast areas of the Mediterranean world which it never managed to bring together in complete unity.

Right from the start, however, its creative power is such that, at those points in its history when it draws on the techniques or stock themes of neighbouring artistic traditions, all its borrowings are at once transposed and assimilated to a civilization in which the measure of man and the organization of human communities never cease to impose their own laws and requirements. Here, beneath the semblance of great diversity, we find a unifying principle; but unity does not mean uniformity, and it is characteristic that at each stage of its development Greek art assumes a different appearance, so that it becomes of importance to isolate the contributions and creations which come in turn from the shores of the eastern Aegean, from Crete or the Cyclades, from the Peloponnese or Attica, from the cities of Magna Graecia or Sicily. It emerges

as a kind of relay race in which each region contributes to the common store certain forms that have been renewed and enriched by its unique contacts with neighbouring civilizations. It was in this way that various artistic phenomena – seventh-century pottery, sixth-century *kouroi* and *korai*, the same period's monumental architecture, architectural compositions of the fourth and third centuries – were developed and enriched, by the introduction of various foreign elements which every region refined and modified. Thus we have a never-failing supply of potential innovations feeding an innate gift of life and creativity which continued unabated until the very end of Hellenistic art. Whatever the field in which such influences make themselves felt – monumental sculpture, such as the archaic friezes, or the *kouroi*; architecture, as in the great temples of Ionia; or decorative standards, whether architectural or ceramic – assimilation is achieved through a precise adaptation of the new forms to the purpose and function of the work in question. From the very first Greek art was always functional, being closely linked to religious beliefs, ritual observance, political institutions and thought. Form, for the Greeks, was never something gratuitous; even when it became purely decorative it remained inseparable from structure. There comes a point at which we can discern this divorce in certain artifacts of the Hellenistic period, but by then they are already very close to the Roman world – which they provided with decorative themes, stripped of their original structural functions.

It is true that Hellenistic art spread itself in enormous compositions, both sculptural and monumental, conceived on the scale of a vastly enlarged Greek world, and as the expression of a new political set-up in which kingdoms replaced the city-states. Yet its component parts had been perfected by earlier ages. As early as the sixth century both the colonial towns of western Greece and the tyrants of city-states on the Aegean seaboard had shown a talent for grandiose planning and for stimulating the creative imagination of architects and sculptors. They had been clever enough to profit by that widespread intellectual ferment which, in the seventh and sixth centuries, promoted so much pioneer research and created a mass of new and original formulas. Classical thought, however, had disciplined and stabilized the main trends; it imposed rules and principles which reflected that politico-economic equilibrium attained, albeit for a short period of time only, by the more important city-states, and by Athens in particular.

During the fourth century, such innovatory impulses, though moving more slowly and at times completely dammed up, were nevertheless preparing those elements necessary for the vigorous efflorescence typical of the final phase: a softening (or complete transformation) of classical rhythms; the development of consciously asymmetrical movements and attitudes; proportional enlargement, the mastery of the spatial aspects of composition, a subtle interplay of contrasted light and shade. Thus Greek art evolved without any violent breaks; periods of equilibrium and stability succeeded those of advance or seeming revolution and tendencies towards generalization or idealization tempered those crises of development and growth which were liable to breed particularism, individualism and over-picturesqueness.

The maintenance of this state of comparative equilibrium was doubtless largely due to an endless two-way traffic between the various branches of art. Architecture,

338

sculpture and painting were for ever pooling their modes of expression, and drawing on the standards which properly belonged to each other, and, here again, the Hellenistic era strove (at times excessively) for plastic or pictorial effects which resulted from the association of sculpture and painting with architecture. Yet though the creative work of this period may, because of their violence or excesses, suggest a civilization on the point of collapse, all its constituent elements had been in preparation since the Archaic period. It was then that the avenue of the Branchidae at Miletus, or that of the Lions on Delos, together with the more or less general practice of alignment of votive figures, first introduced a plastic quality into landscape or the architectural arrangement of sanctuaries. However, its hieratic impact was subsequently broken by a disorderly accumulation of classical or Hellenistic votive offerings.

Throughout the fifth and fourth centuries this interplay between arts ceaselessly produced original rhythmic patterns. Ictinus was obliged to comply with the requirements of Pheidias. Scopas' fundamentally sculptural temperament influenced his architectural designs. The 'Monument of the Nereids' at Xanthos and the Mausoleum of Halicarnassus already embodied all those features which the monumental altars of Pergamum or Magnesia were to explore two centuries later.

If Greek art has been able to exercise so deep and far-reaching an influence, if its range and variety prove equally attractive to the classically-minded, with their passion for balance and continuity, and to the temperament which thirsts after endless experiment, and appreciates continual revision, that is because it never stood still. It existed in a non-stop creative rhythm, a state of perpetual adaptation to the thought, ideas and beliefs of a civilization that always kept itself in step with humanity, that always remained open to external influences, yet never allowed itself to be swamped by them. With the most astounding fertility it threw up formal and structural innovations which afterwards met the requirements of a world as centralized as that of the Roman Empire and of civilizations as disparate as those (Nabataean, Parthian or Sassanid) which flourished in the Middle East. This is a tribute to its capacity for emulating the flexibility and variety of human nature, which, continually changing and evolving, yet remains firmly anchored to its more permanent elements. Being thus bound up with the *élan vital* of a civilization in which the moving force was a well-balanced and rational humanism, Greek art drew thence not only its profoundly dynamic quality, its creative force and its powers of renewal, but also its feeling for symmetry and proportion, its functional standards, and the limits imposed by an equilibrium that was always in tune with human nature.

<div style="text-align: right">ROLAND MARTIN</div>

General Documentation

SCIENTIFIC ADVISER MADELEINE DANY

Supplementary Illustrations

SCULPTURE

Coins and ancient replicas

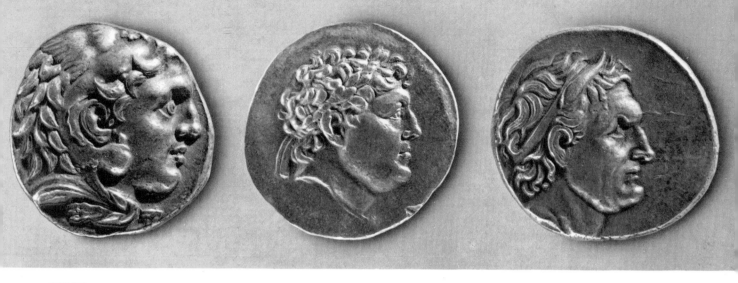

367-369. ALEXANDER; PHILETAERUS; SELEUCUS NICATOR. BIBLIOTHÈQUE NATIONALE, CABINET DES MÉDAILLES, PARIS.

370. POLYEUCTUS: DEMOSTHENES.
NY CARLSBERG GLYPTOTEK, COPENHAGEN.

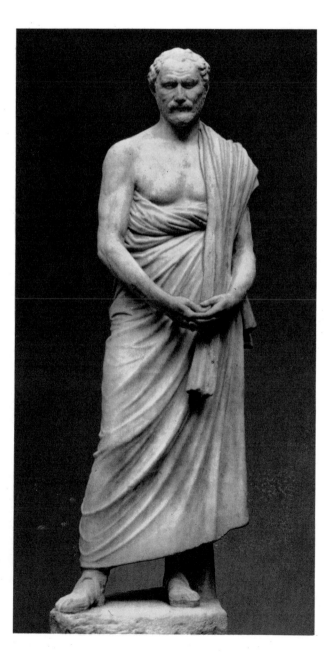

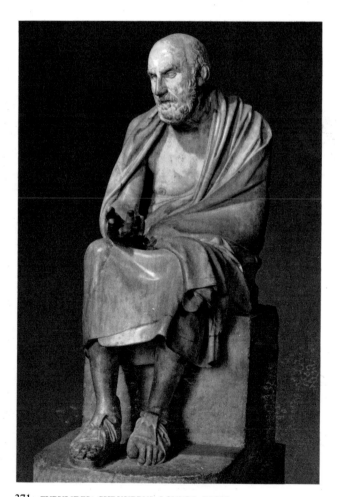

371. EUBULIDES: CHRYSIPPUS. LOUVRE, PARIS.

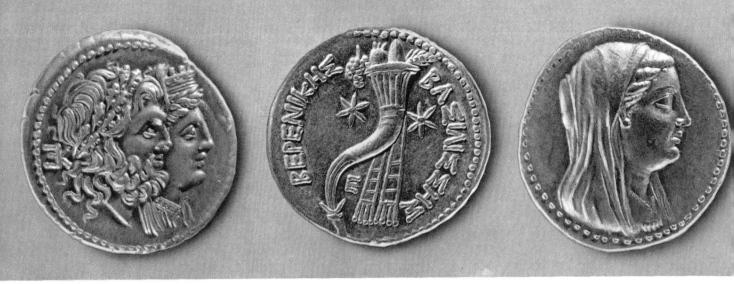

372-374. ZEUS OF DODONA AND DIONE; THE PTOLEMAIC CORNUCOPIA; BERENICE II.
BIBLIOTHÈQUE NATIONALE, CABINET DES MÉDAILLES, PARIS.

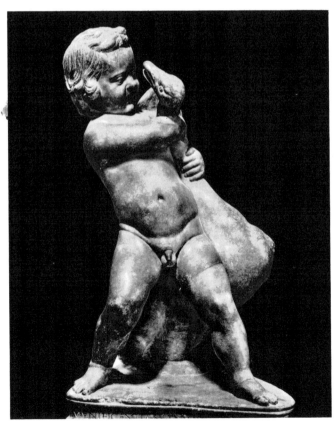

375. BOETHUS: CHILD WITH A GOOSE. MUSEO CAPITOLINO, ROME.

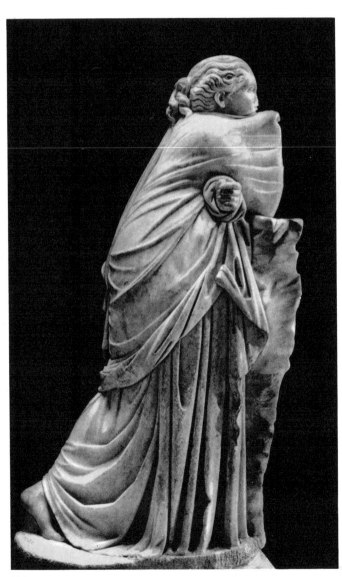

376. PHILISCUS: POLYHYMNIA. MUSEO CAPITOLINO, ROME.

346

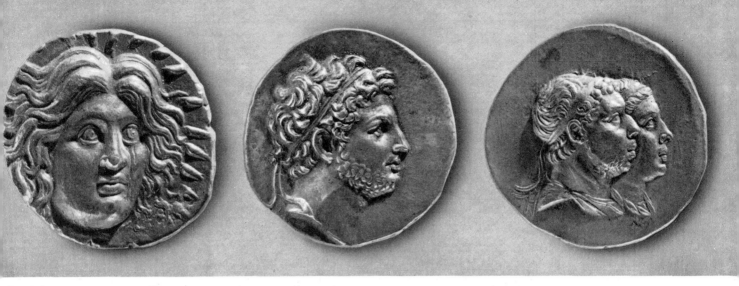

377-379. HELIOS; PERSEUS; MITHRIDATES IV AND LAODICE. BIBLIOTHÈQUE NATIONALE, CABINET DES MÉDAILLES, PARIS.

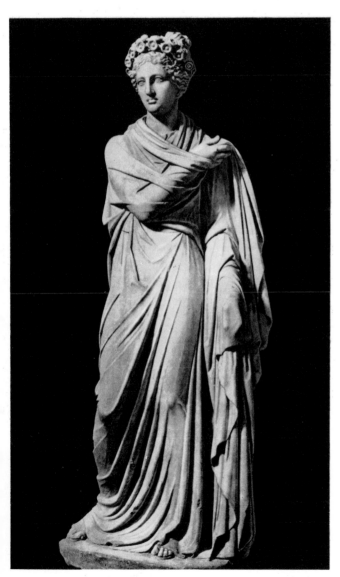

380. ROME. A MUSE. VATICAN MUSEUMS.

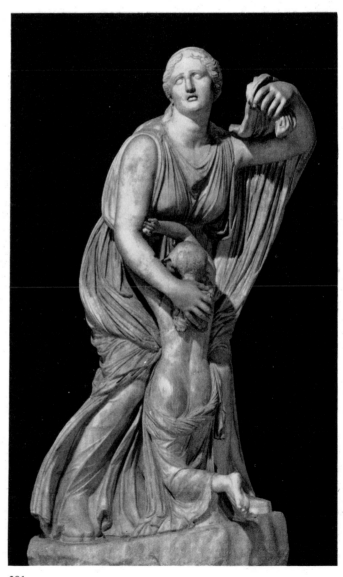

381. ROME. NIOBE AND HER DAUGHTER. UFFIZI, FLORENCE.

347

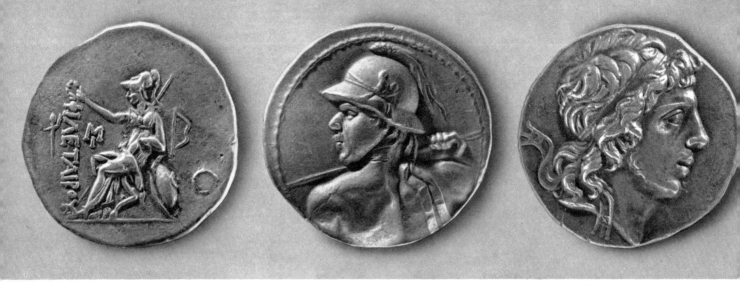

382-384. ATHENA SEATED; EUCRATIDES; MITHRIDATES VI EUPATOR. BIBLIOTHÈQUE NATIONALE, CABINET DES MÉDAILLES, PARIS.

385. ROME. MENELAUS AND PATROCLUS. LOGGIA DEI LANZI, FLORENCE.

386. RECONSTRUCTION OF·THE GREAT EX-VOTO OF ATTALUS I AT PERGAMUM.

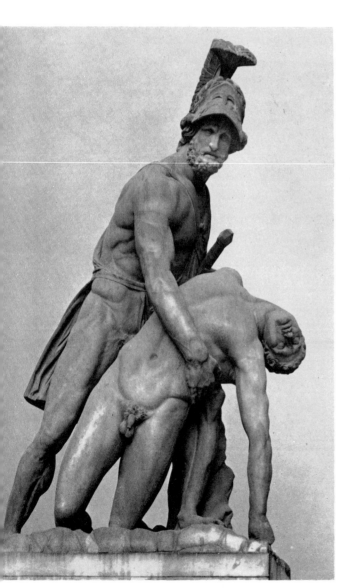

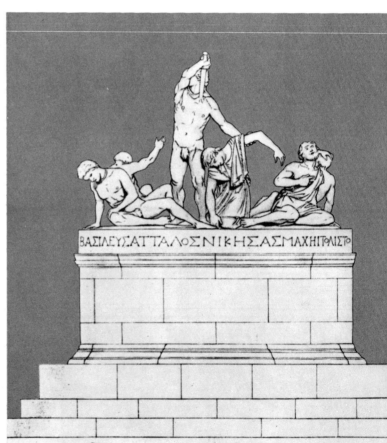

Plans and Reconstructions

Plans drawn by Claude Abeille.

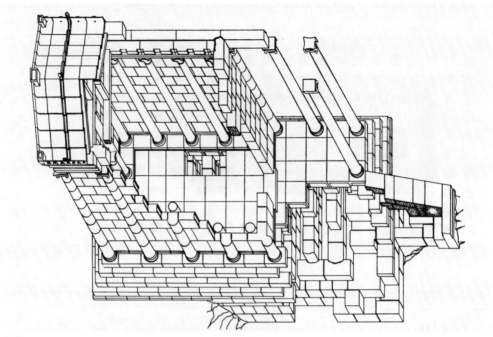

387. EPIDAURUS, TEMPLE L. AXONOMETRIC PERSPECTIVE.

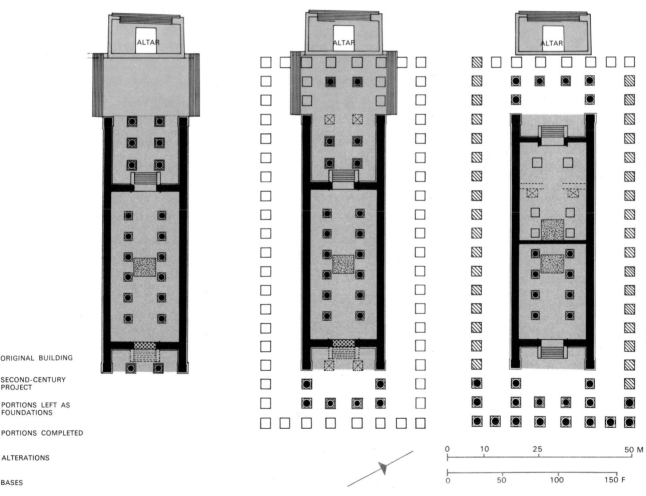

ORIGINAL BUILDING

SECOND-CENTURY PROJECT

PORTIONS LEFT AS FOUNDATIONS

PORTIONS COMPLETED

ALTERATIONS

BASES

CONJECTURAL

NAOS

ALTAR

0 10 25 50 M

0 50 100 150 F

388-390. SARDIS, TEMPLE OF ARTEMIS. THE THREE PHASES OF CONSTRUCTION.

351

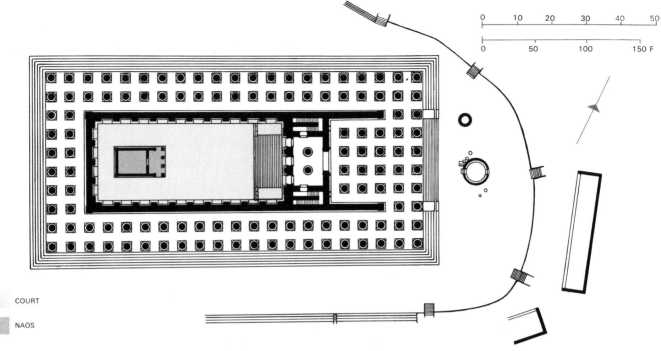

391. DIDYMA, THIRD-CENTURY TEMPLE OF APOLLO.

COURT

NAOS

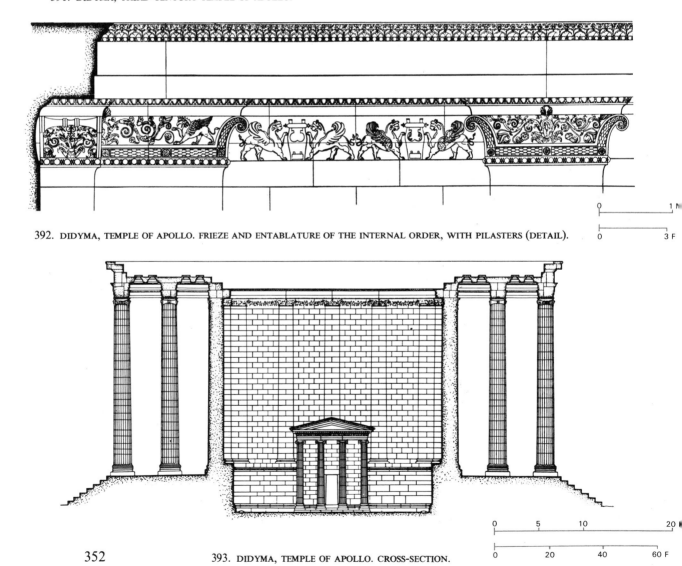

392. DIDYMA, TEMPLE OF APOLLO. FRIEZE AND ENTABLATURE OF THE INTERNAL ORDER, WITH PILASTERS (DETAIL).

393. DIDYMA, TEMPLE OF APOLLO. CROSS-SECTION.

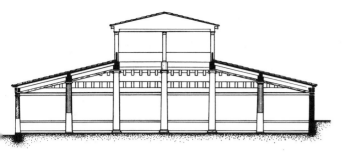

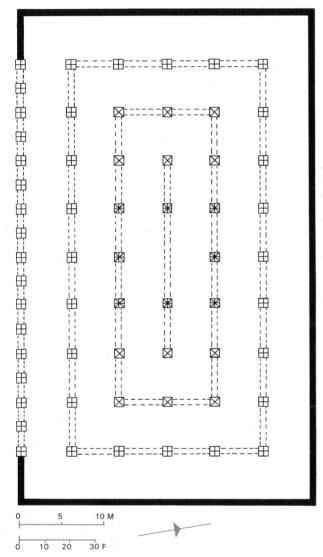

396-397. LEVKADHIA, VAULTED TOMB.
CROSS-SECTION AND GROUND-PLAN.

0 3 6 M

0 10 18 F

0 5 10 M

0 10 20 30 F

⊞ DORIC ORDER

⊠ IONIC ORDER

⊠ SUPERIMPOSITION OF BOTH ORDERS

394-395. DELOS, HYPOSTYLE HALL.
CROSS-SECTION AND GROUND-PLAN.

398. VERGINA, HELLENISTIC PALACE.

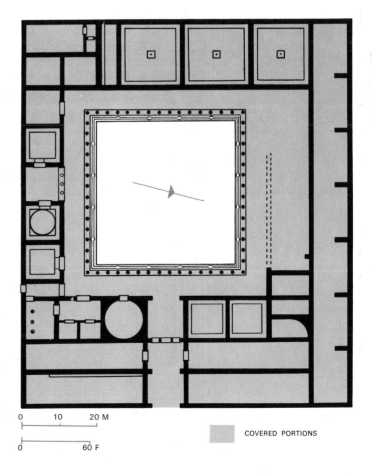

0 10 20 M

0 60 F

COVERED PORTIONS

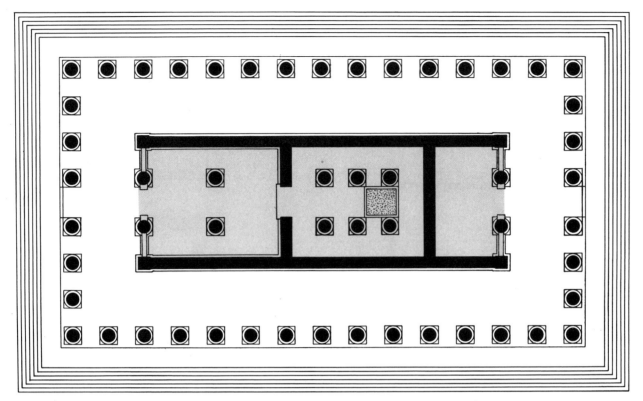

NAOS

BASE

399. MAGNESIA-AD-MAEANDRUM,
TEMPLE OF ARTEMIS LEUCOPHRYENE.

0 5 10 20 M

0 20 40 60 F

400. PERGAMUM, PLAN OF THE GREAT ALTAR.

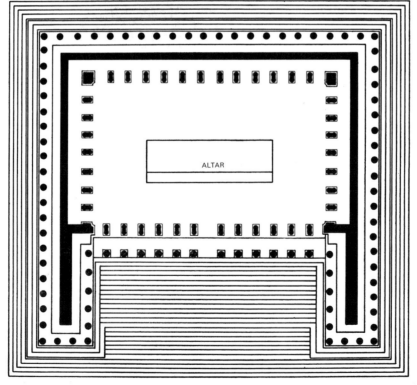

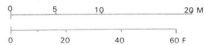

ALTAR

354

0 5 10 15 M

0 10 20 30 40 F

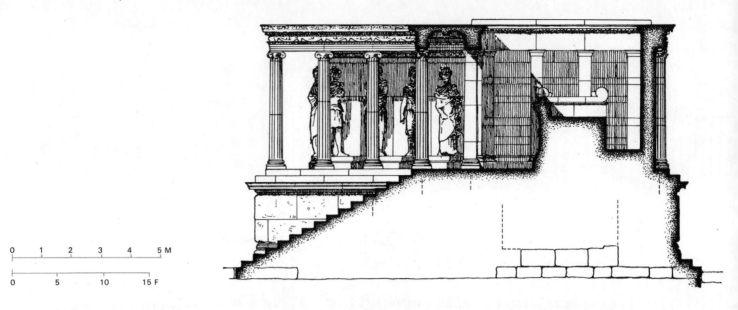

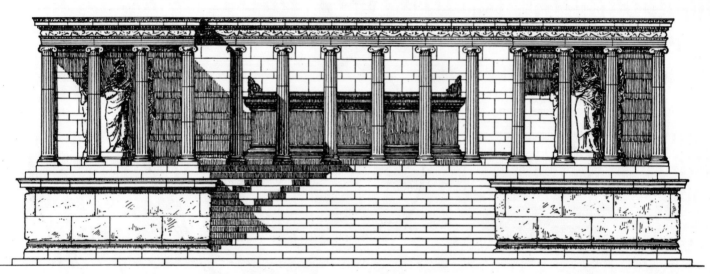

401-402. MAGNESIA-AD-MAEANDRUM, ALTAR OF ARTEMIS. CROSS-SECTION AND ELEVATION OF THE FAÇADE.

403. MAGNESIA-AD-MAEANDRUM,
ALTAR OF ARTEMIS.

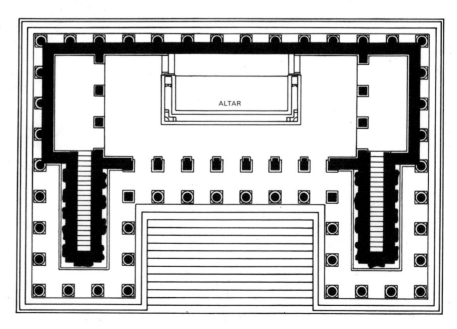

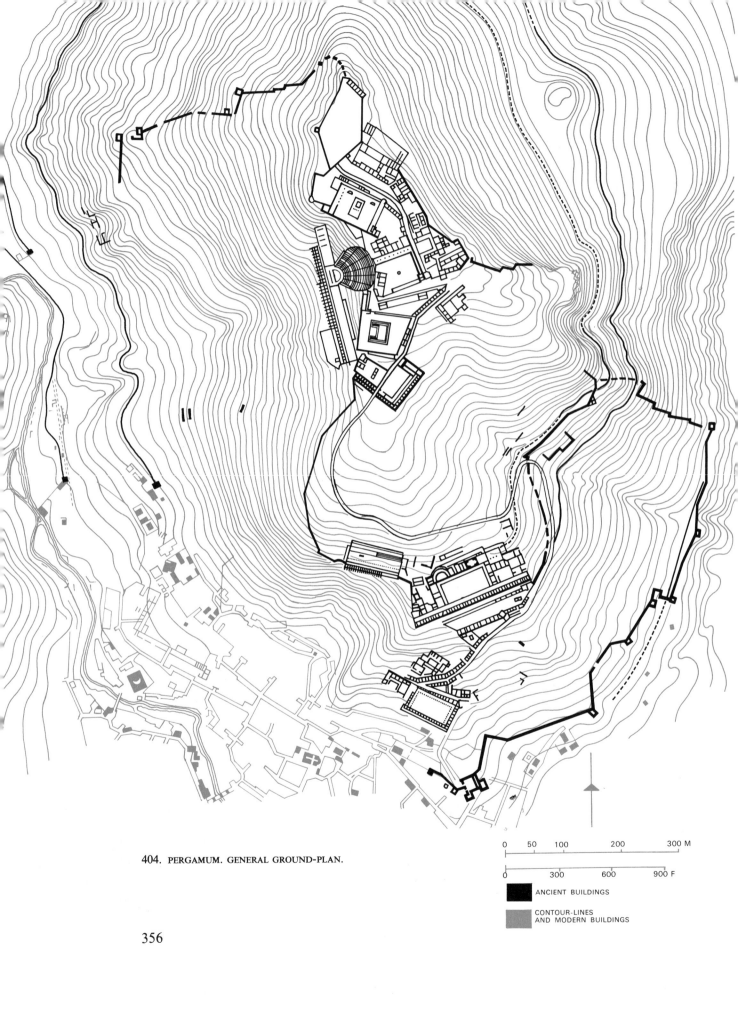

404. PERGAMUM. GENERAL GROUND-PLAN.

0 50 100 200 300 M

0 300 600 900 F

■ ANCIENT BUILDINGS

▦ CONTOUR-LINES AND MODERN BUILDINGS

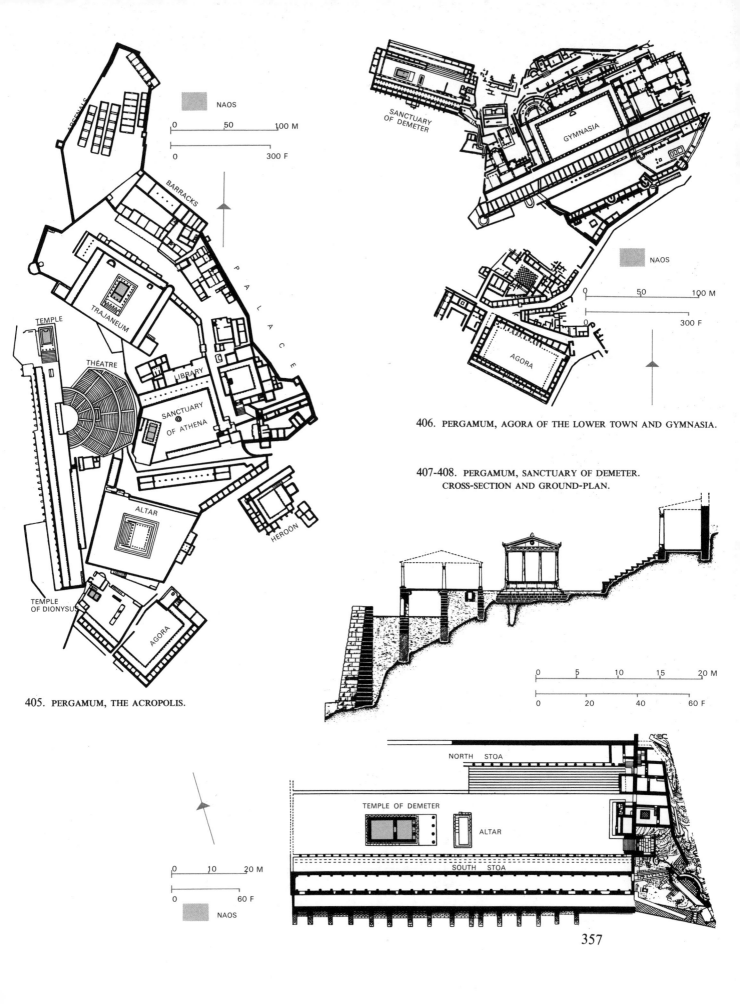

NAOS

0 50 100 M

0 300 F

BARRACKS

PALACE

TEMPLE

THÉATRE

TRAJANEUM

LIBRARY

SANCTUARY
OF ATHENA

ALTAR

TEMPLE
OF DIONYSUS

HEROÖN

AGORA

405. PERGAMUM, THE ACROPOLIS.

SANCTUARY
OF DEMETER

GYMNASIA

NAOS

0 50 100 M

0 300 F

AGORA

406. PERGAMUM, AGORA OF THE LOWER TOWN AND GYMNASIA.

407-408. PERGAMUM, SANCTUARY OF DEMETER.
CROSS-SECTION AND GROUND-PLAN.

0 5 10 15 20 M

0 20 40 60 F

0 10 20 M

0 60 F

NAOS

NORTH STOA

TEMPLE OF DEMETER

ALTAR

SOUTH STOA

357

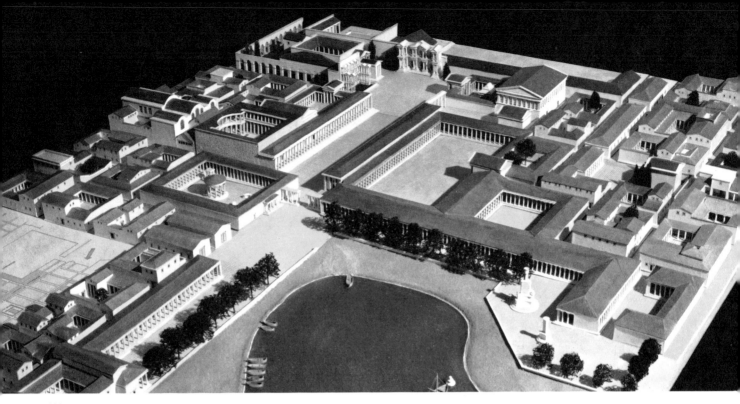

409. MILETUS, NORTH HARBOUR AREA. SCALE MODEL. STAATLICHE MUSEEN, BERLIN.

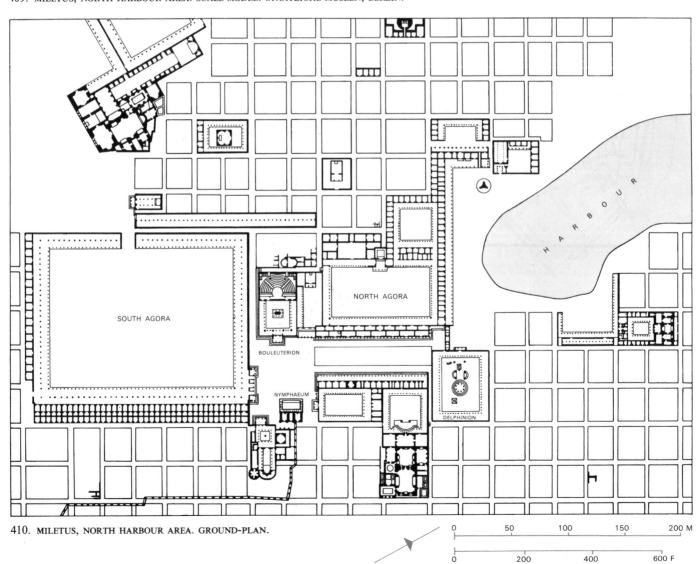

SOUTH AGORA

NORTH AGORA

BOULEUTERION

NYMPHAEUM

DELPHINION

HARBOUR

410. MILETUS, NORTH HARBOUR AREA. GROUND-PLAN.

| 0 | 50 | 100 | 150 | 200 M |

| 0 | 200 | 400 | 600 F |

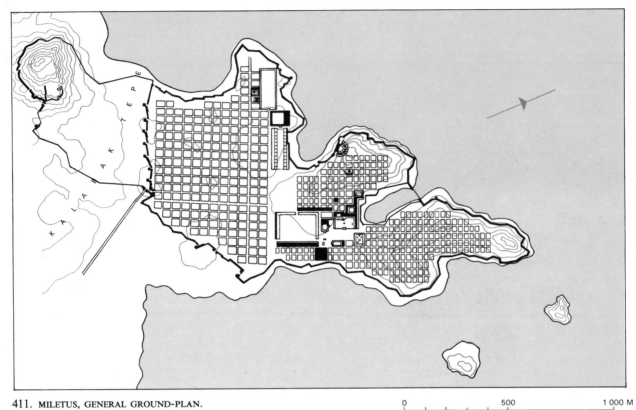

411. MILETUS, GENERAL GROUND-PLAN.

412. MILETUS, THE NYMPHAEUM.

| 0 | 500 | 1 000 M |

| 0 | 1 000 | 2 000 | 3 000 F |

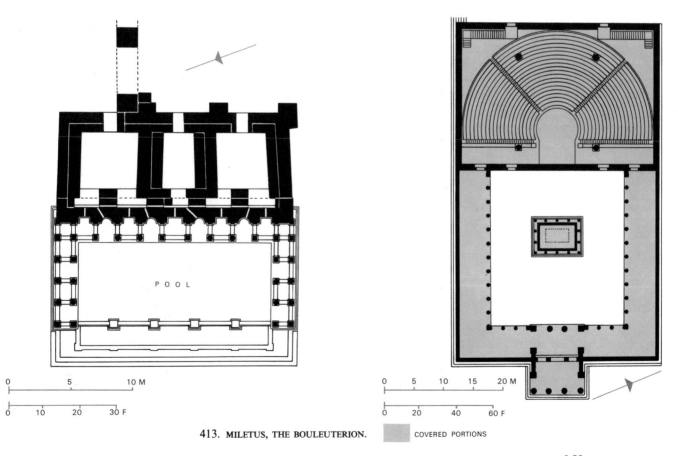

P O O L

| 0 | 5 | 10 M |

| 0 | 10 | 20 | 30 F |

| 0 | 5 | 10 | 15 | 20 M |

| 0 | 20 | 40 | 60 F |

413. MILETUS, THE BOULEUTERION. COVERED PORTIONS

359

STOA OF HERMES

PAINTED STOA

T. OF APHRODITE URANIA

STOA OF ZEUS

ALTAR OF THE TWELVE GODS

PERISTYLE COURT

HEPHAESTEUM

TEMPLE OF APOLLO PATROOS

OLD BOULEUTERION

NEW BOULEUTERION

EPONYMOUS HEROES

KOLONOS AGORAIOS

P A N A T H E N A I C W A Y

THOLOS

STRATEGEION

BOUNDARY OF THE AGORA

HELIAEA

SOUTH STOA (I)

ENNEAKROUNOS

414. ATHENS, THE AGORA IN THE FOURTH AND THIRD CENTURIES B.C.

0 50 100

0 100 200 300 F

NAOS ANCIENT ROADS

360

415. ATHENS, THE AGORA IN THE SECOND AND FIRST CENTURIES B.C.

STOA OF HERMES

PAINTED STOA

T OF APHRODITE
URANIA

STOA OF ZEUS

ALTAR OF THE
TWELVE GODS

HEPHAESTEUM

TEMPLE OF
APOLLO PATROOS

P A N A T H E N A I C W A Y

STOA OF ATTALUS

BOÜLEUTERION

METROON

EPÖNYMOUS HEROES

ROSTRUM

KOLONOS
AGORAIOS

STRATEGEION

THOLOS

MIDDLE STOA

HELIAEA

SOUTH STOA (II)

ENNEAKROUNOS

0 50 100 M

0 100 200 300 F

NAOS ANCIENT ROADS

361

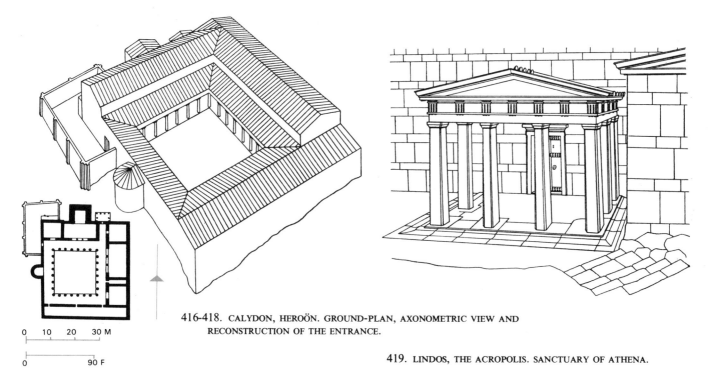

416-418. CALYDON, HEROÖN. GROUND-PLAN, AXONOMETRIC VIEW AND
RECONSTRUCTION OF THE ENTRANCE.

0 10 20 30 M

0 90 F

419. LINDOS, THE ACROPOLIS. SANCTUARY OF ATHENA.

TEMPLE
OF
ATHENA

ALTAR

PROPYLAEA

S T O A

NAOS

0 10 20 30 40 50 M

0 50 100 150 F

Chronological Table

	EVENTS	MAINLAND GREECE AND ATHENS
350		
340	Battle of Chaeronea (338).	Pediments at Tegea (Scopas). The chryselephantine statues in the Philippeum at Olympia (Leochares).
335	Accession of Alexander (336).	Portrait of Satyrus the pugilist at Olympia (Silanion). Ex-voto of Daochus and statue of Agias (Lysippus).
330	Foundation of Alexandria (331).	The painters Nicias and Athenion. The 'Alexander with a Spear' (Lysippus).
325	Death of Alexander (323).	The painters Apelles and Protogenes. 'Alexander Hunting' group at Delphi (Leochares and Lysippus).
320	The partition of Triparadeisus (321). Ptolemy seizes Syria (319).	The Metroön at Olympia. The monument of Nicias.
315	Cassander ruler of Greece (316-297). Antigonus creates the Islanders' confederacy.	South Stoa of the Corinth Agora. Extension of the theatre in Athens.
310		
305	The Diadochi (Successors) assume royal titles and prerogatives. Siege of Rhodes (305-304). Menander.	Mosaic by Gnosis at Pella. The painter Philoxenus of Eretria.
300	Battle of Ipsus (301). Foundation of Antioch on the Orontes.	Statue of Menander (Cephisodotus and Timarchus).
295	Demetrius Poliorcetes, King of Macedon (294).	Portico of Echo at Olympia. Tomb-paintings of Kazanlak.
290	Museum and Library of Alexandria.	Statue of Demetrius Poliorcetes (Teisicrates).
285	Ptolemy II, King of Egypt (283-246).	Large houses in Pella. Muses group (Vatican type). 'Niobe and her Children' group (Florence type).
280	Battle of Corupedion (281): deaths of Lysimachus and of Seleucus I.	Statue of Demosthenes (Polyeuctus). Palace of Palatitsa.
275	Invasion of the Galatians (Gauls). Antigonus Gonatas (276-239). Hiero II, King of Syracuse (275-215). Eratosthenes, Theocritus, Callimachus, Herodas.	Vaulted tombs in Macedonia, especially at Levkadhia.
270	Antiochus I's victory over the Galatians.	Portrait of Epicurus.
265		
	Eumenes I ruling Pergamum (263-241).	
260		Painted stelae of Demetrias.
255		
250	Bactria and Soghdiana gain their independence. Foundation of the Parthian kingdom.	Cynosarges gymnasium at Athens.
245	Ptolemy III, King of Egypt (246-221).	
240	Attalus I ruling Pergamum (241-197).	
235	Apollonius of Rhodes. Chrysippus.	
230	Attalus I's victory over the Galatians. Antigonus Doson in Macedonia (229-221). Reforms by Cleomenes in Sparta.	

EAST GREECE AND THE ISLANDS	SICILY AND MAGNA GRAECIA	AFRICA AND THE EAST	
The sculptors of the Mausoleum at Halicarnassus (Timotheus, Scopas, Bryaxis, Leochares).			350
			340
			335
		Plan of Alexandria drawn up.	
			330
Temple of Artemis at Sardis (second version).			325
		First building period at Aï Khanum.	320
			315
Work begins on the new Didymeum.			
Work begins on the temple of Apollo at Claros.	The 'Amazon sarcophagus' at Tarquinia.	Portrait of Seleucus Nicator (Bryaxis).	310
Monument of the Bulls on Delos.			
	End of painted pottery with figure-decoration.	The so-called 'Alexander Sarcophagus'.	305
		The 'Apollo Citharoedus' from Daphne (Bryaxis).	300
Colossus of Rhodes (Chares).		The 'Tyche of Antioch' (Eutychides).	
			295
Temple of Athena at Pergamum.		The Museum at Alexandria.	290
		The Alexandria Pharos built by Sostratus of Cnidus.	285
			280
Temple of Aphrodite at Messa.			
		The Great Portico of the Agora in Cyrene.	275
		Second building period at Aï Khanum.	270
			265
Cult-statue of Zeus Stratios at Nicomedea (Doedalses).			
	Hiero II's altar at Syracuse.	Hellenistic fortifications of Dura-Europos.	260
'Child with a Goose' (Boethus I).	Theatre of Syracuse (scene-building by Hiero II).		255
Antigonus' portico on Delos.			250
	The 'Fanciulla d'Anzio'.		
Great Stoa of the South Agora at Miletus.	Development of the Hellenistic quarters in Agrigento.		245
Work begun on the Asclepieum of Cos.	Corinthian temple and organization of the Forum at Paestum.	Development of Greek architecture in Bactria.	240
			235
Portico of Attalus in Athena's sanctuary at Pergamum.			230
'Monument of the Galatians' at Pergamum (Epigonus).			

	EVENTS	MAINLAND GREECE AND ATHENS
225		
220	Antiochus III (223-187). Philip V (221-179) and Ptolemy IV (221-203).	
215	Battle of Raphia (217).	
210	Archimedes. Sack of Syracuse by the Romans (212).	Portrait of Chrysippus (Eubulides).
205	Ptolemy V, King of Egypt (203-181).	
200		
195	Eumenes II of Pergamum (197-159). Flamininus proclaims freedom for the Greeks (196).	
190	Defeat of Antiochus II at Magnesia (189) and the Treaty of Apamea (188).	Great portico of Philip at Megalopolis.
185		
180	Perseus, King of Macedonia (179-168).	
175	Antiochus IV (175-163).	Architectural complex (agora and gymnasium) at Sicyon.
170		Work resumed on the Olympieum at Athens.
165	Pydna, end of Macedonia as an independent kingdom (168). Athens receives Delos, which becomes a free port (166).	
160	Attalus II ruling in Pergamum (159-138).	
155	Polybius the historian.	Attalus II's ex-voto in Athens. Stoa of Attalus in Athens.
150		Attalid complex at Delphi. Damophon's statues in the temple at Lycosura.
145	Sack of Corinth by the Romans (146). Ptolemy VII, King of Egypt (145-116).	The agora at Messene. The great Middle Stoa in the Athenian Agora.
140		
135	Attalus III bequeaths his kingdom to Rome (133).	The Metroön at Athens.
130	Creation of the Roman province of Asia (129).	
120		
110	Mithridates VI Eupator (112-63).	
100		Statue of C. Ofellius Ferus (Dionysius and Timarchides).
90	Sack of Delos (88). Sack of Athens by Sulla (86).	
80		
70		
60	Rome annexes Syria (64).	
50		

EAST GREECE AND THE ISLANDS	SICILY AND MAGNA GRAECIA	AFRICA AND THE EAST	
			225
			220
	Hellenistic houses at Glanum.		
Hypostyle Hall on Delos.			215
Work in progress on the Lindos acropolis.			210
			205
Work in progress on the theatre at Pergamum.			200
	Theatre at Segesta.		
			195
Portico of Philip V on Delos.			190
The 'Victory of Samothrace'.			185
Sosus of Pergamum (mosaic artist).			180
Construction of the Great Altar of Pergamum.			
			175
The temple of Dionysus at Teos built by Hermogenes.		The 'Farnese Cup'.	
			170
The Bouleuterion of Miletus.	Centuripe pottery.		165
			160
The agoras of Pergamum.			
			155
Hermogenes builds the new temple of Magnesia-ad-Maeandrum. Mahdia bronze group (Boethus II). Agora at Assos. Sanctuary of Hera Basileia at Pergamum.			150
			145
Gymnasia of Pergamum. Work in progress on the terraces of the Asclepieum (Cos). Temple on the upper terrace (Cos). Statue of Cleopatra the Athenian on Delos.			140
	Refounding of Massalia (Marseilles).		135
Mosaics on Delos.			130
Delian group of Aphrodite, Eros, and Pan.			
	Temple of Apollo at Pompeii.		120
Work in progress on the great agoras of Miletus.			110
The 'Venus de Milo' and the 'Pseudo-Inopus' (Louvre).			100
			90
	Architectural complex of the temple of Fortuna at Praeneste.		80
	Mosaics at Praeneste.		
			70
			60
The painter Timomachus of Byzantium.	Wall-paintings at the Villa of the Mysteries, Pompeii.		50

Bibliography

ABBREVIATIONS USED IN THE BIBLIOGRAPHY

AA	*Archäologischer Anzeiger*, Beiblatt zum Jahrbuch des deutschen archäologischen Instituts, Berlin, W. de Gruyter.
AE	*Archaiologikè Ephemeris*, published by the Société archéologique d'Athènes.
AJA	*American Journal of Archaeology*. The Journal of the Archaeological Institute of America.
AK	*Antike Kunst*, Berne, Francke Verlag.
AM	*Mitteilungen des deutschen archäologischen Instituts, Athenische Abteilung*, Berlin, Gebr. Mann.
Arch. Class.	*Archeologia Classica*, Rome, ' L'Erma' di Bretschneider.
BCH	*Bulletin de correspondance hellénique* (École française d'Athènes), Paris, E. de Boccard.
BEFAR	*Bibliothèque des Écoles françaises d'Athènes et de Rome*, Paris, E. de Boccard.
BSA	*The Annual of the British School at Athens*, London, Macmillan.
BWPr.	*Winckelmannsprogramm der archäologischen Gesellschaft zu Berlin*, Berlin, W. de Gruyter.
GBA	*Gazette des Beaux-Arts*, Paris, Presses universitaires de France.
Hesperia	*Hesperia*, Journal of the American School of Classical Studies at Athens.
Istanb. Forsch.	*Istanbuler Forschungen*, Baden bei Wien, Verlag Rudolf M. Rohrer.
Istanb. Mitt.	*Mitteilungen des deutschen archäologischen Instituts, Abteilung Istanbul*, Berlin, W. de Gruyter.
Jahrb.	*Jahrbuch des deutschen archäologischen Instituts*, Berlin, W. de Gruyter.
JHS	*The Journal of Hellenic Studies*, London, Macmillan.
JOEAI	*Jahreshefte des österreichischen archäologischen Instituts*, Vienna, Roher.
Mon. Piot	*Monuments et mémoires publiées par l'Académie des Inscriptions et Belles-Lettres* (Fondation Eugène Piot), Paris, Presses universitaires de France.
REA	*Revue des Études anciennes*, Bordeaux, Féret et fils éditeurs.
RIA	*Rivista dell'Istituto nazionale di archeologia e storia dell'arte*, Rome, ' L'Erma' di Bretschneider.
RM	*Mitteilungen des deutschen archäologischen Instituts, Römische Abteilung*, Berlin, F. F. Kerle Verlag.

In assembling bibliographical material and references for the section on sculpture Professor Jean Marcadé was assisted by Marie-Françoise Briguet.

Architecture

GENERAL WORKS

1. DURM (J.), *Die Baukunst der Griechen*, Stuttgart, A. Kröner, 3rd ed., 1910.

2. ROSTOVTSEV (M. I.), ' Die hellenistisch-römische Architekturlandschaft', in *RM*, XXVI, Berlin, 1911, pp. 1-185.

3. WEICKERT (C.), *Das lesbische Kymation. Ein Beitrag zur Geschichte der antiken Ornamentik*, Munich, W. Schunke, 1913.

4. GÜTSCHOW (M.), ' Untersuchungen zum korinthischen Kapitell', in *Jahrb.*, XXXVI, Berlin, 1921, pp. 44-83.

5. CHOISY (A.), *Histoire de l'architecture*, Paris. Baranger, 1929.

6. WREDE (W.), *Attische Mauern*, Athens, Deutsches archäologisches Institut, 1933.

7. FYFE (D. T.), *Hellenistic Architecture*, London, G. Bell and Sons; Cambridge University Press, 1936.

8. SHOE (L. T.), *Profiles of Greek Mouldings*, Cambridge (Mass.), Harvard University Press, 1936.

9. YAVIS (C. G.), *Greek Altars. Origins and Typology*, Monograph Series (Humanities) I, St Louis University Press (Mo.), 1949.

10. DINSMOOR (W. B.), *The Architecture of Ancient Greece, an Account of its Historic Development*, London, Batsford, 3rd ed., 1950.

11. GERKAN (A. von), ' Griechische und römische Architektur', in *Bonner Jahrbücher*, CLII, Bonn, 1952, pp. 21-26.

12. SHOE (L. T.), ' Profiles of Western Greek Mouldings', *Papers and Monographs of the American Academy in Rome*, XIV, Rome, American Academy in Rome, 1952.

13. PLOMMER (H.), *Ancient and Classical Architecture*, Simpson's History of Architectural Development, I, London-New York, Longmans, 1956.

14. LAWRENCE (A. W.), *Greek Architecture*, The Pelican History of Art, Harmondsworth, Middlesex, Penguin Books, 1957.

15. GERKAN (A, von), *Von antiker Architektur und Topographie. Gesammelte Aufsätze*, collection edited by E. Boehringer, Stuttgart—Berlin — Cologne — Mainz, W. Kohlhammer, 1959.

16. ROBERTSON (D. S.), *A Handbook of Greek and Roman Architecture*, Cambridge University Press, 3rd ed., 1959.

17. DELORME (J.), *Gymnasion. Étude sur les monuments consacrés à l'éducation en Grèce, des origines à l'Empire romain*, BEFAR, 196, Paris, E. de Boccard, 1960.

18. HODGE (A. T.), *The Woodwork of Greek Roofs*, Cambridge University Press, 1960.

19. BERVE (H.) and GRUBEN (G.), *Greek Temples, Theatres and Shrines*, London, Thames and Hudson, 1963, New York, Abrams, 1968.

20. BIEBER (M.), *The History of the Greek and Roman Theater*, Princeton Univ. Press, 2nd ed., 1961.

21. GRUBEN (G.), *Die Tempel der Griechen*, Munich, Hirmer Verlag, 1961, 2nd ed. 1966.

22. GINOUVÈS (R.), *Balaneutiké. Recherches sur le bain dans l'antiquité grecque*, BEFAR, 200, Paris. E. de Boccard, 1962.

23. SCULLY (V. J.), *The Earth, the Temple and the Gods. Greek Sacred Architecture*, New Haven, Conn. —London, Yale Univ. Press, 1962.

24. LANGLOTZ (E.) and HIRMER (M.), *The Art of Magna Graecia. Greek Art in Southern Italy and Sicily*, London, Thames and Hudson, 1965; *Ancient Greek Sculpture of Southern Italy and Sicily*, New York, Abrams, 1965.

25. MARTIENSSEN (R. D.), *The Idea of Space in Greek Architecture*, Johannesburg University Press, 2nd ed., 1964.

26. SCRANTON (R. L.), *Aesthetic Aspects of Ancient Art*, Chicago—London, University of Chicago Press, 1964.

27. MARTIN (R.), *Manuel d'architecture grecque*: I, *Matériaux et Techniques*, Paris, A. and J. Picard, 1965.

28. PRITCHETT (W. K.), *Studies in Ancient Greek Topography*, I, Berkeley, University of California Press, 1965.

29. MARTIN (R.), *Monde grec*, Architecture universelle, Fribourg, Office du livre, 1966.

SPECIAL STUDIES

A	1. URBANISM

30. GERKAN (A. von), *Griechische Stadtanlagen*, Berlin, W. de Gruyter, 1924.

31. MARTIN (R.), *Recherches sur l'agora grecque. Études d'histoire et d'architecture urbaines*, BEFAR, 174, Paris, E. de Boccard, 1951.

32. MARTIN (R.), *L'Urbanisme dans la Grèce antique*, Paris, A. and J. Picard, 1956.

33. WYCHERLEY (R. E.), *How the Greeks built Cities*, London, Macmillan, 2nd ed., 1962.

34. BRUNEAU (P.), ' Contribution à l'histoire urbaine de Délos à l'époque hellénistique et à l'époque impériale', in *BCH*, XCII, Paris, 1968, pp. 633-709.

2. DOMESTIC ARCHITECTURE

35. FRICKENHAUS (A.), ' Griechische Banketthäuser', in *Jahrb.*, XXXII, Berlin, 1917, pp. 129 ff.

36. ROBINSON (D. M.) and GRAHAM (J. W.), *Olynthus*; VIII, *The Hellenic House*, Johns Hopkins University Studies in Archaeology, no. 25, Baltimore, Md, Johns Hopkins Press, 1938.

37. ROBINSON (D. M.) and GRA-HAM (J. W.), *Olynthus*; XII, *Domestic and Public Architecture*, Baltimore, Md, Johns Hopkins Press, 1946.

38. RIDER (B. C.), *Ancient Greek Houses. Their History and Development from the Neolithic Period to the Hellenistic Age*, Chicago, Argonaut, new ed., 1964.

39. DRERUP (H.), *Prostashaus und Pastashaus*, Marburger Winckelmannsprogramm, Marburg, 1967, pp. 6-17.

40. NOWICKA (M.), *La Maison privée dans l'Égypte ptolémaïque*, Bibliotheca Antica, IX, Warsaw, Polish Academy of Sciences, 1969.

B **1. ATHENS**

41. DINSMOOR (W. B.), ' The Choragic Monument of Nicias' in *AJA*, XIV, Athens, 1910, pp. 459-484.

42. ' Excavations in the Athenian Agora. Reports and Studies', in *Hesperia*, Athens, The American School of Classical Studies at Athens, 1933.

43. DINSMOOR (W. B.), ' The Temple of Ares and the Roman Agora', in *AJA*, XLVII, Athens, 1943, pp. 291-305.

44. ROBINSON (H. S.), ' The Tower of the Winds and the Roman Market Place', in *AJA*, XLVII, Athens, 1943, pp. 291-305.

45. PICKARD-CAMBRIDGE (A. W.), *The Theatre of Dionysos in Athens*, Oxford, Clarendon, 1946.

46. TRAVLOS (J.), ' The Topography of Eleusis', in *Hesperia*, XVIII, Baltimore, Md, 1949, pp. 138 ff.

47. TRAVLOS (J.), ' The West Side of the Athenian Agora Restored', in *Hesperia, Suppl.*, VIII, Baltimore, Md, 1949, pp. 382-393.

48. THALLON HILL (I.), *The Ancient City of Athens*, London, Methuen, 1953.

49. RUBENSOHN (O.), ' Das Weihehaus von Eleusis und sein Allerheiligster', in *Jahrb.*, LXX, Berlin, 1955, pp. 1-49.

50. FIANDRA (E.), ' La stoa di Attalo nell'agora ateniese', in *Palladio*, n.s. VIII, Rome, 1958, pp. 97-120.

51. WYCHERLEY (R. E.), ' The Olympieion of Athens', in *Greek, Roman and Byzantine Studies*, V, London, 1964, pp. 161-179.

2. CENTRAL GREECE

Calydon

52. DYGGVE (E.), POULSEN (F.) and RHOMAIOS (K.), ' Das Heroon von Kalydon', in *Mémoires de l'Académie royale des Sciences et des Lettres de Danemark*, 7th series, vol. IV, Copenhagen, E. Munksgaard, 1934, pp. 289-433.

53. DYGGVE (E.), *Das Laphrion. Der Tempelbezirk von Kalydon*, Copenhagen, Munksgaard, 1948.

Delphi

54. POUILLOUX (J.), *Fouilles de Delphes: II, Topographie et architecture*; XII, *La Région nord du sanctuaire, de l'époque archaïque à la fin du sanctuaire*, Paris, E. de Boccard, 1960.

Dodona

55. DYGGVE (E.), ' Dodonaeiske Problemer', in *Arkaeologiske og Kunsthistoriske Afhandlinger tilegnede F. Poulsen*, I, Copenhagen, Gyldendal, 1941, pp. 95-110.

Palatitsa

56. RHOMAIOS (K. A.), ' Le Palais de Palatitsa', in *AE*, Athens, 1953-1954, pp. 141-150.

Thebes

57. WOLTERS (P.) and BRUNS (G.), *Das Kabirenheiligtum bei Theben*, Berlin, W. de Gruyter, 1940.

3. THE PELOPONNESE

Argos and the Argolid

58. VOLLGRAFF (I. W.), with the collaboration of VAN DER PLUYM and ANNE ROES, *Le Sanctuaire d'Apollon Pythéen à Argos*, École française d'Athènes (*Etudes péloponnésiennes*, I), Paris, J. Vrin, 1956.

59. ROUX (G.), *L'Architecture de l'Argolide aux IVe. et IIIe. siècles avant J.-C.*, *BEFAR*, 169, Paris, E. de Boccard, 1961.

60. DEFRASSE (A.) and LECHAT (H.), *Epidaure. Restauration et description des principaux monu-*

ments du sanctuaire d'Asclépios, Paris, Librairies-imprimeries réunies, 1895.

Corinth

61. ROEBUCK (C.), *Corinth*: XVI, *The Asclepieion and Lerna*, Princeton, N.J., American School of Classical Studies at Athens, 1951.

62. SCRANTON (R. L.), *Corinth*: I, 3, *Monuments in the Lower Agora, and North of the Archaic Temple*, Princeton, N.J., American School of Classical Studies at Athens, 1954.

63. STILLWELL (R.), *Corinth*: II, *The Theatre*, Princeton, N.J., American School of Classical Studies at Athens, 1952.

64. BRONEER (O.), *Corinth*: I, 4, *The South Stoa and its Roman Successor*, Princeton, N.J., American School of Classical Studies at Athens, 1954.

65. COULTON (J. J.), ' The Stoa by the Harbour at Perachora,' in *BSA*, 59, London, 1964, pp. 100-131, pls 18-27.

66. HILL (B. H.), *Corinth*: I, 6, *The Springs*, Princeton, N.J., American School of Classical Studies at Athens, 1964.

Lusoi

67. REICHEL (W.) and WILHELM (A.), ' Das Heiligtum der Artemis zu Lusoi', in *JOEAI*, 4, Vienna, 1901, pp. 1-90.

Olympia

68. CURTIUS (E.), ADLER (F.) *et al.*, *Olympia. Die Ergebnisse der von dem deutschen Reich veranstalteten Ausgrabungen*, II: *Die Baudenkmäler von Olympia*, Berlin, A. Ascher, 1892.

69. *Olympische Forschungen*. I-VI *Berichte* (in particular II, *Bericht über die Ausgrabungen in Olympia*), Berlin, W. de Gruyter, 1944-1966.

Sicyon

70. ORLANDOS (A. K.), ' Fouilles de Sicyone', in *Praktika*, Athens, 1955-1956, pp. 387-395, 184-190.

4. THE ISLANDS

Chios

71. BOARDMAN (J.), ' Delphinion in Chios', in *BSA*, LI, London, Macmillan, 1956, pp. 31-54.

Cos

72. SCHAZMANN (P.), *Asklepieion, Baubeschreibung und Baugeschichte: Kos*, I, Berlin, H. Keller, 1932.

Cyprus

73. SCRANTON (R.), ' The Architecture of the Sanctuary of Apollo Hylates at Kourion', in *Transactions of the American Philosophical Society*, 57, New Series, 5, Philadelphia, 1967.

Delos

74. VALLOIS (R.), *L'Architecture hellénique et hellénistique à Délos jusqu'à l'éviction des Déliens (166 av. J.-C.): Les Monuments*; II, *Grammaire historique de l'architecture délienne, BEFAR*, 157, Paris, E. de Boccard, 1944, 2nd impression 1966.

75. WILL (E.), ' Le Dôdélathéon', in *Exploration archéologique de Délos*, XXII, Paris, E. de Boccard, 1957.

76. DELORME (J.), ' Les Palestres', in *Exploration archéologique de Délos*, XXV, Paris, E. de Boccard, 1961.

77. AUDIAT (J.), ' Le Gymnase', in *Exploration archéologique de Délos* XXVIII, Paris, E. de Boccard, 1969.

Rhodes

78. JACOPI (G.), ' Il tempio ed il teatro di Apollo Eretimio', *Clara Rhodos*, II, Rhodes, Istituto storico archeologico, pp. 77-116.

Samothrace

79. LEHMANN (K.), *Samothrace*, IV, 1: *The Hall of Votive Gifts*, Bollingen Series, LX, New York, Pantheon Books, 1962.

80. SALVIAT (F.), ' Addenda samothraciens. Bâtiment de la Milésienne', in *BCH* LXXXVI, Paris, 1962, pp. 268-304.

81. LEHMANN (K.) and SPITTLE (D.), *Samothrace*, IV, 2: *The Altar Court*, Bollingen Series, LX, New York, Pantheon Books, 1964.

82. LEHMANN (P. W.) *et al.*, *Samothrace*, III: *The Hieron*, Bollingen Series, LX, 3, Princeton, N.J., Princeton University Press, 1969, 3 vols.

Thasos

83. MARTIN (R.), *L'Agora. Etudes thasiennes*, VI, 1, Paris, E. de Boccard, 1959.

5. MAGNA GRAECIA

Naples

84. NAPOLI (M.), *Napoli greco-mana. Topografia e archeologia*, Naples, Società editrice storia, 1964.

Megara Hyblaea

85. VALLET (G.) and VILLARD (F.), *Mégara Hyblaea*, IV, *Le Temple du IVe. siècle*, Mélanges d'archéologie et d'histoire, Supplément 1, Paris, E. de Boccard, 1966.

Paestum

86. KRAUSS (F.), *Der korinthische-dorische Tempel am Forum vom Paestum*, Denkmäler antiker Architektur, VII, Berlin, W. de Gruyter, 1939.

87. VIGHI (R.), *Il Foro di Paestum e l'edificio di tipo italico*, Rome, Danesi, 1967.

Palestrina

88. FASOLO (F.) and GULLINI (G.), *Il santuario della Fortuna Primigenia a Palestrina*, Rome, Istituto di Archeologia, 1953, 2 vols.

Pompeii

89. KRISCHEN (F.), *Die Stadtmauern von Pompeji und griechische Festungsbaukunst in Unteritalien und Sizilien*, Die hellenistische Kunst in Pompeji, VII, Berlin, W. de Gruyter, 1941.

Selinunte

90. DI VITA (A.), ' L'elemento punico a Selinonte nel IVo. e nel IIIo. s. A.C.', in *Arch. Class.*, V, Rome, 1953, pp. 39-47.

91. DI VITA (A.), ' La stoa nel temenos del tempio C e lo sviluppo programmato di Selinonte', in *Palladio*, n.s., XVIII, Rome, 1967, pp. 1-60.

Syracuse

92. MAUCERI (L.), *Il castello Eurialo nella storia e nell'arte*, Syracuse, Soc. Primavera Siciliana, 1939.

6. ASIA MINOR

93. BOHN (R.), ' Altertümer von Aegae', in *Jahrb.*, supplementary vol. II, Berlin, Deutsches archäologisches Institut, 1889.

94. HAHLAND (W.), ' Datierung der Hermogenesbauten', in *Bericht* VI, *Kong. arch. Berlin 1939*, Berlin, 1940.

95. DE BERNARDI FERRERO (D.), *Teatri classici in Asia Minore*, I, Rome, ' L'Erma' di Bretschneider, 1966.

96. AKERSTRÖM (A.), *Die architektonischen Terrakotten Kleinasiens*, Acta instituti Atheniensis regni Sueciae, 11, Lund, Gleerup, 1966, 2 vols.

97. MACHATSCHEK (A.), *Die Nekropolen und Grabmäler im Gebiet von Elaiussa Sebaste und Korykos im Rauhen Kilikien*, Ergänzungsbände zu den Tituli Asiae Minoris, 2, Vienna—Cologne—Graz, Hermann Böhlaus Nachf., 1967.

98. AKURGAL (E.), *Ancient Civilisations and Ruins of Turkey, from Prehistoric Times until the End of the Roman Empire*, Ankara, Türk Tarih Kurumu Basimevi, 1969.

Assos

99. BACON (F. H.), CLARKE (J. T.) and KOLDEWEY (R.), *Investigations at Assos*, Cambridge (Mass.), Harvard University Press, 1902.

Belevi

100. PRASCHNIKER (G.), ' Die Datierung des Mausoleums von Belevi', in *Anzeiger und Mitteilungen der Österreichischen Akademie der Wissenschaften*, 20, Vienna, 1948, pp. 271 ff.

101. KEIL (J.), ' Der Grabherr des Mausoleums von Belevi', in *Anzeiger und Mitteilungen der Österreichischen Akademie der Wissenschaften*, 21, 4, Vienna, 1949, pp. 51 ff.

Colophon

102. HOLLAND (L. B.), ' Colophon', in *Hesperia*, XIII, Athens—Baltimore, Md, 1944, pp. 1-35.

Ephesus

103. BENNDORF (O.), *Forschungen in Ephesos*, I, Vienna, Österreichisches archäologisches Institut, 1906.

104. LETHABY (W.R.), *Greek Buildings Represented by Fragments in the British Museum*, London, Batsford, 1908. (Temple of Ephesus, pp. 1-37.).

373

105. TRELL (B.L.), *The Temple of Artemis at Ephesus*, Numismatic Notes and Monographs, 110, New York, American Numismatic Society, 1945.

106. MILTNER (F.), *Ephesos, Stadt der Artemis und des Johannes*, Vienna, F. Deuticke, 1958.

Kastabos

107. COOK (J.M.) and PLOMMER (W.H.), *The Sanctuary of Hemithea at Kastabos*, Cambridge, University Press, 1966.

Labranda

108. WESTHOLM (A.), *Labraunda*, I, 2, *The Architecture of the Hieron*, Acta instituti Atheniensis regni Sueciae, V, I, 2, Lund, Gleerup, 1963.

Lagina

109. SCHOBER (A.), *Der Fries des Hekateions von Lagina* (*Istanb. Forsch.*, vol. 2), Baden bei Wien, Deutsches archäologisches Institut, 1933.

Magnesia-ad-Maeandrum

110. HUMANN (C.), KOHTE (J.) and WATZINGER (C.), *Magnesia am Mäander. Bericht über die Ergebnisse der Ausgrabungen der Jahre 1891-1893*, Berlin, Staatliche Museen (Abteilung der Antiken Bildwerke), 1904.

111. GERKAN (A. von), *Der Altar des Artemis-Tempels in Magnesia am Mäander*, Studien zur Bauforschung, 1, Berlin, H. Schoetz, 1929.

Miletus and Didyma

112. RAYET (O.) and THOMAS (A.), *Milet et le golfe Latmique: Tralles, Magnésie du Méandre, Priène, Milet, Didymes, Héraclée du Latmos*, I, instalments 1-5, Paris, J. Baudry, 1877-1885.

113. KNACKFUSS (H.), *Milet:* I, 2, *Das Rathaus von Milet*, Berlin, G. Reimer, 1908, reissued W. de Gruyter, 1967.

114. KAWERAU (G.) and REHM (A.), *Milet:* I, 3, *Das Delphinion in Milet*, Berlin, G. Reimer, 1914, reissued W. de Gruyter, 1967.

115. GERKAN (A. von), 'Der Kaiskos im Tempel von Didyma', in *Jahrb.*, LVII, Berlin, 1942, pp. 183-198.

116. WIEGAND (T.), *Didyma* (I, H. KNACKFUSS, *Die Baubeschreibung*), Berlin, Deutsches archäologisches Institut, 1941, 3 vols.

117. VAN ESSEN (E.), 'Note sur le deuxième Didymeion', in *BCH*, LXX, Paris, 1946, pp. 607-616.

118. KLEINER (G.), 'Die Ruinen von Milet', in *Istanb. Mitt.*, Berlin, W. de Gruyter, 1968.

Pergamum

119. BOHN (R.), *Altertümer von Pergamon:* II, *Das Heiligtum der Athena Polias Nikephoros*, Berlin, Spemann, 1885.

120. SCHAZMANN (P.), *Altertümer von Pergamon:* VI, *Das Gymnasium der Tempelbezirk der Hera Basileia*, Berlin, W. de Gruyter, 1923.

121. SCHIETZMANN (W.), 'Pergamon' in PAULY-WISSOWA-KROLL, *Real-Encyclopädie der klassischen Altertumswissenschaft*, Stuttgart–Berlin, 1937.

122. HANSEN (E.V.), *The Attalids of Pergamon*, Cornell Studies in Classical Philology, vol. 29, Ithaca, N.Y., Cornell University Press, 1947.

123. KÄHLER (H.), *Der grosse Fries von Pergamon*, Berlin, Gebr. Mann, 1948.

124. SCHOBER (A.), 'Zur Datierung Eumenischer Bauten', in *JORAI*, XXXII, Vienna, 1940, pp. 151-168.

125. ZIEGENAUS (O.), and DE LUCA (G.), *Altertümer von Pergamon:* XI, 1, *Das Asklepieion*, Berlin, W. de Gruyter, 1968.

Priene

126. SCHEDE (M.), *Die Ruinen von Priene*, Berlin, W. de Gruyter, 1964, 2nd ed., rev. by G. KLEINER and W. KLEISS.

Sardis

127. BUTLER (H. C.), *Sardis:* II, *Architecture* (1, *The Temple of Artemis*), Leyden, E. J. Brill, 1925.

128. GRUBEN (G.), 'Zum Artemis Tempel von Sardis', in *AM*, LXXVI, Berlin, 1961, pp. 155-196.

Side

129. MANSEL (A.M.), *Die Ruinen von Side*, Berlin, W. de Gruyter, 1963.

Smyrna

130. NAUMANN (R.) and SELAHATTIN KANTAR, 'Die Agora von Smyrna', in *Istanb. Forsch.*, XVII, Berlin, 1950, pp. 69-114, pls 20-48.

Teos

131. HAHLAND (W.), 'Der Fries des Dionysos Tempels in Teos', in *JOEAI*, XXXVIII, Vienna, 1950, pp. 66-109.

Troy

132. GOETHERT (F. W.) and SCHLEIF (H.), *Der Athenatempel von Ilion*, Denkmäler antiker Architektur, 10, Berlin, W. de Gruyter, 1962.

133. WEBER (H.), 'Zum Apollon Smintheus-Tempel in der Troas', in *Istanb. Mitt.*, XVI, Berlin, 1966, pp. 100-114.

Xanthos

134. DEMARGNE (P.), *Fouilles de Xanthos:* I, *Les Piliers funéraires*, Institut français d'archéologie d'Istanbul, Paris, Klincksieck, 1958.

7. THE EAST

135. GOOSSENS (G.), 'Artistes et artisans étrangers en Perse sous les Achéménides', in *La Nouvelle Clio*, I, Paris, 1949, pp. 32-44.

136. SCHLUMBERGER (D.), 'Le Temple de Surkh Kotal en Bactriane', in *Journal asiatique*, CCXL, 4, Paris, 1952, pp. 433-453.

137. SCHLUMBERGER (D.), 'A Late Hellenistic Temple in Bactria', in *Archaeology*, VI, London, 1953, pp. 232 ff.

138. LENZEN (H.), 'Architektur der Partherzeit in Mesopotamien und ihre Brückenstellung zwischen der Architektur des Westens und des Ostens', in *Festschrift für Carl Weickert*, Berlin, Gebr. Mann, 1955, pp. 121-136.

139. NYLANDER (G.), 'Clamps and Chronology. Achaemenian Problems II', in *Iranica antiqua*, VI; *Mélanges Ghirshman*, I, Leyden, E. J. Brill, 1966, pp. 130-145.

140. BERNARD (P.), 'Chapiteaux corinthiens hellénistiques d'Asie centrale découverts à Aï Khanoum', in *Syria*, XLV, Paris, 1968, pp. 111-151.

8. AFRICA AND EGYPT

Alexandria

141. PERDRIZET (P.), 'Sostrate de Cnide, architecte du Phare', in *REA*, I, Paris 1889, pp. 261-272.

142. THIERSCH (H.), *Pharos. Antike Islam und Occident*, Leipzig–Berlin, Teubner, 1909.

143. ROWE (A.), 'Discovery of the Famous Temple and Enclosure of Serapis in Alexandria', in *Annales du Service des Antiquités d'Egypte*, Supplément 2, Cairo, 1946, pp. 1-70.

144. BERNAND (A.), *Alexandrie la Grande, d'Hérodote à Lawrence Durrell*, Signe des temps, Paris, Arthaud, 1966.

Cyrene

145. PESCE (G.), *Il Palazzo delle colonne in Tolemaide di Cirenaica*, Rome, 'L'Erma' di Bretschneider, 1950.

146. STUCCHI (S.), *L'Apollonion di Cirene*, Rome, 'L'Erma' di Bretschneider, 1961.

147. STUCCHI (S.), 'L'Apollonion di Cirene', *Quaderni di Archeologia della Libia*, 4, Rome, 1961, pp. 55-82.

148. STUCCHI (S.), *L'Agora di Cirene*: I, *I lati Nord e Est della platea inferiore*, Monografie di archeologia libica, VII, Rome, 'L'Erma' di Bretschneider, 1965.

Ptolemaïs

149. KRAELING (C. H.), *Ptolemais. City of the Libyan Pentapolis*, Oriental Institute Publications, XC, University of Chicago Press, 1963.

Sabratha

150. CAPUTO (G.), *Il teatro di Sabratha e l'architettura teatrale africana*, Rome, 'L'Erma' di Bretschneider, 1959.

Painting

GENERAL WORKS

151. PFUHL (E.), *Malerei und Zeichnung der Griechen*, Munich, F. Bruckmann Verlag, 1923, 3 vols.

152. RIZZO (G. E.), *La Pittura ellenistico-romana*, Milan, Fratelli Treves, 1929.

153. MÉAUTIS (G), *Les Chefs-d'œuvre de la peinture grecque*, Paris, Albin Michel, 1939.

154. RUMPF (A.), 'Malerei und Zeichnung', in *Handbuch der Archäologie*, VI, IV, 1, Munich, C.H. Beck'sche Verlagsbuchhandlung, 1953.

155. ROBERTSON (M.), *Greek Painting*, Geneva, Skira, 1959.

156. ARIAS (P.E.), 'Storia della ceramica de età arcaica, classica ed ellenistica e delle pitture di età arcaica e classica', in *Enciclopedia classica*, III, vol. XI, tome V, Turin, Società editrice internazionale, 1963.

SPECIAL STUDIES

A | PAINTING AND MOSAICS

Hellenistic Painting

157. MATZ (F.), 'Die Stilphasen der hellenistischen Malerei', in *AA*, LIX, LX, 1944, pp. 89-112.

158. RUMPF (A.), 'Classical and Post-Classical Greek Painting', in *JHS*, LXVII, 1947, pp. 10-21.

159. MANSUELLI (G. A.), *Ricerche sulla pittura ellenistica*, Studi e ricerche, IV, Bologna, C. Zuffi, 1950.

160. BIANCHI BANDINELLI (R.), *Storicità dell'arte classica*, Florence, G. C. Sansoni, 2nd ed., 1950, 2 vols.

161. BIANCHI BANDINELLI (R.), *Il problema della pittura antica*, Florence, Editrice Universitaria, 1952.

162. HANFMANN (G.M.A.), 'Hellenistic Art', in *Dumbarton Oaks Papers*, XVII, Washington, D.C., 1963, pp. 79-94.

163. MORENO (P.), 'Il realismo nella pittura greca del IV secolo a.C.', in *Rivista dell'Istituto Nazionale d'archeologia e storia dell'arte*, XIII-XIV, 1964-1965, pp. 27-98.

Italian and Roman Painting

164. PALLOTTINO (M.), *Etruscan Painting*, Geneva, Skira, 1952.

165. MAIURI (A.), *Roman Painting*, Geneva, Skira, 1953.

166. BORDA (M.), *La pittura romana*, Milan, Società editrice libraria, 1958.

167. NAPOLI (M.), *Pittura antica in Italia*, Bergamo, Istituto italiano d'arti grafiche, 1960.

168. BALIL (A.), *Pintura helenística y romana*, Madrid, 1962.

169. DENTZER (J.M.), 'Les Systèmes décoratifs dans la peinture murale italique', in *Mélanges de l'École française de Rome*, LXXX, 1968, pp. 85-141.

170. 'Pittura e Pittori nell'Antichità', in *Enciclopedia dell'arte antica, classica, e orientale*, Rome, Istituto della Enciclopedia Italiana, 1968.

Perspective

171. BEYEN (H.G.), 'Die antike Zentralperspektive', in *AA*, LIV, 1939, pp. 47-72.

172. WHITE (J.), *Perspective in Ancient Drawing and Painting*, Society for the Promotion of Hellenic Studies, Supplementary Paper, no. 7, London, 1956.

Literary Sources

173. REINACH (A.), *Recueil Milliet: Textes grecs et latins relatifs à l'histoire de la peinture ancienne*, I, Paris, Klincksieck, 1921.

174. FERRI (S.), *Plinio il Vecchio, storia delle arti antiche*, Rome, Palombi, 1946.

Technique

175. ALETTI (E.), *La tecnica della pittura greco-romana a l'encausto*, Rome, 'L'Erma' di Bretschneider, 1951.

375

Landscape

176. ROSTOVTZEFF (M.), ' Die hellenistisch-römische Architekturlandschaft', in *RM*, XXVI, 1911, pp. 1-185.

177. DAWSON (M.C.), *Romano-Campanian Mythological Landscape Painting*, Yale Classical Studies, IX, New Haven, Conn., Yale University Press, 1944.

178. ADRIANI (A.), *Divagazioni intorno ad una coppa paesistica del Museo di Alessandria*, Rome, ' L'Erma' di Bretschneider, 1959.

179. PETERS (W.J.), *Landscape in Romano-Campanian Mural Painting*, Groningen, Van Gorcum, 1963.

180. GALLINA (A.), *Le Pitture con paesaggi dell'Odissea dall'Esquilino*, Studi e Miscellanei, 6, Rome, ' L'Erma' di Bretschneider, 1964.

Painters

Apelles

181. LEPICK-KOPAIZYNSKA (W.), *Apelles, der Berühmteste Maler der Antike*, Berlin, 1962.

Philoxenus

182. WINTER (F.), *Das Alexandermosaik aus Pompeji*, Strasbourg, 1909.

183. FUHRMANN (H.), *Philoxenos von Eretria*, Göttingen, W. F. Kästner, 1931.

184. ANDREAE (B.), *Das Alexandermosaik*, Opus nobile, chefs-d'œuvre de l'art antique, 14, Bremen, Walter Dorn Verlag, 1959.

185. RUMPF (A.), ' Zum Alexandermosaik', in *AM*, LXXVII, 1962, pp. 229-241.

Mosaics

186. PHILLIPS (K. M.), ' Subject and Technique in Hellenistic-Roman Mosaics from Sicily', *Art Bulletin*, XLII, New York, 1960, pp. 243-262.

187. ROBERTSON (M.), ' Greek Mosaics', in *JHS*, LXXXV, 1965, pp. 72-89.

B | MEDITERRANEAN SITES

Alexandria

188. BROWN (B.), *Ptolemaic Paintings and Mosaics and the Alexandrian Style*, Cambridge (Mass.), Archeological Inst. of America, 1957.

Delos

189. BULARD (M.), ' Peintures murales et mosaïques de Délos', in *Mon. Piot*, XIV, Paris, 1908, pp. 5-20.

190. CHAMONARD (J.), *Les Mosaïques de la Maison des Masques*, Exploration archéologique de Délos, XIV, Paris, E. de Boccard, 1933.

191. BRUNEAU (P.), and DUCAT (J.), *Guide de Délos*, Paris, E. de Boccard, 2nd ed., 1966, pp. 52-60, pls 10-17.

Demetrias

192. ARVANITOPOULOS (A. S.), *Painted stelae from Demetrias-Pagasai* (in Greek), Athens, 1928.

Kazanlak

193. MICOFF (V.), *Le Tombeau antique près de Kazanlak*, Monuments de l'art en Bulgarie, Sofia, Ed. de l'Académie bulgare des sciences, 1954.

194. VASSILIEV (A.), *Das antike Grabmal bei Kasanlak*, Cologne—Sofia, 1960.

Levkadhia

195. PETSAS (P.M.), *The Levkadhia Tomb* (in Greek), Publications of the Archaeological Society, 57, Athens, 1966.

Pella

196. PETSAS (P.), ' Mosaics from Pella', in *La Mosaïque gréco-romaine*, Paris, C.N.R.S., 1965, pp. 41-55.

C | POMPEII AND HERCULANEUM

Paintings and Mosaics

197. ELIA (O.), *Pitture e mosaici nel Museo di Nicoli*, Le Guide dei musei italiani, Rome, Libreria dello Stato, 1932.

198. PERNICE (E.), *Hellenistische Kunst in Pompeji Pavimente und figürliche Mosaiken*, Berlin, 1938.

199. BEYEN (H. G.), *Die pompejanische Wanddekoration von zwei-ten bis zum vierten Stil*, I-II, The Hague, M. Nijhoff, 1938-1960.

200. SCHEFOLD (K.), *Pompejanische Malerei. Sinn und Ideengeschichte*, Basle, B. Schwabe, 1952.

201. SCHEFOLD (K.), *Vergessenes Pompeji*, Berne–Munich, Francke Verlag, 1962.

202. DE FRANCISCIS, *Antichi mosaici al Museo di Napoli*, Cava dei Tirreni, Di Mauro, 1962.

Pompeian house-decoration

203. ELIA (O.), *Le pitture della ' Casa del Citarista'*, Monumenti della pittura antica scoperti in Italia: Pompei, I, Rome, Libreria dello Stato, 1938.

204. MAIURI (A.), *La Villa dei Misteri*, Rome, Libreria dello Stato, 2nd ed., 1947.

205. LEHMANN (P.W.), *Roman Wall Paintings from Boscoreale in the Metropolitan Museum of Art*, Cambridge (Mass.), Archaeological Institute of America, 1953.

206. BLANCKENHAGEN (P.H. von) and ALEXANDER (C.), ' The Paintings from Boscotrecase', in *RM, Suppl.* 6, Heidelberg, F.H. Kerle Verlag, 1962.

207. ZEVI (F.), *La casa Reg. IX., 5, 18-21 a Pompei e le sue pitture*, Studi e Miscellani, 5, Rome, ' L'Erma' di Bretschneider, 1964.

Campanian Painters

208. GABRIEL (M. M.), *Masters of Campanian Painting*, New York, H. Bittner, 1952.

209. RICHARDSON (L.), *Pompei, the Casa dei Dioscuri and its Painters*, Memoirs of the American Academy in Rome, XXIII, Rome, American Academy in Rome, 1955.

210. RAGGHIANTI (C. L.), *Pittori di Pompei*, Milan, Edizioni del Milione, 1963.

Other Italian sites

211. BENDINELLI (G.), *Le pitture del Colombario di Villa Pamphili*, Monumenti della pittura antica scoperti in Italia, Rome, V, Libreria dello Stato, 1941.

212. GULLINI (G.), *I mosaici di Palestrina*, Rome, Ministerio della pubblica istruzione, 1956.

213. TINE-BERTOCCHI (F.), *La pittura funeraria apula*, Naples, G. Macchiaroli, 1964.

D | VASE PAINTING

Italian Red-figure

214. TRENDALL (A. D.), *The Red-Figured Vases of Lucania, Campania and Sicily*, Oxford Monographs on Classical Archaeology, Oxford, Clarendon Press, 1967, 2 vols.

White-ground pottery

215. THOMPSON (H.), 'Two Centuries of Hellenistic Pottery', in *Hesperia*, III, 1934, pp. 438-447.

216. FORTI (L.), *La ceramica di Gnathia*, Monumenti antichi della Magna Grecia, II, Naples, G. Macchiaroli, 1965.

Decorated ornamental pottery

217. LEROUX (C.), *Lagynos. Recherches sur la céramique et l'art ornemental hellénistiques*, Paris, E. Leroux, 1913.

218. GUERRINI (L.), *Vasi di Hadra*, Studi e Miscellani, 8, Rome, 'L'Erma' di Bretschneider, 1964.

The polychrome ware of Centuripe

219. LIBERTINI (G.), *Centuripe*, Catania, Libr. Tirelli, 1926. pp. 145-186.

220. RICHTER (G.), *Polychrome Vases from Centuripe in the Metropolitan Museum*, Metropolitan Museum Studies, II, 2, New York, 1930, pp. 187-205.

221. RICHTER (G.), *A Polychrome Vase from Centuripe*, Metropolitan Museum Studies, IV, New York, 1932, pp. 45-54.

222. LIBERTINI (G.), 'Nuovo ceramiche dipinte di Centuripe', in *Atti della società per la Magna Grecia*, Rome, Società Magna Grecia, 1934, pp. 187-212.

Sculpture

GENERAL WORKS

1. ANCIENT SOURCES

223. OVERBECK (J.), *Die antiken Schriftquellen zur Geschichte der bildenden Künste bei den Griechen*, Leipzig, Wilhelm Engelmann, 1868.

224. LOEWY (E.), *Inschriften Griechischer Bildhauer*, Leipzig, Teubner, 1885.

225. MARCADÉ (J.), *Recueil des signatures de sculpteurs grecs*, I and II, Ecole française d'Athènes, distributed by E. de Boccard, Paris, 1953 and 1957.

2. GUIDES AND CATALOGUES

Greece

226. HARRISON (E. B.), *The Athenian Agora*: I, *Portrait Sculpture*; XI, *Archaic and Archaistic Sculpture*, Princeton, N.J., American School of Classical Studies at Athens, 1953, 1965.

227. THOMPSON (H. A.), *The Athenian Agora, a Guide to the Excavations and Museum*, Princeton, N.J., American School of Classical Studies at Athens (printed in Greece by Aspioti-Elka Ltd), 2nd, rev. ed., 1962.

228. KAROUZOU (S.), *National Archaeological Museum, sculpture collection* (descriptive catalogue), Athens, Antiquities and Restoration Service, 1968.

Greek Islands

229. JACOPI (G.), *Monumenti di scultura del Museo Archeologico di Rodi*, Clara Rhodos, V, 1 and 2, Rhodes, Istituto Storico Archeologico, 1932.

230. MICHALOWSKI (C.), *Les Portraits hellénistiques et romains*, Exploration archéologique de Délos, XIII, Paris, E. de Boccard, 1932.

231. LAURENZI (L.), *Monumenti di scultura del Museo Archeologico di Rodi*, Clara Rhodos, IX, Rhodes, Istituto Storico Archeologico, 1938, pp. 9-120, pls I-VIII.

232. LAUMONIER (A.), *Les Figurines de terre cuite*, Exploration archéologique de Délos, XXIII, Paris, E. de Boccard, 1956, 2 vols.

233. BRUNEAU (P.) and DUCAT (J.), *Guide de Délos*, Ecole française d'Athènes, Paris, E. de Boccard, 1965.

234. ECOLE FRANÇAISE D'ATHÈNES. *Guide de Thasos*, Guides archéologiques, Paris, E. de Boccard, 1967.

Turkey

235. MENDEL (G.), *Catalogue des sculptures grecques, romaines et byzantines*, Constantinople, Imperial Museum, 1912-1914, 3 vols.

236. FIRATLI (N.) and ROBERT (L.), *Les Stèles funéraires de Byzance gréco-romaine*, Bibliothèque archéologique et historique de l'Institut français d'archéologie d'Istanbul, XV, Paris, Librairie Adrien Maisonneuve, 1964.

Cyrenaica

237. PARIBENI (E.), *Catalogo delle sculture di Cirene, Statue e Rilievi di carattere religioso*, Monografie di Archeologia libica, V, Rome, 'L'Erma' di Bretschneider, 1959.

238. ROSENBAUM (E.), *A Catalogue of Cyrenaican Portrait Sculpture*, London, Oxford Univ. Press, 1960.

Egypt

239. PERDRIZET (P.), *Bronzes d'Egypte de la Collection Fouquet*, Paris, Bibliothèque d'Art et d'Archéologie, 1911.

240. PERDRIZET (P.), *Les Terres cuites d'Egypte de la collection Fouquet*, Nancy–Paris–Strasbourg, Berger-Levrault, 1921, 2 vols.

241. ADRIANI (A.), *Repertorio d'arte dell'Egitto greco-romano*, series A I-II, Palermo, Fondazione Ignazio Mormino del Banco di Sicilia, 1961.

Tunisia

242. FUCHS (W.), *Der Schiffsfund von Mahdia*, Bilderhefte des deutschen archäologischen Instituts, Rom, 2, Tübingen, Verlag Ernst Wasmuth, 1963.

CHARBONNEAUX (J.), Review of the preceding item in *Gnomon*, XXXVII, 1965, pp. 523-526.

Germany

243. *Beschreibung der antiken Skulpturen mit Ausschluss der Pergamenischen Fundstücke*, Berlin, Verlag W. Spemann, 1891.

244. NEUGEBAUER (K. A.), *Die griechischen Bronzen der klassischen Zeit und des Hellenismus*, Staatliche Museen zu Berlin, Katalog der statuarischen Bronzen, II, Berlin, Akademie-Verlag, 1951.

Great Britain

245. SMITH (A.H.), *A Catalogue of Sculpture in the Department of the Greek and Roman Antiquities, British Museum*, II-III, London, British Museum, 1900-1904.

246. HIGGINS (R. A.), *Catalogue of the Terracottas in the Department of Greek and Roman Antiquities, British Museum*, London, British Museum, 1954-1959, 3 vols.

Denmark

247. POULSEN (F.), *Catalogue of Ancient Sculpture in the Ny Carlsberg Glyptotek*, Copenhagen, Nielsen and L. Dicke, 1951.

U.S.A.

248. RICHTER (G.M.A.), *Catalogue of Greek Sculptures in the Metropolitan Museum of Art*, Cambridge, Mass., Harvard University Press, and Oxford, Clarendon Press, 1954.

249. RICHTER (G.M.A.), *Catalogue of Engraved Gems, Greek, Etruscan and Roman, in the Metropolitan Museum of Art, New York*, Rome, 'L'Erma' di Bretschneider, 1956.

France

250. RIDDER (A. de), *Collection De Clercq*, III, *Les Bronzes*, Paris, E. Leroux, 1904-1905, 2 fascicles.

251. RIDDER (A. de), *Les Bronzes antiques du Louvre*, Paris, E. Leroux, 1914-1915, 2 vols.

252. CHARBONNEAUX (J.), *La Sculpture grecque et romaine au Musée du Louvre*, Guides du visiteur, Paris, Ed. des Musées nationaux, 1963.

253. MOLLARD-BESQUES (S.), *Catalogue raisonné des figurines et reliefs en terre cuite grecs et romains*, II, *Myrina*, Musée du Louvre et collections des universités de France, Paris, Ed. des Musées nationaux, 1963, 2 vols.

Italy

254. KASCHNITZ-WEINBERG (G. von), *Sculture del Magazzino del Museo Vaticano*, Monumenti Vaticani di Archeologia e d'Arte, IV, Rome, 'L'Erma' di Bretschneider, 1936-1937, 2 vols.

255. LIPPOLD (G.), *Die Skulpturen des Vatikanischen Museums*. Deutsches archäologisches Institut, III, 1-2, Berlin, W. de Gruyter, 1936-1956.

256. FELLETTI MAJ (B. M.), *Museo Nazionale Romano. I Ritratti*, Rome, Libreria dello Stato, 1953.

257. MANSUELLI (G. A.), *Galleria degli Uffizi. Le Sculture*, Rome, Istituto poligrafico dello Stato, Part 1, 1958, Part 2, 1961.

258. HELBIG (W.), *Führer durch die öffentlichen Sammlungen klassischer Altertümer in Rom*, I-III, Tübingen, Verlag Ernst Wasmuth, new rev. ed., 1963-1969.

3. HANDBOOKS AND SURVEYS

259. KLEIN (W.), *Vom antiken Rokoko*, Vienna, Hölzel, 1921.

260. LAWRENCE (A. W.), *Later Greek Sculpture and its Influence on East and West*, London, Jonathan Cape, 1927.

261. SÜSSEROTT (H. K.), *Griechische Plastik des 4. Jahrhunderts vor Christus*, Frankfurt-am-Main, Vittorio Klostermann, 1938.

262. ZSCHIETZSCHMANN (W.), 'Die hellenistische und römische Kunst', in *Handbuch der Kunstwissenschaft. Die antike Kunst*, II, 2, Potsdam, Akademische Verlagsgesellschaft Athenaion, 1939.

263. PICARD (C.), *Manuel d'archéologie grecque, la sculpture*, III, IV and index, Paris, A. and J. Picard, 1948-1966, 5 vols.

264. RICHTER (G.M.A.), *The Sculpture and Sculptors of the Greeks*, New Haven, Conn., Yale Univ. Press, 2nd ed., 1950, pt II, ch. IV, V.

265. RICHTER (G.M.A.), *Three Critical Periods in Greek Sculpture*, Oxford, Clarendon Press, 1951, chapters II and III.

266. SALIS (A. von), *Die Kunst der Griechen*, Erasmus-Bibliothèque, Zurich, Artemis Verlag, 4th ed., 1953, sections IV and V.

267. ALSCHER (L.), *Griechische Plastik. IV. Hellenismus*, Berlin, Deutscher Verlag der Wissenschaften, 1957.

268. LIPPOLD (G.), 'Die griechische Plastik', in *Handbuch der Archäologie*, III, 1, Munich, Hirmer Verlag, 2nd ed., 1960, pp. 233 ff.

269. LULLIES (R.), *Greek Sculpture*, London, Thames and Hudson, and New York, Abrams, 1960.

270. BIEBER (M.), *The Sculpture of the Hellenistic Age*, New York, Columbia Univ. Press, 2nd ed., 1961.

271. HAFNER (G.), *Geschichte der griechischen Kunst*, Zurich, Atlantis Verlag, 1961, pp. 329 ff.

272. LANGLOTZ (E.) and HIRMER (M.), *The Art of Magna Graecia. Greek Art in Southern Italy and Sicily*, London, Thames and Hudson, 1965; *Ancient Greek Sculpture of Southern Italy and Sicily*, New York, Abrams, 1965.

273. WEBSTER (T.B.L.), *Hellenistic Poetry and Art*, London, Methuen, 1964.

274. SCHEFOLD (K.), *Die Griechen und ihre Nachbarn*, Propyläen Kunstgeschichte, I, Berlin, Propyläen Verlag, 1967.

The *Enciclopedia dell'arte antica, classica e orientale* (1958-1966) contains articles on Greek sculptors, as well as on sanctuaries and cities in which important works of sculpture have been discovered.

SPECIAL STUDIES

A | **1. TECHNIQUES**

275. BLÜMEL (C.), *Griechische Bildhauer an der Arbeit*, Berlin, W. de Gruyter, 4th ed., 1953.

276. REUTERSWÄRD (P.), *Studien zur Polychromie der Plastik, Griechenland und Rom: Untersuchungen über die Farbwirkung der Marmor- und Bronzeskulpturen*, Stockholm, A. Bonniers, 1960.

Bronzes

277. KLUGE (K.) and LEHMANN-HARTLEBEN (K.), *Die antiken Grossbronzen*, Berlin, W. de Gruyter, 1927, 3 vols.

278. LAMB (W.), *Greek and Roman Bronzes*, London, Methuen, 1929.

279. CHARBONNEAUX (J.), *Les Bronzes grecs*. L'Œil du connaisseur, Paris, Presses universitaires de France, 1958, pp. 97-109.

Terracottas

280. WINTER (F.), *Die Typen der figürlichen Terrakotten*, Berlin–Stuttgart, Verlag W. Spemann, 1903, 2 vols.

281. KLEINER (G.), 'Tanagrafiguren. Untersuchungen zur hellenistischen Kunst und Geschichte', in *Jahrb.* (Supplementary vol. 15), Berlin, W. de Gruyter, 1942.

282. THOMPSON (D.B.), 'Three Centuries of Hellenistic Terracottas', in *Hesperia*, XXI, 1952, pp. 116-164, pls 31-42.

283. HAUSMANN (U.), *Hellenistische Reliefbecher aus attischen und böotischen Werkstätten*, Stuttgart, W. Kohlhammer Verlag, 1959.

284. MOLLARD-BESQUES (S.), *Les Terres cuites grecques*, L'Œil du connaisseur, Paris, Presses universitaires de France, 1963.

285. MOLLARD-BESQUES (S.), 'Un atelier de coroplathe au début du IIe. siècle av. J.-C., à Myrina' in *La Revue du Louvre et des Musées de France*, 14, Paris, 1964, pp. 299-311.

Jewellery and precious metals

286. RUBENSON(O.), *Hellenistisches Silbergerät in antiken Gipsabgüssen*, Berlin, Verlag Karl Curtius, 1911.

287. AMANDRY (P.), *Collection Hélène Stathatos*: I, *Les Bijoux antiques*; III, *Objets antiques et byzantins*, Strasbourg, n.d. [1953, 1963], obtainable from the author at the Institut d'archéologie de l'Université de Strasbourg.

288. BECATTI (G.), *Orificerie antiche, dalle minoiche alle barbariche*, Rome, Istituto poligrafico dello Stato, 1955.

289. COCHE DE LA FERTÉ (E.), *Les Bijoux antiques*, L'Œil du connaisseur, Paris, Presses universitaires de France, 1956.

290. HIGGINS (R.A.), *Greek and Roman Jewellery*, London, Methuen, 1961.

Coins and intaglios

291. FURTWÄNGLER (A.), *Antiken Gemmen*, Berlin–Leipzig, Giesecke Devrient, 1900, 3 vols.

292. FRANKE (P.R.) and HIRMER (M.), *Die griechische Münze*, Munich, Hirmer Verlag, 1964; English ed., *Greek Coins*, London, Thames and Hudson, and New York, Abrams, 1966, with new text by C. M. KRAAY.

293. RICHTER (G.M.A.), *The Engraved Coins of the Greeks and the Etruscans*, London, Phaidon Press, 1968.

293a. BOARDMAN (J.), *Greek Gems and Finger Rings*, London, Thames and Hudson, and New York, Abrams, 1971.

2. TYPES

Statuary

294. BIENKOWSKI (P.R.), *Die Darstellung der Gallier in der hellenistischen Kunst*, Vienna, Österreichisches archäologisches Institut, 1908.

295. LIPPOLD (G.), *Kopien und Umbildungen griechischer Statuen*, Munich, Oskar Beck, 1923.

296. HORN (R.), 'Stehende weibliche Gewandstatuen in der hellenistischen Plastik', in *RM*, II, Berlin, Deutsches archäologisches Institut, 1931.

297. MUTHMANN (F.), *Statuenstützen und dekoratives Beiwerk an griechischen und römischen Bildwerken, ein Beitrag zur Geschichte des römischen Kopistentätigkeit*, Abhandlungen der Heidelberger Akademie der Wissenschaften, Philosophisch-historische Klasse, Jahrgang 1950, 3, Heidelberg, Carl Winter, Universitäts Verlag, 1951.

298. CHARBONNEAUX (J.), 'Déesses en action', in *Essays in Memory of Karl Lehmann*, New York University, Institute of Fine Arts, 1964, pp. 70-73.

299. KÜNZL (E.), *Frühhellenistische Gruppen*, Cologne University, 1968.

Reliefs

300. SCHREIBER (T), *Die hellenistischen Reliefbilder*, Leipzig, Verlag Wilhelm Engelmann, 1889-1894, 2 vols.

301. MÖBIUS (H.), *Die Ornamente der griechischen Grabstellen. Klassischer und nachklassischer Zeit*, Berlin-Wimersdorf, Heinrich Keller Verlag, 1929.

302. PARIBENI (E.), 'Ninfe, Charites e Muse su rilievi tardo-attici', in *Bollettino d'Arte*, XXXVI, 1951, pp. 105-111.

303. HIMMELMANN-WILDSCHÜTZ (N.), *Studien zum Ilissos-Relief*, Munich, Prestel Verlag, 1956.

304. FUCHS (W.), 'Die Vorbilder der neuattischen Reliefs', in *Jahrb.* (supplementary vol. 20), Berlin, W. de Gruyter, 1959.

305. CHARBONNEAUX (J.), 'Sur deux reliefs antiques du Louvre', in *Mélanges d'archéologie, d'épigraphie et d'histoire offerts à Jérôme Carcopino*, Paris, Hachette, 1966, pp. 205-214.

Portraits

306. BOEHRINGER (R.), *Platon, Bildnisse und Nachweise*, Breslau, Ferdinand Hirt, 1935.

307. SCHEFOLD (K.), *Die Bildnisse der antiken Dichter, Redner und Denker*, Basle, B. Schwabe, n.d. [1943].

308. BIEBER (M.), 'The Portraits of Alexander the Great', in *Proceedings of the American Philosophical Society*, XCIII, 1949, pp. 373-427.

309. BUSCHOR (E.), *Das hellenistische Bildnis*, Munich, Biederstein Verlag, 1949.

310. HAFNER (G.), *Späthellenistische Bildnisplastik*, Berlin, Gebr. Mann, 1954.

311. RICHTER (G.M.A.), *Greek Portraits, A Study of their Development*, Coll. Latomus; XX, XXXVI,

XLVIII, LIV, Brussels—Berchem, Latomus, Revue d'Études latines, 1955-1962.

312. CHARBONNEAUX (J.),' Bagues hellénistiques à effigies royales ', in *Bulletin de la Société des Antiquaires de France*, 1958, pp. 79-80.

313. BIEBER (M.), *Alexander the Great in Greek and Roman Art*, Chicago, Argonaut, 1964.

314. LORENZ (T.), *Galerien von griechischen Philosophen und Dichterbildnissen bei den Römern*, Mainz, Philipp von Zabern, 1965.

315. RICHTER (G.M.A.), *The Portraits of the Greeks*, London, Phaidon Press, 1965, (vols II, III).

316. RICHTER (G.M.A.),' Realismus in der griechischen Porträtkunst', in *Das Altertum*, 14, 1968, pp. 146-157.

317. RICHTER (G.M.A.),' Greek Portraits on Engraved Gems of the Roman Period', in *Hommages à Marcel Renard* III, Coll. Latomus, vol. 103, Brussels-Berchem, pp. 497-501, pls CLXXVII-CLXXX.

3. ASPECTS OF STYLE

318. KRAHMER (G.),' Stilphasen der hellenistischen Plastik', in *RM*, XXVIII-XXIX, 1923-1924, pp. 138-189, pls V-VII.

319. KRAHMER (G.),' Die einansichtige Gruppe und die späthellenistische Kunst', in *N G Göttingen*, 1927. pp. 53 ff.

320. BECATTI (G.),' Attika. Saggio sulla scultura attica dell'Ellenismo', in *RIA*, VII, 1940, pp. 7-116.

321. BECATTI (G.),' Lo stile arcaistico', in *La Critica d'Arte*, VI, 1941, pp. 32-48, pls XIX-XXIV.

322. LAURENZI (L.),' Lineamenti di arte ellenistica', in *Arti Figurative*, I, 1945, pp. 12-28, pls I-XIII.

323. GULLINI (G.),' Su alcune sculture del tardo Ellenismo', in *Arti Figurative*, III, 1947, pp. 61-72, pls XXXII-XXXIII.

324. BUSCHOR (E.), *Maussollos und Alexander*, Munich, C. H. Beck Verlag, 1950.
Explains the variations of style in the Mausoleum by a chronological break.

325. HANFMANN (G.M.A.), ' Hellenistic Art', *Dumbarton Oaks Papers*, XVII, 1963, pp. 79-94.

326. CHARBONNEAUX (J.), ' Le Mythe humanisé dans l'art hellénistique', in *Comptes rendus de l'Académie des Inscriptions et Belles-Lettres*, 92, Paris, 1965, pp. 473-481.

B 1. SCULPTORS

Lysippus

327. JOHNSON (F.P.), *Lysippos*, Durham (North Carolina), Duke University Press, 1927.

328. VISSCHER (F. de), *Héraclès Épitrapézios*, Paris, E. de Boccard, 1962.

Bryaxis

329. ADRIANI (A.), *Alla ricerca di Briasside*, Memorie della Classe di Scienze morali e storiche dell'Accademia Nazionale dei Lincei, VIII, I, fasc. 10, 1947, pp. 435-473.

330. JONGKEES (J.H.),' New Statues by Bryaxis', in *JHS*, LXVIII, 1948, pp. 29-39.

331. CHARBONNEAUX (J.), ' Bryaxis et le Sarapis d'Alexandrie', in *Mon. Piot*, LII, 1962, pp. 15-26.

Leochares

332. ASHMOLE (B.),' Demeter of Cnidus', in *JHS*, LXXI, 1951, pp. 13-28.

333. DONNAY (G.),' Un sculpteur grec méconnu: Léocharès', in *GBA*, VIth period, vol. LIII, 1959, pp. 5-20.

334. DONNAY (G.),' La Chronologie de Léocharès', in *REA*, LXI, 1959, pp. 300-309.

335. CHARBONNEAUX (J.),' Le Zeus de Léocharès', in *Mon. Piot*, LIII, 1963, pp. 9-17.

336. TÖLLE (R.),' Zum Apollon des Leochares', in *Jahrb.* 81, 1966. pp. 142-172.

Eutychides

337. DOHRN (T.), *Die Tyche von Antiocha*, Berlin, Gebr. Mann, 1960.

Boethus

338. RUMPF (A.), ' Boethoi', in *JOEAI*, XXXIX, 1952, pp. 86-89.

Doedalses

339. LAURENZI (L.), ' La personnalità di Doidalses di Bitinia ', in *Annuario*, XXIV-XXVI, 1946-1948 (1950), pp. 167-179, pl. XVIII.

340. LULLIES (R.), *Die kauernde Aphrodite*, Munich-Pasing, Filser Verlag, 1954.

Archelaus

341. PINKWART (D.), ' Das Relief des Archelaos von Priene', in *Antike Plastik*, IV, Berlin, Gebr. Mann, 1956, pp. 55-65.

Damophon

342. DESPINIS (G.J.),' Ein neues Werk des Damophon', in *AA*, LXXXI, 1966, pp. 378-385.

343. LEVY (E.),' Sondages à Lykosoura et date de Damophon', in *BCH*, XCI, 1967, pp. 518-541.
This article's conclusions have, however, recently been called in question.

2. SITES AND SCHOOLS OF SCULPTURE

Pergamene art

344. WINTER (F.), *Altertümer von Pergamon*: VII, *Die Skulpturen mit Ausnahme der Altarreliefs*, Berlin, G. Reimer, 1908.

345. SCHWEITZER (B.), ' Die Menelaos-Patroklos-Gruppe. Ein verlorenes Meisterwerk hellenistischer Kunst', in *Die Antike*, XIV, 1938, pp. 43-72.

346. KÄHLER (H.), *Der grosse Fries von Pergamon*, Untersuchungen zur Kunstgeschichte und Geschichte Pergamons, Berlin, Gebr. Mann, 1948.

347. SCHOBER (A.), *Die Kunst von Pergamon*, Vienna—Innsbruck—Wiesbaden, Margarete Friedrich Rohrer Verlag, 1951.

348. STÄHLER (K.P.), *Das Unklassische im Telephosfries*, Münster, Aschendorff, 1966.

Alexandrian art

349. POULSEN (P.), ' Gab es eine Alexandrinische Kunst?', in *From the Collections of the Ny Carlsberg Glyptotek*, Copenhagen, Levin and Munksgaard, 1938, vol. 3, pp. 1-52.

350. ADRIANI (A.), *Sculture monumentali del Museo Greco-Romano di Alessandria*, Documenti e Ricerche d'arte Alessandrina, I, Rome,' L'Erma' di Bretschneider, 1946.

351. ADRIANTI (A.), *Testimonianze e Momenti di scultura alessandrina*, Documenti e Ricerche d'Arte Alessandrina, II, Rome, ' L'Erma' di Bretschneider, 1948.

352. LAUER (J.P.) and PICARD (C.), *Les Statues ptolémaïques du Sarapieion de Memphis*, Publications de l'Institut d'Art et d'Archéologie de l'Université de Paris, Presses Universitaires de France, 1955.

353. CHARBONNEAUX (J.), ' Sur la signification et la date de la Tasse Farnèse', in *Mon. Piot*, L, 1958, pp. 85-103.

354. ADRIANI (A.), *Divagazioni intorno ad una coppa paesistica del Museo di Alessandria*, Documenti e Ricerche d'Arte Alessandrina, III-IV, Rome, ' L'Erma ' di Bretschneider, 1959.

355. SEGALL (B.), 'Tradition und Neuschöpfung in der frühalexandrinischen Kleinkunst', in *BWPr.*, 119-120, Berlin, 1966.

Other centres

356. HERKENRATH (E.), *Der Fries des Artemisions von Magnesia am Mäander*, Berlin, G. Schade, 1902.

357. HUMANN (C.), *Magnesia am Mäander*, Berlin, Georg Reimer, 1904.

358. SCHOBER (A.), *Der Fries des Hekateions von Lagina* (*Istanb. Forsch.*, vol. 2), Baden bei Wien, Verlag Rudolf M. Rohrer, 1933.

359. LAURENZI (L.),' Problemi della scultura ellenistica: la scultura rodia', *RIA*, VIII, 1940, pp. 25-44.

360. BORELLI (L.), *Una scuola di ' manieristi' dell'ellenismo rodioasiatico*, Rendiconti della Classe di Scienze morali, storiche e filologische dell'Accademia Nazionale dei Lincei. series 8. vol. IV. 1949, pp. 1-16.

361. SICHTERMANN (H.), *Laokoon*, Opus Nobile, chefs-d'œuvre de l'art antique, 3, Bremen, Walter Dorn Verlag, 1957.

362. MARCADÉ (J.), *Au Musée de Délos. Essai sur la sculpture hellé-nistique en ronde bosse découverte dans l'île*, Paris, E. de Boccard, 1969.

Sperlonga

363. JACOPI (G.), *L'Antro di Tiberio a Sperlonga*, I Monumenti Romani, IV, Rome, Istituto di Studi Romani, 1963.

364. LAUTER (H.), 'Der Odysseus der Polyphemgruppe von Sperlonga', in *RM*, LXXII, 1965, pp. 226-229.

365. SÄFLUND (G.), *Das Faustinusepigramm von Sperlonga*, Opuscula Romana, VII, 1-2, 1967, pp. 9-23.

366. SÄFLUND (G.), *Sulla Ricostruzione dei Gruppi di Polifemo e di Scilla a Sperlonga*, Opuscula Romana, VII, 1-2, 1967, pp. 25-52. ANDREAE (B.), review of the two preceding items in *Gnomon*, XLI, 1969, pp. 811-815.

367. ANDREAE (B.), *et al.*, ' Abformung der Polyphemgruppe von Sperlonga in GfK nach einem neuen Verfahren', in *Der Präparator*, XVI, 1/2, 1970.

3. SOME RECENT DETAILED STUDIES

368. CHARBONNEAUX (J.), ' La Vénus de Milo et Mithridate le Grand', in *La Revue des arts*, I, 1951, pp. 9-16.

369. FELLETTI MAJ (B.M.), ' Afrodite pudica, saggio d'arte ellenistica', in *Arch. Class.*, III, 1951, pp. 33-65.

370. CHARBONNEAUX (J.), ' Antigone et Démétrius sont-ils figurés sur le sarcophage d'Alexandre?', in *La Revue des arts*, II, 1952, pp. 219-223.

371. CHARBONNEAUX (J.), ' La Main droite de la Victoire de Samothrace', in *Hesperia*, XXI, 1952, pp. 25-37.

372. CHARBONNEAUX (J.), ' Un Poseidon hellénistique au Musée du Louvre', in *Mon. Piot*, XLI, 1952, pp. 25-37.

373. CHARBONNEAUX (J.), ' Portraits ptolémaïques au Musée du Louvre', in *Mon. Piot*, XLVII, 1953, pp. 99-129.

374. CHARBONNEAUX (J.), ' Un portrait de Cléopâtre VII au Musée de Cherchel', in *Libyca*, II, 1954, pp. 49-63.

375. CHARBONNEAUX (J.), and LAUMONIER (A.), ' Trois Portraits d'Alexandre Ier Balas', in *BCH*, LXXIX, 1955, pp. 528-538.

376. CHARBONNEAUX (J.), ' Le Geste de la Vénus de Milo', in *La Revue des arts*, VI, 1956, pp. 105-106.

377. CHARBONNEAUX (J.), ' Miroir grec à manche. Athlète alexandrin', in *La Revue des arts*, VII, 1957, pp. 85-86.

378. CHARBONNEAUX (J.), *La Vénus de Milo*, Opus Nobile, chefs-d'œuvre de l'art antique, 6, Bremen, Walter Dorn Verlag, 1958.

379. CHARBONNEAUX (J.), ' Un double Hermès de Zénon et Platon', in *AJA*, LXVI, 1962, pp. 269-271.

380. SÄFLUND (G.), *Aphrodite Kallipygos*, Acta Universitatis Stockholmiensis, Stockholm—Göteborg–Uppsala, Almqvist & Wiksell, 1963.

381. HEINTZE (H. v.), *Das Bildnis der Sappho*, Mainz, Kupferberg, 1966.

382. CHARBONNEAUX (J.), ' Prêtres égyptiens', in *Mélanges d'archéologie et d'histoire offerts à André Piganiol*, Paris, SEVPEN, 1966, 3 vols, pp. 407-420.

383. MINGAZZINI (P.), ' La Fanciulla d'Anzio', in *Jahrb.*, 81, 1966, pp. 173-185.

384. CHARBONNEAUX (J.), ' Un portrait de Ptolémée VI au Musée du Louvre, in *Mélanges offerts à Kazimierz Michalowski*, Warsaw, Panstwowe Wydawnictvo Neukowe, 1967, pp. 53-57.

385. NEUMANN (G.), ' Ein Bildnis des Königs Perseus', in *Jahrb.*, 82, 1967, pp. 157-166.

386. PARLASCA (K.),' Ein verkanntes hellenistisches Herrscherbildnis', in *Jahrb.*, 82, 1967, pp. 167-194.

387. DEL MÉDICO (H.E.),' A propos du Trésor de Panaguriste: un portrait d'Alexandre par Lysippe', in *Persica*, III, 1967-1968, pp. 37-67, pls I-IV.

388. BIELEFELD (E.), ' Zu einem attischen Mädchenkopf aus der Sammlung Käppeli', in *AK*, XII, 1969, pp. 111-113, pls 48-49.

INDEX TO THE BIBLIOGRAPHY

List of Illustrations

Reference numbers given in brackets denote other entries in the List of Illustrations and the corresponding plates.

In both the List of Illustrations and the Glossary-Index all dates are B.C. except where otherwise indicated.

In entries concerning paintings and coins in museum collections the inventory number follows the name of the collection.

century. In situ. Marble. Diameter of column, 6 ft 6 in. (1.98 m.). (Photo Antonello Perissinotto, Padua.)

Ionic columns, their bases revealing an octagonal cushion decorated with various plant motifs.

22. **DIDYMA, Temple of Apollo.** *South-east anta* (cf. 23). 3rd or 2nd century. In situ. Marble. Façade of the anta, 8 ft 9 in. (2.69 m.). (Photo Antonello Perissinotto, Padua.)

23. **DIDYMA. Temple of Apollo.** *Sculpted decoration* (detail). 3rd or 2nd century. In situ. Marble. Height 1 ft 6 in. (45 cm.). (Photo Antonello Perissinotto, Padua.)

Decoration from the foot of the Ionic wall consisting of a scotia bracketed by two tori, the top one adorned with imbricated leaves, the lower one with tracery.

24. **DIDYMA, Temple of Apollo.** *Pilaster capital with animal motif.* 3rd or 2nd century. In situ. Marble. Height 3 ft (90 cm.); width 5 ft 6 in. (1.70 m.). (Photo Antonello Perissinotto, Padua.)

Capital crowning one of the pilasters set at intervals along the high wall of which the 82 ft (25 m.) long footing encloses the inner court.

25. **BELEVI, Heroön.** *Corinthian capital.* Early 3rd century. In situ. Marble. Height 2 ft 4 in. (70 cm.). (Photo Antonello Perissinotto Padua.)

26. **DIDYMA, Temple of Apollo.** *Pilaster capital with floral decoration* (detail). 3rd-2nd century. In situ. Marble. Height 3 ft (90 cm.); width 5 ft 6 in. (1.70 m.). (Photo Antonello Perissinotto, Padua.)

27- **BELEVI, Heroön.** *Two successive*
28. *stages in the decoration of the krepis.* Early 3rd century. In situ. Marble. (Photo Antonello Perissinotto, Padua.)

Unfinished decoration, on which one can follow each stage of the work, from the compass-drawn outline of the motif to the final sculpture.

29. **BELEVI, Heroön.** *Weather-moulding block (corona) with dentils.* Early 3rd century. In situ. Marble. (Photo Antonello Perissinotto, Padua.)

30. **MAGNESIA - AD - MAEANDRUM, Temple of Zeus Sosipolis.** HERMO-GENES. *Cross-section.* (cf. 31, 32). About 195-190. 24 × 52 ft (7.38 × 15.82 m.) on the stylobate. (After Gottfried Gruben, *Die Tempel der Griechen*, Munich, Hirmer Verlag, 1966, p. 365, fig. 293.)

Prostyle Ionic temple. Example of eustyle, defined by Vitruvius as (a) a

ratio of 1:2¼ between intervals and column-base diameter, and (b) a column-height 9½ times the same diameter.

31. **MAGNESIA - AD - MAEANDRUM, Temple of Zeus Sosipolis.** *Ground-plan.* (cf. 30, 32). About 195-190. (After Gottfried Gruben, *Die Tempel der Griechen*, Munich, Hirmer Verlag, 1966, p. 365, fig. 292.)

32. **MAGNESIA - AD - MAEANDRUM, Temple of Zeus Sosipolis.** *Façade* (cf. 30, 31). About 195-190. Staatliche Museen, Berlin. Marble. Height of column 20 ft 8 in. (6.30 m.); interaxial distance 20 ft 10 in. (6.35 m.); height of entablature 4 ft (1.26 m.). (Arts of Mankind Photo.)

33. **MAGNESIA - AD - MAEANDRUM, Temple of Artemis Leucophryene.** HERMOGENES. *Reconstruction of the façade.* First half of 2nd century Marble. 95 × 181 ft (28.89 × 55.16 m.) on the stylobate; width of façade 95 ft (28.89 m.); height of column 40 ft 6 in. (12.40 m.). (After Gottfried Gruben, *Die Tempel der Griechen*, Munich, Hirmer Verlag, 1966, p. 369, fig. 296.)

Peripteral and pseudo-dipteral Ionic temple of 8 × 15 columns. Deep pronaos with 4 columns and two rows of three columns in the cella (cf. 399).

34. **PRIENE, Agora, north stoa.** *Entablature* (detail). Second half of 4th century. Staatliche Museen, Berlin. Marble. Height 5 ft (1.52 m.). (Arts of Mankind Photo.)

Example of the contamination of a Doric element (frieze with triglyphs) by an Ionic motif (dentils).

35. **PRIENE, Temple of Athena.** *Entablature* (detail). Second half of 4th century. Staatliche Museen, Berlin. Marble. Height 7 ft (2.11 m.). (Arts of Mankind Photo.)

Entablature without a frieze, in the Ionian tradition: a plain sculptured Ionic moulding separates the dentils from the architrave.

36. **EPHYRA, Necromanteion.** *View through inner chambers.* 3rd century. Limestone. (Photo Henri Stierlin, Geneva.)

37. **EPHYRA, Necromanteion.** *Entrance.* 3rd century. In situ. Limestone. (Photo Henri Stierlin, Geneva.)

38. **EPHYRA, Necromanteion.** *Vaulted underground chamber.* 3rd century. In situ. Limestone. (Photo Henri Stierlin, Geneva.)

Semicircular or barrel vault with projecting arches.

39. **XANTHOS, Letoön theatre.** *Entrance-gate.* 3rd-2nd century. In situ. Limestone. (Photo Adam, Paris.)

One of the earliest, examples of an arcature being associated with the traditional pediment motif.

40. **DELOS.** *Cistern of the theatre.* 2nd century. In situ. Schist. (Arts of Mankind Photo.)

Arcature designed to support a flag-stone covering.

41. **CLAROS, Temple of Apollo.** *Vaulted doorway in the adyton* (cf. 42). 4th-3rd century. In situ. Marble, width 2 ft (60 cm.). (Photo Prof. Roland Martin, Fixin.)

42. **CLAROS, Temple of Apollo.** *Adyton: arches of the vault* (detail; cf. 41). 1st century. In situ. Marble. (Photo Prof. Roland Martin, Fixin.)

43. **PERGAMUM, Stairway to the gymnasium.** *Arches of the vault* (detail). 2nd century. (After A. W. Lawrence, *Greek Architecture*, The Pelican History of Art, London, Penguin Books, 1962, p. 229, fig. 126.)

44. **PERGAMUM, Acropolis.** *Cistern* (detail). 2nd century. In situ. Limestone. (Photo Prof. Roland Martin, Fixin.)

45. **ATHENS, Tower of the Winds.** *Roof-vaulting.* 1st century. In situ. Marble. Octagonal ground-plan: each face 9 ft 2 in. (2.80 m.); diameter 26 ft (7.95 m.). (Arts of Mankind Photo.)

The roof consists of long triangular stone slabs meeting in a central key-stone. A water-clock, erected at the expense of a Syrian named Andronicus.

46. **PERGAMUM.** *The Great Altar: general view* (cf. 66, 400, 405). First half of 2nd century. Staatliche Museen, Berlin. Marble and limestone. Platform 120 ft 6 in. × 112 ft (36.44 × 34.20 m.); base dimensions 226 ft 6 in. × 252 ft 6 in. (69 × 77 m.). (Arts of Mankind Photo.)

Central ramp with 28 steps: width of ramp 65 ft 6 in. (20 m.).

47. **PERGAMUM.** *The Great Altar: north-west corner* (cf. 46). First half of 2nd century. Staatliche Museen, Berlin. Height of frieze 7 ft 6 in. (2.28 m.). (Arts of Mankind Photo.)

48. **BELEVI.** *Heroön: general view.* Early 3rd century. In situ. Rocky limestone mass which supported the architectural frontage.

49. **CYRENE.** *Rock-tomb: façade.* 3rd-2nd century. In situ. (Arts of Mankind Photo.)

50. **AGRIGENTO.** *Monument of Theron.* 1st century. In situ. Limestone. (Arts of Mankind Photo.)

Type of funerary monument with appliqué architecture decorating an upper storey which stands on a massive foundation.

51. **ALEXANDRIA, Necropolis of Mustapha Pasha.** *Funerary monument* (detail). 3rd-2nd century. In situ. (Arts of Mankind Photo.)

52. **CYRENE.** *Rock-tomb: façade.* 3rd-2nd century. In situ. Natural rock. (Arts of Mankind Photo.)

Note the mixed style of the rock façades and the development of the Attic storeys.

53. **LEVKADHIA, Tomb.** *Reconstruction of the façade* (cf. 396, 397). First half of 3rd century. Stucco on limestone. (After M. Petsas, *The Levkadhia Tomb,* Bibliothèque de la Société archéologique d'Athènes, No. 57, Athens, 1966, pl. A.)

Composition in stucco and paint.

54. **YAZILIKAYA, Phrygian tomb.** *Rock façade.* 5th-4th century. In situ. Natural rock. (Photo Antonello Perissinotto, Padua.)

Design and decorative motifs, originally meant to be carved in wood, transferred to a rock façade.

55. **PERGAMUM, Sanctuary of Athena.** *Propylon.* First half of 2nd century. Staatliche Museen, Berlin. Marble and limestone. Façade 29 ft (8.80 m.). (Arts of Mankind Photo.)

Doric order at ground level, Ionic in the upper storey. Trophies of arms carved on the balustrade.

56. **MILETUS, South Agora.** *The Great Gate.* 1st century A.D. Staatliche Museen, Berlin. Marble. Whole façade 98 ft 6 in. (30 m.). (Arts of Mankind Photo.)

Marks the final development of decorative values, to a point where they no longer serve any structural purpose. This represents a kind of rag-bag of Hellenistic decorative motifs. (Cf. 57, 80, 409.)

57. **MILETUS, South Agora.** *The Great Gate* (detail). 1st century A.D. Staatliche Museen, Berlin. Marble. (Arts of Mankind Photo.)

The broken pediment motif, frequently used in the decoration of façades. (Cf. 56.)

58. **PELLA.** *Mosaic floors made of large pebbles.* 4th-3rd century. In situ. (Arts of Mankind Photo.)

59. **PELLA.** *House with peristyle and mosaic floor.* 4th-3rd century. In situ. (Arts of Mankind Photo.)

60. **DELOS.** *House with peristyle (the so-called 'House of Cleopatra').* 3rd-1st century. In situ. (Arts of Mankind Photo.)

61. **DELOS.** *Reconstruction of the so-called 'House of Hermes'* (cf. 62). 2nd century. (After J. Delorme, 'La maison dite de l'Hermès à Délos', in *Bulletin de correspondance hellénique,* LXXVII, 1953, pls L-LI.)

62. **DELOS.** *The so-called 'House of Hermes': interior colonnades* (detail). 2nd century. In situ. Height of the order, 14 ft 9 in. (4.50 m.). (Arts of Mankind Photo.)

This house is located in the Inopus Valley. Its ground-plan is adapted to the slope of the hill, against which all three levels were built, and the Peristyle motif repeated in the upper storey. (Cf. 61.)

63. **DELOS.** *Peristyle of house with mosaic pavement.* 2nd-1st century. In situ. (Arts of Mankind Photo.)

64. **PERGAMUM.** *The theatre and view over the plain* (cf. 66, 405). 2nd century. (Photo Antonello Perissinotto, Padua.)

65. **PERGAMUM.** *Upper terrace of the gymnasia* (cf. 404, 406). 2nd century. In situ. Dimensions of 312 × 164 ft (95 × 50 m.) with porticoes. (Photo Antonello Perissinotto, Padua.)

66. **PERGAMUM.** *Scale model of the acropolis.* As during 2nd and 1st centuries. Staatliche Museen, Berlin. (Arts of Mankind Photo.)

As restored after Roman alterations and the building of the Trajaneum. (cf. 14, 46, 64, 404-405, 407-408.)

67. **PERGAMUM. Asclepieum.** *Court and porticoes.* 2nd century B.C.-2nd century A.D. In situ. Dimensions of court 335 × 460 ft (102 × 140 m.). (Photo Antonello Perissinotto, Padua.)

68. **COS, Asclepieum.** *Lower court and terraces.* 2nd-1st century. In situ. Dimensions of court 305 × 154 ft (93 × 47 m.). (Arts of Mankind Photo.)

The approach-ramps linking the terraces are between 32 ft 9 in. (10 m.) and 37 ft 8 in. (11.50 m.) wide. (Cf. 71.)

69. **COS, Asclepieum.** *Middle terrace and Temple C* (cf. 71, 72). 2nd century B.C.-2nd century A.D. In situ. Marble. Height of column 13 ft 6 in. (4.15 m.). (Arts of Mankind Photo.)

70. **COS, Asclepieum.** *Cross-section* (cf. 71). 2nd-1st century. (After P. Schazmann and R. Herzog, 'Asklepieion', in *Kos,* I, Berlin, Verlag Heinrich Keller, 1932, pl. 39 bottom).

71. **COS, Asclepieum.** *Ground-plan* (cf. 68-70, 72-73). 2nd-1st century. (After P. Schazmann and R. Herzog, 'Asklepieion', in *Kos,* I, Berlin, Verlag Heinrich Keller, 1932, pl. 37).

72. **COS, Asclepieum.** *View over the lower and middle terraces* (cf. 71). 2nd-1st century. (Arts of Mankind Photo.)

73. **COS, Asclepieum.** *Temple A and the upper terrace* (cf. 71). First half of 2nd century. In situ. Marble. 52 × 102 ft (15.96 × 31.17 m.) on the stylobate; 106 × 59 ft (32.28 × 18.07 m.) on the euthynteria (levelling-course). (Arts of Mankind Photo.)

Doric temple of 6 × 11 columns.

74. **LINDOS, Sanctuary of Athena.** *Temple of Athena on the upper terrace* (cf. 419). 4th-3rd century. In situ. Marble, 25 ft 6 in. × 71 ft (7.75 × 21.65 m.) on the stylobate. (Arts of Mankind Photo.)

Amphiprostyle ground-plan with four columns on the façades.

75. **LINDOS, Sanctuary of Athena.** *Detail of the monumental stairway* (cf. 419). 3rd-2nd century. In situ. Width of access ramp 65 ft 6 in. (20 m.). (Arts of Mankind Photo.)

A ramp of 35 steps, linked to the stoa itself.

76. **LINDOS, Sanctuary of Athena.** *Stoa and monumental stairway* (cf. 419). 2nd century. In situ. Marble and limestone. Width of stoa 285 ft 6 in. (87 m.); of central structure 223 ft (68 m.). (Arts of Mankind Photo.)

77. **CAMIRUS.** *General view.* 4th-3rd century. (Arts of Mankind Photo.)

78. **CAMIRUS.** *Lower part of the town* (cf. 77). 4th-3rd century. In situ. (Arts of Mankind Photo.)

This includes the sanctuary and the agora, behind the port area.

79. **DELOS.** *Street leading from the Theatre.* 2nd-1st century. In situ. (Arts of Mankind Photo.)

80. **MILETUS.** *Scale model of the approach to the South Agora* (cf. 56, 409). As during 1st century. Staatliche Museen, Berlin. (Arts of Mankind Photo.)

Note the main gateway, with the Bouleuterion on the right and the monumental nymphaeum to the left.

81. **COS, Gymnasium.** *Street and colonnade.* 2nd-1st century. In situ. Marble and limestone. (Arts of Mankind Photo.)

82. **PRIENE, Gymnasium.** *The fountain.* 3rd century. In situ. Marble and limestone. (Photo Deutsches Archäologisches Institut, Instanbul.)

83. **DELOS.** *The Minoe fountain.* Condition as after 2nd-century repair work. In situ. Dimensions of basin, 13 ft × 12 ft 2 in. (4 × 3.75 m.); depth 13 ft (4 m). (Arts of Mankind Photo.)

 Note the column which formerly supported the roof.

84. **MESSENE.** *The Agora.* 4th-3rd century. In situ. Local limestone. (Arts of Mankind Photo.)

 The hall of the Bouleuterion is in the foreground.

85. **ATHENS, Stoa of Attalus.** *Upper gallery.* Mid-2nd century. In situ. Marble and limestone, in conformity with the original material. (Arts of Mankind Photo.)

 Complete reconstruction of the building on the basis of American excavations. (Cf. 86-87, 415.)

86. **ATHENS, Stoa of Attalus.** *Ground floor* (cf. 85, 87, 415). Mid-2nd century. In situ. (Arts of Mankind Photo.)

87. **ATHENS, Agora.** *Scale model* (cf. 85-86, 415). As during 2nd and 1st centuries. Agora Museum, Athens. (Arts of Mankind Photo.)

88. **Apulian art. GNATHIA.** *Aryballoid lekythos: seated woman holding a mirror.* Last quarter of 4th century. Museo Nazionale, Taranto. Terracotta. (Arts of Mankind Photo.)

89. **Apulian art. RUVO.** *Oenochoe* (detail): *dance scene.* About 320. Jatta Collection, Ruvo (1167). Terracotta. Height of vase 6¾ in. (17.3 cm.). (Arts of Mankind Photo.)

90. **Sicilian art. ADRANO.** The ' ADRANO GROUP'. *Oenochoe* (detail): *the drunken Heracles.* About 325. Hermitage Museum, Leningrad (2079). Terracotta. Height of pot 12 in. (32 cm.). (Museum Photo.)

 (A. D. Trendall, The Red-Figured Vases of Lucania, Campania and Sicily, p. 604, no. 104.) This nocturnal scene is illuminated by the torches in the hands of the two girl musicians.

91. **Sicilian art. ADRANO.** The 'ADRANO GROUP'. *Pyxis* (detail): *the bride's toilet.* About 325. Pushkin Museum of Fine Arts, Moscow (510).

Terracotta. Height of pot 9¼ in. (23.6 cm.) (Museum Photo.)

 (A. D. Trendall, The Red-Figured Vases of Lucania, Campania and Sicily, p. 604, no. 105.)

92. **LIPARI.** The ' LIPARI PAINTER'. *Polychrome lekanis: seated woman.* About 330-320. Museo Eoliano, Lipari (7450). Terracotta. Height of pot 5¾ in. (14.5 cm.). (Photo Hirmer-Fotoarchiv, Munich.)

 (A. D. Trendall, The Red-Figured Vases of Lucania, Campania and Sicily, p. 658, no. 474.) On the other side Nike is shown befoe an altar.

93. **Sicilian art. FALCONE.** *Pyxis* (detail): *Silenus and Eros among Nymphs.* Late 4th century. Museo Nazionale, Palermo (GE 4730). Terracotta. Height of pot 15 in. (37.5 cm.). (Arts of Mankind Photo.)

 (A. D. Trendall, The Red-Figured Vases of Lucania, Campania and Sicily, p. 625, no. 278.)

94. **Apulian art. GNATHIA.** *Polychrome hydria: last leave-taking of a dead woman (shown sitting); on the neck, a file of female mourners.* About 300. Louvre, Paris (CA 3239). Terracotta. Height of pot 17½ in. (44 cm.). (Arts of Mankind Photo.)

95. **Greek art from Macedonia. PELLA.** *Abduction of Helen by Theseus.* Second half of 4th century. Pella, temporary museum. Mosaic. (Photo M. Petsas.)

96. **Alexandrian art. ALEXANDRIA, Necropolis of Mustapha Pasha.** *Funerary monument (cf. 51): horsemen, and ladies offering sacrifice.* Early 3rd century. In situ. Wall-paintings. Height 2 ft (60 cm.); width 5 ft 6 in. (1.67 m.). (Arts of Mankind Photo.)

97. **Greek art from Macedonia. PELLA.** *Dionysus on a panther.* Late 4th century. Pella Museum. Mosaic. (Arts of Mankind Photo.)

98. **Greek art from Macedonia. LEVKADHIA, Tomb** (cf. 53). *Painted metope: battle between a centaur and a Lapith.* Early 3rd century. In situ. Height 1 ft 5 in. (42.5 cm.); width 1 ft 7 in. (48 cm.). (After M. Petsas, *The Levkadhia Tomb*, Bibliothèque de la Société archéologique d'Athènes, no. 57, Athens, 1966, pl. 4.)

99. **Alexandrian art. ALEXANDRIA (Hadra).** *Funerary stele: a horseman and his servant.* About 300. Musée Gréco-Romain, Alexandria (22116). Painted limestone. Height 14 in. (35 cm.); width 10 in. (25 cm.). (Arts of Mankind Photo.)

100. **Alexandrian art. ALEXANDRIA (Chatby).** *Funerary stele of a Macedonian horseman.* Late 4th century. Musée Gréco-romain, Alexandria (10228). Painted limestone. Height 16 in. (40 cm.); width 15 in. (37 cm.). (Arts of Mankind Photo.)

101. **Etruscan art. ORVIETO, Golini Tomb.** *Preparations for a banquet* (detail): *servant with pestle and mortar.* About 330-320. Museo Archeologico Florence. Wall-painting. Height of detail 4 ft 7 in. (1.40 m.). (Photo Scala, Florence.)

102. **Greek art from Italy. TARQUINIA.** *Painted sarcophagus* (detail): *battle between Greeks and Amazons* (cf. 103-104). Late 4th century. Museo Archeologico, Florence. Painted limestone. Height of frieze 1 ft 8 in. (50 cm.), (Photo Scala, Florence.)

103. **Greek art from Italy. TARQUINIA.** *Painted sarcophagus* (detail): *Amazons in a quadriga fighting a Greek* (cf. 102, 104). Late 4th century. Museo Archeologico, Florence. Painted limestone. Height of frieze 1 ft 8 in. (50 cm.). (Photo Scala, Florence.)

104. **Greek art from Italy. TARQUINIA.** *Painted sarcophagus* (detail from one end): *Amazons fighting a Greek* (cf. 102-103). Late 4th century. Museo Archeologico, Florence. Painted limestone. Height of picture 15 in. (37 cm.); width 1 ft 10 in. (55 cm.). (Photo Scala, Florence.)

105. **Greek art from Macedonia. PELLA.** *The lion-hunt* (detail). Late 4th century. Pella Puseum. Mosaic. Height of figure 5 ft 4 in. (1.635 m.). (Arts of Mankind Photo.)

106. **Greek art from Macedonia. PELLA.** *The lion-hunt* (detail). Late 4th century. Pella Museum. Mosaic. Height of figure 5 ft 4 in. (1.635 m.). (Arts of Mankind Photo.)

107. **Greek art from Macedonia. PELLA. GNOSIS.** *A stag-hunt* (detail; cf. 108). Early 3rd century. In situ. Mosaic. (Arts of Mankind Photo.)

108. **Greek art from Macedonia. PELLA. GNOSIS.** *A stag-hunt.* Early 3rd century. In situ. Mosaic. (Photo M. Petsas.)

109. **Greek art from Thrace. KAZANLAK, Tomb.** *Cupola of the burial-chamber: the princely pair receiving their servants' homage. In the lantern, a chariot-race.* About 300. In situ. Wall painting. Height 1 ft 10 in. (55 cm.). (Photo Antonello Perissinotto, Padua.)

110. Greek art from Thrace. **KAZANLAK, Tomb.** Cupola (detail): *the princely pair receiving their servants' homage* (cf. 109). About 300. In situ. Wall-painting. Height 1 ft 10 in. (55 cm.). (Photo Antonello Perissinotto, Padua.)

111. Greek art from Thrace. **KAZANLAK, Tomb.** Cupola (detail): *procession of serving-women with offerings; groom with quadriga.* About 300. In situ. Wall-painting. Height 1 ft 10 in. (55 cm.). (Photo Antonello Perissinotto, Padua.)

112. Greek art from Thrace. **KAZANLAK, Tomb.** Cupola: *detail of the groom* (cf. 111). About 300. In situ. Wall-painting. (Photo Antonello Perissinotto, Padua.)

113. Greek art from Thrace. **KAZANLAK, Tomb.** Cupola: *detail of the princess* (cf. 109-110). About 300. In situ. Wall-painting. (Photo Antonello Perissinotto, Padua.)

114. Graeco-Roman art from Campania. **POMPEII, House of the Vettii.** After APELLES (?). *Alexander Keraunophoros wielding a thunderbolt* (?). About A.D. 70, after an original of about 330. In situ. Wall-painting. (Arts of Mankind Photo.)

The attribution of the original to Apelles was suggested by P. Mingazzini, in Jahrb. Berliner Museen III, 1961, pp. 1 ff.

115. Graeco-Campanian art. **POMPEII, House of the Faun.** After PHILOXENUS OF ERETRIA(?). *Battle between Alexander and Darius* (detail): *Alexander the Great* (cf. 117). Second half of 2nd century, after an original executed about 300. Museo Nazionale, Naples. Mosaic. (Arts of Mankind Photo.)

116. Graeco-Campanian art. **POMPEII, House of the Faun.** After PHILOXENUS OF ERETRIA(?). *Battle between Alexander and Darius* (detail): *Darius in his chariot* (cf. 117). Second half of 2nd century, after an original executed about 300. Museo Nazionale, Naples. Mosaic. (Arts of Mankind Photo.)

117. Graeco-Campanian art. **POMPEII, House of the Faun.** After PHILOXENUS OF ERETRIA(?). *Battle between Alexander and Darius.* Second half of 2nd century, after an original executed about 300. Museo Nazionale, Naples. Mosaic. Height 8 ft 11 in. (2.71 m.); width 16 ft 10 in. (5.12 m.). (Arts of Mankind Photo.)

118. Graeco-Roman art from Campania. **POMPEII** (Reg. IX, ins. 5, 18-21).

After ARISTOLAUS(?) *Medea meditating the murder of her children.* Early 1st century A.D., after a late 4th century original. Museo Nazionale, Naples (114321). Wall-painting. Height 4 ft 7 in. (1.40 m.); width 2 ft 9 in. (83 cm.). (Arts of Mankind Photo.)

The Roman replica is attributed by C. L. Ragghianti to the 'MAESTRO CHIARO'; see his Pittori di Pompei, p. 72.

119. Graeco-Roman art from Campania. **HERCULANEUM.** The 'HELLENIC MASTER'. *A young girl's toilet.* Early 1st century A.D., probably after a late 4th century original. Museo Nazionale, Naples. Wall-painting. (Arts of Mankind Photo.)

Attribution by C. L. Ragghianti, Pittori di Pompei, pp. 55-57.

120. Graeco-Roman art from Campania **HERCULANEUM.** The 'HELLENIC MASTER'. *Celebration in honour of a champion flute-player.* Early first century A.D., probably after a late 4th century original. Naples, Museo Nazionale. Wall-painting. (Arts of Mankind Photo.)

Attribution by C. L. Ragghianti, Pittori di Pompei, pp. 55-57.

121. Graeco-Roman art from Campania. **POMPEII** (Reg. IX, ins. 2,5). *Perona suckling her old father Micon in prison.* 1st century A.D., probably after a 3rd century original. Museo Nazionale, Naples. Wall-painting. (Arts of Mankind Photo.)

122. Graeco-Roman art from Campania. **HERCULANEUM.** The 'HELLENIC MASTER'. *Celebration of a tragic actor's victory.* Early 1st century A.D., probably after a late 4th century original. Museo Nazionale, Naples. Wall-painting. (Arts of Mankind Photo.)

123. Graeco-Roman art from Campania. **POMPEII, House of the Tragic Poet.** The 'MASTER OF THE POETESS'. *Achilles surrendering Briseis to Agamemnon's emissaries.* About A.D. 70, after original executed about 300. Museo Nazionale, Naples (9105). Wall-painting. Height 5 ft (1.51 m.); width 4 ft 3 in. (1.29 m.). (Arts of Mankind Photo.)

Attribution by C. L. Ragghianti, Pittori di Pompei, p. 55.

124. Graeco-Roman art from Campania. **POMPEII** (Reg. IX). After ATHENION(?). *Achilles on Scyros, discovered by Odysseus and Diomedes among the maidens.* 1st century A.D., after a late 4th century original.

Museo Nazionale, Naples (116085). Height 4 ft 9 in. (1.45 m.); width 4 ft 6 in. (1.375 m.). (Arts of Mankind Photo.)

C. L. Ragghianti, Pittori di Pompei, p. 63, attributes the Roman replica to the 'EPIC MASTER'.

125. Graeco-Roman art from Campania. **POMPEI, House of the Dioscuri.** After ATHENION(?). *Achilles on Scyros, discovered by Odysseus and Diomedes among the maidens* (fragment). 1st century A.D., after a late 4th century original. Museo Nazionale, Naples (9110). Wall-painting. Height 4 ft 3 in. (1.30 m.); width 2 ft 9 in. (84 cm.). (Arts of Mankind Photo.)

126. Greek art from Thessaly. **DEMETRIAS.** *Painted funerary stele of Demetrius, son of Olympus.* 3rd century. Volos Museum. (Arts of Mankind Photo.)

The dead man is shown seated on a stool, with a young slave in attendance on him.

127. Greek art from Thessaly. **DEMETRIAS.** *Painted marble funerary stele of Hediste* (detail). Mid-3rd century. Volos Museum. (Arts of Mankind Photo.)

The young woman, who died in childbirth, is shown surrounded by her relatives.

128. Alexandrian art. **ALEXANDRIA (Hadra).** *Stele of the Thessalian cavalier Pelopides* (detail). Mid-3rd century. The Metropolitan Museum of Art, New York, gift of D. O. Hills, 1904 (04.17.3). Painted limestone Height 15½ in. (39.4 cm.); width 10¼ in. (26 cm.). (Metropolitan Museum Photo.)

129. Greek art from Thessaly. **DEMETRIAS.** *Painted marble funerary stele of Archidice* (detail): *the dead woman and her maid.* Mid-3rd century. Volos Museum. (Arts of Mankind Photo.)

130. Greek art from Sicily. **CENTURIPE.** *Polychrome pyxis* (detail from lid): *Woman offering sacrifice.* Second half of third or early 2nd century. The Metropolitan Museum of Art, New York, Fletcher Foundation, 1930 (30.11.4). Terracotta. Height of pot 12 in. (30 cm.). (Museum Photo.)

131. Greek art from Sicily. **CENTURIPE.** *Polychrome krater* (detail): *cult scene.* 3rd century. The Metropolitan Museum of Art, New York, gift of Joseph Pulitzer, 1953 (53.11.5). Terracotta. Height of pot 15½ in. (39.7 cm.). (Museum Photo.)

153. Graeco-Roman art from Campania. **POMPEII** (Reg. I, ins. 7, 7). The 'MASTER OF AMANDUS'. *The Seduction of Helen by Paris.* First quarter of 1st century A.D., probably after a 3rd century original. Museo Nazionale, Naples (114320). Wall-painting. (Arts of Mankind Photo.)

Attribution by C. L. Ragghianti, Pittori di Pompei, p. 75.

154. Graeco-Roman art from Campania. **POMPEII.** The 'MASTER OF FORESHORTENING'. *The Three Graces.* 1st century A.D., probably after a late 3rd century of early 2nd century original. Museo Nazionale, Naples (9236). Wall-painting. Height 1 ft 10¼ in. (56.5 cm.); width 1 ft 9 in. (53.5 cm.). (Arts of Mankind Photo.)

155. Graeco-Roman art from Campania. **HERCULANEUM, Basilica.** The 'MASTER OF TELEPHUS'. *Heracles discovers his son Telephus in the mountains of Arcadia.* About A.D. 70, after an early 2nd century original. Museo Nazionale, Naples (9008). Wall-painting. Height 7 ft 1 in. (2.16 m.); width 6 ft 1 in. (1.85 m.). (Arts of Mankind Photo.)

For the attribution cf. C. L. Ragghianti, Pittori di Pompeii, pp. 50-52.

156. Pergamene art. **ROME.** After SOSUS. *The Unswept Room* (detail). 1st century A.D., after an early 2nd century original. Museo Laterano (repository), Vatican. Mosaic. (Photo Anderson-Giraudon, Rome-Paris.)

157. Attic art. **ALEXANDRIA (Hadra).** *Hydria with ornamental decoration* (detail). 3rd century. Musées Royaux d'Art et d'Histoire, Brussels (A 13). Terracotta. Height of vessel 15 in. (38 cm.). (Photo Institut Royal du Patrimoine artistique, Brussels. Copyright A.C.L.)

158. Pergamene art. **TIVOLI, Hadrian's Villa.** After SOSUS. *Doves on a bowl.* About 100, after an early 2nd century original. Museo Capitolino, Rome. Mosaic. (Arts of Mankind Photo.)

159. Alexandrian art. **ALEXANDRIA (Hadra).** *Polychrome hydria* (detail): *Gorgon's head (Gorgoneion) on a shield.* 3rd century. The Metropolitan Museum of Art, New York, purchased 1890 (90.9.67). Terracotta. Height of vessel 16 in. (40.5 cm.) Height of detail 2¾ in. (7 cm.). (Museum Photo.)

160. Art of Central Italy. *Fragment of phiale: quadriga race between Amorini* (detail). Late 3rd century. Formerly in the Museo Nazionale di Villa Giulia, Rome. Terracotta. Height of vessel 4¼ in. (11 cm.). (After *Annali dell'Istituto di corrispondenza archeologica,* XXXXIII, Rome, 1871.) *This phiale no longer exists.*

161. Attic art. **ATHENS.** *White-painted skyphos* (detail): *hunting scene.* 3rd century. Agora Museum, Athens. Terracotta. (Arts of Mankind Photo.)

162. Alexandrian art. **THMUIS. SOPHILUS.** *Personification of Alexandria.* Late 3rd century. Musée Gréco-Romain, Alexandria (21739). Mosaic. Height 4 ft 1 in. (1.25 m.). (Arts of Mankind Photo.)

163. Alexandrian art. **BEGRAM.** *Goblet: the abduction of Ganymede* (cf. 164). 2nd century. Musée Guimet, Paris. Painted glass. (Arts of Mankind Photo.)

164. Alexandrian art. **BEGRAM.** *Goblet: the abduction of Europa* (cf. 163). 2nd century. Musée Guimet, Paris. Painted glass. (Arts of Mankind Photo.)

165-167. Alexandrian art from Campania. **POMPEII, House of the Faun.** *Nilotic scene* (details). 2nd century. Museo Nazionale, Naples (9990). Mosaic. (Arts of Mankind Photos.)

168. Hellenistic Greek art. **DELOS, House of the Dolphins.** ASCLEPIADES OF ARADOS. *Eros and dolphins* (detail). Second half of 2nd century. In situ. Mosaic. (Arts of Mankind Photo.)

169. Graeco-Roman art from Campania. **POMPEII.** *Mountainous landscape with pastoral scene.* 1st century A.D., after a 2nd century original. Museo Nazionale, Naples. Wall-painting. Height 1 ft 8 in. (50.5 cm.). (Arts of Mankind Photo.)

170. Graeco-Roman art from Campania. **BOSCOREALE, Villa of Fannius Sinistor.** *Architectual perspectives* (detail). About 40. The Metropolitan Museum of Art, New York, Rogers Foundation, 1903 (03.14.13). Wall-painting. (Museum Photo.)

171. Graeco-Roman art. **ROME, House on the Esquiline.** *Landscape illustrating the 'Odyssey'* (detail from a frieze): *Odysseus and his companions in the land of the Laestrygonians.* About 50-40. Biblioteca Apostolica, Vatican. Wall-painting. Width 5 ft 1 in. (1.55 m.). (Library Photo.)

172. Graeco-Roman art. **ROME, House on the Esquiline.** *Landscape illustrating the Odyssey* (detail from a frieze): *the palace of Circe.* About 50-40. Biblioteca Apostolica, Vatican. Wall-painting. Width 5 ft 1 in. (1.55 m.). (Photo De Antonis, Rome.)

173. Graeco-Roman art from Campania. **POMPEII** (Reg. IX, ins. 7, 16a). *Landscape with the abduction of Hylas* (detail). Early 1st century A.D., probably after a 2nd or 1st century original. In situ. Wall-painting. (Arts of Mankind Photo.)

174. Graeco-Roman art from Campania. **POMPEII, Via della Fortuna.** The 'LUNAR MASTER'. *Landscape with buildings and small figures* (detail). 1st century A.D., after a late 2nd century original. Antiquarium, Pompeii. Wall-painting. (Arts of Mankind Photo.)

Attribution by C. L. Ragghianti, Pittori di Pompei, p. 78.

175. Graeco-Roman art from Campania. **HERCULANEUM.** The 'LUNAR MASTER'. *Landscape with shrines.* 1st century A.D., probably after a late 2nd century original. Museo Nazionale, Naples (9423). Painting on marble. 10½ × 13½ in. (27 × 34 cm.) (Arts of Mankind Photo.)

Attribution by C. L. Ragghianti, Pittori di Pompei, p. 78.

176. Graeco-Roman art. **ROME, Columbarium of the Villa Pamphili.** *Bucolic landscape.* About 25. Museo Nazionale, Rome. Wall-painting. (Arts of Mankind Photo.)

177. Graeco-Roman art from Campania. **POMPEII** (Reg. VII, ins. 15, 2). *Landscape with tower, various buildings and house on a rock.* 1st century A.D., probably after an Alexandrian original of the 2nd century. Museo Nazionale, Naples. (Arts of Mankind Photo.)

178. Graeco-Roman art from Campania. **BOSCOTRECASE, so-called 'Villa of Agrippa Postumus'.** The 'MASTER OF AMANDUS'. *Bucolic and sacred landscape.* First quarter of 1st century A.D., probably after a late 2nd century original. Museo Nazionale, Naples (9414). Wall-painting. Height 5 ft (1.53 m.); width 3 ft 2½ in. (98 cm.). (Arts of Mankind Photo.)

Attribution by C. L. Ragghianti, Pittori di Pompei, p. 76.

179. Graeco-Roman art from Campania. **POMPEII** (Reg. IX, ins. 5, 18) The 'MAESTRO CHIARO'. *The Rape of Europa.* Early 1st century A.D. Museo Nazionale, Naples (111475). Wall-painting. Height 4 ft 1 in. (1.24 m.); width 3 ft 1 in. (94 cm.). (Arts of Mankind Photo.)

Attribution by C. L. Ragghianti, Pittori di Pompei, p. 76.

392

replica). 2nd century. Vatican Museums. Marble. Height 2 ft 9 in. (85 cm.). (Photo Hirmer Fotoarchiv, Munich.)

New version of a model which undoubtedly dates back to the early 4th century.

333. Neo-classical art. **PIRAEUS.** *Votive relief: Visitation of Dionysus to the poet.* Early 2nd century. Louvre, Paris. Marble. Height 1 ft 9½ in. (55 cm.); width 2 ft 3 in. (69 cm.). (Arts of Mankind Photo.)

Variation on the theme of the 'heroization banquet'. Dionysus, supported by a young satyr, is arriving at the dramatic poet's feast. The poet himself is stretched out beside a laden table. On the right a serving-boy (in the pose of Praxiteles' 'Satyr pouring wine') is filling a cup. The subject of Dionysus' visitation was often attempted by ancient artists; this is the oldest known example.

334. Neo-Attic art. *The 'Borghese Vase'* (detail). Second half of 2nd century. Louvre, Paris. Marble. Height 5 ft 7 in. (1.71 m.). (Arts of Mankind Photo.)

The sculptured decoration on the belly of this large krater is Dionysiac in character: Dionysus and Ariadne, satyrs and maenads. Here we see a young satyr supporting old Silenus, who is drunk and has dropped his kantharos. On the right is a dancing maenad.

335. Alexandrian art. **EGYPT.** *Gold octodrachm* (obverse): *Ptolemy V Epiphanes wearing the royal fillet and radiate crown.* 203-181. Bibliothèque Nationale, Paris, Cabinet des Médailles, Fonds général no. 359. Diameter 1⅛ in. (3 cm.). (Arts of Mankind Photo.)

336. Alexandrian art. *The 'Farnese Cup'.* About 175. Museo Nazionale, Naples. Sardonyx cameo. Diameter 8 in. (20 cm.). (Arts of Mankind Photo.)

On the reverse, a Gorgoneion.

337. Alexandrian art. *Female head.* Late 3rd-early 2nd century. Musée Gréco-romain, Alexandria. Marble. Height 1 ft 4½ in. (42 cm.). (Arts of Mankind Photo.)

Part of the hair is covered with a kind of shawl.

338. Alexandrian art. *Portrait of Cleopatra II.* Mid 2nd century. Louvre, Paris. Marble. Height 14½ in. (37 cm.). (Arts of Mankind Photo.)

339. Alexandrian art. **ARMANT.** *Statuette of a priest of Isis, known as the*

'Isiaque Fouquet'. Second half of 2nd century. Louvre, Paris. Bronze. Height 5 in. (13 cm.). (Arts of Mankind Photo.)

340. Alexandrian art. *Ring-bezel: Ptolemy VI Philometor wearing the Egyptian double crown.* First half of 2nd century. Louvre, Paris. Gold. Height 1¼ in. (3.4 cm.); width 1 in. (2.5 cm.). (Arts of Mankind Photo.)

341. Alexandrian art. *Ring-bezel: Ptolemy VI Philometor wearing the Greek diadem.* First half of 2nd century. Louvre, Paris. Gold. Diameter 1 in. (2.5 cm.). (Arts of Mankind Photo.)

342. **CAPE ARTEMISION.** *Jockey.* Second half of 2nd century. National Museum, Athens. Height 2 ft 9 in. (84 cm.). (Arts of Mankind Photo.)

This statue (which belonged to a group) formed part of the cargo of a wrecked ship; it was recovered from the sea off Cape Artemision in Euboea.

343. Alexandrian art. **CHALON-SUR-SAONE.** *Statuette of a Nubian,* 2nd century. Bibliothèque Nationale, Paris, Cabinet des Médailles. Bronze. Height 7½ in. (19.1 cm.). (Arts of Mankind Photo.)

This youth was doubtless playing the sambuca.

344. *Portrait-statuette of Ptolemy VII.* 145-116. Louvre, Paris. Bronze. Height 10½ in. (26.5 cm.). (Arts of Mankind Photo.)

345. Greek art from Asia. **MYRINA.** *Dionysus and Ariadne.* 2nd century. Louvre, Paris. Terracotta. Height 9½ in. (24 cm.). (Arts of Mankind Photo.)

346. Alexandrian art. **LOWER EGYPT.** *Dionysiac group.* Late 2nd century. Louvre, Paris. Bronze. Height of largest figure 12½ in. (34 cm.); of smallest figure 9½ in. (24 cm.). (Arts of Mankind Photo.)

Dionysus, a satyr playing the double flute (the instrument is modern), and two dancing maenads. It is not known how the group was originally arranged.

347. **ROME.** *Eros and Psyche, known as the 'Capitoline Kiss'* (ancient replica). Date of original, first half of 2nd century. Museo Capitolino, Rome. Marble. Height 4 ft 1 in. (1.25 m.). (Arts of Mankind Photo.)

348. **PERGAMUM.** *Hermaphrodite.* First half of 2nd century. Archaeological Museum, Istanbul. Marble. Height with plinth 6 ft 1½ in. (1.865 m.). (Arts of Mankind Photo.)

349. *Erotic group: Satyr and nymph* (ancient replica). About 150. Museo Nazionale, Rome. Marble. (Arts of Mankind Photo.)

350. ROME. *Sleeping Hermaphrodite* (ancient replica). Date of original, first half of 2nd century. Museo Nazionale, Rome. Width 4 ft 10 in. (1.47 m.). (Arts of Mankind Photo.)

351. *Satyr-musician from the 'Invitation to the Dance' group* (ancient replica; cf. 352). Date of original, early 2nd century. Uffizi, Florence. Marble. Height 4 ft 8 in. (1.43 m.). (Photo Scala, Florence.)

352. *Seated nymph from the 'Invitation to the Dance' group* (ancient replica; cf. 351). Date of original early 2nd century. Musée d'Art et d'Histoire, Geneva. Marble. Height 3 ft 6 in. (1.08 m.). (Museum Photo.)

353. **DELOS, Establishment of the Poseidoniastes of Berytus (Beirut).** *Erotic group: Aphrodite, Eros and Pan.* About 100. National Museum, Athens. Marble. Height (without base) 4 ft 3 in. (1.29 m.). (Arts of Mankind Photo).

354. **MELOS.** *Statue of Aphrodite known as the 'Venus de Milo'.* Late 2nd century. Louvre, Paris. Marble. Height 6 ft 7½ in. (2.02 m.). (Arts of Mankind Photo.)

The statue originally consisted of six pieces of Parian marble, worked separately. Original work based on the 'Venus of Capua' type created during the 4th century, no doubt by Lysippus.

355. Greek art of Asia Minor. *The 'Heyl Aphrodite'.* Late 2nd century. Staatliche Museen, Berlin. Terracotta. Height 1 ft 3 in. (37.8 cm.). (Museum Photo.)

Though clearly related, the pose here looks contorted and awkward in comparison with the Venus de Milo.

356. **DELOS.** *Torso of the 'Pseudo-Inopus'.* About 100. Louvre, Paris. Marble. Height 3 ft 1½ in. (95 cm.). (Arts of Mankind Photo.)

It is likely that this is a portrait of King Mithridates VI Eupator (120-63), idealized so as to resemble Alexander, by the same hand as the Venus de Milo.

357. **MELOS.** *The 'Venus de Milo'* (detail; cf. 354). Late 2nd century. Louvre, Paris. (Arts of Mankind Photo).

Compare the profile with that of the 'Pseudo-Inopus' (356).

358. **LYCOSURA, Temple of the Great Goddesses.** DAMOPHON OF MESSENE. *Head of Demeter.* The date is

controversial. Both the 2nd century B.C. and the 2nd century A.D. have been proposed, but about 140 seems most likely. National Museum, Athens. Marble. Height 2 ft 5½ in. (75 cm.). (Arts of Mankind Photo.)

From a colossal statue, numerous fragments of which survive. The treatment of the eyeballs suggests that the irises were inlaid.

359. Attic art. **AEGEIRA. EUCLEIDES OF ATHENS(?).** *Head of Zeus.* The date is disputed; suggestions include the 4th century, the 2nd century, or the Age of the Antonines. It is most probably an eclectic work of the 2nd century. National Museum, Athens. Marble. Height 2 ft 10 in. (87 cm.). (Arts of Mankind Photo.)

The eyeballs were executed separately; the hair was finished off with further pieces of marble, and a metal crown originally encircled the head. Doubtless from the great seated cult-statue which Pausanias saw.

360. **LYCOSURA, Temple of the Great Goddesses.** DAMOPHON OF MESSENE. *Head of the Titan Anytus.* The date is controversial. Both the 2nd century B.C. and the 2nd century A.D. have been proposed, but about 140 seems most likely. National Museum, Athens. Marble. Height 2 ft 5 in. (74 cm.) (Arts of Mankind Photo.)

361. **LYCOSURA, Temple of the Great Goddesses.** DAMOPHON OF MESSENE. *Head of Artemis.* The date is controversial. Both the 2nd century B.C. and the 2nd century A.D. have been proposed, but about 140 seems most likely. National Museum, Athens. Marble. Height 1 ft 7 in. (48 cm.). (Arts of Mankind Photo.)

As in the cases of the Aegeira Zeus and the head of Anytus (359-360) the eyeballs were executed separately in a different material and added afterwards. This technique was that primarily used for bronze statuary. The ears are pierced to take metal rings.

362. Rhodian art. **ROME, Baths of Titus.** *Laocöon and his children entwined by serpents.* Second half of 2nd century (?). Vatican Museums. Marble. Height from the central figure's right hand to base 7 ft 11 in. (2.42 m.). (Photo Hirmer Fotoarchiv, Munich.)

A recent restoration of the group has sensibly modified certain details, in particular Laocöon's right arm. Both the date and status (original or reproduction) of this work are still the subject of the lively controversy. Pliny gives the names of the three Rhodian sculptors who created the group as Hagesander, Polydorus, and

Athanodorus; however, these names are common in Rhodes during the 2nd and 1st centuries.

363. Rhodian art. **SPERLONGA, the Grotto.** *A companion of Odysseus.* Late 2nd century(?). Museo Archeologico Nazionale, Sperlonga. Marble. Height 6 ft 9 in. (2.05 m.). (Arts of Mankind Photo.)

From a sizeable collection of sculptured fragments found in some converted grottoes near a villa which belonged to Tiberius. The reconstruction, interpretation, origin and dating of the colossal marble statues which adorned the grotto pose a number of still unresolved problems. The most interesting group showed Odysseus' boat attacked by the monster Scylla.

364. Rhodian art. **SPERLONGA, the Grotto.** *Fragment of the group showing Odysseus' boat: the Palladium.* Late 2nd century(?). Museo Archeologico Nazionale, Sperlonga. Marble. (Arts of Mankind Photo.)

The magic image of Athena is given the archaic features appropriate to an early 5th century figure. Of the person who bore it only the hand can be seen, treated in a highly realistic manner.

365. Rhodian art. **SPERLONGA, the Grotto.** *Head of Odysseus.* Late 2nd century(?). Museo Archeologico Nazionale, Sperlonga. Marble. Height 1 ft 6 in. (45 cm.). (Arts of Mankind Photo.)

366. Aegean art. **AMORGOS.** *Head of an idol.* About 2000. Louvre, Paris. Marble. Height 14 in. (35.5 cm.). (Photo Tel-Vigneau, Paris.)

367. *Macedonian silver tetradrachm with the name and type-portrait of Alexander as Heracles (obverse).* Probably struck at Pella during the reign of Cassander (316-297). Bibliothèque Nationale, Paris, Cabinet des Médailles, no. R4121. Diameter 1⅛ in. (2.9 cm.). (Arts of Mankind Photo.)

368. *Silver tetradrachm from Pergamum (obverse): portrait of Philetaerus.* Struck during the reign of Eumenes II (197-159). Bibliothèque Nationale, Paris, Cabinet des Médailles, Fonds général, no. 1465. Diameter 1¾ in. (3.5 cm.). (Arts of Mankind Photo.)

The issue of Attic-weight tetradrachms, such as that showing Philetaerus (obverse) and Athena seated (reverse), ceased, according to some scholars at the time of the Battle of Magnesia, in 190; others, however, prefer a date some ten years later.

369. *Silver tetradrachm from the Sardis mint (obverse): portrait of Seleucus Nicator.*

Struck during the reign of Antiochus I, between 277 and 272. Bibliothèque Nationale, Paris, Cabinet des Médailles, Fonds général, no. 1965. Diameter 1⅛ in. (3 cm.). (Arts of Mankind Photo.)

370. Attic art. **POLYEUCTUS.** *. Demosthenes* (touched-up ancient replica) Date of original 280. Ny Carlsberg Glyptotek, Copenhagen. Marble. Height without plinth 5 ft (1.52 m.). (Photo N.C.G.)

371. Attic art. **EUBULIDES.** *Statue of Chrysippus* (touched-up ancient replica). Date of original late 3rd century. Louvre, Paris. Marble. Height 3 ft 10 in. (1.16 m.). (Arts of Mankind Photo.)

372. *Silver didrachm of Epirus (obverse): Zeus of Dodona and Dione.* 230-220. Bibliothèque Nationale, Paris, Cabinet des Médailles, Luynes no. 1905. Diameter 1⅛ in. (2.8 cm.). (Arts of Mankind Photo.)

373. *Gold octodrachm from Egypt (reverse): the cornucopia of the Ptolemies.* Struck during the reign of Ptolemy III (246-221). Bibliothèque Nationale, Paris, Cabinet des Médailles, Collection Bestegui no. 50. Diameter 1¼ in. (3.4 cm.). (Arts of Mankind Photo.)

374. *Gold octodrachm from Egypt (obverse): portrait of Berenice II.* 246-221. Bibliothèque Nationale, Paris, Cabinet des Médailles, Collection Bestegui no. 51. Diameter 1⅛ in. (2.7 cm.). (Arts of Mankind Photo.)

375. Greek art from Asia. **ROME. BOETHUS OF CHALCEDON.** *Child with goose* (ancient replica). Date of original second half of 2nd century. Museo Capitolino, Rome. Marble. Height 2 ft 9½ in. (85 cm.). (Photo Alinari, Florence.)

376. Rhodian art. **ROME. PHILISCUS OF RHODES.** *Polyhymnia* (ancient replica). Date of original, second half of 2nd century. Museo Capitolino, Rome. Marble. Height without plinth 4 ft 11 in. (1.50 m.). (Photo E. Richter, Rome.)

Philiscus created for a Sanctuary of the Muses a group of Muses, in which Polyhymnia was beyond any doubt the most original figure.

377. *Rhodian silver tetradrachm (obverse): head of Helios.* 300-250. Bibliothèque Nationale, Paris, Cabinet des Médailles, Luynes no. 2721. Diameter 1⅛ in. (2.9 cm.). (Arts of Mankind Photo.)

378. *Macedonian silver tetradrachm (obverse): portrait of Perseus.* 179-168.

Bibliothèque Nationale, Paris, Cabinet des Médailles, Fonds général, no. 1713. Diameter 1¼ in. (3.3 cm.). (Arts of Mankind Photo.)

379. *Silver tetradrachm of the kingdom of Pontus (obverse): profiles of Mithridates IV and Laodice.* 170-150. Bibliothèque Nationale, Paris, Cabinet des Médailles, Fonds général, no. 11. Diameter 1⅜ in. (3.5 cm.). (Arts of Mankind Photo.)

380. Attic art. **ROME.** *A Muse* (ancient replica). Date of original, early 3rd century. Vatican Museums. Marble. Height without plinth 5 ft 5 in. (1.65 cm.). (Photo Alinari, Florence.)

The original formed one of a group of nine Muses. The best copies are in the Vatican Museums.

381. **ROME.** *Niobe and her daughter* (ancient replica). Date of original 300. Uffizi, Florence. Marble. Height 7 ft 5 in. (2.28 m.). (Arts of Mankind Photo.)

None of the reconstructions proposed for the group of Niobe and her children is really convincing. However it seems reasonable to assume that Niobe, in the act of protecting her youngest daughter, dominated the centre of the composition, which otherwise fell into two groups on either side consisting of her sons and daughters, either wounded or in flight.

382. *Silver tetradrachm from Pergamum (reverse): Athena seated.* Struck during the reign of Eumenes II (197-159). Bibliothèque Nationale, Paris, Cabinet des Médailles, Fonds général no. 1466. Diameter 1⅜ in. (3.4 cm.). (Arts of Mankind Photo).

383. *Silver tetradrachm from the kingdom of Bactria (obverse): portrait of Eucratides.* About 150. Bibliothèque Nationale, Paris, Cabinet des Médailles, Fonds général no. 95. Diameter 1⅜ in. (3.4 cm.). (Arts of Mankind Photo.)

384. *Silver tetradrachm from the kingdom of Pontus (obverse): portrait of Mithridates VI Eupator.* 91-90. Bibliotheque Nationale, Paris, Cabinet des Médailles, Luynes no. 2394. Diameter 1¼ in. (3.2 cm.) (Arts of Mankind Photo.)

385. ANTIGONUS OF CARYSTOS(?). *Group of Menelaus supporting the body of Patroclus* (replica). Date of original, second half of 3rd century. Loggia dei Lanzi, Florence. Marble. (Arts of Mankind Photo.)

386. Pergamene art. *Reconstruction of the great ex-voto of Attalus I at Pergamum.* 220-210. (After Arnold Schober,

Die Kunst von Pergamon, Vienna, M. F. Rohrer Verlag, 1951, fig. 21.)

387. **EPIDAURUS.** *Temple L, axonometric perspective.* 3rd century. Limestone. Foundations 44 ft 6 in. × 26 ft 2 in. (13.53 × 7.96 m.). (After G. Roux, *L'Architecture de l'Argolide aux IVe et IIIe siècles avant J.-C.*, BEFAR 199, Paris, E. de Boccard, 1961, pl. 66.)

Prostyle ground-plan. The walls of the cells are supported by engaged columns, the interior order being Corinthian, the exterior Ionic.

388- **SARDIS, Temple of Artemis.** *The*
390. *three phases of the construction.* 3rd century B.C.-2nd century A.D. Dimensions (on the axes of the angle-columns): 135 × 311 ft (41.87 × 94.92 m.). (After G. Gruben, 'Beobachtungen zum Artemis-Tempel von Sardis', in *AM*, LXXVI, 1961, pl. V.)

Pseudo-dipteral ground-plan, with 8 columns on the façade and 20 on the sides, carried out in three stages (cf. 1-4):

(1) Early 3rd century: naos with deep pronaos to the west, cella with three aisles and opisthodomus.
(2) First half of 2nd century: peristyle ground-plan, of which only the prostyle at the east end was constructed. Cella unchanged. Alterations made to the old pronaos on the esplanade of the altar.
(3) Second century A.D. Both long sides of the peristyle completed; cella now divided into two.

391. **DIDYMA, Temple of Apollo.** *Ground-plan.* 3rd century. Marble 168 × 359 ft (51.13 × 109.34 m.) on the stylobate. (After H. Berve and G. Gruben, *Greek Temples, Theatres and Shrines*, London, Thames and Hudson, 1963, and New York, Abrams, 1968, p. 463, fig. 129.)

Dipteral ground-plan with 10 columns on the façade and 21 down the sides. Deep pronaos with 12 columns. (Cf. 8-10, 393-394.)

392. **DIDYMA, Temple of Apollo.** Detail of frieze, entablature and pilaster capitals of the internal order (cf. 393). 3rd-2nd century. Marble. Height of frieze (83 cm.). (After H. Berve and G. Gruben, *Greek Temples, Theatres and Shrines*, London, Thames and Hudson, 1963, and New York, Abrams, 1968, p. 466, fig. 133.)

393. **DIDYMA, Temple of Apollo.** *Transverse section* (cf. 8-10, 391-392). 3rd-2nd century. (After H. Berve and G. Gruben, *Greek Temples, Theatres and Shrines*, London, Thames and Hudson, 1963, and New York, Abrams, 1968, p. 466, fig. 133.)

394- **DELOS, Hypostyle Hall.** *Cross-*
395. *section and ground-plan.* 3rd century. 185 ft × 118 ft 6 in. (56.45 × 34.30 m.). (After A. W. Lawrence, *Greek Architecture*, The Pelican History of Art, London, Penguin Books, 1962, p. 273, p. 273, fig. 159, and p. 272, fig. 158.)

Ground-plan designed with concentric lines of support and a square-based central lantern.

396- **LEVKADHIA, Vaulted tomb.** *Cross-*
397. *section and ground-plan* (cf. 53). First half of 3rd century. Limestone and stucco. (After M. Petsas, *The Levkadhia Tomb*, Bibliothèque de la Société archéologique d'Athènes, no. 57, Athens, 1966, p. 26, fig. 3, and p. 24, fig. 1.)

Consists of a vaulted chamber 15 ft 9 in. (4.80 m.) square, and a somewhat broader vestibule measuring 21 ft 9 in. × 7 ft (6.50 × 2.12 m.) covered over with high-pitched vaulting, height 25 ft (7.70 m.).

398. **VERGINA, Hellenistic palace.** *Ground-plan.* 3rd century. 343 × 300 ft (104.50 × 88.50 m.). (After M. Andronikou and X. Makarona, *The Palace of Vergina*, Athens, 1961. pl. I.)

399. **MAGNESIA-AD-MAEANDRUM, Temple of Artemis Leucophryene.** *Ground-plan* (cf. 33). First half of 2nd century. Marble. 94 × 181 ft (28.89 × 55.16 m.) on the stylobate. (After G. Gruben, *Die Tempel der Griechen*, Munich, Hirmer Verlag, 1961 [2nd ed. 1966], p. 369, fig. 295.)

Ground-plan inspired by the dipteral scheme (double pteron), but without the inner column-row this creates a very broad gallery under the peristyle. 8 × 15 columns; enlarged central intercolumniation 17 ft 3 in. (5.25 m.) at either end.

400. **PERGAMUM, Great Altar.** *Ground-plan.* About 160. Dimensions of platform 119 ft 6 in. × 112 ft (36.44 × 34.20 m.). (After A. W. Lawrence, *Greek Architecture*, The Pelican History of Art, London, Penguin Books, 1962, p. 214, fig. 117.)

401. **MAGNESIA-AD-MAEANDRUM, Altar of Artemis.** *Cross-section of the façade* (cf. 402-403). 2nd century. 70 ft 6 in. × 46 ft (21.50 × 14.10 m.). (After A. von Gerkan, *Der Altar des Artemis-Tempels in Magnesia am Mäander*, Studien zur Bauforschung, I, Berlin, H. Schoetz, 1929, pl. IX, 2.)

402. **MAGNESIA-AD-MAEANDRUM, Altar of Artemis.** *Elevation of the façade* (cf. 401, 403). 2nd century. (After A. von Gerkan, *Der Altar des*

Glossary-Index

ACHAEMENIDS. Dynasty of Persian kings (*c.* 550-330) descended from Achaemenes, or Hakamanish, *p.* 3.

ACHILLES. Son of the sea-goddess Thetis by a mortal, Peleus. His parents, knowing he must perish before Troy, hid him among the daughters of King Lycomedes on Scyros (one of these, Deidamia, subsequently bore him Neoptolemus) and it was here that he was discovered by Odysseus and Diomedes. He thus came to take part in the Trojan War, which enabled him to put his legendary courage to good use. When Agamemnon demanded that he give back his captive, the maiden Briseis, Achilles retired to his tent, but the death of Patroclus drove him back into battle to avenge his friend. Thetis brought him magnificent new arms and armour, specially forged by Hephaestus, and with these he killed Hector, *pp.* 123-126; *fig.* 123-125.

ACROPOLIS. Upper area of an ancient Greek town, serving as a fortified stronghold, *pp.* 18, 21-22, 44, 46, 71, 75-76, 80, 83, 265-266; *fig.* 44, 66.

ADRANO GROUP. A group of late fourth-century Sicilian red-figure pottery with rich polychrome decoration. So named because some of the pieces were found at Adrano, south-west of Etna, *p.* 100; *fig.* 91.

ADYTON. Sacred precinct which is out of bounds except to initiates. Refers in particular to the seat of oracular utterance, or incubation portico, in temples where oracles are delivered and in the sanctuaries of deities effecting miraculous cures, *pp.* 11, 28, 43, 79; *fig.* 5, 41, 42.

AEGAE. Ancient town of Asia Minor, near Myrina, *pp.* 74, 76.

AEGEIRA. Ancient town of Achaea, near the south shore of the Corinthian Gulf, *p.* 333; *fig.* 359.

AESCHINES. Athenian orator, born in 390. A political adversary of Demosthenes, he advocated a policy of peace and alliance with Macedonia. In 330, as the result of losing a law-suit (the Ctesiphon case) involving his rival, he had to go into exile, and practise his trade as a rhetorician in Asia, *p.* 221.

AETHER. Son of Erebus and Nyx, *fig.* 289.

AÉTION. Greek painter of the second half of the fourth century. His most famous work, the celebrated 'Wedding of Alexander and Roxane', is described at length by Lucian (*De Merced. Cond.* 42, *Herod*, or *Aëtion* 4 ff., *Imag.* 7.), *p.* 122.

AGAMEMNON. Homeric hero, king of Mycenae and leader of the expedition against Troy. His quarrel with Achilles over the captive maiden Briseis nearly brought the expedition to disaster, *p.* 123.

AGIAS. Thessalian athlete of about the middle of the fifth century, several times victor of the pancratium contest (cf. PANCRATIAST) at the great Panhellenic festivals. A descendant, Daochus II, *hieromnemon* of the Thessalians during the years 336-332, consecrated at Delphi a 'family monument', including a marble statue of Agias copied directly from Lysippus' bronze original at Pharsalus, *pp.* 216, 220; *fig.* 229-230.

AGON. Personification of competition, or civilized contest, the principle underlying the major Greek Games, which were celebrated under the protection and in honour of the Gods, *p.* 256; *fig.* 275.

AÏ KHANUM. Town of the Hellenistic period at the confluence of the Oxus and the Kokcha, founded at the time of Alexander's expedition; now being excavated *p.* 69.

ALABANDA. A Carian town, developed during the fourth century by the satraps of Caria, *pp.* 24, 33, 38.

ALCMENA. See AMPHITRYON.

ALCYONEUS. The greatest and strongest of the giants, who was their leader in the Gigantomachy, *fig.* 288, 290.

ALEXANDER III OF MACEDON (THE GREAT). Born in 356, he succeeded his father Philip II as king of Macedon (336). In a little over ten years, between 334 and his death in 323, he enormously enlarged the Greek world, conquering the immense Persian Empire, with his defeat of Darius III Codomannus, and reaching the borders of India, *pp.* 3, 69, 70, 115-116, 122, 208, 210, 215, 220-221, 237, 248, 250, 299, 301, 308, 310; *fig.* 114-115, 117, 219, 232-233, 248-250, 318, 367.

ALEXANDER I BALAS. King of Syria (150-145). He was the first Seleucid to take the name of Alexander, thus declaring his claim to follow in Alexander's footsteps, *p.* 301; *fig.* 324.

ALEXANDRIA. City founded by Alexander the Great in 332 on the Mediterranean coast, west of the Nile Delta, on the borders of Egypt. This cosmopolitan city had a remarkable history; it formed the capital of the Lagid dynasty of the Ptolemies and was also a meeting-point and *entrepôt* for the Nile Valley and the rest of the Hellenistic world, *pp.* IX, 4, 54, 68-69, 92, 103, 105, 129, 158-160, 173, 194, 201, 243, 285, 308, 310; *fig.* 51, 96, 128, 157, 159, 162.

ALINDA. Town in Caria, south-west of the modern town of Aydin, personally developed by Ada, the sister of Mausolus, during the second half of the fourth century, *pp.* 21, 22, 40; *fig.* 16.

ARAEOSTYLE. Style of building mentioned by Vitruvius in which the peristyle colonnade has markedly elongated proportions, the intercolumniations being so wide that a stone entablature cannot be supported, p. 34.

ARAP ADASI, fig. 261.

ARCADIA. Central district of the Peloponnese, topographically suited to an agricultural economy and isolated by high rugged mountains. In this region (where cults long preserved certain highly archaic features) the main town was Tegea, where during the fourth century Scopas worked on the temple of Athena Alea, pp. 154, 266, 333.

ARCESIUS, p. 23.

ARCHELAUS OF PRIENE. The creator of a famous votive relief datable to the Hellenistic era found near Bovillae and now in the British Museum, London. The bottom 'strip' portrays a festival in honour of Homer at the Museum in Alexandria, whence its modern name, the 'Apotheosis of Homer'. On a higher level we see Zeus (at the top), Apollo as cithara-player (Citharoedus), and the choir of the Muses, p. 292; fig. 317.

ARCHIDICE, p. 129-130; fig. 129.

ARIADNE. Daughter of Minos and Pasiphaë. Abducted by Theseus, who abandoned her on Naxos, and rescued by Dionysus, who made her his bride, pp. 146, 148, 252, 292, 308, 315; fig. 147, 148, 345.

ARISTEIDES. Theban painter of the second half of the fourth century; renowned for the expressive quality of his art, and his ability to convey pathos, p. 125.

ARISTOLAUS OF SICYON. Peloponnesian painter of the second half of the fourth century. Ancient tradition seems to have attributed a *Medea* to him, p.118.

ARISTOTLE. Famous philosopher, founder of the Peripatetic School. Born in 384 at Stagira in Macedonia, died in 322 at Chalcis in Euboea. His father, Nicomachus,

was court physician to King Amyntas of Macedon; he himself was the tutor and friend of Alexander the Great, p. 259.

ARMANT, fig. 339.

ARSINOË II. Daughter of Ptolemy Soter, p. 17.

ARSINOË III. Queen of Egypt. Sister and wife of Ptolemy IV Philopator, who reigned from 221 to 203, p. 292.

ARTEMIS. Daughter of Zeus and Leto and twin sister of Apollo. Goddess of hunting and the Moon, she ranked as one of the great Olympian deities, pp. pp. 5, 6, 9, 11, 23, 28, 33, 34, 50, 333; fig. 361; Artemis Leucophryene, known from the cult of the goddess at Magnesia-ad-Maeandrum, where a famous temple was dedicated to her during the second century – one of Artemis' many incarnations in the East, pp. 36, 285; fig. 33, 306.

ARTEMISIA, p. 22.

ARTEMISION (Cape), fig. 342.

ARTEMON. Greek painter of the first half of the third century; it seems fairly certain that he came from Asia Minor, p. 148; fig. 149, 150.

ASCLEPIUS. Greek god of medicine, son of Apollo and Coronis. His principal sanctuaries were at Epidaurus and on Cos, pp. 17, 23, 77, 79, 254; fig. 211; the Blacas Asclepius, head of a colossal effigy of a bearded god (probably Asclepius) found on Melos in 1828, is named after the collector who purchased it, p. 200; fig. 209.

ASSOS, p. 74.

ASTRAGAL. Semi-rounded moulding (bead-and-reel), most often associated, in the Ionic order, with the upper part of the column-shaft, the abacus of the capital, and with other mouldings used for wall-decoration, pp. 25, 27, 36.

ATHANODORUS. Rhodian sculptor, p. 333.

ATHENA. Goddess of Wisdom, Intelligence, and War, but also patron

deity of the Arts and of Peace. She was born, fully armed, from Zeus' head, and acted as the protectress of heroes such as Heracles or Theseus. Patron goddess of Attica, her most famous temple was the Parthenon in Athens, pp. 7, 13, 23-24, 38, 40, 50, 61, 71, 75, 80, 262, 265, 268, 270; fig. 288, 382; Athena Lindia, p. 80; Athena Nikephoros ('Bringer of Victory'), title given to Athena, notably at Pergamum, pp. 71, 76, 265.

ATHENION OF MARONEA. Greek painter of the second half of the fourth century; little is known of his career, pp. 125-126; fig. 124-125.

ATHENS, pp. 3-5, 69, 94, 201, 243, 247, 265-266, 338; fig. 85-87, 210, 219, 243, 245. Acropolis, p. 5; Agora, American excavations in the Athenian Agora have brought to light a mass of evidence, from all periods, testifying to the multifarious activities centred on the main square of the city, its immediate environs, and the monuments (civil and religious) which surrounded it, pp. 92, 158, 172; fig. 87, 414, 415; Bouleuterion, p. 92; Demeter (temple of), p. 92; Kolonos Agoraios, a rock west of the Stoa of Zeus, by the Agora, p. 92; Metroön, p. 92; Olympieum, p. 25; fig. 19; Parthenon, temple on the acropolis, built between 447 and 432 by the architects Ictinus and Callicrates, and decorated under the direction of Pheidias, who himself executed the huge statue of Athena, plated with gold and ivory, that was designed to stand in the cella, pp. 266, 270; 'Tower of the Winds', monument presented to Athens by Andronicus and in fact a water-clock; well-known for its octagonal ground-plan, its decorative sculpture, and its stone roofing, p. 46; fig. 45.

ATTALIDS. Name given to the dynasty of kings of Pergamum, the successors of Attalus I, who first assumed the title of *basileus*. The last of the Attalids was Attalus III, who died in 133, bequeathing his kingdom to Rome, pp. 3, 4, 18, 44, 69, 76, 92, 194, 243.

ATTALUS I. The first sovereign officially to reign in Pergamum (241-197). His predecessors – Philetaerus,

the founder of the dynasty, and Eumenes I, the consolidator (d. 241) – had bequeathed him an already sizable domain, an army, and a full war-chest. With these he set about building up a solid and respected kingdom. A brilliant victory over the Galatians, at the headwaters of the Caïcus, and a successful defensive campaign against the kings of Syria, brought him glory and renown. As a Philhellene, he received a triumphal welcome at Athens in 201; he also implemented a policy of alliance with Rome, *pp.* 21, 44, 70, 72, 76, 259; *fig.* 386.

ATTALUS II. King of Pergamum (159-138), he succeeded Eumenes II, who, shortly before his death in 159, had fallen into disgrace with Rome. Attalus II did all he could to restore good relations but in the process he virtually surrendered his independence. His successor Attalus III (138-133) completed the process of liquidation by bequeathing his kingdom to Rome, *pp.* 92, 94, 262, 300; *fig.* 85, 86.

ATTICA. Peninsula of central Greece, bounded to the north by Boeotia and to the west by the Megarid; principal city, Athens, *pp.* 36, 237, 337.

AUGE. Daughter of Aleus, king of Tegea, and mother of Telephus by Heracles, *fig.* 237, 303.

AUGUSTUS. Religious title which the Roman Senate conferred on Julius Caesar's great-nephew and heir, Octavian, in 27, after he had finally defeated Antony and put an end to the Civil Wars. This point marked the inauguration of the Imperial regime. The so-called 'Augustan Age' (Augustus himself died in A.D. 14) marks an exceptionally brilliant era in **Roman** literature and art, *pp.* 167, 246.

AZARA HERM. Upper portion of a marble pillar topped by a portrait-head of Alexander the Great – as the Greek inscription on the pillar confirms. It was found near Tivoli and is now in the Louvre; its traditional title derives from the name of the donor. The piece shows us, in reproduction, the head of the 'Alexander with a spear', a famous

bronze by Lysippus, datable to the period 330-320, *pp.* 220-221; *fig.* 232.

BALUSTER. Term used to describe the cushion which, in a traditional Ionic capital, links the volutes of each of the capital's opposite faces in pairs, *pp.* 24-25.

BAVAI. Small town in northern France, near Avesnes-sur-Helpe, *fig.* 227.

BEGRAM. Town of Afghanistan (ancient Kapiçi) in the upper Kabul Valley; it acquired considerable importance during the third and second centuries, under the Greek kings of Bactria, *pp.* 160, 188; *fig.* 163, 164.

BELEVI. Site near Ephesus, notable for the presence of a fine, but anonymous, mausoleum from the early third century, *pp.* 30, 33, 52; *fig.* 25, 27-29, 48.

BENDIS, *fig.* 242.

BERENICE II. Queen of Cyrene from 258 to 247, Berenice became queen of Egypt in 247 by her marriage to Ptolemy III, and (after the latter's death in 222) continued to reign jointly with her son, Ptolemy IV, until in 221 he had her assassinated. It was for her that the poet Callimachus composed his poem *On the lock of Berenice*, which Catullus afterwards translated into Latin, *p.* 259; *fig.* 374.

BOEDAS OF BYZANTIUM, *fig.* 253.

BOETHUS. Several artists of this name are known, from literary and epigraphical sources, to have lived during the third and second centuries. The best-known, creator of that famous and much-copied group, the Child with a Goose, was not only a sculptor but also a toreutic artist; according to Pliny (*HN*. 34, 19. 84) his speciality was embossing silver. Boethus of Chalcedon, whose signature occurs on a bronze herm recovered off the Tunisian coast at Mahdia, could conceivably be his grandson; his name can also be read on bases from Lindos and Delos. Furthermore, according to the testimony of Pausanias (5,17.1) a certain Boethus of Carthage executed a gilded statue of a Sitting Child,

dedicated at Olympia, *pp.* 256, 257; *fig.* 274-275, 375.

BORGHESE. Distinguished Roman family, noted for its patronage of the arts; a number of well-known works of art from antiquity were at one time in the Borghese collection, *p.* 262; *fig.* 334.

BOSCOREALE. Place in Campania at the foot of Vesuvius, near Pompeii. A number of wealthy country residences there (e.g. the villa of Fannius Sinistor) were buried in A.D. 79 by the volcanic eruption, *pp.* 134-135, 167, 172, 187; *fig.* 132-134, 170.

BOSCOTRECASE. Place in Campania, near Boscoreale, *p.* 175; *fig.* 178.

BOVILLAE. Small town in Latium (Frosinone), 11 miles south of Rome, *fig.* 317.

BRANCHIDAE, *p.* 339.

BRAURON, *fig.* 239, 240.

BRISEIS. Achilles' captive and dearly loved by him. Agamemnon forced Achilles to surrender Briseis, but, when Achilles refused to fight the Trojans any longer, was compelled to let him have her back, *pp.* 123, 125; *fig.* 123.

BRYAXIS. Fourth century Athenian sculptor, perhaps of Carian origin. He was partly responsible for decorating the Mausoleum of Halicarnassus, and joint-author of a famous statue of Sarapis, *pp.* 50, 201; *fig.* 210.

CABEIRI. Divinities of a predominantly chthonian nature, whose cult was established in various parts of the Greek world, notably the Troad and the islands of the Thracian archipelago. Mysteries were celebrated in their honour on Samothrace, *p.* 287.

CALATHUS. Stylized basket, which could either form a kind of head-dress for certain deities, or else constituted the central portion of a Corinthian capital, *p.* 27.

CALLIMACHUS. Scholar and poet of the third century, originally from Cyrene. He settled in Alexandria

and was singled out for advancement by Ptolemy II Philadelphus. From that time on he worked in the Library, and composed a variety of such pieces in verse (elegies, hymns, iambics, epigrams) as the sovereign might require. These are typical of that refined and delicate Alexandrian taste, *p.* 285

CALYDON, *p.* 92; *fig.* 416-418.

CAMIRUS. One of the three most ancient cities on Rhodes, the other two being Lindos and Ialysos. During the fifth century these provided contingents of settlers, to create the city of Rhodes itself. Camirus continued to enjoy considerable prosperity during the fourth and third centuries, *p.* 83; *fig.* 77, 78.

CAPUA. Wealthy city of Campania, 25 miles north of Naples, *p.* 323.

CARYSTIUS, *fig.* 260.

CASSANDER. Son of Antipater, and ruler of Macedonia and Greece from 316 to 297; in 306 he assumed the title of King, *p.* 116.

CAVEA. Latin term which has passed into general use to denote the stepped semicircular auditorium of an ancient theatre, *p.* 18; *fig.* 13.

CAVETTO. Hollow moulding, the profile of which forms the arc of a circle, *pp.* 28, 39.

CELLA. In a Greek temple, denotes the main cult-area, where the deity's cult-statue stood, *pp.* 5-6, 8-11, 13, 33, 36-37, 333; *fig.* 3, 4.

CENTOCELLE, *fig.* 332.

CENTURIPE. Town in eastern Sicily (ancient *Centoripa*), situated about 64 miles from the coast, in the hinterland beyond Etna. Originally a native settlement, it enjoyed considerable prosperity during the Hellenistic and Roman periods, *pp.* 108, 132, 135, 187; *fig.* 130, 131, 193.

CEPHISODOTUS THE YOUNGER. Grandson of the Athenian sculptor Cephisodotus the Elder (Praxiteles' father), Cephisodotus the Younger mostly worked in collaboration with his brother Timarchus. The joint signatures of these two 'sons of Praxiteles' have been found at both Megara and Athens. One is on a portrait-statue of Menander attributable to the early third century, *p.* 244.

CHALON-SUR-SAÔNE, *fig.* 343.

CHANNEL. Term used to describe the smooth band linking the two volutes of an Ionic capital, *pp.* 25, 27.

CHARES OF LINDOS. Rhodian sculptor attached to the school of Lysippus. He won fame with his Colossus of Rhodes, a gigantic bronze effigy of Helios, which was paid for with the proceeds of the sale of equipment abandoned by Demetrius Poliorcetes, when he lifted the siege of Rhodes (304). The Colossus of Rhodes passed for one of the Wonders of the World, but before the close of the third century it was destroyed by an earthquake, *p.* 240.

CHLAMYS. Short, light cloak used by travellers or soldiers, a kind of cape that was pinned at the right shoulder, *pp.* 250, 301.

CHRONOS. Personification of Time; Archelaus of Priene represented Chronos crowning the poet in the relief known as the 'Apotheosis of Homer', giving him Ptolemy IV's features, *p.* 292.

CHRYSA, *p.* 38.

CHRYSIPPUS (281-205). Greek philosopher, disciple of Zeno, and the founder of Stoicism, the principles of which he defended against the New Academy, *pp.* 248, 297; *fig.* 371.

CIRCE. Enchantress and daughter of the Sun, who lived on Aeaea, an island off the coast of Italy. Odysseus took refuge there, and the goddess changed his companions into swine. Odysseus himself was able to resist her enchantments and became her lover, thus saving his companions, *pp.* 170-171; *fig.* 172.

CIVITALBA. Small Italian city near Sassoferrato (Ancona), *p.* 292.

CLAROS. Site of the oracular shrine of Apollo Clarios, located on the territory of the city of Colophon, a little over a mile north of its port, Notium, *pp.* 9-10, 12, 23, 43; *fig.* 5-7, 41, 42.

CLEOPATRA. Several princesses bore the name Cleopatra, the most famous being the last Queen of Egypt. But Cleopatra was also the name of a middle-class Athenian lady, whose statue, with that of her husband Dioscurides, adorned a house in the Theatre Quarter of Delos. Apart from lacking a head, the statue is well preserved; it can be accurately dated by means of an inscription (138/137), and offers a fine example of virtuosity in the treatment of clothing, *pp.* 66, 290; *fig.* 60, 312, 313.

CLEOPATRA I. (d. 173). Daughter of Antiochus III; became Queen of Egypt through her marriage in 194/193 to Ptolemy V Epiphanes. After her husband's premature death (182/181), she acted as Regent for her son Ptolemy VI Philometor (181-145), *p.* 308.

CLEOPATRA II. Daughter of Ptolemy V and Cleopatra I; married in turn to her brothers Ptolemy VI and VII (d. 115), *fig.* 338.

CLEOPATRA VII (69-30). Queen of Egypt (51-30). The most famous of all the princesses who bore the name Cleopatra. As Egypt's last queen she captivated first Caesar, then Antony, and by committing suicide escaped Octavian's final triumph, *p.* 3.

CLYTIUS. A Giant, killed by Hecate in the Gigantomachy, *fig.* 291, 298.

CNIDUS, *p.* 208; *fig.* 218.

COAE VESTES ('Coan robes'). The luxury fabrics woven on Cos were renowned for their fineness. During the second half of the second century, the Greek sculptors of Asia Minor devoted much ingenuity to reproducing the transparent texture of these great linen shawls, under which the folds of the dress were still visible. The Delos Cleopatra is a notable example, *p.* 290.

COS. Aegean island in the Dodecanese near the ancient peninsula of Halicarnassus. Birthplace of Hippo-

crates the physician (fifth-fourth century) and the painter Apelles (fourth century). Site of a famous sanctuary of Asclepius, *pp.* 77, 92, 254, 290; *fig.* 68-73, 81, 255.

COURRIÈRE (LA), *fig.* 269, 270.

CRATERUS. One of Alexander's most devoted companions, who accompanied him to the very heart of Asia, and saved his life during a lion-hunt (this episode was commemorated by a statue-group at Delphi on which Leochares and Lysippus collaborated). After the conqueror's death, he and Antipater became jointly responsible for the government of Macedonia and Greece. Craterus was killed in 321, *p.* 210.

CRYPTOPORTICO. Term meaning 'hidden portico' or covered gallery: a type of portico built below ground level and vaulted over. Found in Pompeian houses, and more frequently in association with public squares, both Hellenistic and Roman, *pp.* 74, 142; *fig.* 142.

CYBELE. The 'Great Goddess', of Phrygian origin: the primordial Earth Mother, *p.* 271.

CYRENE. Greek colony founded at the end of the seventh century, by emigrants from Thera, in accordance with a Delphic oracle. The site chosen was on the coastal plateau of Cyrenaica. Highly prosperous until the Roman period, *p.* 53; *fig.* 49, 52, 226, 246.

CYZICUS. Greek colony (founded seventh century) and city of Asia Minor, on the southern shore of the Sea of Marmara, *pp.* 72, 74, 316.

DAEDALUS OF SICYON. Bronzeworker of the late fifth and early fourth centuries; executed numerous statues of athletes, *p.* 218.

DAMOPHON OF MESSENE (second century). Greek sculptor, who executed statues for Messene, Megalopolis and Lycosura, *p.* 333; *fig.* 358, 360, 361.

DAPHNE. Religious suburb of Antioch in Syria. During the fourth century Bryaxis made a large cult-effigy for the sanctuary of Apollo Daphnaeus.

During the Hellenistic period Antioch was the residence of the Seleucid rulers, *p.* 204.

DAPHNIS. Milesian architect who collaborated with Paeonius on the construction of the temple of Apollo at Didyma, *pp.* 13, 33.

DARIUS. Darius III Codomannus, last King of Persia. He came to the throne in 336. Defeated by Alexander the Great at the battles of Issus and Gaugamela, he was forced to flee, and in 330 was assassinated by Bessus, the satrap of Bactria, *pp.* 116, 118, 122-123; *fig.* 116, 117.

DELOS. Small island in the central Cyclades, famous for its sanctuaries of Apollo and Artemis. During the Hellenistic era it became an important commercial staging-post, especially after 166, when the Romans made it a free port. But the depredations of Mithridates (88) and pirates (69) brought about its ruin, *pp.* 4, 27, 43, 64, 66, 69, 84, 92, 156, 159, 184, 187, 290, 316, 339; *fig.* 40, 60-63, 79, 83, 168, 191-192, 194, 260, 312, 313, 326, 353, 356, 394, 395.

DELPHI. Seat of an oracle and sanctuary of Apollo situated in Phocis, 4½ miles north of the Corinthian Gulf, on the slopes of Mt Parnassus. Its influence was widespread throughout antiquity, *pp.* 4, 17, 23, 27, 44, 69, 210, 221; *fig.* 20, 229, 230, 319.

DEMETER. Daughter of Cronos and Rhea; goddess of the cultivated earth, in particular of corn and fertility. She was particularly venerated (together with her daughter Kore, or Persephone) in the Eleusinian Mysteries, and in Sicily, *pp.* 72, 92, 333; *fig.* 261, 358.
Demeter of Cnidus. Marble statue of a seated, matronly goddess with a touching expression and with a veil covering her hair, found at Cnidus in the mid-nineteenth century and now in the British Museum, London. Thought, probably rightly, to portray Demeter in search of Kore. A most valuable original, attributed to Leochares, *pp.* x, 208; *fig.* 218.

DEMETRIAS. Town in southern Thessaly, near modern Volos. Founded by Demetrius Poliorcetes, king of

Macedonia, partly on the site of the ancient city of Pagasae, *pp.* 121, 129; *fig.* 126, 127, 129.

DEMETRIUS (son of Olympus), *p.* 129; *fig.* 126.

DEMETRIUS I. King of Syria (162-150). A large bronze statue probably preserves his (somewhat idealized) likeness, *p.* 299; *fig.* 323.

DEMETRIUS I POLIORCETES (336-282). Son and successor of Antigonus the One-eyed. Driven from Asia Minor by the Diadochi, he took refuge in Macedonia, and proclaimed himself king there in 294. An expert at siege-warfare (hence his title, 'besieger'), he scored a number of military successes and for some years was an important figure. He was defeated by a coalition (in which his immediate adversary was Pyrrhus) and died in captivity (283/282), *pp.* 237, 240, 248; *fig.* 248, 268.

DEMETRIUS OF PHALERON (*c.* 350-*c.* 283). In the troubled period which followed Alexander's death, he was made chief administrator of Athens by Cassander, and ruled the city in an oligarchic manner from 317 to 307. His law against over-luxurious tombs put an end to the manufacture of large sculptured funeral stelae in Attica, *p.* 237.

DEMOSTHENES. The most illustrious of the Athenian orators (384-322). An impassioned patriot, he lost no time in denouncing Philip of Macedon's ambitions to achieve supremacy over all Greece. After the defeat at Chaeronea (338), however, he found himself up against some determined political adversaries, even in Athens itself. On Alexander's death, he put his eloquence at the service of those Greeks who rebelled against Macedonian overlordship; but when the city-states were defeated he took poison to escape capture by Antipater, *pp.* 247-248; *fig.* 370.

DERVENI, *fig.* 236.

DESPOENA, *p.* 333.

DIASTYLE. Arrangement of columns in a portico in which, according to

Vitruvius (3.3.4.), the intercolumniation was equal to three times the diameter of the foot of the column, *p.* 34.

DIDYMA. Town 12 miles south of Miletus; today its site is occupied by the village of Yenihisar. Famous for its temple of Apollo, known as the Didymeum, *pp.* 5, 8-9, 13, 24-25, 27, 30, 33, 38; *fig.* 8-10, 21-24, 26, 391-393.

DIOMEDES. Aetolian hero, who took part in the Trojan War. He accompanied Odysseus in most of the latter's enterprises, notably the search for Achilles, then hidden at the court of King Lycomedes on Scyros, *p.* 125.

DIONE. One of Zeus' consorts, and mother of Aphrodite; her worship was primarily centred on Dodona, *fig.* 372.

DIONYSUS. Son of Zeus and Semele; god of the vine, wine and mystical ecstasy. Generally accompanied by his rout (*thiasos*), Adriadne, his wife, and the Maenads and Satyrs, *pp.* 23, 38, 103, 105, 146, 148, 185, 243, 270, 292, 315; *fig.* 97, 146-148, 192, 260, 262, 333, 345.

DIOSCURIDES. See CLEOPATRA.

DIOSCURIDES OF SAMOS. Greek mosaic artist who flourished during the second half of the second century; he executed small mosaic pictures which drew their inspiration from the earliest Hellenistic paintings, *pp.* 140, 142; *fig.* 139, 140.

DIPTERON (DOUBLE PTERON). Ground-plan of an Ionic temple in which the peristyle incorporates a double row of columns enclosing all four sides of the cella, *pp.* 8, 13, 33.

DODECASTYLE. Name given (as we know from inscriptions at Didyma) to the monumental pronaos of the temple of Apollo, its roof being supported by three rows of four columns, *pp.* 13, 28.

DODONA. Famous oracular sanctuary of Zeus in Epirus, south-west of the modern town of Ioannina, *pp.* 18, 69; *fig.* 12, 13.

DOEDALSES OF BITHYNIA. Executed the cult-statue of Zeus Stratios at Nicomedeia, shortly after 264. Also invented a new statue-type, the Crouching Aphrodite, made famous by a statue which was afterwards put on display at Rome, in the Portico of Octavia, *pp.* 256-257.

DORIS. Daughter of Oceanus, wife of Nereus, *fig.* 300.

ECHINUS. Part of the capital which forms a cushion between the column-shaft and the abacus carrying the architrave, *pp.* 25, 40, 53.

ELEUSIS. Town of Attica, 14 miles north-west of Athens. The sanctuary of the 'two Goddesses' (Demeter and Kore) and the Mysteries which took place there gave it considerable religious importance, *p.* 201; *fig.* 212.

EOS. The Dawn. Sister of Helios (the Sun) and Selene (the Moon). As we know from the *Theogony*, she is one of the earliest deities – the Titans. Mythology represents her as eternally in love, *p.* 271.

EPHEBEUM. Gymnasium reserved for ephebes during training, *p.* 72.

EPHESUS. City of Ionia, at the mouth of the Cayster, *pp.* 5-6, 8, 13, 24, 27, 33, 38, 92.

EPHIALTES. Brother of Otus; rebelled with him against the gods, and was killed by Apollo and Heracles, *fig.* 292.

EPHYRA. Site in Acarnania of a famous third-century oracle which operated by consultation of the dead, *p.* 40; *fig.* 36-38.

EPICURUS. Greek philosopher (341-270), who rejected both Pyrrho's scepticism and the philosophy of Plato. His doctrine was that of Democritus, modified by what were primarily moral considerations. From 306 on he settled at Athens; where he taught in the famous 'Garden', *pp.* 244, 246; *fig.* 264.

EPIDAURUS. City of the Argolid on the Saronic Gulf. Famous for a great sanctuary of Asclepius which reached its apogee during the fourth century. Its numerous monuments include the Doric temple of Asclepius by Theodorus and Timotheus, and Polycleitus the Younger's *thymele* and theatre, and numerous votive reliefs dedicated to the god have been found, *pp.* 17-18, 21, 23, 27, 33, 61, 79, 201; *fig.* 211, 387.

EPIGONUS OF PERGAMUM. The greatest Pergamene sculptor of the third century. He collaborated on the great ex-voto of Attalus I, as well as on the dedicatory offering made by his general, Epigenes. Pliny (*HN* 34. 19. 88) credits him with a 'Trumpeter' (copy: the 'Dying Gaul' from the Capitol?) and the moving group of a 'Weeping infant pitifully caressing its murdered Mother' (adaptation: the 'Dead Amazon' in Naples?). These statues probably belonged to a series of 'Galatomachic' subjects assembled for Attalus I's triumphal monument, *pp.* 136, 259, 262, 267.

ERASISTRATUS. Third-century Greek doctor, one of the first to practise dissection on human cadavers, *p.* 271.

EROS. God of Love. Our most ancient theological sources place him among the primordial divinities; he was later described as the son of Aphrodite. Most often represented as an adolescent, or a winged child with a bow, *pp.* 253, 256, 315-316; *fig.* 168, 272, 273, 332, 347, 353.

ETESIAN WINDS. Seasonal northerly winds, which blow in the Eastern Mediterranean, *pp.* 308, 310.

EUBULEUS. Hero connected with the legends and Mysteries of Eleusis. According to the most popular tradition, he witnessed the abduction of Kore by Hades, and a part of his herd was engulfed with the god's chariot as it plunged down to the underworld, *p.* 201; *fig.* 212.

EUBULIDES THE ELDER. Late third-century Athenian sculptor who produced a portrait-statue of Chrysippus, *pp.* 248, 297; *fig.* 371.

EUCLEIDES OF ATHENS, *fig.* 359.

EUCOLINE, *fig.* 245.

EUCRATIDES. King of Bactria (second century), *fig*. 383.

EUMENES. Eumenes I (263-241) and Eumenes II (197-159) were princes of Pergamum who beat off the Galatians and enhanced their dynasty's renown by the architectural development of their capital. During the reign of Eumenes II (who succeeded Attalus I) the kingdom of Pergamum was at the height of its power. It was he who carried out a building programme in the capital, especially on the acropolis, which completely remodelled the city. The Library and the Great Altar of Zeus and Athena Nikephoros both date from this period, *pp*. 18, 21, 50, 61, 70-72, 75-77, 80, 259, 265-266, 287; *fig*. 15.

EUROPA. Daughter of the Phoenician King Agenor. Zeus, in the form of a bull, abducted her while she was playing on a beach with her companions, and took her to Crete, *pp*. 160, 176; *fig*. 164, 179.

EUSTYLE. Arrangement of columns in a portico in which the intercolumniation was equal to $2\frac{1}{4}$ times the diameter of the foot of the column; an arrangement favoured by Hermogenes, *pp*. 34, 36.

EUTYCHIDES OF SICYON. Disciple of Lysippus; worker in bronze and marble as well as a painter. His masterpiece was a Tyche in gilded bronze (*c*. 300), personifying the fortune of Antioch-on-the-Orontes, capital of the new kingdom of Syria, *pp*. 237-238; *fig*. 251.

'FANCIULLA D'ANZIO'. Statue discovered at Antium (Anzio). It portrays a young girl carrying a tray with what are doubtless cult-objects on it, *pp*. 257, 259; *fig*. 278-280.

FARNESE. Illustrious Italian family, originally from the Orvieto region, which boasted men of taste as well as warriors. A number of famous ancient works of art passed through the Farnese Collection, *pp*. 221, 308; *fig*. 234, 336.

'FARNESE CUP'. Large cameo in the form of a hollow plate, now in the Museo Nazionale, Naples. On the outside is a Gorgon's head; on the inside, eight figures in relief, *pp*. 308, 310; *fig*. 336.

FAUSTINA THE ELDER (Anna Galeria Faustina Maior; 105-141). Wife of Antoninus Pius, *pp*. 5, 9.

FLAMININUS (Titus Quinctius; 229-174). Consul in 198, proconsul in 197; defeated Philip at Cynoscephalae and proclaimed freedom for the Greeks at Corinth in 196, *fig*. 319.

FOLIATE SCROLLWORK; FOLIAGE (ORNAMENTAL). Sculptured or painted ornamentation composed of vegetal motifs, found in association with pillars, friezes, or channels, *pp*. 27-28, 30, 33, 39-40.

FORTUNA. Ancient Italian divinity of Chance and Luck worshipped in particular at Praeneste (Palestrina), where a large sanctuary was built in her honour during Sulla's dictatorship, about 80, *pp*. 177, 238.

GALATEA. Daughter of Nereus; Polyphemus, the monstrous Sicilian Cyclops, fell in love with her, but was rejected in favour of a handsome youth named Acis, son of the god Pan and a nymph, *p*. 262.

GALATIANS (or GAULS). Tribes of Celtic origin which formed themselves into an empire after the migrations of the fourth century, *pp*. 70, 259-260, 262, 266, 310; *fig*. 281, 282, 285.

GANYMEDE. Son of Tros and Callirrhoë; a beautiful Trojan youth who was abducted by Zeus and became the gods' cup-bearer on Olympus, *p*. 160; *fig*. 163.

GAULS. See GALATIANS.

GE. Goddess of the Earth, who created the universe and the Titans, *fig*. 288.

GIGANTOMACHY ('Battle of Gods and Giants'). Legendary war between the Olympian gods and the Giants, who were children of Earth (Ge). One of the favourite subjects in Greek art, *pp*. 50, 264, 265-272, 285; *fig*. 286-302.

GNATHIA. Town in Apulia (ancient Egnathia) on the Adriatic coast of Italy between Bari and Brindisi. It has yielded a considerable amount of pottery decorated with white, red and yellow painting on a black varnished ground; hence the name 'Gnathia style', conventionally given to this particular technique of Graeco-Italian ceramic art dating from the second half of the fourth and throughout the third century, *pp*. 98, 158; *fig*. 88.

GNOSIS. Greek mosaic artist who worked at Pella, in Macedonia, towards the end of the fourth century, *pp*. 110, 112; *fig*. 107-108.

GOLINI. Two Etruscan tombs of the second half of the fourth century, discovered at Porano, near Orvieto; the paintings from them are preserved in the Museo Archeologico, Florence, *p*. 106; *fig*. 101.

GORGON. Of the three sisters, Stheno, Euryale and Medusa, only the last was mortal, and it is she who is normally referred to by the description 'Gorgon'. She was decapitated by Perseus with Athena's assistance. The head of Medusa (or Gorgoneion) possessed various magical properties, *p*. 158; *fig*. 159.

GRACES. In Greek, *Charites*. Most often represented as three sisters, Euphrosyne, Thalia and Aglaë. Originally, it seems clear, they were vegetation-spirits, but later they became patron deities of Beauty, and were endowed with every kind of influence over intellectual activities and works of art, *pp*. 153, 308; *fig*. 154.

GRANICUS. Small river in Asia Minor, on the banks of which Alexander the Great, at the outset of his Persian campaign (334), won the victory which left him master of Lesser (Maritime) Phrygia, *p*. 221.

HADRA. South-eastern suburb of Alexandria and site (during the third century) of one of its main necropolises. A special category of painted funerary hydrias is named after this locality, *p*. 158.

HADRIAN (Publius Aelius Hadrianus; A.D. 76-138). Roman Emperor 117-138, *pp*. 12, 25, 333.
Hadrian's Villa. Magnificent country residence of the Emperor

Hadrian at Tibur (Tivoli) not far from Rome. It contained reproductions of some of the places of monuments he had particularly admired during his travels, *p.* 259.

HAGESANDER. Rhodian sculptor (second or first century?), *p.* 333.

HALICARNASSUS. Coastal city of Asia Minor which became the capital of Caria. In the middle of the fourth century it was ruled by Mausolus, for whom was built and decorated the temple-tomb known as the Mausoleum, reckoned in antiquity among the Seven Wonders of the World, *pp.* 52, 84, 201, 208, 339; *fig.* 214, 216, 220.

HAWKSBEAK. Concave moulding in the Doric style; its exterior profile resembles the beak of a bird of prey, *p.* 40.

HECATAEUM. Sanctuary or monument dedicated to Hecate, *p.* 38; *fig.* 307.

HECATE. Ancient goddess said by Hesiod to be a direct descendant of the Titans. A benevolent yet disquieting figure, she was in touch with the world of the dead and took a guiding interest in magic. She is most often shown as triple-bodied, bearing a torch and accompanied by a dog, *p.* 285; *fig.* 291.

HEDISTE, *p.* 130; *fig.* 127.

HELEN. Daughter of Zeus and Leda. While still a young girl she was abducted by Theseus, but was rescued by her brothers, the Dioscuri. Though married to Menelaus, she could not resist the advances of Paris, who ran off with her, thus provoking the Trojan War, *pp.* 103, 150, 152; *fig.* 95, 151, 153, 241.

HELICON. Mountainous massif in Boeotia regarded as the residence of the Muses, *p.* 243.

HELIOS. Greek god of the Sun, offspring of the Titan Hyperion and Theia, brother of Selene and Eos (the Dawn). Every day he traversed the firmament in a fiery chariot drawn by four horses. He saw and knew everything, *pp.* 240, 271; *fig.* 286, 322, 377.

'HELLENIC MASTER'. Campanian painter who worked in Herculaneum and Pompeii about the beginning of the first century A.D. and whose work reveals typically Greek inspiration, *pp.* 121, 136.

HERA. Sister and wife of Zeus; the matronal goddess *par excellence*; protectress of hearth and home, *pp.* 33, 254, 270.

HERACLES. This prodigiously strong hero was the son of Zeus and Alcmena. As a punishment for murder, committed in a fit of madness – he killed the children he had sired on Megara – Heracles was obliged to carry out twelve Labours, imposed on him by Eurystheus. He also fought the Amazons and killed Nessus the Centaur, who had attempted to ravish his wife Dejanira; this led directly to his own death. However, he was admitted to the ranks of the gods, *pp.* 99-100, 148, 152, 154, 216, 221, 254, 266-267, 301; *fig.* 90, 149-150, 152, 155, 227-228, 234, 237.
Heracles Epitrapezios. A bronze statuette by Lysippus. According to one literary source Alexander always kept it by him, and would never let it out of his sight. Later it passed into the possession of Nonius Vindex. The sculptural type, often reproduced, showed Heracles sitting on a rock, a cup in his right hand, while his left grasped his club, *p.* 221.

HERCULANEUM. Ancient town of Campania, on the Gulf of Naples. In A.D. 79 it was buried by the eruption of Vesuvius, *pp.* 120, 130, 136, 145, 154, 172, 198; *fig.* 119-120, 122, 143, 155, 175, 207, 213, 225, 235, 268.

HERMAPHRODITE. Fabulous person possessing the physical characteristics of both sexes, *pp.* 308, 316; *fig.* 348, 350.

HERMARCHUS. Greek rhetorician who, in 311, having heard Epicurus teach on Mytilene, attached himself to him and became his successor, *pp.* 244, 246; *fig.* 265.

HERMES. Son of Zeus and Maia. Zeus' messenger, and the god of shepherds, flocks, and trade, he also

guided the souls of the dead to the Underworld, *pp.* 221, 301; *fig.* 235.

HERMOGENES. Famous second-century architect from Alabanda, best-known for his creations at Magnesia-ad-Maeandrum, and the theory of eustyle. His works form one of Vitruvius' more important sources (see, e.g., *De Arch.* 3.2.6; 2.2.8; 4.3.1), *pp.* 7, 8, 23-24, 27, 33-34, 36-39, 46, 50, 77.

HERODAS (Mimes of). As a literary genre the mime (a brief, realistic little playlet for two or three characters) was made famous during the Hellenistic period by Herodas, a dozen of whose pieces turned up on a papyrus-roll in 1889, *p.* 254.

HEROÖN. Monument consecrated to the cult of some hero. During the Hellenistic period the type took on a monumental character, certain elements of which may lurk behind the earliest Christian edifices, *pp.* 69, 76; *fig.* 25, 27-29, 48.

HEROPHILUS. Greek doctor from Chalcedon in Bithynia, whose work in dissection advanced the knowledge of anatomy. He lived at the beginning of the Hellenistic period, *p.* 271.

HESIOD. Born at Ascra in Boeotia. Poet of the second half of the eight century, the oldest one known to us after Homer. In his *Theogony* he traces the origins of the world back to the primordial deities and hymns the successive generations of Immortals. In the *Works and Days* he blends myth and allegory with an evocation of rural life, *p.* 268.

HIPPOCAMPUS (SEA-HORSE). Fabulous animal, half horse, half fish, *p.* 268.

HIPPODAMUS. Fifth-century political philosopher from Miletus who evolved the first clear idea of city-planning geared to the political framework of the Greek *polis*, *p.* 86.

HOMER. The epic poet *par excellence*; today it is generally agreed that he was a native of one of the Ionian cities, that he lived in the ninth century and organized, in their final and definitive form, those epic

poems traditionally attributed to him. Various imaginary portraits of Homer survive, *pp.* 268, 292, 294, 296-297, 335; *fig.* 317, 320.

HORBEIT, *fig.* 330.

HORUS. Ancient dynastic god of Pharaonic Egypt who in the theological system of Hieropolis became the son of Isis and Osiris, *pp.* 308, 310.

HOUSE OF THE CITHARA-PLAYER. Otherwise known as the house of L. Popidus Secundus Augustianus, in the southern sector of Pompeii (*Reg.* I, *ins.* 4, 5). Its rich collection of paintings, and the bronze 'Apollo Citharoedus' which gave the house its name, are now in the Naples Museum, *p.* 146.

HOUSE OF CLEOPATRA, *p.* 66; *fig.* 60.

HOUSE OF THE DIOSCURI: Situated in the western sector of Pompeii (*Reg.* VI, *ins.* 9, 6-7), it was decorated with paintings in the Pompeian 'Fourth Style' (between A.D. 60 and 79), *pp.* 126, 197.

HOUSE OF THE DOLPHINS. One of the most sumptuous houses on Delos, in the Theatre Quarter. It is decorated with mosaics, one of them signed by Asclepiades of Arados, *p.* 159; *fig.* 168.

HOUSE OF THE EPIGRAM. Situated in the old north-west quarter of Pompeii (*Reg.* V, *ins.* 1, 18), *p.* 198; *fig.* 208.

HOUSE OF THE FAUN. One of the oldest, finest and most important houses in Pompeii, situated at the west end of the town (*Reg.* VI, *ins.* 12, 2-5). Its construction goes back as far as the second century, and its great mosaics also date from this period, *pp.* 116, 162, 181, 183, 187; *fig.* 115-117.

HOUSE OF HERMES, *p.* 66; *fig.* 61, 62.

HOUSE OF THE MASKS. House on Delos, in the Theatre Quarter, dating from the second half of the second century and decorated with a series of mosaics of the same period, *p.* 185; *fig.* 192.

HOUSE OF THE TRAGIC POET. Situated in the western sector of Pompeii (*Reg.* VI, *ins.* 8, 5). A smallish house, covered with frescoes and mosaics that were executed shortly before the catastrophe of A.D. 79, *pp.* 123, 139; *fig.* 123, 138.

HOUSE OF THE TRIDENT. House on Delos, in the Theatre Quarter, dating from the second half of the second century and decorated with mosaics, *p.* 184; *fig.* 191.

HOUSE OF THE VETTII. A house in the western sector of Pompeii (*Reg.* VI, *ins.* 15,1) containing some of the best-preserved painted decorations from the final period (A.D. 60-79). Certain compositions, however, appear to be inspired by originals of the Hellenistic period, *p.* 114; *fig.* 114.

HYDRIA. Three-handled pot, basically designed for carrying water but often used also as a cinerary urn, *pp.* 100, 158; *fig.* 94, 157, 159.

HYGIEIA. Goddess of Health, daughter of Asclepius, *p.* 201; *fig.* 238.

HYLAS. Young prince beloved of Heracles; when the Argonauts landed in Mysia he was carried off by the Nymphs, who were captivated by his beauty, *p.* 171; *fig.* 173.

HYPNOS. The personification of Sleep, son of Night and Erebus, twin brother of Thanatos (Death). He is represented in the form of a winged genie, *p.* 253; *fig.* 271.

ICTINUS. Athenian architect who drew up the plans for the Parthenon. He worked at Eleusis and perhaps also at Bassae, *p.* 339.

IDRIEUS. Carian prince, son of Hecatomnus, brother of Mausolus, Artemisia and Ada. He married his sister Ada and reigned in Caria from 351 to 344, *p.* 22.

ILIAD. Epic poem, traditionally attributed to Homer, which narrates the Wrath of Achilles during the Trojan War, and its consequences, *p.* 123.

ILISSUS. One of the two small rivers that run through Athens from north to south, the Ilissus in the east, the Cephisus in the west, *p.* 225; *fig.* 243.

INOPUS. A water-course on the island of Delos, Apollo's birthplace, periodically fed by streams from Mount Cynthus. A fragmentary statue (head and shoulders), found on Delos and presented to the Louvre by the painter Gibelin, was originally named 'Inopus', or 'Alexander as Inopus'; in fact it is rather a portrait of Mithridates Eupator (120-63), *pp.* 65, 84, 324; *fig.* 356.

INTERRUPTED PEDIMENT. Type of decorative pediment characterized by a gap in the lower moulding-course and the tympanum between the two supporting quoins. Characteristic of Hellenistic and Roman architecture, *p.* 61.

IPHIGENEIA. Daughter of Agamemnon and Clytemnestra. She was about to be sacrificed at Aulis, to facilitate the departure of the Greek fleet for Troy, when Artemis snatched her away and carried her off to Tauris. Here she became the goddess's priestess, and was given the task of sacrificing to her all strangers who came that way. One day two such persons were brought to her, whom she recognized as her brother Orestes and his friend Pylades. She rescued them, and they all escaped together, *p.* 197; *fig.* 204.

ISODOMUM. Type of wall-construction consisting of courses of rectangular blocks, all the same width and height, *pp.* 53, 67.

KAZANLAK. Locality in Bulgaria, 25 miles north-west of Stara Zagora. Here were found a number of cupola tómbs designed for the burial of Thracian princes in the late fourth and early third centuries. The most important of them is decorated with painted frescoes (discovered in 1944), *pp.* 112, 114; *fig.* 109-113.

KRATER. Large vessel in which were mixed the wine and water served at banquets, *p.* 133; *fig.* 131, 236.

KREPIS. Literally, the 'sole'; the stepped foundation-base on which a building stands, *pp.* 10, 36, 50, 53; *fig.* 6, 27, 28.

KYMATION. Greek term employed to describe a moulding, generally decorated with sculptured motifs, *p.* 7.

LABRANDA. Famous Carian sanctuary, excavated by Swedish archaeologists, which owed its lavish architectural adornment to the Hecatomnids. It stood in the territory of Mylasa, first capital of the Carian satraps, *pp.* 21-22.

LAESTRYGONIANS. A race of cannibal giants, who supposedly dwelt in Italy. Odysseus and his companions came to their harbour after leaving the island of Aeolus. Odysseus lost all his ships there except his own, in which he contrived to escape, *pp.* 170-171; *fig.* 171.

LAGIDS. See PTOLEMIES.

LAGINA. Sanctuary of Hecate in Caria, *pp.* 24, 38, 285; *fig.* 307.

LAMIA. The principal city of Malis, situated near the Malian Gulf, *p.* 304.

LANGAZA. Site in Macedonia, well-known for its vaulted tombs, *p.* 56.

LANTERN. Square or circular erection on top of a roof (whether gable, terrace, or cupola) provided with openings or windows to illuminate the interior, *pp.* 37, 112.

LAOCOÖN. Priest of Apollo in Troy. He advised the Trojans not to bring into the city the wooden horse which the Greeks had left on the shore outside. But as he was preparing to offer sacrifice to Poseidon, two monstrous serpents appeared and strangled Laocoön and his sons in their coils, *pp.* 296, 333, 335; *fig.* 362.

LAODICE, *fig.* 379.

LAPITHS. A Thessalian tribe famous for their victory over the Centaurs at the wedding-feast of Pirithous, *fig.* 98.

LEAF-AND-TONGUE. Decoration associated with Lesbian mouldings, *pp.* 30, 33; *fig.* 27-29.

LEKANIS. Vessel with lid, shaped like a fairly flat box, *fig.* 92.

LEKYTHOS, ARYBALLOID. Small, swag-bellied perfume-flask with a narrow neck and vertical handle, *p.* 98; *fig.* 88.

LEOCHARES. Fourth-century Athenian sculptor. A member of the team which decorated the Mausoleum of Halicarnassus, he also executed numerous statues, both of gods and of individuals. Scholars attribute to him originals of which the 'Versailles Diana' (Louvre) and the 'Belvedere Apollo' (Vatican Museums) are ancient reproductions, *pp.* 201, 206, 211, 225, 253; *fig.* 214, 216.

LERNA, *p.* 92.

LETO. Daughter of the Titans Coeus and Phoebe, and loved by Zeus, by whom she bore Apollo and Artemis on Delos. As a result Delos became a sacred island, *pp.* 11, 28.

LETOÖN. Sanctuary of Leto, 2½ miles south-west of Xanthos, the Lycians' federal capital, *p.* 40; *fig.* 39.

LEVKADHIA. Site in western Macedonia. A richly painted vaulted burial chamber was discovered here, one of the most ornate in all Macedonian tombs (early third century), *pp.* 56, 105; *fig.* 53, 98, 396, 397.

LINDOS. One of the three cities on the island of Rhodes, lying on the east coast 34 miles south of Rhodes itself. Contributed contingents for the foundation of Rhodes as a city in the fifth century. Famous for the sanctuary of Athena which crowned its acropolis, *pp.* 80-83; *fig.* 74-76, 419.

'LIPARI PAINTER'. A Sicilian painter, who decorated red-figure pottery (often in rich polychrome). Most of his work comes from Lipari, where his studio was possibly located (late fourth century), *p.* 100; *fig.* 92.

LOCRI, *p.* 92.

LUDOVISI. A noble family from Bologna, which boasted cardinals, princes and at least one Pope among its members and also owned a remarkable collection of antiquities, *pp.* 259, 262; *fig.* 282.

LUYNES. French family which produced warriors, prelates and politicians in considerable numbers.

Honoré de Luynes (1802-1867) was an archaeologist, scholar, and numismatist, *p.* 308.

LYCOMEDES. King of the Dolopians, in the island of Scyros. Thetis hid her son Achilles with him, *p.* 125.

LYCOSURA. Ancient town in Arcadia, south-east of Bassae, famous for its temple of Despoena, *p.* 333; *fig.* 360, 361.

LYSIMACHUS (*c.* 360-281). A general of Alexander the Great, later king of Macedonia and Asia Minor, *pp.* 17, 70.

LYSIPPUS. From Sicyon; born in all likelihood about 390. Famous sculptor, especially in bronze. A highly prolific artist, he continued to produce work throughout the greater part of the fourth century: portraits, allegories, statues of gods and athletes. He took a particular interest in the representation of movement, and was Alexander's official portraitist. His influence on Hellenistic art was considerable, *pp.* 110, 211, 216-221, 225, 237-238, 240, 250-251, 253, 259, 299, 301, 323; *fig.* 229-231.

MACEDONIA. Ancient kingdom to the north of Greece. Two kings of Macedonia, Philip II and his son and successor Alexander the Great, embarked on the conquest of Greece, followed by that of the Eastern world, *pp.* 3-5, 40, 54, 64, 92, 106, 167.

MAENADS. General title for the female followers of Dionysus; they underwent periods of orgiastic and ecstatic possession, *pp.* 100, 198; *fig.* 208, 260, 309, 334.

'MAESTRO CHIARO'. Pompeian painter of the first century A.D. who produced numerous Hellenistically-inspired compositions, *pp.* 176, 197; *fig.* 179-180.

MAGNESIA-AD-MAEANDRUM. Important town situated about half-way up the Maeander Valley in Asia Minor, 22 miles to the south of Ephesus. Famous for its sanctuary of Artemis Leucophryene, *pp.* 6, 8, 23-25, 33-34, 36, 38, 46, 50, 285, 339; *fig.* 30-33, 306, 399, 401-403.

MAGNESIA-AD-SIPYLUM (Manisa). Ancient town of Asia Minor, 27 miles north-east of Izmir, *p.* 287.

MAHDIA. Tunisian locality between Susa and Sfax. Some sponge-fishers found an ancient wreck in 1907 about 3 miles off-shore, at a depth of 128 ft. Between 1907 and 1913 this wreck yielded up an important collection of Hellenistic bronzes. It seems clear that the boat was transporting to Italy part of the loot acquired by Sulla after his capture of Athens (86 B.C.), *p.* 256; *fig.* 274-275.

MANTINEA. Ancient town of Arcadia in the Peloponnese, 9 miles from Tripolis, *p.* 262; *fig.* 258, 259.

MARSYAS. A Phrygian, proud of his skill at flute-playing. He challenged Apollo to a musical contest, was defeated and, as a punishment for his presumption, was flayed alive by order of the god, *pp.* 262, 264-265, 304; *fig.* 259, 284.

MAUSOLEUM. The monument of Mausolus, numbered among the Seven Wonders of the World. It was executed by the most famous Greek architects and sculptors of the second half of the fourth century (architects: Satyrus and Pytheus; sculptors: Timotheus, Scopas, Bryaxis and Leochares). The description mausoleum was later applied to any funerary monument with architectural pretensions, *pp.* x, 30, 52-53, 56, 201, 206, 260, 339; *fig.* 214, 216, 220.

MAUSOLUS. The best-known of the satraps of Caria (377-353), son of Hecatomnus, brother of Artemisia, Idrieus and Ada. He brought fame to his capital of Halicarnassus, in particular by his funerary monument, work on which started while he was still alive, to be continued by his wife and sister Artemisia – though perhaps it was left to Alexander to put the finishing touches on it, *pp.* 22, 50, 201.

MEDEA. An enchantress, daughter of the king of Colchis. She fell in love with Jason, helped him to win the Golden Fleece and returned to Greece with the Argonauts. However, the king of Corinth, Creon, persuaded Jason to marry his daughter, Creüsa. To avenge herself for this betrayal, Medea encompassed the death of Creon and his daughter, and killed the children she had had by Jason, *pp.* 118, 197-198; *fig.* 118, 206, 207.

MEGARA. Greek town halfway between Athens and Corinth, *p.* 201.

MELOS (Milo). Greek island in the south-west Cyclades, where in 1820 the famous Venus de Milo (now in the Louvre) was discovered, *pp.* 323, 333; *fig.* 209, 354, 357.

MENANDER. The greatest poet of the ' New Comedy' in Athens (342-292), *pp.* 244, 246, 294; *fig.* 263.

MENEDEMUS OF ERETRIA. Third-century Platonic philosopher; teacher and friend of Antigonus Gonatas, king of Macedonia, *p.* 135.

MENELAUS. Son of Atreus, brother of Agamemnon and husband of Helen. When Helen was abducted by Paris, he naturally joined the expedition against Troy. At the time of the city's capture his first instinct was to kill his faithless wife; but Helen's beauty (and the will of Aphrodite) prevented him from doing so, *pp.* 259, 262; *fig.* 385.

MESSENE, *p.* 94; *fig.* 84.

METOPE. Square or rectangular panel, alternating with triglyphs in the Doric frieze. Originally decorated with paintings and later with sculptured motifs in relief, *pp.* 23, 40, 61, 105, 225.

METRODORUS OF LAMPSACUS. Friend and cherished disciple of Epicurus. When he died, in 277, the Master cared for his children, *pp.* 244, 246.

MICON. An old man who was imprisoned at Rome together with his daughter Perona, who gave him suck to relieve his hunger. This incident, which stirred up much public feeling, led to the construction in 181 of a temple dedicated to Pietas. The anecdote may perhaps be Greek in origin, *p.* 122; *fig.* 121.

MILETUS. One of the great Ionian cities on the west coast of Asia Minor; situated at the entrance to the Latmian Gulf, near Didyma, *pp.* 3-4, 13, 18, 33, 40, 61, 74, 85-86, 92, 339; *fig.* 56-57, 80, 409-413.

MINOE, *p.* 92; *fig.* 83.

MINOTAUR. Monster with a man's body and the head of a bull; the son of Pasiphaë, the wife of Minos. He was shut up in the Labyrinth and every year received as tribute seven youths and seven maidens from Athens. Theseus killed him, and thus delivered the Athenians, *p.* 142.

MITHRIDATES IV PHILOPATOR. King of Pontus (170-150), *fig.* 379.

MITHRIDATES VI EUPATOR, known as THE GREAT. King of Pontus in the north of Asia Minor (120-63). His ambition was to dominate the entire Greek world. To achieve this end he needed to get rid of the Romans, and he set about doing so with ruthless determination. His policy, and the audacity with which he implemented it, brought him important initial successes. The Italians in the province of Asia were massacred, a landing was made on Delos, and Athens rallied to his side. Sulla, however, re-asserted Rome's domination in 85 B.C. and in the new war which broke out in 74 Lucullus, followed by Pompey, finally destroyed Mithridates' hopes. In 63 he was betrayed by his son and had himself killed by a soldier, *p.* 324; *fig.* 384.

MNESICLES. Athenian architect who supervised the construction of the Propylaea on the Athenian Acropolis between 437 and 431, *pp.* 7, 81.

MODULE. Basic dimensional measurement which served as a unit for determining the type and proportional composition of any edifice, *pp.* 13, 27, 37.

MUSES. Daughters of Zeus and Mnemosyne (Memory), these nine sisters presided over all forms of intellectual and artistic expression, *pp.* 243, 247, 264, 291-292; *fig.* 258, 315, 380.

MUSEUM (Mouseion). Originally a sanctuary dedicated to the Muses. Such 'museums' became increasingly important during the Hellen-

istic period; sovereigns took a personal interest in them, making them a meeting-place for philosophers, astronomers, scholars and poets, and endowing them with libraries, some of which (Alexandria, Antioch, etc.) were of considerable importance, *p.* 243.

MUSTAPHA PASHA. Small necropolis consisting of seven hypogaea (underground chambers), discovered in an eastern suburb of Alexandria, *pp.* 54, 103; *fig.* 51, 96.

MYRINA. Ancient Greek town of the Aeolid in north-west Asia Minor, 25 miles south of Pergamum. During the Hellenistic period, it possessed some fairly important *ateliers* which turned out terracotta statuettes, *p.* 140; *fig.* 272, 309, 315, 345.

MYSIA. District in north-west Asia Minor, cradle of the kingdom of Pergamum, *p.* 266; *fig.* 305.

NAISKOS. Small edifice, generally of a votive or funerary nature, built to resemble a miniature temple or temple façade, *p.* 159.

NAOS. That part of a temple formed by the cella, the front vestibule (pronaos) and the opisthodomus, inside the peristyle colonnade, *pp.* 6, 8, 37.

NAUCYDES. Argive sculptor of the second half of the fifth century. Our literary sources credit him with various statues of gods and of mortals, including one which portrayed Phrixus sacrificing the ram, and a 'Discus-thrower' (Discophoros), of which a later surviving piece may be the reproduction, *p.* 216.

NAXOS. Greek island, the largest of the Cycladic group, *pp.* 146, 292.

NECROMANTEION or MANTEION. Oracular chamber in the temples of prophetic deities, *p.* 40; *fig.* 36-38.

NEREIDS. The fifty daughters of Nereus, the sea-god, and Doris. Friendly nymphs who gave assistance to sailors and lived at the bottom of the Ocean. Their statues adorned the funerary monument at Xanthos which is named after them, *pp.* 27, 50, 52, 288, 339.

NEREUS. Son of Pontus and Ge; father of the Nereids, *fig.* 300.

NICIAS. Athenian painter of the second half of the fourth century, highly esteemed for his rendering of the play of light and shade on bodies, *pp.* 97, 105, 136.

NIKE. Greek personification of Victory, regarded as being of divine essence, *pp.* x, 287-288, 290; *fig.* 254, 288, 311.

NIKEPHORIA. Festival in honour of those deities (at Pergamum, Zeus and Athena) who 'bring victory', *p.* 265.

NILE. The great river which waters and fertilizes Egypt. Found as a setting for numerous picturesque scenes in Alexandrian art of the Hellenistic era, *pp.* 162, 177, 181, 308, 310; *fig.* 165-167, 181-186.

NIOBE. Daughter of Tantalus and wife of Amphion, by whom she had seven sons and seven daughters. Proud of her abundant offspring, she challenged the goddess Leto, who had given birth to two children only, Apollo and Artemis; the latter avenged their mother by killing Niobe's children, the Niobids, with their arrows, *pp.* 136, 243, 259; *fig.* 136, 381.

NYMPHAEUM. Literally, an edifice consecrated to the Nymphs. In Roman architecture the name can designate any monument built round a spring or fountain, *pp.* 50, 61, 69, 88, 92.

NYMPHS. Secondary deities, daughters of Zeus, who dwelt in the countryside, in woods and rivers, *pp.* 100, 176, 270, 316; *fig.* 93, 180, 316, 349, 352.

NYX (Night). In Hesiod's *Theogony* she is the daughter of Chaos, mother of Aether and Hemera (Day) and ancestor of a whole series of abstractions. She is the sister of Erebus, who personifies subterranean darkness, *p.* 271; *fig.* 293, 294.

ODYSSEUS (Ulysses). Son of Laertes, king of Ithaca, famous for his exploits during the ten-year-long Trojan War, and for the cunning

ruses which enabled him to get back home again after ten more years of wandering, *pp.* 125, 170, 333, 335; *fig.* 171, 363, 365.

ODYSSEY. Epic poem, traditionally attributed to Homer, which chronicles the adventures of Odysseus during his return from Troy to Ithaca, *fig.* 142.

OECUMENE. Personification of the inhabited world; figures, with Chronos (Time), in the scene portraying the 'Apotheosis of Homer' on the relief by Archelaus of Priene (where the sculptor gives her the features of Arsinoë III), *p.* 292.

OENOCHOE. Wine-pitcher, with a more or less convex body; often with a trefoil mouth and a slightly protruding vertical handle, *pp.* 98-99; *fig.* 89-90.

OLYMPIA. Sanctuary of Zeus, in Elis; other cults (that of Hera in particular) were also celebrated there. Every four years the Olympic Games were held there, *p.* 212; *fig.* 224.

OMPHALE. Queen of Lydia, to whom Heracles became enslaved. As her servant the hero was compelled, for a while, to lead the life of a woman, *pp.* 152-153; *fig.* 152.

OPISTHODOMUS. Term applied to the area in a Greek temple at the back of the cella; corresponds to the pronaos (which forms the entrance-lobby). The opisthodomus has no opening to the cella, *pp.* 5-6, 36-38.

ORCHESTRA. In the Greek theatre a circular, in the Roman a semicircular, space which provides room for the Chorus in front of the scene-building, *p.* 18.

ORESTES. Son of Agamemnon and Clytemnestra; with the aid of his sister, Electra, he killed his mother in order to avenge his father. After being purified of this murder he was still required to journey to Tauris with his faithful friend Pylades; there he was reunited with his sister Iphigeneia, who saved his life, *p.* 197; *fig.* 203.

ORVIETO. Town in central Etruria, half-way up the valley of the Tiber,

PHILETAERUS. An officer serving Lysimachus, who put him in charge of his war-booty. On his death Philetaerus seized this treasure, and used it to found the kingdom of Pergamum (early third century), *pp*. 70, 75, 259; *fig*. 368.

PHILIP V (*c*. 237-179). King of Macedonia (221-179), *p*. 64.

PHILISCUS. Second-century Rhodian sculptor. In Pliny's day a number of his works adorned various Roman sanctuaries; he was chiefly famous for his group of the Nine Muses. It is thought that this artist invented (or at any rate practised with notable skill) a technique for rendering transparent draperies, in such a way that other, contrasting, folds could be seen through the diaphanous material, *pp*. 291-292; *fig*. 376.

PHILOCLES. The Greek who was in 304 imposed as successor to Abdalonymus, the last Oriental-born ruler of Sidon, *p*. 237.

PHILOXENUS OF ERETRIA. Painter of the Attic school; his *floruit* was towards the end of the fourth century. The 'Battle between Alexander and Darius', which he painted for King Cassander, probably served as the model for the mosaic from the House of the Faun in Pompeii, with a closely similar theme, *p*. 116.

PHOENIX. Son of Amyntor, king of Boeotia, *fig*. 145.

PILASTERS. Squared supporting half-columns, either set against a wall or forming the frame for an architectural bay; very often adorned with decorative sculpture, *pp*. 13, 27, 28, 43, 120, 130, 136, 145; *fig*. 24, 26.

PLATO (427-347). Philosopher; born in Athens of an aristocratic family. A disciple of Socrates, and a widely travelled man, his most notable residence abroad was at the court of two successive tyrants of Syracuse, the Elder and the Younger Dionysius. He also founded the philosophical school known as the Academy, in Athens. His voluminous written works consist of 'Dialogues', including the *Apology*, the *Phaedrus*, the *Symposium*, the *Republic*, the *Laws*, etc., *pp*. 215, 315; *fig*. 223.

PLINY THE ELDER (C. Plinius Secundus; A.D. 23-79). Author of a vast Latin encyclopaedia, the *Natural History*, in which Books XXXIV and XXXV are devoted to Greek sculpture and painting. Pliny was a member of the Equestrian Order, and Prefect (Admiral) of the Fleet at Misenum, near Naples. He died during the eruption of Vesuvius which buried Pompeii, Herculaneum and Stabiae, *pp*. 111, 116, 122, 125, 150, 156, 157, 195, 204, 210, 216, 240, 299, 333.

PLUTARCH (A.D. 46-126). Philosopher and historian, born at Chaeronea in Boeotia. He studied at Athens and travelled to Alexandria and Rome, where he taught philosophy for a while before returning to his birthplace. His best-known work is the collection of *Parallel Lives* of Greeks and Romans, *p*. 116.

PODIUM. Foundation-base on which a temple stands. Access to it is at one end only, up a monumental flight of steps. Serves to distinguish a certain type of temple, originating in the East, which differs from the traditional kind with a krepis, *pp*. 5, 18.

POLYCLEITUS. Fifth-century Argive sculptor (there was another artist of the same name, who lived somewhat later). Primarily a worker in bronze, his main field of study was the standing male nude. The 'canon' (literally 'rule') he worked out was a mathematical system of proportions that were to constitute the ideal formula for this type of statue; the best-known examples are the Spearbearer (*Doryphoros*) and the Youth Binding his Head with a Fillet (*Diadumenos*). Arising out of this, he originated the *chiasmus* or crossover relationship between the torso and pelvis (shoulder lower on the side of the weight-bearing leg), *pp*. 210, 216, 299.

POLYDORUS. Rhodian sculptor (second-first century?), *p*. 333.

POLYEUCTUS. Sculptor who flourished during the first half of the third century. At the request of Demochares (280), he executed a bronze statue of Demosthenes for the Athenian Agora, *pp*. 247, 248; *fig*. 370.

POLYGNOTUS OF THASOS. Greek painter from Thasos, who subsequently acquired Athenian citizenship. It was at Athens that he spent his most vital working years, *c*. 470-440. He was the true founder of classical painting, *p*. 142.

POLYHYMNIA. One of the nine Muses, she inspired songs (hymns) in honour of gods and heroes, *p*. 291; *fig*. 310, 376.

POLYPHEMUS. The most famous of the Cyclopes, the son of Poseidon. The *Odyssey* tells us how he kept Odysseus and his companions prisoner in his cave with the intention of devouring them; but the survivors managed to put out his single eye, and so got away. He is equally well-known, however, for his jealous love for Galatea: when the beautiful maiden chose the shepherd Acis rather than him, he crushed both lovers beneath a rock, *p*. 262.

POMPEII. Town in Campania, towards the southern end of the Bay of Naples. During the Roman period it enjoyed a certain importance, both as a commercial centre and as a residential area. Its wealthier houses were often decorated with paintings and mosaics which drew their inspiration from earlier Greek originals. The eruption of Vesuvius in A.D. 79 ensured their preservation, *pp*. 114-118, 122-125, 136, 139, 140, 142, 145, 148, 156, 162-164, 170-172, 181, 183, 197-198, 292, 301; *fig*. 114-118, 121, 123-125, 135, 136, 138-142, 144, 145, 147-154, 165-167, 169, 173, 174, 177, 179, 189, 190, 195-206, 208, 328.

PONTUS. Kingdom in Asia Minor, on the Euxine (Black Sea), *p*. 324.

PORPHYRION. Giant who, during the Gigantomachy, conceived a violent passion for Hera which gave Heracles the opportunity to kill him, *fig*. 287.

POSEIDON. One of the chief Olympian gods, son of Cronos and Rhea, brother to Zeus; lord of all seas and waters, *pp*. 250, 266, 268, 300; *fig*. 325, 327.

PRAENESTE (PALESTRINA): Town in Latium, 23 miles south of Rome,

celebrated for its temple of Fortuna Primigenia and the 'landscaping' of its sanctuary on stepped terraces early in the first century, *pp.* 76, 172, 177, 181, 187; *fig.* 181-186, 188.

PRAXITELES. Fourth-century Athenian sculptor, son of the Elder Cephisodotus. He spent most of his life in Athens, where he worked in both bronze and marble, with a preference for the second. He entrusted the painter Nicias with the task of painting his marble statues. Our literary sources credit him with numerous cult and ex-voto statues for Athens, Boeotia, Olympia, Mantinea and the cities of Asia Minor; his best-known work was the 'Aphrodite of Cnidus'. The Hellenistic period was profoundly influenced by his artistic achievement, *pp.* 66, 225, 243-244, 251, 253.

PRIAPUS. Son of Dionysus and Aphrodite, god of Fertility (afterwards of Viticulture and Horticulture) and protector of gardens. His main distinguishing feature was an enormous and permanently erect phallus, *p.* 188; *fig.* 196.

PRIENE. Ancient city of Ionia, on the Aegean; its ruins lie about 75 miles south of Izmir, *pp.* 7, 13, 23-25, 33, 38, 40, 50, 92; *fig.* 17, 34, 35, 82.

PRONAOS. Monumental vestibule giving access to the cella, the interior chamber of the naos; generally embodies two columns set within the antae (or free extremities of the walls of the cella), *pp.* 6, 9-11, 13, 28, 36-38; *fig.* 4.

PROPYLAEA. Monumental entrance, consisting of a porch, with columns, in front of a doorway. Written with an initial capital, the term designates the edifice built by Mnesicles between 437 and 431, on the Athenian Acropolis, *pp.* 7, 22, 61, 69, 81, 83, 91.

PROPYLON. Monumental doorway giving access to a sacred precinct, *pp.* 61, 72, 74, 79, 88; *fig.* 55.

PROSTYLE. Term applied to a detached colonnade set in front of the cella or a monumental entrance – as opposed to columns *in antis*, *pp.* 8-9, 36, 61, 81, 83.

PROTOGENES. Celebrated Greek painter, a contemporary of Alexander the Great. Originally from Asia Minor, he worked for the most part at Rhodes and was highly esteemed by Demetrius Poliorcetes, *p.* 111.

PROTOME. Term used to describe a piece of decorative sculpture, generally in the form of an animal's head (as a wall-bracket, etc.), *p.* 28.

PSEUDO-DIPTERON. A dipteral ground-plan in which the peristyle's interior row of columns has been omitted to make the gallery wider, *pp.* 7, 33, 37-38.

PSYCHE. In Greek *psyche* means, literally, 'the soul'. The tale of Psyche's s love-affair with Eros, as recounted by Apuleius, involves the young girl in a series of ordeals and dramatic episodes which, however, lead finally to a happy marriage. Behind the story we may perhaps infer a Platonic myth symbolizing the fate of the soul, which – after many setbacks and hazards – is united for ever with Divine Love, *pp.* 315-316; *fig.* 347.

PTOLEMAÏS. A member-city in the confederation of Cyrenaica, famous for its palace, the so-called 'Palazzo delle colonne' (first century), *p.* 27.

PTOLEMIES. Dynasty of Greek sovereigns who reigned over Egypt after the death of Alexander (also known as the Lagids, this being a reference to Ptolemy I's father, Lagus). The dynasty's founder, Ptolemy I Soter, who ascended the throne in 323, had a hard struggle to safeguard (and later to extend) his authority in the eastern Mediterranean basin. But the Egyptian empire, under his successor Ptolemy II Philadelphus (283-245), was beyond any doubt the wealthiest and liveliest of all the Hellenistic Kingdoms, and Alexandria a brilliant centre of art and culture, *pp.* 3, 69, 194, 237, 243, 308; *fig.* 373.

PTOLEMY III EUERGETES (246-221). Under this monarch Egypt was still at the height of her glory, but the king pursued an expensive and dangerous policy of intrigue (backed by military aggression) against his foreign rivals, *p.* 259.

PTOLEMY IV PHILOPATOR (221-203). His reign began brilliantly, with a victory over Antiochus at Raphia (217); but problems were emerging both at home and abroad. In particular, the growing power of Rome threatened Egypt's prestige, *p.* 292.

PTOLEMY V EPIPHANES (203-181). His reign was marked by brutality at home, with the savage repression of several popular uprisings, and by a vacillating, ineffectual foreign policy. As a result Egypt's greatness soon declined, *p.* 308; *fig.* 335.

PTOLEMY VI PHILOMETOR (181-145). Despite every kind of trouble and conflict with his own brother, he worked hard to restore the dynasty's fortunes and regain the confidence of his subjects. He scored some valuable military successes in Syria. After him Egypt had no further leaders worth the name to set a limit to Rome's ambitions, *p.* 308; *fig.* 340, 341.

PTOLEMY VII. King of Egypt (145-116); son of Ptolemy VI, *fig.* 344.

PYCNOSTYLE. Arrangement of columns in a portico in which the intercolumniation was equal to $1\frac{1}{2}$ times the diameter of the foot of the column, *p.* 34.

PYLADES. Son of Strophius; cousin and friend of Orestes. He married Electra, *p.* 197; *fig.* 203.

PYRRHUS (*c.* 318-272.) King of Epirus (295-272) celebrated for his expeditions against Rome – in particular for the support he gave Tarentum and Magna Graecia against Rome's growing ascendancy, *p.* 3.

PYTHEUS. Well-known fourth-century Ionian architect who designed the temple of Athena at Priene and worked on the Mausoleum of Halicarnassus, *pp.* 4, 7, 13, 23-24, 27, 50.

PYXIS. Cylindrical or spherical box with lid, made in terracotta, *pp.* 100, 132, 188; *fig.* 91, 93, 130, 193.

RED-FIGURE. A pictorial technique invented by Attic ceramic artists about 530, it involves outlining the figures on the clay and then painting

in the background with black, so that they stand out in light reddish-brown. During the fourth century, especially on Italian-Greek pottery, we find these 'red figures' enriched with generous touches of additional colour – especially white, yellow, and red. The technique passed out of use towards the end of the fourth century, *pp*. 98, 100, 103.

REGULA. Vitruvian term denoting the smooth band with guttae, found beneath the upper edge of the architrave under each triglyph in the Doric entablature, *p*. 54.

RHAMNOUS. Attic fortress 9 miles north of Marathon and opposite Euboea: part of the east coast defences. Famous for its sanctuary and temple of Nemesis, *p*. 225.

RHEA. Wife of Cronos and mother of the Olympians, *fig*. 297.

RHODES. Most important island in the Dodecanese, in the south-east part of the archipelago; originally colonized by the Dorians. Also the name of the island's chief city, *pp*. IX, 3, 83-84, 240, 247, 285, 287, 296; *fig*. 273, 308, 310, 316.

RHODOPE, *fig*. 228.

ROME, *pp*. 4, 34, 76, 167, 170, 183, 221, 287, 300; *fig*. 156, 171, 172, 187, 256, 277, 283, 320, 323, 347, 350, 362, 380, 381, 385.
Esquiline, *pp*. 170, 181, 187, 333; *fig*. 171, 172; Farnesina, villa built in the early sixteenth century by B. Peruzzi for A. Chigi, the banker; it stood at the foot of the Janiculum and in its gardens the remains of an important villa (*c*. 30 B.C.) were discovered (1879), complete with stuccoes and paintings, *p*. 146; *fig*. 146; Marcus Aurelius' Column, *p*. 285; Trajan's Column, *p*. 285; Vatican, Sistine Chapel, *p*. 272.

SALAMIS (CYPRUS). Ancient capital of the island of Cyprus, situated on the east coast. Demetrius Poliorcetes won a great naval victory over Ptolemy's fleet there (306), *p*. 237.

SAMOS. Ionian island lying closest to the coast of Caria (Asia Minor); celebrated for its sanctuary of Hera, *pp*. 6, 8, 27, 33.

SAMOTHRACE. Island in the Aegean Sea, close to the Thracian coast. Great sanctuary of the Cabeiri, *p*. X, 17, 287, 290; *fig*. 11, 311.

SAPPHO. Greek poetess born on Lesbos before the end of the seventh century. Here she directed a kind of institute for young girls of high birth, consecrated to the Muses, the Graces, and Aphrodite. Her lyric poems addressed to girls and lovers describe her feelings with passionate intensity, reaching out to include nature, indeed the whole universe, in the agonies she is undergoing, *p*. 215; *fig*. 225.

SARAPIS. Egyptian divinity of the Hellenistic period, whose cult – encouraged by the Ptolemies – marks an attempt to bridge the gap between Greek and Egyptian religious sentiment. Both Osiris-Apis and Pluto were more or less assimilated to Sarapis. In fact it was chiefly outside Egypt that the Sarapis cult acquired a following; as a result, 'sanctuaries of the Egyptian gods' multiplied throughout the Greek world and the cult of Isis enjoyed a widespread popularity, *p*. 201.

SARDIS. Capital of Lydia, famous in the time of King Croesus for its temple of Artemis (60 miles east of Izmir). Excavations have yielded important evidence about Lydian civilization, *pp*. 5-10, 24, 27; *fig*. 1-4, 18, 388-390.

SATIRICON. Novel by Petronius, the action of which is set in Campania, fairly certainly during Nero's reign, *p*. 105.

SATYR. Spirit of nature and the woods, half-man, half-animal, portrayed as a shaggy creature with goat's feet, horns and a tail. The satyrs and Sileni form part of Dionysus' train, together with the Maenads, and personify the grosser, more sensual instincts, *pp*. 148, 198, 270, 304, 316; *fig*. 208, 334, 349, 351.

SATYRUS. Fourth-century Greek athlete, *fig*. 224.

SCOPAS. Fourth-century architect and sculptor, born on Paros. He worked on the temples of Nemea, of Athena Alea at Tegea, and the Mausoleum

of Halicarnassus; he also sculpted one of the storied columns of the Artemisium at Ephesus and executed statues of gods and heroes such as Aphrodite Pandemos and Meleager. His influence was very great, *pp*. 13, 50, 201, 225, 243, 253, 339.

SCOTIA. Deep, grooved moulding which, set between two tori, constitutes the profile of the Attic-type Ionic base, *pp*. 27-28, 33, 36.

SCYLLA. Nymph whom Circe metamorphosed into a monster, *p*. 334.

SCYROS. Island in the Aegean (northern Sporades) opposite Euboea, *p*. 125; *fig*. 124, 125, 145.

SCYTHIANS. Ancient Iranian people dwelling in southern Russia, and divided into three vast nomadic tribes, *p*. 262; *fig*. 283.

SEASONS. The so-called 'Hours'; daughters of Zeus and Themis (Justice). Three in number, they presided over the vegetation cycle; at the same time they were also deities associated with order, *p*. 308.

SELENE. Sister of Helios and personification of the Moon, she traversed the heavens on a silver chariot drawn by two horses, *p*. 271; *fig*. 302.

SELEUCIDS (312-64). Dynasty founded by Seleucus, one of the Diadochi, who received Syria at the share-out of Alexander's empire, *pp*. 3, 69, 250, 299, 301.

SELEUCUS NICATOR (355-280). A former general of Alexander's. In 321 he became governor of Babylonia, Media and Persia; later (301) he annexed Syria and subsequently reinforced his own territories with those of Lysimachus in Asia Minor. Finally (281) his troops proclaimed him King of Macedonia, but he was assassinated a year later. He had earlier established his capital at Antioch on the Orontes. His successors as rulers of the kingdom of Syria are known as the Seleucids, *pp*. 204, 237; *fig*. 213, 369.

SENECA. We need to distinguish between Seneca the Elder (or Rhetorician) – born at Cordoba about 60 or

55 B.C., died between A.D. 35 and 40, a professor of rhetoric in Rome – and his son, Seneca the Younger (or Philosopher; A.D. 1-65), who was Nero's tutor but ultimately fell out of favour with the emperor and was forced to commit suicide. The latter's treatises on moral philosophy are inspired by pure Stoic doctrine, *pp*. 294, 297.

SIDE. Ancient port. Important town in Pamphylia, 47 miles east of Antalya, *p*. 92.

SIDON (SAÏDA). One of the Phoenician cities on the coast of Lebanon, 32 miles south of Beirut. Its necropolis, which lies to the east of the town, at Ayaa, was discovered in 1855 and has yielded some remarkable royal tombs and sarcophagi; the most famous is that known as the 'Alexander Sarcophagus' (Istanbul Museum), *p*. 237; *fig*. 248-250, 256, 257.

SILANION. Fourth-century Greek sculptor who executed statues of various famous living persons (Plato, the sculptor Apollodorus, Satyrus the boxer) as well as of historical celebrities (Sappho, Corinna). He also turned his hand to effigies of heroes, such as Theseus or Achilles. In his portraits Silanion aimed to achieve a true likeness, but he was also adept at expressing character and at reconstituting the 'heroic image'. According to Vitruvius (7. praef. 14), he wrote a treatise on the rules of proportion, *pp*. 212, 215; *fig*. 224.

SKYPHOS. A kind of goblet, with two small handles, either horizontal or vertical, attached to the rim of the pot, *pp*. 158, 172; *fig*. 161.

SMYRNA (IZMIR). Port on the gulf of the same name on the Asia Minor coast; well protected by the peninsula running out towards Chios. The primitive settlement, going back to the period of early colonization (first Aeolian, then Ionian), lay on the north side, near Bayrakli. During the fourth century, Lysimachus built a new town further to the south, on the slopes of Mt Pagus. The growth of this town was encouraged by the increasing prosperity of the port, *pp*. 74, 301; *fig*. 324.

SOCRATES (470-399). Socrates, from the deme of Alopeke, began his adult life as a sculptor and a highly patriotic citizen before devoting the rest of his life to philosophy. Despite the illumination which his thought and dialectical method brought to his many disciples (the most notable of whom was Plato), he found himself accused of attempting to introduce new gods and of corrupting the young – a charge which earned him the death sentence. His features have often been compared to those of a Silenus, *pp*. 212, 315; *fig*. 222.

'SOFA' TYPE, *EN SOFA*. The 'sofa' type of pilaster capital is of elongated dimensions, with a central decorative motif framed between two volutes resembling the arms of a sofa, *pp*. 13, 28.

SOPHILUS. Late third century Alexandrian mosaic artist, *p*. 159; *fig*. 162.

SOPHOCLES (496-406). Tragic poet born at Colonus, near Athens; his total output amounted to 128 plays, of which seven tragedies and a satirical drama survive today, *p*. 221.

SOSUS. Famous mosaic artist from Pergamum whose career spanned the early years of the second century, *pp*. 156-157, 183, 185; *fig*. 156, 158.

SPERLONGA. Between Gaeta and Terracina, on the west coast of Italy. A remarkable collection of fragments from large-scale sculptures was discovered there (1957) in the so-called 'Grotto of Tiberius'. They included the remains of two groups, one portraying the blinding of Polyphemus by Odysseus and his companions, the other Scylla's attack on Odysseus' ship. A Latin epigram attributes the design of the decorative relief-work to one Faustinus. The signatures of three artists are visible on Odysseus' craft: Athanodorus son of Hagesander; Hagesander, son of Paeonius; and Polydorus, son of Polydorus – all natives of Rhodes. The inscription can be dated, on epigraphical grounds, to the first century A.D., *pp*. 296, 333; *fig*. 363-365.

STABIAE. Town on the Gulf of Naples, destroyed at the time of the eruption of Vesuvius (A.D. 79). Today known as Castellammare di Stabia, *pp*. 138-140; *fig*. 137.

STOA. Gallery with one of its long sides designed as an open colonnade, *pp*. 4, 18, 40, 61, 74, 92; *fig*. 34, 76, 85, 86.

STOIC. Adherent of the philosophical doctrine worked out by Zeno of Citium (336-264), and expounded by him in Athens under the portico known as the Stoa Poikile (Painted Stoa), *pp*. 135, 248.

STYLOBATE. Forms the uppermost layer of the krepis, on which the columns of the peristyle rest, *pp*. 5, 83.

SYMMETRIA. Greek word indicating harmoniously balanced measurements, or a system of proportions such as sculptural or architectural theorists loved to work out during the classical period, *p*. 216, 221.

SYSTYLE. Arrangement of columns in a portico in which, according to Vitruvius (3.3.2.), the intercolumniation was twice the diameter of the foot of the column, *p*. 34.

TAENIA. Latin term designating the smooth band or fillet which crowns the frontal ornamentation of the Doric architrave, *p*. 40.

TANAGRA. Village in Boeotia, 12 miles east of Thebes, famous as a production-centre for terracotta figurines, *pp*. 221, 243.

TARENTUM (Taranto). Greek city in Southern Italy, on the Gulf of Taranto. During the late classical and early Hellenistic period it was the chief distribution-centre in Magna Graecia, *pp*. 98, 106; *fig*. 244, 254.

TARQUINIA. Town in Etruria which possessed an important school of painting, as is clear from a number of painted tombs, dating from the sixth up to the second century, *pp*. 106, 110, 112; *fig*. 102-104.

TAURIS. A barbarous region, located in literature at the eastern extremity

of the Black Sea, where Iphigeneia was transported by Artemis and in due course met Orestes. Historically more or less equivalent to the modern Crimea, *p.* 197; *fig.* 204.

TEGEA, *pp.* 13, 27; *fig.* 238.

TEISICRATES OF SICYON. Third-century sculptor. A pupil of Euthycrates, he was so closely linked to the school of Lysippus that, even in antiquity, it would seem people found it hard to tell some of his statues from those of Lysippus himself. One of his best-known works was an effigy of Demetrius Poliorcetes, *p.* 250.

TELEPHUS. Son of Heracles and Auge, daughter of the king of Tegea. Exposed on the mountainside as a baby, he was suckled by a doe and rescued and brought up by shepherds. He was reunited with his mother in Mysia at the court of King Teuthras, to whom he gave armed assistance against his enemies. In a fight against the Greeks (who landed in Mysia, mistaking it for Troy) Telephus was wounded by Achilles. The invaders withdrew. Telephus, however, could only be cured by the weapon which had inflicted his wound, and therefore sought out the Greeks at Aulis, where they were mounting a new expedition against Troy. He seized Orestes (then a child in arms) and, by threatening to kill him, made Achilles cure his wound. This done, he personally guided the Achaean fleet to Troy, *pp.* 50, 154, 156, 266; *fig.* 155, 305.
Telephus Frieze. Small frieze of the Great Altar of Pergamum depicting the adventures of Telephus, *pp.* 50, 282, 285, 292; *fig.* 303-305.

TEMENOS. Sacred terrain, its boundaries marked by a wall or other enclosure, *pp.* 22, 79.

TEOS, *pp.* 23-24, 38.

TEUTHRAS. King of Mysia who gave asylum to Auge, married her and adopted Telephus as his son, *fig.* 304.

THALAMUS. Term designating a kind of chapel contained within the Romano-Hellenistic temples of Syria. The thalamus was built inside the cella, and contained the cult-statue of the deity, *p.* 13.

THASOS. Island in the northern Aegean, colonized at the beginning of the seventh century by the Parians. An ally of Athens in the fifth century and latterly a subject-state of the Athenian Confederacy until 411, Thasos retained its prosperity and played an important role in the economic life of the ancient world. The painter Polygnotus was born there, *p.* 243; *fig.* 262.

THEOCRITUS. Poet, born at Syracuse about 300. Lived on Cos and in Alexandria under the protection of Ptolemy II Philadelphus. He wrote verse which portrayed familiar scenes of country or city life. His *Idylls* are among the most charming works of Alexandrian literature, *pp.* 173, 254, 259, 262, 285.

THEOGONY. Genealogy and origins of the gods. Hesiod wrote a long poem on this topic in the second half of the eighth century, *p.* 270.

THERON (d. 472). Tyrant of Acragas (Agrigento). His name is linked with a late funerary monument situated to the south of the hill on which the temples stand, *p.* 54; *fig.* 50.

THESEUS. Athenian hero, son of Aegeus, King of Athens and Aethra. He conquered the Minotaur in Crete and carried off Ariadne, the daughter of King Minos, whom he abandoned on Naxos while travelling home. He subsequently assumed the kingship in Athens and, later, carried off Helen, who was still a young girl at the time, but failed to make her marry him, *pp.* 103, 142; *fig.* 95, 143, 144.

THMUIS, *fig.* 162.

THOLOS. Monument with a circular ground-plan: the best-known examples are the tholos of the sanctuary of Athena at Delphi and that of the sanctuary of Asclepius at Epidaurus. Latterly the term was used to describe any comparable building, however small, *pp.* 17, 27, 33, 46.

THRACE. Barbarian kingdom along the north-east coast of the Aegean, roughly corresponding to modern Bulgaria, European Turkey and the Greek province of Thrace, *p.* 106.

THYMELA. Name of the tholos in the sanctuary of Asclepius at Epidaurus, *p.* 17.

TIMARCHUS. Brother of, and collaborator with, Cephisodotus the Younger and son of Praxiteles. Their careers spanned the last years of the fourth and the beginning of the third century. They executed a signed portrait-statue of Menander in Athens, *p.* 244.

TIMOMACHUS OF BYZANTIUM. The *floruit* of the last great Greek painter can be dated to the first half of the first century. The Romans of his day, led by Caesar in person, fought to obtain works by him, and paid huge prices for them, *pp.* 118, 167, 195, 198; *fig.* 203, 204, 206.

TIMOTHEUS. Sculptor who lived during the first half of the fourth century. Primarily a worker in marble, he provided the models for the sculptures of the temple of Asclepius at Epidaurus (except those on the pediments) and the acroteria of the west façade. He was also one of the team that decorated the Mausoleum at Halicarnassus, *p.* 201.

TINOS. Greek island in the northern Cyclades, *p.* 66.

TITANS. The male offspring of Uranus and Gaia, they belonged to the earliest generation of deities. After the mutilation of Uranus by Cronos, they assumed power; but Zeus, with a view to dethroning Cronos, fought a battle against them known as the Titanomachy, *p.* 270.

TITUS (Titus Flavius Vespasianus; A.D. 39-81). Roman Emperor, 79-81, *p.* 333.

TIVOLI, *fig.* 158, 232, 276.

TORRE ANNUNZIATA, *fig.* 263.

TRALLES. Ancient town in Asia Minor, near Aydin, *p.* 333; *fig.* 331.

TRICLINIUM. Roman dining-room containing three banqueting-couches, *p.* 136.

TRIGLYPH. Characteristic feature of the Doric frieze, consisting of three jambs divided by hollow channels and topped off with a smooth projecting band. Triglyphs and metopes alternate in the frieze, *pp.* 23, 40, 54, 61.

TRIPTOLEMUS. Greek hero, son of Celeus king of Eleusis, and Metaneira. In return for the hospitality she received from his parents during her long search for her daughter Kore (who had been carried off by Hades) Demeter gave Triptolemus a few wheat-ears and a chariot drawn by winged dragons, so that he could spread the knowledge of agriculture throughout mankind. Triptolemus' mission is represented on a relief from Eleusis, *pp.* 308, 310.

TRITON. Son of Poseidon. He aided the Olympians by making a terrible noise with his conch, thus scaring the Giants, *fig.* 299.

TROMPE-L'ŒIL. A decorative motif without any relation to an actual physical structure, *pp.* 68, 134, 142, 159, 167.

TROY. Town in Asia Minor situated near the Hellespont (Dardanelles) on the spur of Hissarlik. Captured by a coalition of Achaean allies after a ten-year siege, about 1250 B.C., *pp.* 123, 125, 170.

TYCHE. Fortune in the form of a divinity: half Providence, half Chance. She rules over the destinies of individuals, kingdoms and cities, *pp.* 237, 316; *fig.* 251.

ULYSSES. See ODYSSEUS.

URBS. The city of Rome, *p.* 114.

VELIA. A Phocaean colony established about 540 on the Tyrrhenian coast south of Paestum, near the mouth of the Alento, *p.* 40.

VENUS. In the archaeological vocabulary of the nineteenth century this name was regularly used to describe a portrait of Aphrodite (the Romans had identified the Greek goddess of love with their own deity Venus), *pp.* 256, 308, 323, 333; *fig.* 354, 357.

VERGINA. See PALATITSA.

VERRIA, *fig.* 252.

VICTORY. See NIKE.

VILLA OF AGRIPPA POSTUMUS. Important suburban villa near Pompeii, in the Campanian locality known as Boscotrecase, at the foot of Vesuvius. It dates from the early first century A.D., *p.* 175.

VILLA OF CICERO. Wealthy Pompeian residence situated near the north-west entrance to the town (Porta di Ercolano), excavated in 1763, and subsequently reburied. It probably has no real connection with the Roman orator and statesman, *p.* 140; *fig.* 139, 140.

VILLA OF FANNIUS SINISTOR. Important villa in the suburbs of Pompeii, situated in the Campanian locality known as Boscoreale, at the foot of Vesuvius. It was built and decorated with paintings about the middle of the first century, *pp.* 135, 167, 187; *fig.* 132-134.

VILLA, THE IMPERIAL. Large suburban villa situated below the ramparts of Pompeii, south-west of the town. Its construction and decoration can be dated to the first half of the first century A.D., *p.* 136; *fig.* 135.

VILLA OF THE MYSTERIES. Vast suburban villa situated north-west of Pompeii. Originally built as early as the third century, it was decorated with paintings about the middle of the first. The most notable of them – the great scene of initiation into the Bacchic mysteries – would seem to indicate that such a cult held its rituals there at this period, *pp.* 108, 135, 187-188, 197; *fig.* 195-202.

VILLA PAMPHILI. The Villa Doria Pamphili stands immediately to the west of Rome, behind the Janiculum. In its gardens were found the remains of a tomb decorated with paintings, dating from about 25, *p.* 173; *fig.* 176.

VIRGIL (Publius Vergilius Maro; 70-19). The most famous of all Latin poets. Born at Andes near Mantua, died at Brundisium (Brindisi); the protégé of Octavius and Maecenas. The *Bucolics*, *Georgics*, and *Aeneid* constitute his complete works, *pp.* 173, 246.

VITRUVIUS (Vitruvius Pollio). Roman architect of the Augustan era, who wrote a treatise entitled *De Architectura*, in ten books (*c.* 30), *pp.* 23, 33-34, 167, 170.

VONITSA, *fig.* 241.

'WOMEN OF HERCULANEUM' (Large and Small). Two draped female effigies in marble, discovered at Herculaneum between 1706 and 1713 and now in the Albertinum at Dresden, *p.* 221.

XANTHOS. Capital of Lycia in south-west Asia Minor, celebrated for its tombs, in particular that of the Nereids, or 'Nereid Monument'. Not far away was the federal sanctuary of the Lycians, the Letoön, *pp.* 27, 40, 50, 288; *fig.* 39.

XENOPHON. Attic soldier, writer and historian who lived from 425 until about 350. An aristocrat and a disciple of Socrates, he sought, in his *Memorabilia*, to draw a retrospective picture of the sage whom he had admired when young, *p.* 315.

YAZILIKAYA. Small Turkish village 57 miles south of Eskisehir, *fig.* 54.

ZEUS. Supreme god of Olympus; son of Cronos and Rhea. His most important sanctuary was at Olympia, *pp.* 18, 21-22, 28, 50, 75-76, 156, 160, 210, 221, 259, 265-267, 270-271, 333; *fig.* 221, 287, 359, 372.
Zeus Sosipolis. The epithet means 'saviour of the city'; a temple to Zeus Sosipolis stood in the agora of Magnesia-ad-Maeandrum (second century), *pp.* 36-37, 39; *fig.* 30-32.

Maps

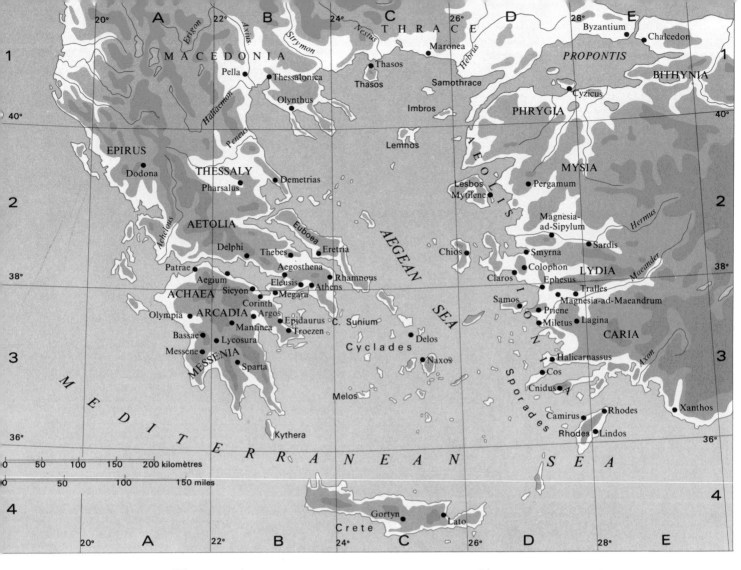

420. DIFFUSION OF GREEK ART DURING THE HELLENISTIC PERIOD (DETAIL OF GENERAL MAP).

THIS, EIGHTEENTH, VOLUME OF ‘THE ARTS OF MANKIND’ SERIES, EDITED BY ANDRÉ MALRAUX AND ANDRÉ PARROT, HAS BEEN PRODUCED UNDER THE SUPERVISION OF ALBERT BEURET, EDITOR-IN-CHARGE OF THE SERIES, ASSISTED BY JACQUELINE BLANCHARD. THE BOOK WAS DESIGNED BY MICHEL MUGUET, ASSISTED BY SERGE ROMAIN. THE TEXT WAS FILMSET BY IMPRIMERIE STUDER, GENEVA. THE TEXT AND THE PLATES IN BLACK-AND-WHITE WERE PRINTED BY LES ÉTABLISSEMENTS BRAUN ET CIE, MULHOUSE-DORNACH; PLATES IN COLOUR BY DRAEGER FRÈRES, MONTROUGE; PLANS AND MAPS BY GEORGES LANG, PARIS. THE BINDING, DE-SIGNED BY MASSIN, WAS EXECUTED BY BABOUOT, GENTILLY.